D0808801

# The Curious Life of Robert Hooke

## THE MAN WHO MEASURED LONDON

## LISA JARDINE

**HARPER PERENNIAL**

Harper Perennial
An imprint of HarperCollins*Publishers*
77–85 Fulham Palace Road,
Hammersmith, London W6 8JB

www.harpercollins.co.uk/harperperennial

This edition published by Harper Perennial 2004
2

First published by HarperCollins*Publishers* 2003

ISBN 0-00-715175-6

Set in PostScript Linotype Minion with
Janson and Trajan display by
Rowland Phototypesetting Ltd, Bury St Edmunds, Suffolk

Printed and bound in Great Britain by
Clays Ltd, St Ives plc

# CONTENTS

PREFACE     vii

INTRODUCTION: WINNER TAKES ALL     1

1 The Boy from the Isle of Wight     21

2 A Sincere Hand and a Faithful Eye     57

3 Take No Man's Word for It     86

4 Architect of London's Renewal     131

5 Skirmishes with Strangers     177

6 Never at Rest     214

7 Friends and Family, at Home and Abroad     247

8 Argument Beyond the Grave     288

NOTES     325

ILLUSTRATIONS ACKNOWLEDGEMENTS     391

BIBLIOGRAPHY     397

INDEX     415

# PREFACE

*The Curious Life of Robert Hooke* has been written to sit alongside my biography of Sir Christopher Wren, *On a Grander Scale: The Outstanding Career of Sir Christopher Wren* (HarperCollins, 2002), as a companion volume. Wren and Hooke were friends and colleagues throughout their lives, beginning in their university days. Since I discussed their scientific and architectural collaborations at length in *On a Grander Scale*, I do not rehearse the same material here, but refer the reader to my previous treatment at the appropriate points.

This book could not have been written without generous help from a very large number of scholars and colleagues. Hooke scholars are, in my experience, particularly generous in sharing their knowledge, and I have been the beneficiary of this. First and foremost, I owe a debt of gratitude to Professor Michael Hunter. His published researches have now helped shape three of my books – *Ingenious Pursuits*, *On a Grander Scale* and *The Curious Life of Robert Hooke*. In the present case, beyond the published materials, he has been a friend and counsellor, scrupulously steering me through the shoals and rapids of Hooke scholarship, and making himself freely available to give me advice whenever I asked. He has read this book in manuscript and commented on it meticulously, though any remaining errors are, of course, my own. Our fellow-authors for the OUP volume, *London's Leonardo*, Dr Michael Cooper and Dr Jim Bennett, have also given me the benefit of their wisdom, both specifically on Hooke, and in their areas of particular expertise (surveying and scientific instruments, respectively).

I would like particularly to thank Susan Snell, Archivist and Records Officer at the Natural History Museum, for her enthusiastic help in exploring the history of the portrait which I believe to be of Hooke. Rachel Jardine got me started on a biography of Hooke with the exciting finds she made on the Isle of Wight at the time when my attention was largely focused on Wren. In the course of my writing of this book, Ellie

Naughtie – archival sleuth extraordinaire – has come up with a series of breath-taking leads, most of which I have been able to follow up, and which have contributed immeasurably to redrawing the map of Hooke's life. Dr Mat Dimmock has contributed both to the research materials, and to the assembling of the pictures. Dr Jerry Brotton and Dr Alan Stewart have continued to give me constant intellectual support, way beyond anything I have a right to ask of them. Dr Rachel Holmes read the final manuscript, and gave me the benefit of her incisive comments.

Dr Stephen Inwood's biography of Hooke, *The Man Who Knew Too Much*, came out as I was writing mine. I know that his meticulously detailed book enabled me to find my own narrative voice, and to give my own book coherence and shape.

Libraries and archives are the life-blood of historical books for a general readership, just as they are of scholarly monographs. My thanks are due in particular to the librarians and archivists at the Royal Society, the Guildhall Library, the Natural History Museum, the Codrington Library, All Souls, Oxford, Trinity College Library, Cambridge, the British Library, the Wellcome Library for the History and Understanding of Medicine, Cambridge University Library, the Bodleian Library, Oxford, the Institute of Historical Research Library and the Warburg Institute Library. Gresham College hosted a series of lectures on Hooke in 2002, to which I contributed in the early stages of writing the present book, and where I met many other Hooke enthusiasts. My thanks to them for their continuous support for all things to do with Robert Hooke. My colleagues at Queen Mary, University of London, have consistently given me intellectual nurture and encouragement.

I would like to thank my agent, Gill Coleridge, for her wisdom and support. At HarperCollins I have had the privilege of working with the very best of editorial and production specialists. First and foremost, my thanks go to my editor Michael Fishwick, who is indefatigable in his support for my writing. Kate Johnson and Mary Ore have helped polish the final manuscript. Peter James is, as any author who has worked with him knows, simply the best copy editor there is, and I owe the correction of several significant errors to his vigilance. For the physical production of a beautiful book, I have been fortunate enough to have been able to work with the identical, outstanding team who produced *On a Grander Scale*: Melanie Haselden, Vera Brice, Nicole Abel, Caroline Noonan and

James Annal. In the final stages, Jim Bennett and Kate Farquhar-Thompson came to my aid to complete the illustrations.

I hope I never come to take the support and encouragement of my family for granted. This time, it seems to me, they were unusually encouraging, when I was trying to write the book, establish the new AHRB Research Centre for Editing Lives and Letters and chair the Booker prize, at the same time as fulfilling my teaching and administrative commitments at Queen Mary. John Hare knows how many crucial extra responsibilities he took on as a result, how often he stepped in to resolve a crisis entirely of my own making. He always told me it was not a problem, and we could cope, and I believed him. All my books are, in the end, for him.

## Transcription conventions

Ampersand has been retained; thorn has been silently altered to 'th'; the use of i/j and u/v has been modernised; long s has been silently altered to 's'; contractions have been silently expanded; insertions have been enclosed thus, < >; clarifications and authorial comments have been placed inside square brackets.

# INTRODUCTION

## *Winner Takes All*

> Merely because one says something might be so, it does not follow that it has been proved that it is.
>
> Newton in conversation with Hooke, concerning Hooke's claim to have discovered the inverse square law of gravitation before him[1]

The name of Robert Hooke does not have a familiar ring to it. Occasionally, should he come up in conversation, someone might recall Hooke's law of elasticity: tension = λ × extension, or as Hooke put it himself, 'The Power of any Spring is in the same proportion with the Tension thereof'.[2] They might link him to the Father of Modern Chemistry, Robert Boyle, or be dimly aware of him as Sir Christopher Wren's close friend and fellow surveyor, involved in the rebuilding of London's City churches after the Great Fire of 1666.

He is most likely to be remembered, though, as a boastful, cantankerous, physically misshapen know-all, who was somehow involved with the early Royal Society and was Sir Isaac Newton's sworn enemy. Unlike his contemporaries, Wren, Newton and Boyle, Hooke has faded, over time, from the public's imagination.

Although his name crops up regularly in English seventeenth-century histories of ideas, from anatomical dissection to cartography, and from architecture to scientific instrument-making, no single major discovery or monument (apart from the law of elasticity) is any longer securely

attributed to him. Instead, Hooke is the man who *almost* made great discoveries now tied to the names and enduring fame of others: Boyle's law of pressure of enclosed gases; Newton's inverse square law of gravitational attraction; Huygens's theory of the isochronous pendulum clock; Harrison's longitude timekeeper. Hooke is the man who had a hand in designing the dome of St Paul's and the Monument to the Great Fire, the College of Physicians and several stately homes, yet no one is sure what the nature of his input was. He designed a whole range of precision instruments and devices, none of which survive; he claimed to have developed a pocket watch precise enough to be used by astronomers and navigators, but could apparently never produce a convincing working prototype. Wren or Newton may be hailed as the genius of his Age; not so Hooke.

Biography is the art of giving shape and coherence to the life of an individual. Where the subject has a major achievement to his or her name, a life can be crafted as a 'before' and 'after' around that beacon moment. Where an individual has been prolific and varied in his endeavours and achieved a breathtaking amount, yet without leaving his lasting mark on history in the form of a single significant discovery, it is far harder to give him his place in history. Hence Hooke's shadowy presence – a man without a defining great work to give his life shape.

It is Newton's laws of motion, for instance, which guarantee his life and career its coherence and make it memorable. A precocious boy sits alone in a country orchard and observes a ripe apple drop from a tree. A young man keeps vigil far into the night, tracking the progress of a comet through a telescope from his college window. A grown man, asked what the orbit would be of a body moving under a constant attractive force inversely proportional to the square of its distance from its centre, replies unhesitatingly, 'An ellipse' – then spends almost two years obsessively repeating the mathematical calculations necessary in order eventually to demonstrate conclusively that the hypothesis is true. Once published, the world struggles with the implications of a thought beyond the comprehension of ordinary minds. Poets marvel at the grandeur of it:

> Nature and Nature's laws lay hid in night;
> God said, Let Newton be! and all was light.

Gradually, over time, such shocks to the prevailing intellectual framework become permanent alterations in the community's world-view,

and the originator of the grand idea is hailed as an intellectual giant and global hero.

Here lies the challenge for anyone who embarks on writing a life of Robert Hooke. How does one convey the genius of a man whose versatility condemned him, in each field of his interest, to miss the mark by a whisker – the man who, in the helter-skelter race to make the fundamental discoveries of modern science and technology, always took second place?

The book that follows aspires to tell a different story from the customary version of the life and brilliant career of Robert Hooke which records him as the vain, bad-tempered, quarrelsome adversary of Sir Isaac Newton. Nevertheless, Hooke's lasting reputation does derive from his having taken Newton on, in public, and lost. So, as we set out in pursuit of the wayward, idiosyncratic and elusive Hooke, how better to begin than by revisiting that critical moment in his life, in the latter half of the 1680s, when 'gravity' was the scientific topic of the moment, and the race was on to determine the laws governing the motions of heavenly bodies.

In May 1686, Edmond Halley, astronomer, sea-captain, adventurer and newly appointed Clerk to the Royal Society, wrote to Isaac Newton in Cambridge. For a period of almost two years he had been coaxing and encouraging Newton to produce for publication his *Principia Mathematica* – the great, landmark mathematical work which for the first time made public both Newton's laws of motion and his inverse square law of gravitational attraction. Halley's letter contained the good news that the Royal Society had received the manuscript of the first book of this epic work with enthusiasm, and had that week authorised Halley to publish it under its auspices:

> Sr
>
> Your Incomparable treatise intituled *Philosophiae Naturalis Principia Mathematica*, was by Dr Vincent presented to the Royal Society on the 28th [April] past, and they were so very sensible of the Great Honour you do them by your Dedication, that they immediately ordered you their most hearty thanks, and that a Councell should be summon'd to consider about the printing thereof.

So eager was the Royal Society that this great work should see the light of day, Halley continued, that it had even been agreed that they would begin printing at their own expense:

> By reason of the Presidents attendance upon the King, and the absence of our Vice-Presidents, whom the good weather had drawn out of Town, there has not since been any Authentick Councell to resolve what to do in the matter: so that on Wednesday last the Society in their meeting, judging that so excellent a work ought not to have its publication any longer delayd, resolved to print it at their own charge, in a large Quarto, of a fair letter; and that this their resolution should be signified to you and your opinion therin be desired, that so it might be gone about with all speed.[3]

There was, however, one small problem, of which Halley was anxious to inform his notoriously over-sensitive correspondent, before the news reached him from other, less circumspect informants. At that Society meeting, from which all the senior Council members had been absent (including the President, Samuel Pepys, who might have encouraged restraint), Robert Hooke, former Curator of Experiments and Secretary to the Royal Society, had protested volubly that the theoretical cornerstone of Newton's book was his discovery, not Newton's. It was he – Hooke claimed – who had first published the inverse square law of gravitational attraction, he who had brought the idea to Newton's attention. At the Society meeting, Hooke had insisted that due acknowledgement must be made in Newton's text, before it could be authorised for publication.

Halley imparted this information to Newton with obvious trepidation – he knew how volatile and disproportionate Newton's response could be to the slightest setback:

> There is one thing more that I ought to informe you of, viz, that Mr Hook has some pretensions upon the invention of ye rule of the decrease of Gravity, being reciprocally as the squares of the distances from the Center. He sais you had the notion from him, though he owns the Demonstration of the Curves generated therby to be wholly your own; how much of this is so, you know best, as likewise what you have to do in this matter, only Mr Hook seems to expect you should make some

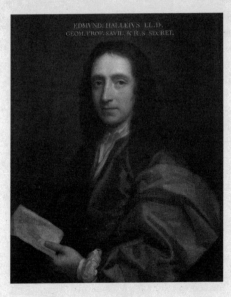

Edmond Halley, Clerk to the Royal Society, whose careful handling of the notoriously difficult Newton was responsible for the completion and publication of Newton's ground-breaking *Principia* in 1686.

mention of him, in the preface, which, it is possible, you may see reason to praefix.

Halley's nervousness here is unmistakable, as he apologises for being the bearer of such disagreeable news:

> I must beg your pardon that it is I, that send you this account, but I thought it my duty to let you know it, that so you may act accordingly; being in myself fully satisfied, that nothing but the greatest Candour imaginable, is to be expected from a person, who of all men has the least need to borrow reputation.[4]

Much to Halley's relief, Newton's initial response was measured: Hooke's outburst was not entirely unexpected, since he and Newton had failed once before to resolve the question of whether remarks of Hooke's had prompted Newton to his ultimately fruitful line of thought concerning the nature of planetary motion, in 1679. 'I thank you for what you write concerning Mr Hook,' he replied to Halley, 'for I desire that a good understanding may be kept between us.'[5]

Brooding alone in his rooms at Trinity College, Cambridge, however, Newton had second thoughts. Three weeks later he wrote to Halley

using far less conciliatory language, and stating unequivocally that he owed Hooke no acknowledgement whatsoever in the business of gravitational theory. His change of heart was occasioned at least in part (as Halley had feared) by his having received other accounts from London of Hooke's behaviour at the Royal Society meeting. These had informed him that Hooke had made a 'great stir pretending [Newton] had it all from him & desiring they would see that he had justice done him'. Nothing, Newton now retorted, could be further from the truth. Hooke, Newton insisted, had simply guessed at both the elliptical shape of planetary orbits and the nature of the attractive force. It had been left up to Newton, the mathematician, to determine the truth 'by the drudgery of calculations & observations'. The idea that this work was trivial compared to the original flash of inspiration incensed Newton:

> Now is this not very fine? Mathematicians that find out, settle & do all the business must content themselves with being nothing but dry calculators & drudges & another that does nothing but pretend & grasp at all things must carry away all the invention.[6]

Newton's most memorable (and frequently quoted) words on the matter follow. Rather than provide the acknowledgement Hooke was demanding, Newton threatened to suppress entirely the third book of his *Principia* – the most important and lastingly original part of his work. Exasperated that the incident was likely to continue to reverberate in scientific circles, he rejected Hooke's originality in the matter in brutal terms. The judgement, on the evidence available, was ungenerous and unjust. It has, however, stood for three hundred years:

> And why should I record a man for an Invention who founds his claim upon an error therein & on that score give me trouble? . . . Should a man who thinks himself knowing, & loves to shew it in correcting & instructing others, come to you when you are busy, & notwithstanding your excuse, press discourses upon you & through his own mistakes correct you & multiply discourses & then make this use of it, to boast that he taught you all he spake & oblige you to acknowledge it & cry out injury and injustice if you do not, I beleive you would think him a man of strange unsociable temper.[7]

The damning verdict stuck. For most historians, Hooke has been 'a man of strange unsociable temper' ever since.

Outraged by Hooke's conduct, Newton proceeded to remove his rival's name, wherever any acknowledgement to him whatsoever occurred in the manuscript of the third book of *Principia*, which he had yet to submit to Halley for scrutiny. At the beginning of Book 3, Newton struck through the acknowledgement of Hooke 'and others of our nation' for making the original suggestion that planetary motion was a combination of a forward motion and an attraction towards the centre of rotation. In his discussion of the orbits of comets, which included a reference to 'Clarissimus Hookius' ('most distinguished Hooke'), he reduced the acknowledgement to a bare minimum by crossing out the 'most distinguished'. In the end, he deleted all but the most perfunctory of references to Hooke.[8]

What is there to be said on Hooke's side of this quarrel?

Most of what we know about their disagreement comes from Newton's well-documented and much discussed point of view.[9] That well-rehearsed story inevitably hinders the reconstructing of the case for the other side. What we can discover of Hooke's feelings on this occasion – his actual feelings, as opposed to the loud formal complaints he made – is fragmentary and inconclusive. But we are able to get a sense of the intensity of the affront he felt at being, in the end, almost entirely edited out of the official story of the law of gravitation.

Hooke was in no doubt that he had made an important contribution to Newton's evolving thought on planetary motion and gravitational attraction, and thus deserved a mention in the final, formal presentation of the laws of planetary motion, whose huge scientific significance he undoubtedly understood. He had, he believed, published a clear statement of these in 1674, at the end of his description of an experimental attempt to prove the motion of the earth around the sun, using a zenith telescope set up in his lodgings at Gresham College (*An Attempt to prove the Motion of the Earth*).[10]

He was intensely disappointed to find that the scientific community was unconvinced, on the ground that what he had published fell short of a proper proof and amounted to no more than a statement of a supposition. Hooke felt humiliated in the London social circles, the salons, coffee houses and dining rooms in which he – a bachelor without

PHILOSOPHIÆ

NATURALIS

PRINCIPIA

MATHEMATICA

Autore JS. NEWTON, Trin. Coll. Cantab. Soc. Matheseos
Professore Lucasiano, & Societatis Regalis Sodali.

IMPRIMATUR·
S. PEPYS, Reg. Soc. PRÆSES.
Julii 5. 1686.

LONDINI,

Jussu Societatis Regiæ ac Typis Josephi Streater. Prostat apud
plures Bibliopolas. Anno MDCLXXXVII.

Flamsteed's inscribed copy
of Newton's *Principia*, a gift
from the author.

a home life – moved on a daily basis. The figure he cut there, as a minor celebrity among the gentlemen-about-town eager to be briefed on matters technological and philosophical, was, he believed, permanently damaged by what he saw as Newton's high-handedness.

On this as on a number of other occasions during his Royal Society career, Hooke considered himself to have been thoroughly let down by those he had considered friends among the members, who had failed to support him or to come publicly to his defence. They had formed themselves, over the years since the Restoration of Charles II, into a band of 'virtuosi' – gentlemen scientists with ingenuity and flair, and an aptitude for inventing useful devices and scientific instruments. They shared information and exchanged recipes for therapeutic remedies, chemistry and cookery. The Royal Society was their 'club' – their social meeting place, and where they exchanged ideas.

Sir John Hoskins – the man who, from the chair, had welcomed the arrival of Newton's manuscript with such enthusiasm – was an old coffee-house companion of Hooke's, and close friend. He and Hooke had been at school together. After the meeting, those who had attended

adjourned to a favourite watering-place near by, where Hoskins and others told Hooke he had only himself to blame for not publishing his discovery in full, earlier: 'If in truth he knew of it before [Newton], he ought not to blame any but himself, for having taken no more care to secure a discovery, which he [now] puts so much Value on.' Hooke's friendship with Hoskins, according to Halley, was permanently damaged: 'They two, who till then were the most inseparable cronies, have since scarce seen one another, and are utterly fallen out.' Hooke treated Hoskins's failure to back him as a personal betrayal (though in spite of what Halley told Newton, the two were swiftly reconciled).[11]

This public show of lack of confidence could not have come at a worse time for Hooke. A few months earlier, a series of scurrilous attacks on Hooke's scientific integrity in exchanges of letters between another old adversary of Hooke's, the distinguished Polish astronomer Johannes Hevelius, and various correspondents had been reprinted in the *Philosophical Transactions*, the journal of the Royal Society. These contained frank and insulting remarks by Hevelius on Hooke's competence as an observational astronomer, and on his inability to substantiate claims he had made concerning astronomical data and discoveries.[12]

The directness of this attack against a long-standing member of the Royal Society, aired in the pages of the Society's own journal, was shocking, and deeply offended Hooke. In the ensuing row, the two honorary Secretaries of the Society in charge of publications, Francis Aston and Tancred Robinson, resigned. In their place, Edmond Halley resigned his FRS to take up a new, salaried post of Clerk, with responsibility for publications. Since Halley was a man of means, in no need of the stipend, it seems likely that he allowed his name to go forward for this post because he – like Thomas Gale and John Hoskins, who replaced the two honorary Secretaries – was a man acceptable to the victim of the published insults, Robert Hooke.[13]

The recycled Hevelius slurs may actually have had their own part to play in the row between Hooke and Newton, in which the tone of Newton's remarks was particularly *ad hominem* and insulting. The reclusive Newton had no direct contact with the Royal Society at this point in his life, nor did he attend its meetings. Like many out-of-town virtuosi, however, he did have regular access to the *Philosophical Transactions*, on which he largely relied to keep him up to date on the Society's activities. The cutting remarks Newton made to Halley regarding

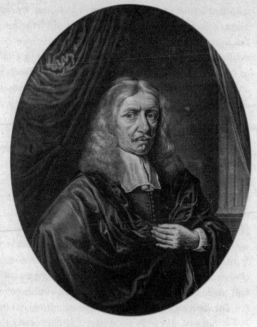

Johannes Hevelius, the great astronomer from Danzig, who clashed with Hooke over the usefulness or otherwise of telescopic sights for accurate observation of the heavens.

Hooke's scientific and mathematical competence are all too close in tone to those he will have read, six months earlier, in the pages of the Royal Society's own journal.

Long after the initial fuss had died down, Hooke remained convinced that he had 'discovered' the universal inverse-square law of gravitation, and deserved some of the laurels publicly heaped upon Newton. On Friday, 15 February 1689, Hooke and Newton met by chance at Halley's house. Hooke recorded in his diary that he had once again tried to raise with Newton the matter of his being publicly acknowledged as one of the contributors to gravitational theory. He was roundly rebuffed by Newton, who 'vainly pretended [his] claim yet [would not] acknowledge my information. Interest has noe conscience.'[14]

Newton brushed Hooke's claim aside with an old Latin tag from the logic manuals: 'Merely because one says something could be so, it does not follow that it is so.' The meaning in this context is clear. In

Newton's mind, priority lay with the person who had produced the mathematical proof of the elliptical motion of the planets, not the one who had proposed such a motion hypothetically in conversation, as part of a broad speculative discussion of planetary movement.

The rebuff continued to rankle. Later that year, on 15 September 1689, Hooke's friend John Aubrey wrote a letter to Anthony à Wood, who was compiling a compendious memoir of Oxford alumni, urging him to attribute the inverse square law, for posterity, to Hooke as its rightful originator:

> Mr Wood!
> This [the inverse square law] is the greatest discovery in nature, that ever was since the world's creation: it never was so much as hinted by any man before. I know you will doe him [Hooke] right. I hope you may read his hand: I wish he had writt plainer, and afforded a little more paper.[15]

In fact, we know that this letter to Wood was choreographed by Hooke himself – the surviving manuscript of Aubrey's letter is closely annotated with technical explanations and inserted passages in his own hand. Although during this period Hooke was particularly busy with surveying and building projects in his capacity as City surveyor and architect, as well as his scientific and Royal Society obligations, he found the time to insert the necessary supporting technical details in this letter to make sure the case was well put.[16]

Wood was to discover that Aubrey's contributions to his manuscript could land him in serious trouble – an interpolated comment concerning the first Earl of Clarendon resulted in Wood's imprisonment and his book being seized and burned. In Hooke's case, he chose to take no notice of Aubrey's support for a known close personal friend, with whom he frequently lodged, and who had lent him substantial sums of money. Once again, Hooke's hopes that posterity would learn of the crucial part he had played in one of the founding laws of modern science were dashed.

Early the following year, Hooke created one more opportunity to put the priority of his claim over Newton's in the matter of the inverse-square law on the official record. He interpolated another attempted vindication of himself into a Royal Society lecture delivered on 26 February 1690.[17] Newton, he declared with feigned innocence, had 'done [him]

the favour to print and publish as his own Inventions' Hooke's discovery of the properties of Gravity:

> And particularly that of the Ovall figure of the Earth was read by me to this Society about 27 years since upon the occasion of the carrying the Pendulum Clocks to Sea and at two other times since, though I have had the ill fortune not to be heard. And I conceive there are some present that may very well Remember and Doe know that Mr Newton did not send up that addition to his book till some weeks after I had read & shewn the experiments and demonstrations thereof in this place.[18]

Newton, Hooke went on, had promised that he would do him justice, but had in fact done 'Just nothing', and instead had made 'a pretence of falling out and being much offended with me who should dare to chalenge what was my owne'. Those present, and the Society in general, chose studiously to ignore Hooke's remarks.

By now, however, Hooke's tone has an edge of hopelessness to it. In the same lecture, he makes a moving plea to have his scientific contributions over the years recognised:

> And though there have been Diverse who have Indeavoured to Represent me to the world as one that hath done nothing towards the Advancement of Natural knowledge and that the same passes under the Name of the Declaration of this Society in the transactions[19] yet I hope In time I may obtain a Declaration of it to the Contrary, which is a peice of Justice which I am confident they will not Deny to any other person whatsoever. For though I had done nothing Els yet I conceive that Discovery of the Cause of the Celestiall motions to which neither Mr. Newton nor any other has any right to Lay Clayme might have been argument sufficient to have hindred such Expressions. Since I conceive it to be one of the greatest Discoverys yet made in Naturall Philosophy.[20]

His appeal went unheeded – for the members listening, here was simply one more occasion on which Hooke made extravagant claims to his own priority. His hope of vindication was, it turned out, vain.

\*    \*    \*

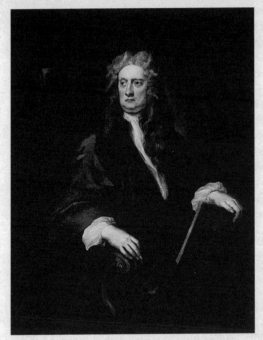

Sir Isaac Newton at the height of his powers and influence. By 1690 he had become a formidable figure in London political life. Hooke, characteristically, continued to challenge his preeminence as an experimental and theoretical scientist.

Hooke never obtained his acknowledgement from Newton, and posterity has seen fit to accept Sir Isaac's partial, self-interested verdict on Hooke, as a man who lacked the mathematical genius to turn a good idea into a great reality. Here, then, is the challenge as we take a fresh look at the life of Robert Hooke. The biographer's task, faced with the man who thought of the grand idea second, is to find a way of accommodating him to a universe already framed to fit the winner. At the time, both Hooke and Newton were highly regarded by their scientific colleagues – Hooke, indeed, the better known and more respected. Newton was known to be the better mathematician, Hooke the more able experimentalist. Both were accomplished instrument-makers; both were regarded as 'ingenious' – intellectually original and innovative.

Winners and losers in the race to define the motions of the planets were, as in any other race, engaged in a pursuit of fame and fortune in which chance, and the actions of others, played an important part. But the achievement of Newton's *Principia* permanently obscures our access

to the life and times of the two men, in one London intellectual arena. In what follows I shall try to retrieve Hooke and his genius, and give him back the status he undoubtedly deserves today, as a groundbreaking thinker and brilliant experimentalist, a founding figure in the European scientific revolution.

My own scholarly interest in Robert Hooke goes back some time. While I was researching a general book on the English scientific revolution in the 1990s, Hooke's extraordinary talents and oversized personality played a significant part in my story at a number of points, in connection with clocks and watches, scientific instruments of all kinds, innovative building methods and anatomical dissections. He took a leading role in developments in each area, yet in each he was somehow overshadowed in the end by a more familiar figure from the pantheon of 'great' men of science.

When I came to research a biography of Hooke's lifelong friend Sir Christopher Wren, I found the same thing happening. Hooke would enter the story, exercise his extraordinary influence, and then withdraw once more to the sidelines. In *On a Grander Scale* I argued that the collaboration between Wren and Hooke in significant and diverse areas of Wren's activities – architecture, engineering, town planning, astronomy, microscopy, anatomy, mathematics – was so close that often it is difficult to decide whose was the greater creative contribution. The talents of the two men were complementary, and their working partnership a remarkable one, which allowed both men to develop their ideas, and put them into practice, to arrive at outcomes beyond anything they might have achieved individually.[21] And yet (I noted there) major architectural works like the Monument to the Great Fire and the Greenwich Observatory have consistently been attributed to Wren as sole design architect, in spite of reliable evidence which shows that Hooke played a major role in the design and building of both.

In the realm of science, too, Wren's involvement in the Royal Society tends to be characterised as that of an original scientific mind, while Hooke's is represented as the supporting role of a technician or laboratory assistant. The meticulous records of the meetings of the early Society, however, clearly show Wren and Hooke side by side, arguing their way to an understanding of difficult ideas in science and engineering, demonstrating innovative experimental and technological outcomes,

and generally contributing equally to important advances in knowledge on a wide range of topics.

Yet even as I was deliberately bringing this fundamental partnership to the attention of my readers, the very act of writing a biography focused upon Wren meant that Hooke was once again overshadowed – relegated to a minor, subsidiary role – foil for the accomplishments and achievements of the heroic man of genius, Sir Christopher Wren himself.[22]

The obvious place to start, when I finally resolved to tackle Hooke in his own right, was Margaret 'Espinasse's biography, published in 1956, but still an important piece of work. Imagine my astonishment when, on opening it, I found that she paid special tribute to my father, Jacob Bronowski, as the person who had encouraged her to write a biography of Hooke. 'I should not have dared to undertake this book', she wrote, 'but for the encouragement of Dr. J. Bronowski ... Its existence is primarily owing to him.'[23] I recall no conversations with my father about Hooke, yet, surely, there were some, and they too must have played their part in bringing me back, again and again, to this most gifted, elusive and overlooked character.[24]

I owed Robert Hooke a book of his own, then, on a number of grounds – one which did justice to his considerable talents and influence, and allowed him space to be his own remarkable self. In the story that follows, Robert Hooke at last steps out, I hope, from the shadow of the contemporary figures who have for so long eclipsed his unique, restless, remarkable genius.

## POSTSCRIPT ON A PORTRAIT

One of the difficulties for any would-be biographer of Hooke has always been the absence of a portrait. It is hard to build a relationship with a man of whom no known physical image survives. The first thing a publisher asks, when presented with a proposal for a life of any important figure, is What did they look like? The lack of such a representation has meant, in the case of Hooke, that a story has had to be invented to cope. So deep was Newton's hatred of Hooke, we are told, that he destroyed the portrait of him (or possibly two portraits) known to have hung at the Royal Society.

We have to make do instead with Hooke's friend Aubrey's prose picture: 'He is but of middling stature, something crooked, pale faced, and his face but little belowe, but his head is lardge; his eie full and popping, and not quick; a grey eie. He has a delicate head of haire, browne, and of an excellent moist curle.' His colleague and protégé Richard Waller's later version is harsher – hardly surprisingly, as Waller knew Hooke towards the end of his life, when he had ruined his health and suffered from increasingly frequent bouts of depression:

> He was always very pale and lean, and laterly nothing but Skin and bone, with a meagre Aspect, his Eyes grey and full, with a sharp ingenious Look whilst younger; his Nose but thin, of a moderate height and length; his Mouth meanly wide, and his upper Lip thin; his Chin sharp, and Forehead large; his Head of a middle size ... He went stooping and very fast (till his weakness a few Years before his Death hindred him) having but a light Body to carry, and a great deal of Spirits and Activity, especially in his Youth.

The absence of any physical likeness at all of Hooke, let alone a likeness which might have given him the kind of dignity and presence missing from the contemporary written accounts, is particularly grave because his adversary Newton turns out to have been, in later life, a canny manipulator of his own portraiture.[25]

Two years after the publication of his *Principia*, in the wake of the storm of publicity this great work had attracted, and on the eve of his appointment to a politically significant post in London, Newton commissioned a portrait from the most fashionable painter of the day, Godfrey Kneller.[26] Newton emerged from twenty years at Trinity College, Cambridge, to establish himself as a London celebrity, man-about-town and senior official at the Royal Mint. An imposing portrait was an essential part of this social transformation, and Newton knew it:

> It was Newton's desire to assert his consequence that led him to Kneller's studio. The portrait was for 150 years less well known than other works by Kneller, but it is now widely reproduced ... The 1689 Kneller portrait gives us an apparently uncluttered Newton plainly dressed, with a full head of his own hair, intense and abstracted, an uncompromising, rigorous and unworldly

thinker – an appropriate household god for an academic community.[27]

Kneller painted Newton again in 1720, at the height of his fame, this time in a full-bottomed periwig, rather than his own hair. Paintings, engravings, busts, medallions and coins of Newton disseminated the image of Sir Isaac Newton, scientific genius, worldwide. The loss of the portraits of Hooke is all the more troublesome as a consequence. Once again Newton appears to have outsmarted his adversary.

My own view has always been that Hooke's portrait was more likely to have been mislaid or overlooked than destroyed. Galleries and private homes are liberally decorated with seventeenth-century paintings and engravings of men, once recognisable to friends and family, but who now – unlabelled – languish under the title, simply, of 'unknown'. Like all other Hooke scholars I have, for years, kept my eye open for one of those 'unknowns' who matches Aubrey's or Waller's description, to no avail.

While researching for this biography I found what I was looking for. The portrait I believe to be Robert Hooke is not labelled 'unknown', but mislabelled as 'John Ray' – the naturalist and FRS, five years older than Hooke, who introduced Hans Sloane to botany and invented the taxonomical classification of plants still in use today. The painting in question is in the Natural History Museum in London. From 1788 it hung in the British Museum, whose natural history collections (comprising the important collections of Sir Hans Sloane and Sir Joseph Banks) were transferred to its sister-museum in South Kensington upon completion of its buildings in 1880.

The portrait is by Mary Beale, and is plainly not of Ray, since many other representations of Ray survive, with which it may readily be compared. It does, however, closely match the two descriptions by Hooke's contemporaries. Comparison with portraits of the poet Alexander Pope, who also had a crooked back, shows that painting the right shoulder of the sitter significantly higher than the left – as is the case in my 'Hooke' portrait – was the conventional way of both acknowledging and discreetly underplaying spinal curvature in portraiture of the period.[28]

We know that Mrs Beale painted Boyle's portrait, and that it was Hooke who introduced Boyle to her. On Monday, 20 April 1674 Hooke

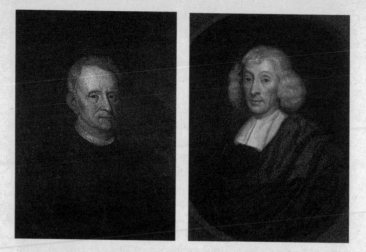

*Left* Portrait believed since the 1780s to be the distinguished botanist
John Ray, now thought to be Robert Hooke and *right* the great
pioneering botanist and taxonomist John Ray, mentor to Sir
Hans Sloane.

recorded in his diary, 'At Boyles. He promised eye water and to sit at
Mrs. Beales. At Mrs Beales. Shavd and cut hair at Youngs.'[29] So, although
Boyle did not sit on this occasion, Hooke did go to Mrs Beale's (and
tidied up his appearance later the same day). In 1674 Hooke was at the
peak of his career: he was Chief Surveyor for the City of London, and
held in great esteem by the Corporation, and by leading figures in the
East India Company. He was first officer in Wren's architectural office,
a prominent Royal Society member and its chief experimentalist. A week
before he visited Mrs Beale he had been officially retained by Sir William
Turner (President of the Board of Governors) as the architect for the new
Bethlehem (Bedlam) Hospital at Moorfields – his biggest independent
London commission.[30] It was an appropriate moment for Hooke to
have his portrait painted.

The fact that the Beale portrait is to be found today at the Natural
History Museum also makes it plausible that it may be one of the lost
Hooke portraits. We know that a portrait of Hooke once hung in the
Royal Society Repository at Gresham College, and was probably not
rehung when it moved to the new Crane Court building in 1711. It may

have entered Hans Sloane's collection from the Royal Society Repository. Sloane was President of the Royal Society at the time of Hooke's death, and a great one for acquiring collectible materials discarded by others. Certainly Newton was not anxious to have Hooke hanging in the hallways of the Royal Society. Perhaps Sloane quietly took the portrait home.

If so, he passed it as a gift to his protégé in botany, William Watson.[31] It was Watson who bequeathed the painting to the British Museum – newly established to house Sir Hans Sloane's collections – in 1787. The bequest is associated in Watson's will both with Sloane and with the Royal Society. My interpretation is that Watson considered that he was returning the portrait (which he believed to be of Ray) to Sloane's collection in its permanent resting place.

I propose to claim this portrait as Robert Hooke's, until it is proved to me that this is in fact recognisably a portrait of somebody else. Since I discovered my Hooke I confess that I have found it much easier to reconjure in my own mind the man to match the image. I hope my portrait of Hooke will make it possible for the reader of this book to do likewise. For Hooke, I believe, is a man we should learn to treat with affection, in and for himself, as well as to admire.

# 1

## *The Boy from the Isle of Wight*

> Many other things I long to be at, but I do extremely want
> time.
>
> Hooke to Robert Boyle, 5 September 1667[1]

On Saturday, 10 April 1697, a little less than six years before his death, Robert Hooke sat down with 'a small Pocket-Diary', specially purchased for the purpose, to write his autobiography:

> I began this Day to write the History of my own Life, wherein
> I will comprize as many remarkable Passages, as I can now
> remember or collect out of such Memorials as I have kept in
> Writing, or are in the Registers of the Royal Society; together
> with all my Inventions, Experiments, Discoveries, Discourses,
> &c. which I have made, the time when, the manner how, and
> means by which, with the success and effect of them, together
> with the state of my Health, my Employments and Studies, my
> good or bad Fortune, my Friends and Enemies, &c. all which
> shall be the truth of Matter of Fact, so far as I can be inform'd
> by my Memorials or my own Memory, which Rule I resolve
> not to transgress.[2]

And there, to all intents and purposes, he broke off. Was he perhaps interrupted? Did some urgent piece of business draw him away from

his task? Even in these, his later years, there were (as we shall see) so many competing calls on his time. Hooke lived his entire working life 'over the shop' at Gresham College, and anyone – from the Curator of the Royal Society, Henry Hunt, to one or other of his fellow Gresham Professors – might stop by, even outside working hours, even on a Saturday, with a scientific or technical problem to discuss, a practical task to be undertaken, or simply to exchange gossip. Hooke put his autobiography to one side, and his ambition to leave posterity a full account of his brilliant, eventful life came to nothing.

Whatever the distraction, abandoning an undertaking when he had barely begun was entirely typical of Hooke. Although he embarked on everything he did with genuine enthusiasm and with the sincere intention of carrying the task through to completion, he habitually took on too much and promised to deliver more than it was sensible for him to commit himself to. Like many other important projects he proposed for himself – in scribbled lists, on loose sheets of paper, on the flyleafs of his books, in letters to colleagues and in his diary – this one foundered on that most mundane of obstacles: lack of time and opportunity to complete it.

All that Hooke's literary executor Richard Waller found among his old friend's personal papers to flesh out the skeletal autobiography was a few schematic paragraphs about Hooke's boyhood and early life. They begin:

> Dr. Robert Hooke was Born at Freshwater, a Peninsula on the West side of the Isle of Wight, on the eighteenth of July, being Saturday, 1635, at twelve a Clock at Noon, and Christened the twenty sixth following by his own Father Minister of that Parish.[3]

Tantalisingly sparse, these matter-of-fact jottings at least provide a starting point. For this discarded shard of an incomplete autobiography focuses immediately on two things which shaped Hooke's life – his Isle of Wight, seaside birthplace and his beloved father's clerical calling.

For a boy born in 1635, where you came from, and what your family's religious and political convictions were, mattered a great deal. Place of origin and parental calling were both deeply bound up with English civil war, the execution of an anointed king, and the ten-year exile of the head of the Anglican Church. However far Hooke rose above his

modest beginnings, and however much he appeared to have put his origins and upbringing behind him, he carried permanently with him the mark of the dramatic political events of those early years.

Robert was the fourth and last child of John Hooke, curate of All Saints Church in Freshwater. His mother, Cecily Gyles, was from a local Isle of Wight family. Later, it would be members of her family who took care of Robert's affairs on the island, including the leasing and rent-collecting for his various properties there, after he had left and taken up permanent residence in London. Later still, they would squabble over who was to inherit his substantial legacies.[4]

John Hooke had been on the island since at least 1610 (he had gentry relations near by in mainland Hampshire).[5] His first appointment (and appearance in the records) on the island was as a 'stand-in' curate that year for the church at St Helen's, near Brading, east of Newport, where there had been an unfilled vacancy since the previous year.[6] There is no evidence that he was at this point an ordained minister, only that he was an intelligent, godly layman.[7]

Around 1615, John Hooke joined the household of Sir John Oglander, a local gentleman remembered for his colourful personal diary of the civil war years and for his unswerving loyalty to King Charles I. The Oglanders were the most prominent family on the Isle of Wight. Sir John took in young John Hooke, by now the properly appointed curate of Oglander's local church, Brading, near the family home of Nunwell, to teach his eldest son George his Latin grammar:[8]

> Afterwards, I took Mr. Hooke, curate of Brading, into my house to teach him his accidence, in which my own care and pains were not wanting. Then not long after growing to more expenses, I procured Mr. Elgor, schoolmaster of Chichester School, to come to Newport and there I placed him, where he continued 4 years.[9]

John Hooke may have remained in Sir John's employment after George Oglander had moved on to the newly improved classroom instruction at Newport Grammar School, as this reminiscence implies, since it suggests additional expenditure for 'procuring' Mr Elgor. By the time John Hooke's son Robert reached school age, Newport Grammar School had a well-established reputation, under the headmastership of William Hopkins (another close friend of Sir John Oglander).

John Hooke was High Anglican by religious conviction, one of those who revered the King as head of the established Church and administered the old ceremonies and rituals, increasingly associated with the autocratic church governance of Archbishop Laud. Sir John Oglander would have been unlikely to have taken into his household a churchman of more radical leanings. Robert Hooke continued in his father's religious footsteps throughout his life; his diary testifies to a deep, sincere Anglican commitment, and a hostility to all low-churchmen – Reformers, Presbyterians or Latitudinarians.

Sir John Oglander may have arranged a brief advantageous marriage John Hooke made in 1615, to a local widow, Margaret Lawson (somewhat older than himself), who had already seen off two husbands and who had grown-up daughters. Margaret died less than a year later, leaving John Hooke modestly endowed with her property.[10]

In 1622 John Hooke remarried, a local Brading girl, Cecily Gyles.[11] Their first child, Anne, may have been born in Brading. By the time his second daughter Katherine and elder son John were born (in 1628 and 1630 respectively), though, the couple had moved to Freshwater, a living in the gift of the Crown since the dissolution of the monasteries, where John became curate to George Warburton, in the parish church of All Saints.[12] Under James I, Samuel Fell (who was a career cleric, and had a number of livings) became rector in 1617, though he is unlikely to have spent much time there.[13] The churchwarden at Freshwater under Fell was Robert Urrey (member of another prominent Isle of Wight family, who later executed John Hooke's will as one of his 'worthy and well beloved Friends').

At the beginning of 1623, King James gave the Freshwater living to John Williams, Bishop of Lincoln, who in turn granted it to St John's College, Cambridge, on 24 March 1623. John Hooke assisted Warburton, officiating both at All Saints and at the neighbouring church of Brooke, although the residents of Brooke contested the decision that their church should be regarded as part of Freshwater parish. The first rector of Freshwater to be presented by St John's was Cardell Goodman, instituted in 1641. Goodman acquired property in Freshwater, and became resident there (combining the roles of rector and vicar). We know that John Hooke officiated alongside Cardell Goodman, because part of Goodman's testimony in the long-running saga of whether or not Brooke church was entitled to its own parson states that 'Mr. Goodman Rector

of Freshwater and his Curate have sometime officiated in the church of Brooke supplied and served that Cure in the right as was alleaged of the Church of Freshwater'.[14]

Robert Hooke was christened in All Saints Church on Sunday, 19 July, the day following his birth (not a week later, as his own autobiographical fragment records – a caution against our leaning too heavily and uncritically on personal reminiscences).[15] The baby, it seems, was delicate, and may not have been expected to survive – John Aubrey, in his *Brief Lives*, records Hooke as saying that his health was cause for concern throughout his childhood. According to Hooke's own 'memorials', as later reported by his close friend John Aubrey, he was not, like Katherine and John, put out to wet-nurse, but instead nursed at home, and indeed schooled at home until he was seven.

The five-year gap in age between Robert and his elder brother John meant that Robert was, to all intents and purposes, raised as an only son. His few recorded remarks about his childhood emphasise his solitude. By the time Robert was old enough to explore the cliffs and beaches overlooked by Freshwater village, John was already an apprentice in Newport, his sisters either occupied around the house or possibly attached to other households.[16] Robert learned his letters at home with his father. Later his father's friend William Hopkins taught him, though whether alone at home or among the other boys at Newport School is not clear. Nowhere in his scattered childhood reminiscences does Hooke ever, even once, mention his mother.[17]

Robert Hooke recalled a charmed, unconstrained childhood, marred only by occasional bouts of stomach trouble and recurrent headaches. But in 1642 that sense of security abruptly vanished. A few months before Robert turned seven, Charles I declared war on his own people at York, marking the beginning of six turbulent years of English civil wars. The Isle of Wight had historic royalist connections, but strategically 'yielded' to parliamentary occupation in 1642, without a shot being fired. The Governor of Carisbrooke Castle was Jerome, Earl of Portland, a declared royalist, who was therefore removed from his position of authority by Parliament. The Mayor of Newport demanded the surrender of the castle, which was tenanted only by Lady Portland, her children and a small number of servants. They surrendered, and the castle was kept by Philip Herbert, Earl of Pembroke until 1647, when he was succeeded by Colonel Robert Hammond.[18]

As a loyal Anglican 'clerk' (with gentry connections), Hooke's father, too, will have fallen under immediate suspicion from the parliamentary authorities, and, from the mid-1640s onwards, was under threat of eviction from his post as curate, along with his rector (a known High Anglican), as a 'delinquent' or royalist-sympathiser.[19] He probably stopped receiving any remuneration, since his income depended directly upon his rector, and Goodman was punitively taxed even before actual sequestration (the seizure of his living).[20]

Cardell Goodman was eventually ejected from the Freshwater living as a delinquent in 1651, under the standard – and in his case peculiarly inappropriate – formulation that he was a 'scandalous, ignorant or insufficient minister'.[21] By then John Hooke senior was dead, and his younger son was safely in London – never again to reside 'in the country' (as he always referred to his island birthplace) for more than brief, temporary periods.

The lozenge-shaped Isle of Wight lies just off the coast of Hampshire, separated from the south coast of mainland England by the Solent, a channel varying in breadth from two to seven miles. In the seventeenth century the island was part of the country of Southampton, and fell within the diocese of Winchester. It has always been a congenial place to live, particularly in the centre and south-west of the island (the extreme southerly coast was perpetually gale-buffeted, the northern coast marshy and inhospitable).[22] A local landowning resident, Sir Richard Worsley, described it as a kind of bucolic paradise in the eighteenth century:

> The air is in general healthy, particularly the southern parts; the soil is various, affording a greater diversity than is to be found in any other part of Great Britain to the same extent. It was many years ago computed that more wheat was grown here in one year, than would be consumed by the inhabitants in eight; doubtless its present produce, under the great improvement of agriculture, and the additional quantity of land lately brought into tillage, has more than kept pace with the increase of population.[23]

Because of its natural beauty, and comparatively easy access from mainland Europe, the Isle of Wight was already a tourist destination in the

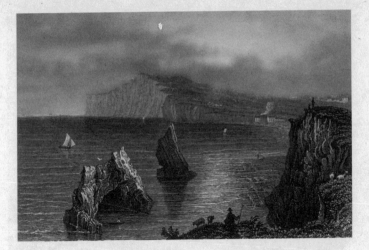

Freshwater Bay, with its dramatic cliffs and the curious chalk formations just off the beach where Hooke played as a child.

seventeenth and eighteenth centuries. In particular, its dramatic scenery attracted landscape artists from the English mainland, and also from the Low Countries, a short journey along the English Channel and across the North Sea. A surprising number of early landscape drawings and watercolours by enthusiastic foreign visitors survive, executed as part of a European artistic tour which also took in Paris and Rome.[24]

The Isle of Wight, then, provided more than a rural backdrop for the growing Robert Hooke. Its sheltered harbours and rich natural resources made it a hub for distribution of early industrial raw materials (until the American civil war, provisions for the New World were largely dispatched from here). The natural harbour of Yarmouth Haven, on which the young Hooke looked down from his home on Freshwater hill, was a thriving port, from where expectant English travellers embarked for voyages to distant, or more proximate, destinations. It was from here, in 1630, that a fleet of nine ships carrying immigrants to the New World, led by John Winthrop, set sail (Winthrop subsequently became Governor of Massachusetts).[25]

Yarmouth was a busy staging post along the route of any number of journeys, where long-distance shipping came and went, and the docks were noisy with the bustle of exotic cargoes being packed or unloaded.

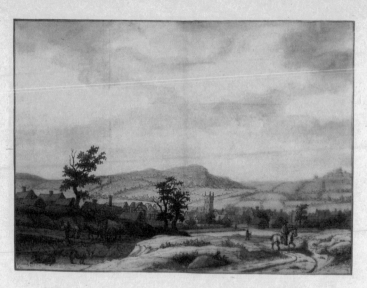

Watercolour of Newport, where Hooke went to school, by the Dutch artist Lambert Doomer, made during a sketching trip to the Isle of Wight in the 1660s.

Worsley describes, admiringly, a thriving, outward-looking community, vigorously exploiting its natural resources:

> The exports from the Isle of Wight are, wheat, flour, barley, malt, and salt; large quantities of grain and flour are shipped for France, Spain, Portugal, and the ports in the Mediterranean: and a considerable inland and coasting trade to Ireland, and all the English ports in the Channel, is carried on . . .
>
> The harbour of Cowes is as safe as any in the British Channel; and by far the most convenient for vessels bound to Holland and the east countries: it is therefore, much frequented by ships, to repair damages sustained at sea, and to winter in, until the season permits them to proceed on their respective voyages.

Like other scientific virtuosi of the period (including both Newton and Wren), Hooke is credited by would-be early biographers with a precocious ability to make precision instruments and diverting working models, even as a small boy. Hooke's, however, are specifically the

diversions of a boy by the seaside. As one of those tantalising fragments of a 'life' found by Waller records:

> Much about the same time he made a small Ship about a Yard long, fitly shaping it, adding its Rigging of Ropes, Pullies, Masts, &c. with a contrivance to make it fire off some small Guns, as it was Sailing cross a Haven of a pretty breadth.[26]

After examining the components of a brass clock, the young Hooke also (we are told) made a working clock entirely out of wood.

Ships and navigation were in Hooke's blood. Many years later, he described to his eminent employer Robert Boyle, youngest son of the Earl of Cork, a story he had been told about the way fishermen in Cornwall and Ireland surveyed the ocean from the cliff-tops, to determine where the shoals of pilchard lay:

> The story in short was this. That in those parts it is usual for a man standing on the top of some hill near the sea, to discover, where the fish lye in the sea, and which way they move, and from thence by certain signs with his feet, and hands, and hat, to direct the fishermen on the water, who can perceive nothing of what he on the mountains sees, though they be just over the shole of fish.[27]

The man on the shore who can see the shoals guides those at sea – who cannot – towards the best location for dropping their nets.

Hooke proceeds to explain to Boyle that he had 'often' used just such observation from cliff-top out to sea himself, to register the way in which the land continued to undulate as 'hills' and 'valleys', beneath the waves, although no such thing could be observed from a boat directly above, on the water:

> Such observations, somewhat like this, I remember I have often taken notice of, from the tops of hills near the sea side, whence I could perceive plainly, how far the rock ran out into the sea, though they were covered with water to a great depth, which I could not at all see, when I was on the water in a boat.[28]

At the time of writing this, Hooke was about to turn thirty. He had spent his entire adult life in London (apart from relatively short periods in Oxford, or at Boyle's Dorset country residence). The remark that he

Detail of a study of ships approaching Cowes harbour, by the Dutch artist Willem Schellinks, who visited the Isle of Wight in the 1660s.

had 'often' watched the sea, from hills high above it, reminds us of the importance of childhood for the development of the grown man. The fishing boats, chalk coastline and sea view were the familiar landscape against which he lived his boyhood – the distinctive world of his physical and intellectual development up to and into adolescence.

Newton, by contrast, who grew up in rural Lincolnshire, never so much as saw the sea in his childhood, so far as we know. Where Hooke built toy ships, Newton built toy windmills. Newton's famous characterisation of his own work, in later life, as 'only like a boy playing on the sea-shore' was a vivid image but not his own experience – and while Hooke designed practical machines for real navigators, Newton concentrated on ideal astronomical systems.[29]

In his account of the wonders of the Isle of Wight, Sir Richard Worsley singles out the therapeutic qualities of the mineral-laced waters around Freshwater for particular comment:

> In several places the springs are found to be impregnated with minerals, though none have yet attained any degree of reputation. At a place called Pitland, in the parish of Chale, there is one, which, whilst flowing, appears pure and transparent, but on stagnating deposits a white sediment equal to half its depth, and as thick as cream. This water is supposed to abound in sulphur, but it has not yet undergone a chemical analysis; cattle drink it without any ill consequence. About half a mile westward of this spring, at a place called Black Gang, under Chale cliff,

there issues a strong chalybeate water, which, by an infusion of galls, exhibits a deeper purple than is given to the water of Tunbridge wells by the same experiment.

A spring, impregnated with alum, was discovered at Shanklin, by Dr. Fraser, physician to Charles the Second; it was for some time drank, as it is said, with success; but as the reputation of these springs depend much on fashion, it was gradually disused, and at length neglected.

In later life, Hooke set great store by mineral waters, dosing himself obsessively, and recording the precise quantities and types of therapeutic effect in his diary. This may be one of the few vestigial memories of Hooke's mother's ministerings to him, as an ailing small boy. Perhaps he had developed such habits then – when his headaches and general malaise may have been treated using tried and tested local medicinal substances.

It is remarkable how many of Hooke's wide-ranging later-life interests can be found foreshadowed in the Isle of Wight's prosperous landscape. Here is Worsley again, commenting on the distinctive earths and minerals yielded by the island, and exploited elsewhere for early industrial uses:

The variety of the soil has before been mentioned; the surface in general is a strong loamy earth, but in different parts are found marle, brick-earth, gravel, tobacco-pipe and potters clay, fullers earth, red and yellow ochres, stone, of good quality, and sand of different kinds. Of the last, a fine white sort is found at Freshwater, superior to any in Great Britain, for the glass and porcelaine manufactories: great quantities of it are shipped off for London, Bristol, and Worcester.

A Bay, situated on the north side of the Needles, has obtained the name of Alum-bay, from the considerable quantities of native alum found there.

The alum, a mordant for cloth dying, from which Alum Bay got its name, was another local natural resource. As Curator of Experiments at the Royal Society in London in the 1660s and 1670s, Hooke was responsible for exploring various industrial processes (including dyeing, glass-making and felt-making) which it was felt could be enhanced using

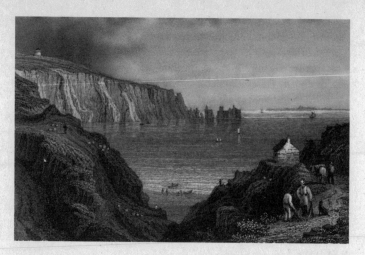

Alum Bay, a natural source for the mordant alum, vital for cloth dying.

the Fellows' theoretical understanding. Although the financier Sir John Cutler was later to claim that Hooke had given insufficient time to the 'History of Trades' in the public Cutlerian lectures he delivered, Hooke was able to show that he had fulfilled the terms of the endowment (and therefore deserved to be paid his salary arrears in full). Throughout his life, Hooke retained a sharp sense of the close liaison between raw materials and their ingenious application to manufacture.[30]

The Sand House in Yarmouth harbour (built by the Urrey family, who owned the rights to the Alum Bay sand) housed the local fine white sand before it was shipped off to the mainland to be turned into glass:

> Copperas-stones are found on the coast, in such abundance, and of so good a quality, that vessels are often freighted with them for London; and the cliffs belonging to Captain Urry, near Alum Bay, produce great quantities of white sand, which is used at London, Bristol, and Worcester, in the composition of the finer sorts of glass and porcelain.[31]

Freshwater itself was known as a source for the white clay used for manufacturing clay pipes, as well as the receptacles within which the ingredients for fine glass were heated to melting point. There may even have been glass-making on the Isle of Wight in the seventeenth century.

Hooke was fascinated with glass and with glass-blowing and lens-grinding techniques (in which he became skilled himself) throughout his life, and rightly so, as a virtuoso of the new science.[32] Of all the 'new materials' required for the explosion in scientific activity we call the English scientific revolution, quality glass-making, of fully transparent, chemically inert white glass, is of particular importance.[33]

Maps of the period also show that there was a working saltern, or salt-manufacturing plant, in Yarmouth Haven. Following a visit to the Isle of Wight in 1665, Hooke wrote a detailed lecture on salt-making, as part of a long-running Royal Society project on the History of Trades.[34] The surviving manuscript of the lecture includes a fine pen-and-ink drawing, heightened in grey wash, by Hooke, of 'the manner of making Salt at a Saltern in Hampshire'. There seems little doubt that Hooke's delightful drawing depicts the saltern he knew best, could visit with ease and draw at his leisure – the one that was only a short walk from his mother's Freshwater home.[35]

The lecture on salt-manufacture was one of a sequence of vacation lectures – the endowed Cutlerian lectures – in which Hooke undertook to 'begin the vacation with some Instances of Naturall history And to finish them with some specimina or instances in Artificiall'. Under the 'Naturall', the series had begun with a consideration of how nature produced 'figures in petrified bodies' (that is, fossils), and how sand and other substances could be turned into stone. The topic of the salt-making lecture was deliberately selected to show how closely the 'Artificiall' or man-made emulates natural processes like petrification and fossilisation. 'Now that the History of the productions of Art may not much differ from the historys I have Delivered already of the productions of Nature I have made choice of the History of making Salt out of Sea water by boyling as It is practised at the Salturnes upon the south parts of England & particularly upon the south shores of Hamshire, for the subject of this present Exercise.'[36]

Both 'natural' and 'artificial' lectures, in this case, derive their materials from a rare recent return to Hooke's family home in Freshwater. Both draw particularly vividly on Hooke's own first-hand experience.[37]

The Isle of Wight has remarkable geological features which have fascinated both visitors and locals since the early seventeenth century.[38] Both in Freshwater Bay and beyond the western end of the island, curious

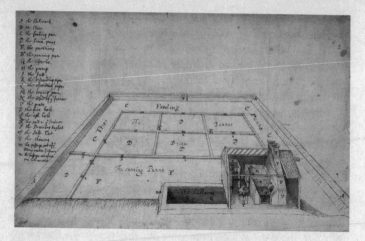

Hooke's drawing of a Hampshire 'saltern', for manufacturing salt, made during a rare return visit to the Isle of Wight in 1665.

rock formations were a constant reminder of the vagaries of geology and the erosion of matter by the relentless pounding of the waves. Already in the seventeenth century these were the endpoint – the final glory – of tourist rides along the Undercliff, the southern sweep of beach beneath the chalk cliffs. It was the tour the two Dutch artists Lambert Doomer and William Schellinks were sent on by their host Benjamin Newland in 1665:

> We returned to Newport and engaged a man who was to ride with us to show us all over the island. We left at 12 o'clock and came to Niton and from there to Onderweath [Undercliff], just across the island towards the south; there we were at the beach and could see a long way to either side along the island and the shore. From there we rode up St. Catherine's Hill, a very high hill on which an old chapel seems to have stood. There was still a tower, in which a watch is kept in wartime, and a fire at night. From this hill we could see almost all round the island as it lies in the sea.[39]

The following day, the party continued towards Freshwater Bay, with its dramatic rock arch and rock-formations. Schellinks's diary record

goes on to describe an impressive view of the Needles. Hooke must have seen just such views regularly as a boy, and have rekindled his memory of the impressiveness of his local landscape when he saw it once again in the very year the Dutch tourists visited:

> The hills we had come over were called Freshwater, 15 miles. We climbed up another hill called Needles Point, which is the extreme point towards the west. These Needles are protruding chalk hills which have some points or pyramids on their seaward ends, which are cut off from the large hill. We went to the highest point and saw from there the island north and southward almost all round us, with Yarmouth in a plain 4 miles away ... From the top we went to the tip of the island and so returned over the height, a heath for sheep, and, coming back to our horses, mounted and rode right through the middle of the island, passing many parishes and several high hills ... So we came back to Carisbrooke and, as we were so high up, let the castle lie on our right below, although the castle itself is on a reasonably high hill.

We might imagine that not much has changed on the Isle of Wight since Schellinks and Doomer took their tourist ride from Newport to Compton Bay and beyond, or since Sir Richard Worsley described his family seat in 1781. In fact, incessant violent erosion of the coastline by the waves altered the landscape before Hooke's generation's very eyes. Worsley himself draws attention to at least one dramatic change to the landscape during his own lifetime. In 1770 the most distinctive of the needle-shaped rock formations at the extreme south-west end of the 'lozenge', which give the Needles their name, and known as Lot's Wife (because of its resemblance to a pillar of salt) collapsed and disappeared without trace:

> The Western termination of this parish, and of the island, is an acute point of high land, from which has been disjoined, by the washing of the sea, those lofty white rocks, called the Needles, formerly three in number, but about seven years ago, the tallest of them, called Lot's Wife, which rose a hundred and twenty feet above low-water mark, and in shape resembled a needle,

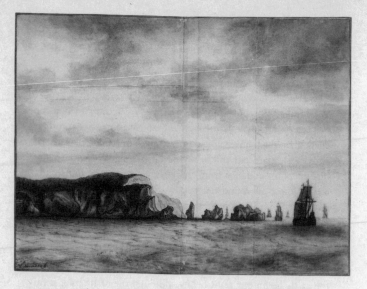

Watercolour by Lambert Doomer of ships off the Needles peninsula on the Isle of Wight, before the needle known as 'Lot's wife' fell.

being undermined by the constant efforts of the waves, overset, and totally disappeared.[40]

Engravings are all that survive to remind us that the view from the Freshwater cliffs was far more spectacular in the 1640s than it is today.[41] When Hooke described his birthplace as a 'peninsula', it was the drama of jagged chalk formations and the extended promontory of rock – his whole childhood landscape jutting peremptorily out towards the sea – that lent his locality its air of being about to break away from the rest of the island, west of the Yar.[42]

Another feature of this wind- and water-beaten coastline was the caves honeycombing the cliffs at beach level – caves we might expect any adventurous lad to have explored. Once again, Hooke fulfils our expectations, when discussing variations in types of rock formation, in terms of hardness and softness of adjacent layers. These are no mere field-trip observations made by the expert geologist – rather, here is a set of snapshot incidents of roaming the shoreline, dredged up from deep within Hooke's memory:

I remember to have taken notice in certain very high Cliffs towards the Sea side, where the Hills seemed, as it were, cleft asunder, the one half having been probably foundered and tumbled down into the Sea, the other half as it were remaining, that at the bottom, near the Water, for almost the whole length, there were very many large Caverns, which, by several Circumstances, seem'd to be made before the access of the Sea thereunto, and not by the washing and beating of the Waves against the bottom of these Cliffs; for I observ'd in many of them, that the Plates or Layers, as I may so call those parts between the Clefts in Rocks and Cliffs, to lean contrary ways, and to meet, as it were at the top like the Roof of a House, and others of them in other forms, as if they had been Caverns left between many vast Rocks tumbled confusedly one upon another.[43]

And then there were the fossils. The island's fossils are remarkable by any standards. Large ammonites and bones of extinct vertebrates like dinosaurs abound, even today, after the Victorian fossil-enthusiasts have combed the area (both Alfred Lord Tennyson and Queen Victoria herself had country homes near Freshwater). In Hooke's day the loosely consolidated strata of rock would have yielded up fossils in abundance to the schoolboy cliff-climber. Memories of those childhood geological riches can be clearly heard once again in a description Hooke gave in the mid-1660s:

To this I shall add an Observation of my own nearer Home, which others possibly may have the opportunity of seeing, and that was at the West end of the Isle of *Wight*, in a Cliff lying within the *Needles* almost opposite to *Hurst-Castle*, it is an Earthy sort of Cliff made up of several sorts of Layers, of Clays, Sands, Gravels and Loames one upon the other. Somewhat above the middle of this Cliff, which I judge in some parts may be about two Foot high, I found one of the said Layers to be of a perfect Sea Sand filled with a great variety of Shells, such as Oysters, Limpits, and several sorts of Periwinkles, of which kind I dug out many and brought them with me, and found them to be of the same kind with those which were very plentifully to be found upon the Shore beneath, now cast out of the Sea.

Similarly, the remarks he goes on to make about the way such fossil remains embedded in clay eventually solidify into fossil-rich stone are plainly based on close scrutiny over time:

> I observed several great lumps of the said Founderings lying below, some whereof, which lay next the Cliff, tho' they were somewhat harden'd together more than they were above in the Cliff, were yet not hard enough to be accounted Stone; others of them that lay further into the Sea were yet more hard, and some of the furthest I could not come at for the Water, were as hard I conceived as *Purbeck* Paving.[44]

Shortly afterwards in the same treatise, Hooke returns again, in memory, to Freshwater Bay:

> The place I mentioned before near the *Needles* in the Isle of *Wight* affords a most evident and convincing [proof] as could well be desired, which was from the following Observation. I took notice that the aforesaid Earthy Cliff did founder down and fall upon the Sea-shoar underneath, which was smooth and Sandy, and bare at low Water so as to be walked on, but at high Water a great part of it was covered by the Sea.[45]

In these fragments of vivid narrative description and recollection, we can recognise the way the landscape of the Isle of Wight entered Hooke's imagination. It was specifically this dramatic geology round Freshwater that Hooke recalled – the sheltered bay, those fossil-rich chalk cliffs, and stratified rock-formations, the curiosity of the Needles – whenever he gave close attention scientifically to matters concerning the sea, the formation of geological features or the properties of stone.[46]

The origin of such spectacular fossils as Hooke collected on the Isle of Wight was a contentious matter in the seventeenth century. Robert Hooke was one of those responsible for the clarified understanding of the relationship between natural matter and its fossilised state. The evidence on which he based his largely correct theory of fossil-formation was the fine collection of fossils kept in the Repository or collection of rarities belonging to the Royal Society, at Gresham College, which was for many years housed in Hooke's own rooms at Gresham College. But above all it was dependent upon his having studied both rock formations and fossils intensively, *in situ*.[47]

Our Dutch visitors also got excited about fossils. On his second trip to the Isle of Wight, Schellinks described in his diary how he and Doomer were taken to an island location rich with fossil wood and other petrified natural remains. The artist responded with fascination to these, in terms which sound confusingly as if he believed his guides were uncovering living trees rather than pieces of frangible rock – nevertheless, he marvelled at the beauty and fragility of these extraordinary natural specimens:

> On the 16th September we rode in the morning from Shorwell back to Brightstone and from there to the village of Brook, and down to a plain called Brook Green, from where a broad ditch, 2 or 3 miles long, runs towards the sea, which, in summer, is without water and almost dry. In the ground, or rather on both sides of this ditch, 25 or 30 feet, and nearer the sea 50 to 60 feet down below ground level, one sees and finds some very large hazelnut trees with their branches, leaves and nuts, which are fully grown . . .
>
> We took two men and a boy with us with a shovel and two pickaxes, but did not have much trouble with digging, as we found them in the ground, trees, branches and nuts, in the loose, broken ground. We found many so fresh and hard, as if they had not long been lying there, but most of the nuts broke up if one did not handle them gently like rotten wood. We took some of them with us as a keepsake.[48]

Schellinks's fascination with fossil phenomena was that of the amateur enthusiast for the natural world; Hooke's was that of the informed intellectual in quest of explanations. Where Schellinks attributed the fossil-wood phenomenon, conventionally, to the great deluge (Noah's flood), Hooke's explanation is both more scientific and, ultimately, convincing:

> I rather suspect . . . that it was at first certain great Trees of Fir or Pine, which by some Earthquake, or other casualty, came to be buried under the Earth, and was there, after a long time's residence (according to the several natures of the encompassing adjacent parts) either rotted and turn'd into a kind of Clay, or *petrify'd* and turn'd into a kind of Stone, or else had its pores fill'd with certain Mineral juices, which being stayd in them,

Engravings based on Hooke's own drawings of Isle of Wight fossils.

and in tract of time coagulated, appear'd, upon cleaving out, like small Metaline Wires, or else from some flames or scorching forms that are the occasion oftentimes, and usually accompany Earthquakes, might be blasted and turn'd into Coal.[49]

Hooke's interest in fossils is part of his enduring involvement with 'rarities' – those kinds of unusual natural phenomena collected together, in the seventeenth century, in 'repositories' or 'cabinets of curiosities'. As we shall see, Hooke's commitment to providing a purpose-built, properly organised building to house that precious collection lasted up to – and beyond – his death.

Our attention, up to this point, has been focused on the ground beneath Hooke's young feet. It would not do, however, to overlook the heavens above him – the expanse of night sky, with its brilliant tapestry of fixed stars and moving planets, which for an island child were inevitably associated with mapping, navigation and the secure progress of ships on the high seas.

Hooke, like his lifelong friend Sir Christopher Wren, probably began his engagement with science, at Oxford, looking through telescopes with the circle of scientific enthusiasts – virtuosi – around Dr John Wilkins, Warden of Wadham College.[50] To begin with, stargazing with telescopes was little more than a natural wonder (equivalent to looking at small animals through the microscope). Enhanced with micrometer eyepieces, swivelling platforms, multi-directional joints and screw adjustments, and in combination with similarly precise time-measurers, telescopes became, in the course of Hooke's lifetime, precision instruments for measuring the motions of the heavens and positions of the stars.

Astronomical instruments and clocks were among Hooke's obsessions – as we have seen, one of the anecdotes told about his childhood is that 'after examining the components of a brass clock, he made a working model out of wood'.[51] Nor did he think of instruments in isolation: they formed part of a coherent vision of advances in theoretical knowledge, accompanied by enhanced technology, leading to progress in fields of trade and commerce.

Throughout his life, Hooke was interested in the design and manufacture of precision instruments for measuring minute increments of time and distance, such as are essential in accurate, quantitative astronomy and navigation. His very first independent publication – a pamphlet entitled *A Discourse of a New Instrument to make more accurate observations in Astronomy, than ever were yet made* (1661) – described just such an instrument for astronomical use. Immediately after publishing a short

paper relating directly to his work as paid scientific operator for Robert Boyle (so his friend John Aubrey reported):

> The next moneth he published another little quarto pamphlet, – Discourse of a new instrument he haz invented to make more accurate observations in astronomy then ever were yet made, or could be made by any instruments hitherto invented, and this instrument (£10 or £12 price) performes more, and more exact, then all the chargeable apparatus of the noble Tycho Brache or the present Hevelius of Dantzick.[52]

Thereafter, almost all his major publications included sections on instruments. Not just *Micrographia* (London, 1665) – Hooke's celebrated work on microscopy, which opens with a technical discussion of microscopes and his own inventions (like the scotoscope) for improving their performance – but also *Animadversions on the First Part of the Machina Coelestis of the Honourable, Learned, and deservedly Famous Astronomer Johannes Hevelius ... Together with an Explication of some Instruments* (London, 1674), *A Description of Helioscopes, and some other Instruments* (London, 1676), and *Lampas: or Descriptions of some Mechanical Improvements of Lamps & Waterpoises. Together with some other Physical and Mechanical Discoveries* (London, 1677).[53] Not without justification did John Aubrey describe his friend as 'certainly the greatest mechanick this day in the world'.[54]

In the course of his life Hooke designed a staggering array of such instruments, many of which the London clock-maker Thomas Tompion manufactured, and which were tested by London astronomers, including the first Astronomer Royal, John Flamsteed, at the Greenwich Royal Observatory (Flamsteed, however, was less than satisfied with the performance of his Hooke quadrant).[55]

Hooke's bitter quarrel by correspondence with Hevelius (whom he never met) was based on Hevelius' refusal to use these new instruments, preferring to observe by means of a large quadrant and the naked eye. Behind Hooke's vehement denunciation of Hevelius' claim that he could achieve astonishing levels of accuracy without mechanical aids for the senses lay his exasperation at the Polish astronomer's obstinate refusal to accept the new technical instruments as a revolutionary advance in the science of astronomy:

It did much trouble me, I confess, that I could not prevail with him to make use of Telescopical Sights at least, since with less trouble he would have afforded the World Observations, and a Catalogue of Stars, ten times more exact. And I am the more sorry to find that he hath proceeded to finish his Machina Coelestis, by instruments not more accurate then those of Ticho [Brahe].[56]

Hooke counted such devices among his greatest mechanical achievements: 'I have my self thought of, and in small modules try'd some scores of ways, for perfecting Instruments for taking of Angles, Distances, Altitudes, Levels and the like, very convenient and manageable, all of which may be used at Land, and some at Sea.'[57] What distinguished Hooke's instruments, indeed, was the fact that they were 'convenient and manageable', together with the real advances they made in areas of life with which he was familiar from childhood, above all position-finding at sea – the much discussed 'problem of longitude'. Hooke understood how accurate measurement with a quadrant or telescope, however theoretically plausible, was actually impossible on a ship tossed by a heavy swell, and how a mist-covered horizon would hamper the taking of a precise bearing.

The most spectacular of Hooke's complex scientific instruments, his equatorial quadrant, is described in detail – with a glorious illustration – in his *Animadversions* (the book in which he publicly attacked Hevelius' rejection of instrumental aids for astronomy).

The equatorial quadrant combines a number of original technological elements in 'a single audacious design'.[58] The mount (with a complex gimbal bearing in its base, allowing the quadrant to swivel smoothly) is itself impressive, but Hooke is not content with that; this is the first such mount which also has a clockwork drive. An equatorial quadrant allows the observer to follow the motion of a heavenly body by pushing his instrument around the axis: 'but Hooke goes further and has a machine to do the pushing'. The clockwork drive allows the machine to follow the celestial sphere without the intervention of the observer. The clock which drives the quadrant is not a simple pendulum clock of the sort recently developed by the Dutch instrument-maker and scientist Christiaan Huygens, but a clock with a conical pendulum regulator, enabling the quadrant to move 'without any noise, and in

Engraving based on Hooke's own drawings of the various mechanisms combined in his ambitious equatorial quadrant – an entirely original scientific instrument of great complexity.

continued and even motion without any jerks'. 'This even motion is just what is needed in a clockwork drive for an equatorial mount, where a to and fro pendulum would not suit, and it is characteristic of Hooke that he sees this connection, that he moves from a timekeeper of complete originality to the first motion governor for an equatorial instrument.'

To allow even smoother operation of the quadrant, Hooke added a tangent screw adjustment of the telescopic sight in its motion around the limb. The form Hooke describes is a micrometer screw with a graduated head, engaging teeth in the quadrant limb. A long handle allows the observer to move the micrometer screw from his station at the quadrant apex, and at this apex he uses mirrors in diagonal eyepieces to superimpose the two images from the fixed and moving telescopic sights in order that the instrument can be used by a single observer.

Finally, Hooke's quadrant can be moved so that it rotates on a horizontal instead of a vertical axis. To achieve this he uses a special

Two details from Hooke's adapted use of his universal joint mechanism, incorporated in the design of his equatorial quadrant to allow azimuth motion.

universal joint – the 'Hooke joint' as it is still known today – which he had introduced and demonstrated to the Royal Society in 1667 for another purpose, but now transfers to the quadrant.[59] For the vertical adjustment he makes use of a bubble spirit-level, which, although not invented by Hooke, had once again been developed by him for easy use.[60]

The remarkable design of Hooke's equatorial quadrant testifies to his absolute commitment to instruments as the means of moving natural knowledge forwards. His instruments encapsulate the latest scientific thinking in ways that allow less skilled operators to achieve significant results. Those same instruments in the hands of expert scientific practitioners are, for Hooke, the key to harnessing human effort to effect improvement in every area of knowledge:[61] 'I would not have the World to look upon these as the bound or *non ultra* of humane industry . . . Let us see what the improvement of Instruments can produce.'[62] To those who worried about whether sense-enhancing scientific instruments might interfere with the 'truth' of what was seen, Hooke responded with incredulity. From middle age, when his sight began to fail, he was the proud owner of a pair of spectacles. To sceptics like Hevelius he retorted: 'I judged that whatever men's eyes were in the younger age of the World, our eyes in this old age of it needed spectacles.'[63]

Until Hooke was twelve the impact on the Isle of Wight of the civil wars which began on the mainland in 1642 was relatively slight. Like other islanders of strong royalist commitment, his father was subject to additional levies or taxation, which will have had an immediate impact on the family's standard of living. On the other hand, diminished income was less of a problem in the country, where home-grown food and a black economy of exchange and barter eased the problems of everyday life. Robert's elder brother John, who might, in better times, have been expected to follow his father into the Anglican Church, was, instead, apprenticed to a Newport grocer (he later ran a butcher's shop, and rose to the rank of mayor). The austerity of the times may have effected Anne's and Katherine's marriage prospects, since there was no spare cash for dowries.[64]

Then, in November 1647, the King himself arrived, to make what turned out to be his final stand as sovereign ruler of England.

On 11 November that year, Charles I eluded his parliamentary captors

at Hampton Court Palace where he was being detained, and fled to the Isle of Wight. The selection of the island as a haven was probably deliberate and presumably carefully planned. Its location was ideal for flight abroad if necessary (either to France or the Netherlands), as for the arrival of overseas military reinforcements if required.[65] It was also, to all intents and purposes, a 'royal' island. Charles's father James I, an enthusiastic huntsman, had come regularly to the island to hunt in Parkhurst Forest, just west of Newport, staying in Carisbrooke Castle when he did so. The islanders had a long reputation of loyalty to the sovereign – historically, the island had belonged to him, with the various local landowners owing service directly to him; only comparatively recently had parcels of land been assigned to other noble, absentee head-lease owners. As recently as 1640 they had made formal application to the King concerning the relationship of service between themselves and the monarch.[66]

The King was not to be disappointed in his expectations of the islanders. He arrived discreetly on 13 November, and took up residence in Carisbrooke Castle, a mile from the island's capital, Newport. The recently arrived, twenty-six-year-old Governor of the castle, Colonel Robert Hammond, was not altogether happy at the sudden arrival of his royal guest. To begin with, however, he was prepared to provide the King with a base for what turned out to be a kind of last, lingering Indian Summer of Charles I's life and reign.

The rumour that the King was in residence soon reached the local population (it was a Sunday, and the whisper passed round the congregation at evening worship). After lunch on the day after Charles's arrival the royalist-sympathising gentry of the island came to pay their respects. We have an eyewitness account of this first encounter between monarch-on-the-run and loyal subjects from the diary of Sir John Oglander, an ardent royalist, and one of the few to have the honour of entertaining the King privately to a formal dinner, at his family home in Nunwell, during his year-long residence on the island:[67]

> On the Monday myself and most of the Island gentlemen went to Carisbrooke Castle to [the King], where he used us all most graciously and asked the names of those he knew not and, when he asked my eldest son his name, he asked me whether it was my son.

Governor Hammond then explained to the assembled gentry that the King was his guest, and would be treated as such. He would, he added, have invited everyone present to dine with himself and the King were it not for his serious lack of provisions. The Isle of Wight gentlemen correctly interpreted this as an appeal for them to provide everything necessary for the proper entertainment of the monarch, and did so for the remainder of Charles I's time on the island. After they had dined separately, the men returned to the castle, where the King in person gave a dramatic account of events leading up to his flight from London:

> His Majesty came to us and, after he had given every man his hand to kiss, he made this speech, but not in these words but, as well as my memory will give me leave, to this effect: 'Gentlemen, I must inform you that, for the preservation of my life, I am forced from Hampton Court. For there were a people called Levellers that had both voted and resolved of my death, so that I could not longer dwell there in safety. And, desiring to be somewhat secure till some happy accommodation may be made between me and my Parliament, I have put myself in this place.' . . .
>
> On the Thursday following, he came to Nunwell [Sir John Oglander's family home] and gave a gracious visit there, and in the Parlour Chamber I had some speech with him, which I shall forbear to discover. . . .
>
> While his Majesty was in our Island I went (most commonly) once a week to see him, and seldom went but his Majesty would talk with me, sometimes almost a quarter of an hour together.[68]

Here Sir John Oglander describes a court in exile, with the minor gentry of the Isle of Wight in the role of courtiers in attendance. In early December 1647 Charles I's coach was shipped to the island, and the King proceeded to tour his tiny island kingdom, much to the delight of the inhabitants, who had never before seen anything so glamorous.[69] Loyal royalist servants made their way to Carisbrooke, just as they had gone to Oxford in 1643 when the court set up its headquarters there (the Oxford court residence had lasted almost three years).[70] It is not surprising that the islanders stayed determinedly loyal to the King even when Hammond was eventually persuaded by Cromwell himself that,

although he had sheltered the King as a guest, he ought now to confine him closely as a prisoner. Islanders assisted in at least three attempts to rescue Charles and get him away to the continent between January and September 1648. As Sir John Oglander indicates in his memoir, he for one was ready and willing to provide a boat to effect such an escape, should the need ever arise.[71]

One of those loyal islanders who may have attended the November dinner held for the King at Oglander's Nunwell country house near Sandown was John Hooke senior. Of his two sons, only the frail, clever, thirteen-year-old Robert remained at home. If John Hooke had a brief taste of life in the royal circle because of his old association with the Oglanders, so too did his intense, intellectual son Robert. It is also possible that the Hookes were involved in the other notable private entertainment of the King shortly after his arrival in November 1647 on the Isle of Wight, that of the Urrey family (Captain John Urrey and his wife Alice Scovell) at Thorley Manor, only a couple of miles from Freshwater. John Hooke's 'well beloved Friend' Robert Urrey may have been Captain John Urrey's brother, and Freshwater seems to have been the Thorley local church.[72]

There are further reasons to suppose the Hooke family were drawn into the close circle of the royal 'court' on the Isle of Wight. Robert Hooke's teacher William Hopkins (friend of Sir John Oglander and of John Hooke) played a prominent role in the final weeks of the King's island stay.[73] Hopkins was a known supporter of the King: his house had been sacked by a parliamentary mob in August 1642, because of his declared support for the King's cause. It was in Hopkins's household that Charles I lodged for the final negotiations in September which culminated in the Treaty of Newport.[74]

Charles I, famous throughout his reign for his autocratic detachment from his people, became, in those final months of illusory regained regal dignity on the Isle of Wight, the people's sovereign. It is easy to see how the islanders, their heads turned by their King's personal attentiveness, became his most loyal subjects. In the schoolmaster's house the King treated Mrs Hopkins 'with a solicitude he had rarely shown the wives of his great officers of state'. 'As for yourself, be sure,' the King promised them, 'when I keep house again there will be those, who shall think themselves happy & yet sit lower at the table than you.'[75] What delusions of grandeur might ordinary families like the Hopkinses and Hookes

have harboured, what dreams of future wealth and prominence, should the King, at this eleventh hour, regain his Kingdom?

At the Restoration, ordinary men who had been resident on the Isle of Wight in 1648 would recall their involvement with the King's short residence there with pride. Robert Hooke records such boasts in his diary, on Sunday, 2 September 1677: 'Sir Jonas More and Lingar here, he told me of an absconding freind in the Isle of Wight, of his voyage with the King to Plinmouth.'[76]

In spite of such loyalty, and local optimism about the outcome of the negotiations at Newport, there were several good reasons for the residents of the Isle of Wight to feel increasingly pessimistic about their own futures at the time. In the first place, the weather that year was terrible. As Sir John Oglander wrote in his diary:

> This summer of the King's being here was a very strange year in all His Majesty's three Kingdoms, if we duly consider the heavens, men and earth. To leave men and their nature to themselves, for it was never more truly verified than now – *homo homini lupus*.
>
> I conceive the heavens were offended with us for our offence committed to one another for, from Mayday till the 15th of September, we had scarce three dry days together. . . . His Majesty asked me whether that weather was usual in our Island. I told him that in this 40 years I never knew the like before. If it doth not please the Almighty to send more seasonable weather, we shall save little pease and barley.[77]

The islanders, lastingly identified as out-and-out royalist supporters because of the positive welcome they had afforded the King, were also hit by punitive fines exacted from them as 'delinquents' by the parliamentary Administration in London.[78] Sir John Oglander recorded the heavy impact of fines on the Isle of Wight in his diary, and commented that because of the level of fines raised Parliament had more money to play with than the average legitimate prince:

> Besides Excise, Customs, Tonnage and Poundage, all the King's lands, delinquents' lands under sequestration, all the King's goods, subjects that have been plundered, the Bishops' lands, the Deans' and Chapters' lands, all the Prince of Wales' estate and the tin

and lead mines, the Parliament lays a tax on the Kingdom of £90,000 for the Army. Of which the Isle of Wight pays every month £305, and the parish of Brading pays every month £21/10s, and of this Sir John Oglander payeth £3/10s, and every week 18s. I believe few princes in Christendom have such a coming in.[79]

When negotiations at Newport finally broke down, King Charles was taken, under close arrest, to Yarmouth, from where he was carried by ship to Hurst Castle – on a promontory clearly visible across the Solent from Yarmouth Haven. Even now, the dignitaries of Yarmouth formally offered their allegiance to the captive King (after the Restoration, Charles II presented his Coronation hand mace to the town, in appreciation of its loyalty to his father).[80]

Robert Hooke's father's death in 1648 may have been linked directly to the King's fading fortunes. John Hooke senior made a will on 23 September, five days after the talks opened in Newport. There is no indication in it of sickness, and a number of clauses in the will refer to the possibility that other members of the family might die before the will is eventually read. As far as Nicholas Hockley – the friend who wrote the draft, which Hooke signed – was concerned, this was a prudent, formal document, with no suggestion that Hooke was on the point of death himself, nor that he anticipated the terms of the will being executed in the near future.[81]

On 25 September, the commissioners for Parliament presented their second major set of proposals to the King at Newport: the abolition of the prayer book and of bishops, the sale of their lands, and the establishment of Presbyterianism. On 8 October Charles capitulated: he accepted all Parliament's demands, sticking only at the total abolition of the bishops.[82] That week or the next, John Hooke died. The Freshwater Parish Register records: 17 October 1648, 'Buried Mr. John Hooke'.[83] The post-mortem inventory of his goods which accompanied the will when it was proved on 18 December 1648 was taken on 9 November.[84]

The King's settlement with the parliamentary commissioners would have deprived John Hooke of his living too. If Robert Hooke's father was already sick, the strain may have been too much for him. He may even have taken his own life, as his son John, heavily in debt and perhaps with a family scandal on his hands, did in 1678.[85] Throughout his life,

Robert too suffered from recurrent periods of chronic 'melancholy', or depression.[86]

Whatever caused John Hooke's sudden death, he seems already to have made arrangements for his son Robert to leave the island for London, in the care (and at the expense) of a likeminded friend or colleague.[87] The boy may indeed have already been gone when his father died – safely conveyed away to set his mind at rest. In John Hooke's will he left Robert 'forty pounds of lawful English money, the great and best joined chest, and all my books'.[88] Whereas his other children received large household goods, Robert's bequest was entirely portable – cash, books and a chest to carry them in.

Robert Hooke never spoke in later years about this traumatic period which abruptly ended his childhood. When he rose to prominence after the Restoration, as a key figure in the Royal Society, and as the City of London's Surveyor after the Great Fire of London, he kept the manner of his arriving in London a mystery. All we know is that someone took him to London – someone who continued to subsidise him financially, since the forty pounds his father left him would not have gone a long way in the circles in which he henceforth moved – and that he was briefly apprenticed to the Dutch émigré painter, much patronised by the King and his circle, Peter (later Sir Peter) Lely.[89] By the end of 1648, however, the young Hooke was in the care of the great royalist educationalist Dr Busby, headmaster of Westminster School in London.

Hooke never married, and for most of his life lived in rooms at Gresham College which 'came with the job' of Curator of Experiments to the Royal Society.[90] Until his death he kept his valuables (including several diamond rings), and a very large sum in cash, in a fine, large chest. One of those 'valuables', not in the chest but on the shelf of his extensive library, was a folio Italian Bible, recorded in the inventory of his books taken after his death as 'The Bible of Giovanni Diodati in folio, gilded, paper, belonging to his Majesty the King and with annotations by the same'. It fetched an unusually high price (£2 0s 0d) at the post-mortem auction of Hooke's library. Was this a precious gift received by John Hooke from his sovereign and bequeathed to his son?[91] Until his death, Robert Hooke fasted every year on 30 January – the anniversary of the execution on the scaffold in front of Inigo Jones's Banqueting House at the Palace of Whitehall of the 'royal martyr', Charles I.[92]

*     *     *

Robert Hooke told a good friend, the antiquarian John Aubrey, that the idea of his being sent for a 'tryall' with the painter Lely (relatively recently arrived in England in the 1640s, and not yet the celebrated artist he later became) arose out of a visit by the English painter John Hoskins to the Isle of Wight. We are told that Hoskins found the young Robert Hooke an able assistant, and recommended that he be apprenticed to a painter.[93]

John Hoskins was Charles I's official miniaturist, whose letters of appointment allowed him to do work for other clients only with the King's express permission.[94] If we believe Aubrey, then he was on the Isle of Wight as part of that entourage that assembled round the King at Carisbrooke in 1647–8, either painting the King from life or, more likely, producing a miniature from an existing full-sized portrait (something he did regularly for his royal employer). A miniature copied from one by Hoskins, now in the National Portrait Gallery collection, appears to show the Isle of Wight Needles in the background – Hoskins's reputation rested specifically on his introduction of tiny landscape backdrops into miniatures.[95]

Hoskins was apparently assisted, on this occasion, by a willing small boy who was unusually deft at small-scale drafting work, and generally good with his hands. Aubrey's version of this story sounds convincing (and Aubrey spent a lot of time in coffee shops talking techniques and processes with Hooke). According to him, Hooke reported how 'John Hoskins the painter, being at Freshwater to draw pictures, grinding chalke, ruddle and coale', made a sort of pastel, to be applied with a brush.[96]

But 1648–9 was a bad time to be thinking of joining the studio of any painter who made their living from portraits of royalty, or even of the nobility. It may have been Hoskins who took Robert Hooke to London (the boy needed to travel with someone who had been granted a safe-conduct). But the Hooke family must already have known that he was destined for some other career, most probably, like his father, in books and letters.

In his will, John Hooke entrusted the carrying out of his last wishes to three close friends:

And this care and trust I commend unto my worthy and well beloved Friends Mr Cardel Goodman Mr Robert Urrey and Mr

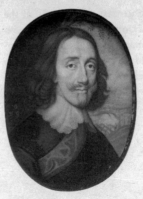

Copy of a miniature of Charles I by John
Hoskins which appears to show the Needles
and perhaps Carisbrooke Castle in the
background.

Nickles Hockley, whome I humbly intreate to bee my Overseers
and intrust to order all things according to ther wisdome and
discretion.[97]

Of the three men named, Cardell Goodman was best placed to carry
out what were apparently his curate John Hooke's last wishes – to find
his son Robert suitable employment in London.

Urrey and Hockley were local Freshwater men. Robert Urrey was
churchwarden at Freshwater church, and an active figure in the local
island defences in the early civil war years.[98] Nicholas Hockley married
one of Robert Urrey's relatives, Elizabeth Urrey, in 1653.[99] Cardell Good-
man had come to Freshwater in 1641 from Oxford, where he had been
a fellow of St John's College, and the college's first appointment to the
newly acquired Isle of Wight living.[100] In 1648 his wife may have been
pregnant with their son (also Cardell Goodman – a notable Restoration
rake and reprobate).[101] Goodman senior had been a pupil at Westminster
School. It was probably he who chose the destination, and made the
approach to Dr Richard Busby, the headmaster, prior to Robert's
departure from the Isle of Wight, contrary to Hooke's later, romanticised
version of events.[102]

On the other hand, perhaps Hooke really did set out for London
with one career planned out for him by those deputed by his father
to take care of his interests, but instead spontaneously embarked on
another course of action once arrived. Perhaps this was simply the first of
many occasions in Robert's life when he wavered between two appealing

alternatives, settling for one, more by chance than forethought, at the last possible moment, and turning his back on the other. Blessed with too many talents, and the option of too many possible career paths to follow, Hooke, throughout his life, would promise too much, to too many people, in too many walks of life, leaving tasks unfulfilled, problems half solved, friends, clients and patrons disappointed.

## 2

# A Sincere Hand and a Faithful Eye

I owe Mr Loach for velvet coat and lyning £5, my shoomaker
for 2 pairs shoos and Goloshoos. Mr Berry for 1 load of Coles,
12 sh. Blagrave for wine 12 sh. Much love to all my friends I
owe.

Hooke in his diary, 31 December 1676[1]

However it came about, the decision to place Robert Hooke at
Westminster School, in the care of Dr Busby, shaped his entire
life. Removed without warning from the consoling routines of home,
and arriving in London at the height of the turmoil of Charles I's trial
and execution, Hooke found safety under the vigilant eye of the great
headmaster. A small, somewhat unprepossessing man, Dr Richard Busby
is nevertheless a towering figure, both in the annals of Westminster
School and as a behind-the-scenes player in political events spanning
the Commonwealth and Restoration periods.[2] His dedication to able
boys placed in his care was legendary.

Busby was appointed Master (head teacher) of Westminster School,
where he had himself previously been a pupil, in 1638. He remained in
charge of the school continuously throughout the Commonwealth and
Protectorate period – remarkably, since he was a committed and unre-
pentant supporter of Charles I. At the Restoration he moved immediately
back into the inner circle of servants to the new King – Busby was one

Dr Richard Busby, Master of Westminster School for more than half a century, with an assiduously attentive pupil.

of those who assisted in the elaborate Coronation ceremonies reinvented for Charles II's official installation in 1661.[3] He remained in charge of the school – though no longer actively teaching or conducting official school business – until his death in 1695.

He had a reputation for discipline, but also for his soft-heartedness when it came to admissions, especially during the period of the civil wars, taking on boys in excess of school numbers, and accommodating them in his own home. Indeed, on one occasion Busby was accused of incompetence, in a published complaint against his running of the school, for 'irregularly' admitting boys beyond the capacity of the teaching staff to cope.[4] Robert Hooke appears to have been one of these supernumerary boys. Although there is no doubt that he studied with Busby at Westminster, his name barely appears in the surviving school records.[5]

Busby was a devout Anglican, and remained throughout his long life an unwavering supporter of the monarchy. Even when the parliamentary regime was at its most stridently republican, his school continued to

instil Anglicanism's traditional values and practices into its pupils on the very doorstep and under the noses of the parliamentary Assembly in Westminster. The distinguished divine Robert South, who was at Westminster at the same time as Hooke, later recalled, 'For though, indeed, we had some of those fellows [that is, Puritans] for our governors ... thanks yet be to God they were never our teachers.'[6] South, who was one of the privileged band of 'King's scholars', also recalled that 'the school [was] so untaintedly loyal [to the King] that I can truly and knowingly aver that in the very worst of times (in which it was my lot to be a member of it) we really were King's Scholars, as well as called so.' When the Master was required, like all others in official posts, to subscribe to the National Covenant (a binding oath to the new Administration), Busby simply absented himself, on grounds of ill health.

After the Restoration, this persistence of Busby in the old ways was turned into a matter of amusing anecdotes – like other distinguished headmasters, he acquired a reputation for excessive beating of boys.[7] At the time when Hooke was a student at Westminster, however, it must have involved considerable courage on the young Busby's part to continue his policy of admitting boys from all backgrounds, and teaching a resolutely highbrow curriculum. We learn something of the delicacy of Busby's situation during the Protectorate period from records concerning differences which arose between himself and his deputy, or Second Master, during the mid-1650s.

In 1656, Edward Bagshawe, a former Westminster pupil, was elected to the post of Second Master, initially with Busby's consent. It rapidly became clear, however, that he disapproved of the way Busby was running the school. He may even have been put up for the post by the Parliament-sympathising Governors expressly to keep an eye on him – to monitor the way Busby was running the school and the curriculum he was instilling into his boys. It was Bagshawe who later lodged public complaints that Busby was admitting too many, poorly qualified students, on his own authority, who were taught outside normal classroom arrangements.[8]

In July 1657, Busby returned to Westminster from his substantial house in Chiswick – a building owned by the school, and designated the summer home of the Master, to which he took the boys for the summer months when London was hot and unhealthy. He had requested

a special meeting with the Governors, of which Bagshawe was not informed.[9] Busby persuaded the Governors to vary the school's established teaching arrangements, so that he would in future have the care and instruction of the senior boys entirely to himself, leaving Bagshawe to look after the most junior boys at Dean's Yard, Westminster. It looks very much as if Busby was proposing to run the senior school almost entirely at Chiswick – well away from parliamentary surveillance.[10] Busby was thereby free to conduct his teaching as he wished, at a safe distance from Westminster and the parliamentary authorities, and crucially without Bagshawe on hand to report back on his activities.[11] After trying unsuccessfully to get the Governors to overrule Busby, and rescind the new teaching arrangements, Bagshawe was eventually ejected at the end of 1657 for 'contesting Dr. Busby'.[12]

The traditional curriculum at Westminister consisted of a thorough training in Latin, Greek and Hebrew, with some biblical Aramaic (Hooke was demonstrably an able Latinist and adequate Hellenist in later life).[13] John Evelyn records in his diary attending one of the competitive exercises at the school, shortly after the Restoration:

> I heard, & saw such Exercises at the Election of *Scholars* at *Westminster Schoole*, to be sent to the Universitie, both in *Latin Greek* & *Hebrew Arabic* &c in Theames & extemporary Verses, as wonderfully astonish'd me, in such young striplings, with that readinesse, & witt, some of them not above 12 or 13 years of age.[14]

While preparing for the exercises which gained him his scholar's place at Christ Church, John Locke explained to his father that he was required to perform a virtuoso Hebrew oration, in addition to a Latin one.[15]

Hooke told John Aubrey that, as a precocious thirteen-year-old, he had impressed Busby by mastering the first six books of Euclid in a week.[16] This anecdote may be less a way of conveying Hooke's natural talent for geometry than of referring to Busby's commitment to practical mathematics, as the ideal training for boys who would need to make their way in the world.[17]

Mathematics was taught as an extra-curricular subject, by the Master himself, in his rooms. We know that Busby adopted William Oughtred's *Key to Mathematics*, which is credited with introducing the sign × for multiplication into general usage, as a textbook, and that Hooke owned

his own copy.[18] Henry Billingsley's 1570 English translation of Euclid, with John Dee's celebrated introduction, cataloguing the practical applications of mathematics, was also used (later in life Hooke wrote an *apologia* for Dee's spirit-works).[19] Hooke's mathematical education was vital for the success of his career as a scientist, technician and engineer. Later, in the 1670s, he became a governor of Christ's Hospital School (in 1673 he designed the badge for the school uniform), where talented, deserving boys were taught mathematics to enable them to become navigators in the English Navy.[20] Hooke knew only too well how ability in mathematics had served him in his struggle for success.

On the other hand, it is significant that Hooke does not appear to have received the kind of rigorous training in pure mathematics that the boy prodigy Christopher Wren gained in the circle of the great mathematician William Oughtred, or that his contemporary, the Dutch mathematical prodigy Christiaan Huygens, received from John Pell (and, by correspondence, with Mersenne).[21] This came to matter in Hooke's later life, when he took it upon himself to challenge the solutions to difficult problems in mathematics proposed by distinguished practitioners like John Wallis, Isaac Newton and Christiaan Huygens.

Through the Commonwealth and Protectorate years, Dr Busby seems surreptitiously to have been offering two separate forms of educational curriculum at Westminster: a standard classical education for the well-to-do, of a kind which scandalised Bagshawe for its Anglican elitism; and a technical, mathematical training for the boys he had rescued by admitting them on his own authority. Such boys might previously have gone into the Church. A career in the Church, however, was out of the question during the Commonwealth and Protectorate periods for any person whose spiritual preparation had been in the hands of someone of Busby's leanings. A new kind of employment was available, however, as a personal secretary or assistant, skilled in mathematics and technology, in the households of men prevented from holding employment in public life, who needed to find ways to make those estates pay.[22]

Busby evidently identified Robert Hooke as one of those bright boys from families deprived of prospects by 'the nature of the times', and destined for a career as a technical assistant. That would explain why Hooke was (so we are told) not seen much at lessons during his time at Westminster.[23]

The arrival of a small, disorientated, fatherless boy, from the Isle of Wight, in the months immediately preceding the trial and execution of the King seems to have lastingly affected the generally unemotional Busby. According to a contemporary, Dr Busby 'had the Power of raising what a Lad had in him to the utmost height in what Nature designed him'. One of those boys he brought centre stage from obscurity on the strength of his natural talents was Robert Hooke. Busby identified Hooke's unusual intellectual talent, and Hooke honoured the trust placed in him with lifelong affection and solicitousness for his old schoolmaster.

Busby and Hooke remained extremely close until the end of Busby's life. Hooke's diary records frequent visits, advice given, particularly on building works at the school and in the Abbey, small jobs undertaken for Busby, and eventually two significant commissions which Busby wished to leave as lasting memorials – the rebuilding of Willen church, and alterations and furnishings at Lutton, Busby's birthplace. They dined together on a regular basis – those who knew Hooke in later life refer to Busby as his 'patron'. At Busby's death in 1695, a codicil to his will left Hooke to complete the 'beautifying' of the church at Lutton.[24] Busby was the closest thing to a father Hooke had after he left the Isle of Wight.[25]

A letter preserved among a small bundle of Hooke-related papers at Trinity College, Cambridge (the property of William Derham, Hooke's posthumous editor, after Richard Waller) tells us that such was the lasting closeness between Hooke and Busby that some contemporaries believed they were related:

> Dr Hook was bred at Wistminster Schoole under Dr Busby, & by Him, (as was as I can inform my Self by those, who remimber his being in Oxford) was sent to Christ Church in Oxford Anno 1654. where He was a very close & diligent Student. & in the yeare 1663. Sept. 28. He was created Master of Arts. Whether He wiz related to Dr Busby I cannot tell, but the Dr at the schoole, in the University & when he return'd from thense was his Patron. He alwais valued Him much, for his great Genius for the Mathimaticks, & all sort of Curiosities in Philosophy.[26]

By the time Charles I was tried, condemned and executed, in January 1649, Robert Hooke was in Busby's care. So too were John Locke (who

remained a friend throughout his life), John Dryden and Robert South. The scaffold outside Inigo Jones's Banqueting House in Whitehall, on which the King was publicly beheaded, was a stone's throw from the school. It is South – ardent royalist himself – who once again records what happened at the school on that day: 'Upon that very day, that black and eternally infamous day of the King's murder, I myself heard and am now a witness, that the King was publicly prayed for in this school but an hour or two before his sacred head was struck off.'[27] The Master had kept the boys in school for this purpose; in every subsequent year, the date of the King's execution was marked by a whole school fast day.[28]

Hooke told Richard Waller that he developed a stoop from the age of sixteen through spending too much time bending over a lathe (by the time Waller knew him, this stoop was pronounced).[29] At sixteen, Hooke was still at school. However nonchalantly this remark may have been made, looking back a full fifty years, the reference to lathe work suggests that Hooke was already involved in precision instrument-making before he left Westminster. He was also already moonlighting – taking on extra work while notionally engaged full time upon his education.

At Oxford, when Hooke began what was to be a brilliant career, it was as an instrument-maker, making scientific instruments to innovative designs for private patrons.[30] In the early 1650s, the new high-accuracy lathes which had been developed in France were used in lens-grinding and microscope tube-making; watch-making also required the use of the lathe.[31] It seems that Busby's training of boys like Hooke included a sensible amount of practical work, to prepare them for their likely futures as skilled technicians for the intellectual virtuosi.

In 1653 Robert Hooke left London for Christ Church, Oxford. Westminster School had close formal and informal links with Christ Church, and, indeed, there were scholarships set aside for Westminster boys, to which able students were normally expected to progress. But these were not normal years. England was recovering from an unprecedented political and social upheaval – two civil wars and the end of the traditional hierarchies of Church and state. In the early 1650s, whom you knew, who would protect you and sponsor you, was – ironically – more important for career advancement than it had ever been.

Planche Première

Pl. N.° I.

French engraving of a lathe for 'turning to perfection', of the kind
Hooke might have used as a boy, while at Westminster School.

Hooke's champion, Dr Busby, had been a teaching fellow of Christ
Church before he came to Westminster. During his tenure as Master
of the school, the longstanding links between the two institutions became

extremely close. But the Westminster scholarships at Christ Church were for notable classicists who were already King's Scholars (John Locke, who became a King's Scholar in 1650, had won one the year before Hooke entered Christ Church).[32] Fortunately, as Hooke told Aubrey, one of the things he had learned to do while at Westminster was to play the organ (he showed musical talent and interests in the science of music throughout his life). According to Anthony Wood (who drew much of his information for his study of Oxford alumni directly from Aubrey), Hooke entered Christ Church as a choral scholar, his college charges reduced in exchange for his regular participation in the chapel activities of the college, including, perhaps, playing the organ.[33]

Waller tells us that Hooke's status when he entered Christ Church was that of 'Servitor to a Mr Goodman' – a form of words which indicates that he was in receipt of some form of financial help from a benefactor. Cardell Goodman, his father's old friend, and former rector of Freshwater, who had himself graduated from Christ Church a generation earlier, had died in 1653, two years after being removed from the benefice by order of the Commonwealth. It is possible that he left money for Hooke to complete his education, in fulfilment of the promise he had had made to John Hooke on his deathbed, to take care of his gifted son.[34]

Hooke's studies were probably intermittent, rather than structured to a traditional BA course of study, as was usually the case for those whose entry into the University was not via the conventional routes – the records show that he did not matriculate (was not officially enrolled for a programme of study) until 31 July 1658, by which time he was well established as 'operator' in Robert Boyle's Oxford laboratory.[35]

Circumstances may have been helped by the years of uncertainty at Oxford that preceded Hooke's arrival. During and after the siege of Oxford (1643–6), when the town became a fortified garrison, with troops billeted in the individual colleges, and students and fellows in residence themselves under pressure to join the defending royalist regiment, student numbers slumped. John Aubrey (later a close friend of Hooke's), for example, was in his first year as an undergraduate at Trinity College when Charles I arrived with his court and army to take up residence in Oxford, at which point Aubrey was immediately called home by his anxious father. He returned briefly in 1644, fell ill (during one of several epidemics which broke out during the siege), and was promptly

summoned home again. He did not properly resume his studies until the King had fled in the autumn of 1646.[36] With student numbers well down, the early 1650s may have been a golden moment for boys like Hooke, who might hitherto have stood little chance of a university education, and whose talents for mathematics and natural philosophy (what we call science) were not catered for under the terms of traditional college endowments.

Even before Hooke arrived, arrangements seem to have been made for him to take up employment as a laboratory assistant to an old Christ Church contemporary of Busby's, Thomas Willis, who had left the University but continued to practise medicine locally (he had gained his bachelorship of medicine in 1646), and had a chemical laboratory where he and a group of like-minded colleagues carried out fundamental research.[37] Willis, like Hooke, came from a modest background (his father was a tenant farmer), and had benefited from a similar sort of arrangement to the one between Goodman and Hooke, to allow him to study at Oxford: in the matriculation record Willis is listed as 'servitor (or batteler) to Dr Iles' (Iles was Canon of Christ Church at the time).[38] In 'better' days Willis would have become an Anglican clergyman. Instead, he turned to medicine, and built up a lucrative medical practice, first in Oxford, and later, under the enthusiastic patronage of the distinguished cleric Gilbert Sheldon, in London.

Hooke probably owed his job as assistant to Thomas Willis, once again, to the Isle of Wight connection: Willis was closely associated with the family of Samuel Fell, ejected Canon of Christ Church, who had held the rectorship of Freshwater church during Hooke's father's time as curate there.

Busby, recognising Hooke's sharp intellect and technical dexterity, may also already have proposed Hooke to Dr John Wilkins, Warden of Wadham College, as a suitable 'servant' for his circle of university-based scientific practitioners, in the capacity of something like a laboratory assistant.[39] If so, the great educator who had started Hooke on the road to success handed him over to a second great figure renowned for his identification of talent, and sustained support for deserving, clever men, to continue his upward progress at university.

Wilkins was a charismatic intellectual and divine, who had made the transition successfully from royalist cleric (he was chaplain to Charles Louis, Elector Palatine and nephew of Charles I, during his residence

in England in the 1640s) to prominent and influential Oxford academic under the Commonwealth. Aubrey described him as 'no great read man: but one of much and deepe thinking and of a working head: and a prudent man as well as ingeniose'.[40]

John Wilkins's appointment as Warden of Wadham came within three months of Charles I's death, and the hasty departure of the Elector Palatine (whose presence in London at the time was judged to render him complicit) for his recently regained Palatine territories.[41] Although Charles Louis rapidly distanced himself from the royal execution, he continued to be considered an ally of the new parliamentary regime, which made a number of conciliatory moves, of which Wilkins's elevation at Oxford may well have been one. Wilkins had in fact left London in March with Charles Louis, accompanying him to Heidelberg, where he reassumed the title of Elector Palatine, under the Treaty of Westphalia which concluded the thirty years war. He did not return to England until late in 1649.[42]

In July 1648, the parliamentary Visitors also nominated Wilkins in his absence to the committee set up to examine applicants for all subsequent positions made vacant by the parliamentary purge of members of colleges who refused to recognise the authority of the new Government (the academic equivalent of the Cromwellian Triers, who dismissed and appointed clergymen, according to their conformity with the new Government's beliefs). Other members of that committee were John Palmer, Warden of All Souls (a physician), and Henry Langley, Master of Pembroke (who also had scientific interests).[43] In October 1652, Cromwell, in his capacity as Chancellor of the University, appointed Wilkins one of three senior academics to oversee University affairs on his behalf (Jonathan Goddard was one of his fellow members).[44] Thus Wilkins was in a position to exert an extraordinary amount of influence over the intellectual development of the University during the Commonwealth and Protectorate years, and he appears consciously to have used that influence to lay impressively 'modern' scientific and mathematical foundations for intellectual life at Oxford in the course of the 1650s.

In spring 1656, Wilkins's political influence was extended further when he married Cromwell's sister, Robina French, widow of the recently deceased Dean of Christ Church, Dr Peter French.[45] Although it has often been suggested that this marriage was undertaken with the express intention of forging strong political links between Oxford and

Dr John Wilkins, Warden of Wadham College, Oxford, during the Commonwealth years, and friend and patron to a generation of gifted young men whose talents he nurtured there.

the Lord Protector (and Wilkins's own contemporaries at Oxford lauded him for altruistically doing so), it is more likely that it was Robina's previous marriage to French which made remarriage to an equally prominent member of the Oxford academic community desirable. Nonetheless, as close relatives of the Lord Protector's, the couple acquired lavish accommodation in London, at Whitehall Palace. Wilkins now shuttled between Oxford and the capital, and his sphere of influence was further enlarged.

John Wilkins – serious, intelligent, charming, personable, courteous – used his formidable influence scrupulously, according to almost all contemporary accounts. As one of his circle, John Tillotson put it in his funeral eulogy to Wilkins in 1672 (by which time Tillotson himself had risen to high clerical office), looking back on the 1650s:

It is so well known to many worthy persons yet living, and has been so often acknowledged even by his enemies, that in the late times of confusion, almost all that was preserved and kept of ingenuity and learning, of good order and government in

the University of Oxford, was chiefly owing to his prudent conduct and encouragement.[46]

In the turbulent early 1650s, when the futures of all young men of good birth looked uncertain, the Warden's rooms at Wadham were the centre of a circle of hand-picked, scientifically, mechanically and medically gifted young men who met there weekly, to debate topical scientific issues and to carry out experiments. They included John Wallis, Seth Ward, Thomas Willis, William Petty, Christopher Wren, Lawrence Rooke, Richard Rawlinson, Thomas Millington, Ralph Bathurst and Jonathan Goddard, all of whom went on to play prominent roles in post-Restoration science and medicine.[47]

To support the activities of this 'club' Wilkins recruited talented young technicians from among the London instrument-makers, to design, build and operate their apparatus and instruments. Wilkins may already have made contact with Hooke while he was still at Westminster. According to Aubrey:

> At Schoole here [Westminster] he was very mechanicall, and (amongst other things) he invented thirty severall wayes of Flying, which I have not only heard him say, but, Dr Wilkins at Wadham College at that time, who gave him his Mathematicall Magique which did him a great kindnes. He was never a King's Scholar, and I have heard Sir Richard Knight (who was his School-fellow) say, that he seldome sawe him in the schoole.[48]

As in the case of Busby, Wilkins was in the habit of making special arrangements for bright young men (particularly of mathematical ability). We know that in 1653 he found a place at Wadham for the scientific instrument-maker Christopher Brooke (or Brookes) 'purposely to encourage his ingenuity', and that he introduced Ralph Greatorex to Boyle shortly after he came into residence in Oxford.[49]

By 1652, Wilkins and Willis were both involved in scientific experimenting at Wadham College, and Willis had been persuaded to invest money in the enterprise. Seth Ward reported in February 1652 that a group which included Willis as well as Wilkins had 'joyned together for the furnishing an elaboratory and for making chymicall experiments which we doe constantly every one of us in course undertaking to manage the worke'.[50] Willis kept an account of his expenditure 'laid out

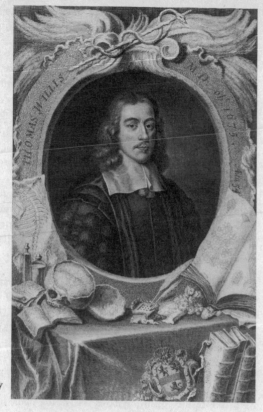

Thomas Willis, pioneering investigator of the structure of the human brain, and Hooke's first employer in the capacity of laboratory assistant.

at Wadham Coll.' in a clinical notebook, recording the precise sums given to the carpenter, smith and mason for alterations to the accommodation, as well as for glassware, stills, a pestle and mortar, drugs, reagents and the payment of one shilling to transfer equipment from his own laboratory to the new one: 'for carriage of the Glasses and things from my chamber'.[51]

It was in 1653 (the year of Hooke's arrival) that Wilkins met, and began to cultivate, Robert Boyle, a young man of considerable personal wealth and an interest in chemistry and medicine, encouraging him to join the Oxford circle of scientific virtuosi. A highly intelligent, well-educated man without occupation (he had no need to work for a living),

Boyle evidently expressed to Wilkins a strong desire to take up residence in Oxford in order to join the activities of his scientific circle. The two men, both personable, serious and well mannered, took to one another immediately. In a letter to Boyle written shortly after what was probably their first encounter, Wilkins compliments his new acquaintance on being 'a great master of civilities as well as learning'.[52]

Boyle was to become an important cornerstone of the Oxford scientific group, his considerable means easing the financial pressures on its members throughout the Commonwealth years. Two of his nephews – the sons of his elder brother the second Earl of Cork, and of his sister Lady Ranelagh – were in Oxford as students from April 1656 until 1658 (when they left on the Grand Tour). Lady Ranelagh's son, Richard Jones, was accompanied by a Bremen-born tutor, Henry Oldenburg, later Secretary of the Royal Society, who, through Boyle, joined the Wadham circle of '*Oxonian* sparkles' (as he later fondly recalled them).[53] (Oldenburg was to become one of Hooke's bugbears at the Royal Society.)

Although Boyle did not in the end settle in Oxford until the autumn of 1655, on 6 September 1653 Wilkins wrote to him proposing a young man as an amanuensis:

This bearer is the young man, whom I recommended to you. I am apt to believe, that upon trial you will approve of him. But if it should happen otherwise, it is my desire he may be returned, it being not my aim so much to prefer him, as to serve you, which your own eminent worth will always oblige me unto with my utmost zeal and fidelity.

Wilkins's hope was that he could encourage Boyle to join his circle of virtuosi in Oxford, where, presumably, the young man in question would act as his laboratory assistant:

If it be not, Sir, prejudicial to your other affairs, I should exceedingly rejoice in your being stayed in *England* this winter, and the advantage of your conversation at *Oxford*, where you will be a means to quicken and direct us in our enquiries. And though a person so well accomplished as yourself, cannot expect to learn any thing among pedants, yet you will here meet with divers persons, who will truly love and honour you.

To this end, Wilkins offered to find Boyle suitably appointed lodgings close to Wadham:

> If I knew with what art to heighten those inclinations, which you intimate in coming to Oxford, into full resolutions, I would improve my utmost skill to that purpose; and shall be most ready to provide the best accommodations for you, that this place will afford.[54]

At the time, Boyle was staying at Stalbridge in Dorset, the estate he had inherited after his father's death in September 1643, and was apparently intending to settle in England. However, urgent family business meant that he departed for Ireland unexpectedly, and in haste, only two weeks after he had received Wilkins's letter. From Bristol, before setting sail for his Irish estates, he sent letters to a number of friends he had planned to see shortly, apologising for his sudden departure. He left, as he told his neighbour John Mallet, because of some 'unwelcome Necessity'.

Already in the late 1640s Boyle had been anxious about the revenues from his Irish estates, as Parliament appropriated lands to give to those who had supported the Irish campaigns. In September 1653 Cromwell strengthened this legislation,[55] and Boyle was probably obliged to return to Ireland to secure the income from his 'substantial holdings' of land there, which was vital for his continued residence as a scientific virtuoso in England (at his death in 1691 extensive estates in Ireland reverted to his elder brother Lord Burlington).[56]

Robert Hooke may have been the young man sent by Wilkins as a possible suitable 'assistant' to Boyle. It is even possible that Boyle agreed then to take him on. Had Boyle not been called home to Ireland, such an appointment would have solved Hooke's financial difficulties, and served Boyle's scientific purposes. Instead, Hooke went on working for Willis, until 1655, when Boyle did finally establish a residence for himself in Oxford.

In November 1654 Samuel Hartlib (whose prolific correspondence spanned the pre-Commonwealth and Commonwealth years) noted, 'Dr Wellis [Willis] of Dr Wilkins acquaintance a very experimenting ingenious gentleman communicating every weeke some experiment or other to Mr. Boyles chymical servant, who is a kind of cozen to him'.[57] By 1652 Wilkins had persuaded Willis and others to invest substantial sums in equipment for the club,[58] while some time during the 1650s

rooms on the third floor of the University premises in the Old Schools Quadrangle were refurbished (probably to designs provided by Wren and Wallis) to house their equipment and provide meeting rooms, including space in the tower for astronomical observation using long telescopes.[59]

The close friendships formed among those Oxford men who had the good fortune to be brought together in Wilkins's Wadham research institute were born out of the exigencies of those early Commonwealth years. No one in that group could have foreseen (as indeed nobody in Europe foresaw) that the republican regime established in 1649 would not last, and that the current drastic alterations to English political and professional life were only temporary. As Wilkins wrote in a sermon delivered in 1649, in the period immediately following Charles I's execution, 'We may infer, how all that confusion and disorder, which seems to be in the affairs of these times, is not so much in things themselves, as in our mistake of them.'[60] Wilkins's Wadham club was a key part of his own concerted efforts to restore order to the 'confusion and disorder, which seems to be in the affairs of these times'. The choices and decisions made, at an extraordinary moment in history, by such men of influence inevitably exerted an inordinately powerful effect on intellectual activities sanctioned (or semi-sanctioned) by the authorities, and left a lasting mark.[61]

The friends and colleagues with whom Hooke formed relationships during his undergraduate years were the friends and colleagues to whom he remained loyal for the whole of the rest of his life, the bonds of emotion and obligation yet more intense and binding than those traditionally formed among young men in places of higher learning.

A chance, surviving book which once belonged to Hooke, and is inscribed by its several owners, gives some sense of Hooke's intense personal commitment to the social and intellectual connections he established at Oxford, in the years immediately following the execution of Charles I. In the Wellcome Library in London is a copy of Thomas Willis's most celebrated work of medical theory, *De anima brutorum* (Oxonii, e theatro sheldoniano [printed at the Sheldonian Theatre], impensis [at the expense of] Ric. Davis, 1672). The title-page is inscribed, in Hooke's handwriting, 'Giuen me by ye Reuerend Dr John Tillotson Dean of Canterbury. for a remembrance of John. Ld. Bp. of Chester. R. Hooke Oct. 8 1673'. On the right-hand blank sheet is written, in

DE
ANIMA BRUTORUM
Quæ Hominis Vitalis ac Sensitiva est,
*EXERCITATIONES DUÆ.*

Prior
PHYSIOLOGICA
Ejusdem Naturam, Partes, Potentias & Affectiones tradit,

Altera
PATHOLOGICA
Morbos qui ipsam, & sedem ejus Primariam,
NEMPE
Cerebrum & Nervosum Genus afficiunt,
explicat, eorumque Therapeias instituit.

Studio *THOMÆ WILLIS* M.D.
Philosophiæ Natural. Profess. Sidleian. *Oxon.*
Nec Non
Inclyti Med. Coll. Lond. & Societ. Reg. Socii.

*OXONII.*
E THEATRO SHELDONIANO.
Impensis RIC. DAVIS.
Anno Dom. M.DC.LXXII.

Frontispiece of Willis's *De anima brutorum*, with an inscription by Hooke indicating that he received the volume as a gift from John Tillotson, in remembrance of his old friend and mentor John Wilkins.

Willis's handwriting, 'Ex dono Autoris [the gift of the author]. Apr: 26. 72'.[62]

Wilkins died on 19 November 1672, at the London home of Dr John Tillotson (later Archbishop of Canterbury), who had married Wilkins's stepdaughter. Hooke had been one of the last to visit Wilkins during his final illness, and was one of those who had been administering remedies for the 'stoppage of urine' from which Wilkins was suffering, for a week or more previously.[63] The inscription on the opening blank page of Willis's handsomely printed book tells us that this was a presentation copy, a gift from the author to his old friend and mentor John Wilkins shortly before Wilkins's death. Hooke's own inscription on the title-page adds that Tillotson (a contemporary of Hooke's at Christ Church, a close friend, and another of Wilkins's intellectual protégés) gave the volume to him a year later, as a keepsake by which to remember

Wilkins – and, by association, those sunlit early intellectual days in Oxford, when Hooke served Wilkins and Willis at the dawn of the London scientific revolution.

We may imagine that Tillotson took Hooke into Wilkins's old study, and invited him to choose a book as a memorial of his mentor. If so, the choice of book was particularly appropriate. Willis had been Hooke's first employer at Oxford, and Willis and Wilkins had been responsible for recommending Hooke to Robert Boyle, his long-term employer and lifelong patron. *De anima brutorum* was dedicated to Gilbert Sheldon, Willis's own patron, Archbishop of Canterbury, the treatment of whose near-fatal apoplexy is discussed in detail in the second part of Willis's book. It was Willis's timely intervention to relieve Sheldon's apoplectic seizure in Oxford which led directly to Sheldon's sponsoring the transfer of Willis's medical practice to London, where he became a much sought-after society physician.

Gilbert Sheldon was also the benefactor behind the Sheldonian Theatre in Oxford, which, in addition to its ceremonial functions, housed the University Printers, under the direction of Dr John Fell. Fell was Willis's brother-in-law – now in his turn Dean of Christ Church.[64] *De anima brutorum* was one of the first books printed in the Sheldonian building (designed by Wren and completed in 1669).[65]

Hooke paid public tribute to Wilkins as his intellectual benefactor in the preface to *Micrographia* (1665) – his best-selling book of microscopical and other experiments conducted for the Royal Society, and the work which signalled Hooke's own rise to prominence in London scientific circles:

> If these my first Labours shall be any wayes useful to inquiring men, I must attribute the incouragement and promotion of them to a very Reverend and Learned Person, of whom this ought in justice to be said, That there is scarce any one invention, which this Nation has produc'd in our Age, but it has some way or other been set forward by his assistance.
>
> My reader, I believe will quickly ghess, that it is Dr Wilkins that I mean. He is indeed a man born for the good of mankind; and for the honour of his Country. In the sweetness of whose behaviour, in the calmness of his mind, in the unbounded goodness of his heart, we have an evident Instance, what the

true and the primitive unpassionate Religion was, before it was sowred by particular Factions.

In a word, his Zeal has been so constant and effectual in advancing all good and profitable Arts, that as one of the Antient Romans said of Scipio, That he thanked God that he was a Roman; because whereever Scipio had been born, there had been the seat of the Empire of the world: So may I thank God, that Dr Wilkins was an Englishman, for whereever he had lived, there had been the chief Seat of generous Knowledge and true Philosophy. To the truth of this, there are so many worthy men living that will subscribe, that I am confident, what I have here said, will not be look'd upon, by any ingenious Reader, as a Panegyrick, but only as a real testimony.[66]

Throughout Hooke's life he continued to honour the intellectual and personal debt he owed Dr John Wilkins. A number of key themes in Hooke's later work are already to be found in Wilkins's 1640s publications – his interest in the moon (and conviction that its landscape resembles that of the earth, and that it might therefore support similar life-forms); his passion for all kinds of devices which might allow a man to fly; and his commitment to the project for a 'universal character', or global scientific language based rationally on a system of classification correlated with systems of signs.

Beyond this, the habits of study and thought of Hooke's later life were lastingly marked by his close association with Wilkins at a formative stage in his intellectual life. Aubrey recalled that Wilkins was above all an engaged and worldly thinker, 'of a working head'. In this regard, Aubrey associated Wilkins's intellectual mode of thought with Thomas Hobbes and William Petty, expressing the view that 'if they had read as much as most men they would have known no more'. 'Neither', he continued, 'are Sir Christopher Wren or Mr Robert Hooke great readers'.[67]

Through John Wilkins's efforts, a hand-picked group of mathematically inclined and scientifically able men was assembled in Oxford in the early Commonwealth years. On the whole, they were men of 'cavalier' persuasion – moderate supporters of the monarchy, whose hopes for the future had been dashed by the violent termination of the reign of Charles I, and who now found themselves with no prospect of political

or clerical preferment, constrained to make their living outside the established Church and the Government.

With hindsight they were a formidable bunch: Wilkins himself, Ralph Bathurst, Jonathan Goddard, William Holder (brother-in-law of Christopher Wren), Richard Lower, William Petty, Walter Pope (Wilkins's half-brother), Lawrence Rooke, John Wallis, Seth Ward, Thomas Willis, Christopher and Matthew Wren.[68] A second tier of able men with similar interests, who were known to the group and occasionally participated in their activities, included Joseph Glanvill, John Locke, Peter Pett, John Owen, Thomas Sprat, Henry Stubbe, John Tillotson, Joseph Williamson and Robert Wood, each of whom would become distinguished in non-scientific fields. They are noted here because every one of these men would continue to play a significant part in Hooke's life, long after most of them had left Oxford and risen to positions of considerable prominence.

The shared intellectual interests uniting the group of men most directly involved with Hooke's university career – Busby, Wilkins, Willis, Goodman, Samuel and John Fell – were strong (including an educational upbringing in common, at Westminster and Christ Church). The religious and doctrinal connections between them were yet stronger, and, in the unstable 1650s, emotionally of the utmost importance to each of them.

While it was crucial for the group's survival that John Wilkins managed somehow to straddle the old and new regimes, in the spiritual realm as well as in the political (as did others of the older generation, like Jonathan Goddard), fundamental beliefs were at stake for those caught in the wake of drastic changes brought about by war and political upheaval. Beliefs might be suppressed, for fear of their consequences, but they went underground rather than disappearing completely.

The two key figures in the immediate circle of Hooke's benefactors, from this doctrinal point of view, were Thomas Willis and John Fell. Others in the group found themselves dependent on Wilkins's goodwill, through the vagaries of the times, and the fact that by accident they had no family to protect them. These two were immediate casualties of political events, marked out as non-conformers.

Both Willis and Fell had been ejected from their college fellowships in March 1648, for refusal to comply with the parliamentary Visitors'

requirement that all academics formally commit to the new order, politically and doctrinally. John's father, Samuel Fell, University Vice-Chancellor and Dean of Christ Church, was ejected forcibly and dramatically at the same time. Refusing to leave his Christ Church lodgings, he had had to be physically removed and was briefly imprisoned in London for his resistance. Upon his release, Dean Fell retired to the rectory of Sunningwell near Abingdon (the only one of his livings, presumably, that he was allowed to keep) and died within the year.[69] His son's resolute commitment to Anglican worship and determined refusal to submit to the Oxford parliamentary authorities stemmed from deeply held personal commitment (John Fell had served as an ensign in the royalist garrison during the siege of Oxford), but was also, no doubt, born out of loyalty to his deceased father.[70]

Before being ejected from Christ Church in 1648, Thomas Willis 'studied chymistry in Peckewater Inne chamber', according to Aubrey. When he lost his fellowship he moved into lodgings at Beam Hall, opposite Merton College. In 1649 he was making 'aurum fulminans' there – an unstable, gold-based compound, experimentation with which formed part of the research aimed at supplementing the short supply of saltpeter for essential civil war explosives. John Fell (who had been ordained in 1647) – similarly deprived of both home and livelihood by his ejection – joined Willis. In April 1657, Willis married John Fell's sister; the Fell family had probably been dependent on Willis's support since Samuel Fell's disgrace and death.[71]

During the early 1650s regular services were conducted by John Fell in Thomas Willis's rooms, under the old Anglican liturgy. Hooke attended these services, as did Christopher Wren (who in 1653 became a Fellow of All Souls). It may have been at Beam Hall that Hooke and Wren met, and it is likely (since both were deeply devout, raised in the old High Anglican way) that it was this shared worship which laid the foundations for the deep and lasting friendship between them.[72] It is important that we understand that these regular acts of worship were not without risk, and involved deep commitment on the part of all those involved. Attendance at the University Church of St Mary's was compulsory; these worshippers chose to follow those rites with ones to which they could give their true commitment, in secret.[73]

Not everyone in the group who remained committed to the old liturgy thought it worth the risk of continuing it in adverse times. Robert

Boyle, Sir Peter Pett later recalled, deliberately did not join the regular worship at Beam Hall, and the terms in which Pett puts this in his reminiscence shed some light on that other small, select group of worshippers:

> For my acquaintance beginning with [Boyle] during his residence at Oxford in the time of Cromwells Usurpation, I observed, that he sufficiently avoyded all guilt of Scandall by shewing the least approbation of it: nor did he there give any visite to Dr Goodwin or Dr Owen who were Oliver Cromwells great Clerical Supporters, and placed in the highest Posts in the University. And there was at the same time there a private Meeting in an Upper roome, where when the afternoone sermon at St Marys [the University Church] was done severall schollars and others went to heare the Common prayer read by Dr Fell who was afterwards Bishop of Oxon, and where the Sacrament was given by him in the way of the Church of England. But Mr Boyle thought not fitt to go to that Meeting, nor by so doing to appeare as a professed Cavalier.[74]

Boyle – highly visible as a brother of the Earl of Cork (conveniently, a parliamentary ally) – chose not to associate himself explicitly with the circle of those who continued to adhere discreetly to their Anglican forms of worship, even though that was the circle to which, by virtue of his association with Wilkins and Willis, he 'belonged'. Instead, he simply attended the University Church, where John Owen (who had followed Samuel Fell as Dean of Christ Church)[75] and the prominent parliamentary preacher Thomas Goodwin (appointed President of Magdalen College in 1650) took it in turns to officiate and deliver the sermon, but distanced himself from the Commonwealth-supporting clergy there.[76]

Pett's comment that Boyle took care not to 'give any visite to Dr Goodwin or Dr Owen who were Oliver Cromwells great Clerical Supporters', thereby actively endorsing the regime, is more pointed than it seems at first glance in relation to the Beam Hall worshippers.

In terms of religious conviction, however, Boyle was broadly of a party with the worshippers in Willis's upper room. What united them all was the view that rational explanations could be arrived at for everything in the natural world, and that such forms of explanation were

confirmation of the existence of an all-knowing God, whose representatives on earth – the Anglican clergy – were the custodians and guides on behalf of those unable to rise to full understanding on their own.[77]

Hooke and Wren, Willis and Fell, were bonded, above all, by their conviction that for devout Anglicans like themselves, the true and only righteous path was that of the established Church. As Thomas Sprat (who was close enough at college to Wren to call him 'Kit') argued after the Restoration, Anglicanism was 'the Profession of such a *Religion*, and the Discipline of such a *Church*, which an impartial Philosopher would chuse', adding that the Anglican Church, 'by falling with the *Throne*, and by rising with it again, has given evident signs how consistent it is with the Laws of humane society, and how nearly its interest is united with the prosperity of our Country'.[78]

Hooke was dextrous, quick and intellectually curious – all talents which made him an invaluable assistant to Willis, as subsequently to Boyle. He was also (as we recall from his stories of his childhood) a talented draughtsman. It is interesting to note that the ability to do fine, accurate line-drawings was a skill which brought a number of young men into the sphere of Oxford science. Hooke drew the arrangements of scientific apparatus for the engravings in Boyle's early published works. Christopher Wren executed a number of the drawings from which the illustrations in Thomas Willis's *Cerebri anatome* (*Anatomy of the Brain*) were made.

The friendship formed between Hooke and Christopher Wren (three years Hooke's senior) was of the utmost importance to both men for the entire duration of Hooke's life.[79] Although their family backgrounds were significantly different – Hooke the son of a humble Isle of Wight curate, Wren the son of the Dean of Windsor, close servant to Charles I – the two young men had a significant amount in common. These shared circumstances were, above all, deeply felt emotionally, and lastingly formative of the two men's personality and outlook.[80]

Both had seen much loved fathers ruined by the civil wars – Hooke's father dead, Wren's reduced to penury, and living in retreat with his sister Susan. Both had been adored boys, taught at home because of poor health and perceived exceptional aptitude, acquiring excellent classical languages from their fathers, and new technical skills (in clock- and dial-making, mechanics and dynamics), in which they had shown themselves particularly precocious. Both were considerable mathematicians,

but also talented artists and draughtsmen. Both had attended Westminster School, and been special favourites of Richard Busby.

In matters of faith, both held strongly and steadfastly to their fathers' convictions, High Anglican, respectful of the memory of the 'martyred' King and head of the Anglican Church, Charles I. Temperamentally, both had coped remarkably well with the transition from cosseted children and the promise of a golden career (for both men, probably in the Church), to becoming simple 'operatives' or scientific servants – in Hooke's case, to Willis and Boyle, in Wren's to the already prominent mathematician and physician Charles Scarburgh. Both were passionate by nature, and in the mid-1650s, for both men, that passion was spent in the knowledge that there was unlikely to be a future for either of them under the Commonwealth regime.

During the early days of Hooke's studies in Oxford, he and Wren became particularly close, their shared intellectual interests reinforced by their closely similar family circumstances (despite their difference in social status). Both belonged to Thomas Willis's circle of 'chemists' (medical and pharmaceutical experimenters). In December 1650, Willis and Petty had achieved instant notoriety when they discovered that the felon's cadaver they had gathered to dissect at Petty's Buckley Hall Lodgings in the High Street was not in fact dead. Nan Greene – a hapless young woman who had been hanged for infanticide – was duly resuscitated and nursed back to health. Her revivers then petitioned the authorities successfully for a pardon, in the light of the extraordinary nature of her survival.[81] Numerous broadsheets and poems were published, including witty verses by Walter Pope (Wilkins's half-brother) and Wren, indicating that Wren was already part of the Petty – Willis circle by this date, three years before Hooke's arrival and employment as Willis's laboratory 'servant'.[82] On the strength of the publicity surrounding the Nan Greene 'miracle' revival, Petty (hitherto a kind of freelance anatomy tutor, based at Brasenose College) was appointed Tomlins Reader in anatomy by the University.[83]

Hooke characterised these Oxford years as the beginnings of his lifetime love-affair with science:

> At these [philosophical meetings in Oxford] which were about
> the Year 1655 (before which time I knew little of them) divers
> Experiments were suggested, discours'd and try'd with various

successes, tho' no other account was taken of them but what particular Persons perhaps did for the help of their own Memories; so that many excellent things have been lost, some few only by the kindness of the Authors have been since made publick; among these may be reckon'd the Honourable Mr. *Boyle's Pneumatick Engine* Experiments, first printed in the Year 1660.[84]

Under the aegis of Wilkins and Willis, in the circle of adept and intellectual friends, including Boyle, Petty and Wren, a close-knit band of experimentalists was formed, which lasted a generation. It was, in Hooke's mind, the group in which the Royal Society originated. It was also the group of friends to whom, in spite of his temperamental inclination to fall out with colleagues and intellectual competitors, he remained lastingly loyal.

In the early months of 1659, Hooke's life seemed to be in order: a settled routine of intellectual service as laboratory assistant and operator to Robert Boyle. He was twenty-four, with secure employment as operator and amanuensis in the household of a nobleman who had managed to remain in favour with successive administrations and regimes, discreetly refusing to be drawn into Sectarian Politics in London. His job matched his talents, and was absorbing and demanding – whenever Boyle was free from the onerous social obligations of an Anglo-Irish gentleman.

But in April 1659 the faltering regime of Oliver Cromwell's son Richard collapsed, and the army resumed control. Once more it was unclear which way power would swing; yet again civil war appeared imminent. This unsettled Hooke and made him – as it made others – keen to avoid the renewed rigours of English unrest. Apparently he dreamed of independence and autonomy, and of a life which would allow him to follow his intellectual curiosity wherever it led him, unconstrained by the bounds of service. If he was to be obliged to be constantly watchful for the alterations in circumstance which each successive change in political administration might bring, at least he wanted that alertness to allow him to be intellectually bold and original.

In his own mind, the direction in which such independence lay was eastwards, as a seaborne adventurer, travelling in search of new knowledge aboard the kind of ships he had seen provisioning in Yarmouth harbour as a boy. He began to read books of adventure abroad and exotic

Lectuli et ratio quibus Chinç proceres primarij (Mandorinos vocant) gestantur, cymbeç, quibus ad oblectationem per fluvios vehuntur... Manere als haer die Manderyns van China welck het princepael governement hebben laten draegen en op die revieren vermeyen waeren. 32 en 33

Engraved plate from the Dutch edition of Jan Huygen van Linschoten's
*Itinerario*, showing the lifestyle of Chinese mandarins – one of many
vivid pictorial representations for the curious European of exotic mores
to the East.

travel. One of these was Jan van Linschoten's *Itinerario*, documenting the
Dutch explorer's travels to the East and West Indies. Hooke read the
*Itinerario* on 14 May 1659, and took notes.

Linschoten's work was the acknowledged serious source for those
intending to embark on travel eastwards, particularly in search of exotic
consumer items for the burgeoning European market in luxury goods.
Describing the preparations for travel made by an early captain with
the East India Company, a recent scholar writes:

> For a chart he used the book of maps and sailing directions
> prepared by the Dutch cartographer, Jan Huyghen van Linscho-
> ten. During five years as secretary to the Archbishop of Goa
> (the Portuguese headquarters in India) van Linschoten had
> quietly compiled a dossier on the eastern sea routes which he
> then smuggled back to Europe, an achievement which may

Engraved plate from the Dutch edition of Linschoten's *Itinerario*,
showing an Indian prostitute dancing and singing for a fascinated
Lascar, and a scantily-dressed farming family.

constitute the most momentous piece of commercial and mari-
time espionage ever. Published in Holland in 1595–6, Linscho-
ten's works were the inspiration for the first Dutch voyages to
the East and, translated into English in 1598, they played no
small part in the East India Company's designs on the spice
trade. The book of maps was required reading for every Dutch
and English navigator, and Saris [an English captain] for one
found it invaluable and 'verie true'.[85]

Studying Linschoten, Hooke noted that in Mozambique there were
'certaine henns that are so black both of fethers flesh & bones that being
sodden they seem [margin: Mozambique hen as black as the negroe] as
black as inke yet of very sweet tast. some are found in india but not
soe many as in Mossembique'. Vicariously, from his position as armchair
traveller, Hooke jotted down Linschoten's observation that 'The neerer

we are to sand the more it stormeth, raineth, thundreth, and calmeth.'[86] He was fascinated with the Turks' use of pigeons to carry messages swiftly across distances of as much as a thousand miles.[87] He imagined the intense heat at Ormus in summer ('The summer is so hot in Ormus that they sleep both men & women with all their bodys saving their heads covered with water in wooden [margin: fresh water from under salt.] troughes'). He marvelled at perfume from Bengalen, and the finest porcelain from China.[88] The Chinese, too, have 'Orringes sweeter then suger. their silver mony is cutt & weighed with instruments they carry for that purpose.'

As a young man with a keen visual eye, no doubt he scrutinised with curiosity the exotic plates which illustrated the *Itinerario* – plates showing the market at Goa, scantily clad oriental women, bustling market places full of jostling crowds of apparently prosperous and eager merchants. Prosperity was something Robert Hooke thought about a good deal whenever in his life it seemed he might be thrown back on his own resources.

Poring over his travel book, Hooke went on to remark in his notes how far preferable this distant Chinese civilisation is to the one he finds himself in. 'None are suffered to rule in the place where they were borne & bred. Schollars highly estimmed & proferd. At the death of any great one their wifes and slaves are kild & together with much provision buried with them. There is not one foot of land that lyeth most even the mountaines are plowed & planted. neuer any plague knowne there. none may goe out or come in without leave.'

In May 1659 the return of the English monarchy was not yet even an early dawn on the horizon. As far as ordinary subjects like Hooke were concerned, the economic and political uncertainty which had followed the death of Cromwell was set to continue. Under that pall of gloom, with little prospect of rising in the world, the adventurer's life appeared at least to offer real possibilities. At thirteen, Hooke had set sail from the Isle of Wight, ready to take his chances of a future to match his extraordinary talents. In 1659, he apparently once more contemplated such a journey into the promise-filled unknown.[89]

## 3

# *Take No Man's Word for It*

Thence ... to Gresham College ... It is a most acceptable
thing to hear their discourses and see their experiments; which
was this day upon the nature of fire, and how it goes out in
a place where the ayre is not free, and sooner out where the
ayre is exhausted; which they showed by an engine on purpose
... Above all, Mr. Boyle today was at the meeting, and above
him Mr. Hooke, who is the most, and promises the least, of
any man in the world that ever I saw.

Diary of Samuel Pepys, 15 February 1665[1]

Hooke was almost twenty-five when Charles II returned in triumph
to England from the Netherlands in the spring of 1660, to assume
the vacant throne. There is no doubt that, with his staunch royalist
family credentials, Hooke was optimistic about the Restoration of the
English monarchy, and a regime which looked firmly back with nostalgia
to the days of the new King's father, Charles I. Nevertheless, his sense
of optimism will have been tempered by uncertainty about his own
career prospects.[2]

For it was not immediately clear that the Restoration would improve
Hooke's own fortunes. Since the dark days at the close of the civil wars,
when, at the age of thirteen, Hooke had been left fatherless and alone
on the English mainland, he had, by dint of hard work, opportunism and
sheer, dogged determination, manoeuvred his way to a good livelihood, a

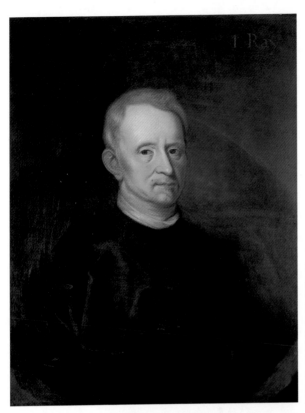

*Winners and losers:*
(*left*) Almost forgotten: portrait believed to be Robert Hooke, by Mary Beale.
(*below*) Always remembered: the boy Newton discovers the law of gravitational attraction in the family orchard (Robert Hannah, 1905).

*Drawings for the record:*
(*above*) 'Instrument for finding the force of falling bodys' drawn and described by Hooke and preserved among his papers at the Royal Society.
(*above right*) Self-portrait of a giant more than 8 foot tall, in the service of the Elector Palatine – copy by Henry Hunt.
(*right*) Drawing by Hooke of a support for a long tubeless telescope.

(*above*) Drawings of bladder and kidney stones for the Royal Society Records, by Henry Hunt.

(*above right*) Drawing of an ornamental urn, possibly for one of Hooke's London churches, found among Royal Society papers.

(*below*) Drawing by Hooke of a support for a long telescope.

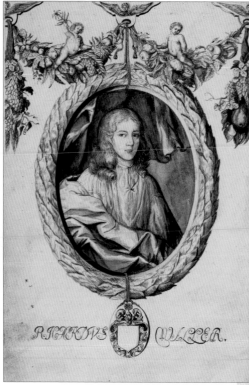

*Accomplished artist and faithful friend:*
(*left*) Self-portrait of a youthful Richard Waller, showing his early artistic talent.
(*below left*) Watercolour botanical drawing of an iris ('yellow water flower de luce') by Richard Waller.
(*below*) Watercolour botanical drawing of 'Knap-weed' by Richard Waller.

respectable occupation and comparative security on the basis of his acknowledged intellectual gifts and practical talents. Now, a fresh set of political events over which he had no control threatened to blow his life off course again.

By 1660 Hooke had achieved a modest success as a technician and operator and specialist instrument-maker in the service of the scientific enthusiast Robert Boyle.[3] Hooke had proved himself indispensable to the bachelor Boyle as a dextrous experimentalist, particularly in his ability to design and build precision items of equipment for Boyle's experimental activities. His sound grasp of theoretical issues combined with excellent Latin meant that Boyle could entrust to him the overseeing of the tedious detail of editing and proofing his published works. In November 1660, for example, Richard Sharrock, who was supervising the translation into Latin of Boyle's *Spring of the Air*, advised in the letter accompanying the first sheet, 'I thincke it convenient that it bee transcrib'd before it bee return'd back to [me] for feare of miscarriage, Mr Whitaker, or Mr Hooke can read my Hand.'[4]

Beyond this, Hooke had carved out a place for himself at the heart of the Boyle family. He travelled with Robert Boyle, lodged when in London with Boyle's sister, Lady Ranelagh, in Chelsea, and was available, as a kind of all-purpose amanuensis, to run small errands, draft letters and simply provide good company, quite apart from his invaluable scientific services. He was likeable and liked. It is with evident affection that Hooke writes to Boyle, on 5 June 1663, for instance:

> I have put up and sent the things you gave order for, together with four pair of gloves *Mr. Whit.* spoke for; and should have come away my self, but that . . . I did hope you would be pleased to dispense with my absence from attending on you for two or three days longer . . . and that because those extraordinary days being holidays you may perhaps have other avocations, especially being newly come thither. For I remember you were pleased to say, that you thought it would be a week before the ceremony of visits would suffer you to settle about any business, and so should have little use of me till then.[5]

Hooke ends this letter, 'your honour's most affectionate, most faithful and most humble servant'; there is no reason to doubt his sincerity.[6]

He could also produce delightful drawings. Hooke was justifiably

proud of his skills as an artist. It was a talent he shared with his college friend Christopher Wren – by the late 1650s they had begun making exquisite drawings of insects and other natural phenomena viewed with the high-magnification help of the new microscope. Hartlib reported to a correspondent:

> The 17 September [1655] Mr Wren told of a Book which hee is preparing with Pictures of observations microscopical. He counteth Reeves makes the best of any Microscopes to bee had. As likewise Tubes of which they have one at Oxford of 24. foot long. which with a thread once placed hee can manage as hee pleases. As likewise to rule the light or Sight in it according to all its diversities.[7]

On occasion Hooke took responsibility for the drawings of experimental equipment and instruments on which the engravings to accompany Boyle's published scientific writings were based, and, sometimes it was he who decided what illustrations were needed to accompany Boyle's text.[8] On occasion, Hooke copied drawings supplied by others. An exquisite Hooke version of a drawing survives, a copy of one by Robert Southwell which accompanied a letter from Rome, describing a long telescope in use in Florence to observe the rings of Saturn.

The Boyle family had weathered the Commonwealth years well. Anglo-Irish nobility of consequence (Boyle's father, the first Earl of Cork, had risen rapidly a generation earlier, through astute land-deals and political manoeuvring), they had trimmed politically to the requirements of the parliamentarians, rendering them sterling service in Ireland.[9] Boyle's elder sister Katherine had married Arthur Jones, Lord Ranelagh in the 1630s.[10]

During the 1650s, Lady Ranelagh's London salon continued to be the meeting place for men of influence, in particular for the growing community of scientific virtuosi (associated with the circle of Samuel Hartlib).[11] Although Lady Ranelagh stopped short of outright collusion, preferring to keep a discreet distance from active political circles, the Boyles were potentially compromised politically by their accommodation to public life under Cromwell. During the early months of the new King's reign, they therefore kept a low profile, taking in the widespread rejoicing and festivities from afar.[12] Unlike Samuel Pepys, who had the good fortune to be employed by his cousin Edward Montagu (elevated

by Charles II to Earl of Sandwich on the eve of his triumphal return), and was catapulted into royal favour, Hooke watched from the wings, as the Boyle family bided their time and considered their options. Meanwhile, old Oxford friends like Christopher Wren – whose father had been a loyal personal servant of Charles I – stepped straight into the close circles around the new King.[13]

While many aspiring courtiers rushed with unseemly haste to the side of the returning King, Robert Boyle stayed in Oxford, tinkering with his chemistry and making only occasional trips to London, until it was absolutely clear that there were to be no general reprisals against Commonwealth sympathisers. Boyle did not in fact relocate permanently from Oxford to London until 1668, when he took up residence with Lady Ranelagh at her house in fashionable Pall Mall.[14] Between 1660 and 1668, he travelled regularly between Oxford and London, pursuing his scientific interests at both addresses, in laboratories specially built and equipped for him, and with Hooke in attendance to make sure the equipment worked.[15]

Hooke's lifelong reticence in the matter of religious observance may be traceable to these early Restoration years, in the service of a circumspect Irish nobleman, whose own strategy was to fulfil the prevailing requirements for worship, so as not to become obtrusive. There is ample evidence from entries in Hooke's diary that he was at heart a man of deep religious conviction. Until the end of his life he sustained his commitment to High Anglicanism, which had brought him close to men like Wren, Willis, Wilkins and Fell at Oxford – a commitment which meant that under the political regimes of James II (a Catholic) and William III (a low-church Protestant) he found himself isolated, along with the other survivors of that Oxford circle, from direct lines of preferment.

After the Restoration, however, Hooke's religious beliefs seem to have become a strictly private affair. By the early 1670s, when his daily activities are recorded in his personal diary, he was no longer a regular attender at church services. His diary entries for Sundays show him as busy with a whole raft of 'business' as on any other day of the week. Unlike Evelyn and Pepys, he does not always record which church he attended, nor comment at length on the quality of the service or the officiating clergyman's sermon. He does, however, regularly record thanks to God (or other kinds of comment on God's treatment of him) in his diary.

There he places responsibility for his health, in particular, squarely

in divine hands. During a bout of troublesome illness in 1672, he treated a feverish cold with a new therapeutic remedy, commenting: '*Alia tentanda est via. Deus prosperet*' ('I must try another way. God will look kindly'). When he took a turn for the worse, he wrote: 'very ill. *Miserere mei Deus*' ('God take pity on me'). A turn for the better and he wrote: 'Slept exceedingly well and miraculously recovered. *Solo Deo misericordi gloria*' ('Glory to the only god of compassion').[16]

In a number of his lectures and papers, particularly those written and delivered in the 1680s and 1690s, Hooke is eloquent in his expressions of belief that the order and beauty of nature bear witness to God's providence and care for mankind. We fail to understand Hooke and his age if we mistake his reticence in matters of personal faith for indifference. Hooke's fascination with and dedication to uncovering the breathtaking diversity and detail of the natural world was consistent with a profound belief in its maker, as architect of the grand design. Hooke's old friend Richard Waller put the matter plainly in contemporary terms:

> He always exprest a great Veneration for the eternal and immense Cause of all Beings, as may be seen in very many Passages in his Writings, and seldom receiv'd any remarkable Benefit from God without thankfully acknowledging the Mercy; never made any considerable discovery of Nature, invented any useful Contrivance, or found out any difficult Problem, without setting down his Acknowledgement to the Omnipotent Providence, as many places in his Diary testify, frequently in these or the like words, abbreviated thus, DOMGM, and was a frequent studier of the Holy Scriptures in the Originals: If he was particular in some Matters, let us leave him to the searcher of Hearts.[17]

Hooke's religious diffidence is that of a man without a profound sense of destiny – of a strongly shaping plan for his life, over which God presided with vigilance. In this as in so many other features of his life, he was altogether a man of his times. His early life had been lived against a background of extreme political and social change: the toppling of regimes, violent termination of dynasties, overthrow of family fortunes, personal disappointments and disaster, the unpredictable rise and fall of individuals, choices shaped by occasion and chance association, luck, opportunity, speculative financial successes based upon unreliable circumstances. Taken together, these vagaries of fortune seem to have

taught ordinary Englishmen like Hooke that, however benevolent the God they worshipped, fortune was fickle, and that paying even lip-service to successive Church administrations was unwise.[18]

This attitude towards fate and destiny is exemplified in the way Hooke spoke of the visible signs of talent noticed during his childhood. Hooke recalled a childhood precocity, remarked on by adults – an unusual ability in making things with his hands. Very similar stories are told of the boy Wren, the boy Newton and the boy Flamsteed: all are singled out by watching adult patrons while children, building remarkable working models, constructing astronomical instruments and clocks, drawing like angels. All these men, born just before or during the English civil wars, recount stories of childhood potential which might have flowered naturally under more fortunate sets of circumstances – of things that might have been. For each, the rewards for such talent are interrupted by the disturbance and incoherence of the late 1650s and early 1660s.

If Hooke could not depend on divine providence to guide the course of his life, he could count on the steady support of the employer who had first lifted him out of obscurity. Hooke remained close to the Boyle household throughout his life. His diary records regular attendances at the Ranelagh house in Pall Mall (although occasionally Lady Ranelagh upset Hooke by failing to accord him the respect he felt he now deserved).[19] In 1677, for example, he dined at Lady Ranelagh's more than thirty times.[20] In 1674 it was Hooke who persuaded Robert Boyle to have his portrait painted by the fashionable artist Mrs Beale, perhaps because she had painted their mutual friend and mentor Dr John Wilkins.[21]

When, later, Hooke became a recognised architect, particularly in demand for private commissions (which his architectural senior partner Wren avoided), he executed building commissions for Lady Ranelagh both in London and in the country, and for her son, Richard Jones.[22]

On 28 November 1660, following a lecture delivered at Gresham College by Christopher Wren, Gresham Professor of Astronomy, Hooke's Oxford protector Dr John Wilkins convened a meeting of the virtuosi who had attended, at which it was proposed to found 'a college for the promoting of Physico-Mathematical Experimental Learning'.[23] After enthusiastic discussions of a scientific 'academy' which would rival those

virtuosi-in-exile like Sir Robert Moray had encountered in mainland Europe, a broad plan for the constitution and activities of the new 'society' was drawn up, and Wilkins was elected its interim chairman. Negotiations then began to obtain royal support through the good offices of Moray, a senior courtier, close to Charles II, and a keen amateur scientist, who had attended both the lecture and the meeting.[24]

A week later Moray announced that the King supported the enterprise, and would provide every encouragement for it. Moray became the Society's first President, and he and Sir Paul Neile began to lobby the King for formal recognition. As Moray explained in a letter to the Dutch virtuoso Christiaan Huygens, after the issuing of a new, improved royal charter to the Society in April 1663, the point of this was above all to ensure that the new Society could be the recipient of (as he hoped) substantial funding:

> We begin now to work on establishing our Society with more energy than hitherto, because the King's patent [charter] was sent to us five or six days ago, which establishes it as a Corporation with various privileges. Such a charter is necessary, according to the laws of this country, in order for it to be able to receive donations, to give it legal status etc. So that we are now concentrating our efforts on other necessary means for the prosecution of the scheme we proposed for ourselves, as the constitution of the Society, which will have an impact on the funds needed to pay the cost of the experiments.[25]

On 16 October 1661 the sponsors of the Society finally achieved their goal (though it would turn out that they would, nevertheless, always be short of funds):

> Sir Robert Moray acquainted the Society that he and Sir Paul Neil kissed the King's hand in the company's name, and is entreated by them to return most humble thanks to his Majesty for the reference he was pleased to grant of their petition; and for the favour and honour he was pleased to offer of himself to be entered one of the Society.[26]

Once the King granted the Society its first charter in August 1662, Moray stood down from the Presidency, and Sir William Brouncker became the first official incumbent of this office.[27] It had been agreed at one of

the earliest meetings that someone skilled in shorthand was to be appointed to record details of what went on – Wilkins and Henry Oldenburg were appointed joint Secretaries, while William Balle became Treasurer.[28]

Boyle re-entered London life as a leading figure in this new scientific initiative, and he did so with Hooke in attendance. Although Boyle accepted no office with the newly established Royal Society, he was prominent in its early arrangements. For at least a month in summer 1662 he was acting President. When Moray persuaded the King to allocate the Society some of the monies paid as restitution out of Ireland, the order issued to the Lord Lieutenant of Ireland stipulated: 'You shall make a grant accordingly to R. Boyle and Sir R. Moray ... in trust for the Royal Society' (unfortunately for the Society, the Lord Lieutenant failed to comply, even after a second royal letter was sent in December 1663).[29]

Boyle's long-term influence on the Royal Society was decisive, since it was he who provided and encouraged the employment of the two key figures most closely associated with the Society's success. One of these was Henry Oldenburg, originally tutor to Boyle's nephew Richard Jones, who had since 1660 been assisting Boyle with foreign correspondence and editing his manuscripts for the press. The other was Boyle's scientific operator, Hooke. Both men had been associated with Boyle's household for some years.

Hooke's name first appears in the records of a meeting of the new Society which took place on 10 April 1661, when it was announced that the subject of the next discussion would be his recently published tract on the capillary action of water in thin glass tubes. Significantly, the full title of this was: 'An Attempt for the Explication of the Phaenomena, Observable in an Experiment Published by the Honorable Robert Boyle, Esq; in the XXXV. Experiment of his Epistolical Discourse touching the Aire. In Confirmation of a former Conjecture made by R. H.' Hooke's name, then, enters the Royal Society records bracketed with that of Boyle, as his personal scientific operator, providing elucidation of experimental effects on which the two had previously worked together. In fact, only Hooke's initials feature on the publication in question. His full name was presumably introduced at the meeting by his employer, with whose backing Hooke had made this, his first, printed contribution to experimental science.

In fact, Hooke demonstrated capillary action in thin glass tubes at

the 10 April meeting. It was presumably this demonstration which led to the suggestion that his text on the subject be the topic of the meeting the following week. Yet Christiaan Huygens, who was in London for the celebrations surrounding Charles's coronation, and was present at the Royal Society as a distinguished visitor, did not register Hooke's presence at all.[30] Huygens only noted in his diary:

> 10/20 [April]. Visited by Mr. Wallis and Mr. Rook. Afterwards by Mr. Boyle after dinner. Mr. Moray and Mr. Brouncker came to fetch me and we went to the assembly where I found Mr. Wren. There was discussion of water rising in narrow glass pipes, and a committee was ordered for Saturday at my lodgings, for improvement of telescopes.[31]

The capillary action Huygens refers to was being observed inside Boyle's evacuated air-pump. As its operator Hooke's presence was critical; *qua* individual he was as yet a person of no consequence. Boyle later made it clear that in his own subsequent publication on 'rarefaction', *A Defence of the Doctrine Touching the Spring and Weight of the Air*, a crucial appendix was also by Hooke, but that the printer had failed to advertise this clearly on the title-page.

Yet a full year later, Huygens was still corresponding with Boyle on details of experiments conducted by Hooke, rather than with Hooke himself. In June 1662, Boyle wrote to Moray:

> As to what [Huygens] says touching the hypothesis assumed to make out the phaenomena of Rarefaction, it will not be requisite for me to inlarge upon it, The Proposer of the Hypothesis [Hooke] being himself ready to give you an account of it. And Monsieur Zulichem though (chiefly through the Printers fault) he mistakes the proposer of it, Yet rightly apprehends both that the Hypothesis is plausible enough.[32]

Hooke, in other words, entered the world of the London virtuosi in the shadow of Boyle.

The diarist John Evelyn – an early Royal Society member – who was also at the 10 March meeting attended by Huygens, likewise fails to mention Hooke's presence as operator:

> To our Society: where were experimented divers ways of rising of water in glasse tubes, above the Super ficies of the stagnant

Engraving based on Hooke's drawings illustrating surface tension and capillary action from his first official publication (1661), commenting on the outcomes of experiments conducted by Boyle.

water: either by uniting one part of the water to the other by a kind of natural appetite to joyne its like; or rather by the pressure of the subjacent water by the super stantial aer, to an *aequilibrium* of Cylinder of the Atmosphere.[33]

Evelyn also attended a Society meeting on 25 April 1661, two days after Charles II's Coronation, when the demonstration was again of 'divers experiments in Mr. Boyle's Pneumatic Engine'.[34] Again, there is no mention of Hooke. At this stage Hooke was 'invisible', his presence in a serving capacity rendering him unworthy of notice or comment.[35]

It was Evelyn, apparently, who coined the name 'Royal Society'

which appeared in its first Royal Charter of July 1662.[36] In his diary he refers to it by the rather cumbersome full title of 'Royal Society for the Improvement of Natural Knowledge by Experiment' – later emended to 'Royal Society of London for promoting Natural Knowledge' – but the short form stuck. It underscored the importance all the early members attached to the connection with the King, and the value they attached to the 'privileges' granted to them by him:

> 13 August 1662: To *Lond.* Our *Charter* being now passed under the *Broad-Seale*, constituting us a Corporation under the Name of the *Royal-Society*, for the Improvement of naturall knowledge by Experiment: to Consist of a President, Council, Fellows, Secretaries, Curators, Operator, Printer, Graver & other officers, with power to make laws, purchasse land, have a peculiar Seale & other immunities & privileges &c: as at large appears in our Graunt, was this day read, & was all that was don this afternoone, it being very large.

Once passed, the members of the Council were sworn in. They immediately began to devise the kind of formal rituals and ceremonies beloved of post-Restoration 'clubs':

> 20 August 1662: To *London*: I was this day admitted, & then Sworne one of the present Council of the Royal Society, being nominated in his Majesties Original Graunt, to be of this first *Council*, for the regulation of <the> Society, & making of such Laws & statutes as were conducible to its establishment & progresse: for which we now set a part every *Wednesday* morning, 'till they were all finished: My Lord *Vicount Brounchar* (that excellent *Mathematitian* &c) being also, by his *Majestie*, our Founders, nomination, our first <*President*>. The *King* being likewise pleas'd to give us the armes of England, to beare in a *Canton*, in our *Armes*, & send us a Mace of Silver guilt of the same fashion & bignesse with those carried before his Majestie to be borne before our President on Meeting-daies &c: which was brought us by Sir *Gilbert Talbot*, Master of his Majesties Jewelhouse.

A little more than a week later the entire membership trooped down to Whitehall, to be received by the King himself:

29 August 1662: The *Council* and Fellows of the Royal Society, went in Body to White hall, to acknowledge his Majesties royal grace, in granting our Charter, & vouchsafing to be himselfe our Founder: when our President, my Lord *Brounchar* made an eloquent Speech, to which his Majestie gave a gracious reply, & then we all kissed his hand: [30] Next day, we went in like manner with our addresse to my Lord *High-Chancelor*, who had much promoted our Patent &c: who received us with extraordinary favour.[37]

On 17 September the King formally granted the coat of arms, with the motto '*Nullius in Verba*' – 'Take no man's word for it'. Evelyn was once again behind the symbolism as well as the graphics. Nothing could have better summed up Hooke's approach to and attitude towards 'natural knowledge'.[38] The early Royal Society and Robert Hooke were entirely of one temperament.

Although the institutional form of the Royal Society was now securely established, the same was not true of its day-to-day practices. By late 1662, some of the Society's leading figures had decided that a degree of professionalisation needed to be introduced in organising its demonstrations and experiments, whose appearance was beginning to look alarmingly incoherent, ranging haphazardly over miscellaneous topics according to the whim of individual members. More could be achieved, more systematically, it was decided, if the Society were to employ, on a full-time basis, one or more people to act as 'Curators by Office'. As a result, in November 1662, Hooke at Last emerged from the shadows, and was appointed to the post of Curator of Experiments, 'offering to furnish them every day, on which they met, with three or four considerable experiments'.[39] The accounts of meetings for the months that followed Hooke's appointment show a marked improvement, a far greater coherence in the Society's experimental programme. Even so, it was Hooke's outstanding competence as an experimentalist which brought him to prominence – in the original minute of his appointment as Curator at the Royal Society his name has apparently been added to the record later.

Hooke's key role in shaping the Royal Society's agenda and designing its meetings from its early years brought him tantalisingly close to real power and influence. To the extent that the whole shaky edifice of Royal

Sketches by John Evelyn of possible coats of arms for the newly formed Royal Society, with a range of mottos, including the one eventually chosen – 'Nullius in verba'.

Society scientific practice rested on the shoulders of its tireless, supremely talented experimental operator, he was at the very centre of the Society's organisation and meetings. When he was rumoured to be dangerously ill, in summer 1672, Sir John Hoskins wrote to John Aubrey: 'The most dire news I ever heard of [the] Royal Society being the indisposition of Mr Hooke'.[40]

Such dependence came at a price. Each and every one of the senior members of the Royal Society considered himself entitled to oblige Hooke to provide support for their latest scientific project, without any thought for existing commitments he was already struggling to fulfil. In the end, these competing demands may be seen as Hooke's personal downfall, as far as lasting reputation is concerned. All things to all men, he had neither the opportunity nor perhaps the inclination to pursue any of the many interesting fields into which he was drawn on behalf of others, so as to see any major project through to completion, or to stick with any knotty mathematical problem through to its solution.

The proliferation of disparate materials which survives from Hooke's long years devising and performing weekly experiments in the records of the Royal Society makes this abundantly clear. It also makes it difficult

to recover the pattern or shape to Hooke's day-to-day life. In an attempt to do just that, we may turn our attention to one small segment of time for which documentation of Hooke's activities survives from a range of sources. The 1660s are well documented in the Royal Society records, an unusually rich sequence of letters between Hooke and those to whom he was professionally answerable (Boyle and Oldenburg) survives for this period, and there is (because of events we shall explore later) further correspondence involving the Dutch Huygens family, whose voluminous papers survive at Leiden and The Hague.

The pattern of Hooke's day-to-day life in the 1660s when he was rising thirty, full of impatient ingenuity, was one of negotiating a flood of competing obligations to a whole range of clients and patrons (not to mention his own personal interests and researches). Hooke was sociable, obliging, enthusiastic and, in terms of the organisation of his efforts, an inveterate optimist. Generous to a fault, he tried valiantly to give adequate attention and time to each of the projects he undertook. That he failed – and in the process earned a reputation for irritability, and a tendency to claim he had achieved more than could be proved by the documentary evidence – says as much about the nature of the demands made upon him as about his personality.

On 3 June 1663, Robert Hooke was elected a Fellow of the Royal Society.[41] His advancement from Curator of Experiments (the job he had been appointed to at the suggestion of Sir Robert Moray in November 1662) to full membership followed the granting of royal approval for the revised Charter of the Royal Society that April, and the re-election of the foundation Fellows a month later, to regularise the Society under the terms of its new Charter.[42]

Although Hooke was by now well regarded in his own right within the circle of the Royal Society, full membership transformed him from *ad hoc* operator, orchestrating equipment and demonstrations for the Society's weekly meetings, to decision-making participant in its scientific and social organisation. The role of Society Curator, which had developed informally, had already been stamped with Hooke's inimitable style.[43] The job involved technical and experimental back-up for absolutely every idea dreamed up for investigation by the virtuosi clustered loosely within the framework of the Society. Hooke was the person who made sure that groups of members could check for themselves, at weekly

and extraordinary meetings, the outcomes of experiments to test every hypothesis.[44]

Hooke's appointment as a Royal Society Fellow also complicated his relationship with his other regular, day-to-day employments, creating what amounted to a potentially serious conflict of interests. As we saw, since the mid-1650s Hooke had occupied the paid post of laboratory assistant to Robert Boyle. Before he could be offered the post of Curator of Experiments, Boyle had to be respectfully asked to release Hooke from some of the duties he carried out for him. Nor was this simply a matter of juggling employment priorities. There were also emotional pressures – Hooke's sense of indebtedness to the noble employer who had taken him in, housed and encouraged him. Hooke had served Boyle since his teens (he was now twenty-eight); he had worked closely alongside him, and learned most of what he knew about chemistry and 'physic' (medical dosing) from him.[45] Hooke remained in Boyle's salaried employ, and continued to have his residence in Boyle's household, until August 1664. His appointment to the Gresham professorship of Geometry in March 1665 entitled him to permanent accommodation within Gresham College, where he remained for the rest of his life (he never acquired any property of his own outside the Isle of Wight).[46]

The immediate problem was that Boyle expected Hooke to be in attendance to carry out a wide range of tasks for him, whether Boyle was residing in London, Dorset (at his country residence) or elsewhere. He might require Hooke's collaboration at any time, as the occasion demanded. As well as designing and operating Boyle's famous air-pump, Hooke assisted Boyle with other technically complicated experiments, including experiments with mercury barometers, and with capillary action. These latter experiments and observations were, as we saw, recapitulated in Royal Society discussions, and again in Boyle's correspondence with Huygens, and were eventually published by Hooke under his own name in *Micrographia*.

As well as carrying out his duties as operator, Hooke acted as a high-level scientific amanuensis, seeing Boyle's works through the London press in his absence, and in particular supplying his own drawings for the vital diagrams in the engraved plates. For instance, during preparations for printing Boyle's *Experiments touching Cold*, Hooke described in a letter how he proposed dealing with the illustrations:

I have ... procured out of Mr. Oldenburg's hands some of the first sheets; and shall delineate as many of the instruments you mention, as I shall find convenient, or (if it be not too great a trouble to you) as you shall please to direct. I think it will be requisite also, because your descriptions will not refer to the particular figures and parts of them by the help of letters; that therefore it would not be amiss, if I add two or three words of explication of each figure, much after the same manner, as the affections of the prism are noted in your book of Colours. The figures I think need not be large, and therefore it will be best to put them all into one copper plate; and so print them, that they may be folded into, or displayed out of the book, as occasions serves.[47]

Hooke reported to Boyle in the same letter that he was also taking important decisions about the composition Faithorne's portrait engraving of Boyle himself.

Whilst I was writing this, Mr. *Faithorne* has sent me the sketch, which I have enclosed, to see whether you approve of the dress, the frame, and the bigness; what motto or writing you will have on the pedestal, and whether you will have any books, or mathematical, or chemical instruments, or such like, inserted in the corners, without the oval frame or what other alteration or additions you desire.[48]

Two weeks later Hooke relayed back to Boyle the outcome of his response to Faithorne. He had himself drawn the air-pump, which he suggested should replace the landscape Faithorne had originally proposed for the background. Drawing precision instruments was, after all, one of Hooke's drafting specialisms:

I have consulted with Mr. Faithorne, who is ready to do any thing he shall be directed, and has desired me to contrive it, how it will be most convenient, and he will punctually follow directions. I have made a little sketch, which represents your first engine placed on a table, at some distance beyond the picture, which is discovered upon drawing a curtain. Now, if you think fit, I think it might be proper also to add, either by that, or in the corners A or B (where also you may have any other

Engraved plate for Boyle's *Experiments touching Cold* (1664), drawn for Boyle by Hooke as his laboratory assistant.

instruments, or any thing else added, if you think fit) your last emendation of the pneumatick engine. I sent by the Wednesday's coach a small weather-glass, and Dr. *Henshaw*'s book, which is printed in *Ireland*, wherein he has mentioned you.[49]

While Hooke continued to act as general intellectual factotum for Boyle, the Royal Society expected Hooke to attend weekly, and to supply each meeting with experimental diversion. Now that Hooke was a full member, as far as Oldenburg and Brouncker were concerned they were entitled to count on him.

\* \* \*

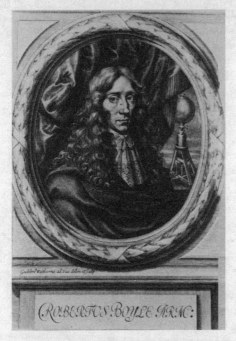

Engraved portrait of Boyle
by William Faithorne, with
the famous air-pump
included in the background,
as drawn by Hooke.

Two days after his election as full Fellow of the Royal Society, on 5 June
1663, Hooke wrote to Boyle, who was visiting his sister Mary, Countess
of Warwick and her family at Leese Priory in Essex. With elaborate and
careful deference Hooke asked his aristocratic employer to agree to his
putting off his previously arranged trip to Leese to join him, for a few
days longer:

> Ever honoured Sir,
>
> I have put up and sent the things you gave order for . . . and
> should have come away my self, but that having received a par-
> ticular favour from the [Royal] Society, and also an extraordinary
> injunction to see the condensing engine [Boyle's air-pump] in a
> little order against the [Society meeting] next Wednesday, I did
> hope you would be pleased to dispense with my absence from
> attending on you for two or three days longer, till the next Wed-
> nesday be past . . . For I remember you were pleased to say, that

you thought it would be a week before the ceremony of visits would suffer you to settle about any business, and so should have little use of me till then; and if your occasions would permit a dispensation for my stay here any longer time, I should endeavour to improve the time the best way I am able to serve you.

But, Sir, I make it no further my desire, than the convenience of your affairs permit, having wholly resigned myself to your disposal. Nor should I have presumed to have trespassed your commands thus far, had I not thought, that the Society might have taken it a little amiss, if, at the very next meeting, after so great an honour done me, I should be absent.[50]

To go some way towards placating Boyle, Hooke proceeded to describe the demonstration at the Society meeting for which his attendance as Curator and operator was so essential – it was the operation of Boyle's air-pump, the much celebrated item of equipment, purpose-built for investigating respiration and the properties of air, designed to his specifications by Hooke, and which Hooke alone could reliably operate:

There was nothing of experiment, but only a trial of the condensing engine, which only held enough to shew us, that it would not hold long enough with that kind of cement we used; for after the air was condensed into about half the dimensions, it forced its way through the cement of the covers, though laid very thick in the joints. But I think that inconvenience will be easily remedied against the next day.[51]

Five days later, after the Wednesday meeting, Henry Oldenburg wrote to Boyle, describing with enthusiasm the events that had taken place, and for which Hooke had so earnestly requested permission to remain in London:

This afternoon we had no ordinary meeting: There were no lesse than 4 strangers [foreign visitors], <two> French, and two Dutch Gentlemen; the French were, Monsieur de Sorbière, and Mr Monconis; the Dutch, both the Zulichems, Father and Son [Constantijn senior and Christiaan Huygens]: all foure, inquisitive after you. They were entertained <first> with some Experiments, of which the bearer hereoff will give you a good account off.[52]

That 'bearer', of Oldenburg's letter – ideally placed to give an account of the experiments conducted before the distinguished foreign visitors – was, however, none other than Hooke himself, who had not been able to postpone his trip any longer, and had now been obliged to give way to Boyle's summons to join him in Essex.

In a postscript, Oldenburg respectfully expressed the hope that Boyle would release Hooke as soon as possible to recommence his Royal Society curatorial duties:

> Seeing the abovementioned Strangers are like to continue here yet a while, at the least some of them, the Society shall much stand in need of a Curator of Experiments; which I hope, Sir, will the sooner procure from your obligingnes a dispensing with Mr Hook for such a public use.[53]

Hooke's presence was especially important, because the visitors were both foreign dignitaries of some significance, and virtuosi themselves, with a serious interest in the new science. Christiaan Huygens already had a considerable international reputation as a mathematician, and had for some time been in correspondence with Boyle directly regarding the air-pump – a costly, prestige piece of equipment, an example of which Huygens had had built for himself in Paris, and which broke down even more often than Boyle's.[54] Christiaan's father was an intellectual of stature, well known in London, who had served as resident ambassador at the courts of both James I and Charles I.

Boyle may, in fact, have absented himself from London deliberately at this moment. He had been in correspondence with Huygens about the air-pump since Christiaan's first visit to the Royal Society in 1661. Christiaan operated his own pump himself. Boyle may have preferred to leave his skilled operator, Hooke, in London to perform the demonstration in person for Christiaan, rather than make it clear that, although he was sponsor, he was not *au fait* with the technical details, or operational idiosyncracies, of his 'pneumatical engine'.[55]

It was not simply that Hooke was required to make the air-pump work effectively in the presence of distinguished foreigners – he alone possessed the necessary experimental brio and showmanship to captivate and delight dilettante visitors, combining technical virtuosity with a keen sense of theatre. On 7 May 1662, John Evelyn recorded in his diary

that he had accompanied the King's cousin, Prince Rupert, to a Royal Society meeting:

> I waited on Prince Rupert to our Assembly, where were tried several experiments of Mr. Boyle's Vaccuum: a man thrusting in his arme, upon exhaustion of the ayre, had his flesh immediately swelled, so as the bloud was neere breaking the vaines, & unsufferable: he drawing it out, we found it all speckled.[56]

The man with his arm in the air-pump, prepared, as an act of bravura, to do himself physical damage in order to entertain his audience, was almost certainly Hooke.[57]

Hooke did not in fact return to London, and to his regular duties at the Royal Society, for several weeks.[58] On 22 June 1663, Oldenburg described to Boyle the formal admission of Christiaan Huygens and Samuel Sorbière to the Society, but added that the air-pump experiment had failed dismally in Hooke's absence.[59] It was the beginning of July before Hooke was back in London. He and Oldenburg sent letters by the same carrier on 3 July, both of them somewhat nervously inquiring when Boyle would himself be returning to London, since plans were under way for a visit to the Society by the King. (Like an earlier royal appearance proposed in 1661, this visit never in fact took place. An 'Extraordinary day' to plan this meeting was set for 6 July – in spite of Oldenburg's and Hooke's urgings, Boyle missed it.)[60]

Nor were Boyle and Oldenburg the only ones making claims on Hooke's time, exploiting his exceptional skills as an experimental scientist. When Sir Robert Moray, during the same period, proposed a project for fixing the positions of the stars in the Zodiac, in April 1663, Wren volunteered himself and Hooke as a team to carry out the observations for the survey of the constellation Taurus together (Hooke included the resulting map of the Pleiades in *Micrographia*).[61]

Wren collaborated with Hooke again in December 1664, to produce joint observations for the Royal Society of a comet which became visible in that month.[62] Wren took responsibility for observations in Oxford, while Hooke recorded and tabulated observations from London. It was Hooke, however, who had the final responsibility for collecting and collating the comet data from the scattered observers, tabulating the results, writing the subsequent Royal Society reports and sending meticulous accounts of proceedings by letter, just as he did in relation

to his activities carried out on behalf of Boyle. Not only did Hooke have to keep track of who was doing what and where; he also – in the days before regular postal services – watched for opportunities to transport precious original materials between observers, and organised the circulation of correspondence among the participants.[63]

The joint observations of the path of the 1664 comet and the subsequent discussions of the generalised motion of comets were part of a cross-Channel collaboration, comprising Wren, Dr John Wallis and Hooke in London, and two overseas astronomers, Adrien Auzout and Christiaan Huygens (both in Paris). Hooke was in charge of the English end; the indefatigable Moray kept the foreign observers abreast of developments, directing his correspondence almost entirely to Christiaan Huygens.

On 20 January 1665 Moray reported to Huygens that Wren was collating the English observations of the comet viewed from London. At the end of that month, Moray promised Huygens that Wren would shortly be producing an account based on Wren's and Hooke's combined observations, and at a meeting on 1 February, 'Dr. Wren produced some observations of the comet, with a theory.'[64] On 17 March, Moray told Christiaan Huygens that Hooke had taken over the comet investigations from Wren.

On 31 March, Huygens reported that a new comet had appeared, and this apparently rekindled Wren's interest. Both Hooke (in London) and Wren (in Oxford) began a fresh set of observations in the first week of April and on 7 April Wren asked Moray 'if I may obtain what observations you have at Gresham of this 2d comet. Also I would desire of Mr. Hooke he would let me have all the last observations of the last Comet when he began to be stationary or slow his Motion, & when & where he disappeared.'[65] On 19 April Wren asked if the Society could return his drawing of the path of the first comet for comparison with that of the second, and Hooke duly copied the drawing for the Society's archive.[66]

In the accompanying letter, Hooke admitted that he had failed to complete the task allocated to him, because of lack of time. It was beginning to become something of a pattern:

> Those observations of my own making I have not yet had time
> to adjust so well as I desired; for the sun came upon me before

I was aware, and so I must stay till the constellation of [Aries] appear in the morning, before I can be able to rectify the places of the telescopical stars, by which I observed the comet to pass; which I hope I may do about a fortnight hence, about which time also I expect to see both the old, or first comet, with a telescope, and second, or last comet, with my eye.[67]

In responding, Wren acknowledged the pressure under which Hooke was evidently working:

I thank you for the freedome of your converse w[hi]ch. I should be glad you would sometimes continue to me whilest I am heer though I dare not importune you to it, for I know you are full of employment for the Society which you allmost wholly preserve together by your own constant paines.[68]

To Hooke it must indeed have felt as if the Royal Society was held together by his 'constant paines'. In the eyes of its senior members like Moray and Oldenburg, however, Hooke could never achieve enough.

When plague broke out with exceptional virulence in London in the summer of 1665, it placed a further strain upon Hooke's working arrangements, research commitments and obligations to employers, clients and friends.

At the end of July 1665, Boyle decamped completely to his Oxford lodgings, while Sir Robert Moray and others in the court circle also relocated to Oxford, where the King had transferred his court and administration, and where they remained until February 1666. Wren left for Paris as a member of the party accompanying Queen Henrietta Maria out of the country.[69] The three leading experimentalists and operators of the Royal Society, Hooke, Sir William Petty and Dr John Wilkins, under instructions from the President and Council, took a quantity of the Society's experimental equipment and materials to the Durdans estate, outside Epsom – the residence (with extensive grounds) of George, Lord Berkeley, loaned to the Society while its owner was with Wren's fact-finding architectural mission in Paris.[70]

For some time the Royal Society had been interested in developing a fast, lightweight carriage which would give both driver and passenger a comfortable ride, and the Society's Mechanical Committee (of which

Hooke was a member) had been directed to conduct experiments on the subject.[71] In April 1665, Hooke was instructed to pursue a design proposed by Colonel Blount:

> Mr Hooke ordered to prosecute the model of his chariot with four springs and four wheels, tending to the ease of the rider.
>
> It was likewise ordered, that the President, Sir Robert Moray, Sir William Petty, Dr. Wilkins, Col. Blount, and Mr. Hooke should be desired to suggest experiments for improving chariots and to bring them in to the mechanical committee, which was to meet on the Friday sevennight following, April 21, at the president's house.[72]

On 26 April, the same committee was instructed to assemble at Colonel Blount's house the following Monday to see his own model chariot, and to 'give an account of what they had done there at the next meeting of the Society'.[73] On 1 May, an appropriately festive band of experimentalists repaired to Blount's house in the country for the trials. Pepys happened to run into them as they were setting out, and has left us a vivid account of their activities: '1 [May]. [A]t noon, going to the Change [Royal Exchange], met my Lord Brunkerd [Brouncker], Sir Robert Murry [Moray], <Deane Wilkins> [John Wilkins], and Mr. Hooke, going by coach to Collonell Blunt's to dinner.' Dinner, however, turned out to be only the beginning of the evening's events:

> No extraordinary dinner, nor any other entertainment good – but only, after dinner to the tryall of some experiments about making of coaches easy. And several we tried, but one did prove mighty easy (not here for me to describe, but the whole body of that coach lies upon one long spring) and we all, one after another, rid in it; and it is very fine and likely to take. These experiments were the intent of their coming, and pretty they are.

The experiments completed, Pepys returned to London in the company of Hooke and Wilkins – clearly close and congenial companions:

> Thence back by coach to Greenwich and in his pleasure-boat to Deptford . . . I stayed not; but Dean Wilkins and Mr. Hooke and I walked to Redriffe, and noble discourse all day long did please me. And it being late, did take them to my house to

drink, and did give them some sweetmeats – and thence sent them with a lanthorn home – two worthy persons as are in England, I think, or the world.[74]

When the Society called its summer recess, and members dispersed to their various country locations, therefore, the chariot-testing group were urged to continue their experiments under ideal conditions at Durdans (where carriage racing was more practical than in the streets of London):

> The members of the society were then exhorted by the president to bear in mind the several tasks laid upon them, that they might give a good account of them at their return; and Mr. Hooke was ordered to prosecute his chariot-wheels, watches and glasses, during the recess.[75]

This particularly devastating outbreak of plague necessitated an especially long recess in the country for the Royal Society members. It eventually began to reduce in intensity in late autumn. On 17 October 1665 Oldenburg, the Society's Secretary, wrote to Christiaan Huygens in Paris: 'God grant that the contagion may cease to ravage us. It continues, indeed, to abate, God be praised. We are not lacking in a spirit of gratitude, because the Heavens begin to confer so much compassion upon us.'[76]

When eventually the outbreak was completely over and it was judged safe for the Society to reassemble and resume its meetings, in March 1666, it was the chariot-improvers who gave the first full report of the successful modifications carried out in Epsom:

> The president inquiring into the employments, in which the members of the society had engaged during their long recess, several of those, who were present, gave some account thereof: viz.
>
> Dr. Wilkins and Mr. Hooke of the business of the chariots, viz. that after great variety of trials they conceived, that they had brought it to a good issue, the defects found, since the chariot came to London, being thought easy to remedy. It was one horse to draw two persons with great ease to the riders, both him that sits in the chariot, and him who sits over the horse upon a springy saddle; that in plain ground [a] 50-pound weight, descending from a pully, would draw this chariot with

two persons. Whence Mr. Hooke inferred, that it was more easy for a horse to travel with such a draught, than to carry a single person: That Dr. Wilkins had travelled in it, and believed, that it would make a very convenient post-chariot.[77]

Wren – ostensibly in Paris to collect information on Louis XIV's ambitious building projects, but also taking advantage of the expenses-paid trip to meet and exchange intellectual ideas with a number of Parisian scientists – brought back comparative information on light-weight carriage construction there; he and Hooke were instructed by the Society to iron out the last defects in the new carriage's performance and report back to the Society:

> Dr. Wren and Mr. Hooke being asked, what they had done in the business of chariots, since the perfecting thereof was committed to them, Dr. Wren answered, that he had given Mr. Hooke the descriptions of those, which they had in France.[78]

Novel and efficient designs for new, lightweight carriages were high on the Society's agenda, because a charge regularly levelled against the Royal Society from its inception was that its investigations yielded nothing of practical, commercial use to a nation on the look-out for wealth-creating investment opportunities.[79] The jibe that the Society's members wasted their time 'on the weighing of air' was widely current (Pepys records it in his diary).

The most potentially significant set of experiments Wilkins, Petty and Hooke undertook at Durdans was one designed to continue testing on land, with the help of those rapidly moving coaches, the viability of new marine timekeepers based on the pendulum clock invented by the Dutch virtuoso Christiaan Huygens (for which the Royal Society had recently been granted a lucrative patent): 'Some further experiments should be made with them, by contriving up and down motions, and lateral ones, to see, what alterations they would cause in them.' Hooke and Wilkins were also instructed to work on 'watches with springs' – an alternative form of precise timekeeper for which Hooke was currently secretly discussing his own patent with Moray, Brouncker and Wilkins.[80]

From the Royal Society's point of view, large sums of money stood to be made if Hooke could perfect a marine timekeeper with either a pendulum or a balance-spring isochronous timekeeping mechanism.

From Hooke's personal point of view, French claims already to have developed a balance-spring timekeeper, and the fact that he had recently been obliged to break off negotiations concerning an English patent, made it imperative that he try to be the first to perfect a working clock or watch.[81]

It appears, however, that the pressure of other demands on Hooke's time at Epsom prevented him from doing so. In spite of the fact that ten years later Hooke characterised his summer 1665 work on his watch as occupying much of his time, no new results came out of the research being carried out at Epsom, although it may have been while they were at Durdans together that Hooke gave Wilkins an early version of his balance-spring watch as a gift.

The reason why Hooke failed to advance the perfection of his marine timekeeper (a project dear to his own heart) was probably that, on top of the projects he had been explicitly instructed by Brouncker and the Council of the Royal Society to continue pursuing during the enforced recess, he was already seriously over-committed to extended programmes of experimentation in his capacity as operator employed by each one of his now scattered clients and patrons. He arrived at Durdans having already promised to work on hydrostatics for Boyle, to carry out a raft of other, specified Royal Society experiments (including air-pump experiments) with Wilkins and Petty (as leading figures on the Council of the Royal Society), and to continue telescopic observations for his astronomical work with Wren, during the latter's absence in France on royal architectural business. In 'recess' in the country, he was now obliged to juggle competing claims upon him more dramatically than ever. In the event, Boyle made the first claim.

Hooke had notified Boyle (in Oxford) in early July that he was likely to have to leave Gresham College to avoid the plague, laying careful emphasis upon the fact that the move out of London would not impede, but rather facilitate, the experimental work to which he was committed on Boyle's behalf:

> I doubt not, but that you have long before this heard of the adjourning of the Royal Society, and of the increase of the sickness, which rages much about that end of the town you left. . . . We have made very few experiments since you were pleased to be present, but I hope, as soon as we can get all

our implements to Nonsuch,[82] whither Dr. Wilkins, Sir W. Petty, and I, are to remove next week, I shall be able to give you an account of some considerable ones, we have designed to prosecute the business of motion through all kinds of mediums, of which kind Sir W. has made already many very good observations.

They would, Hooke told Boyle, be accompanied by the Society's assistant operator (unnamed, as Hooke himself so often was in the early days of his work for the Royal Society), and would be happy to undertake any suitable experiments Boyle could think of:

We shall also take the operator along with us, so that I hope, we shall be able to prosecute experiments there as well almost as at London; and if there be any thing, that you shall desire to be tried concerning the resistance of fluid mediums, or any kind of experiment about weight or vegetation, or fire, or any other experiments, that we can meet with conveniences for trial of them there; if you would be pleased to send a catalogue of them, I shall endeavour to see them very punctually done, and to give you a faithful account of them.[83]

Evidently he was convincing, and his enthusiasm caught Boyle's imagination. Boyle decided to leave Oxford immediately, to take advantage of the circumstance which Hooke described so plausibly as especially conducive to his (that is, Boyle's) experimental requirements, in Epsom.

Actually, Boyle apparently arrived first, settling himself at Durdans by 8 July.[84] In a letter of that date, he described to Oldenburg the experimental programme which he was now conducting. The fact that Boyle had decamped from Oxford suggests that this programme could best be accomplished with Hooke's assistance (Hooke operating, and Boyle, as usual, overseeing in his capacity as patron and virtuoso). Presented with the convenience of his laboratory operator (and a junior) away from home, Boyle was happy to drop experiments involving equipment which could not be readily acquired outside London, and to get on with those which would complete his book of *Hydrostatical Paradoxes*:

I am here about some Hydrostaticall Exercises, & if God vouchsafe me health & opportunity of staying in this place t'is like I

shall <publish> my Hydrostaticall paradoxes without staying for the Appendix to the pneumaticall Booke, which for want of Receivers & other fit glasses; I have here noe conveniency to compleate.[85]

We learn more about these experiments in a letter Boyle wrote to Oldenburg in September. He was trying to write up the experiments for publication, but was being prevented from doing so by the 'crowd & hurry' of Oxford visitors:

> The ground of it is That I had by diligent Experiments (which were difficult & troublesome enough) found out the true weight of a Cubick Inch of water, that is, as much of that Liquor as would exactly fill a hollow vessell of every way an Inch in its Cavity. For this weight being once obtained t'is easy to discover by the weights to be added to that scale at which the Body to be measurd hangs immersd in water, how many times it looses by that immersion as much weight as amounts to a Cubick Inch of water: soe that although by a peculiar Statera the thing may be better performd, without Calculation; yet I soe contrive the matter that only useing peculiar weights (which may be easily made & of what heavy body you please) any <good paire of> ordinary scales may be made with tollerable accuracy to define the magnitude of the immersd Body.[86]

In the version of *Hydrostatical Paradoxes* published by Boyle in 1666, he nevertheless returned to the difficulty of carrying out his experiments at Epsom without access to purpose-made glassware. This perhaps explains why, after a matter of weeks, and one imagines to Hooke's relief, Boyle returned to Oxford, arriving there around 6 August.

Boyle's departure eased the immediate problems Hooke may have been having as he tried to fulfil his experimental obligations for the Royal Society (Wilkins and Petty) and for his old employer.[87] He returned to some of the projects planned before he left London. A contemporary witness paints a picture of a particularly relaxed group of virtuosi, enjoying their recently regained freedom to control their own researches, a few days after Boyle's departure. On 7 August 1665 John Evelyn, returning to London from his family estate at Wotton, in Surrey, visited the Royal Society evacuees at Durdans and reported that the team were

hard at work on those chariot experiments they had been directed to carry out:

> I returned home, calling at Woo<d>cot, & Durdens by the way: where I <found> Dr. Wilkins, Sir William Pettit [Petty], & Mr. Hooke contriving Charriots, new rigges for ships, a Wheele for one to run races in, & other mechanical inventions, & perhaps three such persons together were not to be found else where in Europ, for parts and ingenuity.[88]

Boyle's return to Oxford (which was followed shortly afterwards by Petty's departure for Salisbury)[89] also meant that Hooke could turn some of his attention to work-in-progress with astronomical instruments, to which he was committed as part of his astronomical collaboration with Wren.

For over a year, Wren and Hooke had been making and collating telescopic observations of the movement of the two comets which had become visible in 1664 and 1665. In this case, too, a set of investigations which Hooke was instructed to undertake by the Royal Society involved him in intensive collaborative activities which had to be dovetailed with other commitments, involving other, equally demanding and socially prominent co-workers (in this case, nightly observations beginning shortly before his election to a fellowship, and continuing until Wren left for Paris):

> [12 April 1665] Mr. Howard produced an account of the new comet, to him by his brother from Vienna; which was delivered to Mr. Hooke, to compare it with other observations.

> [19 April 1665]. Dr. Croune presented from Sir Andrew King a paper with a scheme of the first comet, drawn by a Spanish Jesuit at Madrid; which was delivered to Mr. Hooke to compare it with the other observations; who was also appointed to take a copy of Dr. Wren's scheme of this comet, and to return the original to the Doctor for further consideration.

> [26 April 1665] Mr. Howard produced some observations on the second comet, as they were sent to him by his brother from Vienna; which were recommended to the perusal of Mr. Hooke.

> [17 May 1665] Three accounts were brought in of the late comets; one by Dr. Wilkins concerning the first [in 1664], sent out of

Sketches of the progress of the 1664 comet, observed collaboratively for the Royal Society by Hooke and Wren.

New England; the other two by Mr. Aerskine, concerning the latter, written from Prague and Leige: All of which were ordered to be delivered to Dr. Wren and Mr. Hooke.[90]

In the course of their observations of the comet which appeared in spring 1665, Hooke and Wren had together been developing and testing a double telescope of Wren's.[91] At Epsom, Hooke now tested and

adjusted a new quadrant he had designed to be used alongside Wren's telescope. The two men's explicit hope was that, in combination, the instruments could be used to make the precise measurements necessary to determine longitude at sea by astronomical methods.[92]

On 8 July 1665 (prior to travelling to Epsom), Hooke had told Boyle that he was planning to experiment there with his new quadrant:

> Mr. Thompson also has sent home the instrument for taking angles, and demands two and thirty shillings. It is not quite finished, but I intend to take it with me to Nonsuch, and there to make trial of it, and adjusten it. I shewed it the last meeting of the Society, which it was very much approved of; and I hope it will be the most exact instrument, that has been yet made.[93]

On 15 August, Hooke reported to Boyle:

> One of our quadrants does to admiration for taking angles, so that thereby we are able from hence to tell the true distance between [St] Paul's and any other church or steeple in the city, that is here visible, within the quantity of twelve foot, which is more than is possible to be done by the most accurate instrument or the most exact way of measuring distances.[94]

When he and Wren were both back in London, in late February or early March 1666, Hooke and his old friend continued to work together on perfecting their longitude method (which both probably hoped would make their fortunes), adding the final touches to their procedure by the end of the summer. The two of them were scheduled to present their lunar longitude method to the Royal Society at the meeting on 12 September 1666 – a meeting whose agenda items were abandoned following the Great Fire in the first week of September.[95]

Finally, during this period outside London, Hooke took advantage of a local, man-made feature of the Epsom landscape unavailable to him in the London area – deep, abandoned wells.[96] In August he wrote to Boyle:

> I have made trial since I came hither, by weighing in the manner, as Dr. Power pretends to have done, a brass weight both at the top, and let down to the bottom of a well about eighty foot deep, but contrary to what the doctor affirms, I find not the

least part of a grain difference in weight of half a pound between the top and bottom. And I desire to try that and several other experiments in a well of threescore fathom deep, without any water in it, which is very hard by us.[97]

On 26 September Hooke reported that he had indeed tried his experiments in the deeper well, though it had turned out to be 'three hundred and fifteen foot in its perpendicular depth', which was less than he had been promised, 'so that it seems no less than a hundred foot is filled with rubbish [rubble], at least it is stopped by some cross timber, which I rather suspect, because I found the weights to be stayed by them if I suffered them to descend below that depth'. He had, he reported, already conducted several experiments, including one 'of gravity', 'which upon accurate trial I found to succeed altogether as the former', and a less successful one involving lowering lighted candles, to see at what depth they were extinguished (the candles came loose from their sockets and were lost).[98] With characteristic energy, Hooke itemised a list of further well experiments he intended to carry out, so as not to waste 'such an opportunity, as is scarce to be met with in any other place I know':

I have in my catalogue already thought on divers experiments of heat and cold, of gravity and levity, of condensation and rarefaction of pressure, of pendulous motions and motions of descent; of sound, of respiration, of fire, and burning, of the rising of smoke, of the nature and constitution of the damp, both as to heat and cold, driness and moisture, density and rarity, and the like. And I doubt not but some few trials will suggest multitude of others, which I have not yet thought of; especially if we can by any means make it safe for a man to be let down to the bottom.[99]

We may be sure that the man who would have been let down to the bottom of the well – if it had proved humanly possible – would have been Hooke himself.

A fuller record of the well-based experiments, too, is to be found in Hooke's reporting back to his Royal Society employers after the protracted recess, in March 1666. It shows that access to deep wells allowed Hooke in his capacity as virtuoso instrument-designer and

-maker to develop precision instrumentation, as well as to conduct experimental programmes which required to be carried out under as near possible identical conditions at different points above and below the surface of the earth:

> He presented a paper, which was read, containing some experiments of gravity made in a deep well near Banstead Downs in Surry; to which was annexed the scheme of an instrument for finding the difference of the weight, if any, between a body placed on the surface of the earth, or at a considerable distance from it, either upwards or downwards.[100]

The paper itself (duly registered and deposited with the Society) offers us further, precisely vivid detail concerning Hooke's Surrey well-experimenting:

> If all the parts of the terrestrial globe be magnetical, then a body at a considerable depth, below the surface of the earth, should lose somewhat of its gravitation, or endeavour downwards, by the attraction of the parts of the earth placed above it. . . .
>
> For the trial of which I had a great desire, and happily meeting with some considerably deep wells, near Banstead Downs, in Surrey, I endeavoured to make them with as much exactness and circumspection as I was able. My first trials were in a well about 15 fathoms deep, or 90 foot; the packthread I made use of was about 80 foot long; the bodies I weighed, or let down by it, were brass, wood, and flints; each of which, at several times, I counterpoised exactly, and hung the scales, which were very good ones, over the midst of the well, so as that the packthread might hang down to the bottom without touching the sides. The effects were these, that each of those bodies seemed to keep exactly the same gravity at the bottom of the well, that they had at the top.[101]

Here too Hooke tells the reader how he repeated his experiments 'with the like circumspection in a well of near sixty fathoms deep, where the weight, though suspended at the end of a string of about 330 feet long, seemed to continue of the same weight, that it had above, both before it was let down, and after it was pulled up'.[102] His conclusion is that

instruments capable of detecting far smaller increments of change would be needed to test alteration of gravitational pull with height, and he proceeds to describe such an instrument.[103]

While Hooke was juggling commitments and experimental priorities in Epsom, there came yet one more, unlooked-for disruption. His planned series of experiments involving deep wells was interrupted while he returned to the Isle of Wight to attend to pressing family business. Hooke's mother had died in June 1665, but the virulence of the plague had meant that it was not possible for him to travel home immediately. He eventually went to Freshwater in early October. There were family properties to be sold or leased to suitable tenants, and money arrangements to be made with his sisters and brother John (who was notoriously bad with money himself, and perhaps not to be trusted to act on Hooke's behalf).[104]

Typically, Hooke did not take even this enforced break from his professional employment as a chance to relax; instead, he turned it into yet another scientific opportunity for hands-on experimental research. The fossil-rich chalk cliffs around Freshwater Bay, on the south-west of the island, where he had spent his boyhood were the perfect place to pursue his interest in geology – in fossils, and theories of rock-formation. In 1667, in the earliest of his *Discourses on Earthquakes*, Hooke notified his readers that it was during his trip to the Isle of Wight the previous year that he had assembled the substantial collection of fossils on which his lectures (and the exquisite drawings from which Richard Waller, editor of Hooke's *Posthumous Works*, had the engraved plates made for the published texts) were based:

I had this last Summer[105] an Opportunity to observe upon the South-part of *England*, in a Clift whose Bottom the Sea wash'd, that at a good heighth in the Clift above the Surface of the Water, there was a Layer, as I may call it, or Vein of Shells, which was extended in length for some Miles: Out of which Layer I digg'd out, and examin'd many hundreds, and found them to be perfect Shells of Cockles, Periwinkles, Muscles, and divers other sorts of small Shell-Fishes; some of which were fill'd with the Sand with which they were mix'd; others remain'd empty, and perfectly intire.[106]

Hooke proposed that rock formations had once been matter in solution which 'in tract of time settled and congealed into ... hard, fixt, solid and permanent Forms', no longer soluble in water. As evidence for this, he cited his own observations, 'which I have often taken notice of, and lately examined very diligently':

> I made [this Observation] upon the Western Shore of the Isle of Wight. I observed a Cliff of a pretty height, which by the constant washing of the Water at the bottom of it, is continually, especially after Frosts and great rains, foundering and tumbling down into the Sea underneath it. Along the Shore underneath this Cliff, are a great number of Rocks and large Stones confusedly placed, some covered, others quite out of the Water; all which Rocks I found to be compounded of Sand and Clay, and Shells, and such kind of Stones, as the Shore was covered with. Examining the Hardness of some that lay as far into the Water as the Low-Water-mark, I found them to be altogether as hard, if not much harder than *Portland* or *Purbeck*-stone.

Using the tools at his disposal, he proceeded to some hands-on investigation:

> Others of them I found so very soft, that I could easily with my Foot crush them, and make Impressions into them, and could thrust a Walking-stick I had in my Hand a great depth into them. ... All these were perfectly of the same Substance with the Cliff, from whence they had manifestly tumbled, and consisted of Layers of Shells, Sand, Clay, Gravel, Earth, &c. and from all the Circumstances I could examine, I do judge them to have been the Parts of the Neighbouring Cliff foundered down, and rowl'd and wash'd by degrees into the Sea; and, by the petrifying Power of the Salt Water, converted into perfect hard compacted Stones.[107]

Here – in an uncharacteristically personal and vivid reminiscence – Hooke strides out into a familiar seaside landscape with his walking-stick in his hand, and climbs down to the beach, clambering the cliffs of his childhood, and scrambling among the rocks on the shoreline in search of fossil specimens.[108] Here, too, Hooke's tone suggests a man entirely relaxed and at ease with his seaside surroundings. The sense of return,

Fossil shells engraved from drawings made by Hooke of specimens
collected from the fossil-rich cliffs on the Isle of Wight.

of coming back, to formative sights and ideas is palpable. Despite the
pressure he had been under in the months preceding this visit, the
familiar surroundings stimulate in him a renewed burst of vigorous

intellectual and scientific inquiry – Hooke here is entirely in his element.

This is Hooke at his most immediate and enthusiastic. His perception seems to sharpen, as he affectionately engages with the natural surroundings which kindled and continue to illuminate his keenly inquiring scientific mind. It is striking how, immediately following the passage just quoted, Hooke responds with equivalent immediacy to activities in which he was more mundanely engaged in London. In the course of digging foundations for buildings in St James's (where his close friend Sir Christopher Wren was designing housing for City speculators), he has himself clambered down the shafts to inspect the fossil finds turned up by the workmen:

> Another instance I observed ... and that was in *St. James's Fields*, where *St. James's* Square is now built, in which place when they were making Bricks of the Brick earth there dug, they had sunk several Wells, which I judge might be near twenty Foot in depth, to procure Water for that purpose; going down into several of these, I found at the bottom, a Layer of perfect Sea Sand, with variety of Shells, and several Bones, and other Substances, of which kind I dug out enough to fill a small Box and shewed them to Mr *Boyl*, and also to this *Society*. And I was informed also, that the same kind of Substances were found in digging of a Snow Well in St. James's Park.[109]

Cheek by jowl with the vivid memories from the Isle of Wight, Hooke's exuberance as an observer of natural phenomena – whenever and wherever the chance arises – is charming. Yet, however enjoyable the brief return to the landscape of his childhood, in terms of Hooke's relentless pursuit of scientific data to inform his myriad intellectual interests, and the strain this placed upon him, we have here one more example of the relentlessly competing claims on his time and energies.

Hooke was back in Epsom doing more well experiments (in the bitter cold) in January 1666. The candle experiments worked better, but Hooke does not record any experiments involving lowering a person to the bottom of the well.

The plague outbreak over, Hooke returned to his lodgings at Gresham College at the beginning of February, probably arriving in London shortly before Wren (back from Paris) and the court (back from Oxford). He told Boyle that he was dissatisfied with the experimental

Illustration of a fracture surface of Kettering Stone as seen under the microscope – Hooke combines his Royal Society scientific interests with his activities as an architect and builder.

results he had got down the wells, because of the low temperatures, and that he intended to repeat them later that year:

> God willing, I intend to make many other of the like kind, either there or elsewhere, some time this summer; and I have great hopes of having an opportunity of examining both greater depths and much greater heights, in some of our English mines, and some of the mountains in *Wales*, which, with some other good company, I design to visit this next summer.[110]

Once back home, he also invoked divine support for ratcheting up one notch further his energetic pursuit of science on all fronts: he would build himself a laboratory. Shortly after his return to Gresham College he wrote to Boyle:

> I hope we shall prosecute experiments and observations much more vigorously; in order to which also I design, God willing, very speedily to make me an operatory, which I design to furnish with instruments and engines of all kinds, for making examinations of the nature of bodies, optical, chemical, mechanical, etc.[111]

Yet, however hard Hooke worked, he could not, apparently, satisfy senior figures in the Royal Society, who simply assumed (as Boyle had done) that he would drop everything and see to whatever project seemed to them important at that moment. Thus although throughout the winter of 1665 Hooke was officially away from London, pursuing Royal Society business with all the vigour he could muster, there were still complaints from the scattered members that he was not getting to their particular project fast enough.

In November 1665, Moray wrote in some irritation to Oldenburg that Hooke could not find the time to produce the observations he and Wren had made of the 1664 comet. Moray had requested them as a matter of urgency, in order to settle a dispute between the French corresponding member Auzout and the astronomer Hevelius. Hooke, of course, was away, and already at the limit of what he could perform, but, whatever he communicated to Moray, Moray considered them merely 'excuses for his slackness': 'I easily beleeve Hook was not idle, but I could wish hee had finisht the taskes layed upon him, rather then to learn a dozen trades, though I do much approve of time spent that

way too.'[112] Moray – a member of the Society committee directed to come up with more efficient, faster carriages – also grumbled that Hooke had still not produced the results of the carriage experiments he had been sent off to Epsom to carry out ('I will be glad to see a chariot such as wee would have').

This sequence of distinct, intersecting and competing activities of Hooke's, carried out during a relatively short period of intense experimental activity, confirms the extraordinary pressure under which, on a daily basis, he operated. Hooke had the capacity successfully to carry out intellectually and physically taxing work in several different fields simultaneously, sometimes leading the programme of work himself, sometimes collaborating closely with different individuals embarked upon specific interests of their own. In spite of later claims that he was of a somewhat fragile disposition (based largely on a single suggestion that in adolescence paint fumes gave him headaches), we have evidence here that he was physically resilient enough to cope, and that he had a remarkable ability to compartmentalise different activities in such a way that they did not interfere with one another.[113]

In the early years of the Royal Society, Hooke was hugely in demand in scientific and intellectual circles, expected to carry out a daunting number of distinct programmes of practical activities, in a wide range of distinct disciplines, on behalf of an equally wide range of friends, clients, employers and ex-employers.[114] His correspondence is good-natured and enthusiastic about each and every task he undertakes. Those with whom he worked – whether as employer or colleague – treated him with considerable respect. Boyle and Hooke held each other in deep mutual regard, and express themselves in their letters in terms of considerable personal warmth. See for instance, Hooke to Boyle, 8 September 1664:

> Most Honoured Sir, I must in the first place return you my most humble acknowledgement for the honour and favour you have been pleased to oblige me with in your letter, which, to my power, I shall ever be ready to express my sense of.[115]

The pressures exerted on Hooke by his various esteemed colleagues established a habitual pattern in his life which continued thereafter, until shortly before his death. He would move rapidly from commitment to commitment, from topic to topic, and from location to location (both

within and beyond London).[116] He kept his many activities ruthlessly compartmentalised, right down to the fact that he passed, in the course of a day's commitments, from group to group of his acquaintances (each frequenting different coffee-house locations or different districts in London), rarely allowing them to overlap. He documented transactions meticulously for each occupation – his accounts and reports on his London surveys, for instance, are exemplary for the period.[117] And he kept succinct notes of the progress of each of his many activities in his personal diary.

Such a demanding programme of activities, relentlessly pursued, week after week and month after month, eventually took its toll on Hooke's health, and he started to complain of headaches, dizzy spells and trouble with his eyes. He began to treat these minor ailments with an array of proprietary medicines, available over the counter or provided for him by one of his chemical or physician friends. In his prime at the Restoration, by the 1670s Hooke's health was his constant preoccupation, and he was developing a reputation as a hypochondriac.

There was no patent medicine Hooke could take, however, against a malaise which would prove, in the long run, more debilitating than occasional clouded vision. Preoccupied as he was with too many demands, made by too many people he wanted badly to please, Hooke failed to notice a rivalry developing inside the Society itself. Secretary Oldenburg, who like Hooke had started life as a Boyle family servant, and now published, at his own expense, the *Philosophical Transactions* of the Society, was beginning to show signs of wishing to belittle Hooke's scientific efforts. In March 1666, Boyle appears to have thought Oldenburg had not sufficiently credited Hooke (in his absence) with a new device for depth-sounding. Oldenburg responded in his own defence:

> What was inserted in Numb. 9 [of the *Philosophical Trans-actions*] about the wayes of sounding depths and fetching up of water, I am apt to think, that if the words, employed by me, be examined, they will not be found to import a new invention, but only, a new contrivance of a way already started; since 'tis said there, that the *following wayes were contrived by Mr Hooke*; which cannot well be otherwise interpreted, than that the wayes,

as they follow, were contrived by him; not, that he first invented that notion of this practise: and he assures me, that that way of sounding with a round leaden or stone ball, he borrowed from no Author. Which makes me conclude, I spoke truly and candidly, when I said, that that way, as it is described there, was contrived by him.

I am sure, I was <in my thoughts> as far from derogating any thing from another, as any person alive, whatsoever, can be; and I am persuaded, it will appear by all the Transactions, that I have been all along scrupulously carefull, not only to give every one his owne, but also to vindicate that to the Owner, which others have appeared to robb him off.[118]

Apparently, Boyle had complained on Hooke's behalf. Oldenburg continues:

But if this should not be thought satisfactory, I would beg, Sir, that the further remonstrating of it may be deferred till our personall meeting; an Amanuensis being, in my opinion, lesse proper to receave into his pen a matter, wherein a mans candor is, or <but> seems to be, calld in question.

Getting a dressing down from Boyle was perhaps, for Oldenburg, nothing new. He was not prepared, however, to have the Society amanuensis eavesdropping on their exchanges.

It is not surprising, given Oldenburg's lack of support, that Hooke felt beleaguered, and became increasingly defensive about his ability to complete work undertaken. Not surprisingly, either, that the one important set of experiments Hooke apparently did not have time to complete, or to document with due care during this period, were his own, independent experiments with sea-going clocks – in particular his design and development of a balance-spring mechanism to drive a reliable pocketwatch. It was the project dearest to his own heart, and the one most likely to bring him fame and fortune. Rough papers relating to encouraging progress he was making with this project survive, but were never written up or published. Hooke may simply have lacked the time, and, like all of us, have left till last those tasks not driven by other people's urgent deadlines. The omission, however, was to prove, in the long run, extremely damaging.[119]

For, in Hooke's absence, Oldenburg and Moray were under pressure from Christiaan Huygens, who was on the point of relocating long-term from The Hague to Paris to help establish the Académie des Sciences – the French equivalent of the Royal Society – for Louis XIV, and eager to prove his practical worth, to communicate any data the Society had on precision clock-design. During precisely the period when Hooke was at Epsom and Oldenburg remained in London, Oldenburg and Moray were conducting a fraught correspondence with Christiaan Huygens (in Paris and The Hague) on the subject of balance-springs and watches.

On 8 January 1666, shortly after his complaint about Hooke's not furnishing him with the 1664 comet data, Moray wrote to Oldenburg: 'Hook concealed his invention about Watches too long: pray tell him not to do so with what other things hee hath of that kind. hee hath seen the folly & inconvenience of it.'[120] It may even, in the end, have been Hooke's trusted friend Wren who inadvertently leaked the crucial details of his balance-spring mechanism to the French savants. On 4 April 1666, Adrien Auzout wrote to Oldenburg:

> I forgot to tell you that there are some here working on making watches run better, just as you have done in England, but without any success. It seems that we must hope for much from Mr Hooke's meditations on this subject, for Mr Wren has told me that he has already achieved something in practice: that would be a wonderful [belle] invention.[121]

While Wren, anxious to prove his *bona fides* as a skilled scientist with the members of the Paris Académie des Sciences, may have been providing crucial details of the workings of Hooke's balance-spring watch to Auzout, Moray and Oldenburg were certainly doing the same in their correspondence with Christiaan Huygens. No wonder Hooke came to believe, when a full-blown priority dispute arose between himself and Christiaan Huygens in 1675, that he had been 'betrayed' by Oldenburg and Moray. Wren's possible breach of confidence, however, apparently never came to his attention.[122]

Whether it was by an act of betrayal or misfortune, Hooke came to believe that precious secrets of his about the design and manufacture of precision timekeepers were given to others – specifically, to Christiaan Huygens. During the period of his greatest celebrity in London virtuoso

circles – when Pepys could unaffectedly bracket him and the renowned Dr Wilkins in one breath as the two most 'worthy persons as are in England, I think, or the world' – pressure of work fatally undermined his quest for lasting greatness as an original scientist.

# 4

## *Architect of London's Renewal*

> The Rebuilding of the City ... requiring an able Person to set
> out the Ground to the several Proprietors, Mr. *Hooke* was
> pitch'd upon, and appointed *City-Surveyor* for that difficult
> Work, which being very great, took up a large proportion
> of his Time, to the no small hindrance of his Philosophical
> Disquisitions.
>
> Richard Waller, 'Life of Dr. Robert Hooke' (1705)[1]

The Great Fire of London started early in the morning of Sunday, 2 September 1666, in Pudding Lane, in the house of Thomas Farriner, a baker supplying ship's biscuit to the Navy. It was slow to take hold – apparently the next-door neighbour had time to remove his possessions before his house, too, caught fire. By three a.m., however, Samuel Pepys's servants could see the flames from Seething Lane, over a quarter of a mile away. Thereafter, fanned by high winds, the conflagration spread with awesome rapidity. By Monday the fire had made inroads into the heart of the City, destroying some of its wealthiest districts: the banking quarters in Lombard Street, and Cornhill, home of merchants and goldsmiths. Sir Thomas Gresham's Royal Exchange in Cornhill was a major casualty, leaving the overseas traders and financiers – lifeblood of London – without a trading headquarters.

Only now did the gravity of the fire become clear to the City authorities, and measures begin to be taken to contain it:

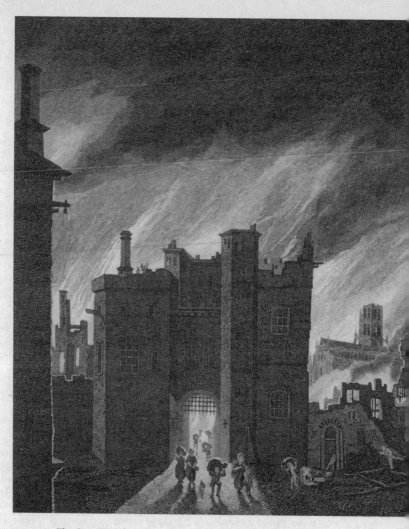

The Great Fire of London, with Ludgate in the foreground, Old
St Paul's burning in the centre, and the tower of St Mary le Bow in the
distance, surrounded by smouldering ruins.

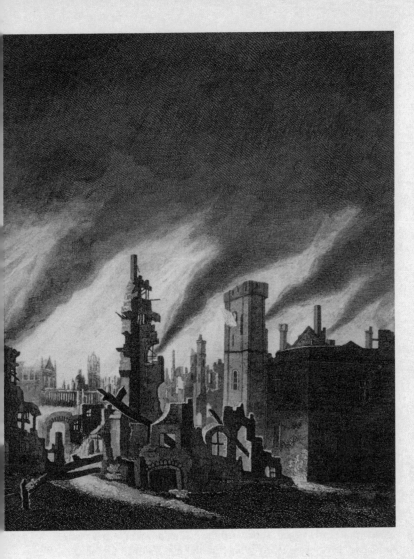

On Monday, as the fire continued to spread, Charles [the King] attempted to bring order to the efforts being made by establishing eight fire posts and putting [his brother James] Duke of York in overall control. . . .

The fire posts were placed around the conflagration and, at that stage, some distance from it. The western side of the City was covered by posts at Temple Bar, Clifford's Inn Gardens, Fetter Lane and Shoe Lane, while on its north side posts were placed at Cow Lane in Smithfield, Aldersgate and Cripplegate. The most easterly post was that at Coleman Street, for none was established in a broad arc around the edge of the fire between that point and the Tower. This may reflect an awareness of the vulnerability of the west of the City if the wind continued to blow from the east, and perhaps, too, a growing concern for the safety of Whitehall and even of Westminster. Control of each post was entrusted to a privy councillor or nobleman, who was assisted by three justices of the peace and the parish constables, with 100 men. In addition, thirty foot-soldiers, commanded by a 'careful officer', were assigned to each post.[2]

By Tuesday, though, the fire had reached Cheapside, and the flames spread northwards to engulf Guildhall, home of the Corporation of London. St Paul's Cathedral was the next major casualty, the scaffolding which had for years supported its tottering, damaged tower, helping the fire to take hold. From St Paul's the fire 'rushed like a torrent down Ludgate Hill'. By dusk, much of the Inner Temple had been gutted, as well as the buildings along both sides of Fleet Street, and there were real fears for Whitehall Palace. The Duke of York ordered the demolition or unroofing of buildings westwards of the Temple, from Somerset House to Charing Cross and Scotland Yard, to try to create a firebreak.

On Wednesday the wind at last dropped, and the Lord Mayor, Thomas Bloodworth (who had been scandalously slow to respond to the fire in its early stages), supervised the pulling down of 'a great store of houses' at Cripplegate. At Whitehall, the firebreak had helped save Inigo Jones's Banqueting House.

The last of the fire was doused at the Temple and at Holborn Bridge. By Thursday it was finally out, and arrangements were hastily made for the thousands left without shelter to be housed in tents on the open

spaces around the City – Moorfields, Lincoln's Inn Fields, Gray's Inn Fields, Hatton Gardens, St Giles Fields and the piazza at Covent Garden.[3] In a state of deep shock, Londoners contemplated the sheer extent of the final devastation – more than 12,000 homes destroyed and an estimated 65,000 inhabitants made homeless, in addition to the loss of public buildings and places of worship.

Hooke was always a restless man. Throughout the Monday and Tuesday, as the fire raged unchecked, he must surely have kept constant watch as the unpredictable flames moved, street by street, approaching ever closer to Gresham, the blaze creating a lurid, artificial daylight even at dead of night. Disaster seemed imminent; with no fire posts between the seat of the fire and the College, he and his neighbours to the east of the main blaze were particularly vulnerable as flames eddied and swirled towards them, in spite of the wind driving it predominantly westwards.

Gresham College was located on Bishopsgate, on the west side, north of its intersection with Threadneedle Street. It was Hooke's only home. The rooms into which he had moved two years earlier housed all his worldly goods, his library and the recently acquired collection of rarities forming the basis for a Society Repository or museum.[4] Telescopes and other valuable instruments belonging to the Royal Society were accommodated in neighbouring rooms in the College's dilapidated, tinder-dry buildings.[5] That Gresham survived the fire was little short of miraculous, and Hooke must have believed his narrow escape providential.

On the Tuesday, as the intensity of the fire increased, the blaze began to make progress northwards and eastwards, contrary to expectations. The fire post in Coleman Street had to be abandoned as the flames advanced rapidly; they stopped, however, just short of its northernmost end. To the east, the buildings along Throgmorton Street were engulfed; so too was the hall of the Drapers' Company, but its extensive garden acted as a firebreak, slowing and eventually halting the fire's progress. The fire reached the Dutch church at Austin Friars and the church of St Martin Outwich at the junction of Threadneedle Street and Bishopsgate, where it burned itself out, severely damaging but not

Overleaf Wenceslaus Hollar's engraved map of London, commissioned by Charles II immediately after the Great Fire, showing the area and extent of the devastation.

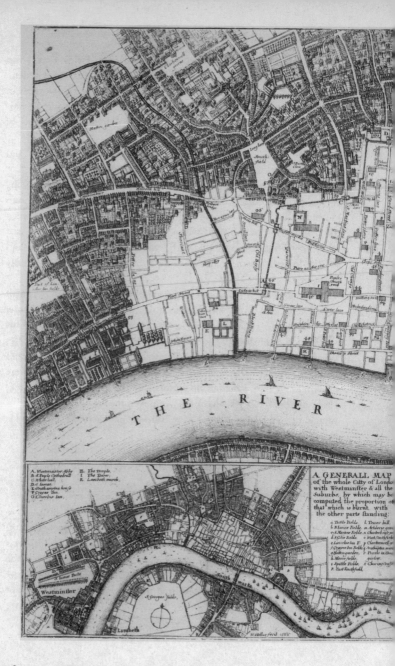

THE RIVER

A. Westminster Abby.
B. S. Paules Cathedrall.
C. Whitehall.
D. S. James.
E. Southampton house.
F. Grayes Inn.
G. Lincolns Inn.

H. The Temple.
I. The Tower.
K. Lambeth marsh.

A GENERALL MAP
of the whole Citty of London
with Westminster & all the
Suburbs, by which may be
computed the proportion of
that which is burnt, with
the other parts standing:

a Tuttle Fields.
b S. James Fields.
c S. Martins Fields.
d S. Gyles fields.
e Lincolns Inn F.
f Grayes Inn Fields.
g Hatton garden.
h Moore fields.
i Spittle Fields.
k East Smithfield.

l Tower hill.
m Artillery gro
n Charterhouse
o West Smithfi.
p Clarkenwell.
q Islington.
r Fields in Cle.
garden.
s Charing Cross

Westminster

Lambeth

S. Georges Fields.

South

W. Hollar fecit 1666.

Detail of Hollar's post-Fire map of London, showing how perilously close the flames came to Gresham College [T], before they were eventually extinguished.

entirely destroying the church. Gresham College stood less than a block north of this junction – saved by a mere whim of the wind and the firefighters' efforts (we may be sure Hooke was part of one of the bucket chains).

Although no diary survives for that year, Tuesday, 4 September 1666 would undoubtedly have been marked with one of Hooke's favourite passionate acronyms, used whenever he judged that some special sign had been shown to him of Divine favour: DOMSHLGISS:A – *Deo. Opt. Max. Summus Honor, Laus, Gloria in secula seculorum, Amen* (To the greatest and most merciful God, be all honour, praise and glory, now and for evermore).[6] Fire threatened Gresham College again, twice, in 1677, and on both those occasions we do have his diary reactions. When the first fire was caught before it spread and caused significant damage, Hooke attributed this to divine intervention. He recorded his escape from the second with the words, 'saved from the fire by a miracle. *Gloria Deo Solo*' ('Glory be to God alone').[7]

The Great Fire of 1666 out, Hooke's immediate neighbourhood looked like a battlefield. The Drapers' Company gardens were covered by a thick layer of ash, fragments of charred paper, linen and 'peices of Ceiling and plaster work'. The streets were littered with debris; southwards was a tangled mess of smouldering timber, tumbled stone and molten metal. Even before the embers of the fire had cooled, Hooke threw himself into the mopping-up operations. He was perfectly placed to do so.

On Thursday, 6 September, the Court of Aldermen of the City of London sat in emergency session at Gresham College – Guildhall was a burned-out shell – and requisitioned the College for their accommodation.[8] Orders were issued that the Lord Mayor and Sheriffs who had

lost their houses should be provided with accommodation there (thus for a period of time, Hooke and the Lord Mayor Thomas Bloodworth became neighbours). On 7 September the City ordered the lodgings of Dr Jonathan Goddard, Gresham Professor of Physic, to be taken over by the City Chamberlain, and the rooms formerly occupied by Dr Horton to be handed over to the Deputy Town Clerk and the City Swordbearer, for lodgings and offices. Apparently there was some resistance: the next day, 8 September, the City reiterated that Horton's lodgings were to be cleared by Monday morning, 'and in case of any contempt or neglect of this Order the City Artificers are to break open the Doors and see it executed accordingly'.[9] It seems that Hooke was allowed to stay in his accommodation at Gresham, because he simply had nowhere else to go – no other place of residence, and no close kin on the English mainland. He found himself swept up in the feverish planning activities of the Corporation of London, available for conversation and consultation at all hours of the day and night. Here was a context in which Hooke's insomnia and extraordinary stamina for business were positive assets.

Gresham College now became the hub of London's business activities too. For the next five years Hooke lived cheek by jowl with the merchants and financiers from the Royal Exchange, whose displaced activities were also relocated to Gresham. The hubbub of commercial life, previously a short walk from Hooke's doorstep, now went on under his very nose – with over a hundred makeshift stalls erected in and around the buildings, the College was turned into a combination of Town Hall and market place. His constant companions were merchants and sea-captains, fresh back from adventures overseas, with valuable cargoes to unload on the market. Evidence of Hooke's intimate knowledge of travel, exotic locations and the price of luxury goods is to be found scattered throughout his work from this point on.

For a lively, gregarious man with no family, usually living alone in largely unoccupied college buildings, the arrival of the Corporation of London and Royal Exchange inhabitants increased the pace of his daily life, giving it colour and variety. It provided him with constant company, activity and a sense of purpose and belonging. London's great catastrophe heralded what appears to have been the happiest and most fulfilling period of Hooke's adult life.

If Providence had intervened decisively on Hooke's side to protect

his home, the same was not true for his scientific activities, which were disrupted by the Fire at what was, in terms of his own researches, a particularly inopportune moment. Hooke and Wren had for some time been investigating the possibility of determining longitude at sea using a quadrant designed by Hooke and a double telescope designed by Wren, in combination. Hooke had worked on the quadrant during his enforced withdrawal from London to Durdans in the summer and autumn of 1665. Wren, Savilian Professor of Astronomy at Oxford since 1661, had been in London for a meeting to assess the condition of the fabric of Old St Paul's in the last week of August 1666, when they had put the finishing touches to their proposed longitude method. Hooke's and Wren's joint presentation of their instruments had been advertised for the meeting of the Society on 12 September.[10]

Evicted from its usual premises, the Royal Society met on 12 September in the nearby lodgings of Dr Walter Pope, Gresham Professor of Astronomy, and stepbrother of Dr Wilkins. Instead of the prearranged meeting there was a general discussion of the form the Society's response should take to the Fire, to prove its usefulness. The problem of longitude – mentioned in the Royal Society's founding charter of 1662 as one of the particularly important problems for which it might find a solution – was set to one side. Hooke and Wren never returned to it in this form, and the instruments were not revealed to the public until the relevant paper of Hooke's was published by Richard Waller, two years after Hooke's death.[11]

At the time, however, it is doubtful whether Hooke paid much attention to the shelving of a scientific project in which he had hitherto taken such a keen personal interest. For he found himself, by virtue of his continued residence at Gresham College, at the very nerve-centre of operations to clear the debris and rebuild the ravaged metropolis. From the end of his street, as far as the eye could see, lay the still smouldering ruins of London's commercial centre. His familiarity with the locality and his expertise where measure and structures were concerned gave him a significant advantage over other well-meaning citizens offering their services. Already known to many men of business from the Royal Society circle, Hooke was soon treated by them as indispensable. Once the Corporation committed itself to rebuilding to the existing property lines (with some significant street-widening), Hooke's intimate knowledge of the streets he had walked two or three times a day became an

invaluable asset – he was the walking memory of the fabric of his local London.

He possessed, moreover, all the skills necessary for taking a leading role in the actual rebuilding operations. Here was a context in which Hooke could confidently shine. His technical skills exactly matched the daunting tasks which needed undertaking. His tendency to be obsessive where anything to do with precise measurement was concerned, and his absolute scrupulousness with money, were exactly what was needed. Even his bossiness had a part to play in directing difficult operations, where confident leadership was essential. The Royal Society already had a reputation for being a mere talking shop. In the planning meetings at Gresham only those who could follow through on their ideas were of any value: only doers counted, and Hooke was a doer.

Hooke rose to prominence in City circles with extraordinary rapidity. He emerged as a tireless and talented surveyor, exemplary in terms of his accuracy, efficiency and acumen, fully deserving of the trust the Corporation of London had placed in him. As the acknowledged expert on Hooke's surveying career, Michael Cooper, points out, 'the City's confidence in Hooke during the hectic months from its approbation in September 1666 of his plan for rebuilding to the publication of the act of Common Council [formalising the rebuilding arrangements] in April 1667 is remarkable':

> A man with, as yet, no formal connection with the City except his appointment at Gresham College [as Professor of Geometry] was trusted effectively to determine on the City's behalf all technical aspects relating to the rebuilding of the city.[12]

Hooke – the leading figure in many of the important early post-Fire decisions – was the only man involved who did not already have an official connection with the Corporation. Five months after he had been sworn in to the team charged with formulating building regulations and determining street-widths for rebuilding, he was appointed to the post of City Surveyor, at a meeting of the Court of Common Council held on 13 March 1667, and ordered to begin the onerous work of pegging out each individual site for rebuilding.

The team of surveyors newly constituted to meet the emergency of the Fire was to consist of Hooke, Mills, Jerman and John Oliver:

Mr Peter Mills Mr Edward Jarman Mr Robert Hooke & Mr John Oliver are chosen to be surveyors & supervisors of the houses to be new built in this Citty & destroyed by the late fire according to the late Act of Parliament in that behalfe.

And it is ordered that the said surveyors doe forthwith proceed to the stakeing out the streets as is ordered & directed by this Court in pursuance of the said Act. . . .

The Aldermen Deputies and Common Councell men of the severall wards of this City destroyed by the late fire are desired to be present in their severall wards at the stakeing out of the streetes.[13]

In fact, at the swearing in the following day, Jerman and Oliver were both absent. So it was Hooke and Mills alone who took the formal oath:[14]

You shall sweare that you shall well and duly see that the Rules and Scantlings sett downe and prescribed in an Act of this present Parliament for building within the Citty of London and Libertyes [suburbs] thereof bee well and truly observed And that in all other things you shall truly and Impartially Execute the place or office of Surveyor or Supervisor within the said Citty and Libertyes as by the same Act of Parliament is directed and intended according to the best of your skill knowledge and Power Soe help you God.[15]

The appointment launched Hooke on an occupation (and a lifelong career) he would never have dreamed of pursuing before the Fire. The Lord Mayor, City Aldermen and Committee members never forgot the debt they owed him, for being the right man in the right place at the right time. Long after his scientific colleagues had grown impatient with his eccentric ways, men saluted Hooke wherever he went in the metropolis, seeking him out for conversation in the coffee houses he frequented, and coming to him for advice in any matters to do with building.

Hooke's employers at the Royal Society made no such effort to adjust their expectations of the Society's Curator, to take account of his important new responsibilities. At the Society meeting on the day following his swearing in by the Corporation, Hooke was forced to apologise to members for having been unable to make observations of two new

stars, one in the 'neck' of the constellation Cetus (the sea monster), the other in the girdle of the constellation Andromeda, because of the amount of dust in the air.[16]

The Royal Society was caught typically off-guard by the speed with which the King and the Corporation of London swung into action within days of the fire's being extinguished. To the annoyance of its Secretary, Henry Oldenburg, their leading expert in the field of building, Christopher Wren (already employed by Charles II in that capacity, for royal works) had jumped the gun and presented his 'model' or plan for the rebuilding of London directly to the King, thereby failing to involve the Royal Society in any way. Oldenburg, who saw Wren's proposal a week later and was impressed by it, made no attempt to hide his irritation when he wrote to Boyle in Oxford:

> Such a modell, contrived by him, and reviewed and approved
> by the Royal Society, or a Committee thereoff, before it had
> come to the view of his Majesty, would have given the Society
> a name, and made it popular, and availed not a little to silence
> those, who aske continually, What have they done?[17]

As salaried Curator to the Society, Hooke was more circumspect; his loyalties, after all, lay with its President and Council.[18] On 19 September, when the Society once again met at Dr Pope's lodgings, Hooke arrived with his own plan for the rebuilding of the gutted heart of the City, recommending complete reconstruction on a rectilinear grid. His formal presentation to the Society demonstrated clearly his important role as a bridge between the City and the Society. He arrived accompanied by the previous Lord Mayor of London, Sir John Lawrence, officially representing the present Lord Mayor, Sir Thomas Bloodworth, and the Aldermen of the City:

> Mr Hooke shewed his model for rebuilding the city to the
> society, who were well pleased with it; and Sir John Laurence,
> late lord mayor of London, having addressed himself to the
> society, and expressed the present lord mayor's and aldermen's
> approbation of the same model, and their desire, that it might
> be shewn to the King, they preferring it very much to that,
> which was drawn up by the surveyor of the city [Peter Mills];

the president answered, that the society would be very glad, if they or any of their members could do any service for the good of the city; and that Mr. Hooke should wait upon them with his model to the King, if they thought fit to present it: which was accepted with expressions of thanks to the society.[19]

This meeting marks a key moment for Hooke. He appeared before the Society with confidence and a new authority. He had already seized the upper hand with the Corporation of London, and convinced them of his competence to take a leading role in the emergency arrangements for assessing the damage caused by the fire. Thenceforth, the men of the City, several of whom were Royal Society members, accorded him enormous respect, and looked to him to take a central role in reaching decisions about its rebuilding. In the process, he forged lifelong relationships of mutual respect with senior figures in the Corporation.[20]

Some of that newly acquired status rubbed off on his dealings with the Royal Society, which was delighted to have one of their number closely involved with practical rebuilding arrangements. No matter that none of these ambitious early rebuilding plans was adopted (it was decided that the clearances of population involved smacked too much of absolutism, and that only returning the City to its former state was appropriately democratic).

On 4 October 1666, the King appointed Christopher Wren, Hugh May and Roger Pratt to represent the Crown on the official Rebuilding Commission. The City nominated Robert Hooke, along with the far better professionally qualified Peter Mills and Edward Jerman, as its representatives.

The earliest meetings of the Rebuilding Committee were largely taken up with the only real concession made to altering existing building boundaries – a widening of roads, and elimination of alleyways which had already been under discussion even before the Fire.[21] From the court side, Roger Pratt recorded the first meetings in his diary, detailing how the earliest decisions were concerned with improving the existing street-plan:

About the beginning of October 1666 wee had our first meeting, wherein it beeing much controverted whether that part of the citty now burned, were commensurable or not, by reason of many difficulties then proposed, it was at last resolved that it

was commensurable. Whereupon at our second meeteing about October the 8, wee ordered that Surveyours should bee appointed for the measurement of each particular Ward of the citty, and that the citty should be sente too to issue out Orders commanding each Proprietor to cleere his foundations within 14 dayes at the farthest, in order to such measurement; and likewise to pitch upon some fitting sallary for each Surveyour, as 12d per howse, etc, wherewith the city most readily complyed.

At our third meeting October the 11, upon the motion of some Lords of ye Council, who resolved to sitt to heare the progresse of our affaires every Tuesday in the afternoon, wee resolved the breadth of the severall future streetes.[22]

These were decisions that could be taken with particular confidence, since a commission on improving London streets had been meeting since 1662, and its active membership overlapped substantially with that of the new Rebuilding Commission.[23]

At the end of October, Hooke, Mills and Jerman were again nominated together as the City's team to draw up building regulations for a new Act of Parliament:

This Court doth nominate & appoint Mr [blank] Hooke, of the Mathematicks in Gresham house Mr Peter Mills & Mr Jermyn from time to time to meet & Consult with Mr May Dr Wren & Mr Pratt Commissioners appointed by his Majesty concerneing the manner forme & highth of Buildings in this City the Scantlings of Timber removeing of Conduits and Churches and Alteration of the Streetes And it is ordered that from time to time they report such their Consultation to this Court and give noe Consent or make any Agreement therein without the speciall Order of this Court.[24]

The regulations introduced by this hastily convened team were of vital importance for the future of London – both its physical appearance and its improved standard of resistance to the threat of fire (or, indeed, of epidemic sickness) in the future. With the grandiose, idealised plans for an entirely new London put firmly to one side, this Committee set about the down-to-earth business of assessing the actual fire damage, and of

drawing up the detailed legislation necessary before rebuilding could begin.[25]

The proposals with the most long-term significance were those stipulating uniformity of construction for buildings. Height of storeys, depth of cellars and thicknesses of walls were all laid down by law.[26] In all of these, Hooke was closely, personally involved, his expertise in mechanics and engineering an invaluable asset. He could calculate the strain on a load-bearing wall, or the amount of support needed for a four-storey brick building – and his swift, faultless arithmetic (from working out areas lost through road-widening to the compensation due to a property-owner) filled the Aldermen with confidence.

At the same time that Hooke was making significant contributions to the new building regulations, he was also the intermediary between the Committee and the Royal Society. On 31 October 1666, the Court of Common Council of the Corporation of London considered a parliamentary Bill on the making of bricks and lime. Hooke, who was in attendance, left that meeting and walked directly down the road to a meeting of the Royal Society, where he introduced brick-making as the day's topic for discussion:

> Mr Hooke took notice, that those earths, which will vitrify, make the most lasting bricks.
>
> It was ordered, that Mr Hooke should make trial of several earths by burning them in a wind furnace, to see, which kind would yield the best brick.[27]

Although these brick experiments did not, so far as we know, yield practical results, Hooke's shuttling between the front line of rebuilding efforts and the Society ensured that the latter was kept abreast of what was going on, and could be seen to respond accordingly with its own experimental efforts. He also thereby made Oldenburg (whose international correspondence was already shaping the way the Society was perceived abroad) aware of his important role in the City's rebuilding efforts.[28]

The most active member of the royal team appointed in October 1666 was Christopher Wren. The key position Hooke had succeeded in establishing in the Commission gave Wren a distinct advantage over the other gentleman members appointed by the King – something which at this early stage was particularly evident to members of the Royal

Society. Writing to Boyle in Oxford, less than six weeks after the Fire, Oldenburg was already yoking their names together:

> The other grand affair about the rebuilding of the Citty, is not neglected neither; Strict injunction being now issued by the Lord Mayor, in the Kings name, which done, the Survey and admeasurement of all such Foundations is to be forthwith taken in hand, and that by the care and management of Dr Wren and M. Hook: which survey is to be exactly registred; for the better stating thereafter every ones right and propriety: And then the method of building will be taken into nearer consideration, and, 'tis hoped, within a short time resolved upon.[29]

It was indeed the 'care and management of Dr Wren and M. Hook' which eventually won the day.

In the months immediately following the Great Fire, Hooke and Wren jointly contributed their expert technical mathematical and engineering advice freely wherever appropriate. In the eyes of the court (and therefore, of posterity), Wren was the more prominent figure. Hooke, however, led the partnership, and was critical to the success of the enterprise from the start. The Wren family archives would have us believe that Wren solicited the assistance of his less well-connected colleague:

> In order to Ease himself of some part of the great fatigue of This extraordinary Service, which at first, by his Majesties Directions, lay wholy on himself, he took to his Assistance his most ingenious friend Dr. Robert Hooke, Professor of Geometry of Gresham College, and assigned him the Measuring and Setting of the Ground of Private Houses for the several Proprietors. Takeing on himself the Care of the Cathedral of Saint Paul; the Parochial Churches; and all other Publick Structures.[30]

As far as the general public was concerned, however, in the City's hour of need, it was the Corporation of London's team of experts who originated the planning and legislation, the King who ratified it, and instructed his own team (led by Wren) to give the project their full support. So, in the four weeks from 4 October, Hooke helped map the fire-damaged area, began compiling a Land Information System for London, and drew up building regulations for an Act of Parliament to

govern the rebuilding. On 8 February 1667 the royal assent was given to the first Act of Parliament for rebuilding. This Act still left the City to determine the widths of the streets to be widened under its provisions, and Hooke and Mills were ordered to undertake this work.[31] By 13 March 1667 the City was ready to present its Acts of Common Council governing the street-widening to the King:

> His Majesty haveing heard the two Acts of the Comon Councell read distinctly to him, of the 26th and 27th of February last, the Map of the Citty lying before him, his Majesty lookeing upon the lines drawne out in the said Map according to the Orders mentioned & deliberating and discoursing much thereupon; his Majesty doth fully approve & commend all the Particulars mentioned in the said Orders.[32]

It was Hooke who (with Lord Mayor Bloodworth and his Aldermen) led the 'deliberating and discoursing much' with the King. The access Hooke gained to Charles II during this national crisis would stand him in good stead when he needed powerful supporters for his patent claim for the first accurate balance-spring watch ten years later.[33]

The Hooke–Wren team became a highly visible London partnership, steering the progress of rebuilding with dignity and circumspection. They dined out together almost daily, and were frequently to be seen engrossed in debate, at one of the coffee houses – notably Jonathan's or Garraway's – which were their favourite meeting-places. The arrangement was an extremely fortunate one for the Corporation of London: Hooke answered directly to them, and was tireless in his work facilitating swift rebuilding by individual householders; Wren had the ear of the King, and previous experience working with Royal Commissions on London planning issues, alongside the other key royal appointees in the rebuilding commission, Pratt, Denham and May.

As the ground-plan of the new London took shape, Hooke became preoccupied with the practical business of surveying, while Wren took an increasingly significant role in the planning and implementation of rebuilding on the King's behalf. In 1668, the Earl of Clarendon fell, and Wren's fellow commissioner Pratt, whose reputation had been irrevocably linked to his patron's since the unfortunate timing of the completion of Clarendon House in Piccadilly just as so many Londoners

lost their homes and goods in the Great Fire, took retirement.[34] The elderly John Denham fell ill in the same year, and Wren took over unofficially as Surveyor of St Paul's Cathedral (one of Denham's responsibilities as Royal Surveyor), before becoming Surveyor of the Royal Works in his place on his death the following year. From then on, official responsibility for all royal buildings destroyed in the Fire rested with Wren. Since rebuilding of public buildings had barely started at this date, this meant that the name of Christopher Wren is associated with the entire rebuilt City, even though individual buildings like the Royal Exchange were designed and built by other royal employees (in this case, by Edward Jerman, who also died in 1668, but whose design for the Exchange was seen through to completion).[35]

In 1670 the City Churches Rebuilding Act was passed, which detailed the procedures for the rebuilding of the City parochial churches.[36] The Act established a Commission to be responsible for this rebuilding, consisting of the Archbishop of Canterbury, the Bishop of London and the Lord Mayor of London then in office. They in their turn nominated Wren to take responsibility on their behalf:

> We ... doe hereby nominate constitute and appoint Dr Christopher Wren, Doctor of Lawes, Surveigher General of all his Majesty's Workes, to direct and order the dimensions, formes and Modells of the said Churches ... to contract with ... Artizans, builders and workmen as shall be employed ... [to] take care for the orderly execution of the workes and accompts ... and to receive from the Chamber of London such ... summes of Mony as we ... shall appoint for the constant and speedy payment.[37]

Nor did devolution of responsibility for actual building stop here. The Commissioners passed responsibility for day-to-day direction of the surveying, site-clearing, designing, hiring of skilled labour, ordering of materials, and on-site rebuilding activities, for the fifteen churches selected as those to begin the process, to a team of qualified experts – which, by now, was bound to include Hooke:

> Dr Christopher Wren, Surveyor General of his Majesty's Works, Mr Robert Hooke and Mr Edward Woodroffe are hereby required to repair forthwith the aforesaid churches and take an

account of the extent of the parishes, the sites of the churches, the state and conditions of the ruins and accordingly prepare fit models and draughts to be presented for his Majesty's approbation and also estimates proper to inform us what share and proportion of the money out of the imposition upon coals [the coal tax] may be requisite to allow for the fabric of each church, and where any contracts have been already made by the church-wardens, the said Christopher Wren and his assistants, are hereby authorised and required to call for the said contracts, and to examine what hath been already expended upon any of the said churches that thereupon we may better judge what is further expedient to allow for the finishing of such churches.[38]

The third member of this team, Woodroffe, was ten years older than Wren and an established surveyor with a wealth of experience in the building industry; he alone actually had the appropriate background and training for the job in hand. In the early stages of the City-churches rebuilding project he took responsibility for the on-site side of the rebuilding, overseeing labour and construction work, while Hooke took charge of contracts and payments, and Wren and Hooke shared the design.[39]

Looked at from the point of view of the City, then, the most important figure in the rebuilding efforts was Hooke, who seized the initiative at the right moment, and unflinchingly took responsibility in a crisis. From the Crown's point of view, the hero of the hour was Wren – a young architect of vision, who took over as the Royal Surveyor just when such a person was desperately needed. As for the two men themselves, they were close enough friends to derive, one imagines, some considerable pleasure from the leading public roles they played in City affairs from the late 1660s to around 1680, and to share a considerable sense of achievement.

Hooke and Wren developed a distinctive way of collaborative planning and execution of building operations over the course of these years.[40] The working relationship crystallised into an original way of organising building and design responsibility – something quite close to the arrangement of a modern architectural office. Both men were paid directly by the Rebuilding Commission, with Wren receiving around

twice Hooke's salary. Starting in 1670, however, Wren began paying Hooke an additional annual salary for work undertaken directly for him, organising the day-to-day running of the work on the City churches inside the Surveyor's office at Scotland Yard (and eventually in the Wren practice's second office adjacent to St Paul's Cathedral).[41]

On top of all his other commitments, Hooke now also took on the role of 'first officer' in the Wren architectural office. It was a job he was well placed to undertake, because of the long-standing personal friendship he had for many years enjoyed with Wren, and the fact that they had worked together as a scientific team since the late 1650s. They no doubt knew each other's ways inside out. Wren remained the senior figure, with the status and decision-making authority to match. Hooke intensified his pattern of shadowing Wren's activities, anticipating his professional needs and desires, and quietly and efficiently providing support and technical expertise whenever necessary. His devotion to Wren was unwavering. Wren appreciated the way the arrangement worked, and that it depended on the balance of skills between himself and Hooke, together with the experienced direction of the building work itself by the third member of the team.[42]

Wren was obviously aware that an ability to work alongside the notoriously difficult-to-please Hooke was a prerequisite for joining his architectural firm. When Woodroffe died in 1675, Hooke proposed that he be replaced by John Hoskins – another of the Royal Society virtuosi, a man well known in the City, and Hooke's long-standing friend. Wren overruled him, appointing Oliver instead, a man much closer to Woodroffe in terms of building experience. The attraction of Oliver was that he had already learned to work with Hooke while the two were City Surveyors.[43]

Because of the way the Wren office functioned, it is often extremely difficult to decide to which of the two men – Hooke or Wren – an individual project should be attributed.[44] This is particularly true in the case of the City churches. In one or two cases there is good reason to suppose that Wren himself took a close interest throughout the process, from drawing-board to completion, because of the prestige associated with the church in question (St Mary le Bow, St Stephen's Walbrook, St Lawrence Jewry). On such occasions, Hooke acts as right-hand man to the master architect. In other cases, and increasingly, as Wren got busier and Hooke became more practised as a design architect, Hooke

acted as the lead architect, taking advice from Wren where necessary, and using all the resources of the Wren office for 'his' building.[45]

During the period covered by Hooke's first surviving diary (1672–83), some forty churches were rebuilt by the Wren architectural office. The diary records visits to about thirty of these, including St Mary le Bow, St Stephen's Walbrook, St Lawrence Jewry, St Martin within Ludgate, St Anne's and St Agnes, St Benets Finck, St Michael Bassishaw and St Magnus. In many cases these visits are sufficiently numerous to suggest that, even if he was not the design architect, he nevertheless played a significant role in their final built form. His most recent biographer, also an authority on the fabric of London, maintains that 'his claim to St Martin within Ludgate, which he visited thirty-one times, is probably the strongest, but surviving drawings also indicate his authorship of St Benet Paul's Wharf, on Upper Thames Street, which is not mentioned in his diary at all'.[46]

The church of St Edmund the King (1670–4) has an equally strong claim to be entirely Hooke's. His drawing of the west front, signed and approved by Wren as Royal Surveyor, survives.[47] Still, the two men were involved together in the church's execution. Sometimes Hooke visited the site alone, sometimes Wren was with him, passing accounts, dining with benefactors and attending meetings of the parish councils. This pattern is repeated with each of the rebuilding projects, to an extent which probably makes attempts to allocate responsibility for design to one or other of them of little value. We do better to understand and appreciate the close sense each had of the other's aesthetic style and understanding of structure and built form, and the extraordinary achievement of the teamwork which produced the London skyline which survives today.

A typical church-visiting day at the height of rebuilding ran as follows, according to Hooke's diary notes: 'April 13th, 1675; Sir Christopher Wren and Mr Woodroof here. To Dionis Backchurch, Buttolphs, Walbrook, Coleman Street, St. Bartholomews. Dind at Levets. With Sir Christopher Wren to Paules.' A few days later we have: 'I was several times about accounts at Sir Christopher Wren with Woodroof. I transacted the business of St. Laurence Church with Mr. Firman.' In April 1676 Hooke 'agreed with Marshall about St. Bride's Church Tower'.

Besides the very many references to the churches themselves there are many others relating to payments from Wren to Hooke 'on the City Churches account'. These are recorded in the diary separately from the

Drawing by Hooke of the west front of the City church of St Edmund the King, with royal approval in the hand of the Royal Surveyor, Christopher Wren.

payments that Hooke was receiving from the City of London for his work as City Surveyor. Between the end of 1674 and October 1681 Hooke received something over eight hundred pounds from Wren for his City-churches responsibilities.[48] Since Hooke held responsibilities for viewing, surveying and advising on rebuilding across the area of devastation of the Fire continuously from 1667 onwards, the habit of walking the rebuilding sites – private homes, public buildings and churches – combined well with his specific responsibilities overseeing projects Wren had no time to monitor himself.

No occasion is recorded on which Hooke failed Wren in any of the tasks assigned him, on an almost daily basis, over a period of more than twenty years. Passionately loyal, Hooke never seems to have let his City

obligations, let alone his mere curatorial duties for the Royal Society, interfere with the burden of trust imposed on him in matters architectural by his oldest and dearest friend.

The physical rebuilding of London commenced surprisingly quickly after the Fire, and was fully under way by 1668. Hooke's labours were – quite literally – fundamental to that entire rebuilding process.

The Act of Common Council of 29 April 1667 (one of those in whose drafting Hooke was closely involved) laid down the procedure to be followed by a person responsible for rebuilding. 'The sum of 6s 8d for each foundation was paid into the Chamber [of the Corporation], where details of the payers name and the number and locations of the foundations were entered into Chamberlain's Day Books. The payer was thereupon issued with a receipt, which was passed on to one of the Surveyors who accepted it as authorization by the City to undertake the foundation survey and write a certificate. The person undertaking the rebuilding was responsible for clearing all rubbish from the foundations prior to the survey.'[49] At an agreed time, Surveyor and client met at the site. Having inspected the old foundations, and satisfied himself as to their precise extent, and the client's entitlement to rebuild, the Surveyor staked out the building lines, party walls and piers, taking into account any street-widening, and measuring the lengths of the boundary lines. All this information was carefully recorded, together with, on occasion, a sketch. Shortly afterwards a certificate was issued to the client, based on the information recorded in the survey book. At this point, rebuilding was allowed to start.

On 27 March 1667 Hooke and Mills began staking out the streets, starting with Fleet Street. An account written by the City's Clerk of Works lists expenses incurred in the week ending 30 March. It shows that workmen were paid for each of the seven days, and that six carpenters and seven labourers used 1220 feet of timber for stakes. In subsequent weeks a carter was engaged to carry the stakes around the City. The major part of staking out of the streets lasted at least nine weeks, but continued intermittently for the next few years in response to specific requests to the Court of Aldermen from individuals, groups of neighbours and corporate bodies.[50]

1667        *Brought over*       60 0000

June

3. Rec'd of John Vaughan for on: foundacon } 300   06 00
in St Mathewes Alley neare Shop: Gate
Mr Mills

4 Rec'd of Mr Robert Radaway for 2 foundacion 300   13 04
in Fetter Lane Mr Mills Surveyo

4 Rec'd of William Meade for one foundacon
in Grace Church Street over against ye Conduct Mr Hooke 0 06 00

4 Rec'd of William Walker Jun:r for 2 foundacons
without Newgate neer Pye Corner Mr Mills 0 13 04

4 Rec'd of Mr Dutton Clerke of Clothworkers Company
for one foundacon in Mincing Lane Mr Hooke 0 06 00

4 Rec'd of Mr Robert Thurkettle for one foundacon
in Thamestreet in St Bottolphe Billingsgate p'ish Mr Hooke 0 06 00

4 Rec'd of Thomas Hooton for one foundacon in Bread
nedle Street in St Christophers p'ish Mr Hooke 0 06 00

4 Henry Houghton Esq for 2 foundacons in Jerus
Salem Court in Grace Church Street Mr Hooke 0 13 04

4 Rec'd of John Wisse for one foundacon in Fetter
lane Mr Mills 0 06 00

4 Rec'd of Humphry Turkey for one foundacon in
Fleetstreet Mr Mills 0 06 00

4 Rec'd of Benjamin Hill for one foundacon in
Fetter lane Mr Mills 0 06 00

4 Rec'd of Humphry Turkey for one foundacon
in Fetter lane Mr Mills 0 06 00

4 Rec'd of Mr George Juice for one foundacon
in Fleetstreet neer Fetter lane Mr Mills 0 06 00

4 Rec'd of Joseph Doake for on: foundacon in
Fleetstreet neare Bell Court Mr Mills 0 06 00

4 Rec'd of Mr Gerard Vandegiesan for one foundacon
in St Austens Fryers Mr Hooke 0 06 00

5 Rec'd of Thomas Little for one foundacon in Thames
Street neare Dice Key Mr Hooke 0 06 00

5 Rec'd of George Walker for on: foundacon in
Blackfryers Mr Mills Surveyo 00 06 00

5 Rec'd of Robert Adams ye younger for two foun
dacon in Grace Church Street Mr Hooke 0 13 04

5 Rec'd of Ben: Rushton for on: foundacon in
new Fish Streete Mr Hooke Surveyo 00 06 00

100             *Born: over*     067 13 04
23
203

Record of payments made to the City Chamberlain for the staking
out, measuring and certifying of foundations for rebuilding by the
City Surveyors.

The Surveyor's job was an extremely onerous one, even without other commitments. In Hooke's case, the workload of surveys, and the added pressure of timetabling surveys to suit householders anxious to get on with rebuilding, must have been close to intolerable, given his supposedly full-time commitment to the Royal Society as its organiser of the obligatory weekly experiments. It is hard to see how Hooke could possibly have managed to keep up with his Royal Society obligations during this period.

At the height of rebuilding, during a typical period between March and the end of May 1669, the day books show that Hooke was allocated 100 foundations to measure and set out, plus a third of 514 more, not allocated to one of the three surveyors individually, but divided up between them. This works out at around ninety foundations to survey in each of the three months, not counting any outstanding work remaining to be done.[51]

Hooke was further required to measure and certify for compensation, areas of land lost to householders because of the statutory road-widenings:[52]

> The Rebuilding Acts allowed compensation for private land taken by the City to be paid from monies raised by a tax on coal (often referred to as 'the Coal Monies' in City documents) levied specifically to pay for rebuilding. . . .
>
> The procedure adopted by the Committee was for the Surveyors to measure and certify areas of private ground taken away by the City. The area certificate, for which the claimant paid a negotiable fee to the Surveyor, was taken by the claimant and handed in to the City Lands Committee, where the claim was registered to be heard. At the hearing, the Committee treated with the claimant and reached agreement on the amount of compensation, sometimes taking into account melioration of the loss of ground by improvements by the City such as easier access to buildings or a better prospect, but always based on the certified area of ground lost.[53]

More than 650 area certificates for ground lost, written by either Hooke, Mills or Oliver, are still extant. The workload must have been enormous, particularly since these were cases in which individuals were entitled to feel aggrieved at the loss of land involved, and anxious to be sure the

Certificate of two areas of ground taken for the widening of Botolph Lane and Thames Street. Hooke has calculated the total area taken, while a clerk's note at the bottom records the compensation paid.

Surveyor was representing their interests in calculating the compensation entitlement. Hooke was particularly popular in this capacity, since he was known to be absolutely scrupulous in making the calculations.[54]

Hooke played a major part in settling the substantial body of complaints and disagreements which arose during the staking-out process, and in the course of rebuilding itself. Disputes tended to be a consequence of the new, improved building regulations, which tidied up party walls (no longer allowing other than vertical divides between adjoining properties), banning upper-storey overhangs in narrow streets, and doing away with access through narrow passageway and through enclosed inner courtyards. Where complaints arose, Hooke, Mills and Oliver were required to view and report on disputes between neighbours, and on allegations of irregularities in rebuilding. Many of Hooke's reports survive, in his own handwriting, in the Corporation of London Records Office.[55]

Under the first Rebuilding Act, the three City Surveyors – Hooke, Mills and Oliver – were made responsible for reporting to the City court

weekly, in writing, any building irregularities they had noted as they moved around the City, as well as any for which specific complaints had been lodged. It was the Surveyors who provided the evidence for the Fire Courts, which adjudicated in these disputes, making it effectively their responsibility to decide on the respective claims of those in dispute. From 31 March 1669, Mills and Hooke were ordered to attend every meeting of the City Lands Committee – the committee involved in all compensation claims arising from the Fire – to expedite the settling of claims. Of 263 transcripts of reports taken on 'views' (as they were technically known) by the City's three Surveyors between 13 March 1668 and 10 February 1671, a hefty 229 include Hooke's name as one of the viewers.[56]

The views involved were time-consuming, and likely to include tense discussions with the disputants. A typical view gives a sense of how claim and counter-claim were likely to be involved, in even reasonably straightforward cases. Here three neighbours have to resolve the reallocations of space arising from the new legislation requiring that party walls divide premises vertically:

Whereas the Right honourable Sir Richard Ford, Knight Lord mayor of the City of London was pleased by an order bearing Date July 5 1671 to summon the Surveyors of the City of London to view the intermixture between the interests of Mr. Edward Harvy, Mr. John Jackson & Mr. John Neave situate in the south side of Goldsmiths hall & on the north of Kerry [Carey] Lane; and to act and do therein as in and by the Additional Act of Parliament for building the City of London is Limited and appointed.

We the said Surveyors having accordingly mett upon the place and viewd the said Interests and understood from the severall partys concerned their severall intermixtures upon the whole matter we doe order and appoint that Mr. Harvy shall build the Remaining part of the ground that is left in the first story intire and upright making use of the walls built by Mr. Neave and Mr. Jackson as party walls. he the said Harvy paying unto them the said partys Respectively the moyetys of their said party walls. and further that Mr. Harvy shall carry the party wall between the outlet of Mr. Jackson new made

and his own grownd upright upon the same foundations that are now set, returning the same at the west end thereof upon a sqare to the party wall now built by Mr. Jackson. and that Mr. Jackson shall have liberty to come home to the said wall with that part of his house where he hath now placed windowes. but whether he shall so think fitt or not yet that he shall pay the said Harvy for the moyety of the said party wall being about five foot in Length east & west & two foot north and south.

And further that all Differences touching any former intermixtures between the said Harvy & the said Jackson shall cease. Moreover we doe order that Mr. Neave shall pay unto Mr. Harvy in Compensation of the washouse and part of the yard build Upon by him the said Neave the summe of three pounds, and that all Differences between the said partys touching any former intermixtures of yards shall cease in testimony whereof we have hereunto set our hands this 8th of July 1671. [signed] Rob: Hooke [and] Jo. Oliver.[57]

One of the consequences of this side of Hooke's work as City Surveyor was that he learned a great deal about what we would today call conflict management and arbitration. The arrangements put in place (with Hooke's help) by the City of London seem to have been remarkably efficient, while at the same time being generally regarded as fair by all those involved. There appeared to be no problem, where these City matters were concerned, in moving smoothly from perceived injustice, and the lodging of a complaint, to a brokered negotiation and settlement acceptable to all parties. How much more frustrating it must have seemed to Hooke that in his dealings with the Royal Society on matters of intellectual property and priority claims, as well as his dealings with his supposed benefactor Sir John Cutler with regard to arrears in salary which Cutler refused to pay, no such speedy and fair settlement was forthcoming.[58]

It was probably during this period that Hooke began to keep abbreviated notes of his various commitments and obligations, either in his Surveyor's day books or in separate diaries.[59] He considered that his memory was poor – hardly surprisingly considering how much he needed to keep in his head on a day-to-day basis.[60] One of his diary

Report of a view by Hooke and Oliver for a dispute about intermixture
of interests – a dispute over party walls – in July 1671.

entries records what he considered to be a likely therapeutic remedy for improving the mind's capacity to retain information:

> Mr Melancholy [unidentified] told me that a friend of his had recovered of a bad memory and severall other distempers by carrying a small box full of very fine filings of the best silver and now and then licking of it with his finger and swallowing it. It seems very probable that this may be a very efficacious medicine, as is steel mercury gold and the other medicines and mineralls, of this query further.[61]

By now Hooke's habit of self-prescription for every kind of bodily shortcoming, or simply to keep him working beyond the point of exhaustion, had probably become routine.[62]

It is hard to see how Hooke could possibly have managed to cope with his Curator's responsibilities at the Royal Society, on top of the burden of his commitments on behalf of the Corporation of London, the Fire Courts, the Rebuilding Commission, the Commission for Rebuilding the City Churches and Wren's architectural office, during this period.[63]

Nevertheless, the Royal Society records show Hooke keeping up remarkably well with its regular demands during the period when he was busiest with his responsibilities as City Surveyor. He was, fortunately, absolutely in his prime (in the autumn of 1666 he was thirty-one). He had no family commitments, no domestic responsibilities, and was already described as 'restless' and 'indefatigable' by his friends, suggesting that his tendency to sleep little and skip meals was by now well established. But he was a slight man with a stoop and a nervous disposition. The level of his ability to keep demanding projects in a wide range of different areas going – and to keep track of them – is impressive. It is possible that he actually thrived on the sense of prevailing disaster and the constant demands made on him, at all hours, during this period.

In the early months of 1669, when Hooke was at his busiest measuring for ground surveys, issuing rebuilding certificates and adjudicating disputes, he still managed to sustain a full and varied programme of experiments for the Royal Society. This he did by concentrating on experiments which required comparatively little setting up, and depended upon some dramatic effect immediately apparent to his audience. When several proposals were made by members of experiments

suitable for the next meeting, he selected the one which needed least preliminary preparation.

Thus at the end of March 1669:

> Dr. Croone proposed an experiment, to try, whether an animal would be fed by blood alone transfused into it, viz. by enclosing two dogs in a box, and making the blood circulate from the one to the other by way of transfusion, feeding the one and not the other. He was desired to make the experiment, and Dr. Allen and Mr. Hooke to assist him in it.[64]

On 8 April Hooke did not produce a full-blown transfusion experiment, but instead offered a simulated piece of evidence for the circulation of the blood, and the heart's function in driving it:

> There was made one of the experiments appointed at the last meeting, viz. that with guts blown up, and tied on both ends, to show, that for making a pulse in the arteries there needs no more than a compression in the heart, since the gut being compressed on one end, the motion of it was sensible at the other.
>
> Dr. Goddard objected, that this was not sufficient to make out what was intended, since there was no outlet in these guts; whereas there is an issue of the blood in the body of animals out of the arteries into the veins.
>
> Mr. Hooke answered, that there is so, yet there being a return of the blood to the heart again, it could not be otherwise, but that, the vessels being full, there would upon the circulation of the blood into the heart again and its systole, be caused a pulsation in the arteries.
>
> He proposed an addition of a pipe to this experiment, the better to show the truth of his assertion.

The modified experiment is not recorded as having materialised, either in the following week or in the months that followed.

Experiments with microscopes were a guaranteed distraction, since they were always popular with the Society members, and could be prepared by Hooke – a celebrated microscopist – at Gresham in any spare moment. On 11 March, when a series of experiments on momentum was not going well, and the President was requesting complex and

time-consuming modifications to the experimental instrumentation, Hooke distracted the members with an intriguing piece of biology:

> Mr. Hooke remarked that he had examined some frogs, and found in them a seminal and excremental vent: and that he had looked upon the black round spawn of frogs by a microscope, and thought, that he saw a whitish tegument round about a black substance, and was of the opinion, that that was like the white of an egg, as he guessed the black matter within to be instead of the yolk. He undertook to observe the progress of frogs' spawn from time to time.

Even here, however, Hooke was at the mercy of the members' unreasonable demands. During this period, the Royal Society was meeting at Arundel House on the Strand. As a result, Hooke had to transport all his experimental equipment and materials the mile and a half from Gresham, where he still lived and worked, along bumpy cobbled streets, whatever the weather. Occasionally we learn that equipment had failed to work as promised, because of damage in transit. On 7 January 1669, for instance:

> Mr. Hooke made an experiment to prove, that the strength of a body moved is in a duplicate proportion to its velocity. But the experiment not succeeding, by reason (as was supposed by Mr. Hooke) of the frost disordering the instrument employed [presumably as it was transported], it was ordered to be repeated at the next meeting.[65]

This did not deter the members from making demands on their Curator for experiments which involved elaborate equipment. For example, Hooke was unable to be present at the meeting of 11 February because of surveying business. In his absence it was proposed that for the next meeting he be instructed by the operator, Richard Shortgrave, to transport 'Cock's great microscope' from Gresham to Arundel House – a difficult proposition, since the microscope was both unwieldy and fragile.[66] Hooke appears to have ignored the request. In April, however, he did bring in prepared slides and a microscope for the diversion of members:

> Two microscopical observations were made, one of the texture of fat, which appeared to be like froth full of cells; the other of

a kind of mould upon bookbinders' paste, which was found to
have a fine moss growing on it, that had on the tops of its stems
a head-like seed.

Occasionally, even Hooke's resourcefulness was exhausted, and he was
forced to admit to the Society that he had simply failed to prepare the
advertised experiments for the meeting. On these occasions the records
show that the response of the Royal Society members was grudging,
with no recognition or acknowledgement of his having important
responsibilities elsewhere:

> 17 June 1669. Mr. Hooke excused himself for having prepared
> no experiments for this meeting. He was ordered to take care,
> that against the next either his own new instrument for working
> elliptical glasses, or that of Dr. Wren for grinding hyperbolical
> ones, might be ready; as also that a couple of long pendulums,
> to be moved by the force of a pocket watch, be prepared, to
> see how long they would go even together.[67]

The Royal Society records suggest that the members were either oblivious
to Hooke's pressing City commitments or chose to ignore them. They
indicate a striking capacity for knowing better than Hooke in practical
matters, even when his by now daily experience on London's building
sites might have been thought to have given him some authority in
the matter. In July 1669, for example, 'Mr. Hooke proposed an ex-
periment about the strength of twisted cords, compared with untwisted
ones, to be tried at the next meeting, together with those others, that
should have been made at this meeting.'[68] The experiment was duly
conducted the following week, and 'Mr. Hooke concluded that cables
made faggot-wise would be stronger than when twisted.' This was not,
however, good enough for the members, who opined 'that cables would
not be so manageable; and that certainly people had not been wanting
to make trials of this nature, but had doubtless found, that, all things
compared, the inconvenience would prove greater in the use of
untwisted than twisted threads'.

Nor was the pressure on Hooke to perform lifted when the Society
broke for its summer recess, on 22 July 1669: 'It was ordered, that Mr.
Hooke should, during this interval, make such experiments in private,
as were in the former meetings committed to his care and left hitherto

unperformed.' Hooke complied. On 15 July he had informed the Society 'that he was observing in Gresham College the parallax of the earth's orb, and hoped to give a good account of it'. The Astronomer Royal later described to Newton how Hooke 'by ingenious means fixed the objective lens (as it is called) of a telescopic tube, 36 feet in length, in the roof of his chamber, in order to observe the distances of the stars from the vertex'.[69] The measurements Hooke passed to Flamsteed covered precisely the period of the summer recess of 1669.[70]

When the Christmas holidays came, the Society revealed the same lack of awareness or sensitivity. On 20 December 1669, 'Dr. Balle and Mr. Hooke were desired to finish the catalogue of the society's library within the approaching holidays.'

By the end of the year, 1669, Hooke's stamina, and apparently his commitment to the Royal Society enterprise, was beginning to flag. On 9 December, having tried initially to distract the members with a particularly colourful demonstration, he then confessed that he had failed to prepare the experiments requested:

> Mr. Hooke produced another specimen of staining with yellow, red, green, blue and purple colours; which he said would endure washing with warm water and soap.
>
> Mr. Hooke being called upon for the experiments appointed for this meeting, excused himself for not bringing them in, he having had some avocations of a public nature, which had hindered him from preparing those experiments.

The members offered no sympathy, and, 'he was ordered to do [so] against the next meeting'.

In the whole of 1670 only eight performances of experiments by Hooke are recorded. The Council began dismissal proceedings, when it 'resolved that Mr Hooke be summoned . . . to refuse their rebuke for the neglect of his office'. Consideration was given to allowing Hooke to appoint a temporary curator to help him, but nothing came of that.[71]

As London gradually got back to normal, some of the immediate pressure on Hooke was lifted. In November 1673 the Royal Society moved its weekly meetings back to Gresham College, after almost seven years temporarily accommodated at Arundel House. The move was welcomed, 'considering the conveniencey of making their experiments in the place where Mr. Hooke, their curator, dwells, and that the apparatus

Fig 4

*Left and opposite* Engraving showing the zenith telescope Hooke constructed in his lodgings at Gresham College in 1669. The object glass is mounted in the roof, and the eyepiece micrometer at lower floor level is aligned using two plumb-lines.

is at hand'. For Hooke this probably meant a return to dull solitude at home without the distractions he had become used to. At the same time the Mercers' Company (in change of official Gresham College matters) began proceedings to evict relatives of professors who had taken up residence, and to outlaw 'unfit meetings' which were disturbing legitimate occupants.[72] Hooke bought six new chairs to accommodate the members on Royal Society meeting days, and on 1 December the Gresham College officials threw a party in the Committee Room, and 'with wine and sweetmeats welcommed the Society thither'. Hooke no longer had to manhandle his equipment between Gresham and Arundel House, but neither was he any longer as committed as he had been to providing the hard scientific data on which the Society had depended in the 1660s.

By this time there can have been little doubt in Hooke's own mind, in deciding his own priorities, that his surveying-related business – City

Surveyor responsibilities and commitments to the Wren architectural office – came first.

The Corporation of London valued Hooke's efforts highly, and rewarded him regularly: £150 a year, paid quarterly and promptly. From Michaelmas 1666 to Christmas 1673 Hooke received £1062 10s from the City for his duties as Surveyor. In addition, clients paid extra for his foundation certificates.[73] Mr Abraham Jaggard, for example, paid the statutory 6s 8d into the Chamber on 8 September 1673 for a survey of a foundation in Fish Yard, Pudding Lane, while Mr Samuel Defisher paid the same for a foundation in Newgate Street. Hooke records in his diary for 16 September 1673: 'Mr. Jagger in Pudding Lane 20sh' and 'from Defisher, guinny'.[74]

Wren, too, paid Hooke his salary promptly on the whole (occasionally Hooke records in his diary having to press him for arrears, but they are almost always forthcoming as requested). Clients, whether City churches or civic dignitaries, gave gifts of money and valuables like silver plate, as a matter of course, in 'gratitude' for special effort, work completed on time, site visits given priority and other conventional occasions for rewarding the site architect.

The Royal Society managed to behave as if Hooke were theirs to order about as they pleased, and chastised him for 'idleness' whenever he was unable to comply with their demands. Nor was he properly paid for the privilege. During the period discussed here, Hooke was due an annual salary of £30 from the Royal Society for his duties as Curator of Experiments. Payments, however, were irregular and late. The account books show he received no payment for 1667–8, £60 in 1668–9 for two years' salary to Christmas 1668, and £37 10s on 2 May 1670 for 1¼ years' salary to Lady Day 1670.[75]

In December 1670, Hooke obtained his first independent private commission for a major building: the new Royal College of Physicians, to replace the elegant, colonnaded building by John Webb destroyed by the Great Fire. The benefactor who provided the finance which made the project possible was Sir John Cutler, who had made a huge personal fortune from large-scale conveyancing and brokerage during the civil-war years, and who had already sponsored the Cutlerian lectureship which Hooke held at Gresham College, concurrently with his Gresham professorship.[76] He paid for an anatomy theatre modelled on

that at Leiden University, named the *Theatrum Cutlerianum* in his honour at its opening in 1679. During his lifetime he contributed £7000 to the rebuilding of the College – the gift turned sour at his death, when his heirs maintained that the major part of this had in fact been a loan, and the College was forced to repay £2000 of the money.[77]

Hooke was already well known to Cutler, both through the Royal Society and through his City surveying activities. Since the relocating of London's financial sector and administration to Gresham College, following the Fire, the two had moved in the same social circles. Hooke had praised Cutler fulsomely in the preface to his *Micrographia*, for his generosity in supporting the new science – acknowledging the funding which, up to 1670, Cutler had provided punctiliously to support Hooke's lectureship in the 'History of Trades':

> I ought not to conceal one particular *Generosity*, which more nearly concerns my self. It is the *munificence* of *Sir John Cutler*, in endowing a Lecture for the promotion of *Mechanick Arts*, to be governed and directed by This *Society* ... This Gentleman has well observ'd, that the *Arts* of life have been too long *imprison'd* in the dark shops of Mechanicks themselves, and there *hindred from growth*, either by ignorance, or self-interest. ... We have already seen many other great signs of Liberality and a large mind, from the same hand: For by his *diligence* about the *Corporation for the Poor*, by his honorable *Subscriptions* for the rebuilding of St. *Paul's*, by his chearful *Disbursment* for the replanting of *Ireland*; and by many other such *publick works*, he has shewn by what means he indeavours to *establish* his Memory; and now by this last gift he has done that, which became one of the *wisest Citizens* of our Nation to accomplish, seeing one of the *wisest of our Statesmen, the Lord Verulam*, first propounded it.[78]

Hooke's Royal College of Physicians building was a worthy successor to Webb's, though its most impressive features involved innovative scientific provision, rather than fine classical design.[79] As well as the anatomy theatre, there was a purpose-built laboratory, with enhanced ventilation, in the basement.[80] Its achievement also stands, in Hooke's

COLLEGIUM REGALE MEDICORUM LONDINENSIUM

The Royal College of Physicians, designed by Hooke and paid for by Sir
John Cutler. It contained a state-of-the-art anatomy theatre modelled on
the one at Leiden University.

career, as a triumphal statement of his successful fusing of Royal Society
and City identities.

Following the Royal College of Physicians commission, Hooke
received commissions for Bedlam Hospital in Moorfields,[81] and for a
grand town house for Ralph Montagu in Great Russell Street (later the
first home of the British Museum). On the latter Evelyn reached a
slightly equivocal judgement:

> It is within a stately & ample Palace. The Garden is large, & in
> good aire, but the fronts of the house not answerable to the
> inside: The Court at Entrie, & Wings for Offices seeme too
> neere the streete, & that so very narrow, & meanely built, that
> the *Corridore* [is] unproportionable to the rest, to hide the Court
> from being overlook'd, by neighbours; all which might have ben
> prevented, had they plac'd the house farther into the ground, of
> which there was enough to spare: But in summ, 'tis a fine Palace,
> built after the *French* pavilion way; by Mr *Hook*, the *Curator* of
> our Society.[82]

Evelyn, who had spent many years travelling in mainland Europe, and prided himself on his sophisticated architectural taste, regarded Hooke as a minor talent, insufficiently schooled in the finer points of continental neo-classicism. Like the rest of London, however, he was full of admiration for Hooke's capabilities as a structural surveyor, engineer and adept manager of building projects. As speculative construction projects mushroomed, in the years following the Great Fire, prosperous London citizens came to Hooke in large numbers to design and build their houses. In addition to his general competence around the technical aspects of building, his command of building regulations, and access to the Aldermen and officials on the Corporation's planning committees, made him ideally qualified to undertake even the most ambitious of schemes.[83]

None of these buildings, alas, survives. A more lasting memorial to that liaison between City and science – between commerce and knowledge, in Hooke's own terms – was the Monument to the Great Fire. This handsome doric column, crowned by a gilded, flaming urn, was designed by Hooke and Wren together, but executed by Hooke. It was intended to be the focal point of a 'perspective view', at the top of Fish Hill, for the visitor entering London, but it was also a functioning zenith telescope, and a purpose-built location for scientific experiments involving 'heights'.[84]

Hooke took particular care with the foundations, within which he planned to accommodate a laboratory, properly appointed to allow an operator to observe the heavens up the shaft of the column. For stability, these were dug deep enough to take advantage of a bed of gravel beneath, six feet thick.[85]

The Monument was under construction from 1673 to 1677, with Hooke taking charge of the project once it went on site, through to completion. On 19 October 1673 he recorded in his diary, 'perfected module of Piller'; on 1 June 1674, 'At the pillar at Fish Street Hill. It was above ground 210 steps'; on 7 August, 'At the Pillar in height 250 steps'; on 21 September 1675, 'At fish-street-hill on the top of the column'. On 11 April 1676, he was with Wren 'at the top of the Piller'. From the precision of the elements in the column as built (the accuracy of the height of each individual stair-riser, the breadth of the circular apertures) it appears that Hooke took very particular care with the construction of this single, vertical shaft, exercising a close control over its execution,

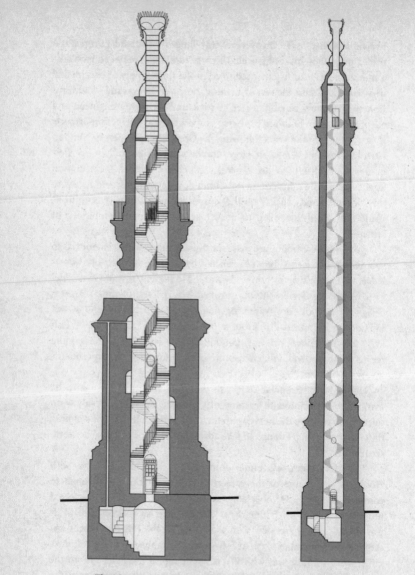

The Monument to the Great Fire which doubles as an oversized
scientific instrument. Section showing basement laboratory and stairway
to hinged 'lid' to the flaming urn. Wren convinced Charles II on
Hooke's behalf that crowning the column with an urn would enable
firework displays to be staged at the top of the column.

which increased the period to completion significantly. On 14 October 1676, Hooke noted, 'scaffolds at fish-street-piller almost all struck', but a year later he went again 'to piller about scaffold' and on 26 October 1677 he 'directed corners'.[86]

Although all of these projects may justly be attributed to Hooke, their realisation depended closely on the well-appointed and meticulously well-organised Wren architectural office, of whose services, as second-in-command to Wren, Hooke was able to make ample use.[87] In the case of Bedlam, for example, the careful records in Hooke's diary show him taking advantage of members of the regular Wren skilled workforce at the Moorfields site: '[Tuesday, 14 April 1674] With Dr. Allen [physician of Bedlam] at Bedlam. Viewd Morefields for new Bedlam. Drew up report for him. At Sir. W. Turner [Governor of Bridewell and Bedlam]. Undertook new Design of it.'[88] On 28 September, Hooke 'set out Morefield for Bethlehem with Sir W. Turner, Sir Th: Player [Chamberlain of London], &c.'. On 29 October, and again the next day, Hooke was 'with Mr. Fitch at Morefields', to 'set out Bethlem wall'. On 6 November he was 'at Morefields with Scarborough'. Scarborough was the measuring clerk in the Wren office (in our terms, the quantity surveyor, though he also acted as surveyor and engineer), and John and Thomas Fitch were Wren's master bricklayers.

By 28 January 1675, Hooke had arrived at a final design, to which the Treasurer and Committee of Bedlam Hospital had agreed: 'Deliverd in propositions about building Bethlehem ... At Treasurer Ducanes [De Quesne]. Presented Designe, liked well.' On 3 February, 'Fitch took Bethlem work' – in other words, Fitch took on the job of 'general contractor', with responsibility for day-to-day management of the site. This was the period during which Hooke was substantially occupied at the Royal Society, contesting Christiaan Huygens's bid to gain a patent for his spring-regulated watch on his own behalf.[89] Although he visited the site weekly, it was Fitch who laid the foundations, dictated and oversaw the masonry construction, and supervised the work of other contractors, such as the carpenters. Scarborough, who had costed the project at the beginning, returned regularly to assess its progress, and measured the completed buildings before submitting a final bill. Individual builders paid at regular intervals as the hospital went up, with Scarborough reporting regularly, if necessary visiting the Bedlam Treasurer himself to collect fees due.

Bethlehem or Bedlam Hospital, designed
by Hooke to provide palatial
accommodation for London's
dispossessed and insane.

In his independent building commissions Hooke was able to take
full advantage of his association with the Wren office. All the contractors
were controlled from the office by either Wren or Hooke. By committing
themselves to the office's centralised administration, their financial risk
was transferred to whichever partner was managing the project – in the
case of Bedlam, Hooke. Like Wren himself, Hooke was able to fulfil an
extraordinary number of architectural undertakings, because of the
office arrangements devised and put in place by Wren.[90]

As Aubrey recorded in his *Brief Lives*, Hooke's career was made in the
aftermath of the Great Fire: he 'was chosen one of the two surveyors
of the citie of London; by which he hath gott a great estate'.[91] Hooke's
appointment as City Surveyor to the Corporation of London, followed
by his nomination for a number of significant private commissions, at
last gave him financial autonomy and assured his future personal pros-
perity. Richard Waller – like Aubrey a close friend of Hooke in his later
years – also records Hooke's wealth and potential for advancement,
based on his activities as City Surveyor:

In this Employment he got the most part of that Estate he died possessed of.... That he might by this place justly acquire a considerable Estate, I think cannot be deny'd, every particular Person after the Fire being in haste to have his concerns expedited; so that as I have been inform'd he had no Rest early and late from Persons soliciting to have their Grounds set out, which, without any Fraud or Injustice, deserv'd a due recompence in so fatiguing an Employ.[92]

In the intimacy of his diary, Hooke's cryptic records of his encounters with the many individuals concerned in his varied London responsibilities, beginning in 1672 (the earliest period for which a diary survives) belie the tidy separations of domains of activity presented here. Hooke hurried between familiar haunts – Gresham College, a handful of favourite coffee houses (built after the Fire in close proximity to the College), Arundel House, the homes of Boyle, Brouncker, Wren, Hoskins, Bloodworth and many others. He did business wherever he stopped (recording the details where necessary), stayed to gossip, or to develop a new

scientific idea or philosophical thought. He listened to conversations between sea-captains and merchants, physicians and patients, brokers and their wealthy clients, fathers with potential suitors for their daughters, or with other fathers, of potential brides for their sons.

He was now a man of substance, adequately rewarded for his hard work for the Corporation, and welcomed into their brotherhood as a trusted member of the City community. Had he had the inclination, he might himself have negotiated a suitable marriage into a reasonably prominent City family. As it was, at some point during this period he brokered a betrothal between Sir Thomas Bloodworth's son and the as yet under-age daughter of his elder brother John on the Isle of Wight.[93]

All in all, the 1660s and early 1670s were the happiest, most prosperous, most fulfilling years of Hooke's life. He looked set for a golden career as a scientific virtuoso, while his City standing suggested that he might end his days as a person of distinction among the ranks of those associated with the Corporation of London. Only his tendency to be tempted into almost any scientific or technical argument, and his subsequent utter inability to back down or admit he might have been wrong, stood in his way.

5

*Skirmishes with Strangers*

The *English* [are] avers from admitting of new *Inventions*, and shorter ways of labor, and from naturalizing New-people: Both which are the fatal mistakes that have made the *Hollanders* exceed us in *Riches* and *Trafic*: They receive all *Projects* and all *People*, and have few or no *Poor*.

Thomas Sprat, *The History of the Royal Society* (1667)[1]

The English are temperamentally an insular nation. Reflecting on the early years of the Royal Society, Thomas Sprat (first official historian of the Society) thought that the Englishman's characteristic suspicion of strangers had impacted damagingly on the Society's ability to produce important (and marketable) innovations on the basis of its research – it was a 'fatal mistake', a failure of imagination likely to hand the scientific advantage to England's more outward-looking Dutch neighbours.

Hooke had grown up on a yet tinier, offshore island, whose inhabitants shared a particularly determined sense of independent local identity. He was not widely travelled, nor was he inclined to keep the company of 'strangers' (foreign visitors), unless they were possessed of factual data he was especially interested in. His coffee-house companions tended to be Corporation of London men, immersed in the minutiae of City life. As a consequence, although Hooke was acutely sensitive to social hierarchy within his immediate circle, he was generally inattentive

to foreigners, and quick to be condescending in his professional assessment of the efforts of the overseas, 'corresponding' members of the Royal Society. Smoothing over a disparaging set of comments by Hooke on one foreign correspondent's work in the 1670s, Oldenburg wrote conciliatingly:

> I would only add one word on what Mr Hooke has said in his book . . . which is, to beseech you not to be offended by the few words there concerning yourself. There are some people who – not having seen much of the world – do not know how to observe the rules of decorum adhered to generally among men of a certain standing [les honestes gens], whatever their country of origin.[2]

Added to this national diffidence, the habitual reluctance on the part of men like Hooke to take those from over the water seriously in intellectual matters was intensified and made more acute, in the 1660s and 1670s, by the manoeuvring for political advantage among the ruling parties of England, France and Holland. During this period, any overseas visitor to the Royal Society might also be suspected of being involved, voluntarily or inadvertently, in military espionage (just as naturalised Englishmen like Oldenburg might readily be accused of 'spying' for foreign powers, on the basis of their foreign correspondence with members of overseas scientific institutions).[3]

So it was entirely in character for Hooke to have misjudged an approach he received from Holland, in 1673, from an elderly amateur scientist eager to correspond with him about the exquisite engravings of natural phenomena viewed under the new microscope, and the scientific explanations proposed on the basis of their magnified structure, published by Hooke on behalf of the Royal Society in 1665, in his much praised *Micrographia*. It was an error of judgement, however, which would have long-term consequences for Hooke's standing, not just in London scientific circles, but also in the wider sphere, beyond Gresham College.

On 8 August 1673, at the height of the third Anglo-Dutch war, the distinguished Dutch diplomat and anglophile Sir Constantijn Huygens wrote a fulsome letter to Hooke, introducing the Delft microscopist Antoni van Leeuwenhoek. Accompanying Huygens's letter was a copy

of the first of hundreds of papers, prepared for the Royal Society by Leeuwenhoek, documenting meticulously (with fine line-drawing illustrations) observed phenomena viewed through a single-lens microscope.[4] Constantijn Huygens now sought to use his prestige and influence to ensure that his self-effacing countryman's scientific efforts got the attention they deserved, even though Leeuwenhoek himself could communicate his findings only in Dutch, lacking the lingua franca of Latin for learned exchange.

Sir Constantijn was himself an enthusiast for microscopy of long standing, and considered himself something of an expert in the use of lenses to magnify tiny natural objects. He never went anywhere without his own single-lens microscope in his pocket, a habit he had been introduced to in the 1620s by the great Dutch natural philosopher and experimentalist Cornelijs Drebbel.[5] Huygens had described the microscope in an early Latin autobiography of 1629, in terms of wonderment which foreshadow those used by Hooke himself in his *Micrographia*:

> Material objects that till now were classified among atoms, since they far elude all human eyesight, presented themselves so clearly to the observer's eye that when even completely inexperienced people look at things which they have never seen, they complain at first that they see nothing, but soon they cry out that they perceive marvellous objects with their eyes. For in fact this concerns a new theatre of nature, another world.[6]

This was, then, more than a formal letter of introduction for Leeuwenhoek. Huygens, who had read and studied Hooke's *Micrographia*, wrote to its author with evident respect for his work, in terms which consciously chose to overlook the social gulf which separated the two men, as it did the fact that they were officially on opposite sides in a war between their respective nations. In the interests of the pursuit of science, the close confidant of English kings (he had been knighted by James I) and Dutch Stadholders, and architectural and artistic adviser to Prince John Maurice of Nassau and Princess Mary of Orange, expressed his personal admiration for Hooke's work in the most fulsomely admiring of terms. He could take advantage of the fact that he had already encountered Hooke in 1663, at the Royal Society in London; their paths had probably also crossed more than once during Sir Constantijn's year-long residence in London in 1670–1, when he found himself

detained at the court of Charles II for almost a year, attempting un-successfully to collect substantial sums of money owed by Charles to William of Orange since the Restoration.[7]

Having vouched for Leeuwenhoek's good character, and given his own assessment of the technical brilliance of the examples of magnifica-tion submitted to the Royal Society (the parts of a bee, and transparent 'tubes' in unseasoned wood), Sir Constantijn moved on to acknowledge graciously the significant part Hooke's work had played in both Leeuwenhoek's and his own work with microscopes:

> I make no question, Sir but that since the <first> publishing of your excellent physiological Micrographie, you haue stored up a great many of new observations, and that this also may be one of them, but <howsoever>, I trust you will not be unpleased with the confirmatione of so diligent a searcher as this man is, though allways modestly submitting his experiences and con-ceits about them to the <censure of and correction of the> learned. amongst whome he hath reason enough to esteem your self beyond all in this kind of philosophic, and many other besides.[8]

The Dutch Stadholder's senior secretary now made a direct appeal to Hooke, requesting him to assist Leeuwenhoek with 'instruction upon the difficultie he doth find in his glas pipes, where out I am sure you are to extricate him by very good and ready solutions'. Indeed, he, Sir Constantijn, would be grateful for technical assistance with his own efforts at lens-assisted observation:

> If you will have the goodnes to let us see what important obser-vations you may have gathered since the sayd edition of your Book, as allso in any other curiosities, as I know your noble <witt and> industrie can never [object], I will take it for a special favour.

As if as an afterthought, Sir Constantijn, again with elaborate courtesy, at this point nudged Hooke on another Royal Society matter. It was now some months since his son Christiaan had sent twelve presentation copies of his new *Horlogium oscillatorium* [*On Pendulum Clocks*] to the Society, inscribed to individuals, including Hooke, for comment.[9] No response had so far been received.[10]

My french sons new oscillatorium I beleeve by this time hath to be the grandfather of that childs child, I doe long to heare the Royal Societys good opinion of it and specialy <the judgment> of Your most <learned and> worthie President the Lord Brouncker and the Illustrious Mr. Boyles whose wonderfull capacity and universal knowledge in omni scienti I doe still admire and little less then adore. Pray let them both find here the assurance of my most humble and devoted affection to their service. I hope our sad and unChristian distractions will not make them <nor your self> loath to heare from, Sir Your humble and affectionate servant &c.

Here was a rather more pointed invitation, soliciting a written communication. Huygens's son had for some time been pressing the Royal Society for a response to his new groundbreaking work on clocks. Since patents for clocks and watches vital for navigation and for the nation's war effort were involved, both Huygenses were becoming concerned at the continuing silence from London.[11]

This was a chance for Hooke to secure international patronage, and to use *Micrographia* to advance his career beyond the somewhat claustrophobic circle of London virtuosi. *Micrographia* had made a tremendous impact, not just with the scientific community, but also with the general public. Pepys records his excitement at acquiring a copy (hot off the press in January 1665), and adds that he, like a number of other London gentlemen, rushed out and bought his own microscope, to join the growing ranks of amateur enthusiasts.[12] It was a field which required exactly Hooke's combination of instrument-making ability, experimental dexterity and sheer showmanship, and to which his flair as a draughtsman made a further important contribution (Leeuwenhoek, who had no such natural talents, had to employ Delft artists to represent what he saw through his lens).

Hooke failed to take advantage of this golden opportunity. Had this been an approach from one of Charles II's senior courtiers (the recently deceased Sir Robert Moray, or Sir Paul Neile, say), Hooke would have had no trouble appreciating his correspondent's rank and status, and would certainly have understood how great an honour such a personal attempt at beginning a scientific correspondence was. But this was a letter from a foreigner – albeit one written in Constantijn Huygens's

faultless English (of which he was justifiably proud). A poor correspondent at the best of times (there were complaints about his failure to answer letters during his brief period as corresponding Secretary for the Royal Society in the 1680s),[13] Hooke did not respond to Sir Constantijn's letter.

This was not necessarily a simple oversight on Hooke's part, a failure to understand the significance of such respect shown to him in his capacity as virtuoso experimentalist by Sir Constantijn. As usual Hooke was under extreme pressure of work, not just handling Royal Society matters, but by now with the onerous responsibilities he carried for the rebuilding of London, in his capacity as Surveyor for the Corporation of London.[14] He did not like conducting business by letter, but had always preferred to do so face to face, even if that meant rushing from location to location in and around London.

Moreover, as Huygens's closing comment indicates, 'sad and un-Christian distractions' stood between the London scientist and his correspondent in The Hague. Holland, France and England were at war in 1673, and collaboration between Dutch, French and English scientists inhibited as a consequence. In August 1673, just days after Huygens wrote his letter to Hooke, England's fortunes in the war took a turn for the worse when Prince Rupert was soundly beaten at the Battle of the Texel. It was not a good moment to enter into enthusiastic exchange with a Dutch virtuoso and his 'French' son, particularly on militarily sensitive subjects like precision clocks (critical for location-finding in naval operations).

On the other hand, Hooke's silence may have been motivated by something more than political prudence. Notwithstanding the importance of his would-be correspondent, he had already made up his mind that he neither liked nor saw eye to eye with Sir Constantijn's virtuoso son (once a child prodigy) Christiaan. The dislike and mistrust was evidently entirely mutual; the two had clashed over scientific issues on a number of occasions. Although in 1665 Christiaan had written a polite letter to the Royal Society complimenting it on the publication of *Micrographia*, he had also made it clear to his father, privately, that the author of that work was neither amiable nor a good enough mathematician for his activities in any field to be taken seriously by Christiaan: 'Thanks for the extracts from Hooke [*Micrographia*]. I know him very well. He understands no geometry at all. He makes himself ridiculous by his

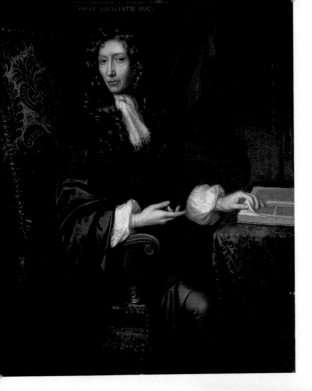

Prominent supporters at the Royal
Society:
(*above*) Robert Boyle FRS with
one of his own published works.
Portrait by Johann Keresboom.
(*right*) John Evelyn FRS holding
his book on varieties of trees,
and their cultivation, *Sylva* (1664)
– a Royal Society publication
venture almost as successful as
Hooke's *Micrographia* (1665).
Portrait by Sir Godfrey Kneller.

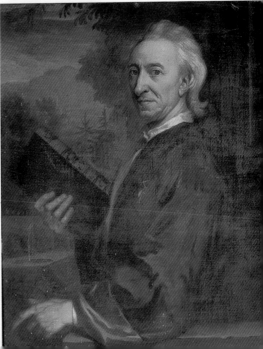

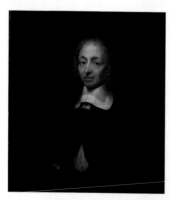

*Distinguished Dutch competition:*
(*left*) Sir Constantijn Huygens in old age (1672)
– still a major player in Anglo-Dutch politics.
Portrait by C. Netscher.
(*below*) Sir Constantijn Huygens, secretary to both
William II of Orange and his father, politician, poet,
artist and connoisseur, in his heyday.
Portrait by Thomas de Keyser.
(*opposite*) Sir Constantijn Huygens in 1640,
surrounded by his beloved children.
Portrait by Adriaen Hanneman.

enomena – from the point of a needle to an entire louse
nder the new microscope. When Pepys wrote in his diary
*ia* was 'a most excellent piece, of which I am very proud',
nt the pictures.[18]
y the Royal Society's second venture into publishing.
ad caused a similar stir: John Evelyn's *Sylva, Or a*
*Trees, and the Propagation of Timber in his Majesties*
That too had been 'a resounding success', and had
r's standing significantly. It established Evelyn in
and the City as one of the most celebrated and

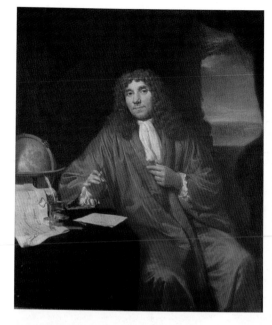

*Dutch contexts:*
Competitor or collaborator?
The virtuoso Dutch
microscopist Antoni
van Leeuwenhoek,
corresponding member
of the Royal Society,
introduced by Sir
Constantijn Huygens.
Portrait by Jan Verkolje.
(*below*) Conquest or rescue?
The arrival of William of
Orange's fleet at Torbay in
November 1688, heralding
the abdication of James II
– as imagined by J M W
Turner in 1832.

boasting.'[15] The real-life drama that unfolded as a result of Hooke's failure to respond to Constantijn Huygens was the result of the kind of mixture of bad luck and poor judgement of people that seems to have bedevilled Hooke throughout his career.

Alas! Sir Constantijn Huygens was not simply some overseas gentleman dabbling in microscopy, and had not approached Hooke light[...] In his own mind he was a fellow enthusiast in an exciting new [...] eager to share experimental materials. For Sir Constantijn, w[...] been an avid explorer of the world of magnification since t[...] Hooke was the virtuoso microscopist, with the latest equipm[...] disposal – a master manipulator of lenses to uncover th[...] nature, hidden deep beneath the surfaces of living thi[...] Huygens's passion for the field that he was prepared [...] rules of social decorum, overlook the gulf in rank [...] separated them, and approach Hooke (as he did th[...] hoek) as a scientific equal.

It is not at all surprising that Hooke's repu[...] had reached Sir Constantijn in The Hague, [...] *Micrographia* – or to give it its full title, *Mic[...] cal Descriptions of Minute Bodies made by [...] vations and Inquiries thereupon* (Lond[...] J. Allestry, 1665) – had given Hooke, [...] a celebrity among amateurs dabblin[...] was an attractive, lavishly illustrat[...] sible text. The format of the boo[...] talents. The text brought toget[...] by Hooke for the Royal Socie[...] lary action, carried out w[...] some characteristic Societ[...] meticulously document[...] Royal Society publica[...] Society's leading ex[...] plates were based [...] he once dreamed [...]

It was abov[...] spread renow[...] off to ideal [...]

of natural p[...]
– as viewed u[...]
that Micrograp[...]
he certainly me[...]
This was on[...]
Its predecessor [...]
Discourse of Forest[...]
Dominions (1664)[...]
increased the auth[...]
the eyes of the cou[...]

By the Council of the ROYAL SOCIETY
of *London* for Improving of Natural
Knowledge.

Ordered, That the Book written by Robert Hooke, M.A. Fellow of this Society,
Entituled, Micrographia, or some Physiological Descriptions of
Minute Bodies, made by Magnifying Glasses, with Observations and
Inquiries thereupon, Be printed by John Martyn, and James Allestry,
Printers to the said Society.

*Novem. 23.*
1664.

BROUNCKER. *P. R. S.*

*Opposite and left*
Frontispiece and
licence to Hooke's
*Micrographia* (1665),
sumptuously
published under the
auspices of the Royal
Society, whose coat
of arms figures
prominently.

distinguished figures in London's scientific community. When a second
edition was printed five years later, Margaret Cavendish, Duchess of
Newcastle, wrote to Evelyn:

> I have by your bounty received a book, named a Discourse of
> Forest Trees: you have planted a forest full of delight and profit,
> and though it is large through number and variety, yet you have

*Overleaf* Engraving of a flea as seen with the powerful magnification of a
microscope. From a drawing by Hooke, or possibly Wren. In the
original volume the flea on this fold-out plate measures a dramatic 18 by
12 inches.

Schem XXXIV

Illustration from *Micrographia*, based on a drawing by Hooke, of part of the leaf of a stinging nettle as seen under the microscope.

enclosed it with elegancy and eloquence, all which proves you more proper to be the head than a member of the Royal Society.[19]

This was the kind of hyperbole Hooke's *Micrographia* also elicited from among educated readers at home and abroad. Hooke, too, stood to benefit from the stir and the general enthusiasm with which his book was received.

To Christiaan Huygens, Sir Constantijn's second son, on the other hand, Hooke was a rather tiresome fellow experimentalist and precision-instrument-maker, a competitor in the potentially highly lucrative field of seventeenth-century new technology. Given Hooke's limitations in mathematics (the only field calculated to gain Christiaan's respect) he was inclined to expect the worst of him. We can be pretty sure he did not let Hooke's discourtesy towards his father escape notice.

Christiaan's impatience with Hooke (and his poor opinion of his mathematical abilities) was based on an earlier period of scientific inter-action and collaboration between himself, Hooke and Boyle, which had nothing to do with either microscopes or clocks. In the course of this Huygens and Hooke had decided they heartily disliked one another.

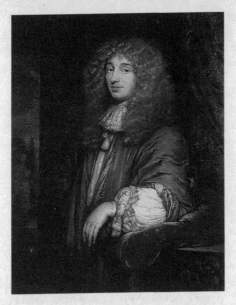

The Dutch diplomat Sir Constantijn Huygens's favourite son Christiaan – mathematical prodigy and accomplished experimental scientist. For most of his professional career he resided in Paris, drawing a handsome stipend from Louis XIV.

In April 1661, on a visit to London as part of the diplomatic entourage accompanying Prince John Maurice of Nassau to Charles II's coronation, Christiaan Huygens had seen Boyle's pneumatic engine or air-pump in action at the Royal Society, brilliantly operated by Hooke.[20] The day after the demonstration Huygens visited Boyle, to begin a long-running exchange of ideas with him on both the theory and practice of the pump: that first day they 'discoursed for a long time'. In June Huygens wrote to his brother Lodewijk that he had seen 'a quantity of beautiful experiments concerning the void [at the Royal Society], which they ... make ... by extracting all the air from a large glass vessel by means of a certain pump'.[21] After Christiaan had returned to Holland in the summer, he was kept up to date on air-pump developments by Oldenburg (who visited him in The Hague), and by Moray, and by September had decided to build a pump of his own, using Boyle's *New Experiments Physico-Mechanical, touching the Spring of the Air* (1660) as his reference guide.

To begin with Boyle and Huygens engaged in what we would recognise as scientific collaboration by correspondence. But characteristically for the times, in which contest seemed more attractive to

experimentalists than co-operation, by the end of 1661 Huygens was maintaining that his air-pump was of a superior design to Boyle's. Disagreement immediately followed. Boyle (in other words his apparatus-designer, Hooke) rejected Huygens's plan to use a copper valve. Huygens rejected Boyle's (that is, Hooke's) idea of placing the pump under water, to prevent leakage. Boyle and Hooke cast doubt on Huygens's experimental results, using his air-pump, which they had been unable to replicate.

Over the next two years, Hooke in London and Huygens in The Hague modified and redesigned their air-pumps to achieve tighter seals at all the possible points of leakage, and thereby to improve their efficiency. Although Huygens, who was lavishing large sums of money on successive prototypes, believed his pump now far out-performed that which Hooke was modifying on behalf of Boyle, the Royal Society flatly refused to accept his evidence to that effect.[22]

Eventually, in early June 1663, Huygens decided to come to London himself to conduct the crucial experiment which he maintained would prove his own pump superior to its English competitor. Boyle chose precisely the weeks of Huygens's visit to absent himself from London, going to stay with his sister, the Countess of Warwick, at Leese in Essex. As we saw above, it was Hooke who demonstrated the London air-pump for Huygens.[23] This was surely no accident (Oldenburg did his best to persuade Boyle to return to London for the visit); in Boyle's absence it was entirely appropriate that all practical experiments and all discussion of the comparative technical details of the two pumps took place between Huygens and Boyle's representative, Hooke – newly elected a full member of the Society, which gave him the appropriate status to lead such a dialogue. Throughout July, Hooke kept Boyle informed of the outcome of the various trials conducted at a distance, by letter.

In August, once it had been safely established that Huygens's 'variation' of the apparatus was not markedly superior to his own design, Boyle finally appeared at the Royal Society to witness a trial in process. Huygens recorded in his journal:

> I saw my experiment of purged water in the void [the evacuated chamber of the air-pump] in a pipe 7 feet in height, where the water stayd up without falling, succeed 2 or 3 times, in the

presence of Lord Brouncker, Mr. Boyle and of many other persons.[24]

In Huygens's mind this confirmed the results he had been getting at home, and proved that his pump was superior. Boyle, however, was equally sure that the trial was inconclusive, the results open to more than one interpretation, and that Hooke had shown himself far better able than Huygens to achieve a vacuum in the pneumatic engine. Boyle did not, however, carry out any air-pump experiments of his own, because the various air-pumps he had there were either out of order or unsuitable. Instead, he reported in a letter to Oldenburg: 'As soon as I came home I apply'd my selfe with <the> Assistant <you know> to try what could be done.'

Once again their results differed from Huygens's. It is hard to resist the thought that the detailed, technically precise letter maintaining this, written to Oldenburg in October, may have been drafted by Hooke. Boyle, as he confesses at its close, was in any case unwell: 'I am reduc'd to give You this hasty account when Physick that has not done working has I fear discompos'd as well the thoughts of my mind as the Humors of my Body.'[25] This letter was entered in the Royal Society records as the definitive account of the Huygens–Boyle pneumatic-engine trials.[26]

Huygens senior accompanied his son on his June 1663 visit to the Royal Society for the trials of the air-pump, and stayed on after Christiaan had left that autumn. At the beginning of September 1664 he dined with Evelyn at his home in Deptford, in the company of 'some other persons of quality', including Moray.[27] Six months earlier, when Moray had again dined at Evelyn's, Hooke had been there too, since on this occasion the company was made up of fellow members of the Royal Society.[28] In other words, if the circles in which Hooke and Sir Constantijn moved did not actually overlap, they had plenty of social contacts in common.

Unfortunately, even before Constantijn Huygens's letter of August 1673 reached him, Hooke had already taken issue with his son's *On Pendulum Clocks* publicly, in one of his Thursday Cutlerian lectures, making a particular point of challenging the originality of Huygens's pendulum timekeeper itself.[29]

There is no mistaking Hooke's tone in this lecture – not for the first

time he was deeply affronted that experimental results on a topic he considered one of his own specialist areas of interest should arrive on his desk in published form, without any acknowledgement from the author of Hooke's own contributions to the field, nor indeed any reference to discussions he and Christiaan Huygens might have had on these or related topics:

> I have Lately Received from the Inquisitive Hugenius van Zulichem a book <written by himself> containing a description of severall mechanicall & mathematicall Inventions Intituled *Christiani hugenij Zulichemij . . . Horologice[m] Oscillatoriu[m] siue de motu pendulorum*. There are <in it indeed> many things very ingenious and very usefull but there are not wanting also severall things that are of a <quite> contrary nature <as I shall show you by some few observations> which I have made in the Cursory reading of it having not yet had time to examine every particular hereof more strictly.[30]

In Hooke's mind, Christiaan was another unwelcome 'stranger', who had eavesdropped on the Royal Society's proceedings as a visitor, and subsequently presumptuously claimed a whole series of English scientific and technological innovations as his own.

Matters were not helped by the fact that Christiaan had subsequently chosen to settle in Paris (he told his brother that the dirt, smog and bad weather in England made it an impossible place to live). There he was under considerable pressure to justify his lavish royal stipend, and his scientific investigations had a habit of mirroring quite closely the kinds of activities being undertaken in London, based on regular exchanges of letters with his father's old friend and diplomatic counterpart Sir Robert Moray.[31]

In his lecture Hooke poured scorn on the breakthroughs in clock technology claimed by Huygens in his book, detailing his disagreements sardonically and with embarrassing frankness. Bearing in mind that this lecture was 'read', we may be sure that word got straight back to Huygens (via that enthusiastic disseminator of scientific 'news', Oldenburg). Aside from the great names in the field of clock technology – Galileo, Descartes, Mersenne – any number of English virtuosi had, maintained Hooke, anticipated Huygens's 'invention', without making such a fuss about it. 'Doctor Wren Mr. Rook Mr. Balle & others made use of an Invention

of Dr. Wrens for numbring the vibrations of a pendulum a good while before Monieur Zulichem publisht his'; they, however, 'did not cry eureka' (as Huygens claimed he had done when he believed he saw the solution to the problem of clock precision):[32]

> I my self had an other way of continuing and equalling the vibrations of a pendulum by clock work long before I heard of Monsieur Zulichems way, nay though equated with a Cycloeid yet I have not either cryd eureka or publisht it and yet I think I can produce a sufficient number of Credible witnesses that can testify for it about these 12 years. Soe that the argument that he soe much Relys upon to secure to him the Invention is not of soe great force as to perswaid all the World that he was the first & sole inventor of that first particular of applying a pendulum to a clock.

Even where Hooke admits Huygens's originality – as in the matter of applying cycloidal cheeks to a pendulum to assure isochrony of swing – he manages to make the admission insulting:

> The next thing which he mentions is his invention that all the vibrations of a pendulum moved in a cycloeid are of equall Duration. this for ought I know he is the first Inventor of for I never heard of any one that claimed the honour from him of it It is indeed an Invention very extraordinary and truly excellent and had been <honour> enough for him justly to have gloried in the happinesse thereof, and I beleive there is none that would have gone to have deprived him of his Due praise.

This much Hooke is prepared to concede, but having done so he goes on immediately:

> But he should also have Remembred that Golden Rule to doe to others as he would have others doe to him <&> not to have vaine gloriously & most Disingenuously Indeavourd to Deprive others of their Inventions that he might magnify himself and with the Jack Daw pride himself in the plumes of others, which how much and often he hath Done in the rest of the book I shall Indeavour to Explaine.[33]

Hooke's lecture audience presumably recognised the irony of this

rebuke. In his own London circle, it was Hooke who was regarded as being inclined to 'magnify himself and with the Jack Daw pride himself in the plumes of others'.[34]

Such provocative directness indicates that Hooke was oblivious to the power of the Huygens connections. This was not the case for Oldenburg, who was increasingly at pains to smooth Christiaan's way with the English virtuosi, making Hooke's hostility and repeated slanders a serious embarrassment. He made no attempt to warn Hooke that he was busy writing conciliatory letters to both Constantijn and his son – letters which, in his efforts to make amends, contained details of Hooke's own horological activities which ought not to have been divulged without his agreement.

The whole affair was a sad case of bad timing. Hooke – tunnel-visioned in matters intellectual, self-absorbed, cliquish, and outside influential court circles – had first encountered the Huygenses in the early 1660s, when Huygens senior's position was at its lowest ebb politically. From 1651 to 1672 Holland was without a Stadholder, and Huygens senior, therefore, as close adviser to the House of Orange (a position he retained throughout this period), was comparatively unimportant on the international stage, though he remained a considerable negotiator on behalf of the orphaned son of Charles I's sister Mary.

In 1672, however, William of Orange regained the position of Dutch Stadholder, and from then on Sir Constantijn Huygens, aged seventy-seven, once again became a major political player. Christiaan's elder brother, also Constantijn, was appointed Secretary to the new Stadholder.[35] William's international standing was helped by the third Anglo-Dutch war, which began in 1672, in the course of which the Dutch under William's leadership drove the French out of the Low Countries, and forced the English to sign a peace treaty in 1674. As far as public opinion was concerned, this was a war provoked by the French (who invaded the Netherlands), and in which the Dutch demonstrated that their sea-power was a match for the English Navy, under the admiralship of James, Duke of York, later James II.

William – Charles II's nephew, son of his beloved sister Mary – was now an important figure on the European stage, a Protestant ruler with close blood ties to the English throne (which was without an immediate heir), and therefore potentially a significant ally for those opposed to the rising tide of Catholic influence associated with the Duke of York.

Thus, at the very moment when Sir Constantijn approached Hooke as a fellow scientist, the Huygenses had once again become major international political players and dynastic power-brokers.[36] The young Stadholder's dependence upon Sir Constantijn's judgement had been obvious in 1670 when he attended William on a visit to London. Those in Charles II's court circle at the Royal Society were certainly aware of what it might mean to gain Sir Constantijn's favour; Hooke, clearly, was not.[37]

Eventually Sir Constantijn decided to bypass Hooke and to go directly to more senior members of the Royal Society. A consummate diplomat, well used to manipulating opinion to his advantage, Sir Constantijn wrote a carefully judged letter to Oldenburg, the official Secretary of the Royal Society, affecting wounded innocence at the slight to his dignity that had taken place. He also dropped all show of interest in Hooke's own specialist expertise in microscopy. Although, on the strength of Sir Constantijn's introduction, Leeuwenhoek corresponded with the Royal Society for almost fifty years, providing them with a constant supply of microscopic data and discoveries, he did so via Oldenburg, and Hooke's involvement was restricted to that of experimental operator, instructed to check and try to replicate findings transmitted to the Society by the Delft microscopist.

Early in 1674, Christiaan's father wrote to Oldenburg, as one gentleman to another, complaining that Hooke had still not responded to his letter. He chose his words carefully, so as to emphasise Hooke's inferior status and education, and to imply his greater confidence in Oldenburg's courtesy and sophistication. He thanked Oldenburg for having 'had the goodness to dissociate [himself] from the idleness [*paresse*] of the good Mr. Hooke' and to have written to him independently. Sir Constantijn was delighted at the encouraging reception of Leeuwenhoek's work reported by Oldenburg, and awaited further news of discoveries made using the microscope with anticipation, as an amateur of microscopy himself, who used a 'simple little device which I always carry with me in my pocket'. Finally Sir Constantijn added a studiedly naive comment on Hooke's discourteous silence. In French as perfect as the English in which he had written to Hooke, he suggested that it was his own linguistic inadequacy which had caused the problem:

There would be nothing easier than for us to accuse Mr Hooke of laziness [*paresse*]. But another thought has occurred to us,

which is that he perhaps had difficulty understanding the atrocious English in which I risked engaging him, because I did not know if he was sufficiently familiar with French. If that was indeed the case, I could put the matter right by rewriting in Latin whenever he chose, rather than that the damaging effect of clumsy use of language should deprive me of his correspondence.[38]

As soon as Hooke's 'laziness' was brought to his attention, the more cosmopolitan and politically astute Oldenburg was immediately sensitive to the awkwardness of the situation that had arisen for the Royal Society. He acted swiftly to smooth the Huygens family's ruffled feathers.

In the first place, it appears that he pressed Hooke to respond to Sir Constantijn, and that Hooke complied. Hooke recorded in his diary for 26 March 1674: 'Sent letter to Constantijn Hugens by Pits.'[39] Two days later he 'sent a book to Hugenius'.[40] This was presumably an early copy of his *An Attempt to prove the Motion of the Earth* (1674).[41]

Hooke's letter contained an apology for his hostile remarks concerning Christiaan's 'circular pendulum' – by which Hooke means a hairspring used in place of a pendulum as a timekeeping device.[42] These were the remarks made in that Cutlerian lecture of which Sir Constantijn had evidently had reports.[43] Christiaan responded in a letter to his father, written on 7 August 1674. He welcomed Hooke's conciliatory tone: 'I am obliged to the civilitie of Mr. Hooke, for what he writeth to you, concerning my Book.' However, Christiaan felt that Hooke was still contesting claims made in his *On Pendulum Clocks*:

> But he doth wrong me, saying I had notice of his contriving of a circular Pendolo-watch [balance-spring watch]: Sir Robert Morray nor any body else did ever write me of it. and I wonder how he can assume that Sir Robert Morray should himself have told it him. . . . I beseech you to communicate all this to Mr. Hooke.[44]

He in turn gave chapter and verse for his reasons for believing that he deserved recognition for his breakthroughs in horology. Sir Constantijn immediately forwarded this justification (or 'apology'), penned by his beloved 'Archimedes' (Christiaan), to Oldenburg. Oldenburg passed it to Hooke as requested. Once again, Hooke delayed in responding, and, in this instance, so too apparently did Oldenburg.

\*      \*      \*

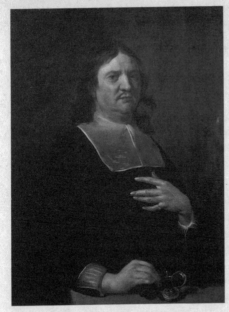

Henry Oldenburg, Corresponding Secretary to the Royal Society, and editor and publisher of its *Philosophical Transactions*. Originally from Bremen, and like Hooke a former employee of the Boyle family, there was a long-running rivalry between the two.

Hearing nothing more from London, on 19/29 March 1675 Sir Constantijn wrote to Oldenburg again, protesting, in terms designed to cause maximum embarrassment, his and his son's sincere wish to remain on good terms with 'good Mr. Hooke', in spite of Hooke's bad manners:

> You see, Sir, that I am here reduced to proving and justifying my loyalty on each occasion, and to serve the interests of a child who I am inclined to love deeply. I beg you to extricate me from this predicament and then to enlighten me as to what decision Mr Hooke will take towards a Father and son who so strongly wish to preserve the bond of his friendship, and who so greatly honour his brilliant intellect. It is crucial that we all conduct ourselves with candour.[45]

In a postscript, Sir Constantijn intensified the pressure on Oldenburg by asking for news of the Royal Society's views on his son's sensational

new horological invention, the pocket watch, for which Christiaan claimed already to have secured a patent in Paris:[46]

> My son asks me to say that he is astonished not to have heard anything from you, concerning what he wrote to you about his new invention of a 'pocket clock' [*pendule de poche*] as the French have christened it.[47]

Christiaan had sent Oldenburg the secret of his original balance-spring watch construction in anagram form on 20 January 1675.[48] He had followed this up with a fuller explanation, just ahead of publication of the details in the *Journal des sçavans* (the journal of the French Académie) on 25 February:

> The fact is, this invention consists of a spring coiled into a spiral, attached at the end of its middle [that is, the interior end of the coil] to the arbor of a poised, circular balance which turns on its pivots; and at its other end to a piece that is fast to the watch-plate. Which spring, when the Ballance-wheel is once set a going, alternately shuts and opens its spires, and with the small help it hath from the watch-wheels, keeps up the motion of the Ballance-wheel, so as that, though it turn more or less, the times of its reciprocations are always equal to one another.[49]

Such a revolutionary clock could be made very small, resulting in 'very accurate pocket watches'; larger models would be particularly useful 'for the discovery of longitude at sea or on land'. Huygens proposed that Oldenburg secure a patent for the invention for the Royal Society (as a foreigner Huygens could not own a patent himself, and actually he was not progressing well with patenting the watch in Paris).[50]

Keen to make up for any slight to Sir Constantijn's honour that Hooke's silence and his own slowness to respond might have caused, Oldenburg hastily republished the diagram and explanation of Huygens's watch in the March issue of the *Philosophical Transactions* of the Royal Society. He thereby, according to the conventions of the Society, also established the priority of Huygens's watch, since no comparable instrument had been recorded there before.

By now Christiaan Huygens regarded Oldenburg as a trusted ally in London, and proposed that Oldenburg apply for a patent for the watch

Christiaan Huygens's
balance-spring watch, as
illustrated in the
*Philosophical Transactions*
of the Royal Society in
March 1675.

on his own behalf, dividing any money that might be made as a result between himself and the Royal Society. Oldenburg began negotiations to establish such a patent.

Hooke learned of Huygens's claim to be the originator of the balance-spring watch a week after Huygens's second letter, and before the publication in *Philosophical Transactions*, while dining at Boyle's house.[51] The very next day he protested vigorously to the Royal Society (at a session at which Flamsteed and Newton both happened to be present), reminding the members that he had presented them with his own invention of a spring-regulated watch in the early 1660s, and declaring that Huygens's spring was 'not worth a farthing'.[52] Nevertheless, to his consternation, the Royal Society, encouraged by Oldenburg, seemed inclined to accept Huygens's claim to priority, and to be keen to pursue

the patent.[53] Hooke now realised the exposed position in which he found himself, and how convincing Huygens's case appeared. He blamed Oldenburg entirely.[54]

Ever since Oldenburg had taken upon himself the role of disseminator of the Royal Society's activities internationally, he had shown a tendency to whip up controversy between correspondents, to spice up exchanges of letters which would later find their way into his published *Philosophical Transactions*. His instinct was that of the adept publicist, and his interventions showed considerable journalistic flair. Their effect, however, on more than one occasion, was to antagonise correspondents needlessly, and on occasion artificially to create a dispute.[55]

A surviving letter from the French virtuoso Adrien Auzout to Hooke, for instance, sent to Oldenburg to be passed to Hooke, carries marginal notes in Oldenburg's hand for Hooke's perusal. Against a contentious point, Oldenburg has scribbled: 'What say you to this?' Further down he goads Hooke: 'A handsom sting again will be necessary.'[56] The argumentative Hooke needed little incitement to launch an attack on an unsuspecting 'adversary' – Oldenburg knew exactly how to provoke him.

By mid-1675, Oldenburg was, indeed, busily orchestrating Huygens's end of the correspondence with London, to give him the tactical advantage in the matter of competing claims between Huygens and Hooke for an English patent for their spring-regulated timekeeper. Every time Hooke responded to Huygens's latest communication at a Society meeting, Oldenburg relayed his comments to Huygens. When Hooke complained of this, and accused Oldenburg of 'spying' on his watch and passing classified information to Paris, Oldenburg advised Huygens on letters he should send (and to whom), and on forms of argument he might profitably use to establish his claim. He urged him to get a working model of his watch to London as soon as possible for trials. In effect he orchestrated Huygens's bid:

> I know Mr. Dominique very well indeed, and I am convinced that he will take care of your watch, which we very much wish to see here. . . . I should, however, like you to write three lines to Lord Brouncker to point out to him that you knew nothing of Mr. Hooke's invention before you sent the anagram, which you said contained a new invention for clocks; to which you

might, if you please, add that the person who was the first to apply the pendulum to clocks, and discovered the cycloidal figure to regulate the vibrations [that is, Huygens], could easily devise some means of replacing the pendulum by a suitable spring.[57]

Oldenburg's habit of characterising Hooke in this correspondence as of a difficult temperament – 'a man of unusual humour' – probably helped to undermine him in the eyes of the Huygenses, and encouraged Christiaan Huygens to pursue his claim more aggressively:

> As for Mr. Hooke he is a man of unusual humour . . . I wish with all my heart that everyone might receive his due, and that the petty jealousies [*jalousies*] of fine minds [*Esprits*] ought not be allowed to terminate their friendships, or the commerce between them which contributes so greatly to the growth of the arts and sciences.[58]

Even when he appeared to express reluctant admiration for Hooke, Oldenburg managed to belittle him:

> [Hooke] is a man of an entirely unique humour, which must be tolerated with so much the more patience, because he has an extraordinarily fertile mind [*esprit*] when it comes to new inventions. 'There can be no great wit [*ingenium*] without [some portion of madness]'.[59]

Oldenburg's well-orchestrated patent application on Huygens's behalf seemed to be going well. The patent document itself was drafted and ready for signature, when the Surveyor-General of the Ordnance Office, Sir Jonas Moore, stepped in on Hooke's side.[60] During April and May 1675, Moore took up Hooke's case, and advised him closely on how to proceed with his own counter-claim for a patent.

Hooke had prudently been hard at work with the London watch-maker Thomas Tompion on an improved, working spring-balance watch of his own, ever since he had got wind of Huygens's 'eureka' discover. On 7 April, Moore arranged for Hooke and Tompion to present this prototype watch to the King himself; it was delivered in early May, inscribed somewhat presumptuously 'Hooke invenit 1658. Tompion fecit 1675' ('Invented by Hooke in 1658; made by Tompion in 1675'). Hooke recorded in his diary: 'With the King and shewd him my new spring

watch, Sir J. More and Tompion there. The King most graciously pleasd with it and commended it far beyond Zulichems [Huygens's]. He promised me a patent and commanded me to prosecute the degree. Sir J. More begged for Tompion.'[61]

Over the following months the King personally 'tested' the Hooke–Tompion watch – reporting on its accuracy, returning it for modification (there seem to have been several models) and correction (when Charles reported the watch ran slow). In between times the King entered into the spirit of Hooke's conspiracy theory by keeping it 'locked up in his closet'. Oldenburg complained in a letter to Huygens in June that Hooke's watch 'is still hidden from us, only the King has seen it, and he refuses to make it public until the matter of the patent is settled'.[62] Meanwhile, in a symmetrical move, Huygens was being pressured by Oldenburg to send over a prototype of his watch for Brouncker to 'try'. It was a long time coming, and did not run well when it did finally arrive in late June. Moore reported to Hooke that it 'wanted minutes and seconds' (had neither minute hand nor second hand).[63]

As the person in charge of all military research and development in England, Moore had a vested interest in ensuring that Hooke's working prototype watch be available for trial, rather than that being designed and constructed across the English Channel, by a Dutchman resident in Paris. His considerable confidence in Hooke's instrument-building competence was based on close observation of his work during the building of the Greenwich Royal Observatory – also a military-backed project, in which Hooke had played a major role.[64] With Moore's powerful backing, Hooke was very nearly successful in obtaining his patent.

The affair, however, left lasting scars on Hooke's professional reputation. His counter-productive strategy of bombarding the press with repudiations of his opponent confirmed a version of his personality as boastful and arrogant. Yet his diary reveals him as hurt and angry at the apparent ease with which the Royal Society abandoned his cause. At the height of his fame, Robert Hooke managed by sheer force of personality to distract his admirers from his unprepossessing appearance, his slight build and bent back. In the dispute with Huygens, there was no avoiding the suspicion that Christiaan Huygens's good looks and aristocratic connections made him a more appealing figure to champion.[65]

*　　*　　*

With hindsight, it was almost inevitable that there would be a price to pay for Hooke's ambition to manage what was effectively two entirely separate careers simultaneously during the years following the Great Fire. It was during the latter half of the 1660s that Oldenburg and Moray independently undermined the advantage Hooke should have gained with his remarkable early work in instrument design and manufacture.[66]

While Hooke was out of London during the plague interruption of 1665–6, Moray and Oldenburg were both corresponding with Huygens in terms which could be regarded as giving away developmental secrets concerning Hooke's watches. When Hooke was going through Oldenburg's papers following his death in 1677, he 'found 2 letters of Sir R. Moray to Hugens about my watches.'[67] Moray had indeed, as Hooke must have realised, described modifications Hooke was making which – transmitted to a specialist in the same field – gave away too much. Responding to one such letter, in September 1665, Huygens shows clearly that he has grasped the significance of Hooke's substitution of an isochronous spring for the time-regulating pendulum:

> Concerning Hooke's idea, which you have been so good as to share with me, of applying a spring in place of a pendulum in clocks, I should tell you that in Paris the Duc of Roanais spoke of the very same thing in 1660, and even took me to meet the clockmaker to whom Mr Pascal had communicated this invention, on condition, however – sworn before a notary – that he would not reveal it, nor claim it for himself.[68]

From the detailed arguments for and against spring-regulators which follows, it is clear that this is a line of research Huygens himself has subsequently pursued. Hence the sensitivity of Moray's detailed report on Hooke's related experiments.

In a letter written shortly afterwards, Moray again betrays confidences by indicating that the context for Hooke's exploration of the potential for substituting a spring-regulator for a pendulum is that of determining longitude at sea. Huygen's pendulum clock had produced mixed results in sea-trials carried out between 1662 and 1664:

> It is now a good three years since Mr Hooke spoke to me about an invention of his for measuring time at sea more accurately than pendulum clocks could do – indeed, as well as the latter

# LECTURES
## De Potentia Reſtitutiva,
### OR OF
# SPRING
Explaining the Power of Springing Bodies.

To which are added ſome

# COLLECTIONS

*Viz.*

A Deſcription of Dr.Pappins *Wind-Fountain and Force-Pump.*
Mr.Young's *Obſervation concerning natural Fountains.*
Some other *Conſiderations concerning that Subject.*
Captain Sturmy's *remarks of a Subterraneous Cave and Ciſtern.*
Mr.G.T. *Obſervations made on the Pike of Teneriſſ, 1674.*
Some Reflections and Conjectures occaſioned thereupon.
A Relation of *a late Eruption in the Iſle of* Palma.

By *ROBERT HOOKE,* S.R.S.

LONDON,
Printed for *John Martyn* Printer to the *Royal Society,*
at the Bell in St. *Pauls* Church-Yard, 1678.

(*Top*) Detail from the diary with drawings of spring experiments.
(*Left*) Title-page of Hooke's Lectures 'Of Spring', which brought together results of experiments he had conducted in the course of his priority contest with Christiaan Huygens for the balance-spring watch.
(*Opposite*) Page from Hooke's diary for late August 1675, with entries recording on-going trials for his balance-spring watch, which the King himself was testing.

can do on land. But having been persuaded then that he could derive substantial profit from it, he was prudent enough to conceal from everybody the nature of his invention. . . . I have to tell you that when Mr Hook finally revealed his invention to us, he told us that he had more than 20 different ways of applying springs to clocks in place of the balance or a pendulum. He told us about 3 or 4 of them.[69]

Even so, Hooke seems to have found Oldenburg's 'betrayal' far harder to take than Moray's loose talk. Oldenburg too was communicating regularly with Huygens during the autumn and winter of 1665, a period when Hooke was fully occupied pursuing Royal Society-related experimenting at Epsom, to the point that his own watch researches had to be put to one side.[70] Far more damagingly, in keeping the official Royal Society records which were increasingly used to validate priority claims, Oldenburg had apparently deliberately left off the record several occasions on which Hooke had produced balance-spring watches for inspection by the Society.

There was, for example, no record of one such occasion, in February 1668, when Hooke later insisted he had produced and demonstrated a spring-regulated pocket watch. Yet the testimony of an Italian visitor, Lorenzo Magalotti, who was present, does indeed record such an event, suggesting if not the 'jealous omission' Hooke accused Oldenburg of, then at least an oversight on his part. Magalotti records:

We also saw a pocket watch with a new pendulum invention. You might call it a bridle, the time being regulated by a little spring of tempered wire which at one end is attached to the balance-wheel, and at the other to the body of the watch. This works in such a way that if the movements of the balance-wheel are unequal, and if some irregularity of the toothed movement tends to increase the inequality, the wire keeps it in check, obliging it always to make the same journey.[71]

Without the official minute, there was only Hooke's word against Huygens's. Maliciously or otherwise, Oldenburg had prevented the strongest possible case being made by Hooke.[72]

*    *    *

If Hooke blamed Oldenburg, Christiaan Huygens became, in the course of 1675, more strongly incensed against Hooke, and his attempts at self-justification contained increasingly virulent personal attacks against the Royal Society's Curator. He clearly felt that Hooke was being unnecessarily obstructive and vindictive in attempting to thwart Huygens's attempt to secure official backing for his watch in England, from which much-needed financial benefit might derive for the Royal Society.[73]

It did not help that he found himself similarly beleaguered in Paris. Following the announcement of his discovery in the issue of the *Journal des sçavans* of 15 February, Jean de Hauteville began a lawsuit against him, claiming that he had produced and submitted a similar watch which Huygens had seen at the Académie the previous year. Although the details were different, the principle, he alleged, was the same: '*Difficile est invenire, facile autem inventis addere*' ('It is difficult to have a groundbreaking idea, but easy to modify it slightly subsequently'). This was the same objection that had been lodged against Hooke's first attempt at filing a patent around 1660.[74] Although Hauteville lost his case, the idea that someone else had had the idea for the original balance spring-regulator and that he, Huygens, had merely modified it slightly, continued to rankle.[75]

Meanwhile, Hooke had accused Huygens's go-between Oldenburg, in print, of 'spying' on Huygens's behalf – a claim which infuriated Oldenburg (who had in fact been briefly imprisoned in the Tower in 1667 on charges of being an enemy alien and a spy). In private correspondence with friends at the time, Hooke was yet more candid in his conviction that Oldenburg was a downright villain. In August 1675 he railed to Aubrey:

> I drive much at setting up a select clubb, whether 'twill take I know not, As we are, we are too much enslaved to a forreine Spye and think of nothing but that, and while 'tis soe I will not doe any towards it. I have many things which I watch for an opportunity of Publishing but not by the Royal Society. Oldenburg his snares I will avoyd if I can.[76]

Indignantly protesting his innocence, Oldenburg's advice to Huygens became increasingly focused on getting even with Hooke:

After having written this, I was sent a piece of Mr Hooke's (you will find here together with my *Transactions*) concerning helioscopes and some other instruments, with a pretty inflated promise of several other grand things and inventions. You will see in his postscript what he says about you, and of the present watches, and also of the circular pendulum. He has mixed in several slanders of me, having called me your spy [*votre Espion*] and accused me of having defrauded him of the profit of his invention in respect of the watch under dispute; but he decided, because of the remonstrance made to him thereon, to withdraw and expunge these gross calumnies, although he has still left in certain words which can still suggest to attentive readers that I had secretly communicated his method of clocks to you. About that, Sir, you can take what measures you judge proper; I only beg you to pay attention both to my innocence and my peace, by making no mention, either in public or private, of what I have told you about the retraction which this man has been obliged to make of the calumnies he had sown against me. Only you may assert on your honour, that I never communicated anything to you of that invention, which he accuses me of, nor of any other, until after it had become publicly known.[77]

At the end, Oldenburg adds a conspiratorial postscript: 'But not a word must be said of all this; it is only to forestall blame which, without it, you might throw on our President, and the printer. Burn this paper, I beg.'

Hooke's printed self-vindication, inserted at the end of his *Helioscopes* volume, was indeed unequivocal in its rejection of Christiaan's claim to have anticipated Hooke's development of an effective balance-spring regulator. It was bound to offend all concerned, including both Oldenburg and the Huygenses. By now Huygens senior had withdrawn from the controversy, confidently leaving Oldenburg to manage Christiaan's defence in London. Christiaan, well and truly stung by Oldenburg's latest inflammatory missive, replied within the week:

I was astonished at what you have brought to my attention concerning the uncalled for [*insolite*] accusation which Mr Hooke has contrived against us both. I had certainly noticed that for some time he had become vain and extravagant, but I

did not know that he was malicious and impudent to the point that I now see to be the case.[78]

He enclosed a copy of the formal letter he had written directly to Brouncker, defending the 'honour' both of himself and of Oldenburg:

> I take the liberty of writing these lines to you, having been forced to do so by the concern I have for the honour of Mr. Oldenburg, and for my own, because I have learned that both have been attacked by the calumnies of Mr. Hooke, on the subject of new watches, of which he pretends to be the inventor. He is presumptuous enough to say that Mr Oldenburg had revealed the secret of his watches to me, and that it is as a recompense for this, and because he acted as a spy for me inside the Royal Society, that I have ceded to him my rights to ask for a patent for that invention in England.[79]

The quarrel which had begun as a matter of wounded Dutch dignity, and developed into an international priority-dispute, ended with the Royal Society formally repudiating Hooke, and conceding that he had behaved dishonourably towards a 'man of some standing'.

It was the Royal Society, in the end, which once again let Hooke down. The technical details which would have decided the feasibility of Hooke's watch as a precision instrument – surely the information on which any Society decision to support his claim should have rested – had been, in the end, entirely overshadowed by Oldenburg's appeals on behalf of his honour. In November 1676 the Council approved a statement to be published in the *Philosophical Transactions* (of which, of course, Oldenburg was the editor) commending Oldenburg's fidelity and honesty 'in the management of the intelligence of the Royal Society', and publicly rejecting Hooke's version of events. The moral victory however was Hooke's: 'May 20, 1677. Oldenburg fled at my sight,' Hooke noted in his diary. But from Hooke's diary it is also clear that he was profoundly disturbed and distressed by the affair. When passions were at their height he resolved to leave the Royal Society. He recorded in his diary: 'Saw the Lying Dog Oldenburg's transactions. Resolved to quit all employments and to seek my health.'[80]

He kept any subsequent modifications he made to his watch to himself.

\*    \*    \*

In spite of Huygens's outraged protestations, there had been calumny in the 1660s, Hooke had – deliberately or inadvertently – been wronged, and Oldenburg undoubtedly knew it. In the pantomime finale to this controversy, Christiaan Huygens managed to reap the full benefit of the elaborate parade of hurt pride with which the exchange of letters between the Dutch virtuosi and the London scientific community had begun. Hooke had been made to look provincial and small-minded, though he almost certainly had some right on his side. The Huygenses honour was satisfied, but relations between Hooke, Oldenburg and Brouncker were soured for ever.[81]

From the moment it became clear that casual gossip in the 1660s had cost Hooke his priority claim, and that, furthermore, Oldenburg and the Royal Society were more concerned to protect their reputation than to make amends, Hooke, together with a small, close-knit group of friends, began to discuss the possibility of getting Lord Brouncker to stand down, and replacing Oldenburg as Secretary.

In December 1675, a 'plot' was hatched, to re-establish the Royal Society as a 'club' which conformed more closely to its original intellectual ambitions. The first evidence is to be found in Hooke's diary for the period. On 10 December 1675 he notes: 'Agreed upon a new clubb to meet at Joes [coffee house]. Mr. Hill, Mr. Lodowick, Mr. Aubrey and I and to joyn to us Sir Jonas More, Mr. Wild, Mr. Hoskins.' By 1 January 1676 there were regular meetings at Wren's house, where new formal practices of delivering and recording information were observed: 'With Wild and Hill to Wren's house. We now began our New Philosophicall Clubb and Resolvd upon Ingaging ourselves not to speak of any thing that was then reveald *sub sigillo* to any one nor to declare that we had such a meeting at all.'

Plans to take control of the Society were discussed at a sequence of meetings held at Wren's official lodgings at Whitehall – details of which were recorded meticulously in Hooke's diary, since Hooke, inevitably, was prime mover in the whole affair. 'Began new Journall of Club,' he wrote on 2 January 1676; and two weeks later: 'Club at Wren's', 'Henshaw, Holder, Aubrey, Hooke at Wren's'.[82]

Then, in September 1677, Henry Oldenburg died. His old employer, Robert Boyle, felt his loss keenly. Boyle's sister, Lady Ranelagh, wrote to him:

I can't, My Brother, but condole with you the remove of our true honest ingenious friends in their severall ways Dr. Worsley & Mr. Oldenburg since it has pleased god to call them hence soe soone one after another. Yet I am not without my feares that my mentioning of them may revive to your good nature the sorow that I assure my selfe you received the news of their deaths with. . . . They each of them in their way diligently served their generation & were friends to us. they have left noe blot upon their memorys (unless their not haveing died rich may goe for one).[83]

Hooke was glad to see the back of him. As far as he was concerned, Oldenburg – another foreigner – was a turncoat and a spy, responsible for divulging key details of his watch mechanisms to Christiaan Huygens, allowing Huygens to steal a march in the race to design a precision timekeeper suitable for astronomers and navigators. Both men had, too, been in competition for Boyle's admiration and affection.

Once again, Hooke's robust antipathy for Oldenburg caused him professional problems he could probably have avoided. In the end, both men had been committed to establishing a great London institution for the promotion of knowledge, and both had played their part in the success of the early Royal Society. However much justification there was for Hooke's belief that Oldenburg had been instrumental in losing him a patent on his balance-spring watch, it was the correspondence Oldenburg assiduously kept up with virtuosi across Europe and beyond which ensured that the reputation of the Royal Society remained high, even at times when day to day the Society was barely functioning, as in the mid-1670s. It was he who had thereby orchestrated its image and prestige with the international community – it hardly mattered if groundbreaking experiments were taking place at Royal Society meetings, or if they were responsible for major scientific advances, as long as Oldenburg's letters kept going the belief that they were.

On 20 September 1677, less than three weeks after Oldenburg's death Hooke was 'with Mr. Evelin [Evelyn] at Sir Christopher Wrens', discussing who should be put up as Secretary to replace Oldenburg. In the meantime, it had been agreed that Hooke would be acting Secretary, without remuneration – an arrangement which was concluded the day after the death of someone much closer to Hooke, that of his boy lodger

Tom Gyles. In his diary, Hooke ran the two events together, the pain of the one probably intensifying the tone of irritation over the other:

> Mrs. Kedges in Silver street to acquaint Hanna Gyles of Toms Death.... Putt things in order for funerall, then to Councell at the repository, they accepted of me for Secretary pro tempore to write the Journalls without reward.... Tom buried in St. Hallows church yard at 7 post prandium, attended by 50 at Least.

On 10 October, Hooke and Wren discussed the possibility of Wren's standing for President, and the following day they successfully proposed the nomination to the other members of the 'new club'. By November, however, it was clear that there was not enough support for Wren's candidacy, and the club agreed, instead, to support the nomination of Sir Joseph Williamson.[84] Williamson was duly elected President, and nominated Wren as his Vice-President.

Sir Joseph Williamson came, significantly, from the City side of Hooke's life, professionally and socially. During his Presidency, and those of Hooke's close friends Wren and Hoskins that followed, Hooke retained a status in the Society's administration, based on his past history within the Society and his present City connections, which was disproportionate to the diminished effort he was by this time prepared to make in pursuing the Society's business.

In 1678 and 1679, Hooke attempted to undertake the huge burden of correspondence work which Oldenburg had for so long carried out for the Society, in addition to his own work of organising and conducting experiments at meetings. From 1679 to 1682 he published his *Philosophical Collections* as a record of the Society's activities, on the model of Oldenburg's *Philosophical Transactions*. As if this double burden were not enough, at a time when Hooke was also heavily committed on architectural projects, many of them necessitating weekly site-visits and meetings, from 1678 to 1680 he collaborated with the publisher Moses Pitt in producing a lavish atlas, designed to be bought by a public increasingly interested in foreign travel.[85] In 1680, his attempt to force Sir John Cutler to pay his arrears on his Cutlerian lectureship reached a crisis; in the early 1680s both Hooke's diary and his letters record an increasing burden of troublesome legal business, 'which took up most of my Leasure time'.[86]

In December 1679 the duty of looking after the Society's correspondence was removed from Hooke – he recorded his dismay at the public humiliation in his diary. Thomas Gale, who had for some time been assisting him, took over. Then, in 1682, there were evidently further complaints from members, this time about Hooke's performance of his more general Secretarial duties. On 30 November 1682 Hooke was 'more or less given the sack'.[87] He was replaced as Secretary by Robert Plot, and was not re-elected to the Council for 1682–3.

The Secretary's job was not one Hooke was equipped to carry out, in spite of his own considerable command of languages. He was not the correspondent Oldenburg had been, nor did he pursue any task as conscientiously over long periods of time as Oldenburg had the network of contacts and sequence of international publications he had masterminded since the Royal Society's inception. Although a significant number of members of the Society had been sympathetic to Hooke over his treatment by Huygens, that sympathy rapidly cooled as the affairs of the Society fell into disarray.

Taking charge of the rudderless Royal Society was, however, a matter of honour for Hooke. He believed it had strayed a long way from its original charter because of Oldenburg, and that he would be able to return it to its original agenda. By now, though, it was actually probably beyond the skill of one individual, however committed and talented, to do this. Hooke, in any case, was no longer the man for the job.[88]

6

_____

## Never at Rest

Whereas the Publisher of the Philosophical Transactions hath
made complaint to the Council of the Royal Society of some
Passages in a late Book of Mr. Hooke, entituled *Lampas*, &c.
and printed by the Printer of the said Society, reflecting on
the integrity and faithfulness of the said Publisher in his man-
agement of the Intelligence of the said Society: This Council
hath thought fit to declare in the behalfe of the Publisher
aforesaid, That they knew nothing of the Publication of the
said Book.

*Philosophical Transactions* (October–November 1676)[1]

In the end, neither Hooke nor Huygens was awarded a London patent
for the balance-spring regulator, although both continued developing
their prototype watches for many years. The inconclusive outcome of the
race to perfect an accurate portable timekeeper permanently damaged
Hooke's relations with the Council of the Royal Society, while the suc-
cession of vindications he inserted into his publications on other topics
over these years left a lasting impression of him as obdurate and intran-
sigent.[2]

The affair also took its toll on his co-claimant. In 1676 Christiaan
Huygens succumbed to a bout of depression whose gravity gave his
father serious cause for concern, and which eventually damaged his
career prospects in Paris.[3] On 20 February 1676, Sir Constantijn wrote
to a Dutch friend complaining about 'the melancholic sickness from

which my precious son in Paris has for some time been suffering'. A week later he wrote:

> I do not know what I am supposed to think about this illness. He has no fever, and the medical men assure me that I need fear nothing grave. But the illness is deeply rooted, let us hope that it is not the 'rats sickness' [*maladie des rats*]. One of his brothers-in-law, always merry and full of entertaining funny stories will go and stay with him. If anyone in the world can give him back his zest for life, it is him.[4]

The diagnosis was an acute case of melancholy – '*melancholia hypochondrica vera et mera*' ('hypochondriacal melancholy, true and simple').[5]

Hooke too had a tendency to depression. Like Christiaan Huygens, he tended to succumb after a series of setbacks – either failed outcomes of experiments or challenges to his work by scientific competitors. Small setbacks were sometimes enough to bring on an attack. On one occasion Hooke was waylaid in the street and 'scuffled with a Rogue that kickd me in the shins and brak them'. Although the attack was not serious, he noted in his diary that it induced 'a great fit of melancholy'.[6]

But in Hooke's case, he was rarely entirely incapacitated by his chronic low spirits. Instead, by the 1670s, he had developed a sophisticated system of mood and pain 'management', or symptom control, through a regimen of regular drug-taking, a habit he had probably learned from the notoriously hypochondriac Boyle during the years he was in Boyle's service.[7] This was in spite of the fact that both William Petty and John Beale warned Boyle against self-administered remedies, on the ground that intellectuals were particularly prone to imaginary illnesses:

> Dr Wedderburne gave mee this Medicall Counsayle (wrote Beale to Boyle in 1663) That I should not be sicke before I was sicke, Noteing the puling spirits of some, & generally of Scholars, who doe allwayes phantsy themselves to be sicke, or sickly, & by phantsye & frequent medicines doe make themselves sick indeede.[8]

'I was not so much guilty of it', continued Beale, 'For I never tooke vomit yet, Nor ever tooke a purge, or opened a veine, till I fell into a

burning feaver.' Hooke, on the other hand, took 'vomits' and purgatives on an almost daily basis.

One of Hooke's tried and tested remedies, which he took regularly, over long periods, was sal ammoniac (ammonium chloride). This was a popular medical preparation at the time, and one which Boyle also favoured. A 1666 manuscript of 'authentic rules for preparing spaguricall medicaments' (compiled by Sarah Horsington, a friend of Lady Ranelagh) includes a recipe for 'making Sal Ammoniac according to Robert Boyle'.[9] It goes on to specify the 'singular good' of inhaled sal ammoniac 'for giddyness of the head & in violent Headaches, & in epileptick fits' (Hooke suffered constantly from giddyiness and headaches). Such inhalations, the compiler continues, may have an effect on 'obstinate griefe & Melancholy', where 'there is that alteration made in the disposition of the heart, & perhaps some other parts by which the blood is to circulate that the lively motion of that liquor is thereby disturb'd and obstructions and other not easily remov'd distempers are occasioned'. Hooke took sal ammoniac for its mild purgative properties – Sarah Horsington notes that taken 'in a cup of beere or any convenient vehicle first, & last, it provokes urine'.[10]

Hooke's drug-taking was also a response to the pressure under which he was forced to work because of the demands made on him by his various clients, employers and patrons. Over time it must have contributed to the personality traits on which Oldenburg and others comment. By the 1670s, according to them, Hooke was a difficult character, who suffered from unpredictable mood-swings and irritability, and who was congenitally suspicious, and prone to anxiety attacks (particularly when he felt others threatened to 'steal' his ideas). Although the diagnosis was unknown in the period, this suggests that he had become addicted to his pain-killers and digestion-managers. He, on the other hand, considered the side-effects of his drugs to be themselves symptoms of disease, and dosed himself with renewed vigour when they occurred. Sal ammoniac 'has a specific effect on mucous membranes as the elimination of the drug takes place largely through the lungs, where it aids in loosening bronchial secretions'. Hooke complained constantly of excessive mucus, and dosed himself to try to control this 'symptom'.

Drug-taking was a response to the lifestyle Hooke had developed during the first decade of the Restoration. The nature of the programme of day-to-day work Hooke had set himself by the 1670s was a

demanding one for any person to undertake, in any historical period. For a man working not much more than fifty years after the founding father of the modern experimental scientific tradition, Sir Francis Bacon – gentleman-amateur, conducting his scientific activities in the slow-paced *otium* of enforced retirement – the fiercely driven practical and mental life he chose to lead was unusual, if not unique. To cope with the pressures and stress, Hooke developed a rigorously compartmentalised fashion of conducting all his business in everything he did, from salaried tasks to personal friendships, recording the details necessary to keep track of each commitment succinctly in his diary.

Under that same pressure he also became a habitual, systematic consumer of a wide range of more or less toxic pharmaceutical 'remedies', which produced as many unpleasant symptoms as they cured, and which ultimately accelerated his physical decline. In his prime, Hooke was a man of boundless energy, enthusiasm and intellectual verve, a popular, gregarious frequenter of dinner tables and coffee houses; in later years, however, he was an irritable, emaciated, physical wreck, 'nothing but Skin and Bone, with a meagre Aspect' (to quote Waller again). Long before any understanding of addiction, toxic build-up in the system and alarming side-effects, Hooke's ruthless management of his own medical symptoms, obtaining drugs, determining doses by trial and error, and switching remedies on the advice of a whole panoply of more or less expert physician friends ultimately ruined his health.

The evidence for this is to be found liberally scattered through the entries in Hooke's diaries, covering significant parts of the 1670s, 1680s and 1690s. Incomplete diaries survive for two periods of Hooke's life.[11] The first, and most complete, covers the period 1672 to 1683. The second begins shortly before the arrival in England of William of Orange, and the Glorious Revolution of November 1688, and continues until August 1693.[12] The earlier diary, in particular, closely corresponds to the kind of record needed to keep track of the detailed demands of the various distinct activities with which Hooke was involved – by the 1670s he had added the gruelling work as London City Surveyor to his already packed schedule, and was the salaried 'first officer' in Wren's thriving architectural firm.[13]

*Overleaf* Hooke's diary for July and August 1678, showing the range of his activities day by day, from taking tobacco at Jonathan's coffee-house, to experiments with weights and springs.

A typical run of entries from the diary is that for the first five days of September 1672:[14]

(1) Drank Steel [therapeutic solution containing iron].[15] benummd my head, somewhat hotter all day. Eat milk. Saw Mr. Wild at Garways [coffee house]. Calculated length of glasses [lenses for telescopes/microscopes]. Mr. Moor here [Jonas Moore, later financial backer of the Greenwich Observatory]. I invented an easy way for a musick cylinder with pewter tipes pinched between cylindrick rings. Slept ill all night and observed Mars with speculum [telescope], but not so good.

(2) Grace [Hooke's niece and lodger][16] went to school after dinner. At Mr. Hauxes [Haak]. Home. At Dr. Goddards tastd tincture of wormwood not spirit of wormwood [unfermented absinthe]. Made instrument for [viewing the] eclipse of starrs by the Moon. Eat raw milk, wrapd head warm and slept well after.

(3) At Skinners Hall, Cotton. Guildhall, Youngs subpoena. Certificat at Fleet ditch next Boucheret 10sh. and 10sh. of Sir W. Humble and Lady Hoskins [surveying activities, and payment for them by clients], Pauls churchyard, Mr. Godfrys. Controuler at Guildhall. Towne clarke and Mr. Rawlins about stable [at Gresham, which Hooke was allowed to let for additional income]. Bought of Mr. Collins 5sh. farthings. Dr. Wrens, Garways, eat boyld milk. Slept pretty well, [orgasm]. took [ii oz.] of infusion of Crocus metallicus [iron oxide], vomited.

(4) B. Bradshaw [diagnosed with] small pox. Purged 7 times [still the effect of the crocus metallicus]. eat dinner well. Disorderd somewhat by physick, urine had a cloudy sediment, but brake not. Slept pretty well.

(5) At Guildhall, Sir J. Laurence, Sir Th. Player. Home all afternoon. Mr. Haux. Drank ale, eat eggs and milk, slept very little and very disturbed.[17]

These entries keep a continuous record of a number of distinct areas of Hooke's energetic activities: scientific experimentation (here, largely

astronomical, including both manufacture of instruments and observa-
tion); City meetings, professional surveying activities and other duties
associated with the rebuilding of London after the Great Fire; and a
regimen of diet and dosing, designed to address specific symptoms of
personal ailments, as well as to alleviate stress and counteract stress-
related insomnia.[18] The first two tend to corroborate information, or
supply additional detail, to materials to be found elsewhere – either
in the Guildhall records or among the Wren, Royal Society and other
professional papers. The third activity, however, is exclusive to the diary,
although its detail corresponds closely to other equivalent evidence to
be found in the writings and correspondence of those associated with
Hooke.[19] Robert Boyle's correspondence, in particular, contains frequent
reference to pharmaceutical preparations requested by him, and supplied
to him by physician friends.

Even these short extracts make it plain that Hooke was a chronic
insomniac and that, whatever other medical symptoms he was
attempting to deal with, his vigilance concerning his diet and dosing
were tied up, in particular, with acute anxiety about getting a good
night's sleep. Most of the substances he took to produce drowsiness
were opium-based – either dilute as 'poppy water', made into a 'syrup'
(one of Goddard's specialties), or mixed with other palliatives, like
'conserve of roses'.

We also get the sense – confirmed by the diary as a whole – that
Hooke's physic-taking was regular and habitual; he dosed regularly to
make himself feel better, rather than to treat specific sicknesses.[20] Indeed,
during the entire period of the diary, Hooke appears to have succumbed
to only one bout of what we would call serious illness (brought on
by depression, following the death of a dear friend), recording, rather,
and treating annoying symptoms such as giddiness, headaches, clouded
vision and palpitations, all of which may have been side-effects of the
preparations he was consuming.[21]

The further symptoms for which Hooke dosed himself were ones
which we might plausibly associate with the hectic intellectual and pro-
fessional life we have scrutinised in some detail in chapter 3: insomnia,
headaches, dizziness, panic attacks and problems with his eyes. His
attempts at 'cures' for these persistent ailments involved several strat-
egies. He took advice from coffee-house friends and acquaintances,
many of whom were themselves regular consumers of remedies of all

Drawer of medical samples, including pills, ointments and suppositories, from the seventeenth-century cabinet belonging to the first Professor of Chemistry at the University of Cambridge, John Francis Vigani. Hooke habitually took preparations like these for his various symptoms.

kinds. He was an adventurous experimenter with new substances as they became available. He bought and consumed all kinds of patent 'waters' and cordials of dubious therapeutic value.

Sometimes he consulted medical friends, and dosed himself with medicinal remedies they prescribed and supplied. The 'steel' (solution of iron) which Hooke took at the beginning of September 1672, for instance, had been prescribed for him by Dr Jonathan Goddard, Gresham Professor, Fellow of the Royal Society, colleague and companion, a month earlier. Before that, he had been taking a daily dose of a substance containing iron and mercury.[22] On another occasion he and Goddard together sampled 'tincture of wormwood' (absinthe before fermentation). In December 1672 Hooke 'transcribed Dr. Godderd['s

recipe for a] clyster' – on this occasion he apparently made up and administered the enema himself.

Boyle may have taught Hooke how to sublime sal ammoniac (or may have supplied it himself); it was Goddard, however, who regularly supplied Hooke with his laudanum (liquid opium)[23] – one of Hooke's habitual remedies for stress and sleeplessness. Evidently dosing with laudanum could be a social event too, since sometimes Hooke's friends were present during his physic-taking:

> [October 1672] (25) Dined Home. Mr. Haux, Dr. Grew, Mr. Hill, Lord Brounker, Dr. Godderd, here, made [mercury] with a brass hole stand 3 inches and better. Dr. Godderd presented Mr. Gunters picture. Lord Brounker, Mr. Colwall and Dr. Godderd promisd theirs. The last time of meeting at my lodgings. Took conserves and flowers of [sulphur] after which I slept well, but had a bloody dysentry the next day (26) soe that I swouned and was violently griped, but I judge it did me good for my Rhume. About 6 at night I eat chicken broth and milk thicked with eggs and took conserve of Roses and Dr. Godderds Syrupe of poppys. Slept disturbedly but had no more griping. Mr. Haux, Mr. Blackburne, Mr. Mayer stayd with me in the afternoon.[24]

Inevitably, Hooke got conflicting advice from his medical friends. After a period of taking Dulwich waters (proprietary mineral waters), he was advised by Dr Whistler that serious illnesses had been contracted by some of those drinking them, and that 'spirit of sal ammoniack' was vastly preferable.[25] A couple of years later, when Hooke had largely moved on to other, newer pharmaceuticals like senna, Whistler's caution looked like wise advice when Hooke dosed himself (unsupervised) with Dulwich water which dramatically disagreed with him:

> Monday 1 June, 1674. – Drank whey, took in Dulwich water, 3d. Eat bread and butter. Subpoenad by carpenter and Andrewes. Wrote this account. Was very ill that day. Was at view at Pudding Lane. The vomit did me much harm. At the pillar at Fish Street Hill. It was above ground 210 steps. Dined Home. Received a letter from Sir J. Cutler.[26]

When he became more seriously debilitated by illness, Hooke consulted the same physicians more systematically, following closely the regimens

they prescribed. His diary documents one such incident in some detail.

In December 1672, following the death of Hooke's old mentor and close friend Bishop John Wilkins (Bishop of Chester, and original founder of the Royal Society), Hooke became deeply depressed and troubled with persistent giddiness.[27] He began by consulting three physician acquaintances, and an apothecary (who presumably supplied the preparations his doctors had prescribed):

> [8 December 1672] At home till 5. Well all day. taken at Garways with vertigo and vomiting. Dr. Ferwether, Dr. Godderd and Dr. King here. Took clyster and blister, wrought all night. Slept well. Mr. Whitchurch[28] here.[29]

Hooke's own view was that the giddiness was due to a combination of things he had eaten, and chill to the head caused by wearing a wig: 'going abroad found a great heavyness and guidiness in my eyes.... I guess of the guiddiness might proceed partly from drinking milk and posset drink and night and partly from coldness of perruck.' Ten days later, however, his symptoms were worse and he tried 'Dr. Godderd tincture of amber', after taking which he got a good night's sleep, though, having inadvertently sat that evening by a cheering fire, he maintained that 'Fire made guiddiness worse'. On the night of 19 December Hooke 'Slept very little, was very giddy all next day'. When he consulted Goddard again, the doctor suggested it was trouble with his eyes that were causing the problem. Hooke 'tryd spectacles, found them help sight'; that night he slept better, with a little help from tobacco.[30]

Over the holiday period, Hooke resorted to an intensive sequence of treatments, for which he now paid a succession of physicians, though he continued to add remedies suggested more informally by his friends.[31] The impression gained from his diary entries is of a man increasingly debilitated by his 'physic':

> (22) Mr. Gidly let me blood 7 ounces. Blood windy and melan-cholly, gave him ½ crown. Mr. Chamberlain here. the vertigo continued but upon snuffing ginger I was much relievd by blowing out of my nose a lump of thick gelly. Slept after it pretty well. went abroad (23) in the morn returnd home very guiddy. Refresht by eating Dinner, in the afternoon pretty well. Mr Lodowick, Lamot, chirurgeon, etc. here. Physitian ordered

20sh. Consulted Dr. Godderd, he advisd amber and ale with sage and rosemary, bubbels, caraways and nutmeg steepd and scurvy grasse.

(24) ... Dined Home very ill and giddy in the afternoon but pretty well before. I took a clyster [enema] after which working but once I was very ill and giddy. Slept little all night save a little next morn. The worst night I ever yet had, melancholy and giddy, shooting in left side of my head above ear.

(25) Christmas day. Slept from 7 to 10, rose pretty well, upon eating broth, very giddy. Mr. Godfry here but made noe effect. Eat plumb broth, went pretty well to bed but slept but little and mightily refresht upon cutting off my hair close to my head and supposed I had been perfectly cured but I was somewhat guiddy

(26) next day and tooke Dr. Godderds 3 pills [purgatives] which wrought 14 times towards latter end. I was again very giddy and more after eating, which continued till I had taken a nap for ½ howr about 5 when I was very melancholly but upon drinking ale strangly enlivend and refresht after which I slept pretty well and pleasantly. Dreamt of riding and eating cream.

(27) After I was up I was again guiddy and was so for most part of the day. Sir W. Jones Mr. Haux, Mr. Hill, Dr. Pope, Mr. Lamot, here. Borrowed Mr. Colwalls ale, agreed not, guiddy head, benummed and guiddy. made oyle of bitter almonds, put some in right ear. . . . Slept ill. (28) With Lamot at Lord Brounkers. Mr. Haux at home. At Guidlys I made an issue in my Pole [blood-letting]. Dr. Chamberlaine was here and directed. He made it with caustick, I gave him 5sh., he did not scarrify.[32]

(30) Slept somewhat better but sweat much, head somewhat easd but about noon I was again very giddy. . . . Dined Home. Mr. Haux, chess. very guiddy and eye distorted. About 9 at night Gidly applyd 2 cupping to my shoulders and scarrifyd whence came about 5 [ounces] of very serous blood. My head eased a little and I slept pretty well the following night without sweat or heat.

(31) Rose about 10, but guiddy. Eye much distorted (Dremt of a medicine of garlick and the night before I drempt of riding and of eating cream with Capt. Grant. . . . Drank a little sack and spirit of amber going to bed. Slept very little.[33]

Hooke's state of mind was clearly not helped by the fact that he kept unusually little company over this period, attended no Christmas dinner, and indeed apparently participated in no holiday festivities of any kind. Wilkin's death, and the mourning period which followed, may have been responsible for this. Hooke did not recover his health until the middle of January, and there is no indication that any of his medication, or the repeated blood-letting and cupping, did more than alleviate his symptoms (at the same time, they probably produced equally worrying side-effects).[34]

Hooke's medical treatment during this illness was in many ways uncharacteristically interventive (with professional medical men regularly in attendance), probably because he was in the grip of a real illness, rather than attending to persistent symptoms and minor ailments.[35] In general, his solitary self-dosing was carefully monitored by himself, the details of dosage and outcome scrupulously recorded in his diary. In 1672, he kept a similarly precise record of the treatment administered to the close friend, Bishop John Wilkins, whose death had sent Hooke into the depression and acute physical malaise just described.

On 16 November 1672, Hooke recorded in his diary that he had learned in conversation with Boyle and Wren that Wilkins was gravely ill 'of the stone', as it was thought. A team of Royal Society medical men prescribed remedies, including Hooke's Gresham colleague and personal physician Dr Goddard:

(16) Blackfryers, Bridewell, Dr. Wren, Mr. Boyle, Cox. Lord Chester [Wilkins] desperately ill of the stone, stoppage of urine 6 dayes. oyster shells 4 red hot quenched in cyder a quart and drank, advised by Glanvill. Another prescribed *flegma acidum succini rectificatum cum sale tartari* [acid precipitate of amber refined with salt of tartar]. Dr. Godderd advisd Blisters of cantharides [Spanish fly] applyd to the neck and feet or to the vains.[36]

The next day Hooke visited Wilkins, and found him somewhat better, but a day later, when Hooke visited again, he had taken a turn for the

worse, and early the following day a friend called at Hooke's residence at Gresham College to inform him that Wilkins had died. Hooke spent the remainder of the day in the company of other friends of Wilkins's, including Wren, and conversation turned repeatedly to alternative therapies which might have cured Wilkins of his kidney stones:

> (18) At Lord Chesters, he was desperately ill and his suppression continued. Bought a retort and separating glasse. Shortgrave, paid 7sh.

> (19) Mr. Lee here. Lord Bishop of Chester dyed about 9 in the morning of a suppression of urine. Dr. Wren here at Dionis Backchurch. Dind at the Bear in Birchen Lane with Dr. Wren, Controuler, Mr. Fitch. At Jonas Mores, sick, he was cured of a sciatica by fomenting the part for an hour with hot steames for one hour afterward chafing in oyles with a rubbing hand and heated firepans, which gave him a suddain ease. Sir Theodore Devaux told me of Sir Th. Meyerns cure of stone in kidneys by blowing up bladder with bellows etc.

On 20 November, however, Hooke was present at dinner with other Royal Society members when the doctor who had performed an autopsy on Wilkins's body arrived and reported that no sign of kidney stones had been found (like many other Fellows of the Royal Society Wilkins had made his body available for 'experiment' after death, to determine the cause of his fatal illness).

> (20) Dined Home with Mr. Hill to Arundell House [Royal Society meeting], Experiment of fire and air [using the Boyle vacuum-pump], Flamsteed's letter [read]. Supd at Kings head with Society. Dr. Needham brought in account of Lord Chesters having no stoppage in his uriters nor defect in his kidneys. There was only found 2 small stones in one kidney and some little gravell in one uriter but neither big enough to stop the water. Twas believed his opiates and some other medicines killd him, there being noe visible cause of his death, he died very quickly and with little pain, lament of all.[37]

Hooke and his medical colleagues administered highly toxic 'physic' to the body of their sick colleague, and watched for alleviating symptoms which did not come. Chemically, these acidic remedies could be thought

of as combining in the blood to dissolve the chalky solids of the stone. One of the phenomena whose greatly magnified image Hooke inspected, and reproduced in his *Micrographia*, was his own clouded urine – urine which contained, in suspension, a chalky substance, or 'gravel'. Hooke announced that close examination revealed this 'gravel' to be crystalline:

> I have often observ'd the Sand or Gravel of Urine, which seems to be a tartareous substance, generated out of a Saline and a terrestrial substance crystalliz'd together, in the form of Tartar, sometimes sticking to the sydes of the Urinal, but for the most part sinking to the bottom, and there lying in the form of coorse common Sand; these, through the Microscope, appear to be a company of small bodies, partly transparent, and partly opacous, some White, some Yellow, some Red, others of more brown and duskie colours.

Hooke found that the crystals could be made to dissolve again in 'Oyl of Vitriol [concentrated sulphuric acid], Spirit of Urine [impure aqueous ammonia, containing ammonium carbonate], and several other Saline menstruums'.[38] Might not this offer a remedy for that most widespread of seventeenth-century complaints, the 'stone', he suggested? What was required was a solvent for the crystals harboured by the blood, which could be injected directly into the bladder:

> How great an advantage it would be to such as are troubled with the Stone, to find some menstruum that might dissolve them without hurting the Bladder, is easily imagin'd, since some injections made of such bodies might likewise dissolve the stone, which seems much of the same nature.[39]

In *Micrographia*, Hooke went on to suggest that Wren's method for injecting liquids into the veins of animals (which Hooke hinted had been more widely tried than had been reported, by Boyle among others) might be adapted to introduce solvents into the bloodstream of those suffering from a variety of common ailments:

> Certainly, if this Principle were well consider'd, there might, besides the further improving of Bathing and Syringing into the veins, be thought on several ways, whereby several obstinate distempers of a humane body, such as the Gout, Dropsie, Stone, &c. might be master'd and expell'd.[40]

Hooke's illustration of 'gravel' in urine, Fig 2, microscopically enlarged, from *Micrographia*.

Failure of the treatment in Wilkins's case is explained, for Hooke, by the fact that the diagnosis on Wilkins's inability to pass urine was incorrect: there was no stoppage in his urethra. Far from curing the

condition, as Hooke laconically observes, it was the powerful toxins which probably proved fatal. The medical 'experiment' had failed, lending some irony to the report that as Wilkins lay dying, 'he said he was "ready for the Great Experiment"'.[41]

The Wilkins case shows that dosing with what seem to us far-fetched (and potentially damaging) remedies was carefully consistent with current experimental scientific views, as described, for instance, in Hooke's analysis of chemical solvents for the chalky precipitate in blood.

Similar attempts at observing dose and outcome in the physic-taking of distinguished friends and colleagues, and relating them as cause and effect, are recorded elsewhere in Hooke's diary – with sometimes tragic, sometimes less drastic outcomes:

4 July 1673: This evening Sir R. Moray died suddenly being choked with flegme in indeavouring to vomit. he had Dind at Lord Chancellers and about an howr before his Death drank 2 glasses of cold water.

30 October 1673: at Dr. Wrens he very sick with physick taking [the] day before.[42]

Most of Hooke's diary entries concerning physic-taking, however, have to do with minutely recording his own intake of measured doses of medicaments and their outcomes. These are the laboratory notebooks of the habitual experimentalist, with himself as the experimental subject. Here are a few typical examples:

27 April 1674: Took Dr. Thomsons vomit [later: Slayer told me that Dr. Thomsons vomit was Sneider's *Antimonia Tartarizatis*]. It vomited [caused me to vomit] twice. Purged 10 or 12 times. Read over discourse against Hevelius. At Garaways till 10. Made me sleep ill, and made my armes paralytick with a great noyse in my head. I had also some knawing at the bottom of my belly.[43]

30 July 1675: Took SSA [spirit of sal ammoniac] with small beer at Supper. Very feavorish all night but slept well. Strangely refresht in the morning by drinking SSA with small beer and sleeping after it, it purged me twice. [and the next morning] In a new world with new medicine.

> 1 August 1675: Took volatile Spirit of Wormwood which made me very sick and disturbed me all the night and purged me in the morning. Drank small beer and spirit of Sal-amoniack. I purged 5 or 6 times very easily upon Sunday morning. This is certainly a great Discovery in Physick. I hope that this will dissolve that viscous slime that hath soe much tormented me in my stomack and gutts. *Deus Prosperat.*[44]

Shortly after this, however, sal ammoniac ceased to produce detectable therapeutic results for Hooke (as habitual use accustomed his body to the toxin, so that it ceased to be effective), and he moved on to poison his system with new 'miracle' remedies.

In a number of places in his diary Hooke links drug-taking with an enhanced mental ability and acuteness. Dosing yourself makes you think more clearly, so he appears to believe. So, in one of the passages cited above, having induced vomiting by taking a patented mixture, and endured a dozen bowel evacuations, Hooke reread his own *Animadversions* against Hevelius' rejection of telescopic sights for taking astronomical measurements, which was in preparation for publication ('Took Dr. Thomsons vomit. . . . Read over discourse against Hevelius'). Hooke's diary contains some telling instances of this kind of medical investigation – an experimental procedure which of its very nature requires the experiment to be carried out on the experimenter as subject, enabling him to monitor inner states of mind known only to the patient.[45]

In the course of Hooke's illness of Christmas 1672, he noted a relationship between the outcome of his self-dosing and an accompanying mental state. The combination of a purge and a glass of ale produces sensations of freshness and alertness. During his period of ill health at Christmas 1672, as we saw, this cured Hooke's melancholy:

> Tooke Dr. Godderds 3 pills [purgatives] which wrought 14 times towards latter end. I was again very giddy and more after eating, which continued till I had taken a nap for ½ howr about 5 when I was very melancholly but upon drinking ale strangly enlivend and refresht after which I slept pretty well and pleasantly. Dreamt of riding and eating cream.

Again, in late July 1675, a diary entry already quoted records: 'Took SSA [spirit of sal ammoniac] with small beer at Supper. Very feavorish all night but slept well. Strangely refresht in the morning by drinking SSA with small beer and sleeping after it, it purged me twice.'

The scientific and dosing entries show a consistent pattern of association of purging with mental alertness. The diary entry for 31 May 1674 reveals a cluster of associations between purging and side-effects, and between the effects on the body of certain therapeutic substances and an increased clarity of the intellectual faculties:

> Took Childs vomit, Infusion Crocus Metallicus. i[oz]. Wrought pretty well. Refresht by it. Dined Home. Made description of quadrant. Lost labour. Slept after dinner. A strange mist before my eye. Not abroad all day. Slept little at night. My fantcy very cleer. Meditated about clepsydra, quadrant, scotoscopes, &c.[46]

A dose of a proprietary emetic and a mildly toxic purgative ('crocus metallicus' is a preparation of iron oxide) produced clouded vision, wakefulness and sharp clarity of 'fancy' – thought or imagination. As a result, Hooke had particularly vivid and interesting thoughts about water-clocks, navigational instruments and tools for microscopy (his diary shows him repeating 'physic' which has thus enhanced his mental faculties, in the hope of inducing the same intellectual clear-sightedness).

Hooke's diary entries suggest that he treated his pharmaceutical experimenting as on a par with the other kinds of experimenting he devised in his capacity as Curator of Experiments to the Royal Society: '6 February 1674: At Spanish coffee house tryd new mettall with Antimony, iron and lead. At Shortgraves. Tryd reflex microscope.'[47] Hooke 'tried' a new toxic chemical compound as a medical remedy, and then 'tried' the reflex microscope. Both trials involved skilled handling of the equipment and materials, and careful observation of outcomes and accuracy. The diary entry records two practical experiments in science and new technology, both meticulously noted in the day-by-day laboratory notebooks of the habitual experimentalist, with himself as the experimental subject. Here are two domains of activity within which Hooke expertly tests the latest thing in control and manipulation of the body and its senses. As he makes clear in his preface to *Micrographia*, he believed that new precision scientific instruments like the telescope

and microscope would give back to mankind the clarity of perception lost at the Fall:

> It is the great prerogative of Mankind above other Creatures, that we are not only able to behold the works of Nature ... but we have also the power of considering, comparing, altering, assisting, and improving them to various uses. And as this is the peculiar privilege of humane Nature in general, so is it capable of being so far advanced by the helps of Art, and Experience, as to make some Men excel others in their Observations, and Deductions, almost as much as they do Beasts. By the addition of such artificial Instruments and methods, there may be, in some manner, a reparation made for the mischiefs, and imperfection, mankind has drawn upon it self.[48]

By that double use of 'trial' – Hooke's customary term for developing such experimentally based 'helps' for the senses – we have at least a suggestion here that chemical 'instruments' might enhance man's postlapsarian mental capacities, just as the microscope and telescope add magnification to his vision.[49]

As we eavesdrop on Hooke's self-experimenting with toxic purgatives, the patterns of dosing himself closely resemble his experiments in other, more conventional scientific areas. Substances used are administered with close attention to causal relations between measured dose, combinations of substances and direct bodily effects. Accompanying mental states – 'strangely refresht', 'Refresht by it', 'much disturbed my head', 'made me cheerful' – are carefully noted. We recall again Wilkins's supposed deathbed comment that he was 'ready for the Great Experiment', following the failed lesser experiments of administering solvents to disperse his 'stone', and that he was in 'little pain'.

It is also significant that, as mentioned above, a regimen of systematic self-dosing with purgatives was habit-forming. This was both because the body adjusted to the remedy over time, necessitating additional (and larger) doses to keep a state of equilibrium or some kind of state of 'health', and because vomiting or excreting were commonly preceded by a state of elation (associated with the chemical side-effects of the drug) – leading Hooke to repeat the performance for the emotional 'lift' it gave his often depressed spirits.[50] On 16 February 1673, for

example, Hooke took Andrews cordial, which purged him, and, he also noted, in combination with tobacco, made him 'cheerful':

> [It] brought much Slime out of the gutts and made me cheerfull. Eat Dinner with good stomack and pannado at night but drinking posset upon it put me into a feverish sweat which made me sleep very unquiet and much disturbed my head and stomack. Taking sneezing tobacco about 3 in the morn cleer my head much and made me cheerfull afterwards I slept about 2 houres, but my head was disturbed when I waked.[51]

Only very rarely, as, for instance, on 3 August 1673, a Sunday, does Hooke record that he 'took no physic'.[52]

On the basis of the evidence in Hooke's diary, he was committed to a regimen (a meticulously planned and observed programme of food and drugs intake, over extended periods) which he regarded as serving two functions simultaneously: it regulated bodily functions (meanwhile producing side-effects like numbness and blurred vision which are then treated with further ingestion of substances); and it excited the mental faculties, producing a clarity which was conducive to slightly fevered intellectual activity of the kind Hooke needed to cope with his burden of overwork and competing demands of clients and employers. It formed part of an orderly sequence of experiments for extending the reach of the human mind and man's ability to control nature, alongside more conventional experimental programmes, such as those involving the microscope and the telescope.

Hooke's health, and the largely unhelpful remedies he took to control his symptoms, took its toll on his temper. He became more and more irritable and inflexible in debate, though he clearly remained warm and welcoming with intimate friends – it is striking how many of his coffee-house cronies stayed close to him long after his relations with senior figures in the Royal Society had cooled. His quarrels, however, became pettier and more entrenched.

It is a cruel irony that the dispute which most directly damaged his personal circumstances was one with another figure who, like himself, seemed successfully to straddle the two worlds of science and business, the City financier and virtuoso Sir John Cutler – one of those 'men of

Converse and Traffick' whose support for the Royal Society and its discoveries Hooke was particularly committed to securing.[53]

Like so many success stories of his generation, Sir John Cutler had risen meteorically at the Restoration, and retained the money, prestige and influence gained throughout Charles II's reign. A prominent member of the Grocers' Company, son of another grocer, Thomas Cutler, he left trade for finance in the 1650s, and made a fortune in banking. But his moment came when he took a leading part in raising the £10,000 taken to The Hague and presented by the City of London to the returning King before he had even left the Low Countries, in spring 1660. Charles responded with a speech in which he stressed his 'particular affection' for London as 'the place of my birth', and proceeded to knight all the delegates.[54] In November 1660 Cutler was made a baronet.

In 1663 Cutler gave £1500 towards the repair of Old St Paul's – a project dear to Charles II's heart, but which was overtaken by events when the Cathedral was devastated by the Great Fire.[55] After the Fire, Cutler paid for the rebuilding of the Hall of the Grocers' Company, and associated Company buildings, which were made available as residence for the Lord Mayor of London (it will be recalled that, immediately following the Fire, the Lord Mayor was forced to reside at Gresham College).

The first mention of a proposed endowment by Cutler in the records of the Royal Society occurs in a report of a Council meeting on 22 June 1664. Abraham Hill and John Hoskins were ordered to confer with Sir William Petty and John Graunt 'concerning the manner and form, in which it might be most proper for Sir John Cutler to put into execution his promise of giving fifty pounds a year to Mr Hooke during his life for the reading of the histories of trades in Gresham-College'.[56] At a further Council meeting five days later it was stated that Cutler intended to establish Hooke as 'Professor' in the History of Trades.[57]

Apparently Cutler's offer of significant sponsorship for a lectureship on the Gresham-professorship model to be held by Hooke was first made to Hooke himself.[58] In May 1664 Hooke narrowly failed to secure the professorship of Geometry at Gresham College, vacated by Isaac Barrow.[59] Hooke recalled later how 'being in the Company of one Captaine Graunt at a Publicke house neer Burchin lane', he ran into Sir John Cutler, 'who as it seemes was verie intimately acquainted with the

said Captain Graunt'.[60] Hooke mentioned his disappointment over the Gresham chair to Cutler, and intimated that there had been collusion among the electors to give the post to Arthur Dacres, the successful candidate. Cutler, thereupon,

> was so concerned thereat that he bid [Hooke] not trouble him-
> selfe at the same disappointment for that he himselfe as he was
> pleased then to say would give [Hooke] as good an allowance
> as the vallue of that place for his encouragement to proceed with
> those matters [Hooke] had already so successfully begunne as
> he had bynn enformed or much to the same effect.[61]

Here Hooke (from whose later legal testimony this account is taken) describes Cutler as spontaneously offering his support for a Gresham-style post, to enable Hooke to continue with the kind of Royal Society experimental work that he had 'already so successfully begunne'. By June this had become a specific offer to the Royal Society of fifty pounds a year 'to Mr Hooke during his life for the reading of the histories of trades at Gresham-College'.

The Royal Society's response was typically self-interested. Spotting an opportunity to secure a long-term endowment from Cutler, its Council hastily redrafted the terms of Hooke's curatorship to take full advantage of it to the Society's own financial benefit. When Hooke had been appointed Curator in November 1662, no arrangements had been made to pay him a stipend, presumably because it was assumed that Boyle – who, it will be recalled, had released Hooke from his personal service to take up the position – would continue to give him board and lodging. Now an opportunity had arisen to secure Hooke proper remuneration without unduly stretching the Society's own limited funds.[62]

At a Council meeting on 27 July 1664 it was ordered that Hooke's appointment be regularised, both financially and institutionally:

> That at the first opportunity Mr Hooke be put to the scrutiny
> for the place of curator: That he should receive eighty pounds
> per annum, as curator to the society by subscriptions of particu-
> lar members, or otherwise: That he forthwith provide himself
> of a lodging in or near Gresham-College: And That these orders

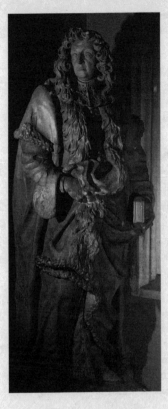

Statue of Sir John Cutler, which once stood with that of Charles II in pride of place on the façade of Hooke's Royal College of Physicians.

and votes be kept secret, till Sir John Cutler shall have established Mr Hooke as professor of the histories of trades.[63]

The fact that it was specifically minuted that these arrangements should not be disclosed to Sir John Cutler suggests that this was a move deliberately made to ensure that the Society (as opposed to Hooke) benefited fully from Cutler's generous gesture. The eighty pounds proposed for Hooke's salary was well beyond anything it was plausible the Society could provide. But if Cutler could be persuaded to settle an annual fifty pounds on Hooke, only thirty pounds would be needed to make up the difference, a sum within the realms of possibility for the Society to provide out of its membership subscriptions (or by special subscription, as later raised to pay for the services of Nehemiah Grew).

On 5 October 1664 Hooke was instructed to begin formal moves in his capacity as Curator to secure the Cutler endowment. He was asked to

> prepare an oration upon the account of Sir John Cutler's founding of a mechanical lecture; and that, between that and the next meeting, he think upon a method to proceed by in his lecture, which, upon the Council's approbation, he might give a hint of in the said oration.[64]

The following day Hooke wrote to Boyle, and reported to him (still technically his employer) the likelihood that he would in future be made financially independent through Cutler's generosity. He was clearly delighted with the proposed arrangement:

> The person I formerly told you of, namely, *Sir John Cutler*, having very nobly and freely, without any compulsion or excitement, not only kept his word, but been better than it, sending me yesterday a half year's salary beforehand, as an earnest of his intention.

After two years of empty promises of remuneration by the Society, here was cash in advance, and freedom to direct his own programme of scientific investigations. Nevertheless, premonitions of difficulties to come are contained in the continuation of the letter. Hooke was already aware that he would have difficulty undertaking significant amounts of additional work, over and above those to which he was already fully committed:[65]

> The most I think I shall be able to do in this business this term (being engaged to read for doctor *Pope*) will be only to make a short speech, both in praise of Sir *John*, my noble patron, and of the excellency and usefullness of the design itself, and of what method and course I shall take in it.[66]

On 2 November, Wilkins told the Society 'that Sir John Cutler had declared to him, that he was firm in his resolution to settle upon Mr Hooke £50 *per annum.* for such employment, as the Royal Society should put him upon'. Wilkins was ordered to draw up a letter of thanks to Cutler from the Society, 'declaring him withal an honorary member'.[67] A week later Cutler was elected honorary Fellow, and a delegation

including Wilkins and Petty was 'appointed to attend him in the name of the society', with a document specifying what form Hooke's commitment should take – how many lectures, when, where and on what topics. Once again, boundaries were blurred between Cutler's and the Society's responsibilities in instructing Hooke, and monitoring the performance of his obligations.

In an attempt to clarify the situation, the Royal Society made Hooke sign an 'obligation' between himself and the Society, agreeing to the terms of Cutler's endowment, as administered by the Society (in other words, formalising the fact that he was answerable to the Society, while the Society was answerable to Cutler). It was formally recorded:

> That Mr Hooke be desired to promise by his hand-writing to observe the ends, for which the report from Sir John Cutler entered in the journal-book of the society, Nov. 9, 1664, affirms the fifty pounds a year to be given him by Sir John.[68]

Matters were further complicated by the fact that in March 1665 Hooke, with the backing of the Royal Society, had successfully challenged the way the Gresham Professor had been appointed, and had gained the professorship for himself. From then on, he was required to give the Gresham Geometry lectures during term-time, while during vacations he was to give Cutlerian lectures according to the terms of Sir John Cutler's endowment. From Hooke's surviving papers it looks as if he often reused lectures prepared for one context in another, even if this involved interpreting the terms of one or other of his lectureships rather loosely. Still, unlike other Gresham professors, who, notoriously, paid others to fulfil their lecturing requirements for them, Hooke appears to have given his Gresham lectures regularly.[69] There is no reason to suppose that he did not read his Cutler lecture whenever there was an audience to lecture to.[70]

Hooke was confident that he had fulfilled the terms of Cutler's endowment to the letter. Although he had quickly stopped lecturing on the History of Trades as such, he believed that the topics on which he did choose to lecture on Wednesday afternoons were heavily orientated towards practical matters, and thus contributed to the kind of applied science in which Sir John Cutler was especially interested. In order to comply with Cutler's instructions, he later wrote in his own defence, he had

wholly left off Such other Studyes which before he had pros-
ecuted and intended to have proceeded in which would have
byn far easier & much more profitable as he beleives unto him
and from that time directed his Studies and endeavours to the
Performance of such things as tended to [the] improvement of
the knowledge of art and nature and in makeing such experi-
ments as might most conduce therunto.[71]

Although it is obvious from his surviving lecture-notes that he some-
times saved time by adapting lectures prepared in his capacity as
Gresham Professor, or for the Royal Society, he mostly appeared punctu-
ally to deliver his Cutlerian lectures, although if there was no audience
he might cancel. Attendance was erratic, consisting sometimes of groups
of schoolboys brought from Christ's Hospital School, or occasionally of
a single individual whom Hooke suspected of being a spy sent by Cutler
to check up on him.[72]

Nevertheless, after paying his annuity regularly throughout the 1660s
Cutler stopped paying Hooke for his Cutlerian lectureship responsibil-
ities as from midsummer 1670. Deprived thereby of fifty of the eighty
pounds the Royal Society had agreed as his total stipend, Hooke kept
a careful tally of the money he was owed in his diary. At the point at
which relations between himself and Cutler were reaching crisis-point,
in 1679, he published a collection of his lectures under the general title
of Lectiones Cutlerianae (Cutlerian Lectures) perhaps so that they could
serve as a bargaining-point in the dispute. They were, after all, evidence
that Hooke had delivered the lectures according to his obligation under
the terms of the endowment.

Matters are complicated by the fact that during the period 1670–4
Cutler was a major benefactor involved in the rebuilding of the Royal
College of Physicians, which Hooke designed and whose construction
he supervised.[73] Hooke, who took a particular interest in the anatomy
theatre at the College (which was directly paid for by Cutler), as a piece
of innovative purpose-built scientific design, gives no sign in his diary
of any apprehensiveness about acquiring Cutler as an architectural client:

At Sir J. Laurences with Andrews. Walkd to Dr. Wrens, dined
there, etc., discoursed of [anatomy] theater. At Sir Robert
Moray's, he told me of a metall of excellent Reflection that

Nineteenth-century drawing of the Royal College of Physicians from the Court looking East.

would not tarnish. . . . With Kayus Sibber at Sir George Ents, first heard Sir J. Cutler would build the theater.[74]

Given his tendency to parsimony, Cutler, however, no doubt felt that Hooke was one of the beneficiaries of this act of generosity on his part also; perhaps he persuaded himself that the remuneration Hooke received in this capacity could be considered to include his Cutlerian lectureship payment too. He may indeed have believed that Hooke's day-to-day involvement with the College building project must be interfering with the time he was able to give to his professorial responsibilities. In fact, as we have seen, Hooke, during this period, apparently managed near-superhuman feats of juggling obligations and demands on his time.

From 1673 onwards, Hooke attempted to get Cutler to settle his mounting arrears by persuasion. On 30 June 1673 he noted in his diary: 'Sir J. Cutler promised me payment for 3 years, Dr Whistler witnesse at Kings armes by the pump in thredneedle street.' Since Hooke was currently being well remunerated for his surveying and architectural work, this was a matter of honour as much as of financial necessity.

Towards the end of 1673, the Society raised the possibility of Cutler's settling all his outstanding debts to Hooke, and cancelling any future obligations, with a one-off payment of £1000 – a possibility which had been written into the original contract with the Society in case Cutler should ever wish to terminate the arrangement. This would have meant a much needed injection of capital for the Royal Society, and for almost the only time in the affair the Society threw its weight wholeheartedly behind their Curator of Experiments.[75] Nothing, however, came of the proposal – to the Society's chagrin as well as Hooke's.[76]

Colleagues of Hooke who had been involved in the original negotiations, and other interested parties, including Cutler's nephew Edmund Boulter, attempted informal arbitration, without success. On 15 January 1674, Cutler promised a 'final determination' before the end of March, agreeing what he owed in the presence of Boulter. In several diary entries later that year, however, Hooke complains that Cutler has 'playd the foole' with him. On another occasion, when Hooke ran into Cutler at one of the coffee houses they both frequented, Hooke records that Cutler promised 'to pay me every farthing soe soon as ever I would call on him with Dr Whistler'.

Yet we find Hooke recording constructive and apparently cordial meetings with Cutler concerning the anatomy theatre at the Royal College of Physicians, during a period which overlaps with anxious entries concerning Cutler's arrears:

> May 1st [1674]. Drew Designe for the Theater, May 26th. To Physitians College. They resolved Theater backwards. June 16th. At Sir J. Cutlers. Spoke to him. He resolved Theater before [in other words, Cutler intervened to reverse the positioning of the anatomy theatre, as Hooke preferred]. July 20th, Set out Theatre at Colledge. August 7th. Propounded open theater. Agreed to. Sir Charles Scarborough pleasd.

Evidently both men were habitual compartmentalisers of their business, capable of keeping their virtuoso scientific interests separate from City business concerns.

On 25 February 1675, at exactly the moment when Hooke's dispute with Christiaan Huygens over balance-spring timekeepers was reaching its most critical stage, Hooke decided to appeal formally to the Council of the Royal Society to take up his case against Cutler: 'Moved the

Councill about Sir John Cutler'. It was, after all, very much their business that Hooke was no longer being fully remunerated for the work he carried out for them. The relevant minutes of the Society, however, have no record of this request. Hooke was already getting a reputation for picking quarrels, and the members of Council were disinclined to get involved.[77]

Fortunately for Hooke, two old, close friends – Sir John Hoskins and Sir Christopher Wren – remained committed to pursuing Hooke's cause in the matter, and it is surely significant that they continued to press vigorously for a settlement in his favour. Both were men of known honour and integrity, greatly respected in City circles. On 27 July 1680, Hoskins and Wren accompanied Hooke to Cutler's house, where their determined representations clearly had Cutler rattled: 'Sir John. Hoskins spoke to [Cutler] much to the purpose, he refused payment, said he designed to arrest me.'[78] Although Cutler's threat was pure bluster, it undoubtedly upset Hooke and made him anxious. The case (and the injustice) preyed on his mind.

Hoskins was President of the Royal Society at the time, and Wren became President in his turn a year later. In 1682 these two men persuaded the Society to take up the outstanding arrears with Cutler, and Sir William Petty, who had been one of those closely involved in the original negotiations with Cutler to secure an endowment, was given the job of brokering a satisfactory settlement between him and Hooke. On 12 July that year, Petty was 'desird to accompany those members of the council who by a former order were desired to speak to Sir John Cutler for obtaining Mr Hooke's arrears'.[79] In December 1682, Sir John Hoskins and Daniel Colwall (another substantial benefactor of the Royal Society)[80] wrote officially to Cutler, confirming on the Society's behalf that they believed Hooke had fulfilled the terms of his lectureship: 'Our own memorys satisfy us that Mr Hooke has done much more then he is ever sayd to have been obliged to, and even in the same kind, at least till stoppage of Payment began.' They requested Cutler to pay Hooke 'what your Bond to him has Given him and made justly his'.[81]

None of these interventions by Hooke's close circle of friends was successful, and eventually, in 1683, the dispute came to court. A final attempt at arbitration by Sir William Petty apparently failed because Hooke was not prepared to make the necessary concessions. Although

Hooke and Petty had been involved together in long-running experiments associated with the History of Trades (the subject of scientific investigation to which Sir John Cutler was so attached), even Petty was unable to persuade Hooke to accept any kind of compromise.[82] On 14 May 1683 Petty wrote to Hooke, clearly in some annoyance: 'Mr Hooke, I am sorry you cannot trust the Society in such a matter as I propound. Wherefore to prevent publick noise, I am content to withdraw that Clause and have sent another award without it.' The modified draft was still unacceptable. An entry in Hooke's diary for the following day, 15 May 1683, runs: 'At Ballets. opend Sir W Pettys Letter. at Sir W. Pettys. hufft. Westminster hall. Very Many [present]. Cause tryd at Guildhall [.] Verdict on Bond. Sir John Hoskins Mr Colwall Lodowick Hunt.'[83] The case dragged on for thirteen more years. It was still undecided in 1693 when Sir John Cutler died. Undeterred, Hooke and the Royal Society continued to pursue their claim with Cutler's heirs.

By now insistence on full financial settlement was clearly a matter of principle and (yet again) personal honour, as far as Hooke was concerned. Although the sums of money involved had mounted up, he was by this time a man of means, who could surely have afforded to treat with contempt Cutler's increasingly intransigent manoeuvring to avoid payment. It must have been understood in London that the dispute did not imply professional shortcomings on Hooke's part, since Cutler was a notoriously reluctant settler of his debts. His heirs, as we saw, reclaimed a large percentage of the money 'gifted' to the Royal College of Physicians rebuilding project, after Cutler's death.[84]

Hooke now enlisted the help of two influential people close to the Cutler family: Sir Richard Levitt, Master of the Haberdashers' Company (with whom Hooke was engaged in a building commission), and Edmund Boulter, the Cutler nephew who had attempted to arbitrate at an earlier stage. In May 1693 Hooke was quite hopeful, noting in his diary that Boulter 'would consider of it soone as some other Accounts were past with Lord Radnor [Cutler's heir] to whom he was going, that he knew of it, and had payd me the last £200'. On 7 June, Levett told Hooke that Boulter 'would shortly consider of it'. June came and went without anything happening. On 6 July, Boulter told Hooke 'that he had not yet had time to settle it with Lord Radnor, but would speedily'; on 8 July, Levett 'promised to urge Mr Bolter to speed my Arrears'. It sounds very much as if Hooke was characteristically over-zealous in

pursuing his case, and that he was beginning to weary even these willing advocates on his behalf.

The case was eventually settled on 18 July 1696 – more than thirty years after the original establishment of the Cutlerian lectures, and twenty-six years after Cutler began defaulting on his payments to Hooke. Hooke's outstanding arrears were computed, and an order made for him to be paid in full out of Cutler's estate. The Royal Society was ordered to 'see that the Lectures be performed by the same defendant according to the condition of the said bond and that the said society doe every five yeares certifie to this Court that the said Lectures are performed'. It was also specifically ordered that the annual payment would be made regularly in future.

Hooke's sixty-first birthday fell on the same day as the settlement. As Waller tells us, the case had made him 'very uneasy for several Years'. Waller also transcribed Hooke's diary entry for that, for him, exceptionally auspicious day (the diary is now lost): 'DOMSHLGISS:A [*Deo Opt. Max. summus Honor, Laus, Gloria in secula seculorum, Amen* – All honour, praise and glory to most merciful God, for ever and ever, Amen]. I was Born on this Day of July 1635, and GOD has given me a new Birth, may I never forget his Mercies to me; whilst he gives me Breath, may I praise him.'[85]

At the same time that Hooke was becoming increasingly dependent on self-administered medical remedies to sustain his hectic pattern of work, and fretting increasingly at Cutler's defaulting on their firm agreement, his City business and contacts were flourishing.[86] As always in the action-packed life of Robert Hooke, it is easy to forget that while he was obstinately pursuing his claim against Sir John Cutler he was simultaneously engaged in a mass of more productive and profitable projects. During the 1670s and 1680s he received a stream of commissions for private houses, in and around London, and corporate commissions from important charitable foundations.

In these spheres, Hooke's status, and the respect in which he was held, are indisputable. The fears recorded in his diary, and in conversation with coffee-house friends, that he might be socially slighted or professionally underrated appear for what they really were – pathological anxieties, probably made worse by his growing dependency on debilitating drugs.

In 1689, for example, the Haberdashers' Company commissioned a school and almshouses in Hoxton. The man who acted as client for the project was Richard Levitt, Master of the Company. In his dealings here with Levitt, Hooke shows none of the nervous tendency to expect the worst, displayed in his dealings with him in the course of the Cutler dispute. A letter to Levitt written in the early stages of construction of the Hoxton almshouses, in June 1691, shows Hooke taking decisions in relation to site management with impressive authority. The proposed carpenter is proving uncooperative, and Hooke suggests first putting pressure on him, and then, if he still demurs at the terms, hiring an alternative whose name he has already supplied:

> Mr. Banks does absolutely refuse to signe the contract which you gave order to Captain Mould to get ready for him. He says he will abide by his first proposalls, but I perceive he will interpret them as to his performance, how he pleaseth, nor will he hear of making the timbers of his floors, window frames, or door cases, square without wain or sap, soe that as the work may be performed he may be much deerer than any of the other preposers duely limited, as they ought to be. In the mean time, I have forborn to give him any Directions for the Hospitall, till he doe comply with your Last orders to me concerning him. But Sir we shall suddainly have occasion for a Carpenter, or be forced to delay the work if therefore you think fitt the other Proposer (I acquainted you with) will be willing to signe the same contract, wither for the whole celler story or for half of it as you shall direct. and possibly that may make Mr. B. comply.[87]

Levitt's opinion of Hooke as an individual may have been coloured by the fretful encounters regarding Cutler's arrears, nevertheless Hooke remained a formidable figure in the construction business. In spite of his small stature and increasingly stooped walk, in spite of the private anxieties of diminishing esteem he confided to his diary, he was still a man who could command respect in his professional sphere, and who expected to be listened to.

*Dwindling expectations:*
(*right*) Sir Christopher Wren at almost 80, architect and geometer, and Hooke's lifelong friend (the book on the table is their shared mathematical passion, *Euclid*). Portrait by Sir Godfrey Kneller.
(*below*) Charles II in 1680, no longer the dashing figure who had inspired such hope at the Restoration. Portrait attributed to Thomas Hawker.
(*below right*) Sir Isaac Newton in 1702, the year before Hooke's death, and visibly now a formidable figure in English public life. Portrait by Sir Godfrey Kneller.

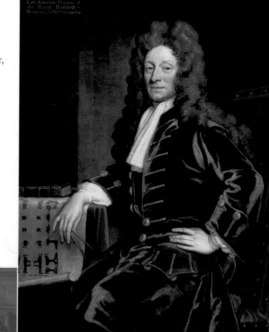

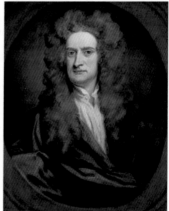

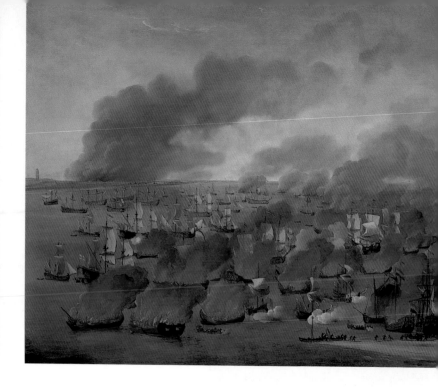

*Anglo-Dutch aggression and flames in 1666:*
(*above*) Dutch painting of the burning of Dutch
merchant ships between Terschelling and Vlieland,
in an unprovoked attack by Sir Robert Holmes,
19 August 1666.
(*far right*) Scourge of the Dutch fleet: Sir Robert
Holmes with Sir Frescheville Holles.
Double portrait by Sir Peter Lely.
(*right*) Dutch painting of the Great Fire of London,
with Old St Paul's silhouetted against the flames,
September 1666. Many believed the Fire was arson –
Dutch retaliation for 'Holmes's bonfire' in August.

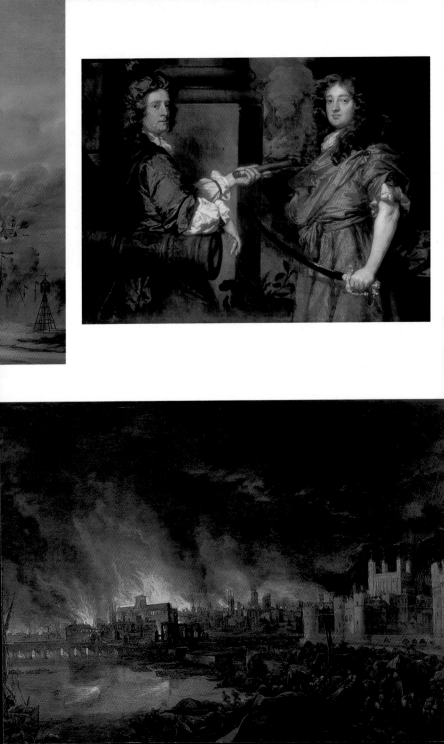

*Scientific investigation in garden landscapes:*
Gardens of Durdans House, Epsom, where Hooke, Wilkins and Petty experimented with new carriage-suspensions and portable pendulum clocks.

Charles II and his court walking in Horse Guards Parade close to Whitehall Palace in 1685 – on many occasions Hooke encountered the King out walking, and they talked together about clocks and patents.

## 7

# *Friends and Family, at Home and Abroad*

He was in the beginning of his being made known to the Learned, very communicative of his Philosophical Discoveries and Inventions, till some Accidents made him to a Crime close and reserv'd.

Richard Waller, 'Life of Dr Robert Hooke' (1705)[1]

Hooke's hectic schedule of work left little time for a proper home life. He kept a bachelor house of a kind typical of the times for a man of his means and with an intellectual vocation. His domestic affairs were looked after by a live-in unmarried woman maidservant, while he also took in a series of boy boarders. Hooke ate his morning meal at home, and sometimes his midday meal, but almost always dined out in the evening, in the company of one or more of his many male acquaintances.

As the temporary residents, installed at Gresham immediately following the Great Fire, vacated their rooms and moved to new premises, Hooke took advantage of the increased space available to himself. The City officers and financiers who had moved in so hurriedly in 1666 had gradually dispersed, and London's financial activities were about to be relocated to the new Royal Exchange premises designed by Wren. By the end of 1673 Gresham College had reverted to its former dilapidated tranquillity.

Detail of George Vertue's engraving of Gresham College showing Hooke's rooms (9) in the south-east corner of the quadrangle. On the roof are the frame of the housing for his zenith telescope (8).

Over the years, Hooke gave lodging and keep to a series of young men – hardly more than boys when they arrived.[2] This enabled him to run an intellectual household of a traditional kind – one which provided him with a 'family' of dependants, while allowing him to lead the life of a sort of secular cleric or college-based teacher (Gresham College itself did not function like a university college).[3] He could do so conveniently, since his quarters at Gresham College were substantially larger than strictly necessary for a solitary inhabitant.[4] In exchange for room and board, Hooke instructed his lodgers in some of his many specialist skills, while they assisted him in his Royal Society duties, acted as amanuenses for his personal research and correspondence, ran errands, and generally provided company and made themselves useful.

This was a kind of virtuoso's apprenticeship, as Hooke explained in a letter to Aubrey in 1675, when he thought he might take on a further such person. Aubrey was recommending a Mr Snell, who sounded

promising (though when he arrived he turned out to have a pronounced stammer, and Hooke sent him home again). Hooke explained his terms:

> I should be very glad to have him live with me if he be a sober, virtuous young man and diligent in following such things as I shall imploy him about which I doubt not will be much for his good hereafter. If he be with me I would have him upon these conditions 1st that he will ingage to stay with me for a certaine time. next that his friends will provide him with clothes or allow soe much towards it as shall be equivalent. And my reasons are because though he doe me service yet I shall assist him much more and therefore I think it will be enough for me if I take him with nothing, if I find him meat, drink, Lodging, washing & Instruction.

The most stringent condition was that, once selected, the young man in question would be prepared to stay for a suitable length of time, so that the investment in him in terms of time and effort might not be wasted:

> And my reason for his obliging himself to stay with me is this that I can have enough that will doe it, and it will not be reasonable that after I have been at the paines to fit him for the doing my busness he should presently leave me to seek a new one, to be taught. my entertainment will be but plaine but he shall not want any thing necessary for his Diet, Lodging or studies. Let me hear from you speedily because I am just agreeing with another, but I like the ingenuity of this boy, if all other conditions please. I would not have him for less then 7 years.[5]

On 1 December 1672, Hooke and Richard Blackburne, a young man hoping to become a physician, reached agreement on Blackburne's becoming Hooke's lodger at Gresham College. A week later, Blackburne moved in, and the same day began giving Hooke Dutch lessons, as part-payment for his rent.[6] Blackburne left in November 1673, and went to Leyden to study medicine. He returned to London in 1676, when he resumed his friendship with Hooke.

Shortly afterwards, on an unseasonably mild day in January 1673, another young man arrived to join Blackburne as one of Hooke's lodgers – Henry Hunt, who was to remain Hooke's companion and assistant

Fish drawn from a living specimen by Henry Hunt.

for the rest of his life. The two immediately established a daily habit of taking tea together in Hooke's rooms:

> January 4th [1673]. – [mercury] 160. fair all day like Aprill weather. Thermometer 4½. Wind S. night cleer. very windy. At home till 3. Dined Home.... Harry [Hunt] first out of the Country. Drank 2 Tea. Guiddy and slept not well.[7]

Harry Hunt turned out to have a certain amount of artistic talent, and Hooke trained him as a copyist. He provided duplicates of drawings in papers submitted to the Royal Society, for the record, and sometimes attempted original drawings of his own – Hooke records his making a drawing of a third lodger, his niece Grace Hooke.[8] In the early years, however, theirs was an up-and-down relationship. In March 1675, Harry was 'surley and proceeded putt on hat'. Hooke decided he had to go: 'he shall march'. But he changed his mind, and ten days later he got Harry a commission to copy pictures for Ralph Montagu (Hooke's client for Montagu House). This was so successful that Montagu proposed hiring Henry Hunt and taking him with him to Paris, where he had just been posted. It was this prospect which occasioned Hooke's letter to Aubrey looking for a replacement trainee:

I have preferred Harry to Mr. Mountague who will imploy him these 2 or 3 years & is soe pleased with him that he hath promised to beare his charges to Italy, that he may see and improve himself, And I doubt not but he will with ease get his £150 or £200 per Annum. He hath lately done some pieces extraordinary well, & will be paid for them accordingly.[9]

Harry, though, resolved to stay with Hooke, becoming increasingly irreplaceable to him as the years went on. However difficult Hooke could be on occasion, there was clearly something about him which led those who once got to know him well to stand by him. A year later, when Hooke suggested his going to work for Wren, he once again refused: '17 November 1676. Sir Ch. Wren's frenchman Dying, I proferd his place to Harry – he refusd it.' Hunt presumably got used to Hooke's outbursts, and, once he was himself appointed a curator for the Royal Society (an appointment which took Hooke by surprise), he could provide for himself, even when his increasingly miserly employer stopped feeding and clothing even himself adequately.

Hooke also played an important role in helping raise two of his young relatives from the Isle of Wight. Some time in 1672, Grace Hooke, the twelve-year-old daughter of his elder brother John, came to live with him; later she became his housekeeper.[10] On 12 July 1675, Tom Gyles (or Giles) from Brading on the Isle of Wight, grandson of his mother's brother, Thomas Gyles, and son of his son Robert (or Robin, as Hooke always called him), arrived for Hooke to look him over. Tom's father Robert appears to have been Hooke's tenant as well as a relation.[11] Hooke tested the boy on his reading and arithmetic, and agreed that he could come and board with him while receiving an education to become a navigator: 'Tom Gyles came by carrier on Thursday, a pretty boy, good at Reading Arithmetic etc. his mind for sea.'[12] A year later he was teaching his two young relatives algebra.[13]

Like Harry Hunt, Tom did not always manage to please the exacting and short-tempered Hooke, and, in March 1677, after a row about his general behaviour, Hooke threatened to send Tom home. Tom dissolved in tears, begged to be given another chance and was eventually allowed to remain. Like Hunt, he too continued in Hooke's immediate household; however stern, Hooke was, in the end, always comforting and compassionate – never more so than when Tom died of smallpox in

September 1677. Recording the progress of the boy's illness in his diary, Hooke shows growing signs of alarm as he realises its gravity:[14]

[Tuesday, 11 September 1677] Gidly here refusd to let Tom Blood, his throat very sore and almost choked. Writ to Brother. Dr. Diodati here directed him to be Let Blood, by reason he had pissed blood all day and had bled at nose and at the mouth. At 8, Mr. Gidly and Mr. Whitchurch here, they let Tom blood in the arme about 7 ounces then under the tongue, this eased his throat, but notwithstanding he continued bleeding out of his throat and nose all the night as also pissed much blood.

[Wednesday, 12 September] I rose at 5 and calld on Gidly, he sent me to the Doctors. I spake with old Dr. King, he affirmd pissing blood in the small pox mortall, as did Dr. Mapletoft. These two with Dr. Diodati met at 9, concluded Tom irrecoverable. Mrs. Davys and Mr. Bates here. Tom spake very piously, began to grow cold, to want covering, to have little convulsive motions, and after falling into a slumber seemd a little refresht and spake very sensibly, and heartly, but composing himself againe for a slumber he ratled in the throat and presently Dyed. It was about 14 minutes after 12 at noon, he seemd to goe away in a Slumber without convulsions.

Deeply distressed, Hooke now sent 'Mrs. Kedges in Silver street' to notify Hannah Gyles (presumably Tom's mother) of his death. He meanwhile arranged the funeral, and afterwards passed a dreadful night.[15] On 25 October, Tom's father wrote 'a letter of Gratefulnesse . . . for Kindness to Poor Tom Gyles'.[16]

With the arrival of Grace Hooke in 1672 came the first of Hooke's live-in maids, Nell Young, who also had Isle of Wight connections, and may have been selected by his brother John and his wife as a suitable chaperone to supervise their daughter's upbringing away from home. She may even have been the sister of John's own family maid. It was through Nell that news regularly reached Robert from his home and family.[17] As with all subsequent maids, Hooke complained bitterly in his diary of her clumsiness, insubordination, idleness and tendency to bring young men into the house. Nevertheless, when she left and married, Hooke kept up a friendship with her, used her services as a

seamstress, and continued to rely on her to provide him with gossip from the Isle of Wight. Although Nell was supposed to ensure a suitably moral environment for Grace, she became Hooke's sexual partner in September 1672: '[12 September] This was the first time that upon cutting hair &c&c&c. Nell lay [orgasm].'[18]

The story of Hooke and Grace, his niece, has fascinated his biographers ever since his death. Aubrey and Waller both comment on her good looks, and on Hooke's close attachment to her. Later biographers have stretched the surviving fragments of factual evidence, to conclude that this was a fully fledged incestuous affair between a supposedly celibate uncle and his much younger niece.

To begin with, however, Hooke seems to have regarded Grace as the means to his continued advancement in London society, at a moment when his star was in the ascendant as a result of his City of London connections. Her arrival coincided with his continuing work for the Corporation of London, his undertaking major building commissions in and around London, and the peak of his prominence in virtuoso scientific circles.

Hooke's brother John was by now a man of standing on the Isle of Wight, twice Mayor of Newport, and a pillar of the local community. Hooke had become close to Sir Thomas Bloodworth following the Great Fire. Although history has seen fit to regard Bloodworth as a buffoon on the basis of Pepys's character assassination for his lack of leadership during the Great Fire, he in fact continued to prosper in City of London circles.[19] By the time Grace arrived in London, a betrothal had apparently been arranged between Grace and Bloodworth's son.[20]

Grace was to be made into a lady, schooled and groomed at her father's expense, while Robert Hooke supervised the arrangements and gave her board and lodging. At the beginning of September 1672, Grace 'went to school', at the establishment of a Mrs Whistler. Ten days later, 'Bloodworth here, when he resolved to continue to have Grace and to send me his dymands next day.' These were the dowry arrangements to be specified, and were bound to be considerable for such a match. It is likely that Robert Hooke was to help financially with these, since his brother John – always in trouble with money, ever since his youth – was in debt to him already. John was, however, paying for Grace's living expenses – the following day a maid brought 40 shillings for Robert, and stayed overnight. Over the following two weeks Hooke

visited Bloodworth three times, and wrote to his brother with the out-
come of his negotiations. On 15 October Hooke relayed his brother's
reply to Bloodworth's offer. On 27 October Grace was called home from
school, and two days later Hooke paid £4 3s for her quarter's schooling.
On 25 November Grace went home 'with Mr. Lee by the Portsmouth
coach'.

There seem to have been no further developments until the following
summer. Grace was, after all, still only thirteen, and was now back on
the Isle of Wight. On 8 July 1673 Hooke visited Bloodworth with Mr
Hill, but the following day Bloodworth began proceedings to cancel the
arrangement they had made. Hooke informed his brother of further
conditions Bloodworth was insisting upon, and on 19 July John Hooke
replied with a 'no'. On 17 August Hooke sent his brother a 'second
coppy of T. Bloodworth's Release'. By now Hooke was anticipating
sending Grace home to her family. He discharged Nell at the end of
September.[21]

In late November John Hooke wrote to Hooke, pursuing the final
stages in annulling of the agreement with Bloodworth; these were
completed in January. Grace also wrote, asking, it seems, for Hooke to
procure a new London wardrobe for her. Hooke put Nell in charge,
and spent 40s on a new coat with 'knots and pendants', which he sent
by way of the carrier, with a letter concerning more Bloodworth business,
on 4 January 1674. In May, his new maid Betty was sent to buy a gown
for Grace, which again Nell either made or saw to being made (it cost
25 shillings). By July Hooke and his brother had arranged that Grace
would return to complete her education, in spite of the broken engage-
ment. In August John sent payment for the coat and gown, and in
September Grace arrived 'out of the country with a mayd'.

Robert Hooke now put arrangements on a new footing, where he
was more closely involved with Grace's upbringing, on the assumption
that she would remain with him until a suitable match could be made.
He decided Grace should learn French, and wrote to John telling him
so. He commissioned Harry Hunt to draw Grace's picture. He put his
foot down when Bloodworth's son attempted to see his ex-fiancée. He
arranged for the wives of some of his coffee-house friends to take Grace
to see the London sights (Nell also saw Grace regularly), and also began
to take her about himself.

Grace's 'divorce' (the voiding of the agreement) came through in

April 1675 and on 6 May, Hooke moved her into the turret room at Gresham College, where she lived from then on whenever she was in London. The following day Nell came to talk to Hooke about Grace – which, given Nell's tendency to gossip, may mean that she was already reporting to Hooke Grace's various escapades on the frequent occasions when she was 'out'. She was by now rising fifteen, and her attractiveness to young men was evident. Hooke laid out large sums of money (particularly large for him) on 'stuff' for gowns, petticoats and knots. In late June Nell came round again and told Hooke 'of Grace being with Trotter related by Sir W. Mews his man. She denyd.'

Grace was still in limbo as far as courtship was concerned, which may explain how she came to be scandalising Nell by being seen with a whole sequence of unsuitable young men. She was yet not entirely free from the Bloodworth agreement – Hooke spoke to Sir Thomas again about final 'Cleering at Law' on 7 June 1675. At last, on Friday, 17 September the release papers were notarised, copied and issued to all the parties concerned.[22]

Grace (who had returned to the Isle of Wight with her mother in late July) was back with Hooke by Christmas, but went home again in the spring, during which absence Hooke took the opportunity to fit out a 'closet' for her (a small retiring room). She came back in April, and concentrated again on her grooming for sophisticated London life, including a course of intensive French (Hooke lent her French books). Hooke became yet more involved with her, being seen in public with her regularly (which presumably began the rumours about a relationship). He was coming to rely on her company, and the pseudo-marital hearth she could provide, knowing that he would never himself marry.[23] By 1676 he was sometimes sharing a bed with her; by 1677 he was finding sexual satisfaction with her, though not necessarily engaging in full sex.[24]

It may have been he who insisted that she return home. On Friday, 10 August 1677, Hooke wrote in his diary: 'Cousen Grace into the Countrey. Paid Grace all to this day, as also 9sh.' He probably believed it was the last he would see of her, and his use of the word 'cousen' suggests his awareness that their relationship was verging on the improper. Though Hooke's diary makes clear that he had some kind of sexual relationship with Nell Young, taking advantage of your female servants for sexual release was one thing during that period, but consorting with your niece almost a third of your age quite another.

Back on the Isle of Wight, however, scandal broke. Grace, a beautiful seventeen-year-old, with London style and London ways, immediately caught the attention of the Governor of the island, Sir Robert Holmes, hero of the Ango-Dutch wars and a swashbuckling scoundrel. Hooke learned the news at Nell's on 31 October, but the affair had probably already been going on for several months: 'heard of Sir R. Holmes courting Grace'. On 3 November, Hooke 'wrote to Brother J. Hooke about Grace and Sir R. Holmes'. On 26 February 1678, after hearing no news for three months, Hooke learned that Grace was confined to bed with 'measles'.

The next day Hooke's brother John committed suicide. Hooke heard the shattering news the following day, at Nell's.[25] Though they rarely met, John and Robert corresponded frequently, exchanged news and gifts. Hooke kept John informed of political developments in the capital (he sent printed copies of the King's most important speeches). Among his gifts were 'a chymicall book', a 'perspective glass', a silver box which he had bought at Holborn Bridge for 20 shillings (Harry 'grained the box'). His brother sent produce – '1 goos, 1 hare, 20 poultry' just before Christmas 1672, on occasions a hare, 'a collar of brawn', 'wild foule'. Above all, Hooke offered John's only daughter the kind of opportunity to make her way in the world he had been given himself twenty-four years earlier. They remained as close as two brothers obliged to live at a considerable distance from one another could be.

In spite of his grief, Hooke's most urgent task was to try to rescue John's family from financial disaster. John had been deeply in debt at the time of his death – he owed large sums to Robert, but yet larger sums, apparently, to Newport Corporation.[26] Debt, in combination with the recurrent depression from which he (like his brother) suffered, was the likely cause of his taking his own life, though his daughter's seduction would have added to his woes. Confiscation of his property would now leave his wife and daughter without any means of support. Hooke rushed directly to the King the next day to beg that he be granted his brother's estate, which by law went to the Crown. A group of prominent friends, among them his loyal companions Hoskins and Wren, helped him gain an immediate audience at court. He learned to his chagrin that Sir Robert Holmes had been there before him and had 'beggd it for wife and child' – that is, for Grace and her mother.[27] Holmes clearly felt he had an interest. Hooke was devastated, and by Sunday had fallen into

one of his black depressions: 'ill all day . . . MMD [Lord have mercy on me]'.

During the next week Hooke saw Sir Robert Holmes several times. On 8 March, it was in the company of his old employer and now friend, Robert Boyle, who came along for support. Grace and her mother, meanwhile, were staying with Dr Harrison in Newport. Harrison's daughter was a friend of Grace's, and Harrison was a local physician. Later Newport Corporation paid Harrison for their room and board. Both Harrison and Grace wrote to Hooke repeatedly between March and May. Hooke also saw Holmes, and completed arrangements about allocating John Hooke's estate. Then, at the end of May, Grace came back to London to live with Hooke. Now she was his official housekeeper, paid regularly, and also sleeping with him regularly. She went out a lot, and on at least two occasions was nearly sent home by Hooke after being caught with young men in the house. But the two developed a comfortable arrangement for cohabiting, and Hooke was as close to content as at any other time in his life. He expected the arrangement to last for his lifetime.

In 1678, Sir Robert Holmes acknowledged an illegitimate daughter Mary, by an unknown young woman. He never married, and it was assumed that the mother of the daughter he raised as his own had not been of suitable birth and standing. At his death, he left his entire estate to his nephew, on condition that he married Mary, which he did. It does seem possible that Grace Hooke's confinement for 'measles' was in fact a pregnancy. The coincidence of dates, and the fact that Grace was known to be involved with Robert Holmes in autumn 1677 makes it entirely possible that Mary Holmes was her child.

If so, Hooke, with his customary compassion for those fallen on hard times, took her in as 'ruined', but far enough away from home for nobody (apart from Nell) to suspect. Her father's death left her with no closer male kin than her uncle Robert to support her. She was no longer in any position to make a respectable, let alone an advantageous, marriage, and her position as Hooke's resident household servant was in all likelihood a lifeline.

Hooke's hopes that in Grace he had found a reliable arrangement that would see him into old age, as he became old and infirm, were not, however, to be realised. In 1687, after a short illness, Grace Hooke died, in the turret room at Gresham College which she had occupied

Detail of Willem Schellinks's pen and ink sketch of ships approaching harbour on the Isle of Wight.

since her return from Newport in 1678. Hooke was inconsolable, and lapsed into a gloom from which he never really recovered. Her untimely death at the age of twenty-seven left him once again with the prospect of a lonely, companionless old age. According to Hooke's first biographer, Richard Waller, 'the concern for [her] Death he hardly ever wore off, being observ'd from that time to grow less active, more Melancholly and Cynical'.[28]

Once again, as in his youth when times were bad, the boy from the Isle of Wight dreamed of long-distance sea-travel, and escape to exotic, unknown lands. There would always be, in Hooke's imagination, a mismatch between the bold, adventurous spirit in which he had set out from the Isle of Wight as a boy in search of his fortune, and the social and (at times) intellectual small-mindedness of the comparatively parochial milieu within which he subsequently lived, rarely even leaving London. When he did go 'abroad', as during the period when he was designing and overseeing the building of Ragley Hall in Warwickshire – hiring a horse, and spending several days on the journey – his diary entries make it clear that he found the experience exhilarating. But his poor health and, in the end, his anxious temperament, made him an unsuitable candidate for ambitious journeys by sea.

He envied those in his Royal Society and coffee-house circles who travelled extensively. After Grace's death, there was nothing except his

by-now fragile constitution to keep him in England, and from then on he became increasingly absorbed with the fascinating stories, information and materials brought back by those who did roam, from far-flung places, or indeed, from expeditions closer to home. In March 1689, Hooke recorded, with a note of envy, in his diary: 'Hally a sayling'.[29] His friend and Royal Society colleague Edmond Halley was off aboard ship on a research trip sounding and surveying the depths of the English Channel. Hooke would have liked to have gone with him.

Hooke had always had a penchant for the sea. He never missed an opportunity for an outing on a ship – even a comparatively short one. The most frequent were those undertaken in the company of distinguished members of the Royal Society, with whom Hooke might travel on a 'pleasure boat' down the river. We may recall the May Day excursion to Greenwich in 1665 described by Pepys, when he joined Hooke, Wilkins, Brouncker and Moray on a trip.

Arriving back by boat at Deptford on that occasion, Pepys alighted with Evelyn, Wilkins and Hooke, and the three of them repaired to Evelyn's house, Sayes Court, for further refreshment. Pepys, Wilkins and Hooke then completed the journey home on foot, the two scientists clearly enchanting the diarist with their talk:

> There stopped, and in to Mr. Evelings [Evelyn], which is a most beautiful place, but it being dark and late, I stayed not; but Dean Wilkins and Mr. Hooke and I walked to Redriffe, and noble discourse all day long did please me. And it being late, did take them to my house to drink, and did give them some sweetmeats – and thence sent them with a lanthorn home – two worthy persons as are in England, I think, or the world.[30]

Evidently an idyllic outing, for Hooke as for Pepys. To Hooke, going on board ship and setting sail into the unknown was a personal romance.

In a Cutlerian lecture of 1674 Hooke reminisced with obvious enjoyment about a trip on one of Charles II's 'pleasure boats' ten years earlier, in the company of the Earl of Kincardine (Alexander Bruce), Lord Brouncker and Sir Robert Moray, testing pendulum clocks:

> In february <or march> 1664 as I remember my Lord Kingkarden [Bruce] having gotten another made here in England did together with my Ld. Brounker Sr. Ro Moray & my self make

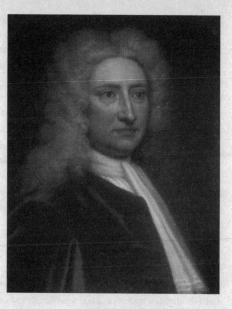

Edmond Halley in his uniform as a sea-captain – a man more inclined than Hooke to take risks in the course of his career.

a further tryall of them with some of the Kings Pleasure boats but not with soe good successe as was expected one of the watches by the shaking of the boat in the carriage from white hall to greenwich ceasing to goe, & the watches afterwards not keeping exact proportion to one another.[31]

It is possible that on this occasion the experiment with the watch took the party as far as Holland.[32] A voyage of some duration was required in order to test whether two watches were keeping time with one another.[33] A similar trip down the Thames as far as the sea, taken by John Evelyn and friends for pleasure in 1669 involved an absence from London of two full days.[34]

Edmond Halley had made his first long-distance overseas voyage in October 1676, when he abandoned his degree course at Oxford and – armed with a letter from Charles II himself instructing the Court of Committees of the East India Company to provide him with free passage – set sail for St Helena, England's southernmost possession, to map the stars in the southern hemisphere.

Halley was just turned twenty when he boarded the East India

Company's ship *Unity*, outward bound for St Helena.[35] Although the purpose of his trip was scientific, his determination to undertake the long sea-voyage had been set by the adventures of his contemporary Charles Boucher, who had sailed six months earlier for Jamaica, and survived storm and shipwreck (though he lost both instruments and books of astronomical tables) to produce outstanding new data based on his observations under the ideal meteorological conditions in the island.

Halley's first departure – impatiently abandoning astronomical observations at Greenwich with the pedantic, punctilious Flamsteed, in search of his own observations of stars in the southern hemisphere – was one of those turning points in Hooke's life, when he was forced to recognise his own comparatively restricted position in relation to the pursuit of knowledge. Hooke was no risk-taker. Halley was well known to him, as Flamsteed's enthusiastic young assistant at the new Royal Observatory at Greenwich. The previous year Hooke had been centrally involved in the hasty building of the Observatory, as well as in the manufacture of some of the instruments in use there. But while Hooke stayed in London, bemoaning the English weather, which frequently made observation of important astronomical events impossible, Halley had assembled a group of prominent financial backers, and persuaded the East India Company to accept him as a passenger on the next boat bound for St Helena.[36]

Hooke regarded new instrument-design as an important part of the quest for natural knowledge. The introduction to *Micrographia*, as we saw, had maintained that, by enhancing the human faculties with the use of instruments, mankind could regain that knowledge lost at the Fall. Each of Hooke's publications of the 1670s bracketed together experimental discovery with new instruments. There too Hooke stressed the gains to be had from properly precise instruments for measuring and exploring natural phenomena:

> I would not have the World to look upon these as the bound
> or *non ultra* of humane industry . . . For I can assure them, that
> I have my self thought of, and in small modules try'd some
> scores of ways, for perfecting Instruments for taking of Angles,
> Distances, Altitudes, Levels, and the like, very convenient and
> manageable, all of which may be used at Land, and some at

*Overleaf* Views of the island of St Helena from Linschoten's *Itinerario*.

Vera effigies et delineatio Insulæ Sanctæ Helenæ
spectat sitæ in altitudine 16 graduum ad
Waerachtighe affbeeldinghe en gelaente vant Eylant Sant
leggen op die hoochte van

casum, et Septentrionem
ncer æquinoctialis.
Oost, Noort, en West zyde ge-
Linea equinoctiael.

Dit is den eersten hoeck, daermen om loopt,
ontrent tt roer schoet daer by heen seylende.

AMPLISSIMO CLARISSIMOQVE
VIRO D. FRANCISCO PETRO
MAELONIO ENCHVSANO OR
DINVM HOLLANDIÆ ET WEST
FRISIÆ APVD PRINCIPEM MAV
RITIVM CONSILIARIO ORDINA
RIO ETC. IOANNES HVGO A
LINSCHOTEN L. M. D. D.

Den tweeden hoeck

ih de Noort zyde vant Eylant Santa Helena
roer schoet nae by heen seylt

Aldus verthoont hem de west zyde vant eylant Santa Helena
als men der op de Reede geanckert leyt ontrent ten roer
schoet vant lant aff

3 40 en 14?
Baptista á Doetechum sculp

Sea. . . . Let us see what the improvement of Instruments can produce.[37]

Halley set off on his travels armed with the latest equipment: Towneley's eyepiece micrometers, the mural quadrant with improvements in the divided scales, better telescopes with long focal length, and accurate pendulum clocks.[38]

In spring 1679, shortly after his return from St Helena, Halley again took to the seas, travelling this time to Danzig. He was sent there as the Royal Society's official emissary, to assess at first hand how precisely Hevelius was able to measure the movements of the celestial bodies, using the best possible equipment (as his was acknowledged to be), but without the help of telescopic sights.

When Hevelius published his *Machina coelestis* in which he described his methods for using open sights to observe directions with the naked eye, he had been severely criticised by Hooke, first in a Cutlerian lecture, and then, a year later, in his published *Animadversions*. This was Hooke's way: an aggressive polemic, combined with a challenge, and a claim that he could produce better results himself. Greatly offended by Hooke's tone, Hevelius complained directly to the Royal Society. It is not clear whether the Society decided to send someone equipped with instruments with telescopic sights to Danzig, to test Hooke's claims against Hevelius', or whether Halley – who had wanted to inspect Hevelius' observatory and instruments – volunteered. Either way, the man prepared to undertake such a trip was Halley.[39]

Halley began observing with Hevelius as soon as he arrived in Danzig, on 26 May 1679. Halley had brought with him the 2-foot quadrant he had used on St Helena. Hevelius used a quadrant, a large sextant for angular distances between stars, and a 12-foot telescope. Six observers participated in the trials, including Hevelius' wife. Halley was surprised at how good Hevelius' results were, in spite of Hooke's incredulity: the skies above the observatory were exceptionally clear, Hevelius' instruments were excellent, and so was his eyesight. Halley wrote to Flamsteed on 7 June:

> But as to the distances measured by the Sextans, I assure you
> I was surpriz'd to see so near an agreement in them, and had
> I not seen, I could scarce have credited the Relation of any;
> Verily I have seen the same distance repeated severall times
> without any fallacy agree to 10″, and on Wednesday last I myself

Johannes Hevelius and his wife making astronomical observations at his private observatory, using a large-scale quadrant and the naked eye.

tryed what I could doe, and first I at the moveable sight, and the Printer at the fixt, did observe ... then we removed the Index, and my Lord [Hevelius] at the moveable sight, and I at the fixt, did observe the same ... and you will find the same distance six times observed in Page 272 of ye fourth book of his Machina Coelestis, so that I dare no more doubt his Veracitye.[40]

Although Halley made conciliatory noises to Hevelius, and Hevelius himself was delighted with his visit, privately Halley admitted on his return that he remained unconvinced. Hooke evidently felt that he had been vindicated. In his diary he recorded: 'Halley returned this day from

Dantzick.' Later Halley told William Molyneux of the Dublin Society that Hevelius had been 'peevish':

> The Controversy between Mr Hevelius and Mr Hook, as you very well observe does, as Hevelius manages the matter, affect all those observers that use Telescopic sights, and myself in particular, and it is our common concern to vindicate the truth from the aspersions of an old peevish gentleman, who would not have it believed that it is possible to do better than he has done, and for my own part I find myself obliged to vindicate my observations made at St Helena and to rectifie some mistakes, whether wilfull or not I cannot say.[41]

Whereas Halley retained Hevelius' esteem, however, Hooke provoked him into a published *ad hominem* attack for having doubted his measurements. This appeared in his *Annus climactericus* (1685) – a volume in which he also gave an extremely favourable account of Halley's observations on St Helena. The publication of this volume precipitated a row within the Royal Society which once again tested the mettle of both Hooke and Halley, and from which, once again, Halley emerged covered in glory, while Hooke's fortunes continued to ebb.

Of course, Halley was a man of very different temperament from Hooke's. But he also had far broader intellectual horizons than Hooke, as a result of his travels. Hooke's peremptory dismissals on paper of the work of others, some published, some still stuffed among the higgledy-piggledy surviving papers strewn through the Royal Society and other archives, always take the tone of the man left behind – the man at home, painstakingly sifting the evidence others set out exuberantly to find.

The September–October 1685 issue of *Philosophical Transactions*, for which Francis Aston and Tancred Robinson were responsible as honorary Secretaries, published a review of a collection of Hevelius' letters included in his recently published *Annus climactericus* volume. The review was anonymous, though Waller indicates in a summary of the row, included in the introduction to Hooke's *Posthumous Works*, that their author was John Wallis – another of Hooke's old Oxford colleagues turned enemy, with whom he had crossed swords over whether or not fossils were petrified organic material (in this case, Hooke was conclusively right).[42]

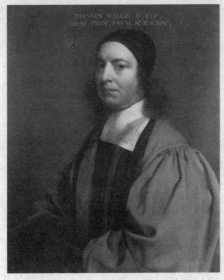

John Wallis, distinguished mathematician, cryptographer and in later life determined adversary of Hooke.

In summarising their contents, the reviewer took apparent delight in recycling yet again Hevelius' damaging slurs on Hooke's reputation, arising from Hooke's criticism of Hevelius' astronomical data:

> After these observations, of the year 1679; are 27 letters which had passed between the *Author* and divers other learned men, relating to the controversy between him and Mr. *Hook*, about the use of *Telescopick Sights* . . . The 10th. is of the *Author* to D. *Fullenius*, complaining of Mr. *Hook's* unhandsome usage of him in his *Animadversions* on the *Authors Organographia*, or first part of his *Machina Cœlestis*, (then newly come to his hands:) As making it his business, to carp at all his Instruments, and render them suspected; to blacken and disparage to the Learned World, all his Observations; (which he had never seen, nor could see.) . . . But wonders that Mr. *Hook*, who hath never yet performed, or so much as attempted, any thing in this kind; should take upon him thus to censure others. Thinking that it more becomes learned Men, not to boast of what they *can*, or *will*, or *mean* to do, but rather to let the world know what they *have* done. And when Mr. *Hook* hath performed such things so

much more accurate, it will then be time to tell the World what they are.

There is no mistaking the enjoyment John Wallis is deriving from recapitulating Hevelius' libels on Hooke. He carefully draws the reader's attention to the place where Hevelius prints correspondence between himself and Oldenburg, in which Hooke is candidly criticised. Once again, here is the long-dead Secretary's betrayal of Hooke to a foreigner:

> The 11th is a letter of his, of like complaint, to Mr. *Oldenburgh* ... That himself useth, in his own studies, to mind rather his own business than that of others; without prescribing to others (Dictator-like) what steps they must follow, and impose on them his own methods and contrivances, as absolutely the best, safest, and subtilest, of all that may ever be invented by any man: whereas Mr. *Hook*, he finds, more inclined to meddle with others business than with his own; and rather to find fault with what is done by others, than to do any thing himself.

Hevelius ends by proclaiming Hooke to be all noise – asserting that in the field of astronomical observation he has achieved absolutely nothing concrete himself:

> That he makes it his own business to perswade him and all the world, that his own way is the best, safest, and most exquisite, which ever can be invented by any; reproching this *Author* all along for not obeying him and following his dictates, (as if this *Author* were one under his command;) Bragging only of what he can do, but doth nothing.[43]

In the row that followed the publication of this issue of the *Philosophical Transactions*, the Secretaries who had sanctioned the publishing of the offending item eventually had to take the blame.[44] On 9 December 1685, Francis Aston and Tancred Robinson resigned their posts. Writing to William Molyneux, Halley affected surprise at the suddenness with which this had come about. A week after his re-election as Secretary when 'every body seemed satisfied and no discontent appeared anywhere':

> On a suddain Mr. Aston, as I suppose, willing to gain better terms of reward from the Society than formerly, on December

9 in Councell declared that he would not serve them as Secretary
. . . after such a passionate manner that I fear he has lost severall
of his friends by it.[45]

After two months of 'heated debate', two close friends of Hooke and
Halley replaced Aston and Robinson – John Hoskins and Thomas Gale.[46]
A salaried post of Clerk was created, to which Halley was elected by
a comfortable majority. Halley immediately assumed responsibility for
publishing the *Philosophical Transactions* (including financing their
printing). One can only imagine the behind-the-scenes drama that had
led to this outcome. Once again, while Hooke fumed and threatened,
Halley stepped in and took control.

Molyneux, whom the news had reached in Lancashire, wrote to
Flamsteed in some anxiety on 22 December:

I am very much troubled at some accidents I have lately heard
has hapend amongst the Royal Society. I hear My Freind Mr
Aston has given up his place. Of Secretary, and so Dr Robinson.
I should be much obleidged by an Account from you of these
Transactions, for I fear these Animositys will do the Society no
Service.

Molyneux is particularly worried that he may inadvertently have contri-
buted to the row, by an accident of phrasing in a recent communication
with the Society of his own:

I lately writt a Letter to Mr Aston concerning Hevelius Annus
Climactericus, if it lye in your way, Pray desire from him a sight
of that Letter, and lett me know what you think of the Remarks
and Collections I make therein; I hear that when it was Read
to the Royal Society, the Word Pamphlet (by which I stiled Mr
Hookes Animadversions on Hevelius Instruments) did Movere
Bilem [brought up bile] in Hookes Party, but tho I do not
much Matter it, yet I declare I designed no slight in the Word,
for I thought all little books that were that way Loosly stitched
together and usually so sold may be called a Pamphlet.[47]

'I hear Dr Wallis has taken up the Cudgels and Vindicated Hevelius
against Hook,' writes Molyneux in conclusion. If so, he adds, he is
content to be of Wallis's party: 'I should be very glad if the Dr and I
have jumpt together.'

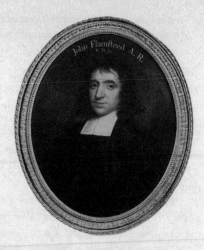

John Flamsteed, the first Royal
Astronomer, a man as difficult and
argumentative as Hooke himself.
The two quarrelled regularly, and
Flamsteed was only too happy to
comment with some amusement
on Hooke's altercations in print
with others.

On 20 February 1686, Molyneux wrote to Flamsteed again. According
to what he had heard, the controversy over Hevelius was still raging: 'I
perceive the Controversy between Hevelius and our English astronomers
will never be Ended whilst the Old-Man lives, and indeed ... I think
Hevelius much to Blame.' Molyneux has also heard that, to pacify
Hooke, Halley is preparing to print a letter refuting Hevelius' charges in
*Annus climactericus* himself. However, Molyneux goes on, 'Surely he can-
not for shame Contradice that large encomium he gives of Hevelius Instru-
ments in his Epistle to that Book' – Hevelius had reprinted Halley's letter of
endorsement, written following his Danzig visit, in *Annus climactericus*.[48]

By this time Molyneux knew that Halley was 'Chozen Head-Clerk
or under secretary to the Royal Society', and he sent his congratulations,
though he is sceptical about the phlegmatic Halley's ability to cope with
the heavy responsibilities of the job: 'If Mr Halley will be Diligent, he
may Discharge that place with great advantage, but I fear he may love
his eas a little too much, and if so, all the Correspondents fail of Cource.'
In spite of Molyneux's fears, however, Halley's temperament seemed a
good deal better suited to the task than had Hooke's.

When Flamsteed finally responded, his partisanship is evident:

> You need not be concerned at Dr Wallis his account of Hevelius
> his booke hee is onely minding to gratifie his old freind, and
> speakes the better of him both because hee is sensible with the

rest of the World of Mr Hookes intollerable boastes, as also by reason hee . . . understands not the advantages of telescope sights above plaine ones.[49]

It was in his new capacity as salaried Clerk that Halley took the momentous step of bringing Newton's *magnum opus* on planetary motion before the Society, to recommend its publication. On 21 April 1686, Halley announced to the Royal Society that Newton's treatise on celestial motion was almost ready to go to the press (the manuscript of Book One of *Principia* was presented to the Society at the meeting the following week). Epoch-making moment though this was the Hooke row rumbled on.

Ever the urbane conciliator, Halley also read to the Society part of a letter from William Molyneux. Molyneux had been quite right in thinking that his 'pamphlet' slip of the pen in his letter read at the Royal Society had further inflamed the row between Hooke and the Society's Secretaries. Now (in spite of that admission to Flamsteed that he tended towards Wallis's side in the argument) he wrote praising Hooke's continuing ingenuity:

Indeed I have always had a great esteem of his mechanical inventions, of which I look upon him to be as great a master as any in the world; and that is a most curious part of philosophy, and really useful in man's life.[50]

Eventually Halley once again gave up the hothouse atmosphere of the Royal Society, where Hooke found himself more beleaguered with every passing day. In 1698, after many years of lobbying to be given a suitable vessel in which to sail, Halley set out for destinations much farther afield. He embarked on a long-projected attempt – the first of its kind – to map the earth's magnetic field.[51] He sailed from Deptford on 20 October, as captain in command of his Majesty's pink, *Paramore*. The Admiralty instructions issued with his commission (which Halley had drawn up himself) stipulated that he was to 'endeavour to gett full information of the Nature and Variation of the Compasse over the whole Earth, as Likewise to experiment what may be expected from the Severall Methods proposed for discovering the Longitude at Sea'.[52] A bold project, on a global scale, and one which set itself goals well beyond the horizon of current knowledge.

From then on his return trips to London were increasingly infrequent, though when he was there he invariably met up with Hooke. He was away, however, when Hooke died in 1703; it was another sea-captain who took his place as the companion of Hooke's final days.

If Hooke could not go a-sayling himself, he could interrogate those who did. With his own travels no more than a daydream, he satisfied his thirst for knowledge from all corners of the globe by keeping the company of those who were globe-trotters and adventurers. From the 1680s Hooke took a growing interest in travel narratives, cartography and exotica (this last for the Repository at the Royal Society, much of it housed in his Gresham College rooms). He cultivated men-about-town with connections with London's maritime trade, and above all the East India Company. Of the many with whom he sat down to coffee, chocolate or a pipe of tobacco in Jonathan's or Garraway's in these years, Robert Knox became his closest friend.

In autumn 1680, Captain Robert Knox returned to England, after twenty years in captivity on the island of Ceylon. He and his father – traders in oriental goods in the Far East – had been taken prisoner while trading under the auspices of the East India Company. Knox's brother was a long-standing coffee-house friend of Hooke's, and was evidently a painter or engraver. The younger Knox was one of Hooke's sources for the kind of anecdotal knowledge on the history of 'trades' which he liked to collate for presentation at Royal Society meetings. On 8 August 1677, for example, Hooke was at his favourite haunt, Garraway's:

> Knox [Robert's brother] told way of cleansing pictures by scraping i [ounce] of castlesope in a pint of water and mixing with it flower enough to make a batter, which layd on a dirty old picture and let lye for ¼ of an hour till dry would fetch off when washt with water and a fine soft brush, all the dirt stains and varnishes and leaves the picture as fair as if new.[53]

It was coffee-house gossip, too, that gave Hooke the news of Robert Knox's fortunate escape, and his imminent return to London:

> Sunday, September 12th [1680] – Perused 1st Journal [of the Royal Society]. Dined Home. Haak chesse. Knox his brother escaped out of Ceylon after 22 years detainder. . . .

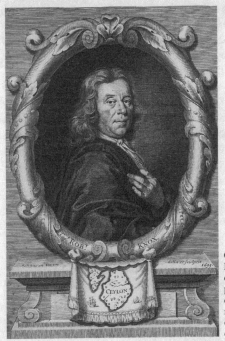

Captain Robert Knox. Engraved with Hooke's encouragement for a possible second English edition, which never materialised, of his account of his long captivity and life on the Island of Ceylon.

Monday, September 20th – Scarborough and Bates here. At Tooths, Bird talkd of Knox. At Garways. Dined Home. Slept p.p. Scarborough on Sir W. Jones account. mist Knox.[54]

Hooke, fascinated by the tales Knox had to tell, which Knox had begun writing down during his return voyage from captivity, encouraged him to publish his experiences. He probably contributed substantially to the narrative itself, whose reflections often sound uncannily like Hooke's own. Knox's brother may have assisted Hooke with the engravings. Robert Knox's *An Historical Relation of Ceylon together With somewhat concerning Severall Remarkeable passages of my life that hath hapned since my Deliverance out of my Captivity*, was published in autumn 1681.[55] The fold-out map it contained was for centuries the definitive representation of the interior of Ceylon.

Hooke and Knox evidently intended the book to attract the attention

and support both of the Royal Society and of the East India Company (whose service Knox was anxious to re-enter, following his release). The book was twice presented to the East India Company's Court of Committees for their 'approbation', in March and August 1681, and was ultimately dedicated to the Court of Directors of the Company.[56]

Hooke contributed a preface, in which there is no doubting his enthusiastic support for Knox's account of his extraordinary experiences. The Royal Society is committed, Hooke explains, to collecting accounts like Knox's of remarkable voyages and experiences in distant lands. These are a crucial part of the project to increase the bounds of human knowledge. Knox's narrative will encourage many others to do the same:

> 'Tis to be hoped that the kind Acceptance only the Publick shall give to this present Work, may excite several other Ingenuous, and knowing Men to follow this Generous Example of Captain Knox, who though he could bring away nothing almost upon his Back or in his Purse, did yet Transport the whole Kingdom of Conde Uda in his Head, and by Writing and Publishing this his Knowledge, has freely given it to his Countrey, and to You Reader in particular.

Hooke goes on to admit that it was he who persuaded Knox to publish:

> 'Twas not I confess without the earnest Solicitations and Endeavours of my self, and some others of his Friends obtain'd from him, but this uneasiness of parting with it was not for want of Generosity and Freedom enough in Communicating whatever he knew or had observed, but from that usual Prejudice of Modesty, and too mean an Opinion of his own Knowledge and Abilities of doing any thing should be worthy the view of the Publick. And had he found leisure to Compose it, he could have filled a much greater Volume with useful and pertinent, as well as unusual and strange Observations. He could have inrich't it with a more particular Description of many of their curious Plants, Fruits, Birds, Fishes, Insects, Minerals, Stones; and told you many more of the Medicinal and other uses of them in Trades and Manufactures. He could have given you a compleat Dictionary of their Language, understanding and speaking it as well as his Mother Tongue. But his Occasions

would not permit him to do more at present. Yet the Civil Usage this his First-born meets with among his Countrymen, may 'tis hoped oblige him to gratifie them with further Discoveries and Observations in his future Travels.

Hooke concludes with an uncharacteristic rhetorical flourish: 'Read therefore the Book it self, and you will find your self taken Captive indeed, but used more kindly by the Author, than he himself was by the Natives.'[57]

At several points in the book the author refers to the friendship he has formed with Hooke. Describing for the reader a particular kind of thornbush, Knox refers the reader to a specimen to be found in the Repository at Gresham College, 'each stick or branch whereof thrusts out on all sides round about, sharp prickles, like Iron Nails, of three or four inches long: one of these very thorns I have lately seen in the Repository at Gresham College'.[58] Later, he refers the reader to a book Hooke has shown him:

> I shall forbeare to write a description of the forme of this tree [the 'Cocornut'] since that & many other Indian trees & plants are so excelently done in prints in India by the life by order of the famous Dutch Generall Matt-Sucar in a booke I have seene at Dr. Robert Hooke called Ortus Mallibaricus, that I thinke it cannot be done more Lively.[59]

Quite apart from his own fascination with Knox's tales of Ceylon life, Hooke quickly realised how useful his meticulously detailed information could be to the Royal Society as part of its investigations into peoples, cultures and trades. In January 1681, Hooke made his first presentation to the Royal Society of material derived from Knox and his travels:

> Mr. Hooke shewed a piece of talipat leaf, which one Mr. Knox, who had been nineteen years captive in Ceylon, had brought with him from thence. It was about seven feet long and nine feet wide at one end, shaped like a woman's fan, closing and opening like that. The whole leaf was said to be a circle of twenty feet diameter.[60]

Knox describes the oversized talipot leaf in the *Historical Relation of Ceylon*, and a vivid engraving is included of its convenient use as a sunshade or umbrella. There too he mentions that he brought one

Gedrukt by WILHELM BROEDELET Boekverkoop

Frontispiece and title-page of the later Dutch edition of Knox's *An
Historical Relation of Ceylon*, published in 1692.

T' EYLAND

# CEYLON

In sijn binnenste, of 't Koningrijck

## CANDY;

Geopent, en Nauwkeuriger dan oyt te vooren ontdeckt

DOOR

# ROBERT KNOX,

Scheeps-Capitain der Engelsche Oost-Indische Compagnie, die
20. Jaren langh in dit Gewest gevancklijck aengehouden ge-
weest, en eyndlijck 't selve door de Vlugt ontkomen is.

## BEHELSENDE

Een eygentlijcke Beschrijvingh, soo van 't Landschap in sigh selven,
als der Inwoonderen Politie, Regeeringh, Godsdienst, Zee-
den, Konsten, en meenigerley seldsame Gewoonten.

*Vertaeld*

DOOR

## S. DE VRIES.

*Met koopere Figueren, en een nieuwe nauwkeurige Land-kaert van 't
geheele Eyland* CEYLON.

Tot UTRECHT,

By WILHELM BROEDELET, Boeckverkoper
CIƆ IƆC XCII.

*between p. 14 & 15.*

*The manner of their sheltring themselves from the Raine by the Tolipat leafe*

Engraving of a man sheltering under a talipot leaf, from the English edition of Knox's *An Historical Relation of Ceylon* (1681).

away with him when he was finally rescued (this was apparently the first English appearance or mention of this species, or its curious leaves).[61]

In May 1681, just as Knox's book was published, Sir Josiah Child, Governor of the East India Company, appointed him to a new commission as captain of the *Tonqueen Merchant*, with instructions to conduct the Company's trading business in Vietnam and Java, returning with a cargo of pepper.[62] Here was an opportunity for Hooke to give specific instructions for gathering interesting specimens for the Royal Society, issued to a responsible and trusted traveller. During their regular

coffee-house conversations Hooke explained to Knox the kinds of rarity which might be suitable to be added to the Society's Repository.

Knox lived up fully to Hooke's expectations, returning to London on 29 August 1683 with a magnificent collection of exotic curiosities. On 21 November 'Mr. Hooke brought in a paper of curiosities brought by Captain Robert Knox from Tonquin, upon the main of China, and presented by him to their depository'. These included 'a Tonquin plow and yoke, both varnished with the true lacker varnish. . . . This plow is so light and easy to be made and used that the Captin judged it might be of very good use here in England,' 'A true dolphin's skin, caught by the Captain in his homeward bound voyage, and stuffed' and 'the root of the tea-tree, which the Captain designing to bring home growing had planted, and kept in a pot of earth aboard the ship'. Knox's package also included a wide variety of seeds and cuttings from which Hooke hoped to grow viable plants in England: seeds of 'Tunquin oranges, the best in the world', 'of a certain bean or pease that grows in Java, and is there eaten commonly as pease or beans are here' and 'of watermelons, which grow in the island of St. Jago . . . carried to Tunquin . . . the melon grew and throve very well . . . and so, it was hoped, they might do in England'.

Three days later the Society agreed to present Knox with a handsome sum in appreciation of the pains he had taken in assembling the Tonquin collection: 'It was ordered . . . That a present be made from the Society to Mr. Knox and that it be of about 50s. or £3 value.' On 28 November, Hooke arrived with the curiosities themselves: 'Mr. R. Hooke delivered in a box for the repository the curiosities given by Captain Knox.'[63]

In early December 1683 Knox, by now a celebrity, was presented to Charles II at Whitehall Palace. He had 'an hours discourse' with him, 'many flocking about to hear it', among them presumably Hooke, who had had relatively easy access to the King's presence since the early days of the rebuilding of London after the Fire, and may indeed have facilitated the audience.[64]

Knox's East India Company commission for his next voyage on the *Tonqueen Merchant* was an unusual one, and came as a consequence of his success in identifying plant species for the Royal Society. In spring 1684 he was ordered to sail to Madagascar, where he was to take on board a cargo of mature male slaves and transport them to St Helena, to establish a plantation on behalf of the King, whose produce would

be used for reprovisioning East India Company ships on their way from London to the Far East. It was part of Knox's instructions that he should procure seeds and grain from Madagascar and Sumatra which in his judgement would thrive on St Helena:

> The greatest defect we know of in that Island is the want of grain to supply which he have already ordered you in our former letters to make some experiments. But among many thoughts and much discourse tending to the Improvement of that Island, we are at length in hopes you may produce very good Rice upon your highest Lands. Captain Knox that lived twenty years in Ceylon informing us, That there is a peculiar sort of Rice that growth best on high and dry Lands, the seed an cultivation whereof he knoweth very well.[65]

Nothing seems to have come of this experiment in transplanted species (Knox's arrival on St Helena coincided with a local uprising, and perhaps the project was abandoned, or the rice failed to prosper). Still, here is a vivid example of Hooke's influence extending beyond the coffee shop, and the circle of Royal Society virtuosi, to actual experiments in botany and agriculture, conducted *in situ*, by well-qualified associates.

At home, curiosity about exotic produce led Hooke and Knox together to conduct some unlikely experiments. In autumn 1689, they discussed the Indian use of 'bangue' or cannabis on three separate occasions:

> [Thursday, 24 October 1689] Cap Knox. Manna tree calld Ossagoi. in the Mauritius. Sanguis draconis [a much vaunted remedy for bleeding and malaise of all sorts] tree some as big as a mans middle. Wood spongy like a rush. beset with thornes 2 inch long & sharp like furs. 6 or 7 sorts of Ebeny wood other close yellow wood like box. the Island Diego Rodriges or Digo Rois east of Mauritius as big as the Isle of Wight. an excellent Island uninhabited out of trinidad &c.

> [Saturday, 26 October 1689] at Jonathans Captain Knox chocolate. ganges strange intoxicating here like hemp takes away understanding & memory for a time frequently used in India with benefit Rice not ingurious to the Sight nor damage to the teeth. . . .

[Tuesday, 5 November 1689] Captain Knox told me the intoxi-
cating herb & seed like hemp by the moors calld Gange is
in Portuguese Banga; in Chingales. Consa. tis accounted very
wholsome. though for a time it takes away the memory &
vnderstanding.[66]

Given Hooke's own regular use of intoxicants of all sorts, particularly
on account of his chronic insomnia, he clearly regarded the prospect
of 'trials' of this new substance with relish. On 18 December he delivered
a lecture at the Royal Society on 'bangue':

It is a certain Plant which grows very common in *India*, and
the Vertues, or Quality thereof, are there very well known; and
the Use thereof (tho' the Effects are very strange, and, at first
hearing, frightful enough) is very general and frequent: and the
Person, from whom I received it, hath made very many Trials
of it, on himself, with very good Effect.

Knox clearly reported his personal experiences with cannabis with gusto,
as also the details of how it should be taken:

The Dose of it is about as much as may fill a common Tobacco-
Pipe, the Leaves and Seeds being dried first, and pretty finely
powdered. This Powder being chewed and swallowed, or washed
down, by a small Cup of Water, doth, in a short Time, quite
take away the Memory and Understanding; so that the Patient
understands not, nor remembereth any Thing that he seeth,
heareth, or doth, in that Extasie, but becomes, as it were, a
mere Natural, being unable to speak a Word of Sense; yet he
is very merry, and laughs, and sings, and speaks Words without
any Coherence, not knowing what he saith or doth; yet he is
not giddy, or drunk, but walks and dances, and sheweth many
odd Tricks; after a little Time he falls asleep, and sleepeth very
soundly and quietly; and when he wakes, he finds himself
mightily refresh'd, and exceeding hungry.[67]

Drawing on that careful reading of Linschoten's *Itinerario* begun thirty
years earlier, Hooke remarked that Linschoten, too, had advocated the
therapeutic use of cannabis, for its aphrodisiac effects. It was, according
to Linschoten, 'said to be likewise used to excite Venery [sexual passion],
of which quality the Captain [Knox] is silent'.[68]

In autumn 1689 Knox also gave Hooke two books, one in Arabic, the other in Malabaric characters. From notes among Hooke papers it appears that they explored the characters and meanings of the Vietnamese language together. Knox also talked to Hooke over their usual cup of chocolate about Mauritius, the Cape and Bombay. Knox told Hooke that ebony was 'very black when cut' and that you could get 'true musk' at the Cape of Good Hope. 'The malabar arithmetick the same with ours. characters only differing'.[69]

Knox's involvement via Hooke with the Royal Society went beyond the collecting of specimens while abroad. With Hooke's encouragement, he also became involved in conducting scientific 'trials' during his long voyages. On 18 December 1689, in a Cutlerian lecture attended by, among others, Pepys, Aubrey and Evelyn, Hooke announced that he had found a volunteer to make a series of scientific observations involving astronomical and horological instruments, during a forthcoming voyage to China:

> There are two other instruments which I have heretofore mentioned to be worth the Imploying for the making of very usefull Discoverys in Nature which are as yet undetermined but may be by tryalls made with them be adjusted. . . . I would humbly propose that an Instrument might be sent by a person who will carefully make the observations and bring back a true account thereof to be Recorded as a Discovery first made and adjusted by this Society. the same person will also make exact observations of the Dipping & Variation of the magneticall needle if he be furnisht with one fitt to make the observations and will giue an account thereof at his Returne from China which I conceiue may be of Great Use to Navigation as well as of Single information as to the perfecting the theory of the magnetisme of the Earth, of which I conceiue noe one has yet suggested a probable cause.[70]

The 'careful person' mentioned here was Captain Robert Knox. According to Hooke's notes, the Royal Society accepted Knox's offer, and agreed to pay his expenses. A year later, on 3 December 1690, in one of his Cutlerian lectures concerning navigation and astronomy, Hooke mentions explicitly his scientific collaborations with Captain

Knox, whom he trusted to test his instruments and theories in remote locations:

> I much rejoice at this which I have now met with of Captain
> *Knox* his Voyage to *India*, who has promis'd to be very observant
> of it, and to keep an account thereof; and in pursuance of the
> Order of this Society, I have got a Pendulum Watch fitted for
> that purpose, which I now produce.[71]

Hooke's friendship with Knox was based on a shared passion for new experiences and knowledge, from all sources. They also shared a way of life – both single, and frequenters of the same coffee houses. Both, as it turned out, eventually felt undervalued by the institutions to which they had devoted their lives. Knox felt increasingly exploited by the East India Company, who eventually refused to commission him for any more voyages.[72] From the mid-1690s Knox was one of Hooke's closest companions. Hooke may never have managed to take that voyage beyond the eastwards horizon, but at least he could sit comfortably with a good friend, and fill his head with the sights and sounds of Vietnam, India and China.

A note from Knox to Hooke, written in February 1697, survives among Hooke's papers in the British Library.

> Sir, I desire you to except. these 2 bottles of Tent: which I am
> sure is true wine. for it was given me by one that sayled with
> me formerly. and is now come whome from Cales in Ship
> Tonqueene:
>
> > Your obligd humble servant
> > Robert Knox[73]

Tent is a kind of wine 'of a deep red color, chiefly from Galicia or Malaga in Spain'. Knox, recipient of so many cups of chocolate and pipes of tobacco, imbibed with Hooke at Jonathan's, here reciprocates, with the gift of an unusual, imported beverage for his friend.

Knox was not the only long-term inhabitant of exotic foreign parts whose experiences Hooke helped bring to the attention of the London reading public. He was also responsible, this time in conjunction with Sir John Hoskins, for persuading Samuel Baron – born and raised in Tonqueen – to publish his own account of his experiences.[74] Baron,

A London coffee house of the kind frequented regularly by Hooke and Knox together in the 1680s and 90s.

offspring of an English father and a Vietnamese mother, appears in Hooke's diary as someone he encountered regularly in coffee houses in the 1670s. He returned to Tonqueen in the 1680s, where he seems to have had dealings with Knox in his post-1681 travels for the East India Company.

Baron sent his manuscript to Hooke, who seized upon this vivid travel narrative, as he had done Knox's. The book had begun as a simple updating of Tavernier's travels, but Baron had gradually been persuaded (perhaps by Hooke) to rewrite an account of Tonqueen of his own. He describes Hooke's involvement in the 'advertisement' attached to his *Description of the Kingdom of Tonqueen* (1686):

> My design at first was not to undertake an historical narration of *Tonqueen*, but only to note the errors in Monsieur *Tavernier's*

description of that country, as it was desired of me by Sir *John Hoskins* and Mr. *Robert Hooke* out of *England*; but having made some small progress therein, I was quickly tired with finding faults and noting mistakes, also thinking I should thereby give but small satisfaction to the curiosity of those worthy gentlemen, whose highly active genius's penetrate the very essence of the most occult things, and finding it much more easy for me to compose a new description of *Tonqueen* (the country of my nativity, and where I have been conversant with persons of all qualities and degrees) than to correct the mistakes of others.

The autograph manuscript of Baron's dedicatory letter to Hooke and Hoskins, in which Baron several times reiterates his 'thankfulness and profound respects' to the two men, who 'induced [him] to undertake and finish the work', survives among Hooke's papers (mostly associated with the period in the early 1680s when he was Secretary of the Royal Society) in the British Library. The letter makes it clear that Hooke was once again the person who saw Baron's manuscript through the press, and it closes, much like Knox, by offering to become a source of Repository rarities:

I am now on a Voyage to China, where If I can Pick up any Curiosity or discouer any thing worthy your Sight or information, you are Sure to hear from me. the mean while recommend my selfe to the Continuation of Your favour.[75]

In an unpublished Cutlerian lecture Hooke explained the vital importance of foreign informants and the rich resources they assembled on their travels, to the global pursuit of 'natural knowledge':

In my late lecture I have treated concerning two of the Branches of Naturall Knowledge which I Reckond among the Number of Deficient <i.e.> which need to be further prosecuted and cultivated in order to their augmentation and increase. The first was the procuring and Collecting of Information and Descriptions of All such Inventions Are manufactured, or operations as are Extant and practised in Severall parts of the world, of which notwithstanding we for the most part ignorant here at home.

And <the> Second was the procuring the Description of the Naturall, Geographicall, and Artificiall History of Regions

countrys Island seas Citys, towns, Mountains, Deserts, plaices, woods and the like places, parts, and Regions of the Earth, whether Inhabited and Cultivated, or not Habetable or unfrequented, which may yet afford great Information for the Explication of various phenomena highly necessary to the augmenting and perfecting of Naturall philosophy. for that such instances doe often afford the limitations and boundarys of Naturall operations and Effects and seem to be sett as *termini* boundary stones or as the Lord Verulam stiles them *Experimenta Crucis*, to inform the traveller in Naturall inquiries that here is the utmost limit, and that this way or that way then is a *ne plus ultra*. and therefore he must turne another way.[76]

At the beginning of 1693, Hooke organised the printing and distribution of Simon de la Loubère's *New Historical Relation of the Kingdom of Siam, wherein a full account is given of the Chinese way of Arithmetick and Mathematick*, which his friend Alexander Pitfield had edited and translated from the French. Hooke saw the book through the press, and delivered twelve copies to Pitfield on 11 January 1693.

Another of Hooke's closest friends, Francis Lodowick, was a notable linguist, and for years they had both toyed with the idea of studying Chinese as a model for their projected universal language. In summer 1693 they had the opportunity to test their linguistic skills on some real Chinese visitors. Hooke heard about them at Jeremy's coffee house on 2 June, and met them on 10 July, when they came to Jonathan's with Sir James Houblon, a City alderman.

Two days later Hooke was out looking for them: 'Sought out Chinese: visited Lod . . . With Lod to Chinese: I shewed him Repository, Atlas Sinensis, Chinese Almanack etc.'. Eventually, on 31 July, they met them over tea, but found it impossible to understand the visitors' attempts at explaining their language: 'With Lod at the Chinese, tea: I could learn little, 8 or 10 characters pronounced all alike but of differing signification.'[77] Nevertheless, Hooke's attempt at explaining Chinese characters was published in the Society's *Philosophical Transactions*, complete with illustrations.

Hooke's transcribed Chinese characters brought his pursuit of knowledge from afar back to his early interest in the possibility of a universal

language. This had been one of his early mentor John Wilkins's projects, which had culminated in his *Essay towards a Real Character, and Universal Language*, in whose taxonomic systems Hooke had played his part.[78]

But Hooke's engagement with an escalating flood of material from afar was beginning to look more and more unfocused. Out of the mass of information, he, like the increasing numbers of Londoners investing haphazardly in money-making 'schemes', seemed to hope to turn up something which would make him once more the centre of London attention, and perhaps earn him a fortune. The likelihood of that happening grew smaller with every new informant, encountered at Jonathan's or Garraway's, and who, for the price of a cup of chocolate, was prepared to regale Hooke with their unique and fascinating stories.

Long after Hooke's death, just such a chance financial windfall finally restored Robert Knox's faith in God's benevolence. His niece Phoebe entered one of the many London lotteries and won: 'Phoeby . . . had in this lottery a ticket of ten thousand.' Some of it – one imagines a sizeable amount – she gave to Knox. He writes in exultation to his cousin John Strype that Phoebe 'is very generous':

> And as to my owne part: I doe take notice with great thankfulnesse to God, that hath Continewed my life, while all my fellow prisoners one Ceylone are longe since dead, & for the 20 yeares I was on Ceylone (whare he fed me with the fatt of the Land) And had laid up for me his holy Bible, he hath Continewed, my life 40 yeares since in freedome & prosperity.[79]

No such prizes came Hooke's way. In a locked chest in his Gresham College rooms he was amassing a huge fortune in coin and gems. But who knew what misfortunes might lie around the corner? As his wealth grew, Hooke's way of life became more parsimonious. In his diary he recorded each expenditure to the last penny; and he watched over the parcels of tea, for his daily brew in Harry Hunt's company, with increasingly obsessive vigilance.

# 8

## *Argument Beyond the Grave*

> I doe give to Knox Ward who beareth my Name viz: My Booke
> of Ceylon with Maniscripts of my owne Life – and my Ceylone
> Knife . . . the ceder I brought from Berbados, and the ebony
> I Cut my Selfe at the Iland of Maurushus . . . and my Ring
> Dyall and Sea-quadron, and my Load Stone and Anchor which
> was the Honorable Robert Boyles and after Dr Robert Hooke
> . . . all to keepe in Remembrance of me.
>
> Last will and testament of Captain Robert Knox[1]

The final long, slow decline in Hooke's active professional life began
with the abdication of James II in 1688, and the installation of
William of Orange and his wife Mary Stuart as King and Queen of
England in spring 1689. It is doubtful, though, whether Hooke or
any of his close friends fully understood at the time the impact the so-
called Glorious Revolution would have on the careers of those who
had 'trimmed' in the twilight years of James II's reign. In the new
diary Hooke began on 1 November 1688, as a Dutch invasion seemed
increasingly inevitable, he kept a vivid record of the uncertainty of
those days. On several occasions he reported 'confusion' among those
frequenting Jonathan's – where Hooke found he could generally get the
most up-to-date news of unfolding events – and on several others there
was general 'alarm' at news of riots and looting in and beyond London.

William's forces landed at Torbay on 5 November, although rumours

of his arrival had been circulating at Jonathan's for almost a week. In the days that followed, Hooke, more often than not in the company of his old friend Wren, shuttled between the more fashionable coffee houses with even more than their usual determination, seeking reliable information concerning the political situation. On 5 November itself, Hooke recorded:

> Dutch seen off the Isle of Wight. Dined Home. At Jonathan's. Henshaw, Hally [Edmund Halley, FRS], Gof [Sir Godfrey Copley, FRS], Lod [Francis Lodwik, FRS], Pif [Alexander Pitfield, FRS], Wall. [Richard Waller, FRS]. In vault did little. At Jonathan's. Dutch sayd to be landed at Pool. Tison and Henry Hunt here tea, chocolate. A mystick letter Aubrey. Horn at Jonathan's. DmD [God help me]. Candles.[2]

Hooke had been at his local coffee house no fewer than three times that day, gathering gossip and news about the Dutch assault. On 12 November, Hook, Wren and Wren's brother-in-law William Holder went to Jonathan's where there was 'news of yesterdays and this days riots of Rabble'. On Saturday, 17 November, Wren and Hooke were at Man's coffee house at Charing Cross, when they learned that King James had sent his wife and baby son to Portsmouth, and thence to the safety of the French court.

By 11 December the situation was deteriorating, and Hooke's diary reveals his growing anxiety:

> Tuesday 11 [December 1688]. This morn at 3 of the Clock the King left White Hall; tis not yet known whither he is gon. Many Nobles and Bishops with Lord Mayor at Guildhall: Common Councell in the evening voted an address to the Prince of Orange: rable rifled Salisbury house and all the masshouses about the town, as Lincoln Inn feild, St Jones, Bucklersbury, Line street and burnt the furniture: 3 regiments in the Gard, papists disarmed: the tower surrendred to Lord Mayor and Lord Lucas Governor disarmed all Papists in the tower. Jeffrys, Herbert etc. said to be gone.

Saturday, 15 December was for Hooke the low point of his private nervousness and uncertainty concerning the unfolding events. He was at the Feathers with Wren, where they were joined by Sir John Hoskins, Waller, Halley, and other members of his circle – 'confusion all', Hooke

noted. They all went on together to Jonathan's where the atmosphere was 'much the same'. Back at home, Hooke fell into one of his debilitating depressions: 'Melancholy MmD [Lord have mercy on me]'.

On a frosty Christmas day, with snow on the ground, Hooke had recovered his spirits enough to thank God ('DG [Deo Gracias]') for continuing peace, and the fact that when he went to Jonathan's – to find only Halley also had nowhere to go on the holiday – there was 'noe news'. The following day, however, came the news that the Convention, or assembly of elected representatives charged with deciding the outcome of the Prince of Orange's bid for the English throne, had declared in William's favour:

> Newes in the Conuention this day: 350 of Charles II Parliament men and 74 of City desired Prince of Orange to be Regent to January 22: young Terkonnel, Castlemain and others said to be seized in Glocestersheir, where 40000 was sayd to be in armes [on] the Larum night. All subscribed Association, as did the Convention this day. TDL [God be praised].

'God be praised' was written by Hooke with considerable feeling. The prospect of another period of civil unrest, of the kind which had blighted his childhood, had narrowly been averted. Even the rule of a foreigner was preferable. Now it was a matter of waiting to see which English factions would be in the ascendant alongside the Dutch administration William quickly installed at Hampton Court (within days of his arrival, the appalling smog in central London gave him such an acute attack of asthma that he moved all court business out of town).

While Hooke and his friends were waiting anxiously to see which way the wind would blow under William and Mary, his old adversaries, Newton and Christiaan Huygens, were both moving with assurance into positions of power and influence within the new Anglo-Dutch regime.

Christiaan Huygens's elder brother Constantijn arrived in London in February 1689 in the train of William of Orange. Having replaced his father as the Prince's first secretary and trusted adviser, Constantijn was now a person of real political significance in England.[3]

Constantijn's new position offered Christiaan the temptation to come out of retirement, with the prospect that he could now be assured of real respect from the English virtuosi. He had been discreetly sacked

Coronation of William and Mary in 1689, showing the joint monarchs
on adjacent thrones, with matching regalia. Hooke reluctantly accepted
the arrival of the Dutch King and Queen, preferring smooth succession
to the kind of civil unrest he had experienced in his youth.

from his salaried post in Paris, following the death of his protector,
Colbert, and growing anti-Protestant feeling there, which led Christiaan
to fear for his safety. In January 1685 Huygens had retired to Hofwijk,
the Huygens family home on the outskirts of The Hague. By the summer
he was once again in a state of nervous collapse, suffering from fevers
and migraines, and, recognising that he would never hold down a proper
job again, the aged Sir Constantijn, his father, settled an annual pension
for life on his beloved Archimedes.[4]

Christiaan had a further reason for being lured away from the se-
clusion of Hofwijk. For two years he had been poring over Newton's
*Principia*, of which the author had sent him a presentation copy, work-
ing painstakingly through its mathematical calculations, with growing
admiration. Shortly after he read it, Christiaan Huygens told Constantijn
that he had enormous admiration for 'the beautiful discoveries that I
find in the work he sent me'.[5] When John Locke came to visit him, and
asked him if he thought the mathematics – which he admitted he could
not himself follow – were sound, Christiaan told him emphatically that
they were to be trusted. Newton, to whom Locke reported this, proudly
repeated the Dutch mathematician's endorsement in London. A visit to
London would enable Huygens to meet Newton face to face.

He resuscitated and rewrote his ten-year-old treatise *Traité de la lumière* [*Treatise on Light*], to provide him with his credentials for re-entering European intellectual life, and prepared to travel to England. He wrote to Constantijn:

> I had intended to stay here at Hofwijk for the whole winter. . . . However, you might have an opportunity to see Mr. Boyle. I would like to visit Oxford, if only to make the acquaintance of Mr. Newton [in fact, of course, Newton was at Cambridge] for whose excellent discoveries [*belles inventions*] I have the greatest admiration, having read of them in the work [*Principia*] which he sent me.[6]

Christiaan arrived in London on 6 June 1689. He joined his brother Constantijn and his son in lodgings close to Whitehall, and a week later the three of them went together to stay at Hampton Court Palace, where the King and Queen were in residence. On 12 June Christiaan travelled by boat back to London for a meeting of the Royal Society:

> Meeting at Gresham College in a small room, a small cabinet of curiosities, over-full but well kept. Hoskins President, Henshaw Vice-President, Halley Secretary. Van Leeuwenhoek's letter was read. Newton and Fatio were there too.[7]

Two weeks later, having returned to Hampton Court, Christiaan Huygens had an audience with the new King and dined with William Bentinck, Earl of Portland, the most powerful man at court. It was suggested that, as an esteemed virtuoso particularly well connected with the Dutch royal household, Christiaan might put in a word with William III on Newton's behalf, for a promotion. Two days later, on 10 July, Christiaan, Nicolas Fatio de Duillier and Newton assembled at seven in the morning in London, 'with the purpose of recommending Newton to the King for the vacant Mastership of a Cambridge College'.[8] On 28 July Christiaan attended a fashionable concert, at which Hampden introduced him to the Duke of Somerset, Chancellor of the University of Cambridge, and Newton's preferment was once more discussed.[9]

The Cambridge college whose headship Newton had ambitions to fill was King's, and the court lobbyist on Newton's behalf who approached Huygens was John Hampden, a leading parliamentary player. Huygens's intervention evidently had the desired effect. Shortly thereafter, William

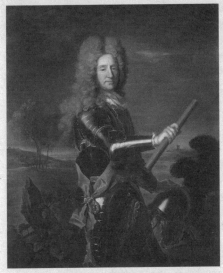

William Bentinck, 1st Earl of Portland, the most powerful man at the court of William and Mary. Christiaan Huygens lobbied him on behalf of Newton in 1689.

wrote to the Fellows of King's College, informing them of his desire that they appoint Newton as their new Provost. The new foreign King was, however, roundly rebuffed by the Fellows, who chose another candidate. This was probably just as well for Newton's future career as a public figure, since imposed royal appointments were deeply unpopular.[10]

Although this personal intervention of Huygens's to advance Newton's career was unsuccessful, their scientific relationship was thereby strengthened. In August, before he left for home, Huygens received two papers from Newton on motion through a resisting medium. At some point during the visit they also had lengthy discussions of optics and colour.[11] Huygens told Leibniz that Newton had communicated 'some very beautiful experiments' to him – probably his experiments with thin films, similar to the ones Huygens himself had performed twenty years earlier, and similar to those Hooke had recorded in his *Micrographia* even earlier.[12]

As Christiaan Huygens had discovered, the Glorious Revolution had begun the process of improving Newton's prospects under the new Anglo-Dutch regime also. In the period of uncertainty leading up to the Dutch invasion, and William's claiming the English throne, Newton

had already begun to emerge from his sheltered position as a solitary scholar at Trinity College, Cambridge. In 1687, when James II's interference with the University roused even those as aloof as Newton from their political indifference, he found himself nominated to act for the University in what turned out to be a critical piece of resistance to James II's policy of installing Catholic cronies in key administrative positions. Newton was one of nine prominent members of Cambridge University who, in April 1687 – at the very moment when Halley was seeing the *Principia* through the press – confronted the notorious Lord Jeffreys, and refused to allow James II to appoint his personal nominees, without qualification or oath, to senior academic positions.[13]

So, at the beginning of 1689, Newton was already among the most prominent Protestant-supporting members of the University community, with impeccable credentials to serve the incoming regime. On 15 January he was elected one of the three University representatives to the national Convention appointed to settle the legitimacy of William and Mary's claim to the English throne. He came to London to sit on the Convention, and remained there until early the next year. Following the Coronation of William and Mary, the Convention to which he had been appointed became the Convention Parliament, and Newton stayed in the capital until a week after it was prorogued on 27 January 1690.[14]

A sign of Newton's new status was the invitation he received from Christiaan Huygens to visit him at Hampton Court, on 9 July, as part of the manoeuvring to secure him the King's College position. It was there that Newton met Fatio de Duillier for the first time – a meeting which began an intense infatuation between the two men, one lasting a number of years and with far-reaching consequences for Newton.[15] There were, one imagines, vigorous intellectual exchanges between the three gifted natural philosophers, as well as strategic political planning. The next day, the group set out together from Hampton Court to lobby for Newton in London.

After Huygens had returned to The Hague, at the end of August 1690, Fatio spent a month with Newton in London, followed by fifteen months in the Netherlands, mostly in Huygens's company.[16] Over the next several years, Fatio facilitated the exchange of ideas between the two men. Huygens came to regard Fatio as his personal direct link through which he could learn Newton's latest thoughts on mathematics, gravity and light.

Although Christiaan Huygens retreated rapidly to his self-imposed life as an intellectual invalid at Hofwijk, his brother Constantijn continued to wield considerable power at the court of William and Mary.[17] Newton, meanwhile, became Master of the Royal Mint, and a formidable figure in London political circles. He was also by now an international celebrity as the author of *Principia* – the man who had finally unlocked the secret of the motion of the heavens. In terms of his own continuing career, Hooke now found himself doubly disadvantaged – his influence with the Royal Society in decline, his position in the City no longer secure because of his known Stuart loyalties. In neither place did he any longer wield any kind of authority, and in neither could he find powerful protectors who had survived the change of dynasty.[18]

So it was that, when on 12 June 1689 Huygens, Newton and Hooke found themselves together at a meeting of the Royal Society, Newton and Huygens were – unbeknown to Hooke – about to embark on a new, yet more intense phase of their intellectual relationship. Hooke, meanwhile, was increasingly ill at ease with the Royal Society, where all but a few of his oldest friends among the members seemed to take him less and less seriously.[19]

Of all Hooke's claims to scientific breakthrough, and to have anticipated Huygens's and Newton's ideas, those in optics were probably the most convincing and well documented. Both Newton and Huygens had started their work on thin coloured films in 1665–6 after having read Hooke's suggestive discussion in *Micrographia*.[20] Similarly, both men had pursued the wave-theory of light proposed in *Micrographia*, and the associated calculation of the velocity of propagation of light. In the early 1670s, when Newton first wrote to the Royal Society with his theory of colour, and first crossed swords with Hooke, who inevitably challenged him, he was open in having been influenced by Hooke's work.[21] By 1675, however, egged on by Oldenburg, he was denying Hooke's influence and claiming that any ideas the two men shared were simply 'common thoughts': 'I desire Mr Hooke to shew me therefore ... [that] any part of [my hypothesis] is taken out of his *Micrographia*.'[22] Nevertheless, Hooke's experiments in optics were an authoritative contribution to the reputation of the Royal Society, and some important contribution from him at that auspicious meeting of the Society in which Huygens and Newton participated was to be expected. None is recorded.

Following the meeting of the Royal Society on 12 June, Hooke worked through the arguments propounded in Huygens's *Treatise on Light* with even more than his usual punctiliousness. We can surmise that he was discouraged and depressed by the confident authority with which Huygens and Newton had conducted themselves at the Royal Society. He responded by drafting two lectures defending in detail his own 'philosophical' contributions: the first dealing with those concerning light and its properties (wave theory and thin films), the second dealing with planetary motion (orbits of the planets, and the shape of the earth). Hooke's health that year was particularly bad. According to Waller, he was 'often troubl'd with Head-achs, Giddiness and Fainting, and with a general decay all over, which hinder'd his Philosophical Studies'.[23]

Eight months later Hooke delivered his response to the Society, on 19 and 26 February 1690.[24] The first lecture includes a particularly poignant restatement of his own originality, in which he appeals to his listeners to assess his own contribution before deciding that Huygens's competing views are correct:

> This is in brief what I thought necessary to be considered before what I have formerly Deliverd concerning Light be rejected and before what is here Deliverd be Received, for though I doe readily assent that Mr Huygens & others much more Able than myself may penetrate farther into the true causes of the *Phenomena* of Light than I had done at that time; yet I confess I have not yet found any *phenomenon* or *hypothesis* propounded by any writer since that time that has given me cause to alter my sentiments concerning it. However I should be very gladd to meet with any such and shall be as Ready to Relinquish this Upon the meeting with a better as I was in making choice of it for the best at the time of publication.[25]

In the second lecture, Hooke went on to analyse Huygens's *Discours sur la cause de la pesanteur* (*Discourse concerning the cause of weight*). Here he fastened on to Huygens's treatment of gravity:

> For what follows afterwards is additionall to that Discourse as he himself Declares in his preface, which is concerning those proprietys of Gravity which I myself first Discovered and shewed to this Society many years since, which of late Mr. Newton has

done me the favour to print and Publish as his own Inventions. And Particularly that of the Ovall figure of the earth was read by me to this Society about 27 years since upon the occasion of the Carrying the Pendulum Clocks to Sea And at two other times since, though I have had the Ill fortune not to be heard, and I conceive there are some present that may never well Remember and Doe [not] know that Mr. Newton did not send up that addition to his book till some weeks after I had read & shewn the experiments & Demonstration thereof in this place.[26]

As usual Hooke insisted that he had himself long ago made every one of the discoveries Huygens and Newton claimed for themselves. This time he had clear justification for maintaining his influence, and documented the indebtednesses with measured intelligence. A group of well-disposed members attended the lectures – including Sir Robert Southwell, Sir John Hoskins, Waller, Halley, Wallis Sloane 'and divers others'.[27] But Huygens and Newton had moved on. They did not trouble themselves to respond.[28]

There was time in Hooke's life now for reflection. His practical employment in Wren's architectural practice had ended when he was no longer agile enough to climb scaffolding; he stepped down as Wren's architectural lieutenant in 1693. He continued to draw his regular stipend from the Corporation of the City of London until at least 1700, signing his name each time in the register.[29]

He chose to prolong his on-and-off relationship with the Royal Society until almost the very end of his life. There was an increasing sense that his interests and views were irrelevant to the Society's current concerns. But he was, after all, with Wren, one of the Society's elder statesmen, an original member, whose presence and participation were grudgingly tolerated. In 1699 he was still delivering regular Wednesday lectures. The text of a lecture on a *camera obscura* and other optical devices, delivered on 14 July 1697, in Hooke's handwriting, carries a note at the end:

Present Sr J Hoskins. Sr R Southwell. Mr Hill. Dr Slon [Sloane]. D. Woodward. M Folie. M Bird (from Virginia) M Houton [or Hoxton] (2 Strangers introduced by D. Slone) Henry Hunt, all well pleasd. Ordered that the Royal Society should defray all

the charges of the experiments I should have occasion to make & thought fit for further information &c.[30]

On 1 December he read again, again 'at a full meeting' of the Royal Society on 8 December, and again at the meeting of 15 December. Each of these was a fully prepared, meticulously documented lecture, on a topic of general interest to the members.

His health, however, was now poor. He had become a vegetarian, living on milk and vegetables, 'no flesh in the least agreeing with his weak constitution'.[31] His eyesight had deteriorated dreadfully, though he never actually lost it, as he had for so many years feared might happen. Above all, his by now almost phobic reluctance to spend money was being widely talked about. Sir Godfrey Copley, an out-of-town member of the Royal Society, wrote to his friend and fellow member Thomas Kirke, just before Hooke's death, with the gossip that Hooke had failed to feed the elderly relative called in to take care of him, driving her from his home: 'Dr Hooke is very crazy much concern'd for fear he should outlive his Estate. He hath starved one old woman already, & I believe he will endanger himself to save six pence for any thing he wants.'[32] In his personal conduct Hooke was apparently now insufferable. His conviction that he had been deprived of due recognition on any number of scientific topics – however justified – was a source of embarrassment to his fellow members of the Royal Society.

In May 1699 the wretched question of Hooke's priority claims surfaced once again. On the 3rd, Hooke was delighted when Dr Hans Sloane pointed out to him a reference in the French scientific literature to the fact that Hooke had been the first to invent particular features of the weather-gauge – Hooke transcribed the passage into his personal papers and added: 'Copied from a Paper shewd me by Dr. Slone May. 3. 1699. R Hooke.'[33]

On 31 May, however, in the midst of presenting a review for the Society of the French scientist Jean de Hautefeuille's most recent publication, in which he, in robustly Hooke-like fashion, claimed priority over Christiaan Huygens in the matter of the spring-regulated pocket-watch, Hooke could not resist restating his own claim: 'I my self had made severall of them [balance-spring watches] about 15 years before and had a Warrant for a Patent for it from King Charles the 2nd in the year 1660.'[34] Further on in the same document, Hooke identifies a number

of passages in which Hautefeuille is borrowing from his own *Micrographia*. He disparagingly shrugs off Hautefeuille's claims to originality altogether, pronouncing him not worth wasting time on:

> By what he doth here present I perceive he understand or believes very little. though at the same time he pretends to have made the very Experiment which I had long before made and which is printed as mine in the History of the Royall Society, and take noe notice of that at all But Relates it whole as his own. by which & 20 other Passages in this booke he proves himself to be 10 times a greater Plagiary than Monsieur Hugens in those particulars that he exclaims soe much against him for. But in many other particulars I conceave they may be both sufficiently as alike culpable.[35]

Once again, Hooke here casually libels Huygens – a powerful and distinguished corresponding member of the Society, from an even more powerful family, a man who, besides, had by now been dead for almost five years.

No doubt the fault lay partly with Hooke's own personality. He simply could not let go of the idea that he had somehow not received the recognition he deserved for so many inventions imperfectly conceived, and none of them taken through to completion. But, as Waller recognised, other people were also to blame for his indignation against those more successful than himself, and his pathological reluctance to disclose his inventions in later life:

> He laid the cause upon some Persons, challenging his Discoveries for their own, taking occasion from his Hints to perfect what he had not; which made him say he would suggest nothing until he had time to perfect it himself, which has been the Reason that many things are lost, which he affirm'd he knew.[36]

Some men mellow in later life; Hooke was clearly not one of them. No wonder there were members of the Society who developed an 'aversion' to the long-standing Curator – a lingering relic of an earlier age, whose irritable, indignant presence coloured the weekly meetings.

Some of Hooke's growing anxiety in his dealings with fellow virtuosi was a product of his domestic circumstances. As he grew older, he knew himself to be increasingly vulnerable, that at any moment it would prove

impossible for him to care for himself. He had watched his old mentor and school teacher Dr Busby decline into old age, still living a bachelor life, alone, increasingly unable to manage humdrum domestic tasks. Like so many old people, he feared his funds would not prove adequate to pay for the escalating levels of care he would need as his health declined. Always careful about money, he became an acknowledged skinflint, reluctant to spend the smallest amounts of money on the most modest necessities of life.

It was Hooke's understanding that he was likely to end his days exactly like Busby which committed him to assisting his old mentor and Master even when he had become bad-tempered and difficult. Hooke's care for the elderly Busby reflect his own fears of descending into helplessness with nobody to care for him. His assiduous pursuit of Busby's commissions – including the posthumous 'beautification' of Lutton church, where probably Busby expected to be buried (he was in fact buried with all honours in Westminster Abbey) – reflects his own anxiety of being forgotten, because he had no kin to ensure his fame persisted. Busby, not least because of the posthumous dedication of men like Hooke, was, in the end, lastingly remembered. Hooke, as he feared, was not so fortunate.

In the early 1670s, when Busby went into semi-retirement from Westminster School (officially he remained in post until his death), he acquired a small estate at Willen, near Newport Pagnell. Busby, like Hooke, remained loyal to the memory of Charles I throughout his life, and the choice of Willen was no accident. It was a score-settling with one of those Busby associated with the betrayal and martyrdom of the King in 1649.

Willen had been purchased by Colonel Robert Hammond, in 1651 – one of the many estates 'sequestered' or confiscated by the parliamentary authorities from old families who were royalist sympathisers, and sold to supporters of the Protectorate. This was the same Robert Hammond who had been Governor of Carisbrooke Castle on the Isle of Wight, when Charles I arrived there to try to re-establish his sovereignty from the very edge of his Kingdom, in autumn 1647. After a few months' indecisiveness (the months during which Charles's entourage established their little 'court in exile' on the island), Hammond, who had initially been quite sympathetic to the King, gave in to personal pressure from Cromwell to take his visitor into custody. Eventually he handed him over

to the parliamentary authorities. To Busby this was the most profound of betrayals.[37]

By 1672 the Hammond family were bankrupt, and the estate up for sale. We may surmise that Busby bought it as an act of exquisite vengeance on the individual by whose actions Charles I came into the hands of Cromwell, the man whose failure to fulfil Charles's expectations had started the chain of events which led inexorably to the King's death. One of Busby's first acts as the new owner was to apply to take down the medieval church which was 'badly in need of repair', and to build a new one at his own expense. Rebuilding Willen church (at considerable cost) was Busby's personal thanks-offering for the Restoration, and for his own long and prosperous life.[38] At the same time, this was a way of obliterating all trace of Robert Hammond (whose family monument was presumably in the old church).[39]

Who better to design and build Busby's church than another man from the Isle of Wight, one whose family had remained staunchly loyal to the 'martyred' King, and whom Busby had first encountered in those desperate, dark days? Busby gave the commission for Willen church to Hooke, who produced a charming, Dutch-style building, with a small cupola. It is one of the few Hooke buildings to survive, although its cupola was removed in the nineteenth century. Willen church was consecrated to St Mary Magdalen – the saint who protects the weak and oppressed, and is 'saviour of those without hope'.[40]

Shortly before Busby's death, he decided, as a further lasting monument to his memory, to refurbish the parish church at Lutton in Lincolnshire, where he was born.[41] Among Hooke's papers is a copy of the codicil they drafted together entrusting the refurbishment of Lutton church to Hooke. Busby's own, official copy is dated April 1695, the month before his death:

> And whereas I have long intended to have repaired and beautified the Chapel of Lutton in the county of Lincoln the place of my nativity and have already by the assistance of Dr Hooke begun the said work now my Will is that if it should please God that I happen to die before the same be finished that then my Executors with the advice and assistance of the said Dr Hooke do finish and complete the same in such manner as I have acquainted the said Dr Hooke I intend to have performed.[42]

Busby died on 5 April 1695. The codicil was the subject of a Chancery case because it was not properly signed, although Busby's friend Dr Peter Barwick testified that, before the witnesses could be got together, Busby declared that he was too faint to execute it, and died a few hours later.

Hooke, as he had promised, saw to it that Busby's last wishes for Lutton church were carried out. On 12 July 1697, aged sixty-one (according to the court documents), he appeared in person to have the codicil ratified. He began by explaining his relationship to Busby – he had been 'Schollar to the said Dr Busby':

> The said Deponent being sworne &c deposeth and saith To the first Interrogation That he did know Richard Busby Dr in Divinity late deceased in this Interrogation inquired of when he was living & hath been acquainted with him for the space of forty yeares now last past & upwards this Deponent being Schollar to the said Dr Busby & further he deposeth not to this Interrogation.[43]

Hooke explained that Busby had intended to complete the beautification of Lutton while he was still alive, and had previously employed Hooke to build a church for him at Willen, and 'in beautyfieing' Westminster School, both at Busby's own expense:

> This Deponent saith That he doth know that the said Dr Richard Busby did in his Life time positively resolve to adorne & beautify the Church of Lutton in the County of Lincolne the place where he was borne & baptized & in order to putt such his resolution into practice did consult with this Deponent who was Citty Surveyor & whom the said Dr Busby hath consulted with formerly in & about the building of a Church at Willen in County of Bucks where his the said Dr Busby's estate lay & in his doing whereof he laid out a considerable sume of money & also for that this Deponent assisted him the said Dr Busby in the beautyfieing of the School & Colledge at Westminster where in the said Dr Busby laid out about the Summe of Two Thousand Pounds.

Busby's intention at Lutton had been to provide a new communion table with railings around it, paving the area within the railings, and

installing new seats there. He proposed paving the body of the church, and erecting a new pulpit and marble font. The parishioners' consent had been obtained for all these improvements.[44] Hooke records discussions with Busby concerning Lutton in 1693.[45]

Hooke had, he said, sent someone to Lutton 'to take a view thereof & to see in what state & condition of repaires the same was in'. On his return, this informant told Hooke and Busby that the walls and tiling in the church were also badly in need of repair. Busby, however, declined to involve himself in the expense of these more radical renovations, in spite of lobbying from the local incumbent, Dr Dove:

> Dr Busby would not as he declared medle with the repaires thereof in those particulers tho' Dr Dove (who did concerne himself upon some account on relacon that he had to the said place & who went severall times between the said Dr Busby and this Deponent [Hooke] in order to consult & advise with this deponent about the said affair) would have persuaded the said Dr Busby to have repaired the said Church in the defects of the Walls & tileing or covering thereof but said & declared his intencon to be that If the parish would repair the said Church that then he would at his owne charge now pave the floor & adorne & beautyfye it.[46]

Hooke drew up several designs, and spent a number of hours with Busby, discussing the changes he wanted to make. Busby would have liked Hooke to take charge of the renovations himself, but he 'would by no means undertake the same but told the said Dr Busby that he would give him all the assistance he could therein'. Instead, Noel Ansell (a carpenter) took charge of the works, and 'did frame some of the worke & send it into the said Dr Busby's house in the said Drs Life time'. Evidently the work – which probably included the inlaid pulpit, with Hooke's and Busby's initials intertwined – met with Busby's approval, and Ansell executed further work, while Hooke inspected the results at Busby's house to make sure they were to his satisfaction.

At the time of Busby's death, all the new church furniture was at his house in Westminster, 'where they remained att his death ready to have been sent downe to Lutton but the paveing (tho intended) was not bespoken or gott ready by reason of the Testators sudden Sicknesses & death which happened the 5th of Aprill 1695'. In his supporting

deposition concerning the codicil to Busby's will, Noel Ansell indicated that Wren (also a former pupil of Busby's) had been involved in costing the works: 'That Sir Chr Wren made an Estimate of the worke amounting to £400 odd money including wainscotting the Church & the same day conferr'd with Dr Busby 2 houres about the worke.'[47]

The pulpit at Lutton church, executed to a design by Hooke, was recently rediscovered and re-erected in the church, thereby 'remembering' once again Lutton's benefactor and Hooke's old friend and teacher.

The most damaging conflict of interests in Hooke's crowded and demanding life turned out, in the end, to have been his assiduous therapeutic self-dosing. On the face of it, this self-experimenting constituted the most systematic and sustained programme of experimental science in Hooke's varied repertoire – conducted more regularly and conscientiously even than his astronomical observations with long telescopes at Gresham College. Knowing what we now do about addiction, however, and about the accumulation of toxic substances in the system (imbibed over long periods, even in small doses), it is probable that Hooke's regimen was ultimately fatal, and that even before it killed him the side-effects of his medicines (clouded vision, giddiness, lassitude, melancholy) proved damaging and disabling.

By the age of sixty-five Hooke was a physical wreck, emaciated and haggard; he was irritable and prone to paranoia; he rarely any longer bothered to attempt a proper night's sleep. In his prime Hooke had been something of a dandy, and a popular man-about-town. At the peak of his career his self-dosing with pharmaceuticals helped him sustain the kind of punishing, over-demanding metropolitan professional life we associate with the twenty-first, not the seventeenth, century. Now it had reduced him to a shadow of his former self. Not for Hooke the relaxed style of the genteel, virtuoso natural philosopher; he operated in a permanent state of extreme tension, on the edge, wary and wakeful, constantly under the influence of stimulants.[48]

Apart from the harm Hooke did to himself during his lifetime, his physic-taking habit certainly contributed to his long-lastingly negative reputation after death. In his latter years he turned increasingly in on himself, cutting himself off from the broad and varied support network of friends who had fuelled his early career intellectually, and sustained

his position socially. In middle life Hooke was generous, gregarious and good-natured. His posthumous reputation, however, is that of a difficult, reclusive man, suspicious by nature, and secretive in his behaviour.

Hooke died on 3 March 1703. Although he had stepped down from his official responsibilities at the Royal Society in the late 1690s, after several bouts of ill health, he had carried on with a more restricted scientific social life and assorted intellectual activities until at least 1699.[49]

His last months, however, had been ones of ghastly deterioration, and physical collapse, leading to a miserable passing away. Friends – those still alive – fell away, unable to cope. Hooke could not decide which of them he should leave in charge of his affairs after his death. He drafted a will, but hesitated over the instructions to be attached to it. In the end he signed neither, and therefore died technically intestate. His daily needs were seen to by a maid, who to judge from the way colleagues referred to her was far from being a suitable servant for a man of his standing.

On the day he died, feeling the end at hand, Hooke sent the 'girl' to find his trusted old friend Robert Knox. Knox came as quickly as he could, but was too late to find Hooke alive. He and Harry Hunt laid out Hooke's body, and sealed up his apartments – the traditional act on such an occasion, to protect from petty pilfering, or more serious removal of goods by interested parties. Knox wrote an account of what happened in the margin of the copy of his *Historical relation of the island of Ceylon* which he was annotating in order to produce a second edition (with Hooke's encouragement):

> The 2th March 1703[.] this Night about 11 or 12 of the Clocke, my Esteemed friend Dr Robert Hooke, Professor of Geomitry & Naturall Philosophy in Gresham Colledge Died thare, only present a Girle that wayted one him, who by his order, (just before he died) came to my Lodging & Called me: I went with her to the Collidge, whare with Mr Hunt the Repository Keeper: we layed out his body in his Cloaths, Goune, & Shooes as he Died, & Sealed up all the Doores of his appartment with my Seall, & so left them.[50]

Hooke had let himself go in his last months, as his health worsened. He neither washed nor undressed, and refused to spend money even

on necessities. It was no longer appropriate to send for his gentlemen friends like Wren and Hoskins. A sea-captain was less likely to raise an eyebrow at the state of Hooke's living arrangements. Had Halley been in the country, we may be sure it would have been he who was summoned first. A friend of the Astronomer Royal Flamsteed wrote some weeks later:

> I heard in the Publick News of Dr Hooks death, but not all the Circumstances you relate, I have heard he had many valuable things in his Papers, 'tis pity they should be lost, presume they will fall to the Royal Society, who may possibly in time produce such things as will be of publick use. I never heard of Mr Halleys Journey into Germany nor the designe of it whether on publick or private account.[51]

Hooke's death was rapidly reported to the scientific community outside London. The day after his death, Copley wrote to Kirke, with a tinge of wry affection:

> Your old Philosopher is gone at last; to try experiments with his ancestors. He is dead, they say, without a will; had only a poor girl with him, who, seeing him ill, went to call somebody; and he was quite gone before they came. Thus departed the great Dr Hook.[52]

The distant relations who came into his substantial fortune at least saw to it that he made a fine show at his passing, according to Knox:

> He died without a Will, but his Executors or Heires at Law, buried him the 6th March in St. Hellens Church, & made a Noble funerall giving Rings & gloves, & Wine, to all, his friends thare, which ware a great Number, for he left a very Considerable Estate all in Mony, besides some Lands, yet Notwithstanding he lived Miserably as if he had not Sufficient to afford him foode & Rayment.[53]

Hooke's funeral was a grand occasion, and a fitting finale for one of the founding figures of London Restoration science. As his biographer, and the friend of his later years, Richard Waller testified also: 'His Corps was decently and handsomely interr'd in the Church of St. Hellen in London, all the Members of the Royal Society then in Town attending

his Body to the Grave, paying the Respect due to his extraordinary Merit.'

Knox's sealing up of Hooke's rooms was to little avail. In the weeks following his death items from among his own rarities and instruments were dispersed, some of them transferred surreptitiously to the Royal Society.[54] The relatives who had manoeuvred themselves into position in the hope of a legacy had started removing Hooke's effects even before his death. Now they immediately laid claim to his fortune.

This, however, was not the end of the affair. Four years after Hooke's death another claimant to his estate emerged, and challenged the settlement. A lengthy court case ensued. The stages of Hooke's physical deterioration in his final illness, and the way this impacted – disastrously and permanently – on his lasting reputation can be reconstructed from glimpses in that court case, the documents concerning which have recently come to light in the Chancery Court Records in London.[55]

There was no one of substance and influence left to see to Hooke's posthumous fame. His last remaining close friends were not in a strong position to help: Hunt, Waller and Knox were of comparatively modest background and means, Halley was away 'a sayling', Wren was over seventy (and the two men had drifted apart of late). In the absence of close heirs (since Hooke had never married) Hooke's estate went to surviving Isle of Wight kin – Elizabeth Stephens, supposedly the daughter of Hooke's father's brother; Mary Dillon, her daughter; and Anne Hollis, daughter of Hooke's mother's brother. They inherited:

> great quantities of ready money in Gold and Silver and other medalls and a considerable library of Books and Jewells Plate Gold and Silver Rings Pictures Ornaments Statues Naturall and other Rarities and Curiosities of Great Value Household Stuff and Implements of household linnen woollen and apparrell and other Goods Chattells and Effects amounting in the whole to the value of Eighteen Thousand pounds and upward.[56]

Such, at least is the assertion of the new person who stepped forward for his share of Hooke's fortune. Thomas Gyles was another cousin of Hooke's, twin brother of Robert Gyles, who had been Hooke's tenant on the Isle of Wight, and whose son Tom had, until his untimely death, been part of Hooke's domestic household in London. Although she had

lost touch with him, Gyles was Anne Hollis's brother. In 1707 he sent letters to the Court of Chancery in London claiming a share in the Hooke inheritance. Since Thomas Gyles had emigrated, and become a prominent member of the Isle of Wight colony in Virginia, he had (he submitted) not heard of Hooke's death until several years after it took place.

> After the decease of his said father Thomas Gyles and many years before the said intestate [Hooke] died he went beyond the seas and was at the time of the said Intestates death residing and settled in Virginia in the West Indies and being <absent> at so great a distance did not hear of the said Intestates death till a long time after he dyed but for the unjust and purposes herein after charged and set forth the said <Anne Hollis at the instigation or by or with the advice of Lewis Stephens of the parish of St James's Westminster> and Elizabeth his wife industriously concealed the same from your Orator and taking advantage of your Orators ignorance thereof and of his absence and swore that the said Elizabeth was the only surviving <next of kin to the said Intestate of his fathers side and that she and the aforementioned> the only next of kin or nearest relation of the said Intestate Robert Hooke and that Your Orator was dead.

In the course of Thomas Gyles's complaint he describes these distant members of the family dividing up Hooke's effects, with complete disregard for the great man or his memory. Indeed, Gyles alleges that this process began even before Hooke's death:

> The said Confederates some or one of them did after the said Intestates death and during the last sicknings [his last illness] possess themselves or him or herself of all or the greatest part of the said Intestates Deedes Evidences Writings and securities for moneys Goods Plate Jewells Ready Moneys Effects and charges on all Estate to such value and amount as herein before mentioned or thereabouts.

What happened in those last months becomes a little clearer from these witness statements. Stephens and her daughter Elizabeth (or Mary) Dillon were to hand, keeping a close eye on their prospective inheritance,

until shortly before Hooke died. As Hooke's health failed, and he began to need nursing attention at home, coffee-house friend and instrument-maker Reeve Williams had suggested that Hooke write to relatives on the Isle of Wight:

> These Defendants have Heard that the said Robert Hooke about Four or Five months before he dyed being in company with Reeve Williams one other of the Defendants ... was complaining that [he lacked] a Servant Maid or to that effect and that the said Reeve Williams thereupon told the said Robert Hooke that he had heard the Complainants said late wife [Elizabeth Stephens] was some ways related to him and that she had a daughter married to one Joseph Dillon chairmaker and persuaded him to take one of them into his service.[57]

Hooke duly summoned the elderly Elizabeth, who brought her daughter: 'in regard your Orators wife [the deposition is by Lewis Stephens] was very aged herself and infirm and not of strength and ability of body to attend <on> and look after him'. Hooke later apparently regretted the decision (the same deponent reports that 'the said Robert Hooke did then deny that the Complainants said late wife was anyways related to him'). His misgivings may have arisen from that fact that Stephens and Dillon apparently supplanted Hooke's support system of close friends, who had until that point tended him lovingly themselves, and, above all, protected his interests.

According to the testimony of the depositions in the Gyles case, documents and valuables were systematically removed from Hooke's possession during his final illness. His properties on the Isle of Wight, including the one leased by Gyles's father, and in which Thomas Gyles had grown up, do indeed seem to have been quietly transferred into the names of others. No wonder no trace remains of Hooke's many scientific instruments, nor (until now) of the portrait by Mary Beale. As Hooke lay dying, those who tended him stripped him of his assets, pocketed his valuables and took over the leases on his properties – his friends apparently helpless to interfere.[58]

What we learn from these, in the end, inconclusive legal documents (it is not clear if Thomas Gyles received any kind of reparation for his lost inheritance – he appears to have died himself before the matter was settled), is that Hooke, by the time of his death, had no close family to

speak up for him, or to protect his interests, and his appalling state of bodily deterioration – the legacy of years of overwork and substance abuse – had almost entirely distanced him from even his closest friends.[59]

Perhaps it was Newton, as has often been claimed, continuing his grudge against Hooke beyond the grave, who denied his Royal Society colleague his well-deserved posthumous fame. Perhaps, though, it was simply the absence of a living, loving family, to keep his name alive and to promote and celebrate his achievements to the generation that followed.[60]

If Hooke had intended a memorial, it would, everybody agreed, have been a suitable building – a purpose-built Repository – to house the collection of rarities over which Hooke had presided, with greater or lesser attention and efficiency, throughout his Royal Society career. There were, over the years, curators appointed specifically to see to the collections – indeed, at the end of Hooke's life, Harry Hunt was the Repository keeper – but, housed as the Repository contents were under Hooke's very nose, and much of the collection in his own home, he always considered it 'his'.[61]

Zacharias Conrad von Offenbach, a German virtuoso who visited London in 1710, gives a scathing account of the state of the Society's rooms in Gresham. He describes the Repository as in being in a state of total disorder and neglect:

> [In the museum] lie the finest instruments and other articles ... not only in no sort of order or tidiness but covered with dust, filth and coal-smoke, and many of them broken and utterly ruined. If one inquires after anything, the operator who shows strangers round ... will usually say: 'a rogue had it stolen away', or he will show you pieces of it, saying: 'It is corrupted or broken' and such is the care they take of things!

He does, however, provide us with evidence that at this date Hooke had not been entirely forgotten. Describing such instruments and curiosities as they were able to see, von Offenbach adds:

> Finally we were shown the room where the Society usually meets. It is very small and wretched and the best things there are the portraits of its members, of which the most noteworthy are those of Boyle and Hoock.[62]

We saw that the Repository made a more favourable impression on Christiaan Huygens, on his visit to the Royal Society in June 1689: '30 June. Meeting at Gresham College in a small room, a cabinet of curiosities, very full, but well kept up'.[63] Possibly the neglect of the Repository came after Hooke's death. Several well-meaning virtuosi acquired items from the collection in the months that followed. In June 1703, Copley wrote to Kirke excitedly that he had obtained a fine technical instrument which had been given to Hooke for the collection. He told Kirke that Hooke had so valued the item that even its maker had rarely been able to have sight of it once it entered the Repository – here Copley seems to have been unclear whether his prize actually belonged to Hooke or to the Royal Society.[64]

In the end, officers of the Society – Hooke's old friends Waller and Hunt among them – recognised that something had to be done to rescue the collection Hooke had so cherished. Their solution was a new location, and a fresh effort to organise and catalogue the Repository's contents. It was almost inevitable that the spirit of Hooke should be associated with this project.

The Royal Society had begun to accumulate materials for a Repository from its beginnings in the early 1660s.[65] The largest single donation, in these early years, was made in the autumn of 1663 by Dr John Wilkins (founding figure of the Society, whose protégés both Hooke and Wren had been in the 1650s). At about the same time, Hooke, then the Society's Curator of Experiments, was named as Keeper – a post he continued to occupy effectively until the late 1670s, when Nehemiah Grew was appointed.[66] In early 1666 it was widely known that Hooke was in the process of soliciting benefactions for the Repository.

> Those of the Society, that are now in London, doe endeavour to gett a good Collection of Naturall and Artificiall Curiosities for the Societies repository; and they hope, to make shortly an acquest of a very good stock of that kind, which will looke as something towards a foundation, and will invite generous men to increase it from time to time.[67]

At the very beginning, Hooke was as enthusiastic and ambitious for the Society's museum as he was for every other aspect of the scientific enterprise. In a letter to Boyle of 3 February 1666, he wrote, with characteristic ambition:

I am now making a collection of natural rarities, and hope, within a short time, to get as good as any have been yet made in the world, through the bounty of some of the noble-minded persons of the Royal Society. I hope we shall have again a meeting, within this week or fortnight at farthest . . . and then I hope we shall prosecute experiments and observations much more vigorously; in order to which also I design, God willing, very speedily to make me an operatory, which I design to furnish with instruments and engines of all kinds, for making examinations of the nature of bodies, optical, chemical, mechanical, &c. and therein to proceed by sych a method, as may, I hope, save me much labour, charge, and study; and in this design there will be some two or three others, that will join with me, who, I hope, are of the same mind with me.[68]

When, at the end of 1673, the Council of the Royal Society moved its weekly meetings back to Gresham College from Arundel House, rehousing the Repository was high on Hooke's list of projects. Many of these he carried out himself, setting to with his usual energy, to refurbish rooms, and rearrange their contents. Hooke (a chronic insomniac) was up and hyperactively about before daylight, during the last days of November 1673, sawing out beams and trusses, and demolishing partitions, in the basement of the College to create additional library (and possibly laboratory) space, so that the Repository premises could be extended beyond the large gallery allocated to it upstairs.[69]

In the last year of Hooke's life, during the summer of 1702, shortly after the accession of Queen Anne, a new home for the Repository once again seemed likely, when the Royal Society began to make plans to expand their premises on the Gresham College site.[70] The Gresham authorities were proposing total rebuilding of the College, and this seemed a golden opportunity to redesign the facilities there used by the Royal Society. Alterations would allow the creation of a museum to house their collection of rarities and instruments, exhibition space and laboratories for their experimental activities. At the Society's invitation, Wren submitted a 'Proposal for Building a House for the R. Society' to the President, John, Lord Somers:

It is proposed as absolutely necessary for the continuing the Royal Society at Gresham College, that they should have a place

Gresham College accounts book for the 1690s, showing Hooke's signature for regular receipt of his salary as Gresham Professor of Geometry.

to be Seated in the said Ground, that the Coaches of the Members (some of which are of very great Quality) may have easy access, and that the Building consist of these necessary parts.

1. A Cellar under Ground so high above it, as to have good lights for the Use of an Elaboratory and House-keeper.
2. The Story above may have a fair Room and a large Closet.
3. A Place for a Repository over them.
4. A Place for the Library over the Repository.
5. A Place Covered with Lead, for observing the Heavens.
6. A good Stair Case from bottom to Top.
7. A reasonable Area behind it, to give light to the Back Rooms.

All which may be comprized in a Space of Ground Forty
Foot in Front and Sixty Foot Deep.[71]

Plans for expansion were abruptly halted, however, once it became clear
how precarious the Society's continued tenancy of Gresham was. It
transpired that the Gresham authorities would cheerfully get rid of the
Society if they could, and that the Society's continued occupancy there
was entirely dependent upon Hooke. It was Hooke's position as a Gre-
sham professor which entitled him – and thus the Royal Society – to
accommodation in the buildings. As the sitting tenant, Hooke had in
fact taken court action the previous year, with the encouragement of
the Royal Society, to prevent the Gresham trustees from evicting him
in order to begin demolition before rebuilding.

On 24 March 1703, three weeks after Hooke's death, the trustees of
Gresham College notified the Royal Society that they were to remove
themselves and their belongings from the College, and return the keys
to Hooke's lodgings. It would have amused Hooke to know that his
death immediately presented the new President, Sir Isaac Newton, with
a serious headache over where to house the Society. A hastily assembled
committee succeeded in negotiating a stay of execution of the Society's
eviction until new premises could be found.

As usual with the Royal Society, things moved impossibly slowly.
A year later, in February 1704, the Council voted to hand over to
Wren responsibility for finding them new accommodation. It was not
until 1710, however, that a suitable property became available.[72] On
8 September Newton informed the Council that there was an oppor-
tunity to purchase 'the late Dr. Browns House in Crane Court in Fleet
Street being now to be sold being in the middle of the Town out of
Noise'.[73] Evidently it was Wren and his son, Christopher Wren junior,
who decided the premises were suitable.[74] On 2 November Wren, his
son and Richard Waller were authorised to negotiate with the house's
tenant to purchase any fittings which might suit the Society.[75]

In March 1711 it was agreed that, in addition to refurbishment of
the existing house, the Society would build a 'New Repository' at Crane
Court. Wren was asked to draw up the plans. On 28 March Wren junior
informed the Society that his father had made a model, which 'may
give ye Gentlemen a better idea, then the designe on paper'. Wren also
reassured the members that the building would be cheap: 'It will be

very light, very commodious, and the cheapest building that can be contrived.'[76]

Once again, however, the project now ground to a halt over costs. When estimates were produced for Wren's design, the figure came out at almost exactly twice the £200 the Society had budgeted for their new Repository. This time, however, two active members of the Society stepped in and saved the day. Hooke's old friend Waller immediately provided £300 to get the project moving, followed by a further £100 over the period of construction.[77] Henry Hunt made available the astonishing sum of £900 (as two separate donations), thereby underwriting the entire building.[78] Two more unlikely benefactors could hardly be imagined. Waller was a man of comfortable but not excessive means; Hunt was the Society's artisan operator, in charge of the existing, run-down Repository.[79]

So who really paid for the Repository? Everyone involved with it was closely associated with Hooke. The committee convened to handle the Crane Court accommodation problems which followed Hooke's death consisted of his oldest and dearest friend, Sir Christopher Wren, Wren's son (Clerk of the Royal Works, and by now substituting for his father's regular attendance at meetings of all kinds) and Richard Waller, Hooke's closest friend and confidant at the time of his death. Waller was the person who, in the absence of near relatives, took charge of Hooke's post-mortem affairs, and who edited the 1705 edition of his *Posthumous Works*, which includes a 'Life of Hooke'.[80]

The other crucial player in the successful completion of the building was Henry Hunt, Hooke's protégé, who had begun his career as boy servant and risen to take over Hooke's more menial duties at the Royal Society.[81] He was thus a mere employee of the Royal Society, who had spent his entire adult life in Hooke's service, and who, at the end of Hooke's life, was the person on whom he relied for his everyday comforts (for as long as Hooke kept a dairy, Hunt made him tea, sometimes several times a day).[82]

Waller reported that, during his last days, Hooke had told him that he wanted his money to go to the Royal Society, so that new quarters, meeting rooms, laboratories and a library might be constructed:

> I indeed, as well as others, have heard him declare sometimes
> that he had a great Project in his Head as to the disposal of the

most part of his Estate for the advancement of Natural Know-
ledge, and to promote the Ends and Designs for which the Royal
Society was instituted: To build an handsome Fabrick for the
Societies use, with a Library, Repositary, Laboratory, and other
Conveniences for making Experiments, and to found and endow
a perpetual 'Physico-Mechanick Lecture' of the Nature of what
himself read.[83]

Those in the scientific community who heard of the huge fortune dis-
covered at Hooke's death were surprised that he had not made provision
for it to go to that purpose:

I wonder old Dr Hooke did not choose rather to leave his
12,000£ to continue what he had promoted and studied all the
days of his life (I mean mathematical experiments) than to have
it go to those whom he never saw or cared for. It is rare that
virtuosos die rich, and it is a pity they should if they were like
him.[84]

Hooke in fact died intestate. But a draft will – unsigned – has recently
come to light, drafted five days before his death, and now lodged along-
side the probate inventory in the Public Record Office. This draft indi-
cates plainly that Hooke intended to divide his considerable personal
wealth between four unspecified friends, and that they had been given
instructions on how to dispense certain sums:

This is the Last Will & Testiment of me Robert Hooke M.D.
Professor of Geometry & Experimental Philosophy in Gresham
College London & Survayor of the City of London &c. Made
the [blot] twenty fifth day of February 1703 for the notification
of the Persons to whome I do bequeath all the several parts of
such goods real & Personal as it shall please God to bless me
withall at the time of my decease, with the Quallifications &
quantities of them. First I doe bequeath & give to my good
friends A, B, C, & D. [Hooke apparently could not decide which
four names to insert here] my whole Estate Real & Personal
together with all debts owing to me yet unpaid, upon trust and
Confidence that they shall & will dispose & pay unto the persons
nominated in a schedule annexed to this present will signed &
sealed by me the several summs therein particularised And also

discharge the Charges or Expences of my funeral which I would not have to exceed the vallue of forty pounds, And the Remainder to be equally distributed between the foresaid A. B. C & D. In testimony whereof I have here unto Subscribed my name & affixed my Seale, & declared the same to be my Act & deed to the Persons following [rest of sheet blank].[85]

The gossipy Kirke maintained in a letter that Hooke had intended to leave Wren, Hoskins, Knox and Reeve Williams in charge of his affairs. Waller and Wren (with Wren's son as his father's right-hand man) were, in the end, the friends who took responsibility for the arrangements immediately following Hooke's death. These resulted in the provision of a purpose-built repository and library at Crane Court. Wren personally designed the building (waiving his fee), which a contemporary guide book describes as 'in a little paved Court' behind the main house at 'Two Crane Court in Fleetstreet'. The guide book continues: 'The Repository of Curiosities is a Theatrical Building, resembling that of Leyden in Holland.' Hooke would have been delighted with the Dutch influence, and the allusion to the theatre he personally designed for the Royal College of Physicians, as the architect who rebuilt their premises after the Great Fire.

Some of Hooke's money found its way to Hooke's close friend Waller, allocated to cover the costs of sorting out his affairs, disposing of his substantial library, and editing and publishing his *Posthumous Works*. It seems reasonable to assume that Hunt too received some kind of cash gift, as the person who had taken care of Hooke in his later years, and throughout his final illness, providing him with a measure of company and affection; Hunt may even have been given some kind of recompense directly by Hooke, during his last days. There may have been further funds available from the sale of Hooke's library, which was significantly undervalued in the probate inventory.

Because, for once, ample funds were available, the Crane Street Repository was completed in a year. In April 1712 a committee was appointed 'to take care of the due placing of the Curiosities in the New Repository built by Mr. Waller'. In late June 1711 the Council ordered Henry Hunt to remove the Society's 'curiosities' from Gresham College and transfer them to Crane Court 'with what convenient speed he could'.[86]

Crane Court, Fleet Street, the house bought by the Royal Society as its first real home in 1711, and for which Wren designed a purpose-built Repository as part of the renovation and refurbishment.

The very last building actively designed by Wren became the first real, properly appointed home for the Royal Society, and in particular the first museum building designed expressly to house the Society's by now extensive collection of rarities, scientific instruments and books.[87] That building was also, in a sense, the final collaboration between those lifelong friends, Hooke and Wren, with Hooke, on this unique occasion, as the ghostly client.

There is a further poignancy to the fact that Hooke's name has been erased so entirely from the story of the Crane Court 'museum'. It was Hooke who designed and built Montagu House for Ralph Montagu in the 1670s, and it was to that building that the contents of the Royal Society Repository were eventually transferred to form part of the collection we now know as the British Museum.[88] Even in his role as architect, Hooke's name has been expunged from the history of the British Museum, because his Montagu House supposedly 'burned to the

ground' in 1686. In fact, the current view is that the fire at Montagu House gutted the interior, but left the building intact.[89] Thus a further opportunity to associate the name of the Royal Society's greatest enthusiast for the collecting side of the Society's activities, and champion of proper museum facilities for displaying the collections, has once again been lost.

When Christiaan Huygens visited the Royal Society in June 1689, the Newton faction was already in the ascendancy, but the change of emphasis Newton would bring, from a general, encyclopaedic to a stringently mathematical view of science, had only just begun. Christiaan brought with him from Holland yet more observations from the Delft microscopist Leeuwenhoek, who was by now a world-famous celebrity. And the Repository was still 'very well kept', and of some interest to the visitor.

Hooke never really belonged among the mathematical virtuosi, in spite of his considerable mathematical ability. He was an experimentalist, a tester of practical outcomes, a man who loved to design, construct and refine scientific instruments. He openly acknowledged his inability to reduce the 'notions' – brilliant hunches about how the physical world worked – to equations.

In January 1681, Hooke, on the basis of experiments he had carried out with Henry Hunt (and repeated for the amusement of his circle of friends at Garraway's), arrived at the inverse square law of gravitational attraction: 'that the Attraction is always in a duplicate proportion to the Distance from the Center Reciprocall'. He knew how momentous this discovery was, recording in his diary for 4 January 1681 that he had arrived at the 'perfect Theory of the Heavens'. It was Hooke himself, however, who, writing to communicate his theory to Newton two weeks later, frankly admitted that it would be Newton who would be able to provide the mathematical demonstration of the orbit of a body moving under such a force (in fact, an ellipse with the stationary body at one of its foci). His own mathematics was simply not up to the challenge:

> It now remaines to know the proprietys of a curve Line (not circular nor concentrical) made by a centrall attractive power which makes the velocitys of Descent ... in a Duplicate

proportion to the Distances Reciprocally taken. I doubt not but that by your excellent method you will easily find out what the curve must be.[90]

For the next, mathematical generation of scientists, alas, Hooke's insight was not sufficient. It was knowledge of 'what the curve must be' – the mathematical proof – which counted. Merely having the idea, or even showing by practical experiment that an outcome predicted in line with that idea did in fact occur, was not enough; certainly not enough for the proponent of the idea to claim it as his own.

Had Hooke been, in later life, a man of geniality and charm, like Wren, he might, nevertheless, have achieved the acknowledgement for which he so craved. But Hooke was not such a man. Rather, he was at best, as Pepys saw him, an unprepossessing man of enormous talent (one who 'is the most, and promises the least'), at worst, in Newton's all too memorable phrase, 'a man of strange unsociable temper'.[91]

We have, I hope, warmed in the course of this story to Hooke's personality and peculiar charms; we all want a happy ending. The problem is, as I suggested in my Introduction, that without a great discovery to attach Hooke's name to, no amount of careful research can give him the stature of one of history's winners. Newton for ever frustrates the possibility of allowing Hooke real standing in the history of science.

Those few who tried to rescue Hooke's reputation after his death were already aware of this. Richard Waller left a temptingly poignant note for posterity, written before 1705, saying he could prove, were it a proper time, that Hooke was the first to invent or hint of those things about which great heroes of renown had contested the priority.[92] This intriguing statement prompts speculation that among Hooke's papers Waller found evidence giving Hooke the final verdict in at least one of his priority disputes. No claim, however, was ever substantiated.

The marginal annotations made by Waller and his fellow editor of Hooke's posthumous papers, William Derham, against the manuscripts concerning clocks or watches at Trinity College, Cambridge, suggest that they may have believed these papers to contain a crucial breakthrough in horology, which might eventually yield a solution to the long-standing problem of longitude.[93] It appears, alas, that such hopes amount to no more than the wishful thinking of a pair of loyal friends. Derham also

claimed, in his *Artificial Clock-Maker* (1696), that Hooke was the first inventor of the anchor escapement. That too, we are now told, was claiming too much. Although Hooke was an early proponent of this important innovation in timekeeping, others had arrived independently at similar devices.[94]

## CODA: HONOURED, NOT LAMPOONED

Hooke, as we have seen, aspired to and achieved so much, in so many fields, that we are fully justified in celebrating his exceptional talents and outstanding ingenuity. We long to accord him the ultimate prize of proclaiming him a genius who has been unjustly overlooked. Perhaps we cannot, in the end, go quite that far. Too much historical debris, too many partisan testimonies stand in our way, in the end, to allow us that option. We can, however, avoid further damage to his memory caused by paying undue attention – as so many who mention Hooke have idly done – to his more mocking contemporary detractors.

In 1676, Margaret Blagge, royal lady in waiting, and passionate Platonic friend of John Evelyn, married her long-standing beau, Sidney Godolphin. Since Godolphin held only a modest post at court at this time, they agreed to continue living in his bachelor rooms in Scotland Yard – part of the court compound at Whitehall Palace. Fortunately these lodgings were substantial: Evelyn described them as 'an house, or rather an apartment, which had all the conveniences of a house'. In August 1676 permission was obtained from the Lord Chamberlain, and Wren, the Royal Surveyor, was ordered to put the work in hand. To Evelyn's delight, his friend and Royal Society colleague Robert Hooke was appointed architect.[95]

The summer was a long, hot one, and the entire court was obliged to stay in central London, because their summer quarters at Windsor Castle were currently under refurbishment. Malicious gossip circulated, quarrels broke out, and the badly behaved courtiers conducted themselves even more scandalously than usual.

One of their distractions was the theatre, and the most successful play of the season was Thomas Shadwell's *The Virtuoso*, a clever topical farce, with liberal amounts of sex and innuendo, which poked malicious fun at the goings-on of the Royal Society. Its main character, Sir Nicholas

Gimcrack, was a scientific enthusiast, whose personality and antics were closely based on the real activities at Gresham College. Sir Nicholas was preoccupied with microscopes and telescopes, he fell into raptures over maggots and spiders, the geography of the moon and projects for bottling air, he had hair-brained ideas to enable men to fly, and engaged in cruel and pointless dissections of living animals.

It was widely assumed that Sir Nicholas Gimcrack was Robert Hooke. On Thursday, 25 May 1676, Hooke himself was given an account of the play by Hoskins and Aubrey, and went off to see for himself on 2 June with Godfrey and Tompion. Feeling thoroughly humiliated by the caricature, he wrote bitterly in his diary: 'Damned Doggs. *Vindica me deus* [God grant me revenge]. People almost pointed.'[96]

Margaret Godolphin went to see *The Virtuoso* in the company of Lady Yarburgh. Learning that the main butt of satirical humour was none other than the architect retained to remodel her first married home, she wrote to Evelyn expressing some concern. Was this really the man with whom she would be dealing over fittings and furnishings? Evelyn responded with an outburst of righteous indignation, rebuking Margaret for allowing herself to be swayed by vulgar, uninformed opinion. 'I was amaz'd', he wrote, 'to see one of your Sex . . . pleas'd with what the wretches said.' The Royal Society, he told her, was a magnificent institution, whose only purpose was 'the investigations of Truth, & discovery of Errors and Impostures . . . without any Offence or provocation to anybody'. As a result of their activities, a whole range of important and useful inventions had been developed, including watches, lifting devices, pumps and mathematical instruments. He utterly condemned court vitriol, and 'the Trade of Mocking and Jeasting', and he certainly expected Margaret to rise above shallow and fatuous mockery of a great man like Hooke.[97]

Hooke remained the Godolphins' architect, and the couple moved into Scotland Yard in March 1677. Evelyn had been closely involved in the renovation, helping Margaret to pick the chimneypieces at Gerrard Weyman's 'magazine [shop] of marble' at Lambeth, mirrors at the Duke of Buckingham's glassworks, and 'Indian Curiosities' at the East India warehouse at Blackwall. We may be sure that he advised Hooke on stylish details of the rebuilding as well.

In spite of Evelyn's rebuke, it is Shadwell's unkind satirising of Hooke which has continued to inform historians' versions of his character and

life.[98] If we are to accord Hooke the respect and admiration he deserves we would do well to remember Evelyn's indignation at the idea that Shadwell's caricature had anything whatsoever to do with the brilliant man himself.

# NOTES

INTRODUCTION: *Winner Takes All*

1 H. W. Robinson and W. Adams (eds), *The Diary of Robert Hooke MA MD FRS 1672–1680* (London: Taylor & Francis, 1968), (hereafter Hooke, *Diary*), Friday, 15 February 1688/9.

2 See L. Jardine, *Ingenious Pursuits: Building the Scientific Revolution* (London: Little Brown, 1996), p. 323.

3 H. W. Turnbull, J. F. Scott, A. R. Hall, and L. Tilling (eds), *The Correspondence of Isaac Newton*, 7 vols (Cambridge: Cambridge University Press, 1959–77) 2, 431. See R. Westfall, *Never at Rest: A Biography of Isaac Newton* (Cambridge: Cambridge University Press, 1980), pp. 445–6. In fact, since the Royal Society was largely without income, Halley himself footed the bill for publication.

4 Turnbull et al., *Correspondence of Isaac Newton* 2, 431. 'Candour' here means 'A disposition to treat subjects with fairness; freedom from prejudice or disguise; frankness; sincerity' (Webster's dictionary).

5 He continued: 'In the papers in your hands there is noe one proposition to which he can pretend, & soe I had noe proper occasion of mentioning him there. In those behind where I state the systeme of the world, I mention him and others. But now we are upon this business, I desire it may be understood. The summe of what past between Mr Hooke & me (to the best of my remembrance) was this. He soliciting me for some philosophicall communications or other I sent him this notion. That a falling body ought by reason of the earth's diurnall

motion to advance eastward and not fall to the west as the vulgar opinion is. and in the scheme wherein I explained this I carelesly described the Descent of the falling body in a spirall to the center of the earth: which is true in a resisting médium such as our air is. Mr Hooke replyd it would not descend to the center, but at a certaine limit returne upwards againe. I then took the simplest case for computation, which was that of Gravity uniform in a medium not Resisting – Imagining he had learnd the Limit from some computation, and for that end had considered the simplest case first, and in this case I granted what he contended for, and stated the Limit as nearly as I could. he replyed that gravity was not uniform, but increased in descent to the center in a Reciprocall Duplicate proportion of the distance from it. and thus the Limit would be otherwise then I had stated it, namely at the end of every intire Revolution, and added that according to this Duplicate proportion, the motions of the planets might be explain'd, and their orbs defined. This is the summe of what I remember. If there was anything more materiall or any thing otherwise, I desire Mr Hooke would help my memory. Further that I remember about 9 years since, Sir Christopher Wren upon a visit Dr Done and I gave him at his Lodgings, discours'd of this Problem of Determining the Hevenly motions upon philosophicall principles. This was about a year or two before I received Mr Hooks

letters. You are acquainted wth Sir Christopher. Pray know whence & whence he first Learnt the decrease of the force in a Duplicate Ratio of the Distance, from the Center' (Turnbull et al., *Correspondence of Isaac Newton* 2, 433–4).

6 This outburst is preceded by an accusation that Hooke has plagiarised from Borelli: 'I cannot forbeare in stating that point of justice to tell your further, that he has published Borell's Hypothesis in his own name & the asserting of this to himself & completing it as his own, seems to me the ground of all the stir he makes. Borel did something in it & wrote modestly, he has done nothing & yet written in such a way as if he knew & had sufficiently hinted all but what remained to be determined by the drudgery of calculations and observations, excusing himself from that labour by reason of his other business: whereas he should rather have excused himself by reason of his inability. For tis plain by his words he knew not how to go about it. Now is not this very fine?' (Turnbull et al., *Correspondence of Isaac Newton* 2, 437–8).

7 Westfall, *Never at Rest*, p. 448; Turnbull et al., *Correspondence of Isaac Newton* 2, 439.

8 Westfall, *Never at Rest*, p. 449.

9 The scholarly work on the controversy, generated almost entirely out of the Newton 'industry' which has dominated history of science research since Newton's death, is hopelessly partisan. See, for instance, Westfall: 'Newton had clashed with Hooke twice before. The charge of plagiary in 1686 was the final straw. He never forgot it, and he never forgave it. Hooke remained his enemy until Hooke's death in 1703. The interest in the incident does not attach to the light it casts on the discovery of universal gravitation. It casts none. The discovery was Newton's, and no informed person seriously questions it. The interest of the incident lies in the glimpse it provides into the tormented soul of a lonely genius [Newton]. Not all that we see there is attractive' (Westfall, *Never at Rest*, p. 451).

10 The relevant passage runs: 'At which time also [after more experiments] I shall explain a System of the World differing in many particulars from any yet known, answering in all things to the common Rules of Mechanical Motions: This depends upon three Suppositions. First, That all Coelestial Bodies whatsoever, have an attraction or gravitating power towards their own Centres, whereby they attract not only their own parts, and keep them from flying from them, as we may observe the Earth to do, but that they do also attract all the other Coelestial Bodies that are within the sphere of their activity; and consequently that not only the Sun and Moon have an influence upon the body and motion of the Earth, and the Earth upon them, but that also ... and by their attractive powers, have a considerable influence upon its motion as in the same manner the corresponding attractive power of the Earth hath a considerable influence upon every one of their motions also. The second supposition is this, That all bodies whatsoever that are put into a direct and simple motion, will so continue to move forward in a streight line, till they are by some other effectual powers deflected and bent into a Motion, describing a Circle, Ellipsis, or some other more compounded Curve Line. The third supposition is, That these attractive powers are so much the more powerful in operating, by how much the nearer the body wrought upon is to their own Centres. Now what these several degrees are I have not yet experimentally verified; but it is a notion, which if fully prosecuted as it ought to be, will mightily assist the Astronomer to reduce all the Coelestial Motions to a certain rule, which I doubt will never be done true without it. He that understands the nature of the Circular

Pendulum and Circular Motion, will easily understand the whole ground of this Principle, and will know where to find direction in Nature for the true stating thereof.'

11 Turnbull et al., *Correspondence of Isaac Newton*, 2, 442–3; S. Inwood, *The Man Who Knew Too Much: The Strange and Inventive Life of Robert Hooke 1635–1703* (London: Macmillan, 2002), p. 361. Actually, as we shall see, Hoskins remained close (or perhaps once again became close) to Hooke. He was one of the four friends who we are told were intended to act as his executors after Hooke's death in 1703 (the others were Wren, Robert Knox and Reeve Williams). See below, chapter 8.

12 The insulting remarks about Hooke's grand claims, and lack of competence to execute them, were part of a review (in English) of recently published Latin correspondence of Hevelius', covering the late 1670s, when he was in dispute with Hooke and the Royal Society over the usefulness of telescopic sights in astronomical observation.

13 See A. Cook, *Edmond Halley: Charting the Heavens and the Seas* (Oxford: Clarendon Press, 1998), pp. 151–2.

14 'At Hallys met Newton – vainly pretended [his] claim yet [would not] acknowledge my information. Interest has noe conscience; *a posse ad esse non valet Consequentia*' (cit. R.T. Gunther, *Early Science in Oxford*, 15 vols, (Oxford: printed for the author, Oxford University Press, 1920–67) 10, 98; cit. Westfall, *Never at Rest*, pp. 451–2. 'From the general contention [ the possible] the actual does not follow.' The mere fact that in our thought we can form a conception does not prove that this conception is the true one, nor that reality corresponds to this conception. This is a general tenet of Aristotelian logic – the whole phrase runs, '*Ab esse ad posse valet, a posse ad esse non valet consequentia.*'

15 cit. Westfall, *Never at Rest*, p. 452.

Hooke was himself involved in composing this letter, and some of the crucial sentences are interpolations by Hooke in Aubrey's draft. See P. J. Pugliese, 'Robert Hooke and the dynamics of motion in a curved path', in M. Hunter and S. Schaffer (eds), *Robert Hooke: New Studies* (Woodbridge: Boydell Press, 1989), pp. 181–205; 186–7: 'It has long been known that the Aubrey letter was composed jointly with Hooke, and that the original contains passages inserted in Hooke's hand. One such passage immediately follows the reference to his having told Newton that gravitation was reciprocal to the square of the distance. Hooke claims that this relation: "would make the motion in an ellipsis, in one of whose foci the sun being placed, the aphelion and perihelion of the planet would be opposite to each other in the same line, which is the whole coelestial theory concerning which Mr Newton hath made a demonstration".'

16 For Hooke's business at this precise moment, see the later *Diary*, and Inwood, *The Man Who Knew Too Much*, p. 396: 'If we take the four days on either side of 15 September 1689, the day the letter was written, it at once becomes clear that his life was not devoted to fighting and refighting his war with Newton. On Wednesday 11 September he set out the foundations of a house with Godfrey, visited Knox's ship at Deptford, met his friends at Jonathan's, went to a book auction and did a view for 5s. On Thursday he lost his ring dial and asked Hunt, Halley and Waller if they had seen it, met friends at Man's and Jonathan's coffee houses, visited Boyle, went with Sir Edmund King to see Boyle's new portrait, and bought several books at an auction. On Friday he sent a collection of books to Sir John Long, received Tycho Brahe's globe from Boyle, visited his old friend Thomas Henshaw, walked with Lodwick, met the usual crowd at Jonathan's and looked for his ring

dial. On Saturday he did another view, called on his cousin Hannah Giles (who was out), treated his troublesome eyes with apple juice, returned a book to the Master of the Mint, and spent the evening at Jonathan's discussing the news of Prince Louis of Baden's crushing defeat of the Turks two weeks earlier. On Sunday, the day of the letter, he showed Brahe's globe to Tompion. On Monday he found his ring dial, "demonstrated equal motion in a parabola", worked with Hunt on fitting and soldering a brass microscope, and spent another evening at Jonathan's with Halley, Godfrey, Lodwich, Currer and others rejoicing over the utter rout of the Turks. On Tuesday he worked with Hunt on the brass microscope, dealt with the carpenters who were working on a new house he had designed for Mr Vaughan, and went to Jonathan's. On Wednesday he worked on Henshaw's microscope, showed him the new brass one, and had a "good discourse" with him. The two went to Jonathan's to meet Halley, Sloane and the usual Royal Society set [it was meeting day], and then he sat up until five in the morning watching an eclipse of the Moon.'

17  Huygens had been in London the previous year, from June to August, following correspondence with Fatio about Newton's *Principia* (of which he was sent a copy by Fatio in 1687). See below, chapter 8, and see J. A. van Maanen, 'Chronology', in H. J. M. Bos, M. J. S. Rudwick, H. A. M. Snelders and R. P. W. Visser (eds), *Studies on Christiaan Huygens* (Lisse: Swets & Zeitlinger, 1980), pp. 19–26; 25.

18  A. R. Hall, 'Two unpublished lectures of Robert Hooke', *Isis* 42 (1951), 219–30; 224. See also below, chapter 8.

19  For the Society's formal declaration taking Oldenburg's part in the balance-spring watch patent dispute, see below, chapter 5.

20  Hall, 'Two unpublished lectures of

Robert Hooke', p. 225. Characteristically, Hooke cannot resist continuing: 'And Moreover Huygens is so ingenuous as both to admire the Discovery of it and expressly to acknowledge that he had noe thoughts of it, till he had met with it in Mr. Newtons book though he had in his *Horologium Oscillatorium* considered the gravitation of pendulous motions in order to demonstrate the Isochrone motion of a circular pendulum which I had also Discoverd, made and shewn to the Society above 7 years before as will appear by their Journalls & Registers thereof.'

21  See L. Jardine, *On a Grander Scale: The Outstanding Career of Sir Christopher Wren* (London: HarperCollins, 2002), chapter 5.

22  It has to be said that, to a quite remarkable extent, the fascinating mailbag of letters from readers of both *Ingenious Pursuits* and *On a Grander Scale* has consisted of requests for more and more detailed information about Hooke and his life.

23  M. 'Espinasse, *Robert Hooke* (London: William Heinemann, 1956), p. v.

24  Hooke does figure in Bronowski's classic TV series, *The Ascent of Man*, but I had not seen it for many years, and had forgotten that, too.

25  See P. Fara, *Newton: The Making of a Genius* (London: Macmillan, 2002).

26  See the account of Newton's manipulation of his portraiture by Tristram Hunt, in J. Cooper (ed.), *Great Britons: The Great Debate* (London: National Portrait Gallery, 2002), pp. 72–80.

27  Hunt, 'Isaac Newton', p. 74.

28  The painting of the right shoulder as significantly higher than the left most closely resembles the classic sixteenth-century version of the portrait of Richard III – another man with a crooked back. I am grateful to Dr Warren Boutcher for pointing out to me the way in which late-Tudor paintings of Richard imply a hunchback by altering earlier painted

images of him so that the right shoulder is higher than the left.

29 Hooke, *Diary*, p. 98. It was not until 8 June 1675 that Hooke finally escorted Boyle to Mrs Beale's for his own portrait sitting. If Hooke himself sat for Mrs Beale during this period he would have been approaching forty, which is consistent with the portrait we have. The Beale portrait of Boyle, if it was completed, has also disappeared.

30 See J. Heyman, 'Hooke and Bedlam' (seen in draft, for delivery at the Hooke tercentenary conference, July 2003).

31 The records of the Natural History Museum show that the painting was received as a bequest from Sir William Watson (1715–87), a celebrated early experimentalist at the Royal Society, whose discoveries in electricity were contemporary with (and somewhat overshadowed by) those of Benjamin Franklin. Watson had begun his scientific career as a botanist, and was a protégé of Sir Hans Sloane. He received a Royal Society medal for his investigations into electricity in the 1740s. He left the painting to the Trustees of the British Museum in 1787. Watson's will (London, 14 January 1787) is entirely concerned with substantial money bequests to his son and daughter. It allocates only three individual items, as follows: 'I also [in addition to money bequests] give [my son] my silver watch made by Graham and the medal of Gold given me by the Royal Society and in case of his death without children I give the said watch and medal to Mary my daughter and I earnestly desire that the medal be not parted with but on account of the pressing necessities of the Possessor as I would have it continue in my Family not so much on account of its intrinsic value but as a Testimony of the regard of the late Sir Hans Sloane and of the Royal Society and as a reward which they considered to be due for my discoveries in Electricity. I give and bequeath my Picture of the late learned and ingenious Dr. John Ray painted by Mrs. Beale a Scholar of Sir Peter Lely to the Trustees of the British Museum to be placed if the Trustees think proper in the Room of the said Museum wherein Ray's Bust is already placed' (PROB 11/1153). I am extremely grateful to Susan Snell, Archivist and Records Officer in the Department of Library and Information Services at the Natural History Museum, for her generous assistance in tracing the provenance of the painting, and for allowing me access to the original. Since Watson refers to the portrait as being of John Ray, it may have been he who was responsible for the inscription. Ray died in 1705. His appearance would not have been familiar to most members of the Royal Society after 1710. Watson was born (1715) after the deaths of both Hooke (1703) and Ray (1705).

CHAPTER I: *The Boy from the Isle of Wight*

1 M. Hunter, A. Clericuzo and L. M. Principe (eds), *The Correspondence of Robert Boyle*, 6 vols (London: Pickering & Chatto, 2001) 3, 332.

2 Words found by Richard Waller 'in a small Pocket Diary', after Hooke's death. R. Waller, 'The Life of Dr. Robert Hooke', in *The Posthumous Works of Robert Hooke* (London, 1705).

3 Waller, 'Life of Dr. Robert Hooke'.

4 This property seems to have been in Brading and Newport. The Brading property may have come from John Hooke's first marriage; the Newport property was probably his brother John's (retrieved from Newport Corporation after it fell to them by default following his suicide in 1678). We will comment later with what happened to the Freshwater property, which was clearly not 'tied' to the church, since Cecily continued to live in the house after John's death (see

details of his will). Sir Robert Holmes acquired property in Freshwater, which I will argue came through the family of his natural daughter Mary.

5  A 1675 entry in Robert Hooke's diary notes, 'Cozen John Hooke dangerously ill'. This may have been the 'John Hooke of Bramshott' who became embroiled in a dispute over jointure lands with the widow of Sir John Oglander's grandson (also Sir John Oglander) in May 1678. See PRO C10/133/93 Oglander v. Oglander and Hooke: Hants 1678. 'Espinasse has a Hooke who is married to a Wren, thereby making Hooke and his friend distant 'cozens': 'Apparently they were even related by marriage. Wren wrote to Hooke as "Cosin", and on 9 February 1677 the diary records the burial of "Cozen Wren Hooke". This is probably the "Cozen Hooke" who appears several times in the diary in connexion with Wren. It may even be Wren's sister, whom Wood notes as having married John Hook, B.D., formerly a Fellow of Magdalen. This John Hook died in 1674 and was buried in Bletchington, where Wren lived in his youth with his brother-in-law the rector, Dr. Holder.' Principe 'Espinasse, *Robert Hooke*, p. 114. 'Cosin': see Wren, letter to Hooke, 20 April [1665], R. S. letter book W.3.6 (4207). 'Cozen Hooke': see *Diary*, 1673, 13 March; 1674, 21 Dec.; 1675, 24 Sept.; 1676/7, 9 Feb. John Hook: see A. Wood, *The Life and Times of Anthony Wood, antiquary of Oxford, 1632–1695*, 5 vols (Oxford: Oxford Historical Society, 1891–5) 2, 282.

6  'John Hooke to be allowed to act as curate for reading prayers in Church of St Helens till Lady Day next. 25 July 1610'.

7  In the parish records Hooke is twice referred to as 'clerk'. For his first marriage he is called 'minister', and his own signature on his will might read 'P[resby]ter'. None of these words necessarily refers to someone in holy orders in the 1620s and 1630s.

Hooke always implied that his father had church training.

8  Born 1609. 'He was christened in Brading Church by Mr. Gilbert, then minister, and Doctor Hampton preached: all the better sort in the country were at his christening. Afterwards we put him to nurse to George Oglander's wife, my tenant then living at Upton, and gave a great rate for the nursing of him. When he was fit to be weaned, we took him home and bred him carefully under our own wings, and I may truly say that never was woman more careful of a child than his brother was of him: she and her gentlewoman taught him to read. Afterwards, I took Mr. Hooke, curate of Brading, into my house to teach him his accidence, in which my own care and pains were not wanting' (*A Royalist's Notebook. The Commonplace Book of Sir John Oglander Kt. Of Nunwell. Transcribed and edited by Francis Bamford* (London: Constable & Co., 1936), p. 177).

9  'Thence I sent him to Oxford and for love of his tutor, one Mr Reynolds, Fellow of Merton College, I placed him as a fellow commoner, where he profited very well under Mr Reynolds . . .' (Bamford, *A Royalist's Notebook*, p. 177). See also the Oglander account book (1622-3OG 90/1): 'Given to him that teacheth my boys astronomy – 2–0–0', 20 May 1623 (p. 192), 'To Mr Hooke for my privie tithe – 3–0–0'. George died of smallpox in France in 1632.

10  '1615 Hooke, John Minister married. Margaret Lawson, Widow in Brading' (Brading Parish Register); 'John Cordreye d. 1609, Brading. Edward Lawson married Margaret Cordray, *widow*, Brading 1611; Edward Lawson buried 17th Dec 1614' (Brading Parish Register); 'Margaret Hooke buried 1615/16 18th Jan. Wife of John Hooke, minister and curate of Brading' (Brading Parish Register). Both daughters by the earlier marriages were dead by 1625.

11 '1622 Married Cecilie Gyles' (Brading
Parish Register). '1628 11th May
Katherine Hooke, daughter of Mr
John Hooke, clerk – bapt. 1630
9th May John Hooke baptised in
Freshwater' (Freshwater Parish
Register).

12 George Warburton was appointed in
1621. Since there are payments to John
Hooke for 1623, the most likely date
for his transfer to Freshwater is 1624,
perhaps linked with the new
association with St John's.

13 Fell was elected Canon at Christ
Church, Oxford in 1619, becoming
chaplain to James I around the same
time; in 1638 he became Lady
Margaret Professor of Divinity and
Dean of Christ Church, and in 1645
Vice-Chancellor of the University of
Oxford. G. F. Russell Barker and Alan
H. Stenning (eds), The Record of Old
Westminsters, 2 vols (London:
Chiswick Press, 1928) 1, 325.

14 AC 95/32 178.

15 '1635 19th July Robert Hooke baptised
in Freshwater, son of Mr John Hooke
clerk' (Freshwater Parish Register).
The same caution needs to be
exercised when dealing with John
Aubrey's 'brief life' of Robert Hooke,
although we know Aubrey was a close
personal friend. It is unlikely that John
Hooke officiated at his son's baptism,
as the 'curate', unless perhaps this was
an emergency and the pastor was
absent.

16 Both daughters are referred to as
'Hooke' in their father's will of 1648,
so neither was yet married at that
date.

17 Hooke did stay in close touch with his
brother John. His sister-in-law is
recorded as staying with Hooke in
London on two occasions while her
daughter Grace was living in the home
of her uncle Robert.

18 Hammond's appointment was
intended as a 'retirement' from the
centre of political action, as a
recompense for services rendered to
Cromwell on the field of battle.
Hammond was the nephew of Charles

I's chaplain. See C. Carlton, Charles I:
The Personal Monarch (second edition;
London: Routledge, 1995).

19 The received opinion is that John
Hooke signed his will 'cleric[us]' –
clerk. But it looks more plausibly like
'P[resby]ter' ('priest') to me.
Alternatively, it could simply read
'p[a]ter' (father) to distinguish him
from his son, also John.

20 The islands had suffered punitive
taxation even before the civil wars,
under the infamous 'ship money'
system of taxation.

21 'Report of the Commissioners under
the Act for ejecting scandalous,
ignorant or insufficient minister'. M/
14.fo.48 (Isle of Wight Records Office).
'Freshwater Rectory. Value. £180.p.a.
Incumbent. Cardill Goodman'. When
Goodman died in the 1670s he left his
son (also Cardell Goodman) £2000
(DNB).

22 Among its famous residents we might
number Queen Victoria and Prince
Albert, Alfred Lord Tennyson and the
Edwardian photographer Julia
Cameron. All of the above chose to
live on the Isle of Wight (and all in
the vicinity of Freshwater) for its
climate and congenial landscape.

23 Sir Richard Worsley (ed.), The History
of the Isle of Wight (London: A.
Hamilton, 1781), p. 1.

24 See The Journals of William Schellinks'
Travels in England 1661–3, Camden 5th
Series, vol. 1, Royal Historical Society,
1993, p. 138.

25 '[Easter Monday, 1630] About 10 of
the clock we weighed anchor [at
Cowes] and set sail with the wind at
N. and came to an anchor again over
against Yarmouthe, and the Talbot
weighed likewise and came and
anchored by us ... In the morning
about 10 of the clock, the wind being
come to the W. with fair weather, we
weighed and rode nearer Yarmouth.
When we came before the town, the
castle put forth a flag. Our captain
saluted them and they answered us
again'. R.S. Dunn and L. Yeandle, The
Journal of John Winthrop 1630–1649

(Cambridge, Mass: Harvard University Press, 1996).

26 Waller, 'Life of Dr. Robert Hooke'.

27 Hooke to Boyle, between 1 and 5 July 1664, Hunter et al. *Correspondence of Robert Boyle* 2, 292.

28 Hunter et al. *Correspondence of Robert Boyle* 2, 292.

29 See J. Gleick, *Isaac Newton* (London: Fourth Estate, 2003), p. 4.

30 For the terms of the Cutler endowment, which stipulated that Hooke take a special interest in the History of Trades, see below, chapter 6. The most striking example is his lifelong involvement with stone as used in building. Portland, whence the prime fossil-rich stone came which faced all Wren's and Hooke's finest buildings, was, as Hooke himself noted, the continuation westwards of the same geological stratum which he was observing on the seashore at Freshwater Bay. Hooke also examined the structure of Ketton or Kettering stone using his microscope. See D. Hull, 'Robert Hooke: a fractographic study of Kettering-stone', *Notes and Records of the Royal Society* 51 (1997), 45–55.

31 There was a glasshouse on the Isle of Wight manufacturing glass during the late seventeenth century.

32 See 'Espinasse, *Robert Hooke*, pp. 149–50: 'He had practised glass-grinding and glass-blowing all his scientific life, and had expert knowledge. (In 1691 he got a patent for a new kind of glass, as well as being nominated Warden of a company which was about to be incorporated – the Company of Glass Makers.) He visited London glass houses repeatedly, for instance Reine's, one in the Minories and one in the Savoy. On 23 February 1674 he gives a long description of Reine's method of joining glass plates.'

33 See A. Macfarlane and G. Martin, *The Glass Bathyscaphe: How Glass Changed the World* (London: Profile Books, 2002).

34 It was as part of this undertaking that

Hooke was sponsored by Sir John Cutler, leading to his later protracted lawsuit to try to extract from the notoriously tight-fisted Cutler the £50 per annum he was supposed to have been paid by him. See below, chapter 6.

35 Royal Society Classified Papers XX.40.

36 Hunter, *Establishing the New Science*, pp. 300–1; Royal Society Classified Papers XX.42.

37 For more on this visit see below, chapter 3.

38 'The Isle of Wight was separated from the Purbeck Peninsula of the Dorset mainland by marine erosion and is part of the geological structure called the Hampshire–Dieppe Basin. The island's river system shows that the land once extended much farther south. The upper Cretaceous to Oligocene rocks on the island have been folded and faulted by tectonic activity in the Cenozoic in several episodes from early Paleocene to the Oligocene or early Miocene. The oldest Cretaceous and oldest rocks on the island are exposed in the cores of two east–west trending, monoclinic, asymmetrical anticlines, the Brighstone or Brixton Anticline in the west and the Sandown Anticline in the east, arranged *en echelon*. The most intense of the Alpine orogeny (mountain-building forces) in Britain, in fact, occurred on the southernmost fringe of England, from the Isle of Wight to the Isle of Purbeck and the Weymouth Peninsula. The violent tectonic movement on the island resulted in some overturned and overthrust faulting ... The northern limbs of both folds are almost vertical, as shown by the chalk pinnacles known as the Needles ... Vertical beds are also exhibited by the colourful Eocene beds in Alum Bay' (E. T. Drake, *Restless Genius: Robert Hooke and his Earthly Thoughts* (Oxford: Oxford University Press, 1996), p. 63).

39 'William Schellinks ... was born in Amsterdam in 1623 and died there in 1678. As a visual artist he flourished

from c. 1642 to his death ... In 1646 he travelled in France with a fellow artist Lambert Doomer and made many drawings there. He apparently kept a diary even then, which enabled him to write a journal of the trip some twenty years later. In July 1661 he set out, in some style, with the merchant shipowner Jaques Thierry and the latter's young son, also Jaques or Jacobi, then thirteen years old, from Amsterdam for England. This was the start of a Grand Tour for Thierry junior, also covering France, Italy, Sicily, Malta, Germany and Switzerland, accompanied throughout by Schellinks, who made many drawings, mostly of a topographical nature. The two returned to Holland in August 1665. Two years after his return to Amsterdam, Schellinks married the well-to-do widow of another fellow artist Dancker Danckerts' (Schellinks, *Journals*, p. 1).

40 Worsley, *History of the Isle of Wight*, p. 274. Worsley also discusses the disappearance of various channels and inlets (particularly around Brading).

41 See the engraving of the Needles in Worsley, *History of the Isle of Wight*. Drake reports that another of the Needles collapsed in 1993, shortly after she had photographed them for her book.

42 Sir John Oglander devised a scheme actually to turn Freshwater into an island, and Yarmouth likewise, and to transform them into fortified garrisons, protecting the English coast from foreign marauders. He succeeded in putting his plan in action for Yarmouth in 1662 – in 1664 a drawbridge was built to give access to Yarmouth, and it was across this that Charles II rode when he visited the Governor Sir Robert Holmes at his residence in 1671.

43 Drake, *Restless Genius*, p. 198. These memories had been revived by his recent visit, but it is unlikely that in that packed couple of weeks Hooke had occasion to do all the roaming he describes in these vivid passages

written shortly after his return to London.

44 Drake, *Restless Genius*, p. 232. Hooke continues: '[D]ivers of these I observ'd to be made up of the peices of Earth that had foundered down from the Cliff, which I was assured of by careful observing and finding divers of them to consist of the several Layers, and in the same order as I saw them in the Cliff; among the rest I found divers that had the Layer of Sea Sand and Shells which I had observed in the Cliff inserted in the Stone with the adjoyning Layers all petrify'd together into a hard Stone. Here I found multitudes of the said Shells I before mention'd to have observ'd in the Cliff, mix'd loosely with a Sea Sand; now together with the same Sand both fill'd, inclos'd, and petrify'd altogether, and I broke off many peices of the said Rocks, where I found the said Petrifications, and found them much like other Stones I had seen from other Inland Quarries here of *England*.'

45 Drake, *Restless Genius*, pp. 233–4.

46 The first person explicitly to draw attention to this link between Hooke's childhood experience of geology and his later theories of earthquakes and fossils was E. T. Drake. See Drake, *Restless Genius*, especially chapter 2.

47 These included an intact ammonite of spectacular size, presented to the Society by Henry Howard, grandson of the great artistic patron and collector Sir Thomas Arundel, and another discovered by Sir Christopher Wren during excavations for St Paul's.

48 Schellinks, *Journals*.

49 Hooke, *Micrographia*. The extended discussion of petrified wood found in *Micrographia* antedates by six months his unexpected return visit to the Isle of Wight following his mother's death.

50 See below, chapter 2. For Wren's early astronomical observations, see Jardine, *On a Grander Scale*. Bennett argues that Hooke had seen a micrometer eyepiece in use on telescopes at Wadham; see J. A. Bennett, 'Hooke's

instruments: for astronomy and navigation', in Hunter and Schaffer, *Robert Hooke: New Studies*, pp. 21–32.

51 Waller, 'Life of Dr. Robert Hooke'.

52 Aubrey, *Brief Lives*, cit. G. Keynes, *A Bibliography of Dr Robert Hooke* (Oxford: Clarendon Press, 1960), p. 12. No copies of this pamphlet survive, but Keynes is convinced of its existence by corroborating testimony in other contemporary sources, and remarks of Hooke's elsewhere. See also Bennett, 'Hooke's instruments', pp. 21–2.

53 Keynes, *Bibliography of Dr Robert Hooke*, pp. 18–38.

54 cit. Keynes, *Bibliography of Dr Robert Hooke*, p. ix.

55 See Jardine, *Ingenious Pursuits*.

56 Hooke, *Animadversions on the First Part of the Machina Coelestis of . . . Johannes Hevelius* (London, 1674), included in Hooke, *Lectiones Cutlerianae* (London, 1679), cit. Bennett, 'Hooke's instruments', pp. 26–7.

57 Hooke, *Animadversions*.

58 This section is closely based on J. A. Bennett, 'Hooke's instruments', in J. A. Bennett, M. Cooper, M. Hunter and L. Jardine (eds) *London's Leonardo* (Oxford: Oxford University Press, 2003), pp. 63–104. See also Bennett, 'Hooke's instruments', pp. 29–31.

59 T. Birch, *A History of the Royal Society of London for Improving Natural Knowledge, from its first Rise*, 4 vols (London, 1756) 2, 156, 158–60.

60 Bennett, 'Hooke's instruments', p. 29.

61 Many of Hooke's discussions of instruments are to be found in printed or manuscript Cutlerian lectures. Hooke clearly believed that he was thereby contributing to the programme of commercial advancement and improvement of trade techniques that Cutler wished him to pursue. As we shall see, Cutler withheld payment for many years, largely on the ground that Hooke had failed to lecture on the sort of History of Trades topics specified under the terms of his agreement with the Royal Society. See below, chapter 6.

62 Hooke, *Animadversions*, p. 44.

63 Hooke, *An Attempt to Prove the Motion of the Earth from Observations* (London, 1674), included in Hooke, *Lectiones Cutlerianae*, p. 9, cit. Bennett, 'Hooke's instruments', p. 25.

64 We have practically no information about the lives of Hooke's sisters.

65 Prince Charles (later Charles II) spent some months on the island of Jersey, for the same reason, before finally fleeing to France.

66 See Worsley, *History of the Isle of Wight*, appendix no. XXVIII, p. lxix: 'The Draught of a Bill intended to have been brought before Parliament, 16 Car. I. [1641] to ascertain the true State of the Tenures in the Isle of Wight.' See also Yarmouth website: 'In 1629 Sir John Oglander led a deputation to the King with a plea to make Yarmouth and Freshwater into islands for defence purposes. The King made sympathetic noises but nothing was done until 1662 when a moat was cut through from the Solent to the marshes. For two years Yarmouth was without contact with the rest of the Island, except by boat, until a drawbridge was erected in 1664. This was still in use when Charles I visited Yarmouth in 1671 but no record has been found of its dismantling.'

67 Thomas Urrey and his wife Alice also entertained the King at Thorley, near Yarmouth and Freshwater.

68 cit. J. Adair, *By the Sword Divided: Eyewitness Accounts of the English Civil War* (Bridgend: Sutton Publishing, 1998), pp. 219–20.

69 Carlton, *Charles I*, pp. 318–19.

70 See Jardine, *On a Grander Scale*, chapter 1.

71 Such hints are all that survives of Oglander's commitment to seeing the King returned to power. One of the difficulties with Oglander's diary and account books – as with other documents from this period – is that they have been discreetly censored, pages taken out with a sharp knife at

the binding, presumably to avoid further grief during the Commonwealth and Protectorate periods.

72 In 1679 this house was sold by the Urreys to Sir Robert Holmes, Governor of the Isle of Wight.

73 *A Royalist manifesto drawn up by Island gentlemen in 1642, is signed by (among others) Sr Wm. Hopkins & Sr John Oglander.* Newport Corporation Manuscripts *Convocation Book* vol. 1 (1609–59), p. 426. See also J. D. Jones, *The Royal Prisoner: Charles I at Carisbrooke* (Northumberland Press, 1965).

74 Carlton, *Charles I*, p. 331.

75 cit. Carlton, *Charles I*, p. 327.

76 Loyal royalists on the Isle of Wight were responsible for saving important artworks associated with the monarchy. See S. E. Lehmberg, *Cathedrals under Siege: Cathedrals in English Society 1600–1700* (Exeter: University of Exeter Press, 1996), p. 65: 'The cathedral at Winchester had not been severely damaged in the [civil] war, so most of the work there involved either adornments or normal maintenance. Shortly after the Restoration the bishop, Brian Duppa, paid £100 to retrieve Le Sueur's statues of James I and Charles I, which had been buried in a garden on the Isle of Wight.'

77 Bamford, *A Royalist's Notebook*, p. 120.

78 On the damaging level of fines for delinquents during this period see P. H. Hardacre, *The Royalists during the Puritan Revolution* (The Hague: Marinus Nijhoff, 1956), chapter 2, 'The delinquents, 1643–1649', pp. 17–38. For the penalties paid by Anglican clergy see chapter 3, 'The religious victims of the Long Parliament, 1642–1649', pp. 39–63.

79 Bamford, *A Royalist's Notebook*, p. 120.

80 In the 1660s Charles II came to the Isle of Wight to confer a knighthood on Benjamin Worsley for his loyalty to his father, Charles I.

81 The statement in the will that John Hooke was 'in good helthe and perfect

memory thankes bee giuen to Allmighty God' is more than formulaic. Wills of this period regularly allude to the state of sickness in which the person making their will finds themselves.

82 Carlton, *Charles I*, pp. 331–2.

83 Parish Register entry transcribed by Rachel Jardine, August 2000. Although we know of only one occasion on which Hooke returned to the Isle of Wight, his mother continued to live there until her death.

84 H. Nakajima, 'Robert Hooke's family and his youth: some new evidence from the will of the Rev. John Hooke', *Notes and Records of the Royal Society* 48 (1994), 11–16; 12–13.

85 See below, chapter 7.

86 See below, chapter 6.

87 If either of Hooke's sisters had been married, with a home of their own, we might have expected Hooke to go there, as Christopher Wren went to the household of his sister Susan Holder under somewhat similar circumstances in 1646.

88 Nakajima, 'Robert Hooke's family', p. 14.

89 Sir Peter Lely was born in Germany to Dutch parents. His real name was Pieter van der Faes. He was patronised by Charles I and later Oliver Cromwell. In 1661, Lely was appointed Principal Painter to King Charles II. He became an English subject in 1662 and in 1680 received the honour of a knighthood. He died in the same year and was buried in St Paul's Church in Covent Garden.

90 He was also a Gresham professor, which entitled him to residence.

91 In the inventory of sale for Hooke's extensive library, auctioned after his death in 1704, are a number of the kind of general books (including arithmetic and the classics) which might have come from his father's library, as his legacy to Hooke in 1648. The most striking entry on this list, however, is a folio Italian Bible which fetched the top price in the auction for a single volume, at £2.0.0. The

inventory entry reads: 'La Sacra Biblia da Giovanni Diodati folio deaurata cartarium Majestatis Regis con medesimi Commentarii – 1640'. 'The Bible of Giovanni Diodati in folio, gilded, from the collection of his Majesty the King and with annotations by the same.' See A. N. L. Munby (ed.), *Sale Catalogues of Libraries of Eminent Persons*, vol. 11 (London: Mansell, 1975), pp. 37–56; 50. I find it irresistible to think that this precious 'relic' of King Charles I was acquired by John Hooke in 1647–8, and passed, as part of his legacy, to Robert. I admit, however, that 'annotations by the same' might mean 'commentary by Diodati'.

92 See Hooke's *diary*, passim.

93 Aubrey passage. 'John Hoskins (1590–1664/5) originally trained as a portrait painter with William Larkin. His earliest miniatures bear the influence of Nicholas Hilliard and Isaac Oliver, but later he was very much influenced by the arrival of Van Dyck in England in 1632. Hoskins was Limner to King Charles I making many miniatures of the royal family and also miniature copies of pictures in the royal collection.'

94 J. Murdoch, *Seventeenth-century English Miniatures in the Collection of the Victoria and Albert Museum* (London: The Stationery Office in association with the Victoria and Albert Museum, n.d.), pp. 43–5. 'From at least 1634 John Hoskins lived and worked in Bedford Street, Covent Garden and was granted by the King on 30 April 1640 an annuity of £200 for life "provided that he work not for any other without His Majesty's licence"' (p. 43).

95 The inferior copyist has not understood the significance of the two chalk masses rising out of the sea – that they are the Needles is clear by comparison with Doomer's drawing of them in the 1660s. 'Hoskins pioneered the use of landscape or sky backgrounds in miniatures, showing consciousness of

Wenceslas Hollar as well as Van Dyck' (Murdoch, *Seventeenth-century English Miniatures*, p. 43).

96 cit. Murdoch, *Seventeenth-century English Miniatures*, p. 43.

97 Hampshire Record Office 1648B9/1.

98 'Robert Urrey: 6th Sept. 1590 Baptised, son of Tho. Urry' (Freshwater Parish Register); 'Married Marey Stevenes 6 Oct. 1631' (Freshwater Parish Register). Listed 1 property in Freshwater in Lay Subsidy. Public Record Office: Lay Subsidy 1642 [?]. 1641/2 Feb. 17th: Letter from Sir John Oglander at Nunwell to Mr Robert Urry, Freshwater, appointing him Captain of the Boats for the West Medine, in place of Mr David Urry, deceased (Oglander papers OG/BB/459, Isle of Wight Records Office). The fact that Urrey was in charge of 'boats' and elsewhere of light horse (Oglander papers OG/71/10, Isle of Wight Records Office) suggests he was a man of some means.

99 'Nicholas Hockley. 26th August 1653 Married Mrs Elizabeth Urrey, Daughter of Mr. Richard. Died 31st March 1668' (Freshwater Parish Register).

100 Cardell Goodman (see also *DNB*). Son of John Goodman of Ware, Herts; at school under Wilson. Emmanuel College, Cambridge, matriculated Easter 1622; BA 1625/6; elected Fellow of St John's College on Bishop Williams foundation 31 March 1626 MA 1629; BD 1636; rector of Freshwater, Isle of Wight 6 March 1640/1. 'Presumably educated at [Westminster] school as these fellowships were confined to Westminster men'. Russell Barker and Stenning, *Record of Old Westminsters*, 1, 383.

101 *DNB* gives Cardell Goodman junior's dates as 1649? to 1699, and describes him as an 'actor and adventurer'. It is hardly surprising that Hooke never linked his fortunes with those of Goodman senior, since by the 1680s he was known as 'Scum' Goodman,

and a byword for villainy. 'His latter years were rendered more affluent by his becoming the paramour of the Duchess of Cleveland.' See *DNB*.

102 It is also possible that Samuel Fell, the previous rector of Freshwater, also an Old Westminster, was involved.

## CHAPTER 2: *A Sincere Hand and a Faithful Eye*

1 Hooke, *Diary*, 31 December 1676, p. 265.

2 Richard Busby (1606–1695) came from Lincolnshire. He was educated at Westminster School and Christ Church, Oxford, where, after graduating in 1628, he became a tutor. In 1638 (at the age of just 32) he became (Head) Master of Westminster School. On Busby see G. F. Russell Barker, *Memoir of Richard Busby* (London: Lawrence & Bullen, 1895).

3 Elias Ashmole was the person who helped design these extravagant ceremonies.

4 See Edward Bagshaw, the younger, *A True and Perfect Narrative of the Differences between Mr Busby and Mr Bagshawe, the first and second masters of Westminster-School. Written long since, and now published, in answer to the calumnies of Mr Pierce* (London, 1659).

5 Eddie Smith of Westminster School tells me he has found Hooke's name in a list of pupils in the 1650s among the school records. In a deposition lodged as part of the process of ratifying a codicil to Busby's will, Hooke declared himself under oath to be a former pupil of Busby's at Westminster School. See below, chapter 8.

6 Robert South, *Sermons*, 1823, III, p. 412, cit. M. Cranston, *John Locke: A Biography* (London: Longmans, Green & Co., 1957), p. 19.

7 In Busby's case this reputation was established in Edward Bagshawe's scurrilous pamphlet.

8 Bagshawe, *A True and Perfect Narrative*.

9 'The College House at Chiswick was secured to the School through the generosity of Gabriel Goodman in 1570. The buildings were intended to be used as a pest-house or sanatorium for the accommodation of one of the prebendaries of Westminster, the master of the School, the usher, and the forty boys on the foundation, who were to retire thither in time of sickness or at other seasons when the Dean and Chapter should think proper. Busby used frequently to reside here in the summer-time' (Russell Barker, *Memoir of Richard Busby*, p. 90).

10 The official histories of Westminster acknowledge long periods during which Busby taught senior boys at Chiswick. 'In some years, though, the threat of plague compelled long retreats to the rural delights of Chiswick, where the School was conducted for fourteen weeks in 1652' (J. Field, *The King's Nurseries* (London: James & James, 1987)).

11 Westminster School accounts for Commonwealth period show payments (a) for extensive rentals of school property at Westminster (in Dean's Yard and adjacent areas) and (b) payments to the school supplier of bed for carrying linen and other necessaries for the boys to Chiswick for periods of up to 20 weeks a year. The records show that Busby continued to be paid, promptly and in full, throughout this period. See PRO E165/58, 'The Booke of Accompts for Moneyes receiued and paid of the Revenues belonging to the Schoole and Almeshouses of Westminster commencing from the last of May 1657'; PRO E165/59, *The Booke of Accompts . . . 1655*. See PRO 1658–60 E101/668/45. Also see SP 28/292 and SP 46/13/fo 160–205. I am grateful to Rachel Jardine for bringing these records to my attention.

12 This story is confirmed in Aubrey's *Brief Lives*, where he characterises

Bagshawe as a low-church man, and a Nonconformist, who got into more trouble after the Restoration. See J. Buchanan-Brown (ed.), *John Aubrey: Brief Lives* (London: Penguin Books, 2000), pp. 67, 166, 313–14.

13 See J. A. Winn, *John Dryden and his World* (New Haven: Yale University Press, 1987), appendix B.

14 Evelyn, *Diary*, 13 May 1661. E. S. de Beer, *The Diary of John Evelyn*, 6 vols (Oxford: Clarendon Press, 1955; reprinted 2000) 3, 287–8.

15 cit. Cranston, *John Locke*, pp. 26–7.

16 Many famous old Westminsters had such stories. Robert South – who had been a full fee-paying student and King's Scholar – claimed to have impressed Busby with his ability to write Latin epigrams. Note also that Aubrey says of Francis Potter, in his *Brief Lives*: 'He understood only common Arithmetique, and never went farther in Geometrie then the first six bookes of Euclid; but he had such an inventive head, that with this foundation he was able to doe great matters in the mechaniques, and to solve phaenomena in naturall philosophy.'

17 'At Westminster Hooke learned Latin, Greek, a little Hebrew, quickly mastered the first six books of Euclid and was competent at musical exercises at the organ. But there is evidence that he also learned from extra-curricular activities. John Aubrey records that one of Hooke's contemporaries at Westminster School noticed that Hooke was not often seen there at lessons [Aubrey]. Perhaps Hooke was out and about in the "dark shops of Mechanicks" [Preface to *Micrographia*] watching and talking to craftsmen, more concerned with trying to make the flying machines he had in mind than taking formal lessons in Euclid, music and languages, mastery of which seems to have taken little of his time' (M. Cooper, 'Hooke as employee', *London's Leonardo*, pp. 1–61).

18 English text of the revised edition, published in 1647; Latin 1648. Hooke's copy of the Latin *Clavis* is in the British Library.

19 Wren collaborated with Scarburgh, Wood and Ward on the 1652 Latin revised version of this textbook – possibly this helped bring him and Hooke together when Hooke arrived at Christ Church in 1653. See F. Willmoth, *Sir Jonas Moore: Practical Mathematics and Restoration Science* (Woodbridge: Boydell Press, 1993), pp. 43–87.

20 See 'Espinasse, *Robert Hooke*, p. 96.

21 See Jardine, *On a Grander Scale*.

22 For Wren's early employment by Charles Scarburgh in this kind of capacity see Jardine, *On a Grander Scale*, chapter 2.

23 Buchanan-Brown, *John Aubrey: Brief Lives*, p. 395.

24 See below, chapter 8.

25 Trinity College Library, Cambridge, O.11a.1[29].

26 Trinity College Library O.11a.1[29]: 'Letter from B Woodroffe to Mr Houghton of London, apothecary on RH's education with a note in another hand (2ff), 28 Jan 1704/5. [On the front of the folded paper] For Mr. Houghton an Apothicary at his house in Grace-church Streete turning into East-cheap. London. [Overleaf] Jan. 28. 1704/5.' The letter continues: 'Dr Knipe the Master of Westminster Schoole or Mr Matlaise who was the Usher there but now lives rilesed, (Lodgeing at Mr Jacob's the next door to the Crouked Billet in Hart – Street in Covent – garden) is most likely to give a full & more particular account of all, concerning which you inquire. [over] I purpose to be in London this Time, where I shall wait on you; My humble Service to your Lady. I am your obliged Friend & most humble servant. B Woodroffe [different hand] 2 Anthony A Woods Athenae Oxonsenfis. Dr Beaumont sayes the Dr Hook was serviteur in Oxford to Dr Goodman who was father to Goodman the Dutches of Clevelands

Steward & this he had from Goodmans mouth.'

27 cit. Cranston, *John Locke*, p. 20.

28 There is an equivalent story of Westminster boys being allowed out to watch Cromwell's funeral cortège pass the school, and stealing the heraldic insignia from the coffin. Busby officiated at the Coronation of Charles II.

29 Waller, *Posthumous Works of Robert Hooke*, p. xxvi.

30 See below, chapter 2.

31 Microscope tubes use the same technology as the well-developed craft of flute-making.

32 Influence also had to be exerted by family and by powerful patrons (neither of which Hooke had). See Cranston, *John Locke*, pp. 19–22.

33 See Buchanan-Brown, *John Aubrey: Brief Lives*, p. 395: 'He was sent to Christ Church in Oxford, where he had a chorister's place (in those days when the church musique was putt-downe), which was a pretty good maintenance.' See also Wood, *Athenae* 4, 628; also J. Sargeaunt, *Annals of Westminster School* (London: Methuen & Co., 1898). Oliver Cromwell was fond of choral music, and Oxford colleges continued uninterrupted through the Interregnum with the full musical programme of their chapel services, although the service content was, of course, emptied of all reference to the monarchy.

34 We can perhaps see how such arrangements worked from the better-documented case of Thomas Willis. Willis (1621–75) began his schooling at Edward Sylvester's school in Oxford. In 1636 he gained the sponsorship of Dr Thomas Iles, Canon of Christ Church (there may have been a distant family connection). In 1637 he matriculated at Christ Church as 'servitor (or batteler) to Dr Iles'; he graduated BA in 1639, and MA in 1642. See *DNB* and Westfall, Rice website.

35 Foster, *Alumni* 2, 740, cit. R. G. Frank Jr, *Harvey and the Oxford Physiologists:*

*A Study of Scientific Ideas* (Berkeley: University of California Press, 1980), p. 324, n. 95.

36 Buchanan-Brown, *John Aubrey: Brief Lives*, pp. 11–12. R. G. Frank Jr, 'John Aubrey FRS, John Lydall, and science at Commonwealth Oxford', *Notes and Records of the Royal Society* 27 (1972–3), 193–217; 196.

37 Willis probably stepped down from Christ Church rather than giving the required commitment by oath to the parliamentary authorities.

38 Thomas Iles supported Willis during his time at Oxford. See Buchanan-Brown, *John Aubrey: Brief Lives*, p. 343: 'He was first servitor to Dr. Iles, one of the canons of Christ Church, whose wife was a knowing woman in physique and surgery, and did many cures. Tom Willis then wore a blew livery-cloak, and studied at the lower end of the hall, by the hall-dore; was pretty handy, and his mistresse would oftentimes have him to assist her in making of medicines.'

39 Wilkins's own father had died when he was eleven. Among the Hartlib papers is a letter from Goddard to an unknown correspondent, written in November 1660, concerning a clock for Westminster Abbey which 'your self with Dr Busby and others are intrusted upon providing', and recommending a clockmaker. Wilkins supports the recommendation and endorses the letter (Hartlib papers, 10/3A).

40 Buchanan-Brown, *John Aubrey: Brief Lives*, p. 341.

41 The parliamentary Visitors appointed Wilkins Warden of Wadham College on 13 April 1648. The holder of this office was required to take the degree of Doctor of Divinity, but on 5 March 1649 the Visitors gave Wilkins a year's dispensation on the ground that he was 'at this time in attendance on the prince elector and cannot in regard of that service have time to do his exercise, and all other things necessary unto that degree' (Montague Burrows (ed.), *The Register of the Visitors of the*

University of Oxford from AD 1647 to AD 1658 (London, 1881), p. 22, cit. H. Aarsleff, 'John Wilkins', *Dictionary of Scientific Biography* 14 (1976), p. 364).

42 In *On a Grander Scale* I cited circumstantial evidence for Wilkins's accompanying the Elector Palatine. Firmer evidence has now emerged among the Hartlib papers (which have recently once again become accessible). On 4 December 1648 William Hamilton wrote to Hartlib: 'Mr Wilkins the Prince Electors chaplaine, & Warden of Waddam ... has come to London to the Prince & so hath continued ever since; & I beleeve will so long continue yet' (Hartlib papers 9/11/2A). On 16 January 1649 Hamilton informed Hartlib that 'Mr Wilkns the prince Electors chaplaine, after he came [back to Oxford] from London, stayd but about a fortnight or 10. days heer, & went back again, wher he hath continued since' (Hartlib papers 19/11/4A). Charles Louis left for the continent shortly after 13 March 1649 (Jardine, *On a Grander Scale*, chapter 2). On 16 December 1658 Hartlib wrote to Boyle concerning a distinguished academic in Germany, and commented that Wilkins might already know him: 'if I should tell his name, perhaps, [he is] not unknown to Dr. Wilkins, when he travelled beyond the seas' (Hunter et al., *Correspondence of Robert Boyle* 1, 294–5).

43 Frank, *Harvey and the Oxford Physiologists*, p. 47.

44 Aarsleff, 'John Wilkins', p. 370.

45 Aarsleff, 'John Wilkins', pp. 370, 378.

46 cit. Aarsleff, 'John Wilkins', p. 370. Tillotson was Wilkins's son-in-law.

47 See Frank, *Harvey and the Oxford Physiologists*, chapter 3.

48 Aarsleff, 'John Wilkins'. Aarsleff cites Gunther, *Early Science in Oxford* 6, 5–9. Buchanan-Brown, *John Aubrey: Brief Lives*, p. 395. *Mathematical Magic* was dedicated to Charles Louis, Elector Palatine, whom Wilkins served as chaplain from the early 1640s until

the Elector returned to Heidelberg immediately following the execution of Charles I. As Aarsleff points out, and as I argue elsewhere, Wilkins spent most of 1649 travelling with Charles Louis, returning to take up his new post as Warden of Wadham in September 1649. See Jardine, *On a Grander Scale*. Aarsleff cites an eighteenth-century 'life' of Wilkins (probably the work of Birch) as a reliable early source, *Biographia Britannica*, 7 vols (London, 1747–66): 'There is good reason to accept the explanation that it was Wilkins' "skill in the mathematics that chiefly recommended him" to Charles Louis, "his Electoral highness being a great lover and favourer of those sciences, in which he must needs have been very agreeable to his Chaplain, who was entirely of the same turn and temper"' (6, 4266).

49 Wood, *Fasti* 1, 403; also E. G. R. Taylor, *The Mathematical Practitioners of Tudor and Stuart England* (Cambridge: Cambridge University Press, 1954), p. 234. Both cit. Aarsleff, 'John Wilkins', p. 378. Aubrey tells us that Christopher Brookes married one of Oughtred's daughters: 'One of [Mr Oughtred's children] [married] to Christopher Brookes of Oxford, a Mathematical Instrument maker. He was sometime Manciple of Wadham College ... This Christopher Brookes printed 1649 an octavo of about two sheetes, sc. A new Quadrant of more natural, easie and manifold performance, than any other heretofore extant, but it was his Father-in-lawe's Invention. I had it from his widow about 1665' (Buchanan-Brown, *John Aubrey: Brief Lives*, p. 227).

50 cit. Frank, *Harvey and the Oxford Physiologists*, p. 55.

51 Frank, *Harvey and the Oxford Physiologists*, p. 55.

52 'You have so well acted the part, which belongs to me, of returning acknowledgments for the favours received at *London*, that I am as much

ashamed, as unable to imitate you. But I have known, Sir, that you are a great master of civilities as well as learning, and therefore shall in all things most willingly submit. I had thought you had gone out of town shortly after the time I waited upon you, which was the reason I did not attempt to trouble you with a visit' (Hunter et al., *Correspondence of Robert Boyle* 1, 145).

53 See Frank, *Harvey and the Oxford Physiologists*, p. 57.

54 Hunter et al., *Correspondence of Robert Boyle* 1, 145.

55 In September 1653 the English Parliament passed legislation seizing land from Irish landowners who had not supported Cromwell in his 1650 invasion, and reallocating it to resettle Irish, displaced from land already seized and allocated to Cromwell's soldiers in Ireland.

56 'Judged by what we know of rentals, Lord Cork and Burlington overtopped all rivals, including his younger brothers. The empire of his father, the first earl, had been dismembered to provide for his numerous offspring. After 1650 four sons survived, each with a substantial holding in the county: the continuously absent Robert Boyle; the often resident Lord Shannon, with his "mongrel" estate, partly in England and partly in Cork around Ballinrea; Lords Orrery and Cork. The last enjoyed the lion's portion: Lismore, Lisfinny, Tallow, Dungarvan, Youghal, Inchiquin, Bandon and Carbery. Moreover he added to his patrimony. In 1666 he spent £8,000 on confiscated property in Youghal, and in 1691, following his brother Robert's death, some of his father's lands reverted to him. Thus supplemented, his Irish rentals yielded over £20,000 and now, in contrast to his father, he also owned extensive English lands' (T. C. Barnard, 'The political, material and mental culture of the Cork settlers, c. 1650–1700', in Patrick O'Flanagan and C. G. Buttimer (eds), *Cork: History and Society:*

*Interdisciplinary Essays on the History of an Irish County* (Dublin: Geography Publications, 1993)).

57 cit. Frank, *Harvey and the Oxford Physiologists*, p. 165.

58 'Ward singled out chemistry as a particularly popular minority interest. The group ... was "furnishing an elaboratory and for makeing chymicall experiments which we doe constantly every one of us in course undertaking by weeks to manage the worke" [Ward to Isham]. Names are not given but the group probably included Ward, Wallis, Dickinson, Willis, Bathurst and Lydall. Their central laboratory was probably at Wadham since Willis recorded the expenditure of £27–4–8d. on chemicals, apparatus and building work, "laid out at Wadham Coll." probably between 1650 and 1652 [Wellcome Institute, London, Wellcome MS 799a, "Liber manuscriptus C1. Doctoris Thomae Willis Medico Insigno"; rough itemised accounts given on last leaves]' (C. Webster, *The Great Instauration: Science, Medicine and Reform 1626–1660* (London: Duckworth, 1975), pp. 164–5).

59 Rooms in the Old Schools Quadrangle had already been refurbished to provide an anatomy theatre in the 1630s, while a third floor was built at the expense of Thomas Bodley, to increase the space for what became the Bodleian Library. See Frank, *Harvey and the Oxford Physiologists*, p. 46; Jardine, *On a Grander Scale*.

60 *Discourse Concerning the Beauty of Providence*, p. 65, cit. Aarsleff, 'John Wilkins', p. 377, n. 40.

61 See Webster, *Great Instauration*.

62 Wellcome Library, Request EPB MSL/ WIL.

63 See Hooke, *Diary*.

64 Sheldon was a major clerical player in the Restoration. On the impetus for building the Sheldonian Theatre, see now A. Geraghty, 'Wren's preliminary design for the Sheldonian Theatre', *Architectural History* 45 (2002), 275–88; 278: 'The impetus for the Theatre

came not from Sheldon, as is commonly supposed, but from Clarendon, who was acting upon the memory of Laud.'

65 *De anima brutorum* is concerned with the mental processes of the brain and their derangement; it also contains discussion of classic medical conditions like palsy and apoplexy. It was among the very first books to be issued by the newly reformed Oxford University Press in its inaugural year. Reform of the press was largely the responsibility of Willis's brother-in-law, Dr John Fell (1625–86), Dean of Christ Church, and subsequent Bishop of Oxford, begun during his tenure as Vice-Chancellor of the University (1666–9). Willis dedicated *De anima brutorum* to Gilbert Sheldon, Archbishop of Canterbury (1598–1677). Willis's appointment in 1660 to the prestigious Sedleian professorship at Oxford was due in no small part to Sheldon's patronage – a fact gratefully acknowledged by Willis in the dedication. Furthermore, the Archbishop, a sufferer of apoplexy, was attended by Willis, who discusses his illustrious patient's affliction in the second part of *De anima brutorum*.

66 Hooke, *Micrographia* (1665).

67 cit. M. Hunter, 'The making of Christopher Wren', in M. Hunter, *Science and the Shape of Orthodoxy: Intellectual Change in Late Seventeenth-Century Britain* (Woodbridge: Boydell Press, 1995), pp. 45–65; 49.

68 See the table of 'Oxford scientists and virtuosi, 1640–1675' in Frank, *Harvey and the Oxford Physiologists*, pp. 63–89.

69 'Samuel Fell. Native of London. Elected to Christ Church Oxford 1619; matriculated November 20th 1601 age 17; BA 1605; MA 1608; BD 1615; DD 1619; Proctor 1614; Prebendary of St. Pauls from Jan 29 1612/13; Canon of Christ Church May 19th 1619; Lady Margaret professor of Divinity. Dean of Lichfield 1637–8; Dean of Christ Church 1638 June 28th; Vice Chancellor of Oxford 1645; was removed 1647, and being adjudged guilty of "high contempt" was deprived of his post as Dean of Ch. Ch. March 2nd 1647/8. [ . . . ] retired after imprisonment in London to Rectory of Sunningwell near Abingdon' (Russell Barker and Stenning, *Record of Old Westminsters* 1, 325).

70 'John Fell, (1625–86) Bishop of Oxford; Dean of Ch. Ch. 1660 Nov. 30th to 1686 July 10th' (Russell Barker and Stenning, *Record of Old Westminsters* 1, 325). '[John Fell] Educated Thame School; and Ch. Ch. Oxford, admitted student May 25th 1637; BA 1640; MA 1643; DD 1660; ensign in Royalist Garrison at Oxford; ordained 1647; ejected from studentship 1648' (Russell Barker and Stenning, *Record of Old Westminsters* 2, 1102).

71 Willis married Mary Fell on 7 April 1657 (*DNB*). Subsequently married the granddaughter of Sir Edward Nicholas, deceased (secretary to Charles I and Garter King of Arms etc. under Charles II).

72 It was at Oxford that Hooke and Wren formed the close friendship which would last for the whole of Hooke's life. On the face of it they were unlikely companions. Wren came from an elite clerical family in the inner court circle; Hooke came from a modest Isle of Wight family. In fact they had shared closely similar lives since the onset of civil war. See Jardine, *On a Grander Scale*, p. 117.

73 As in so many cases, this secret worship is referred to rather casually in reminiscence, after the Restoration, when those involved were no longer at risk (and indeed, were to be commended for it).

74 M. Hunter (ed.), *Robert Boyle by Himself and his Friends* (London: Pickering & Chatto, 1994), p. 71.

75 'From 1648 the Dean was Edward Reynolds, but he was replaced by Owen by order of the parliamentary Visitors in 1650. Edward Reynolds Dean of Christ Church 1648 April 12,

Overseas exchange and exotic friendships:

(*left*) Note from Captain Robert Knox to Hooke, February 1697, accompanying two bottles of wine brought home on his ship the *Tonqueen Merchant*. Knox frequently presented Hooke with gifts brought back from his travels – in return Hooke treated him to chocolate and tobacco at their local coffee-houses.

(*centre*) Page from Hooke's late diary, recording Knox's presenting him with books in arabic and 'malabaric' characters, in autumn 1689.

(*right*) Original letter from Samuel Baron to Sir John Hoskins and Hooke, accompanying the manuscript of his *Description of the Kingdom of Tonqueen* (1686), preserved among Hooke's papers. The work was later published with Hooke's help.

*Written sources for scientific enquiry and an active life:*
(*left*) Hooke's attempt at transcribing and translating Chinese characters, printed in the *Philosophical Transactions of the Royal Society*.
(*below*) Detail of a page from Hooke's diary, with a diagram of the arrangement of springs in his balance-spring watch.
(*opposite*) Detail of a crowded page from Hooke's diary for April 1674.

March. the 1.st 167[5]
to goe below y moon which y here saw goe behind Cer. Flenbury heard nothing of the ... Poddelion hum
At ... D Brouncker, ob. y trespass. agreed with Jarman ... propounded paper for masonry &c.
for view in 8° quarry y &c.
Tuesday. March. 2.d y° gammon. at noon fetch Fitch begune the plankinge &c. of y° foundation, at 8° Chr:
...y coffee house. Discoursd w.th him about w° wages about Observatory of Ball. ratifyd him how books
... fetchd my paper. 10.) at Pikes. other Doughty house. & DH
...
...
...
... about Bricke
Thursday 4. N° Oldenburg here produced Hevelius new book & dicated to the Royall society. Dr Vossius his paper Re...
about Archimedes burning glasse made of many flatts. & of y° inuention of y° spots in y° moon. both agree
at Garaways &c. 8° J wilkinson here & Dr Fisk. in number about 33 . mary. 10.th
Fr. at Bethlem hospitall. masony propossed Receive. fruits formals for M° montacue le lesserfields. M° Filler
wages got y° marking. Knees Dangle &c. pott Digests at Hely. M° Ment. promisd to call & discharge. going to Woorwich
Sat. 8° J Mory. He told me of y° Oxburg, treachery his Disowny, y° society and getting a patent for him. Usefull for
himself. he procurd patent for thousand of 100 y°... and an observatory in Greenwich park. met him afterward at
Garaways. DH. at 8° J°H, Players Scots Fleet Lane. Tompion, Secretary wilkinson, Duffe 8° Ch: Wren
a warrant past w.thout my knowledge. 8° Chr: to newmarket at sunday morn. at Tompiony. took at marking
of Grays book. 8° wilmingtons officware at Garaways &c.
Sunday. at 8° J mory. & D Brouncker. DH. M° Salsbury here. to 8° J mory pp. he promised to undertake longitude force
w.th the use of Dog Tray by y° abyss. every of farum. wrote this account
Mond. Mark y Fitch here. Wittenhove. at marking took N Wrays horologion. & found Baudrand Geographicai Lexicon. 30° 2p.
letter to montacue. at 8° Chr: wren going out of town to newmarket. at Garaways saw Flenburg post words about eight &
measure./ said to have y° path proportionable of a Degree into minutes & seconds. I reckony letter afformd not low
though certainly his. DH. pp. to 8°J King. 10 Drowns. conue agreed w.th wraies hutchinson and cartwright aaa, view of
8° marking. C. 6.d at Garaway. Tompiony Shewd my way of fixing Double springs to y° axstree of y° Ballance
wheel. My. (O) by y° J Replies perpendicular like by Ga a box & fancied it would not goe well by reason of
y° trembulation of y° turret & force of y° wind to ruffle the surface of y° Q
Tu. Treated and agreed w.th Haward. forg... y° post sold in pieces & for uater bale at a sticke corrupt. 5 post
feet w.th Houylope by Richard. 8° Haward 15.s to y° Load of coles w.th Haward gone. at his accompt ...
DH. at Court of Aldermen. J Robinson huffed. commended the... Officir vice 8° J Morelany w° Dutchman ...
engines complained of Flett at Bemards tinck. Sot out at Fleet Lane. Jarman Body & uander lime. Mißo Crowne. Dr. Curre...
funke of Galexy for repository. Inuade a way of 8° J°H. Player he promisd y° payment. Pullett from y° powder
mullet a cheat Tr wilksbury sermon prefund. Sot Sorry about Repository. Hary Led y° books & catalogues.
2 Jordons. mused wormian. Terrentij opera. 2 classij. 2ido. 2 of Besle... 1 quire of papers. afterdiner met
ogilby & flot prace w.th y° worn. Mark y Fitch of clocke sell began to parge much wounted much. wich hunch y° ...
Wedsay. at home all day. y° reason of vomiting & purging. 8° A Kings slime. J remaine in W... y° 7.10. from Langridge Altabl...
Lane. 10.s &c. Flatbugh here. I spent to him answer to Vossius about monks Lens &c. Spreads Archimede....
Thursday. Society here. I propounded my hypothesis of Sight by &c colours by y° Lenth of y° pulse ———
Fryday. w°... ill all day & also Saterday. Hank here. flie Satturday. finish M° montacues fruits from Sunday best
..spent out last Dr... w°... a corse. at N Hily. y° at home w° Degr of Canterbury fett books 11. gaue soo y°
...
Sot at home all day. but grow a much better. composed w° Montacues front. talked w° Fitch &c.
Sunday ill in y° morn. w° Tompion here from 10 till 10.th he brought clockwork by gue —
Munday 15. 8 f & W Hacket went to 8° marking to M° marking. caught cold & ill at Garaways. Abou..y
out Hacker at M° marking. & contend of him hypocr. of stones. M° Jorgans prothsis takeed for fresh Boy.
Twsday. w°M° montacue guest him frout of range w°°... he aked of him to D Barkleys. to wray galey alighted w° mullet at marg...
promisd him ... Surueyor. w.th Dowgy. at Lowes bought snow prices. 3 Guinops. at Attorney General. Dind at J Fish w°...
Thorr & Chapman. to 8° J°H. Players abed al. 3. w.th Hack. & Dlan Wittenhove 8° J Jorg. newtons. Dock Lane. Sir... ould...
Wedsday. at... M° Fitch here. before he went told Montacue. Dowg. & new brought in handsole Directed carpenter about y° Cieling of
the friery & y° putthion w° joining glafs of Dining room. led rollers out of cellar. w° 8° marking Disord... sliming. At y° happe...
agreed w.th Lower Smith. Newton out at times.
Thursday. at Woolf. view 13. 9.d at montifer finchd it abought w° Fitch. Salsbury here. a qualer coled... hauing been only w°
Dogs & some wo hauing. Ruthy & Halleloyo. D Brounker fest in Picken. Snow papers of new propriety of y° w°. tapleaf. Call w...
Gun Distolld w°th Flagsbury. fair Raleching. wich shewe a trough rubbd w°... Soliciteed by M° gregaire for plaines y° reptile...
w° Refusd. Cer. w° J°H more at Garaways. S Chr: wren here.
Fry. at D Brounkers about briquin he signed bill for carriage of quadrant 16.s lattes for quadrant 20.s glasse for telliscope 6.d 2½ how
for quarrell 10.s ... w° Colswoll 95.s... w° Currier. gaue may disowne 20. p... Cer. 8° J°H ... ould... rebuild ... by
profsure preferd to goe but refusd.
... w° Dooly finishd w° Scherley. gathered lumon Repository. singd bricqin by tollachting
... w° Donaphion &c. can Inuion w° Dind ... w° 8° J°H ... J... Fred trd my 24 foot glasse. & found it good.

This is the Last Will & Testament of me Robert Hooke M.D. Professor of Geometry & Experimental Philosophy in Gresham College London. & Survayor of the City of London &c. made the twenty fifth day of february 170 2/3 for the notification of the Persons to whome I do bequeath all the Severall parts of such goods real & Personal as it Shall please God to bless me withall at the time of my decease, with the Qualifications & quantities of them. first I doe bequeath & give to my good friends A, B, C, & D. my whole Estate Real & Personal together with all debts owing to me yet unpaid, upon trust and Confidence that they Shall & will dispose & pay unto the persons nominated in a sedule anexed to this present will Signed & Sealed by me the Several Sums therein particularised and also discharge the Charges or Expences of my funeral which I would not have to exceed the vallue of forty pounds, And the Remainder to be equally distributed between the foresaid A. B. C & D. In testimony whereof I have hereunto Subscribed my name & affixed my Seale, & declared the Same to be my Act & deed to the Persons following

*Undecided to the end:* Hooke's unsigned will, drafted 5 days before his death. He apparently could not decide who to specify as his four trusted 'friends', indicated in the draft only as A, B, C and D.

deprived 1650 [restored 1659/60 March 13th]' (Russell Barker and Stenning, *Record of Old Westminsters* 2, 1074).

76 'On June 7, 1649, both Goodwin and Owen preached before the House of Commons on a special day of public thanksgiving and the next day the House put their names forward for promotion to the presidency of two Oxford colleges. In 1650, Goodwin became president of Magdalen College, Oxford, while Owen similarly became dean of Christ Church. The pair must have had considerable influence, since Cromwell yielded his power as Chancellor to a commission headed by Owen. At his post, Goodwin was made a close adviser to Cromwell and the protector's Oxford Commissioner ... During this time he and John Owen shared a Sunday afternoon lecture for the students at Oxford, and both were chaplains to Cromwell. Goodwin also formed an Independent church and preached to a unique mixture of hearers, uneducated and educated, including Stephen Charnock and Thankful Owen. In 1653 Goodwin was awarded a doctorate in divinity by Oxford University. The following year he was chosen by Cromwell to sit on the Board of Visitors of Oxford University, as well as to be one of the Triers on The Board for the Approbation of Public Preachers, whose task it was to examine men for both pulpit and public instructional work. He was also appointed to the Oxfordshire Commission for the Ejection of Scandalous Ministers. During this decade, Goodwin was probably closer to Cromwell than any other Independent divine and attended the Lord Protector on his deathbed' (http://www.newble.co.uk/goodwin/taskipref.html).

77 Boyle was more broad-minded in matters of religion than other members of the group. According to Hunter, Boyle's religious sympathies 'straddled the divide between the Anglican church and dissent'. See Hunter, *Robert Boyle by Himself and his Friends*, pp. lxx–lxxii. For a fuller account see Hunter, *Robert Boyle, 1627–91: Scrupulosity and Science* (Woodbridge: Boydell Press, 2000). See also M. Hunter, 'Latitudinarianism and the "Ideology" of the early Royal Society: Thomas Sprat's *History of the Royal Society* (1667) reconsidered', in Hunter, *Establishing the New Science*, pp. 44–72; J. R. Jacob and M. C. Jacob, 'The Anglican origins of modern science: the metaphysical foundations of the Whig constitution', *Isis* 71 (1980), 251–67. In the secondary literature on this topic there is a polemic concerning the precise nature of the relationship between Anglicanism and the new science (one on which Hunter and the Jacobs take different lines). For the purposes of this book, however, it is possible to steer a middle road between the two opposed poles of interpretation. I am therefore grateful to those who have written on both sides of the question.

78 Thomas Sprat, *Observations on Monsieur de Sorbiere's Voyage into England. Written to Dr Wren* (London, 1665), pp. 283–9, cit. Hunter, 'The making of Christopher Wren', p. 52. It is possible that Hooke travelled to Holland on Willis's (or Boyle's) behalf, to oversee the publication there of Latin editions of their works. In February 1687, the Council of the Royal Society asked Hooke 'to use his contacts in the Amsterdam book trade to exchange 400 copies of [Newton's *Principia*] for £200 in cash and £300 worth of books' (Inwood, *The Man Who Knew Too Much*, p. 369).

79 Wren outlived Hooke by over twenty years.

80 For a fuller account of what follows, see Jardine, *On a Grander Scale*, especially chapters 1 and 2.

81 Petty, 'The Raising of Anne Greene', 14 December 1650, in Marquis of Lansdowne (ed.), *The Petty Papers: Some Unpublished Writings*, 2 vols (London: Constable & Co., 1927) 2, 157–67. (First-person account by Petty

of the reviving of a woman hanged for
infanticide, followed by the petition of
the physicians that, having been
revived, she be spared. They maintain
that her child was still-born, and the
foetus too under-developed ever to
have been viable.)

82 Frank, *Harvey and the Oxford
Physiologists*, pp. 50, 53.

83 Frank, *Harvey and the Oxford
Physiologists*, p. 50.

84 Waller, *Posthumous Works of Robert
Hooke*, p. iii.

85 J. Keay, *The Honourable Company: A
History of the English East India
Company* (London: HarperCollins,
1991), p. 54. I am grateful to Dr
Matthew Dimmock for this reference,
and for other help with East India
Company material.

86 See Hooke's transcriptions of passages
in Trinity College Cambridge Library,
O. 11a.1[10]: ' "Collections"; notes taken
from a volume on black
Mozambiquan chickens, Turkish
doves, sleeping in water, freshwater
under salt, customs of Pegu, Bengali
herbs, speech of Malacca fisherman,
Java, Chinese foodstuffs and customs,
absence of Japanese prisons, tea
drinking, Japan the greatest tyranny in
the world, Goa, Goanese drugs' (2ff),
14 May 1659. There is a curious note
here which suggests that Hooke might
have an unhealthy interest in avoiding
sodomy: 'The noble men likewise
desire some friend or stranger to
[Margin: Strange Customes of Pegu] ly
with their wifes the first night to ease
them of the paines of taking their
maden heads. they weave bells likewise
on their virile [privity?] fastend on to
prevent sodomy. The women also
weave a cloth before their pudend.
which as they goe openeth, &
uncovereth all. this was first institutid
to prevent sodomy. women likewise
have in their pudend sowd up &
opend only by the husband.'

87 '[Margin: Turkish doues] Throughout
the whole country of Turkey they use
doves which are brought up and
accustomed to carry letters having

rings about their leggs these doves or
Pidgeons are borne from Bassora &
Babilon to Aleppo and constantinople
& soe from these back againe. & when
there is any great occasion of
importance to be advertised or sent
they fasten the letter to the rings
about the pidgeons feet & lett them
fly. wherby the letter with the dove is
brought vnto the place whither it
should goe. they fly sometimes 1000
miles. Ibid. Cap. 6. p 16.'

88 'From Bengalen likewise comest
alyallia or civet sophisticated with salt
oyle & such like ... The finest sort of
China cupps may not be copied which
are soe fine that crystall is not
comparable wit these pots & cupps are
made inwardly in the land of a
certaine earth that is very hard which
is beaten small & then large to steep
in Cistirnes of stone full of water
made for the purpose & when it is
well steeped and often stirred as we
doe milk to make butter, of the finest
thereof which swimmeth on the top
they make the finest work & use the
courser accordingly. wherof some they
paint and then they are dryed and
baked in ovens.'

89 One final intriguing possibility is that
at this point in his life Hooke was
already being drawn into the circle of
the East India Company. F. T. Melton
has shown how the recently reformed
East India Company was involved, in
1659, in funding conspiracies aimed at
bringing back King Charles II,
following the death of Cromwell. See
F. T. Melton, *Sir Robert Clayton and
the Origins of English Deposit Banking
1658–1685* (Cambridge: Cambridge
University Press, 1986), pp. 57–62.

CHAPTER 3: *Take No Man's Word
for It*

1 R. Latham and W. Matthews (eds),
*The Diary of Samuel Pepys*, 11 vols
(London: HarperCollins, 1972; reissued
1995) 6, 36–7.

2 On this nostalgia, as it impacted more

positively on the prospects of Hooke's close friend Christopher Wren, see Jardine, *On a Grander Scale*.

3 The term 'operator' is coined during these years to refer to an assistant with practical skills who carries out the experimental work designed either by himself or others (in Hooke's early career, Willis and Boyle). By the time the Royal Society was founded in 1660 this term and that of 'curator' (the person in charge of experimental equipment, experiments and museum exhibits) were in common use. It was, however, Hooke's activities at the Society which defined the long-term understanding of both terms.

4 Hunter et al., *Correspondence of Robert Boyle* 1, 436. A slightly later letter from Sharrock to Boyle makes it clear that Oldenburg too is now working on Boyle's manuscripts and Latin translations. This letter also already makes it clear that Oldenburg was difficult to work with: 'I have been exceedingly puzzl'd and troubled in this Matter Mr Oldenburg having the emendation of your latine translation well advis'd that where in Your booke the Word sucker was *Embolus* should bee used: & <hee> mended it in Some places in others hee left the Word *sipho* to stand to Signify the same thing. Now so it is that <in my absence> the first sheet and one side of the Second are allready printed off, & therein Mr Oldenburg having not altered the word *Sipho* into *Embolus* the word Sipho remains for the corection of which there are but these ways eyther to put the word Embolus as often in the *errata* as the mistake is in the first sheet & the ensueing half sheet, or to give a generall note of the mistake before the table of the Errata, which both will bee blemishes upon the Sale of Your booke & no credit to the translation, wherein for Your Honours sake I must not bee unconcern'd, or else to reprint this sheet and halfe the charge of which will bee att least. 30s. Were it the printers fault I would make him

reprint it att his owne charge, But his print is well <enough> according to the Copy. The Copy is as it was sent downe the Copy to Mr Robinson & neither mended the word *Sipho* nor sent word to Mr Robinson nor mee that hee had omitted the emendation of that word & willd us to read over againe the translation with the <English> Copy & where Sipho stood for a Sucker to make it Embolus. Had these things been done this fault had not been committed. The remainder will most past my owne hand & hand writing, but however I desire the translation to bee returned, as to verball faults, as correct from Mr Oldenburg as Your Honour expects it from the presse. And for the instant puzzle I have suspended the printing of the other Side of the 2d sheet till by the next returne I may heare whither You thincke fitt to have the sheet & halfe reprinted for the emendation of this mistake, if so I must putt the charge eyther upon Your Honour or defray it my Selfe' (Hunter et al., *Correspondence of Robert Boyle* 1, 447).

5 Hunter et al., *Correspondence of Robert Boyle* 2, 81.

6 See also little touches of familiarity in Hooke's letters to Boyle around this period: 'I have sent a small bag of the [new Jamaica] nuts, understanding by Mr. *Wh.*'s letter, that you will not be here till Thursday. The two foot perspective I also sent, the box was delivered to the carrier the last week before he went away. Mrs. *Kuffler* is very earnest to know, when you will give order about the engine, and seems to be a little angry, and wonders you should be worse than your word, and such kind of speeches; though I have given her the reason, why you could not do it before you went hence' (Hunter et al., *Correspondence of Robert Boyle* 2, 101).

7 These drawings would eventually become the illustrations for *Micrographia* – the Royal Society-sponsored volume, authored by Hooke, on which his lasting

reputation has largely depended. Hooke, who took over from Wren the task of producing a Royal Society-backed published volume featuring engravings of magnified insects, plants etc., subsequently acknowledged the collaboration in the Preface to *Micrographia* (1665): 'By the Advice of that excellent Man Dr *Wilkins*, I first set upon this Enterprize, yet still came to it with much Reluctancy, because I was to follow the Footsteps of so eminent a Person as Dr. *Wren*, who was the first that attempted any Thing of this Nature; whose original Draughts do now make one of the Ornaments of that great Collection of Rarities in the King's Closet. This Honour which his first Beginnings of this Kind have received, to be admitted into the most famous Place of the World, did not so much incourage, as the Hazard of coming after Dr. *Wren* did affright me; for of him I must affirm, that since the Time of *Archimedes*, there scarce ever met in one Man, in so great a Perfection, such a mechanical Hand, and so philosophical a Mind.'

8  See e.g. Hunter et al., *Correspondence of Robert Boyle* 2, 412: 'I have ... procured out of Mr *Oldenburg*'s hands some of the first sheets [of Boyle's *Coid*]; and shall delineate as many of the instruments you mention, as I shall find convenient, or (if it be not too great a trouble to you) as you shall please to direct ... The figures I think need not be large, and therefore, it will be best to put them all into one copper plate; and so to print them, that they may be folded into, or displayed out of the book, as occasion serves' (Hooke to Boyle, 24 November 1664).

9  On the first Earl of Cork see N. P. Canny, *The Upstart Earl: A Study of the Social and Mental World of Richard Boyle first Earl of Cork 1566–1643* (Cambridge: Cambridge University Press, 1982).

10  Their only son, Richard, was tutored by Henry Oldenburg, later the first

Secretary of the Royal Society. On Lady Ranelagh see L. Hunter, 'Sisters of the Royal Society: the circle of Katherine Jones, Lady Ranelagh', in L. Hunter and S. Hutton (eds), *Women, Science and Medicine 1500–1700* (Stroud: Sutton Publishing, 1997), pp. 178–97.

11  From 1658, however, Lady Ranelagh seems to have spent long periods in Ireland. See Hunter et al., *Correspondence of Robert Boyle* 1.

12  It may have helped, in the end, that one of Boyle's brothers, the Earl of Shannon, was raising as his own an illegitimate daughter of Charles II, fathered in exile, during a brief, scandalous liaison with Shannon's wife. See Jardine, *On a Grander Scale*, pp. 194–5.

13  See Jardine, *On a Grander Scale*.

14  Arthur Jones, Lord Ranelagh died in January 1670. Brother and sister kept house together for over twenty years. Lady Ranelagh moved into her house in Pall Mall circa 1660. Later Hooke did renovation and refurbishment work for her there.

15  In 1666 Boyle rented a house in Stoke Newington (Hunter et al., *Correspondence of Robert Boyle* 3, 70–1).

16  cit. 'Espinasse, *Robert Hooke*, p. 153.

17  Richard Waller, 'The Life of Dr. Robert Hooke', reprinted in Gunther, *Early Science in Oxford* 6, 1–68; 59–66. Compare the words of the ground-breaking contemporary taxonomist John Ray: 'There is no greater; at least no more palpable and convincing Argument of the Existence of a Deity, than the admirable Art and Wisdom that discovers itself in the Make and Constitution, the Order and Disposition, the Ends and Uses of all the Parts and Members of this stately Fabrick of Heaven and Earth' (John Ray, *The wisdom of God manifested in the works of the creation: In two parts. viz. the heavenly bodies, elements, meteors, fossils, vegetables, animals, (beasts, birds, fishes, and insects) more particularly in the body of the earth, its*

figure, motion, and consistency, and in the admirable structure of the bodies of man, and other animals, as also in their generation, &c (London, 1691)). The Preface to Hooke's Micrographia is couched in similar terms.

18 I am grateful to Martha Fleming, who first pointed out this aspect of the men of the Restoration to me (personal communication, 2002).

19 Hooke, Diary, p. 81: 'Dind at Lady Ranalaughs. Never more.'

20 'Espinasse, Robert Hooke, p. 111.

21 Hooke, Diary, pp. 98, 163.

22 See below, chapter 4. Hooke, Diary, p. 247.

23 Royal Society Journal Book 1, 1: 'These persons following, according to the usual custom of most of them, met together at Gresham College to hear Mr Wren's lecture, viz. the Lord Brouncker, Mr. Boyle, Mr. Bruce, Sir Robert Moray, Sir Paul Neil, Dr. Wilkins, Dr. Goddard, Dr. Petty, Mr. Ball, Mr. Rooke, Mr. Wren [Matthew Wren], Mr. Hill. After the lecture was ended, they did according to the usual manner withdraw for mutual converse. Where amongst other matters that were discoursed of, something was offered about a design of founding a College for the promoting of Physico-Mathematical Experimental Learning. And because they had these frequent occasions of meeting with one another, it was proposed that some course might be thought of to improve this meeting to a more regular way of debating things, and according to the manner in other countries, where there were voluntary associations of men in Academies.'

24 On Moray, see A. Robertson, The Life of Sir Robert Moray, Soldier, Statesman and Man of Science (1608–1673) (London: Longmans, Green & Co., 1922). A modern biography of this important figure in early science in England, éminence grise of the Royal Society, is long overdue.

25 'Nous commençons maintenant à travailler à l'établissement de notre Société avec plus de vigueur que nous n'avons pu jusqu'ici; parce que la patente du Roi qui l'érige en une Corporation avec plusieur privilèges nous a été expédiée depuis cinq ou six jours, comme nécessaire à la rendre capable selon les lois du pays à recevoir donations et standi in iudicio etc., de sorte que nous nous appliquons aux autres moyens nécessaires à la prosecution du dessein que nous nous sommes proposés, comme la constitution de la Société; ce qui touche le fonds requis pour fournir aux dépenses des expériences' (cit. Robertson, Life of Moray, p. 156).

26 cit. Robertson, Life of Moray, pp. 154–5.

27 Robertson, Life of Moray, p. 152: 'The President was [at first] elected monthly. Sir R. Moray was elected on March 6, 1661, and re-elected April 10, 1661. He was President on Aug. 28, 1661, and on Feb. 5, June 11 and 18, July 2, 9, 16, 1662. Wilkins presided on May 21, 28, June 4, 1662; Boyle on June 25 and July 23.'

28 Wilkins's knowledge of shorthand is evident from the close resemblance of his Universal Character to Timothy Bright's shorthand. I am extremely grateful to Dr Patricia Brewerton for pointing out this resemblance to me. Oldenburg probably acquired shorthand during his years in an earlier role as a diplomatic emissary and intelligencer for his native Bremen.

29 cit. Robertson, Life of Moray, p. 157.

30 See below, chapter 5.

31 cit. Jardine, On a Grander Scale, p. 141.

32 Hunter et al., Correspondence of Robert Boyle 2, 26.

33 De Beer, Diary of John Evelyn 3, 273. Evelyn gives the date of the meeting as 11 March, which was a Friday, whereas at this point the Society met on a Thursday.

34 De Beer, Diary of John Evelyn 3, 284–5.

35 Similarly, Evelyn attended a demonstration of the 'Eolipile, for weighing the aire' – in other words, the pneumatic engine – at Boyle's

home in Chelsea on 9 March 1661, but does not mention the fact that Hooke would have been in attendance (de Beer, *Diary of John Evelyn* 3, 272).

36 Hunter, *Establishing the New Science*, p. 16.

37 De Beer, *Diary of John Evelyn* 3, 330–4.

38 Hunter, *Establishing the New Science*, p. 17.

39 Hunter, *Establishing the New Science*, pp. 22–3.

40 Bodleian MSS, Aubrey 12, fol. 201, cit. 'Espinasse, *Hooke*, p. 152. The quote continues: 'who though he have the use of many physicians yet will I venture to tell you (and thereby him if you think good) of one cure of the consumption (of lungs) that is a piece of naturall science advanc't and experimented by our learned honest Dr Harford'. 'Espinasse adds: 'The learned doctor's cure was passed on to Boyle, for Hooke, by the faithful Aubrey, who added a recipe of his own.' For this letter see Hunter et al., *Correspondence of Robert Boyle* 4, 320, Aubrey to Boyle, 6 September 1672: 'Sir, I newly have received a letter from *Herefordshire* from Mr. *Hoskyns*, wherein is this recipe for Mr *Hooke*, if he mends not upon milk.'

41 M. Hunter, *The Royal Society and its Fellows 1660–1700: The Morphology of an Early Scientific Institution* (Oxford: British Society for the History of Science, second edition, 1994), p. 160. Pumfrey is not correct in thinking there was any problem with Hooke's election on grounds of his rank (S. Pumfrey, 'Ideas above his station: a social study of Hooke's curatorship of experiments', *History of Science* 29 (1991), 1–44).

42 For the issuing of the successive Charters of the Royal Society in 1662 and 1663 see Hunter, *Establishing the New Science*, pp. 18–21.

43 As used in this context, the term 'curator' is a neologisms which quickly entered everyday language. See Pumfrey, 'Ideas above his station'.

44 On the evolving definition of the Curator's job see Pumfrey, 'Ideas above his station'.

45 In Oxford Hooke had divided his working time between Boyle's laboratory and Dr Thomas Willis's dissecting room. See Frank, *Harvey and the Oxford Physiologists*, p. 165.

46 Hooke lived at Lady Ranelagh's in Pall Mall until allocated accommodation at Gresham College in August 1664: 'I have also, since my settling at Gresham college, which has been now full five weeks, constantly observed the baroscopical index' (Hooke to Boyle, 6 October 1664, in Hunter et al., *Correspondence of Robert Boyle* 2, 343). In March 1665 Hooke became Professor of Geometry at Gresham, which independently entitled him to rooms there, securing him a residence for life. The Gresham professorship involved a further layer of lecturing responsibilities, on top of Hooke's existing commitments, but it gave him secure accommodation and regular remuneration.

47 Hunter et al., *Correspondence of Robert Boyle* 2, 412.

48 Hunter et al., *Correspondence of Robert Boyle* 2, 304–5.

49 Hunter et al., *Correspondence of Robert Boyle* 2, 316–17.

50 Hunter et al., *Correspondence of Robert Boyle* 2, 81. Oldenburg's insistence on the indispensable nature of Hooke's attendance as Curator of Experiments is at odds with Stephen Pumfrey's contention that during this period Hooke was merely one among a number of 'curators' at the Society. See Pumfrey, 'Ideas above his station'.

51 Hunter et al., *Correspondence of Robert Boyle* 2, 81–2.

52 Oldenburg to Boyle, 10 June 1663 (Hunter et al., *Correspondence of Robert Boyle* 2, 85–6).

53 Oldenburg to Boyle, 10 June 1663 (Hunter et al., *Correspondence of Robert Boyle* 2, 87).

54 Christiaan's brother had pulled out of the air-pump venture, on grounds of cost.

55 See S. Shapin and S. Schaffer,

Leviathan and the Air-Pump: Hobbes, Boyle, and the Experimental Life (Princeton: Princeton University Press, 1985).

56 De Beer, Diary of John Evelyn 3, 318.

57 In 1671 Hooke constructed an air-pump receptacle large enough to sit in, and occupied it himself while an operator removed a substantial portion of the enclosed air. He reported pain in his ears and giddiness. See 'Espinasse, Robert Hooke, pp. 51–2.

58 He was evidently assisting Boyle with astronomical observations. See Oldenburg to Boyle, 2 July 1663: 'The 8 or 10 dayes, which you allowed yourself in your letter for <the residu of your stay at> Lees, being now elapsed; yet the mixture of my fear, least the influence of that constellation, you then named, should arrest you longer, where you are, I thought, I would try, whether the operation of the starrs (since they are held but to incline) might <not> be diverted by the power of a Royal Society' (Hunter et al., Correspondence of Robert Boyle 2, 95).

59 'An experiment was tryed in the Compressing Engine, but again without successe'. Oldenburg to Boyle, 10 June 1663 (Hunter et al., Correspondence of Robert Boyle 2, 89). Actually, Hooke had not managed to get the air-pump working satisfactorily at the meeting for which he had been allowed to stay the additional days to attend – one more reason why Oldenburg was eager to get him back to London as quickly as possible.

60 Oldenburg to Boyle, 10 June 1663 (Hunter et al., Correspondence of Robert Boyle 2, 95). Boyle had still not returned to London on 18 July.

61 J. A. Bennett, The Mathematical Science of Christopher Wren (Cambridge: Cambridge University Press, 1982), p. 51. Hooke's map of the Pleiades (a constellation within Taurus) is Hooke, Micrographia, pp. 241–2.

62 See Jardine, On a Grander Scale, chapter 5.

63 For Wren's toing and froing see e.g. Oldenburg to Boyle, 22 September 1664: 'This I intreat you, Sir, be pleased to communicate with my humble service to Dr Wallis, I name not Dr Wren, because he was present, when the letter itselfe was read to the society' (Hunter et al., Correspondence of Robert Boyle 2, 329); Hooke to Boyle, 24 November 1664: 'Having received the honour of your commands by Dr. Wren, for procuring an instrument for refraction, whereby, as he told me, you designed to try the refraction of the humours of the eye; I did that very afternoon bespeak it; and I hope within a few days it will be ready to be conveyed to you' (Hunter et al., Correspondence of Robert Boyle 2, 412). The Hooke–Boyle information flow was public knowledge – see e.g. Oldenburg to Boyle, 20 October 1664: 'I suppose, Mr Hook will himself answer your quere, which I acquainted him with, concerning the same' (Hunter et al., Correspondence of Robert Boyle 2, 357). Hooke had indeed answered Boyle's query in his letter of 21 October, from which it is clear that Wren is back in Oxford: 'I have not as yet any time to spend on these things, and therefore should be very glad, if yourself, or Dr. Wallis, or Dr. Wren, would examine what might be done in that kind; and what observations shall be further made, I shall most faithfully give an account of' (Hunter et al., Correspondence of Robert Boyle 2, 363).

64 The theory, apparently, assumed a uniform rectilinear path. Wren produced a solution to his geometrical problem, and a diagram, in which Wren used his mathematical construction to locate the comet and describe its motion in a straight line between 20 October 1664 and 20 January 1665. Hooke later published both in his Cometa (Comets). See Jardine, On a Grander Scale, chapter 5.

65 RS MS EL W.3 no. 5, cit. Bennett,

*Mathematical Science of Christopher Wren*, p. 67.

66 For more on this rare surviving exchange of letters between Wren and Hooke, see Jardine, *On a Grander Scale*, pp. 269–74.

67 J. Elmes, *Memoirs of the Life and Works of Sir Christopher Wren* (London: Priestley & Weale, 1823), pp. 164–5.

68 RS MS EL W.3 no. 6, cit. Bennett, *Mathematical Science of Christopher Wren*, p. 67. I have reversed the order of these letters, in spite of the dates given, since Wren's appears to answer Hooke's.

69 See Jardine, *On a Grander Scale*, chapter 5.

70 'At the time of writing Wren planned to return in December: "My Lord *Berkley* returns to *England* at *Christmas*, when I propose to take the Opportunity of his Company." This was George Berkeley, who had, while himself in Paris with Henrietta Maria, lent his house at Durdans, Epsom to Wilkins, Hooke and others, as a refuge during the summer 1665 plague outbreak. On 30 November, Edward Browne reported in a letter that "Dr. Wren is at Lord Barclays" (*Wren Society*, 20 vols (Oxford: printed for the Wren Society at the University Press, 1924–43) 18, 178). However, Wren stayed in France until the end of February' (Jardine, *On a Grander Scale*, p. 244).

71 For the history of the Royal Society's interest in 'improving chariots' and Thomas Blount's central involvement in the experiments with new carriage suspensions see M. Hunter, 'An experiment in corporate enterprise', in Hunter, *Establishing the New Science*, pp. 72–121; 88–9.

72 Birch, *History of the Royal Society* 2, 30.

73 Birch, *History of the Royal Society* 2, 41.

74 Latham and Matthews, *Diary of Samuel Pepys* 6, 94–5. Blount had already been involved during the Commonwealth years with

experimental development of a faster plough – also tested on his own land. See Hartlib CD ROM.

75 Birch, *History of the Royal Society* 2, 60.

76 'Plût à Dieu, que la contagion cessast de nous ravager. Elle continue pourtant de se diminuer, Dieu soit loué, il ne nous manque tant, qu'un Esprit de gratitude pour une si grande misericorde que le Ciel commence à desployer sur nous.' Oldenburg to Huygens, 17 October 1665, in *Oeuvres complètes de Christiaan Huygens*, 22 vols (The Hague: Martinus Nijhoff, 1888–1950) 5, 500–1.

77 Birch, *History of the Royal Society* 2, 66.

78 Birch, *History of the Royal Society* 2, 74.

79 Financial difficulties dogged Charles II's administration throughout his reign. At the beginning of 1672 the Crown effectively declared itself bankrupt with the 'Stop of the Exchequer', under which all repayments on its debts were suspended.

80 Jardine, *Ingenious Pursuits*, pp. 149–53. For a clear account of Hooke's complicated position in the longitude timekeeper patent race, see M. Wright, 'Robert Hooke's longitude timekeeper', in M. Hunter and S. Schaffer, *Robert Hooke: New Studies* (Woodbridge: Boydell Press, 1989), pp. 63–118.

81 For the later consequences of Hooke's being diverted from his work on balance-spring watches during the plague outbreak of 1665–6, see below, chapter 5.

82 In July Parliament was prorogued, and the Exchequer transferred to Nonsuch Palace at Epsom. Petty was presumably required to be in attendance there. See Latham and Matthews, *Diary of Samuel Pepys* 6, 187–8.

83 Hunter et al., *Correspondence of Robert Boyle* 2, 493. Hooke goes on: 'I very much fear also, that we shall be forced against our wills to stay there long enough to try experiments of Cold

[i.e. into winter], though I have some thoughts of removing to another place farther from London, where I have designed to try a larger catalogue of experiments, such as one cannot every where meet with an opportunity of doing; but the country people are now so exceeding timorous, that they will not admit any, unless one have been a considerable time absent from London. I was this day informed by one, that received a letter thence, that the plague rages so extremely in Southampton, that sometimes there die thirty in a night; and that has made Portsmouth, and the isle of Wight so fearful, that they will suffer none to enter' (Hunter et al., *Correspondence of Robert Boyle* 2, 493). Hooke's mother had died in June, and Hooke is here recording his inability to get home to the Isle of Wight to settle his family affairs: '1665 June 12 Burial, Newport. Mrs. Cisesly Hooke, widow' (Newport Parish Register).

84  Hunter suggests that Boyle left Oxford before 4 July, but the reference in Oldenburg's letter of 4 July actually only implies that Boyle is about to leave Oxford (Hunter et al., *Correspondence of Robert Boyle* 2, 488).

85  Hunter et al., *Correspondence of Robert Boyle* 2, 495. In the 'Publishers Advertisement to the Reader' in the published *Hydrostatical Paradoxes, Made out by New Experiments, (For the most part Physical and Easie.)* (1666) (M. Hunter and E. B. Davis (eds), *The Complete Works of Robert Boyle*, 14 vols (London: Pickering & Chatto, 1999–2001) 5, 189–279), the difficulty in obtaining suitable glassware for Boyle's experiments, during the period when he was out of London (including that at Epsom), is again alluded to: 'He resolv'd to repeat divers Experiments and Observations, that he might set down their Phaenomena whil'st they were fresh in his Memory, if not objects of his sense. But though, when he Writ the following Preface, he did it upon a probably supposition, that he should

seasonably be able to repeat the intended Tryals, yet his Expectation was sadly disappointed by that heavy, as well as just, Visitation of the Plague which happened at *London* whil'st the Author was in the Country: and which much earlier then was apprehended, began to make havock of the People, at so sad a rate that not only the Glassmen there were scatter'd, and had, as they themselves advertis'd him, put out their Fires, but also Carriers, and other ways of Commerce (save by the Post) were strictly prohibited betwixt the parts he resided in and *London*; which yet was the only place in England whence he could furnish himself with peculiarly shap'd Flasses, and other Mechanical Implements requisite to his purposes' (Hunter and Davis, *Works of Robert Boyle* 5, 191).

86  Hunter et al., *Correspondence of Robert Boyle* 2, 535. This experiment does not appear in *Hydrostatical Paradoxes* (1666).

87  On 6 August, Boyle's sister, Lady Ranelagh (herself at Leese Priory with her sister) expressed alarm that Boyle intended to travel from Epsom to Oxford; in fact he had already set out, since he wrote to Oldenburg from there on the same date. Hunter et al., *Correspondence of Robert Boyle* 2, 503, 504.

88  7 August 1665; de Beer, *Diary of John Evelyn* 3, 416.

89  Hunter et al., *Correspondence of Robert Boyle* 2, 513: 'I am still at Durdens, my lord Berkley's house near Epsom, where Dr. Wilkins only remains, Sir W. P. being gone to Salisbury.'

90  Birch, *History of the Royal Society* 2, 30, 31–2, 40 and 48.

91  'When Hevelius claimed that telescopic sights had never been tried on large instruments, Hooke replied that he had used several, "and particularly one of Sr. Christopher Wren's invention, furnished with two Perspective Sights of 6 foot long each, which I made use of for examining the motions of the Comet, in the year

1665." This was Wren's "double telescope" which Hooke describes elsewhere in the Animadversions (1674), as "two square Wooden Tubes, joyn'd together at the end next the Object by a Joynt of Brass, and the Angle made by opening of them, measured by a straight Rule." ... Hooke gives a very detailed account in a lecture that was probably written in the period 1665–9 (see Waller, *Posthumous Works*, pp. 498–503)' (Bennett, *Mathematical Science of Christopher Wren*, pp. 42–3).

92 On astronomical instrument-based versus chronometer-based solutions to the longitude problem see W. J. H. Andrewes (ed.), *The Quest for Longitude* (Cambridge, Mass.: Harvard University Press, 1996).

93 Hunter et al., *Correspondence of Robert Boyle* 2, 493–4.

94 Hunter et al., *Correspondence of Robert Boyle* 2, 512–13. Hooke goes on: 'The other [quadrant], which is yours [i.e. Boyle paid for it], I hope within a day or two to perfect it, so as to go much beyond the other for exactness.' He adds in a postscript that this is still to be paid for: 'There is something above thirty shillings due to Mr. thompason. I have forgot the particular sum, but if I misremember not, it was thirty two shillings.'

95 Hooke had already shown his improved quadrant to the Society among the 'recess' work produced for the meeting on 21 March 1666: 'Mr. Hooke brought in a small new quadrant, which was to serve for accurately dividing degrees into minutes and seconds, and to perform the effect of a great one. It had an arm moving on it by means of a screw that lay on the circumference. But the complete description of it was referred to the inventor' (Birch, *History of the Royal Society* 2, 69).

96 Hooke did hope to construct a purpose-built 'depth' or well at Greenwich, for observational purposes, alongside the Observatory

in 1675. A well is shown on a plan of Greenwich, but apparently none was ever sunk. See Jardine, *On a Grander Scale*.

97 Hooke to Boyle, 15 August 1665, Hunter et al., *Correspondence of Robert Boyle* 2, 512.

98 Hunter et al., *Correspondence of Robert Boyle* 2, 537–8.

99 Hunter et al., *Correspondence of Robert Boyle* 2, 538.

100 Birch, *History of the Royal Society* 2, 69–70. In addition to his experiments with 'depths' (in wells), Hooke mentions having carried out similar experiments with 'heights', 'both on the higher parts of Westminster Abbey, and also on the top of St. Paul's tower'.

101 Birch, *History of the Royal Society* 2, 70–1.

102 Birch, *History of the Royal Society* 2, 71.

103 For Hooke as instrument-maker see J. A. Bennett, 'Hooke as instrument maker', in Bennett et al., *London's Leonardo*.

104 'I am going shortly for a little while into the Isle of Wight, and so perhaps may not till my return be able to make those trials; but I suppose the winter will not afford less instructive experiments than the other. And therefore what you shall please to suggest now will not come too late for winter experiments, especially if I can give order for making ready an apparatus for them before I take my journey' (Hooke to Boyle, 26 September 1665, Hunter et al., *Correspondence of Robert Boyle* 2, 538).

105 Hooke means during the extended summer recess necessitated by the plague outbreak in London, during which this trip was made.

106 Drake, *Restless Genius*, p. 176.

107 Drake, *Restless Genius*, p. 181. Elsewhere in the Discourse, Hooke specifies the location of his fossil-hunting even more precisely: 'To this I shall add an Observation of my own nearer Home, which other

possibly may have the opportunity of seeing, and that was at the West end of the Isle of *Wight*, in a Cliff lying within the *Needles* almost opposite to *Hurst-Castle*, it is an Earthy sort of Cliff made up of several sorts of Layers, of Clays, Sands, Gravels and Loames one upon the other. Somewhat above the middle of this Cliff, which I judge in some parts may be about two Foot high, I found one of the said Layers to be of a perfect Sea Sand filled with a great variety of Shells, such as Oysters, Limpits, and several sorts of Periwinkles, of which kind I dug out many and brought them with me, and found them to be of the same kind with those which were very plentifully to be found upon the Shore beneath, now cast out of the Sea' (Drake, *Restless Genius*, p. 232).

108 For an excellent description of the geology of the Isle of Wight, and its influence on Hooke's lifelong interest in geology, see Drake, *Restless Genius*, chapter 2.

109 Drake, *Restless Genius*, pp. 232–3. On p. 182, Hooke again draws on his own recent experience, when he notes: 'Who can imagine Oysters to have lived on the Tops of some Hills, near *Banstead-Downs* in *Surry*? Where there have been time out of Mind, and are still to this day found divers Shells of Oysters, both on the uppermost Surface, and buried likewise under the Surface of the Earth, as I was lately informed by several very worthy Persons living near thoose Places, and as I mysself had the Opportunity to observe and collect.' In late 1665 and early 1666, Hooke was at Epsom.

110 Hooke to Boyle, 3 February 1666: 'The weather was so very cold, when we made these experiments, that made us hasten then so much the more; and I have not since had an opportunity to repeat them' (Hunter et al., *Correspondence of Robert Boyle* 3, 49).

111 cit. Pumfrey, 'Ideas above his station', p. 27.

112 Moray to Oldenburg, 12 and 16 November 1665, A. R. Hall and M. B. Hall, *The Correspondence of Henry Oldenburg* 13 vols: vols 1–9 (Madison: University of Wisconsin Press, 1965–73); vols 10–11 (London: Mansell, 1975–6); vols 12–13 (London: Taylor & Francis, 1986) 2, 605; 610.

113 On Hooke's childhood constitution see Cooper, 'Hooke as employee'.

114 There is no basis in historical fact for characterising Hooke as a menial, put-upon scientific servant, pulled hither and thither by the competing demands of a number of elite employers. See e.g. Pumfrey, 'Ideas above his station'.

115 Hunter et al., *Correspondence of Robert Boyle* 2, 315.

116 After the Great Fire in September 1666, Hooke had the added (onerous) commitments of Surveyor for the City of London, and delegated responsibilities for rebuilding London, within the Wren architectural practice. See below, chapter 4; Jardine, *On a Grander Scale*; Cooper, 'Hooke as employee'.

117 See M. Cooper, 'Robert Hooke's work as surveyor for the City of London in the aftermath of the Great Fire. Part one: Robert Hooke's first surveys for the City of London', *Notes and Records of the Royal Society* 51 (1997), 161–74; 'Part two: certification of areas of ground taken away from streets and other new works', *Notes and Records of the Royal Society* 52 (1998), 25–38; 'Part three: settlement of disputes and complaints arising from rebuilding', *Notes and Records of the Royal Society* 52 (1998), 205–20.

118 Oldenburg to Boyle, 17 March 1666, Hunter et al., *Correspondence of Robert Boyle* 3, 113.

119 See below, chapter 4.

120 Moray to Oldenburg, 8 January 1666, Hall and Hall, *Correspondence of Henry Oldenburg* 3, 9.

121 'Joubliois de vous dire que quelques uns travailloient icy a rendre les montres meilleurs aussibien que vous

aves fait en Angleterre, mais que lon non voioit aucun succes. il ya apparance que nous devons beaucoup espere des meditations de M. Hook sur ce suiet car M. Wren ma dit icy quil en avoit desia reduit quelque chose en pratique. ce cera une belle Invention' (Auzout to Oldenburg, 4 April 1666, Hall and Hall, *Correspondence of Henry Oldenburg* 3, 83). Wren was in France until early March 1666.

122 See below, chapter 5. On the details of Wren's encounters with Auzout and other French virtuosi during this visit see Jardine, *On a Grander Scale* chapter 5.

CHAPTER 4: *Architect of London's Renewal*

1 Richard Waller, 'The Life of Dr. Robert Hooke', in Waller, *Posthumous Works*, p. xiii, cit. Cooper, 'Robert Hooke's work as surveyor for the City of London in the aftermath of the Great Fire. Part one: Robert Hooke's first surveys for the City of London', p. 161. This account of Hooke's activities as City Surveyor relies closely on Michael Cooper's exemplary work. See now M. A. R. Cooper, *'A More Beautiful City': Robert Hooke and the Rebuilding of London* (Stroud: Sutton Publishing, 2003). I am extremely grateful to him for his generosity in clarifying and elaborating in person on points made in the three important articles he has published on this subject. The book, however, was not available at the time I was writing my own.

2 S. Porter, *The Great Fire of London* (Stroud: Sutton Publishing, 1996), p. 44.

3 Porter, *Great Fire of London*, pp. 34–59.

4 'The other endowment of the 1660s came from a Fellow of the Society, Daniel Colwall, who provided the finance which enabled the Society to purchase a large collection of rarities as the basis for a substantial institutional museum early in 1666' (Hunter, *Establishing the New Science*, p. 32). See also Hunter, 'Between Cabinet of Curiosities and research collection'. Although the Repository was intended to be set up in the West Gallery, where the Fellows held their meetings, they were still in Hooke's rooms 'as in a storeroom' in 1668. See Hunter, 'Between Cabinet of Curiosities and research collection', pp. 139–40.

5 The Society held its meetings in the West Gallery, and instruments and equipment were housed there.

6 This is the expression of joy Richard Waller tells us was marked in Hooke's diary for the day on which the court case against Sir John Cutler was finally settled: 18 July 1696, Hooke's sixty-first birthday. See below, chapter 6.

7 cit. Inwood, *The Man Who Knew Too Much*, p. 253.

8 CLRO Rep. 71, fols 168v–169v, cit. Cooper, 'Hooke as employee'.

9 See Cooper, 'Robert Hooke's work as surveyor. Part one', pp. 162–3.

10 See Jardine, *On a Grander Scale*, chapter 5. When Hevelius claimed that telescopic sights had never been tried on large instruments in 1679, Hooke replied that he had used several: 'and particularly one of Sr. Christopher Wren's invention, furnished with two Perspective Sights of 6 foot long each, which I made use of for examining the motions of the Comet in the year 1665' (Bennett, *Mathematical Science of Christopher Wren*, p. 42).

11 By 12 December Wren had already been swept up in the royal response to the Great Fire. He presented his plan for a rebuilt City on 11 September, and probably did not attend the Society meeting on the 12th.

12 Cooper, 'Robert Hooke's work as surveyor. Part one', p. 164.

13 CLRO Jor. 46 fol. 148r, dated 13 March 1667, cit. Cooper, 'Robert Hooke's work as surveyor. Part one', p. 164.

14 Oliver, who had initially declined to be formally appointed, offered to help

Mills and Hooke informally. He joined the team officially at the beginning of 1668.

15 CLRO Rep. 72 fol. 8ov, dated 14 March 1667, cit. Cooper, 'Robert Hooke's work as surveyor. Part one', p. 166.

16 Cooper, 'Robert Hooke's work as surveyor. Part one', p. 173.

17 18 September 1666. Hall and Hall, *Correspondence of Henry Oldenburg* 3, 230–1.

18 For the next five years those curatorial duties would involve Hooke's transporting all experimental equipment from Gresham to Arundel House, home of Henry Howard, later Duke of Norfolk, generously put at the disposal of the Society for as long as Gresham was unavailable for their meetings.

19 Birch, *History of the Royal Society* 2, 115.

20 It was on the basis of this new-found prominence that Hooke later brokered between the son of the Lord Mayor, Thomas Bloodworth, and his own brother John's daughter Grace. See below, chapter 6.

21 See Jardine, *On a Grander Scale*, chapter 5.

22 R. T. Gunther (ed.), *The Architecture of Sir Roger Pratt, Charles II's Commissioner for the Rebuilding of London after the Great Fire: Now Printed for the first time from his Note-Books* (Oxford: Oxford University Press, 1928).

23 Hence the closeness of match between the road layout in the schemes for rebuilding submitted post-Fire by Wren and Evelyn, who were both members of the earlier Commission. See Jardine, *On a Grander Scale*.

24 CLRO Jor. 46 fol. 129r, dated 31 October 1666, cit. Cooper, 'Robert Hooke's work as surveyor. Part one', p. 163.

25 A stop had been put on too hasty rebuilding on 13 September, until building regulations and street widths had been agreed.

26 Porter, *Great Fire*, pp. 106–7.

27 Cooper, 'Robert Hooke's work as surveyor. Part one', p. 163.

28 Posterity has tended to represent Hooke as constantly envious of Oldenburg – to a large extent, in the late 1660s, the reverse was true.

29 Oldenburg to Boyle, 16 October 1666, Hall and Hall, *Correspondence of Henry Oldenburg* 3, 245.

30 BL MS '*Parentalia*', fol. 54r.

31 CLRO Jor. 46 fol. 146r, dated 25 February 1667, cit. Cooper, 'Robert Hooke's work as surveyor. Part one', p. 164.

32 CLRO Jor. 46 fol. 147v, dated 13 March 1667, cit. Cooper, 'Robert Hooke's work as surveyor. Part one', p. 173. Cooper comments on the 'map': 'This map was probably an annotated version of John Leake's compilation dated December 1666 (BL Add. Ms. 5415E.1) from six sheets drawn from surveys by Leake, John Jennings, William Marr, William Leybourne, Thomas Streete and Richard Shortgrave. Although no evidence has been found that Hooke undertook any surveying for this map, many examples in the records of the Committee for City Lands of the way Hooke worked with Leybourne and Shortgrave – and from Hooke's first diary ... with Leake in private practice – lead to the conclusion that Hooke had much to do with the appointment, organization and supervision of the six surveyors.'

33 See below, chapter 5. Likewise, Robert Knox's hour-long interview in 1683 may have been facilitated by Hooke (Chapter 7).

34 On Pratt's career, see Gunther, *Architecture of Sir Roger Pratt*. 'In 1664, while still heavily engaged upon work at Kingston Lacy and at Horseheath, Pratt undertook a third and yet larger mansion for Edward Hyde, Earl of Clarendon. The site chosen lay on the north side of the "rode to Reading", now Piccadilly, between Burlington House and Devonshire House. Pratt devoted himself most assiduously to the planning of this house and has left

very full notes as to his building practice. The building took three years and was valued at £35,000, but it was not fated to stand long, for it was demolished in 1683, having been in existence less than twenty years. In the interval the place had acquired a site value and had become mature for development. A speculative builder purchased the materials of the house at house-breakers' prices, and many of Pratt's bricks are doubtless below the foundation of Bond Street' (see Gunther, *Architecture of Sir Roger Pratt*, pp. 9–14).

35 It is striking that from immediately after the Fire, Jerman was extensively occupied with commissions for rebuilding from livery companies and guilds, which presumably further lessened his involvement with the overall rebuilding plans. In addition to the Royal Exchange, Jerman designed new buildings for the goldsmiths, fishmongers, weavers, drapers and mercers (Porter, *Great Fire* p. 131). May, meanwhile, was paymaster for the Royal Works, thus fully occupied with the financial side of rebuilding operations.

36 The account that follows is largely based on P. Jeffery, *The City Churches of Sir Christopher Wren* (London: Hambledon Press, 1996). See also the fuller account in Jardine, *On a Grander Scale*.

37 cit. Jeffery, *City Churches*, p. 27.

38 cit. Jeffery, *City Churches*, p. 31.

39 Jeffery, *City Churches*, pp. 37–8.

40 For more on the Wren–Hooke architectural partnership see Jardine, *On a Grander Scale*, chapter 6, and passim.

41 It looks as if the figure was £50 per annum plus occasional payments pro rata. Hooke records these payments – or rather, Wren's accumulating debt, due to his slowness in paying – at regular intervals in his diary. Since Woodroffe also did work in the Wren office directly for Wren, he too may have received additional remuneration. However, he died in 1675, and was replaced by John Oliver. See below. By

1670, Hooke was receiving £150 a year from the Corporation of London for his work as City Surveyor (see Cooper, 'Robert Hooke's work as surveyor. Part one', p. 170).

42 For the evidence from Hooke's diary of his close involvement with the City churches see M. I. Batten, 'The Architecture of Dr Robert Hooke FRS', *Walpole Society* 25 (1936–7), 83–113.

43 See Jeffery, *City Churches*, pp. 38–9. Hoskins was a member of the 'new club' Hooke and Wren were plotting at this time. See Jardine, *On a Grander Scale*, chapter 4. When Hooke stepped down as Wren's second-in-command in 1693 (the same year in which he ceased acting as City Surveyor), his job was taken by Nicholas Hawksmoor, who had joined Wren's office as a draughtsman around 1679, and who, like Hooke, had learned the design side of architecture inside the practice. On Hawksmoor's early career see V. Hart, *Nicholas Hawksmoor: Rebuilding Ancient Wonders* (London: Yale University Press, 2002).

44 Because Hooke acted as draughtsman as well as design architect in his own right, it is not sufficient to identify his hand in a drawing in order to decide attribution.

45 See Jardine, *On a Grander Scale*; Jeffery, *City Churches*; Batten, 'The architecture of Dr Robert Hooke'. Dr Anthony Geraghty is currently cataloguing the All Souls collection of Wren drawings for publication, and will produce the definitive account of how Wren's and Hooke's design efforts should be allocated between building projects jointly undertaken.

46 Inwood, *The Man Who Knew Too Much*, p. 136. See also Batten, 'The architecture of Dr Robert Hooke'.

47 See S. Bradley and N. Pevsner, *London: The City Churches* (London: Penguin, revised edition, 1998), p. 83, which incorporates Anthony Geraghty's recent research on attribution; cit. Inwood, *Man Who Knew Too Much*, p. 136

48 See Batten, 'The architecture of Dr Robert Hooke'.

49 Cooper, 'Robert Hooke's work as surveyor. Part one', p. 166.

50 Cooper, 'Robert Hooke's work as surveyor. Part one', p. 166.

51 Cooper, 'Robert Hooke's work as surveyor. Part one', p. 166.

52 Cooper, 'Robert Hooke's work as surveyor. Part two'.

53 Cooper, 'Robert Hooke's work as surveyor. Part two', pp. 25–6.

54 Michael Cooper, who has checked all Hooke's calculations of area and cost, maintains that he has not detected a single error.

55 Cooper, 'Robert Hooke's work as surveyor. Part three', p. 205.

56 Cooper, 'Robert Hooke's work as surveyor. Part three', p. 207.

57 Cooper, 'Robert Hooke's work as surveyor. Part three', p. 211. Paragraph breaks inserted.

58 On Hooke's priority dispute with Huygens over the balance-spring watch see below, chapter 5. On Hooke's dispute with Sir John Cutler see below, chapter 6.

59 Michael Cooper argues plausibly that Hooke kept these notes in his day books. Unlike the other two City Surveyors, Hooke never handed these in, and they were therefore never transcribed into the Guildhall records. See Cooper, 'Robert Hooke's work as surveyor', passim. From 1672 to 1683, and again from 1688 to 1693 there are surviving diaries.

60 'Now when I have sayd his inventive faculty is so great, you cannot imagine his memory to be excellent: for they are like two bucketts, as one goes up, the other goes downe' (Buchanan-Brown, *John Aubrey: Brief Lives*, p. 396).

61 Hooke, *Diary* 11 September 1677, cit. 'Espinasse, *Robert Hooke*, p. 152.

62 See below, chapter 5. On 18 August 1668, Christopher Kirkby gave Boyle an account of a series of experiments on gravely ill patients in Danzig, involving 'adventur[ing] the opning a veine and infusing some medicines into the blood'. The experiment was repeated 'by infuseing Medicamenta Alterantia, into the veines of the right armes of three persons: the one lame of the goute; the other extremely appoplecticall, and the third reduced to extremity by that odd distemper plica polonica'. The condition of all three improved. Hunter et al., *Correspondence of Robert Boyle* 4, 89–90.

63 On the vexed question of the additional burden of the lectures called for under the newly established Cutlerian lectureship, sponsored by Sir John Cutler, see below, chapter 7.

64 Gunther, *Early Science in Oxford* 6, 349.

65 Gunther, *Early Science in Oxford* 6, 347.

66 'Feb. 11. Mr Hooke being absent, the experiments of motion were not prosecuted. The operator [Richard Shortgrave] was ordered to speak to Mr. Hooke, that the new great microscope of Mr. Christopher Cock's making be brought to the society at the next meeting' (Gunther, *Early Science in Oxford* 6, 348).

67 Birch, *History of the Royal Society of London* 2, 383.

68 Gunther, *Early Science in Oxford* 6, 354.

69 Forbes et al., *Correspondence of John Flamsteed* 2, 730.

70 'He did not begin his observations before July. Yet those taken in the months of August and October show the fixed star to be nearer the vertex, as parallax requires. Of which, therefore, this is evident proof' (Forbes et al., *Correspondence of John Flamsteed* 2, 730). In fact Hooke's measurements of parallax are inconclusive. See also Hooke, *Attempt to prove the Motion of the Earth*: 'The first observation I made was the Sixth of July, 1669. when I observed the bright Star of Dracoto pass the Meridian Northwards of the Zenith point of the Mensurator, at about two Minutes and twelve Seconds. The second observation I made was upon

the Ninth of July following, when I found it to pass to the Northwards of the said Zenith or cross of the Mensurator, near about the same place, not sensibly differing. The third observation I made upon the Sixth of August following; then I observed its transitus North of the aforesaid Zenith, to be about two Minutes and six Seconds. The last observation I made upon the One and twentieth of October following, when I observed it to pass to the North of the Zenith, at one Minute and about 48 or 50 Seconds. Inconvenient weather and great indisposition in my health, hindred me from proceeding any further with the observation that time, which hath been no small trouble to me, having an extraordinary desire to have made other observations with much more accurateness then I was able to make these, having since found several inconveniencies in my Instruments, which I have now regulated.'

71 Gunther, *Early Science in Oxford* 6, 359. For Hooke's curatorial responsibilities over the years see Pumfrey, 'Ideas above his station', p. 7.

72 Cooper, *London's Leonardo*, p. 25.

73 'Negotiable fees were paid by citizens directly to the Surveyors for staking out and certifying foundations, measuring and certifying areas of lost ground and for viewing disputes. The main evidence for assessing how much Hooke received in fees for these services comes from his diaries which on almost every page include notes of sums of money, associated usually with the name of a person or a place, but it is often difficult to decide if he is referring to a foundation certificate, an area certificate, a view, or some other service unconnected with his official City office. Despite these difficulties, the loss of his survey books and the fact that he did not start to keep a diary until most of the rebuilding work was over, it has been possible to correlate enough evidence

from his diaries and the City archives to make reasonable estimates of how much he was paid in fees for his duties as Surveyor up to the end of 1674 when most of the private rebuilding had been completed. He received about £1000 for his foundation certificates, about £280 for his area certificates and about £275 for his views. From 1675 until the 1690s he continued to receive fees for his duties as Surveyor, but with greatly reduced frequency, amounting to at least £129. In all he received at least an estimated £1684 in fees from London's citizens for his work as City Surveyor, in addition to his salary' (Cooper, 'Hooke as employee', pp. 41–2).

74 Cooper, 'Robert Hooke's work as surveyor. Part one', p. 170.

75 Cooper, 'Robert Hooke's work as surveyor. Part one', p. 170. On 1 February 1669, in the middle of the period we have looked at, when Hooke was working under pressure for the City, the Society records: 'It was ordered, That the Treasurer do pay to Mr. Hooke the arrears due to him, according to the allowance appointed him by the order of council of November 23, 1664, of thirty pounds a year.'

76 See below, chapter 6.

77 M. Hunter, 'Science, technology and patronage', in Hunter, *Establishing the New Science*, pp. 279–338; 284.

78 Hooke, *Micrographia*, sig. g1v–g2r.

79 See A. Stoesser-Johnston, 'Robert Hooke and Holland: Dutch influence on his architecture', *Bulletin Kunincklijk Nederlands Oudheidkundig Bond* 99 (2000), 121–37; 126–7.

80 See Jardine, *On a Grander Scale*, p. 319.

81 On Hooke's commission for Bedlam (Bethlehem) Hospital see Heyman, 'Hooke and Bedlam' (seen in draft). I am extremely grateful to Professor Heyman for allowing me to read this paper.

82 10 October 1683. De Beer, *Diary of John Evelyn* 4, 344–5. Evelyn adds that 'Monsieur Jardine [Chardin] the great

Traveller' accompanied him. For Hooke's interest in Chardin's experiences in Persia see below, chapter 7.

83 For full details of Hooke's many building commissions during the 1670s and 80s see Inwood, *The Man Who Knew Too Much*, passim.

84 For a fuller treatment of Wren and Hooke's Monument to the Great Fire, including the details of its purpose-built scientific functions, see Jardine, *On a Grander Scale*.

85 Royal Society Journal Book 7, 219–20, cit. Inwood, *The Man Who Knew Too Much*, p. 140.

86 Hooke also had trouble with the inscription: on 17 June 1678, he 'saw Monument inscription now finished', but as late as 10 April 1679, he writes, 'At Fish Street Piller. Knight cut wrong R. for P.' For more on the Monument see Jardine, *On a Grander Scale*, chapter 6 and Introduction.

87 Occasionally Wren, who was in a position to be more scrupulous about whom he would serve than Hooke, counselled him against accepting a commission, on grounds of the disreputable nature of the client. Hooke nevertheless went ahead with building works for the Earl of Oxford and Ralph Montagu, both of whom were known reprobates.

88 cit. Heyman, 'Hooke and Bedlam'. This account of the building of Bedlam is based on Heyman's article.

89 See below, chapter 5.

90 It might be argued that this is also why a number of these buildings had to be pulled down a century later. 'One hundred and twenty-five years later, in 1800, an architect's report to the governors [of Bedlam] found the building to be dangerously insecure ... The report stated that the walls had not been laid on (vertical) piles, and that the brickwork had simply been set down on the surface of the soil, a few inches below the floor' (Heyman, 'Hooke and Bedlam'). Fitch was responsible for laying the foundations, to much more rigorous

specifications, set by Hooke, but apparently not heeded.

91 '(Oliver, the glasse-painter, was the other.) He built Bedlam, the Physitians' College, Montague-house, the Piller on Fish-street-hill, and Theatre there; and he is much made use of in designing buildings' (Aubrey, *Brief Lives*).

92 Waller, 'Life of Dr Robert Hooke', p. xiii.

93 See below, chapter 6.

CHAPTER 5: *Skirmishes with Strangers*

1 Thomas Sprat, *The History of the Royal Society of London for the Improving of Natural Knowledge* (London, 1667), p. 89, cit. S. Alpers, *The Art of Describing: Dutch Art in the Seventeenth Century* (Chicago: University of Chicago Press, 1983), p. 74.

2 'J'adjouteray seulement un mot sur ce que Monsieur Hook a remarqué dans son livre ... quie est, de vous prier de ne vous offencer point sur quelques paroles qui vous touchent. Il y a des personnes qui n'ayant pas vû beaucoup de monde, ne scavent pas la maniere d'observer le decorum qu'il faut parmi les honestes gens' (Hall and Hall, *Correspondence of Henry Oldenburg* 11, 177).

3 Some time during the 1670s Hooke drafted a document proposing revised rules for the organisation and functioning of the Royal Society. The paragraph there on foreign members reflects evident lack of trust on Hooke's part: 'That every person that is a forrener and elected fellow of this society shall before he receive any benefit or information from the said society, take an othe upon the Evangelists or take the sacrament that he will not either directly or indirectly disclose any thing that shall be communicated to him nor make any use thereof to the detriment of the Society.' See Royal Society, Classified Papers XX.50, fols 92–4, in M.

Hunter, 'Towards Solomon's house: rival strategies for reforming the early Royal Society', in Hunter, *Establishing the New Science*, pp. 185–244; 235. For the dating of this manuscript see pp. 242–4.

4 A much briefer letter had been sent a few months earlier to Henry Oldenburg, the Royal Society's Secretary, bringing Leeuwenhoek formally to the Society's attention.

5 On Huygens and Drebble, see Alpers, *The Art of Describing* chapter 1.

6 J. A. Worp, 'Fragment eener Autobiographe van Constantijn Huygens', *Bijdragen en Mededeelingen van het historisch Genootschap* (Utrecht) 18 (1897), 1–122, cit. Alpers, *The Art of Describing*, pp. 6–7.

7 Huygens's letter of release from Charles II, written in 1671, is preserved among Huygens's papers at The Hague, KA 49–3, headed 'Copie de ma derniere lettre de Residence du Roij de la Gr. Bretaigne à S. A. Whithall 13 Sept. 1671.' It begins: 'I am not a little ashamed that I have delayed Monsieur de Zulichem from time to time wth. promise of a speedy dispatch, and according to what I haue written to you in my former letters. The founds giuen me by the Parliament haue fallen infinitely short of their first computations which hath disturbed and made almost ineffectuall all my orders; so that it were to abuse you to giue you any of them.' It ends with a tribute to Huygens's tenacity: 'I cannot finish this letter, which I meane to communicate to the bearer, before I seal it up, nor before I lett you know how troublesome a sollicitor he hath been to me, though a most zealous one for you and consequently how worthy he is of the continuance of your esteem and good will. This is all I haue to say to you at present, but to assure you that I am with all imaginable kindnesse yours.' Huygens, at seventy-six, was still the Stadholder's most trusted and intimate servant. Leeuwenhoek left the Low Countries only once in his life. In 1667, following the death of his wife, he visited England, on which occasion he may have procured Hooke's *Micrographia*.

8 The Hague KA 48 fol. 7. The full letter runs: 'Our honest citizen, Mr. Leewenhoek (or, Leawenhook, according to your orthographie) hauing desired me to peruse what he hath set downe of his obseruations about the sting of a Bee at the requisition of Mr. Oldenburg, and by orders as I suppose of your nobel Royal Society, I could not forbear by this ‹occasion› to give you this character of the man, that he is a person unlearned both in sciences and languages, and specially a most αγεωμε τρκτος [τριττος?] philosopher, but of his own nature exceeding curious and industrious, as you shall perceive not onely by what he giveth you about the Bee, but also by his cleer observations about the wonderfull ‹transparent› *tubuli* appearing in all kind of wood, though most evidently and Crystal-like in the ordinary white and light wood used for Boxes. His way for this is to make a very small incision in the ‹edge of a box› and then tearing of it a little slice ‹or film as I think you call it› the thinner the better; and setting it upon the needle of his little microscope ‹(a machinula of his owne contriving and workmanship) of (?) brass› he is able to distinguish those *Tubuli* so perfectly, that by these meanes he lighted upon the consideration of those *valvete* you see him reasoning upon, and which in deed do discover themselfe in a perpetual ‹and very pleasant› scene. so that, for my part ‹looking upon this fine fagot of criystal-pipes, which in this particular is a fitter way then that of objects laying under a standing microscope,› I am easily persuaded of what he discourseth further touching the easy rising of the sap by those ‹short› degrees to the highth of a tree. Which otherwise ‹could hardly› be forced up but by a scarce imaginable power. I

make no question, Sir but that since the ‹first› publishing of your excellent physiological Micrographie, you haue stored up a great many of new observations, and that this also may be one of them, but ‹howsoever›, I trust you will not be unpleased with the confirmation of so diligent a searcher as this man is, though allways modestly submitting his experiences and conceits about them to the ‹censure of and correction of the› learned. amongst whome he hath reason enough to esteem your self beyond all. in this kind of philosophic. and many other besides. so that now he doth expect your instruction upon the difficultie he doth find in his glas pipes, where out I am sure you are to extricate him by very good and ready solutions. If you will haue the goodnes to let us see what important obseruations you may haue gathered since the sayd edition of your Book, as allso in any other curiosities, as I know your noble ‹witt and› industrie can neuer [obiect?], I will take it for a special fauour. My french sons new oscillatorium I beleeue by this time hath to be the grandfather of that childs child, I doe long to heare the Royal Societys good opinion of it and specialy ‹the judgment› of Your most ‹learned and› worthie President the Lord Brouncker and the Illustrious Mr. Boyles whose wonderfull capacity and uniuersal knowledge in omni scienti I doe still admire and little less then adore. Pray let them both find here the assurance of my most humble and deuoted affection to their seruice. I hope our sad and unChristian distractions will not make them ‹nor your self› loath to heare from, Sir Your humble and affectionate servant &c.'

9  See C. D. Andriesse, *Titan kan niet slapen: een biografie van Christiaan Huygens* (Amsterdam: Contact, 1993), French trans. D. Losman, *Christian Huygens*, (Paris: Albin Michel, 1998), p. 284: 'Horologium oscillatorium fut imprimé par François Muguet, après

que Colbert eu donné son accord au début du mois d'août 1672 ... mais il fallut attendre le 1er avril 1673 pour qu'il paraisse ... Il envoya en outre un paquet de livres à Oldenburg avec la demande de les faire parvenir en Angleterre à Ball, Boyle, Brereton, Gregory, Hooke, lord Kincardin, Moray, Neal, Newton, Wallis et Wren.'

10  See Christiaan Huygens to Oldenburg, 11 May 1673 (original letter in French): 'It is now already some time ago that I sent you a dozen copies of my book on the clock [*Horologium oscillatorium*]. Mr. Vernon was so kind as to address the package to you and to charge with it one of his friends who was leaving for England. But as travellers don't go as quickly as the post does, I was in no hurry to advise you of it, and to request you kindly to take care of the distribution of all the books following the inscriptions which I have put in them. If you have perhaps already taken this trouble I send you my very humble gratitude for it. I should be very pleased to learn what is said about it by all those learned geometers, who are more numerous in that country than in any other in Europe' (Hall and Hall, *Correspondence of Henry Oldenburg* 9, 673). The copies were personally inscribed to Oldenburg, Ball, Boyle, Brereton, Gregory, Hooke, Alexander Bruce (Lord Kincardine), Moray, Neile, Newton, Wallis and Wren (Andriesse, *Christian Huygens*, p. 284).

11  In fact, Huygens senior was anxious to broker some kind of an English 'consultancy' arrangement for his son Christiaan, concerning his clocks, since Christiaan's salaried position in Paris was increasingly precarious, as Franco-Dutch hostilities intensified, as did anti-Protestant feeling.

12  See Jardine, *Ingenious Pursuits*, chapter 2.

13  See below, chapter 7.

14  See above, chapter 4.

15  cit. Inwood, *The Man Who Knew Too Much*, p. 76.

16  In the same year Hooke published

*Micrographia*, Oldenburg began
publishing a monthly account of the
Society's proceedings in his
*Philosophical Transactions*.

17 Starting in the mid-eighteenth century,
the engraved plates of *Micrographia*
were reprinted a number of times with
a truncated accompanying text,
ostensibly so that even those who did
not read English could enjoy the
pictures. It is possible that the two
most ostentatiously presented images,
those of the flea and louse, each of
which folds out to over double the
size of the folio pages of the book,
were based on drawings by Wren. See
Jardine, *On a Grander Scale*,
pp. 276–8.

18 Latham and Matthews, *Diary of
Samuel Pepys*.

19 See F. Harris, *Transformations of Love:
The Friendship of John Evelyn and
Margaret Godolphin* (Oxford: Oxford
University Press, 2003), p. 56.

20 This account is based on Shapin and
Schaffer, *Leviathan and the Air-Pump*,
pp. 235–56. On Huygens's visit to
London see Jardine, *On a Grander
Scale*.

21 Christiaan Huygens to Lodewijk
Huygens, June 1661, Huygens, *Oeuvres
Complètes* 3, 276, cit. Shapin and
Schaffer, *Leviathan and the Air-Pump*,
p. 235.

22 Drawings in Huygens's notebooks
show that it probably was the case
that he now had a superior pump. On
the other hand, since he would not
pass these sketches and diagrams to
the Royal Society, for fear of
plagiarism by the Hooke–Boyle team,
his design could not be validated. The
experiment he designed to prove his
instrument's performance allowed of a
number of interpretations. See Shapin
and Schaffer, *Leviathan and the Air-
Pump*, pp. 235–56

23 See above, chapter 3.

24 Shapin and Schaffer, *Leviathan and the
Air-Pump*, p. 252.

25 Boyle to Oldenburg, 29 October 1663,
in Hunter et al., *Correspondence of
Robert Boyle* 2, 149–53.

26 Hunter et al., *Correspondence of Robert
Boyle* 2, 153.

27 De Beer, *Diary of John Evelyn* 3, 378.

28 De Beer, *Diary of John Evelyn* 3, 370.

29 The opening paragraph makes it clear
that this was a Cutlerian lecture,
written shortly after the arrival in
London of the twelve presentation
copies of Huygens's new work. There
is a pattern, however, in other
surviving lectures among the Royal
Society papers, of Hooke's writing the
lecture, and possibly delivering it, as a
Cutlerian lecture, and then 'reading' it
again to the Royal Society some four
to six months later. The surviving
manuscript of the lecture dealt with
here begins: 'Gentlemen [this para
struck through] I am very glad you
haue giuen me an opportunity of
Presenting the De-signe of Sr John
Cutler and of Reading his Lecture
<again> in this Place where it was first
begun. I think I need not tell you that
it was appointed in order to the
prosecution of the History of Nature
and of art a subject soe copious that
tis not to be expected from the single
indeauour of <any> one person how
able soeuer that there should be any
very notable progresse made therein,
much lesse from my weak abilityes.
But tis from <the> vnited indeauours
of the Royall Society <wth> whose
<noble> designe <this> is coincident
that great product is to be expected,
Into whose <Grand> treasury however I
shall not (god willing) be wanting to
cast in my mite.' It looks to me as if
Hooke first wrote the lecture when he
got the *Horologium oscillatorium*,
1673–4, then rewrote it (and
redelivered it?) when Huygens sent his
eureka! announcement about the
balance-spring watch in January –
February 1675.

30 Sloane MS 1039 fol. 129r (Hooke's
hand).

31 Work is needed on Huygens's difficult
position in Paris (where he was an
enemy alien during successive Franco-
Dutch wars), and the pressure he was
under to produce impressive scientific

discoveries to justify his generous salary at the Académie. The temptation to recycle English experimental research as his own, with only minor modifications, must have been intense.

32 Hooke is here referring to experiments conducted in the very earliest days of the Royal Society. The minutes of the meeting of 5 December 1660, following Moray's first notification of the King that a 'company' of virtuosi was being mooted, reads that Moray 'brought in word from ye Court that The King had been acquainted with the designe of this Meeting. And he did well approve of it, & would be ready to give his encouragement to it. It was ordered that Mr. Wren be desired to prepare against the next meeting for the pendulum experiment' (cit. Jardine, *On a Grander Scale*, p. 176).

33 BL Sloane MS 1039 fol. 129v.

34 The most telling criticism Hooke levels against Huygens is that his 'geometrical' modifications of the pendulum to get isochronous swing, while offering a theoretical solution, are far from simple to apply to a physical pendulum clock: 'But before I come to these particulars which are indeed noe waye pleasant to me were ther[e] not a necessity & duty incumbent on me to Doe it Give me leave a little to animadvert upon those two Inventions which for ought I know may justly be his own. that is the way of applying a pendulum to a clock and the equation of the motion of a pendulum by a cycloeid. For the first I say the Invention is very simple & plaine and therefore soe much the more to be preferred, but yet if thereby the pendulum becomes affected with every inequality that the clock work <which it really doth> is subject to and the inequality be not removed by the equation of the cycloeid as certainly & experimentally it is not then be the geometricall subtilty and and demonstration thereof never soe excellent yet it is in it self but a tame invention, and he

hath come short by a point if he hath made it dulce & not utile' (BL Sloane MS 1039 fol. 129v).

35 A post he retained thereafter, becoming resident London secretary to William when William and Mary assumed the English throne in 1688.

36 At that same moment, moreover, France's aggression towards the Low Countries meant that Christiaan Huygens's position in royal employment in Paris was becoming increasingly awkward.

37 Because of his web of international correspondents, Oldenburg was acutely conscious of the growing importance of the circle of William of Orange. See, for example, Justel to Oldenburg, 17 February 1674/5: 'On ne parle ici que de la souveraineté de Monsieur le Prince d'Orange' (Hall and Hall, *Correspondence of Henry Oldenburg* 11, 195). At the end of the third Anglo-Dutch war the House of Orange were made hereditary Stadholders, effectively creating them a royal dynasty.

38 'Il n'y a rien de si aysé, nous accusons M. Hook de paresse: mais une autre apprehension qui est venue, de ce qu'il pourra avoir eu la peine à entendre le mauvais Anglois, dont j'ay hazardé de l'entretenir, ne sachant pas si la langue françoise luy est assez familiere. si telle chose y a, je pourray reparer cela en Latin quand il luy plaira plus tost [587r] que de souffrir, qu'aucune sorte de mauvais langage me prive de sa correspondence.' The Hague KA 49–3 fol. 585, 'A la Haye ce 2/12 february 1674.'

39 Hooke, *Diary*, p. 93. The short holding letter in the Hague archives might be an enclosure to this letter, directed to Leeuwenhoek. KA 48 fol. 8: 'To your revered neighbour over the water, my most humble service. I am sure he would have the goodnes to so replie if he could imagine, how highly I doe esteem his exemplarie vertues, and what a joy it were to me, if I might have the happinesse of his conversation for one couple of howres

the world running as it doth.
22.dec. 73.'

40 Hooke, *Diary*, pp. 93–4.

41 The Epistle Dedicatory to Hooke's *An Attempt to prove the Motion of the Earth from Observations made by Robert Hooke Fellow of the Royal Society* (London: John Martyn, 1674) is dated 25 March 1674. Hooke's books often circulated some time before the official publication date on the title-page. See Keynes, *Bibliography of Dr. Robert Hooke*, p. 30.

42 'Pendulum', here as elsewhere in the dispute, is used as the generic term for a device whose isochronous properties enables it to be used as a timekeeper. The spring is 'circular', because the force of restitution governing the watch's movement is exerted in a circle, in a horizontal plane.

43 Perhaps Hooke had not been able to resist repeating his comments in the letter to Sir Constantijn. By January 1675 the remarks had been printed in Hooke's *Helioscopes*, and were circulating publicly – Oldenburg apologises to Christiaan for 'what Mr Hooke has said in his book concerning the circular pendulum' in January–February 1675. See Hall and Hall, *Correspondence of Henry Oldenburg* 11, 177.

44 Hall and Hall, *Correspondence of Henry Oldenburg* 11, 235–6.

45 'Vous voyez, Monsieur, que je suis ici reduit à preuver et justifier ma loyauté, à l'instance, et pour l'interet d'un enfant que j'ai un peu sujet de cherir. Je vous supplie de me sortir de ce pas, et, en suite, de sçavoir un peu à quel decision M. hook en use ainsi envers un Pere et fils qui desirent si fort de conserver le lien de son amitié, et honorent tant son beau sçavoir. Il importe d'agir candidement partout.' Huygens senior to Oldenburg, 19/ 29 March 1674/5, Hall and Hall, *Correspondence of Henry Oldenburg* 11, 233. Manuscript draft, The Hague KA 49–3 fol. 658.

46 In fact, the French patent claim was problematic, and Huygens was in dispute with his watch-maker, who was claiming to have made vital modifications to the design, and therefore to have a right himself to the patent.

47 'Mon fils me mande aussi qu'il s'etonne de n'avoir receu aucune de vos nouuelles, sur ce qu'il vous avoit ecrit de sa nouuelle Invention de Pendule de poche comme les françois la baptisent.'

48 See Hall and Hall, *Correspondence of Henry Oldenburg* 11, 162–3: 'A propos de Pendules, je vous diray devant que finir que j'ay trouvè depuis peu une nouvelle invention d'horologes, à la quelle je fais travailler presentement et avec apparence d'un bon succes. J'en mets icy le secret, en Anagramme, comme vous sçavez que j'ay fair autrefois en cas de nouvelles decouvertes, et par la mesme raison. [*Axis circuli mobilis affixus in centro volutae ferreae* – the axis of the moving circle is fixed in the centre of an iron spiral].'

49 Hall and Hall, *Correspondence of Henry Oldenburg* 11, 186 (translation from the French taken from the version published by Oldenburg in the *Philosophical Transactions* of the Royal Society in November 1676).

50 Oldenburg was by this time a 'denizen', or naturalised Englishman.

51 On 17 February [= 27 February; London dating ran ten days behind Paris]. Hooke, *Diary*, p. 147.

52 Hooke, *Diary*, p. 148.

53 This controversy has been fully documented. See J. H. Leopold, 'The longitude timekeepers of Christiaan Huygens', in Andrewes, *Quest for Longitude*, pp. 103–6; Wright, 'Robert Hooke's longitude timekeeper', pp. 63–118; R. Iliffe, '"In the warehouse": privacy, property and priority in the early Royal Society', *History of Science* 30 (1992), 29–68; and 'Espinasse, *Robert Hooke*, p. 64.

54 Moray had died in 1673, so accusations of leaks of sensitive information by him were largely pointless.

55 See, for example, the exchange of

letters between Newton and Hooke, brokered by Oldenburg in 1672, concerning Hooke's theory of colour as discussed in *Micrographia*, and Newton's response to it. Westfall, *Never at Rest*.

56 Hunter, 'Promoting the new science: Henry Oldenburg and the early Royal Society', in Hunter, *Establishing the New Science*, pp. 245–60; 250.

57 Oldenburg to Huygens, 7 June 1675, Hall and Hall, *Correspondence of Henry Oldenburg* 11, 334.

58 Hall and Hall, *Correspondence of Henry Oldenburg* 11, 334: 'Quant à M. Hook, c'est un homme d'une humeur extraordinaire ... Ce que je conseille pour nulle autre fin, si non que je desire de tout mon coeur que chacun recoive ce qui luy est dû, et que les jalousies des beaux Esprits n'interrompent point leur amitié, et le commerce qui est si utile a l'accroissement des arts et des sciences.' Translation LJ.

59 Hall and Hall, *Correspondence of Henry Oldenburg* 11, 359: 'C'est un homme, qui est d'une humeur toute particuliere, laquelle il faut souffrir avec tant plus de patience, parce qu'il a une grande fecondité d'esprit pour inventer des choses nouvelles. *Nullum magnum ingenium sine* [*mixtura dementiae fuit*].' Translation LJ.

60 'Charles: Whereas we have been informed by the humble Petition of our Trusty and Wellbeloved Henry Oldenburg Esqr Secretary to the Royall Society that the Sieur Christian Hugens hath newly invented a certain Sort of Watches usefull to find the Longitudes both at Sea and Land, and hath transferred his interest therein upon him the said Henry Oldenburg for these Our Dominions; And having therefore humbly besought Us to grant him the Sole Right of making and disposing of such Watches within our Dominions. We being willing to give all encouragement to inventions which may be of publick use and benefit; Our will & pleasure is that you prepare a Bill for our Royall Signature

to passe Our Great Seale containing Our Grant and Licence unto the said Henry Oldenburg and his Assignes of the soul use and benefit of his said Invention for the terme of fourteen yeares' (Hall and Hall, *Correspondence of Henry Oldenburg* 9, 225–6).

61 Hooke, *Diary*, 157.

62 cit. Iliffe, '"In the warehouse"', 46.

63 Hooke, *Diary*, 166.

64 See Jardine, *Ingenious Pursuits*, chapter 4.

65 Compare Frances Harris's remarks on the difficulties John Evelyn's son John had in advancing his career, because of his crooked leg. Harris, *Transformations of Love*, pp. 69–70.

66 See above, chapters 3 and 4. On Hooke's innovative instrument designs see especially Bennett's works cited in the Bibliography.

67 'Espinasse, *Robert Hooke*, p. 68. Waller quotes from a letter from Moray to Oldenburg, 'dated Oxon. Sept, 30. 1665', in which there is clearly betrayal of trust on both men's part in the course of Hooke's and Huygens's discussions with them about their early watches. See Waller, 'Life of Dr. Robert Hooke', p. vi: 'You (meaning *Oldenburgh*) will be the first that knows when his (that is *Huygens*'s) Watches will be ready, and I will therefore expect from you an account of them, and if he imparts to you what he does, let me know it; to that purpose you may ask him if he doth not *apply a Spring to the Arbor of the Ballance*, and that will give him occasion to say somewhat to you; if it be that, you may tell him what *Hooke has done in the matter, and what he intends more*.'

68 'Pour ce qui est de la pensée de Monsieur Hooke, dont il vous a pleu me faire part, d'appliquer dans les horologes un ressort au lieu de pendule, je vous diray qu'estant en 1660 a Paris Monsieur le Duc de Roanais me parla de la mesme chose et mesme me mena chez l'horologer [Thuret] a qui luy et Monsieur Pascal avoient communiquè cette invention,

mais soubs serment et promesse devant Notaire de ne le point reveler ni se l'attribuer' (Huygens to Moray, 18 September 1665, Huygens, *Oeuvres complètes* 5, 486).

69 'Jl y a bien 3. ans que Monsieur Hook m'a parlé dune invention qu'il avoit pour mesurer le temps en mer mieux que peuvent faire les pendules mesme aussi bien qu'ils le font a Terre. Mais ayant pour lors esté persuadé quil en pourroit tirer beaucoup de profit il a esté si sage que de ne reveler point en quoi son invention consistoit ... Je vous dise que lors que Monsieur Hook nous decouvrit son invention il nous a dit qu'il y avoit plus de 20. facons differentes pour se seruir des ressorts aux Horologes, au lieu de balancier ou de pendule. Jl nous en a parlé de 3 ou 4' (Moray to Huygens, 10 October 1665, Huygens, *Oeuvres complètes* 5, 504).

70 See above, chapter 3.

71 W. E. K. Middleton (ed.), *Lorenzo Magalotti at the Court of Charles II: His 'Relazione d'Inghilterra' of 1668* (Waterloo, Ontario: Wilfrid Laurier University Press, 1980), cit. 'Espinasse, *Robert Hooke*, p. 67.

72 Oldenburg does not mention the watch in his correspondence with Boyle for this period either. This might mean that Magalotti and his colleagues saw the watch outside the regular Royal Society meeting (possibly without Oldenburg present). It might mean that Oldenburg found these kinds of instrument difficult to report on – like any non-expert, the intricacies of clock movements were beyond him.

73 Any patent monies, it will be recalled, were to be split between Oldenburg and the Royal Society.

74 See Hooke, *Helioscopes* (1676), cit. Waller, 'Life of Dr. Robert Hooke', p. v: 'This Treaty with me had been finally concluded for several Thousand Pounds, had not the inserting of one Clause broke it off, which was, *That if after I had discover'd my Invention about the finding the Longitude by*

*Watches (tho' in themselves sufficient) they, or any other Person should find a way of improving my Principles, he or they should have the benefit thereof during the term of the Patent, and they should have the benefit thereof during the term of the Patent, and not I.* to which Clause I could no way agree, knowing 'twas easy to vary my Principles an hundred ways; and 'twas not improbable, but there might be some addition of conveniency to what I should at first discover, it being *facile inventis addere*.' Hooke's secret discussions of a possible patent at this date were conducted with Brouncker, Boyle and Moray – another indication that Moray might have conveyed sensitive information to Huygens at the time.

75 'Lorsqu'il [Huygens] publie le 15 février 1675 dans le *Journal des sçavans* un article sur les vibrations isochrones du ressort spiral, il suscite des réactions hostiles. Pour commencer, il y a Jean de Hautefeuille d'Orléans. En 1674, cet abbé avait recherché l'appui de l'Académie pour son idée d'une horloge équipée d'une tige vibrante, une sorte de dispason. Christian a dû voir le projet et – vraisemblablement – donné le coup de grâce pour qu'il soit rejeté. Hautefeuille n'a pas tout à fait tort de voir dans son idée le précurseurdu ressort spiral, et il fait noter par son avocat: *Difficile est invenire, facile autem inventis addere* (Inventer est difficile, broder sur une invention est facile). Il décide de contester le privilège de Christian et va jusqu'à entamer un procès le 16 mai 1675. "Je n'arrête pas d'avoir des problèmes, mais je peux facilement réfuter de telle prétensions stupides. L'essentiel est de faire fonctionner la chose, c'est la seule chose qui m'ait jamais importé." Hautefeuille perd son procès en juillet' (Andriesse, *Christian Huygens*, p. 298).

76 Hooke to Aubrey, 24 August 1675, BL Egerton MS 2231 fols 200–1.

77 Oldenburg to Huygens, 15 October 1675, Hall and Hall, *Correspondence of*

*Henry Oldenburg* 12, 17. Hooke's 'Postscript' in his *A Description of Helioscopes, and some other Instruments* (London: John Martyn, Printer to the Royal Society, 1676), begins: 'I should have here taken leave of my Reader for this time, but that finding in the Transactions a passage inserted out of the French *Journal de Scavans*, about the invention of applying a Spring to the Ballance of a Watch, for the regulating the motion thereof, without at all taking notice that this Invention was first found out by an Englishman, and long since published to the World: I must beg the Readers patience, whilst I, in vindication of my own right against some unhandsom proceedings, do acquaint him with the state of this matter' (Gunther, *Early Science in Oxford* 8, 142–51). See 'Espinasse, *Robert Hooke*, pp. 63–4.

78 'Jay este fort surpris de ce que vous m'avez fair scavoir de l'insolite accusation que M. hooke a controuvée contre vous et moy. Javois bien remarquè depuis quelque temps qu'il estoit vain et extravagant, mais je ne scavois pas qu'il estoit malicieux et impudent au point que je le vois maintenant' (LJ translation; Huygens to Oldenburg, 22 October 1675, Hall and Hall, *Correspondence of Henry Oldenburg*, 12, 19–20).

79 'Je prens la liberté de vous escrire ces lignes, y estant obligé par l'interest, que je prens en l'honneur de M. Oldenburg et au mien propre, puisque j'apprens que l'un et l'autre est attaqué par les calomnies de M. Hook, au sujet des nouvelles montres, dont il pretend estre l'inventeur, et dit avec beaucoup d'effronterie, que M. Oldenb. m'ayant descouvert son secret, c'est en recompense de cela, et de ce qu'il me sert d'espion dan la Soc. Royale, que je luy ay cedé mon droit de demander privilege pour cete invention en Angleterre' (LJ translation; Huygens to Brouncker, 21 October 1675, Hall and Hall, *Correspondence of Henry Oldenburg* 12, 21–2).

80 'Espinasse, *Robert Hooke*, p. 65.

81 This was also exactly the period of the beginning of the controversy with Hevelius over eyepiece micrometers. See below, chapter 7.

82 Sir John Hoskins joined later meetings. On 24 June, Boyle 'desird to be of clubb. Wren promised to come. Met at Childs [coffee house].' By 2 July the club had become a 'new Decimall Society' – comprising 'Boyle, More, Wren, Hoskins, Croon, King, D[aniel]. Cox, Grew, Smethwick, Wild, Haak', and presumably Hooke, 'for chemistry, anatomy, Astronomy and opticks, mathematics and mechanicks'. On 4 July Hooke was at Ranelagh House: 'To Mr. Boyles much discourse with him about new clubb, Sir W. Petty there.' On 13 July, Hooke 'Dined with Sir Chr. Wren. At Mr. Boyles ... Sir J. Hoskins. Hill. Grew. Contrived new club at Garaways [coffee house].'

83 Lady Ranelagh to Boyle, 11 September [1677], Hunter et al., *Correspondence of Robert Boyle* 4, 454–5.

84 'To Sir Joseph Williamson. Met there Sir Christopher Wren, Dr. Holder, Mr. Henshaw, Dr. Whistler, Dr. Pett, Dr King, Mr. Evelin. Dr. Whistler, Mr. Evelyn and I spake to him, Mr. Aubery, Mr Smith, and Sir Joseph himself. We were nobly treated and bid about accepting the presidentship, very kindly welcome, all unanimous for chusing him president' (Hooke, *Diary*, p. 328).

85 See M. Hunter, 'Reconstructing Restoration science: problems and pitfalls in institutional history', in Hunter, *Establishing the New Science*, pp. 339–55; 351. For the atlas project see E. G. R. Taylor, ' "The English Atlas" of Moses Pitt, 1680–83', *Geographical Journal*, 95 (1940). The project was a financial disaster, and Pitt was imprisoned for debt. When he was released, Hooke was obliged to go to law to prevent himself from being involved in the financial repercussions of the collapse of the enterprise. A number of documents

relating to the 'English Atlas' survive in the British Library.

86 Hooke to Yonge, 9 January 1685, cit. Hunter, 'Reconstructing Restoration science', p. 351.

87 Hunter, 'Reconstructing Restoration science', p. 351.

88 The one job, it could be argued, for which Hooke was ideally suited was the removal of the Arundel House Library to Gresham College in 1678. The books had been given to the Royal Society in 1667, but remained at Arundel House after the Society returned to Gresham College. The final transfer of the books was necessitated by the Duke of Norfolk's decision to demolish the house. A considerable bibliophile himself, with a handsome personal library, Hooke oversaw the transfer of the Arundel donation to Gresham College to the Royal Society punctiliously. He had, however, shortly before been in trouble with Brouncker for borrowing books without permission. See Jardine, *Ingenious Pursuits*, pp. 343–8. Hooke's own copy of the printed catalogue, published in 1681, with his own copious additions and further classifications of the library holdings is in the British Library (824 f 52).

CHAPTER 6: *Never at Rest*

1 *Philosophical Transactions* 11 no. 129, p. 749.

2 See the postscripts to *Lampas* and *Of Spring*, reprinted in Gunther, *Early Science in Oxford* 8. Records of the two men's conceptual innovations make it clear that both had made crucial breakthroughs in understanding the principles of precise time regulation using some kind of spring-mechanism. The problem for the historian is that neither man succeeded in making a prototype which convinced men of science that the problem was cracked, or men of business that it was an invention worth investing substantial sums in. It

may be that the limitations in manufacture of precision parts made it impossible for either man to follow through. Tompion clearly came closest, hence Moore's backing for the Hooke–Tompion project. Both Hooke and Huygens themselves experimented with the manufacture of precision parts for clocks and telescopes, including instruments for making lenses and metal parts.

3 Huygens had already had some sort of nervous collapse in 1670. See Andriesse, *Christian Huygens*, p. 269, Francis Vernon to Oldenburg, 22 February 1670. Although in 1676 Christiaan recovered sufficiently to return to Paris, he eventually retired to his family home at The Hague, and spent the rest of his life as a private scholar at the summer house at Hofwijk which his father had built in the 1640s. See Andriesse, *Christian Huygens*, and T. van Strien and K. van der Leer, *Hofwijk: Het Gedicht en de Buitenplaats van Caonstantijn Huygens* (Zutphen: Walburg Pers, 2002).

4 cit. Andriesse, *Christian Huygens*, p. 302.

5 Andriesse, *Christian Huygens*, p. 268.

6 Hooke, *Diary*, 30 May 1681, cit. Inwood, *The Man Who Knew Too Much*, p. 253. The later diary contains a number of entries: 'melan. M[iserere] m[ei] D[eus]' ('God have pity on me'); 'Extream melanch.', 'Melanch'. 'Espinasse, *Robert Hooke*, p. 140: Diary 15 December 1688; 21 January and 1 March 1689/90; 22 February 1692/3; 4 January 1688/9.

7 Compare Beale's assessment of external symptoms of melancholy and how they might be treated by self-dosing, in a letter to Boyle of 2 November 1663: 'About the beginn[in]g of thiese Civile wars I was over-whealmd in Melancholy & griefe to see the publique Confusions & ruines (my neerest alliances & dearest friends being engaged & many loste on both sides). This broke out into the blind piles, stoppage of my stomac

hypochondriacall torments, Jaundices, but nothing did more molest mee, than a Teter, which did seise on the back of my hand, sometimes both hands, sometimes both handwrists allso far upon my armes, & seeming to have devourd the Epidermis. I submitted punctually to the advise of many intimate & friendly Doctors for inward & outward applications'. (Hunter et al., *Correspondence of Robert Boyle* 2, 155).

8 Hunter et al., *Correspondence of Robert Boyle* 2, 159.

9 'Brick and unslakt lime and loij [?], pound them all severally, and grossly in an Iron Morter mix them not, till you are just ready to put them into the retort because of a sutbl fetid urinous steame which will xhale from the Misture, Lute on a Glasse Body as a receiver, close the Joynt round the Neck well with Past & wet double Browne Paper, increase the fire Gradually at the first, as is requisite in all Distillations, but this preparation requires a very strong fire ... to draw it off. The next morning when you take it up, sometimes you will find the flowers sublim'd into the neck of the retort of a yellowish colour; which to preserve must be kept in some warmth' (cit. L. Hunter, 'Sisters of the Royal Society: the circle of Katherine Jones, Lady Ranelagh', in Hunter and Hutton, *Women, Science and Medicine 1500–1700*, pp. 178–97; 192).

10 A standard modern source on the medical qualities of ingested sal ammoniac confirms these therapeutic qualities: 'It possesses only slight influence over the heart and respiration, but it has a specific effect on mucous membranes as the elimination of the drug takes place largely through the lungs, where it aids in loosening bronchial secretions. This action renders it of the utmost value in bronchitis and pneumonia with associated bronchitis. The drug may be given in a mixture with glycerine or liquorice to cover the disagreeable taste or it may be used in a spray by means of an atomizer. The inhalation of the fumes of nascent ammonium chloride by filling the room with the gas has been recommended in foetid bronchitis. Though ammonium chloride has certain irritant properties which may disorder the stomach, yet if its mucous membrane be depressed and atonic the drug may improve its condition, and it has been used with success in gastric and intestinal catarrhs of a subacute type and is given in doses of 10 grains half an hour' before meals in painful dyspepsia due to hyperacidity. It is also an intestinal and hepatic stimulant and a feeble diuretic and diaphoretic, and has been considered a specific in some forms of neuralgia' (http://23.1911encyclopedia.org/S/SA/ SAL_AMMONIAC.htm).

11 Gunther argues that there is a third diary fragment, covering the period October 1681 to September 1683, in the BL, MS Sloane 1039. These are not, however, in Hooke's characteristic diary format, and seem rather to be jottings and lists, mostly associated with his collection of books.

12 BL MS Sloane 4024. This diary is partially transcribed in Gunther, *Early Science in Oxford* 10, 69–265.

13 For the full range of Hooke's professional commitments see Cooper, 'Hooke's career'.

14 For another recent discussion of the medical entries in Hooke's diary see L. Mulligan, 'Self-scrutiny and the study of nature: Robert Hooke's diary as natural history', *Journal of British Studies* 35 (1996), 311–42. Mulligan too argues that Hooke's medical diary entries are 'an integral part of his scientific vision', and that they should be read as recording 'a self that was as subject to scientific scrutiny as the rest of nature', aimed at producing a natural history 'with himself as the datum'. However, she sees the medical diary entries as designed to provide correctives for Hooke's observations and experiments elsewhere, rather than as experiments in themselves.

15 11 August 1672: 'Steel drink from Dr. Goddard.' Hooke, *Diary*, p. 4.

16 Grace, daughter of Robert Hooke's brother John, was being raised and schooled in London pending a proposed betrothal to Sir Thomas Bloodworth's son. See below.

17 Hooke, *Diary*, p. 4.

18 Although the most systematic recording of medical dosing and its outcomes is to be found in the earlier diary fragment, such entries also occur in the post-1688 diary, for example: 'Tue. 6 [November 1688]. Ticket for Com. Sewers Wensday 9. Very ill all day with a colick and stopage: slept ill. Water high colourd; fasted all day. W. 7. Very sore by the collick. Martha made chocolat. Royal Society met: Herbert, Hill, Waller, Pitfield, Lod. Visited Tison [Hooke's physician] severall times. Dutch sayd to be landed at Tor Bay. Malpighius letter read. Pitfield restored 2 vol. of Plutarck and Hollands Pliny in English. I deliverd to Mr Hunt Waller his Algebra & 4 bookes of Mengoli, which he crost out of his book, HH severall times: here also Dr Tison. Beer & bread 17d. Th. 8. HH tea. Not yet well of Colick. Noe auditors in the morn. J. Mayor here. HH Dined with me. 3 in the afternoon, which HH answerd. Gof & Lod here: noe further news. Dr Tyson' (Gunther, *Early Science in Oxford* 10, 71).

19 For another article on Hooke's diary which focuses on his physic-taking see L. McCray Beier, 'Experience and experiment: Robert Hooke, illness and medicine', in Hunter and Schaffer, *Hooke: New Studies*, pp. 235–52.

20 McCray Beier, who compares Hooke's medicinal intake with that recorded in other contemporary diaries, describes Hooke as being of a particularly sickly disposition. It is hard to see how such a person could have kept up the gruelling agenda of work described above. On the other hand, Hooke's treatment of specified or unspecified 'symptoms' with medicinal intake was remarkable: 'For only eighteen months

out of a total of 100 for the period between August, 1672 and December, 1680, he reported no symptoms at all. For 64 months, he mentioned illness or remedies on between one and eight occasions. And for 18 months, he mentioned these matters between nine and 19 times' (McCray Beier, 'Experience and experiment', p. 240).

21 See McCray Beier, 'Experience and experiment', p. 241: 'Despite what he and those around him perceived as his chronic ill-health, he suffered no serious illnesses at all in the period during which he kept his diary. His illnesses were annoying, but neither frightening nor life-threatening.'

22 'August [1672]. (1) Drank [iron] and [mercury]. At Wapping with governors. Took beet, slept not well. Paid Coffin £2 3s. 4d. for shutts etc. (2) Drank [iron] and [mercury]. Dind at Swan, old fish. Capt. Clark. Committee at my chamber. (3) Drank [iron] and [mercury]. Dind at home. Scotland yard. Cox turning object glasses with flints. Mr. Gale. (4) Drank [iron] and [mercury]. DH. Eat coadling. was ill' (Hooke, *Diary*, p. 4).

23 From Goddard's correspondence with Robert Boyle it appears that Boyle, in his turn, supplied Goddard. For Hooke's regular taking of laudanum for insomnia see e.g. Hooke, *Diary*, pp. 8–9: 'October [1672]. (1) At Bow with Kayus Sibber. I took spirit of urine and laudanum with milk for the three preceeding nights. Slept pretty well.' '[6 October 1672] Slept very ill with great noyse in my head. (7) Drank Dulwich water. Chess with Mr. Haux. Garways. Bed. Dr. Bradford here with R. Waters and he promised to procure him his 150 within 3 weeks on condition he put the barrs into the windows before the Sunday following. Subpoenad by Cotton for the Skinners. Bought china. Received 1 pair of shoes and goloshoes from Herne for which and 1 pair of shoes I owe him 11s. 6d. Mr Shortgrave returned. (8) Drank Dulwich water

which worked not well. [orgasm] Nell
... at door. Dr. Wren here, Mr.
Fuller, Mr. Fitz. At home all the
afternoon. Mr. Hauxes at night. took
Dr. Goddard syrupe of Poppy, slept
not.'

24 Hooke, *Diary*, p. 11.

25 Hooke, *Diary*, p. 8: 'At Dr. Tillotsons
with Dr. Whistler. He said many had
died of Fluxes and some of the
Spotted feaver upon drinking Dulwich
water. Mrs. Tillotson recovered of
sowerness in her stomack upon taking
Spirit of Sal armoniack. I found a
great purging from my head after
drinking Chester stale beer, and a very
good stomack.'

26 Hooke, *Diary*, p. 106.

27 Nehemiah Grew also went into a
decline following the death of his old
mentor and protector. See the letter
from Grew to Oldenburg, written a
month after Wilkins's death, in which
he explains that his commitment to
the Royal Society had depended
directly on Wilkins, and he now
needed to reconsider his position. M.
Hunter, 'Early problems of
professionalizing scientific research:
Nehemiah Grew (1641–1712) and the
Royal Society, with an unpublished
letter to Henry Oldenburg', in Hunter,
*Establishing the New Science*,
pp. 261–78; 266–8.

28 Mr Whitchurch was one of the
apothecaries who supplied Hooke with
his pharmaceutical materials.

29 Wilkins's funeral took place on
12 December: '(12) Slept well in my
gown. Sawd wood, took down joyst.
Kept in, rangd and catalogued Library.
Lord Chester buried. (14) I drank a
little milk going to bed this and the
preceding night and slept ill after it,
was feaverish and guiddy next day, but
eat dinner with good stomack. Dean
Tillotson brought me a mourning ring
for Lord Chester' (Hooke, *Diary*,
p. 16).

30 'Slept pretty well, a breathing sweat.
tobacco in nostril inclined to sleep'
(Hooke, *Diary*, p. 17).

31 Once again we should note a certain

tension between Hooke's own recourse
to favoured remedies, and the courses
of treatment prescribed by his
physicians. When Hooke's niece Grace
was ill with smallpox in July 1679, she
was attended by Mr Whitchurch and
Dr Mapletoft, who prescribed on the
26th. On the 27th Hooke administered
'Gascoyne's powder' to Grace (sent by
Grace's mother); when Whitchurch
next visited he was 'angry', presumably
at the taking of remedies other than
those he had prescribed (Hooke,
*Diary*, p. 419).

32 'Scarify: To scratch or cut the skin of;
esp. (Med.), to make small incisions
in, by means of a lancet or
scarificator, so as to draw blood from
the smaller vessels without opening a
large vein.'

33 Hooke, *Diary*, p. 18.

34 Hooke, *Diary*, pp. 23–4.

35 Like Boyle, Hooke was obviously a
considerable hypochondriac. On
15 April 1653 William Petty – who
sometimes acted as Boyle's physician
in Ireland – took Boyle to task for his
hypochondria: 'The next disease you
labour under, is, your apprehension of
many diseases, and a continual fear,
that you are always inclining or falling
into one or the other ... But I had
rather put you in mind, that this
distemper is incident to all that begin
the study of diseases. Now it is
possible that it hangs yet upon you,
according to the opinion you may
have of yourself rather then according
to the knowledge that others have of
your greater maturity in the faculty [of
medicine]. But *ad rem*, Few terrible
diseases have their pathognomonical
signes; Few know those signes without
repreated experiences of them, and
that in others, rather then themselves:
Moreover; The same inward causes
produce different outward signes, and
vice versa the same outward signes
may proceed from different inward
causes; and therefore those little rules
of prognostication found in our
books, need not always be so
religiously beleived. Again 1000

accidents may prevent a growing disease itselfe, and as many, can blow away any suspicious signe thereof, for the vicissitude whereunto all things are subject, suffers nothing to rest long in the same condition; and it being no farther from Dublin to Corke, then from Corke to Dublin, why may not a man as easily recover of a disease without much care, as fall into it. My Cousen Highmores curious hand hath shewn you so much of the fabrick of mans body, that you cannot think, but that so complicate a peece as yourself, will be always at some little fault or other. But you ought no more to take, every such little struggling of nature for a signe of a formidable disease, then to fear that every little cloud portends a cataract or hericane' (Hunter et al., *Correspondence of Robert Boyle* 1, 143–4).

36  Hooke, *Diary*, p. 13.
37  Hooke, *Diary*, pp. 13–14.
38  It was almost another two hundred years before the medical profession came to understand the significance of the structure of the crystalline deposits in gout, and developed a genuine cure (see R. Porter and G. S. Rousseau, *Gout: The Patrician Malady* (New Haven and London: Yale University Press, 1998), chapter 5).
39  Hooke, *Micrographia*, pp. 81–2.
40  Hooke, *Micrographia*, pp. 144–5.
41  J. G. Crowther, *Founders of British Science: John Wilkins, Robert Boyle, John Ray, Christopher Wren, Robert Hooke, Isaac Newton* (London: Cresset Press, 1960), p. 47.
42  Hooke, *Diary*, pp. 49 and 67.
43  Hooke, *Diary*, p. 99.
44  Hooke, *Diary*, p. 172. Entries of this kind can be matched from Anthony Bacon's, Francis Bacon's and Boyle's letters, and from Ward's, Pepys's and Aubrey's diaries.
45  Equivalent reports are to be found in the private jottings of other habitual users of chemical medicines, like Boyle and Sir Francis Bacon. See for example the following, from Bacon, *Commentarius solutus*: 'After a

maceration taken in the morning and working little I took a glister [enema] about 5 o'clock to draw it down better, which in the taking found my body full and being taken but temperate and kept half an hour wrought but slowly, neither did I find that lightness and cooling in my sides which many times I do, but soon after I found a symptom of melancholy such as long since with strangeness in beholding and darksomeness, offer to groan and sigh, whereupon finding a malign humour stirred I took three pills of aggregative corrected according to my last description, which wrought within two hours without griping or vomit and brought much of the humour sulphurous and fetid, then though my medicine was not fully settled I made a light supper without wine, and found myself light and at peace after it. I took a little of my trochises of sal amoniac after supper and I took broth immediately after my pill'. In the margin, Bacon observed, in explanation: 'Note, there had been extreme heats for ten days before and I had taken little or no physic' – external factors, too, may contribute to the peace of mind and equanimity he achieves at the end of his 'regimen'.

46  Hooke, *Diary*, p. 105.
47  Hooke, *Diary*, p. 85.
48  Hooke, *Micrographia*, Preface, sig. a1.
49  Among Hooke's posthumously published papers is one on the therapeutic use of bangue or marijuana, particularly for insomnia. See Derham, *Philosophical Experiments*, 1–3.
50  A number of the remedies used by Bacon, Hooke and others are still listed among modern alternative medical therapies as 'combating melancholy' when administered in small doses. Wormwood (absinthe) is just one of the remedies which elates when imbibed, but over time acts on the nervous system, producing tremors and delusions.
51  Hooke, *Diary*, p. 28. Sometimes the remedy's intoxicating properties – its

ability to give the patient a high –
were discovered accidentally. Hooke's
friend and colleague Edmond Halley
was so taken with the clearheadedness
and calming effect of an over-large
dose of opium he had inadvertently
ingested (because it had been
insufficiently mixed into a compound
he had taken) that he read a paper on
it to the Royal Society in January 1690,
describing how 'instead of sleep, which
he did design to procure by it, he lay
waking all night, not as if disquiet
with any thoughts but in a state of
indolence, and perfectly at ease, in
whatsoever posture he lay' (E. F.
MacPike (ed.), *Correspondence and
Papers of Edmond Halley* (London:
Taylor & Francis, 1937), p. 217).

52 cit. McCray Beier, 'Experience and
experiment', p. 244.

53 The account of the Hooke–Cutler
dispute which follows is based on the
definitive account given in M. Hunter,
'Science, technology and patronage', in
Hunter, *Establishing the New Science*,
pp. 279–338. For Hooke's desire to
involve 'men of Converse and Traffick'
in the Royal Society's activities, see
Hooke, *Micrographia*, sig. g1v: 'But
that that yet farther convinces me of
the *Real esteem* that the more *serious*
part of men have of this *Society*, is,
that several *Merchants*, men who act
in earnest (whose Object is *meum* and
*tuum*, that great *Rudder* of humane
affairs) have adventur'd considerable
sums of *Money*, to put in practice
what some of our Members have
contrived, and have continued *stedfast*
in their good opinions of such
Indeavours, when not one of a
hundred of the vulgar have believed
their undertakings feasable. And it is
also fit to be added, that they have
one advantage peculiar to themselves,
that very many of their number are
*men of Converse and Traffick*; which is
a good Omen, that their attempts will
bring Philosophy from *words* to *action*,
seeing the men of Business have had
so great a share in their first
foundation.'

54 S. Coote, *Royal Survivor: A Life of
Charles II* (London: Hodder &
Stoughton, 1999), p. 174.

55 Both Wren and Hooke were involved
in the surveying and repair proposals
for Old St Paul's, which may have
been one of the contexts in which
Cutler and Hooke met.

56 Birch, *History of the Royal Society* 1,
442, cit. Hunter, 'Science, technology
and patronage', p. 283.

57 Birch, *History of the Royal Society* 1,
453, cit. Hunter, 'Science, technology
and patronage', p. 285.

58 Hooke and Cutler had known each
other, apparently well, for some years.
See, for example, Hooke's diary entry
for 3 November 1672: 'Went with Mr.
Lamot to Sir J. Cutlers, there till night'
(Hooke, *Diary*, p. 12).

59 Hooke had been granted permission to
reside at Gresham College as the Royal
Society's Curator of Experiments. His
claim to long-term residence would
have been strengthened if he obtained
a Gresham chair, since the incumbents
of those posts were entitled to
residence for as long as they held to
post. Hooke lived at Gresham College
continuously from 1664 until his death
in 1703.

60 Captain Graunt was John Graunt,
whose *Natural and Political
Observations made upon the Bills of
Mortality* (1662) laid the foundations
of the science subsequently styled
Political Arithmetic by Sir William
Petty. Graunt and Petty were close
friends, and Petty has been credited
with some of the statistical insights in
Graunt's important book.

61 PRO C7/564/29, item 2, cit. Hunter,
'Science, technology and patronage',
p. 287.

62 See Hunter, 'Science, technology and
patronage': 'Clearly, however, there
was some lack of clarity from the
outset as to whether or not the
benefaction was a personal one. At
one point during the negotiations . . .
it was specifically stated that Cutler
had suggested the benefaction,
"intending a particular kindness to Mr

Hooke": but the Society, true to its ambition to try to establish an institutional infrastructure for the new science with a permanence beyond the life of any individual, seems to have wished to establish itself as the primary beneficiary' (p. 288).

63 Birch, *History of the Royal Society* 1, 453, cit. Hunter, 'Science, technology and patronage', p. 289.

64 Birch, *History of the Royal Society* 1, 473, cit. Hunter, 'Science, technology and patronage', p. 290.

65 See above, chapter 3.

66 Hooke to Boyle, 6 October 1664, cit. Hunter, 'Science, technology and patronage', p. 290.

67 Birch, *History of the Royal Society* 1, 479, cit. Hunter, 'Science, technology and patronage', p. 290.

68 Hunter, 'Science, technology and patronage', p. 296.

69 Hooke was delivering Pope's Gresham lectures in 1664. See Hooke to Boyle, 6 October 1664, Hunter et al., *Correspondence of Robert Boyle* 2, 344. In August 1680, 'the Gresham Joint Committee ordered all the lecturers to evict their [sub-]tenants, reoccupy their rooms and "personally read their lectures there at the usuall times appointed". In the meantime, all salaries were to be suspended, and committee members ... would check on whether lectures took place. Hooke appealed against the suspension of his salary on 26 October, and the committee, "finding that he only of all the lecturers hath bin constantly resident, & for ought that appears hath bin ready to read when any auditory appeared, and besides hath printed many of his lectures for the common benefit", paid him his arrears' (Inwood, *The Man Who Knew Too Much*, p. 308).

70 We might note that the Gresham Joint Committee considered that Hooke's published lectures were Gresham lectures, while Hooke represented to Cutler that they were Cutlerian lectures.

71 PRO C7/564/29, item 2, cit. Hunter, 'Science, technology and patronage', p. 323.

72 It is not entirely clear what the terms of the agreement were concerning the frequency of the lectures. An early Royal Society minute records: 'with regard to the number of the lectures, it was not resolved upon, some urging, that Mr Hooke should be ordered to read once upon all the ordinary weekly meeting-days of the vacations, except those of the three months of August, September, and October, the greater part of half an hour, beginning about two of the clock: others pressing, that Mr Hooke might read but as many lectures as other professors do; and that the rest of the Wednesdays might be left to be endowed by some other benefactor for another philosophical professor' (Birch, *History of the Royal Society* 1, 503, cit. Hunter, 'Science, technology and patronage', p. 292).

73 See above, chapter 4.

74 Hooke, *Diary*, p. 8.

75 Hunter, 'Science, technology and patronage', pp. 307–8. A draft of a later attempt at negotiated settlement survives among Hooke's papers in the BL, Sloane 1039, fol. 95: 'Wee the President and Councell of the Royall Society of London for improving Naturall Knowledge, doe hereby certify all whom it may concern, that Robert Hook. Dr. of Physick and one of the fellows of our Society was (for his Great Learning in Naturall & Mathematicall Sciences, his diligence and Readines of Invention in things of Art,) made choice of and Imployed as Director & Curator of Experiments to be made at the Publique Meetings of the said Society and was by them paid Eighty pounds a year for [in pencil above this is written 'his paines'] the said Imployment. untill Sr. John Cutler Knight & Baronet (both for the said Dr's Encouragement, and also to expresse his Respects to the said Society) did by Bond in the penalty of £1000 secure to the said Dr. an Annuity of £50 to be payd him halfe

yearly During his the said Dr's Life. Whereupon soe much of the said Allowance was by us abated, and only £30 p ann was afterwards payd by the said Society, and the same was accepted by the said Dr. in consideration of the aforesaid annuity Settled on him by S$^r$. John Cutler. And wee doe further Certify that the said Dr. Hooke hath ever since the said annuity was settled, constantly continued to Read Lectures, and to Discourse on, and make Experiments Relating to the History of Nature and Art, on Such Subjects as were Recommended to him by the said Society. All which he hath Performed to their great satisfaction and to the full of his undertaking. In Testimony whereof wee have hereunto caused our comon seale to be affixed.'

76 See Hunter, 'Towards Solomon's House', p. 193.

77 It may also have been felt that Hooke's increasingly lax attitude to the provision of weekly experiments justified a cut in salary. See above, chapter 4.

78 Hooke, *Diary*, pp. 449–60, cit. Hunter, 'Science, technology and patronage', p. 308.

79 Birch, *History of the Royal Society* 4, 155.

80 Colwall funded the Royal Society's Repository. See Hunter, *Establishing the New Science*.

81 Bowood House, Petty MSS H[8]15, cit. Hunter, 'Science, technology and patronage', pp. 309–10.

82 See BL Add 72897: Petty Papers, vol. 48, fols 47–50. 'Descriptions of experiments carried out by Petty, Robert Hooke and others into the penetration of musket bullets through bags of wool; 1680'.

83 Guildhall Library MS 1758, fol. 78v. Transcribed Hunter, 'Science, technology and patronage', p. 316. This is the last entry in Hooke's surviving diary from this period.

84 Cutler was enormously wealthy, so the reluctance, first his own and subsequently that of his heirs, to settle his dues was clearly temperamental, rather than of necessity.

85 Waller, 'Life of Dr. Robert Hooke', p. xxv.

86 As noted above, the concept of 'addiction' was unknown in the seventeenth century, in our terms of an acute dependency. The term 'addiction' as used then means simply a long-term commitment to any pattern of activity – e.g. in Shakespeare's *Henry V*, Act 1, scene 1: 'His addiction was to courses vain,/ ... His hours fill'd up with riots, banquets, sports,/And never noted in him any study.'

87 'Letter from Hooke to 'my highly Hon. friend Richard Leuitt Esq. Alderman of London & Master of the Company of Haberdashers' (Royal Society Classified Papers XX, item 47).

CHAPTER 7: *Friends and Family, at Home and Abroad*

1 Waller, 'Life of Dr. Robert Hooke', p. xxvii.

2 He was also entitled to rent stable space, which provided him with a small additional source of income.

3 Compare, for example, the 'familia' of Desiderius Erasmus. See L. Jardine, *Erasmus, Man of Letters: The Construction of Charisma in Print* (Princeton: Princeton University Press, 1993).

4 'His rooms were located in the extreme right-hand corner of the main quadrangle of the college, the rectangular "Green Court" shown in Vertue's engraving of 1739 ... Vertue's engraving shows a kind of *piano nobile* at the first floor level, with bay-windows and balconies, and one may deduce that it was here that the most impressive-sounding rooms described in the inventory [of decease] were to be found, the "Library", and the "parlour" or "Committee Roome", the latter possibly the room used by the Royal Society in Hooke's later years, which had another smaller

room interconnecting with it. Above the committee room was a "garrett" ... while below it was a "cellar" ... There were two other cellars, one of them described as a workshop, while there was another room on the same floor as the library. Possibly there were further, smaller rooms which do not appear in the inventory because they contained nothing worthy of note.' M. Hunter, 'Hooke's possessions at his death: a hitherto unknown inventory', in Hunter and Schaffer, *Robert Hooke: New Studies*, pp. 287–94; 289. In Hooke's heyday he also had use of "turret" rooms, where Grace lodged, and probably his amanuenses as well, and which Hooke also sometimes used for experiments with telescopes.

5 BL MSS Egerton 2231 fols 200–1 (not in Hooke's hand. All the letters in this volume are copies in the same hand).

6 'Hooke, *Diary*, pp. 15–16:[6] (1) [December 1672] At home till four p.m. Pretty well but much noise. Eat dinner with stomack, agreed well. Garways. Blackburne accepted.' '(11) [December 1672] at home all day, Mr Colwall here in the evening, Mr. Blackburne laid here first last night. Noe news from Arundell house. Putt staples to little back door and ranged timber in celler, had a griping and voided slimy blood. Eat chicken broth. Began to learn Dutch with Mr. Blackburne.'

7 Hooke, *Diary*, p. 19. Hooke tends to use the phrase 'out of the country' to refer to those coming to him from the Isle of Wight. Hunt, like several others of his employees, may have been recommended by Hooke's island relatives.

8 Judging from drawings which survive in the Royal Society archives, Hunt's talents as an artist were modest, whereas Richard Waller (another who furnished copies for the Society's records) had real ability.

9 BL MSS Egerton 2231 fol. 201.

10 See below.

11 This may have been property belonging to Hooke's mother, or it may have been the property Hooke's father had inherited from his first wife. See above, chapter 1. In February 1688/9, Hooke 'instructed [Robert] about repairing his house'.

12 Grace's mother chaperoned this first visit, and took both Tom and Grace back to the Isle of Wight for a short time, before Tom eventually came to stay permanently in London.

13 Hooke was apparently charged with finding Tom a good residential employment with another powerful Londoner with an Isle of Wight connection, Sir John Oglander. Discussions took place between Hooke and Oglander, followed by exchanges of letters with the family back in Brading, but nothing came of this. '[Friday, 3 September 1675] Writ to Sir J. Oglander and Brother by Hewet'; '[Saturday, 9 October 1675] Sir J. Oglander sent to speak with me ... Spoke with Sir J. Oglander'; '[Monday, 29 May 1676] Spoke with Sir J. Oglander for Th. Giles.' Tom Gyles may only have moved in with Hooke when the Oglander negotiations failed – '[Thursday, 15 June 1676] Tom Giles came up by Hewet.' The Oglander negotiations for a place for Tom Gyles overlap with the breaking off of Grace's betrothal to Sir Thomas Bloodworth's son, and may represent another attempt on Hooke's part to establish family bonds with influential Londoners.

14 For convenient transcriptions of diary entries relating to Tom Gyles and Grace Hooke, see the Isle of Wight website devoted to the family life of Robert Hooke (some of its content, however, should be taken with a grain of salt): http://freespace.virgin.net/ric.martin/vectis/hookeweb/.

15 '[Thursday, 13 September] Mrs. Kedges in Silver street to acquaint Hanna Gyles of Toms Death ... Putt things in order for funerall ... Tom buried in St. Hallows church yard at 7 post prandium, attended by 50 at Least. Slept ill after wine and sweat in the morn. Dremt disturbd Dreames.

Hewet here but a little frighted. Downes here.'

16 The relationship between Robert/ Robin Gyles and Hooke went beyond that of a tenant and landlord. In April 1689, Hooke paid 'Yarwell 4s. for 3f. telescope for R. Gyles', and that May, he bought 'Newspapers for R. Giles 4d' – presumably to keep his relations informed about the Glorious Revolution – and sent them down to him.

17 Hooke 'learnt of the two most important pieces of Island news (Holmes courting Grace and his brother's suicide) while he was at Nell's house. The Newport Convocation book names a "Mary Young" as John Hooke's family servant. If Mary and Nell were sisters, then it would explain how Robert came to receive Island news through Nell Young' (Isle of Wight website).

18 Hooke uses the sign for Pisces as code for 'orgasm'. Sometimes he clearly relieves himself alone. Where one of the women of the house – Nell, or one of the subsequent household maids, and eventually Grace – is named, there is almost invariably a full stop before the symbol. My own view is that he engages in sexual play with the girl in question, but does not perform complete intercourse. There is however a single entry re Grace which suggests more: '[Monday, 5 March 1677] Tost and ale agreed well. Grace perfecte intime omne. Slept well.' Note, however, that there is still a full stop between the 'altogether perfect intimacy' and the [orgasm].

19 'The ultimate responsibility [for the Great Fire] rested with the lord mayor, who was described as "a young man of little experience". A merchant trading to Turkey and a Committee [member] of the East India Company, Bloodworth was forty-six years old at the time of the fire and had entered City politics in 1658 as a common councilman. His rapid rise to lord mayor within seven years undoubtedly owed a great deal to his royalism. He was knighted at the Restoration and was elected to parliament for Southwark in 1660 and 1661. The commissioners implementing the Corporation Act appointed him as alderman of Portsoken ward in 1662 on the king's recommendation. While he had only a few years in public office behind him at the time of the Great Fire, he had already served the greatest part of his year's term as lord mayor. Bloodworth's reputation has been tarnished by Pepys's judgement of him as "a silly man" who was also "very weak". Pepys could be a harsh judge and may be a hostile witness in this case, having clashed with Bloodworth earlier in the year over the pressing of men in the City to serve in the Navy. On that occasion he concluded that the lord mayor was "a mean man of understanding and despetch of any public business" ' (Porter, *Great Fire*, pp. 58–9).

20 This account is based on Hooke's diary entries for the period 1672–80. It also picks up on some ideas first proposed on the Isle of Wight's Hooke website. These are enormously suggestive but are in the end too circumstantial and sensationalist to be relied on.

21 On 16 October he hired Doll Lord instead. Perhaps she was more of a straightforward maidservant.

22 '[Monday, 6 September 1675] Spoke with Bloodworth on the Exchange. Lookd dismally'; '[Thursday, 9 September] With Mr. Haak to Th. Bloodworth who promised release before a judge'; '[Thursday, 16 September] To Thompions, to Bloodworths, to Mr. Hills … To Bloodworth abroad met him on the Exchange. He promised to goe to Docters commons post prandium. I coppyd Graces Release and went in quest of him but found him not'; '[Friday, 17 September] To Bloodworth with Thompion. I shewd him Graces Release. He went with me to Mr. Thompion to Mr. Newcourts house. Mr. Newcourt not within. We went to Lyons coffe house hard by where he

writ his Release and Signed and Sealed it. Afterwards we went againe to Mr. Newcourt but he not being returned his two clarks being both Publique Notary saw him Signe it. Read it and Deliver it againe for the use of the party within named, and he paid them 6sh. and 8d. being their Demand for Registering it. Thence we went to Mr. Hills at Mr. Brooms where he Desird Mr. Hill to be witness to his Declaration and Discharge and he took of the Seal and Delivered it as his act and deed for the use of the party within named, where he took his leave and went away.'

23 Both Hooke's physical disabilities and his absence of 'family' in the conventional sense meant that as far as we know he, like many men of the post-Commonwealth period, never considered a formal marriage arrangement.

24 For a helpful understanding of the complexity of a young woman's sexual conduct in as lax and permissive a society as was Restoration London, see Harris, *Transformations of Love.*

25 'Calld on Nell. heard of Fatall news of Brother John Hooke's death from Newland Hayles.'

26 For John Hooke's complicated financial affairs see the Isle of Wight Hooke website.

27 '[Saturday, 2 March 1678] to Sir J. Hoskins with Crawley about Brother J. Hooke. with Scowen. with Sir Ch: Wren. Spake to the King for Brother J. Hooke's estate. he sayd Sir R. Holmes had beggd it for wife and child. DH. Sent Crawley upon Mr. Davys horse to Isle of Wight. Gave him 40sh. Street at Jonathons, also Hill.'

28 Waller, 'Life of Dr. Robert Hooke', p. 59.

29 cit. Cook, *Edmond Halley*, p. 232.

30 See above, chapter 3.

31 'they were afterwards sent by Sir Robert Holmes to Guinny and an account returnd thereof somewhat like that printed by Hugeinus ‹made by one of the Captaines› giving indeed a very favourable account of their performance but concealing all their faileurs & miscarriages whereas another person that was in the same ship gave a relation very differing. which relation was concealed & the other printed' (BL Sloane MS 1039, fol. 129 v).

32 In several places in his papers, Hooke insists that the pendulum timekeeper for which trials were conducted in 1662–4 was to a design of the Earl of Kincardine's own. Some of these trials were conducted by Sir Robert Holmes: notes of such trials preserved among Hooke's papers may be Holmes's. Here is another link between the Hooke and the Holmes families.

33 From this appears that Hooke had taken part in time trials at sea with an English-manufactured version of a marine chronometer (pendulum or balance-spring). For the extent of these trials see Leopold, 'The longitude timekeepers of Christiaan Huygens'. Wright, 'Robert Hooke's longitude timekeeper' reaches this conclusion from evidence from within Hooke's surviving papers: '[In the Trinity papers] he mentions Huygens's pendulum clocks, the performance of which as fixed clocks he evidently admires but states (not surprisingly to us) that such clocks will not perform well at sea. It is not clear whether he refers here to actual trial of Huygens's clocks at sea, first undertaken by Alexander Bruce in 1662. Hooke then proceeds to describe the parts of his timekeeper. It is not clear whether or to what extent Hooke attempted a trial of all these features.' And again: 'Hooke's description of the behaviour of Huygens's clock when transported suggests first-hand experience, possibly of the marine clocks of Alexander Bruce of 1662.' (Wright, 'Robert Hooke's longitude timekeeper', pp. 70, 72.) On the competitive sea-trials of English and Dutch watches during this period see Leopold, 'The longitude timekeepers of Christiaan Huygens'. Alexander Bruce married the daughter

of a close friend of the Huygens family, and he had a family home in Holland.

34 De Beer, *Diary of John Evelyn* 3, 529–30, cit. Harris, *Transformations of Love*, p. 15. See also Harris, p. 16: 'The boat which took the little group of women on their voyage set out from Deptford or Greenwich. Perhaps it was one of the small private pleasure craft which were common on the river; or, since the Evelyns were friendly with the naval officials who lived nearby, one of the royal yachts, the *Henrietta*, the *Catherine*, or the *Charlotte*, tall-masted, fast and graceful, sumptuously carved and fitted out within ... on some official errand or sea-trial perhaps, but able to take this little group of friends as a treat.' Hooke too took a sea-going trip aboard the *Catherine*.

35 This account is closely based on Cook, *Edmond Halley*, chapter 3.

36 See Jardine, *Ingenious Pursuits*, pp. 179–82; Cook, *Edmond Halley*, chapter 3. St Helena was one of the places described in vivid detail in Linschoten's *Itinerario* – the travel book on which Hooke had taken notes in 1659, when not much older than Halley, at a moment when he himself had toyed with the idea of boldly setting sail from the Old Country in search of fame and fortune.

37 Hooke, *Animadversions on the First Part of the Machina Coelestis* (1674), pp. 80–1.

38 Cook, *Edmond Halley*, p. 59.

39 See Cook, *Edmond Halley*, pp. 91–3.

40 cit. Cook, *Edmond Halley*, p. 99.

41 Cook, *Edmond Halley*, p. 103.

42 For the fact that this anonymous review was by Wallis see Waller, 'Life of Dr. Robert Hooke', p. xv. John Wallis is a fascinating figure, with a murky past as a cryptographer both for Cromwell and for the royalist cause during the Commonwealth period, who thereby survived and thrived after the Restoration. He was a mathematician of distinction. On Wallis's feud with Hooke over fossils

see Drake, *Restless Genius*. Wallis's most famous quarrel was with Thomas Hobbes.

43 *Philosophical Transactions* No. 195, p. 1170 (part of an Account of Johannis Hevelii's *Consulis Dantiscani*). *Philosophical Transactions* vol. 15 no. 175 (September–October 1685) (The Royal Society of London, 1963).

44 Hooke produced a characteristically full self-defence for each and every accusation against him laid by Hevelius, and recirculated by Wallis. He also responded to an inadvertent slight included by Molyneux in a letter which had been read to the Royal Society around the same time, in which he referred to one of Hooke's publications as a 'pamphlet'. See Waller, 'Life of Dr. Robert Hooke', pp. xv–xix.

45 Halley to Molyneux, 27 March 1686, in Macpike, *Correspondence and Papers of Edmond Halley*, p. 58, cit. Pumfrey, 'Ideas above his station', p. 15.

46 Hoskins had been at school with Hooke; Gale had been Halley's headmaster at St Paul's School.

47 Molyneux to Flamsteed, 22 December 1685, Forbes et al., *Correspondence of John Flamsteed* 2, 267–9; 268.

48 Molyneux to Flamsteed, 20 February 1685/6, Forbes et al., *Correspondence of John Flamsteed* 2, 276.

49 Flamsteed to Molyneux, 15 March 1685/6, Forbes et al., *Correspondence of John Flamsteed* 2, 281.

50 Birch, *History of the Royal Society* 4, 476–7, cit. Inwood, *The Man Who Knew Too Much*, p. 360.

51 See Jardine, *Ingenious Pursuits*, pp. 30–2.

52 Cook, *Edmond Halley*, p. 256.

53 Hooke, *Diary*, pp. 305–6.

54 Hooke, *Diary*, p..454.

55 Knox's cousin John Strype also helped Knox draft his story. Hooke later encouraged Knox to publish a second edition, which never materialised. See the letter from Knox's cousin James Bonnell to Strype dated 12 December 1683: 'Cos. Knox has been with the King, & had an hours discourse, many

flocking about to hear it, which will help Mr. Chizwel off with some copies. Mr. Hook persuades my Cosen to make some additions, & he will furnish them with a new title page & his pictur, will pass for a 2nd Edition. Mr. Chizwel was present at the debate, & thout well of it. This you may take from my Cos. in shorthand, in one or two nights being at your hous' (D. R. Ferguson, *Captain Robert Knox . . . Contributions towards a Biography* [Colombo and Croydon: privately printed, 1896–7], p. 32).

56 This approach was evidently successful, as Hooke's preface tells the reader of the 'Employment That Worshipful Company have now freely bestowed upon him, having made him Commander of the Tarquin Merchant, and intrusted him to undertake a Voyage to Tarquin'.

57 J. Ryan (ed.), *Robert Knox, An Historical Relation of Ceylon together With somewhat concerning Severall Remarkeable passages of my life that hath hapned since my Deliverance out of my Captivity* (Glasgow: James MacLehose & Sons, 1911), p. xlvi.

58 Ryan, *Robert Knox*, p. 87.

59 Ryan, *Robert Knox*, p. 415.

60 12 January 1681, Birch, *History of the Royal Society* 4, 64, cit. Ferguson, *Captain Robert Knox*, p. 27.

61 Ferguson, *Captain Robert Knox*, p. 27.

62 Knox's new commission is mentioned at the end of Hooke's prefatory letter. Knox was presumably appointed because of his exceptional experience of the culture and practices of Ceylon – he had been only a boy when taken captive, and had little experience of navigation, let alone captaining a ship.

63 Ferguson, *Captain Robert Knox*, p. 31: ' "[On 24 November 1683] It was ordered . . . That a present be made from the Society to Mr. Knox and that it be of about 50s. or 3l. value." "[On 28 November 1683] Mr. R. Hooke delivered in a box for the repository the curiosities given by Captain Knox, which had been shewn at the last meeting." A few months later we find

Knox again referred to (and for the last time) in the records of the Royal Society: "[On 23 April 1684] Mr. Bailey having delivered in an account of the tides at Tonquin, procured from persons, who had lived long in the place; it was ordered to be registered. It was remarkable, that there was at Tonquin but one flood and ebb in twenty-four hours; and as Mr. Hooke observed, that when the moon is in the north of the æquator, the floods, begin in the morning When she is in the south side of the æquator, they begin in the afternoon. Mr. Hooke remarked likewise, that Captain Knox had made several observations confirming the truth of this account, as would appear from his journal in the hands of the Earl of Clarendon, if it were consulted." '

64 Ferguson, *Captain Robert Knox*, p. 32.

65 Ferguson, *Captain Robert Knox*, p. 35.

66 For Hooke's paper on cannabis, taken directly from Knox, see W. Derham (ed.), *Philosophical Experiments and Observations of the late Eminent Dr. Robert Hooke* (London, 1726), pp. 210–12 (paper delivered before the Royal Society, 18 December 1689).

67 Derham, *Philosophical Experiments*, pp. 210–11. The 1683 collection presented to the Royal Society had included a number of intoxicants.

68 Jardine, *Ingenious Pursuits*, pp. 295–6.

69 Tuesday, 24 September 1689.

70 Royal Society Classified Papers XX.

71 See also Hooke's Royal Society lecture delivered on 26 February 1690: 'As an addition to this Discourse [Huygens] gives an account of the tryalls Lately made at Sea for the Discovery of the Longitude by means of the Pendulum Clocks. by which tryalls hee has found (as he alledges) that the account kept from the Cape of Good Hope till the Ships arrivall in the Texell did nott vary from the truth above 5. or 6. Leagues, taking the Longitude of the Cape to be 18 degrees more east then Paris, of which he take himself to be ascertained by the Jesuits that went to Siam from France in the year 1685,

and by other ways also. of which he hath made a Relation at Large to the Directors of the East India Company who have given order for a further tryall thereof. of which in time we may have an account together with which will be an account also of the differing motion of the Pendulum in Differing Latitudes which is the same thing which I have Engaged Captain Knox to make in his voyages to & from the Indies and in severall parts there. I only fear that the Directors [of the East India Company] there will furnish these observers with a much better apparatus than £40 will procure for Cap Knox here however I doubt not but that he will be as carefull in the use of what he shall have as they can be with theres nor shall he want Directions how to make them pertinently for the Purpose destined' (Hall, 'Two unpublished lectures', pp. 225–6).

72 See e.g. Cambridge University Library, Strype Correspondence Add. 5, fol. 244, London 7 February 1697: 'for ingratitude I thinke it layes at the E India Company side ... and pray <of he> the Gentleman or any other wheather in Anno 1660 that I was taken, I did not stand up faine to acquire a good estate, as most of that now present Adventurers, excepting only them that were borne to it ...'.

73 BL MSS Sloane 1039, fol. 111: Letter 'for Dr. Hooke', dated 5 February 1697.

74 S. Baron, A Description of the Kingdom of Tonqueen, in T. Wotton et al., A Collection of Voyages and Travels, some Now first Printed from Original Manuscripts, others Now First Published in English, In Six Volumes. With a General Preface, giving an Account of the Progress of Navigation, from its first Beginning. Illustrated with a great Number of useful Maps and Cuts, Curiously Engraven. Printed by Assignment from Mess^rs Churchill, for John Walthoe (1732), vol. 6.

75 Baron, A Description of the Kingdom of Tonqueen, p. i.

76 Royal Society Classified Papers XX, fol. 80.

77 Inwood, The Man Who Knew Too Much, pp. 419–20.

78 See J. Wilkins, An Essay towards a Real Character, and a Philosophical Language. With An alphabetical dictionary, wherein all English words ... are either referred to their places in the Philosophical Tables, or explained by such words as are in those Tables (London, 1668).

79 Strype Correspondence Add. 9, fol. 331, London 30 December 1719.

CHAPTER 8: *Argument beyond the Grave*

1 Ryan, *Robert Knox*, p. xix.

2 Gunther, *Early Science in Oxford* 10, 70.

3 The fact that the brothers spoke excellent English was a distinct career asset in 1688. Thomas Molyneux, who visited Christiaan in Paris in the 1680s, reported that Christiaan had given him a warm welcome: 'When he understood after a few words that I was English, he spoke to me in my own language, beyond all expectation, and moreover, extremely well' (cit. Andriesse, *Christian Huygens*, p. 348).

4 Sir Constantijn died in March 1687.

5 Huygens to Constantijn Huygens, 30 December 1688, cit. Westfall, *Never at Rest*, p. 473.

6 cit. Andriesse, *Christian Huygens*, p. 377.

7 From the diary of Constantijn Huygens, cit. Andriesse, *Christian Huygens*, p. 378.

8 From the diary of Christiaan Huygens, cit. Andriesse, *Christian Huygens*, pp. 378–9. Fatio had acted as Anglo-Dutch go-between (somewhat on the model of Oldenburg), facilitating the sending of Newton's *Principia* to Huygens.

9 From the diary of Christiaan Huygens, cit. Andriesse, *Christian Huygens*, p. 380.

10 Westfall, *Never at Rest*, p. 480.

11 Some scholars maintain that these discussions took place at Hampton Court. The two men were, however, both in London for several months, and had ample opportunity to seek out each other's company.

12 Westfall, *Never at Rest*, p. 488.

13 This account is based on Westfall, *Never at Rest*, chapter 11. As was customary with an important publication, Halley presented a copy of *Principia* to James II in summer 1687: 'As one of the first acts obligatory on a publisher, Halley presented a copy of the new book to [James II], with a letter which dwelt especially on its treatment of the tides as a topic likely to interest an old naval commander. Probably James did not recognise the author's name. If he bothered to ask his advisers, he learned that the Lucasian professor of mathematics at Cambridge ... had placed himself irrevocably in the ranks of James's enemies' (Westfall, *Never at Rest*, p. 473).

14 It was during this period that Hooke and Newton met at Halley's house, and Hooke failed to get satisfaction once again over his being credited with some part in the inverse-square law.

15 See Westfall, *Never at Rest*.

16 Westfall, *Never at Rest*, p. 496.

17 On the complex politics of the Glorious Revolution see D. Hoak and M. Feingold, *Anglo-Dutch Perspectives on the Revolution of 1688–89* (Stanford: Stanford University Press, 1996). Christiaan Huygens died at Hofwijk in 1695.

18 Wren also found himself largely out of favour, though his ongoing architectural projects and his usefulness to Queen Mary in her many rebuilding projects sustained his public position until her death.

19 Hooke was by now no longer being remunerated as Curator of Experiments, though he continued to appear at meetings, lecture and lead discussions of experiments. It was probably about this time that a letter – evidently orchestrated by Hooke – was sent to Halley as Clerk of the Royal Society, urging him to take Hooke on once more in a salaried position. This letter is reproduced, without any indication of sender or provenance, in J. B. Nichols, *Illustrations of the Literary History of the Eighteenth Century* (London: J. B. Nichols & Son, 1817 and 1822), 4, 66–7. The letter-writer (perhaps Aubrey) declares that he knows of 'none more fit to perform this work than Mr. Robert Hooke, of whose abilities herein there are none of any standing in this Society (witness those many learned lectures by him read to this Society) are ignorant' (p. 67).

20 'The parallel between Newton and Huygens in natural philosophy is remarkable ... Beyond mechanics, there were also parallel investigations in optics. At nearly the same time, and stimulated by the same book, Hooke's *Micrographia*, they thought of identical methods to measure the thickness of thin coloured films' (Westfall, *Never at Rest*, pp. 174–5).

21 In 1672, when Newton was hesitating about publishing his *Lectiones opticae* (Optical Lectures), Oldenburg suggested that, instead of indicating the places where he was directly responding to Hooke's criticisms (based on his own *Micrographia* work), he omit Hooke's name altogether, and simply deal with the objections. Newton responded: 'I understood not your desire of leaving out Mr Hooks name, because the contents would discover their Author unlesse the greatest part of them should be omitted & the rest put into a new Method w[i]thout having any respect for ye Hypothesis of colours described in his *Micrographia*' (Newton to Oldenburg, 19 March 1672, cit. Westfall, *Never at Rest*, p. 245).

22 Newton to Oldenburg, 21 December 1675, cit. Westfall, *Never at Rest*, p. 273.

23 cit. Hall, 'Two unpublished lectures', p. 220.

24 Hall, 'Two unpublished lectures'. See also Hunter, 'Science, technology and patronage', p. 333, n. 181: '[Trinity College, Cambridge, MS] O.11a.1^14A-D, lectures on Huygens' *Traité de Lumière* delivered to the Royal Society on 19 and 26.2.90 (See Journal Book, vii, 266, 268; Hooke, *Diary 1688–93*, p. 189 and perhaps also p. 190.' For Hooke's criticisms of Newton, made in the same lectures, see above, Introduction.

25 Hall, 'Two unpublished lectures', p. 222. Hall notes: 'Easily the most curious feature of this account is the fact that Hooke pays no tribute to Huygens' inventiveness in the field of mathematical optics, especially in the study of the difficult problem of double refraction. He considers Huygens' wave-front superfluous: he does not even notice that Huygens' construction gives a mathematical proof of Descartes' (or Snel's) law of sines, the truth of which is assumed in *Micrographia*. As in his other essays on optics, Hooke's chief interest lies in the investigation of the physical nature of light and of the various media through which it is propagated.'

26 Hall, 'Two unpublished lectures', p. 224.

27 Hall, 'Two unpublished lectures', p. 220.

28 For Newton's detailed marginal annotations in his copy of *Micrographia*, and particularly those relating to the sections concerned with the refraction of coloured light, see Keynes, *Bibliography of Dr Robert Hooke*, pp. 97–108.

29 Hooke did continue with occasional building commissions (especially where engineering expertise was required) for old Royal Society contacts. For example, at the end of 1692, Sir Robert Southwell (President of the Society) retained Hooke to help with flood defences for his estate near Bristol. See Inwood, *The Man Who Knew Too Much*, pp. 413–14.

30 Royal Society Classified Papers XX, fol. 89b.

31 Waller, *Posthumous Works of Robert Hooke*.

32 Copley to Kirke, 2 March 1702/3. Folger V.b.267 MS letter inserted in a printed volume; holograph. It has been amended by a later hand, as if being marked up for publication. I am extremely grateful to Professor Alan Stewart for transcribing this letter for me. It is reprinted in Nichols, *Illustrations of the Literary History of the Eighteenth Century* 4, 78 (the 'marking up for publication' presumably by Nichols). Copley was made FRS in 1691, introduced by Hoskins. See Hunter, *Royal Society and its Fellows*, pp. 216–17. Kirke became FRS in 1693, also through Hoskins (Hunter, *Royal Society and its Fellows*, pp. 220–1). On Elizabeth Stephens see below.

33 'On a porte depuis peu a l academie Des Sciences a Paris une machine tres simple qui marque exactement pendant plusieurs semaines le vent qui a regne et tous les changements qui y sont arrives heure par heure, minutte par minutte avec les differents degres de sorte don't le vent a souffle. Cette méme machin marque aussi avec la méme precision et pendant le méme temps la pesanture de l air, et la quantite de pluye qui est tombee a chaque heure et a chaque minute. On en envoyera a Londres [illegible] le Dessein, mais comm on a trouve dans L'histoire de la Societe Royale d angleterre imprime a Londres en 1667 un petit memoire qui est a la page 163 avec ce titre. A method for making a history of the Weather by M Hook dans le quel on a fait gravir le dessein d'un barometre avec une aiguille et celui a une girouette tres imparfaite pour marquer la force du vent, on seroit fort aise de savoir si quelqu un des messieurs de la Societe Royale n ont rien invente depuis pour perfectioner ces deux machines. Copied from a Paper shewd me by Dr. Slone May. 3. 1699. RHooke' (Royal Society Classified Papers XX, fol. 51).

34 Royal Society Classified Papers XX,

fol. 94. Jean de Hautefeuille had been made a foreign corresponding member of the Royal Society in 1687. See Hunter, *Royal Society and its Fellows*, pp. 214–15.

35 Royal Society Classified Papers XX, fol. 94.

36 Waller, 'Life of Dr. Robert Hooke'.

37 In a personal letter to Hammond, during the period of Charles's residence at Carisbrooke Castle, Cromwell persuades Hammond that the King's falling into his hands is part of a 'chain of providences' that brought Charles to the Isle of Wight, and asks: 'Can't you see that there is a pattern in this?' In addition to all the other family connections, Hammond and Cromwell were second cousins.

38 'After the civil war, the manor of Willen was acquired by Robert Hammond. He was the Colonel of the Parliamentary army, who had custody of King Charles I in Carisbrooke castle. On his death, his three daughters inherited the estate and in 1673 sold it to Dr. Richard Busby, famed headmaster of Westminster School allegedly for £12,000' (Willen Church website).

39 According to the Willen website (http://met.open.ac.uk/genuki/big/eng/BKM/Willen/Index.html), the history of the church is as follows: 'Wyllien, in the hundred and deanery of Newport, lies about a mile and half south of Newport-Pagnell, on the road to Fenny-Stratford. The manor was anciently in the Paganells: in the reign of Henry VII. it belonged to the Hanchets, afterwards to the families of White and Nicholls. In 1657 [should be 1651?] this manor was purchased by Colonel Hammond, who had the custody of King Charles I. in the Isle of Wight: his daughter, in 1673 sold it to Dr. Busby, the celebrated master of Westminster school, who bequeathed it in trust for charitable uses. The parish church, a small brick edifice, was built in 1680, at the expence of Dr. Busby, who gave a library for the vicar, and endowed the vicarage with the great tithes, which had been formerly appropriated to the priory of Tickford. He appointed 22 lectures on the catechism to be preached annually in this church, and vested the advowson of the vicarage in trustees, directing that they should nominate from time to time a student of Christ Church College, in Oxford, who had been educated at Westminster school.' Hammond died in 1654, but is apparently buried in Ireland.

40 In the Anglican liturgy, the collect for 22 July, St Mary Magdalene's Day, is Judith 9:1, 11–14, beginning 'Judith prostrated herself, put ashes on her head, and uncovered the sackcloth she was wearing.' For the Dutch influence on Hooke's architectural style see A. Stoesser, 'Robert Hooke and Holland: Dutch influence on Hooke's Architecture' (Utrecht University: doctoral dissertation, 1997).

41 My thanks to Ellie Naughtie for her detective work at Lutton.

42 'The beautification note in the BL is of course in John Needham's inimitable (unreadable) hand. He was a very close friend indeed to Busby, as you might expect of the Receiver General, but that document may well be the original brief that Busby gave for a codicil' (personal communication, E. Smith, Westminster School). I am extremely grateful to Eddie Smith for sharing his information and documents concerning Lutton church with me. I am also grateful to Ellie Naughtie for first bringing it to my attention.

43 I am grateful to Eddie Smith for providing me with a transcript of this deposition. All quotations are from this transcription. This is the only piece of formal evidence we have that Hooke was Busby's pupil at Westminster School (though, of course, he always maintained so).

44 Busby's Communion arrangements were High Anglican, cutting off the altar from the congregation.

45 'Saturday 10th June, 1693. I Dind with D Busby & Matier ... I viewd cloyster

house about foria M NE Corn. M Musaum with. Dr & M ... Discoursd with Dr. Dove of Lutton church[.] I mentioned a Vault[.] Dr. [Busby] Desyred me to goe to Welling [Willen] with Mr Needham.'

46 In Libro Deposition: fol.: 99: usque fol. 109.

47 Noell Ansell fol. 89 Int 6.

48 On the strong intellectual tradition in Europe of using stimulants to encourage creativity – as Coleridge and others did – see S. Plant, *Writing on Drugs* (London: Faber, 1999).

49 See the volume of Hooke papers in the archives of the Royal Society, Classified Papers XX, which contain 'in progress' works, including work for the Society, down to May 1699. RS Journal book 10 shows he checked out a library book only days before his death.

50 Robert Knox, *An historical relation of the island of Ceylon* ... (1681) BOD MS. Rawl. Q c.15 – to which is attached a manuscript apparently in the author's hand. Fol. 71.

51 Sharp to Flamsteed, 30 March 1703, Forbes et al., *Correspondence of John Flamsteed* 2, 1008–9; 1009.

52 4 March 1702/3. Nichols, *Illustrations of the Literary History of the Eighteenth Century* 1, 478.

53 Robert Knox, *An historical relation of the island of Ceylon* ... (1681) BOD MS. Rawl. Q c.15 – to which is attached a manuscript apparently in the author's hand. Fol. 71.

54 RS Journal book 10, 7 April 1703.

55 Thomas Gyles c. Joseph Dillon. See C9 194/40 and C24/1278 Part II no. 20 and 1289 Part I no. 38 2p/Complaint of Thomas Gyles, 12 February 1706/7. I am extremely grateful to Ellie Naughtie for her help in transcribing these documents.

56 Thomas Gyles's complaint to the Court of Chancery, 12 February 1706: PRO C/9/194/40.

57 PRO C/5/335/67 – Stephens v. Hollis 1708.

58 But for a suggestion of how Wren, Waller and Hunt may have managed

to acquire at least enough of Hooke's inheritance to endow the Royal Society with a 'Repository' or purpose-built museum, in accordance with Hooke's known last wishes, see L. Jardine, 'Paper monuments and learned societies: The Hooke Royal Society Repository', in R. Anderson, M. Caygill and A. MacGregor (eds), *Enlightening the British: Knowledge, Discovery and the Museum in the Eighteenth Century* (London: British Museum Publications, in press) and below.

59 For an account of the way Hooke's close friends of his final years, Richard Waller, Henry Hunt and his long-standing friend Christopher Wren, tried to ensure a lasting posthumous reputation in the form of a permanent Repository for the Royal Society, built with Hooke's money, see Jardine, *On a Grander Scale*, chapter 8.

60 We might contrast the dedicated way in which first Wren's son and then his grandson perpetuated Wren's name and reputation in *Parentalia*, above and beyond St Paul's Cathedral. It is their documentary evidence which allows historians to reconstruct Wren's wider career in its entirety. See Jardine, *On a Grander Scale*, chapter 8.

61 Although later Repository Keepers with official responsibility for the collection were appointed.

62 W.H. Quarrell and M. Mare (eds and trans.), *Travels of Zacharias Conrad von Uffenbach: London in 1710*, (London: Faber & Faber, 1934), pp. 98, 102.

63 '30 juin: Réunion à Gresham College dans une petite chambre, un cabinet de curiosité très rempli mais bien entretenu. Askin [Hoskins] Président, Henshaw vice-président, Halley secrétaire. Remis la lettre de Van Leeuwenhoek. Ensemble avec Newton et Fatio' (cit. Andriesse, *Christian Huygens*, p. 378).

64 Copley to Kirke, 17 June 1703. BL MSS Stowe 748 [9]. I am grateful to Ellie Naughtie for this reference.

65 This account of the history of the

Royal Society's Repository is based on M. Hunter, 'The cabinet institutionalized: The Royal Society's "Repository" and its background', in Hunter, *Science and the Shape of Orthodoxy*, pp. 135–47. See also O. Impey and A. MacGregor (eds), *The Origin of Museums: The Cabinet of Curiosities in Sixteenth- and Seventeenth-Century Europe* (Oxford: Clarendon Press, 1985).

66 Hunter, 'The cabinet institutionalized', p. 140.

67 Hunter et al., *Correspondence of Robert Boyle* 3, 46 (Oldenburg to Boyle, 27 January 1666), cit. Hunter, 'Between Cabinet of Curiosities and research collection', p. 127.

68 Hunter et al., *Correspondence of Robert Boyle* 3, 49 (Hooke to Boyle, 3 February 1666).

69 Hunter, 'The cabinet institutionalized', p. 145; Hooke, *Diary*, p. 11: '[November 1672] (24) Lord Brounkers. told him of Lord Chesters Legacy. order to, take his man. Walkd with Mr. Godfry, Mr Fitch brought a horse. writ a lecture about the new phenomena of light. Nell's cozen at Coffins. at Garways. was not well and slept very little, rose next morning (25) at 6. Sawd wood.' '[29] Slept very little but (30) at 4 in the morning rose and sawd downe the trusses celler.' p. 12: '[December] [6] Garways. supd early. Slept from 12 to 3 only. (7) Rose at 6, threw down middle post and beam in celler.' '(10) Wrought in the celler and threw down post and ranged timbers. Was pretty well all day. Mr. Lodowick here, Mr. Janeway here. Eat broth and slept well. (11) at home all day, Mr Colwall here in the evening, Mr. Blackburne laid here first last night. Noe news from Arundell house. Putt staples to little back door and ranged timber in celler, had a griping and voided slimy blood. Eat chicken broth. Began to learn Dutch with Mr. Blackburne. Mary here. (12) Slept well in my gown. Sawd wood, took down joyst. Kept in, rangd and catalogued Library.' '[14] Lost Diamant in cleerd

celler. Set up octavos and smaller books, set up 3 shelves.' p. 13: '(19) Fitted glasse toole in the morning, mended Repository door. Dined Home.'

70 The account which follows builds on J. A. Bennett, 'Wren's last building?', *Notes and Records of the Royal Society* 27 (1972–3), 107–18. See also Jardine, *On a Grander Scale*, chapter 8.

71 Royal Society Register Book RBC.9.143. The letter is undated, but is copied between letters dated May 1702 and September 1702. The whole volume is strictly chronological.

72 It may have been that political quarrels within the Society forced a move on the Society in that year. See Westfall, *Never at Rest*, pp. 671–9.

73 The Dr Browne in question was none other than the Edward Browne (son of Sir Thomas Browne) who had accompanied Wren on his sightseeing trip to the region outside Paris in 1665.

74 On 13 September 1710 Newton wrote to Sir Hans Sloane, the Society's Secretary: '[I] am glad Sr Christopher & Mr Wren like the house [&] hope they like the price also. I have inclosed a Note [to] Mr Hunt to call a Council on Saturday next at [twe]lve a clock, & beg the favour that you would send [it] to him by the Porter who brings you this' (Turnbull et al., *Correspondence of Isaac Newton* 5, 61; letter 802, Newton to Sloane, 13 September 1710).

75 'Sir Christopher Wren, Mr. Wren and Mr. Waller were Appointed a Committee to see what Mr. Brigstock leaves in the House that may be usefull to the Society and of what Value they may be.' The committee reported back on 30 November: 'Mr. Brigstock was Ordered to have thirty Guineas for the Wainscot and other things he leaves in the House at Crane Court according to the Report of Sir Christopher Wren, Mr. Wren and Mr. Waller.'

76 cit. Bennett, 'Wren's last building?', p. 111.

77 Waller contributed a total sum of £400, of which £300 was apparently treated as an interest-free loan which the Society agreed to repay to him (£300 was the sum eventually agreed as the acceptable cost of the Repository). At his death, £250 was outstanding, and his widow (as happened more than once with 'benefactions' to the Society) sued for return of the money, on the ground that it had been a loan, not an outright gift, eventually receiving from Newton 'two hundred and fifty pounds and fifty three pounds in full Interest' (Bennett, 'Wren's last building?', p. 113).

78 Hunt advanced £464 for the project in its early stages; four months later Hunt lent a further £450, making a total of over £900: 'To pay for the [Crane Court] house, the society put £550 down and took a mortgage for £900 at 6 percent. Before they could move in, extensive repairs had to be made, at a further expense of £310. Having taken the plunge, they decided to go all the way and authorized £200 more to build a repository ... By the middle of January, before the bills for either the repairs or the repository arrived, the society retired the mortgage ... partly by borrowing £464 from their clerk, Henry Hunt. By June, further gifts reduced the debt to £200. For the repairs and the repository, the society borrowed an additional £450 from Hunt and stood £650 in his debt when he died in June 1713' (Westfall, *Never at Rest*, pp. 676–7). £900 was an enormous sum for any individual to provide – Newton's own contributions, for instance, totalled well under £200. In 1663, when Archbishop Sheldon put up £1000 to launch the building of the Sheldonian Theatre, this was regarded as an astonishing sum for one individual to produce, however wealthy.

79 'Henry Hunt (d. 1713) served Robert Hooke as a boy assistant and was trained by him. Soon after the death of Richard Shortgrave, the Society's first operator, Hunt was appointed to succeed him (2 November 1676); he also carried on the making of meteorological instruments for Fellows and others that Shortgrave had commenced. On 14 January 1679/80 his salary was raised from £10 to £40 p.a. (the same as Hooke's) in return for his devoting all his time to the Society's affairs. In 1696 he was appointed Keeper of the Library and Repository. By the time of his death the Society owed him £650 advanced by him for the purchase and fitting out of Crane Court' (note in Turnbull et al., *Correspondence of Isaac Newton* 5, 62).

80 At the end of the manuscript of Hooke's diary, now in the Guildhall Library, there is a note in Waller's hand saying that Waller could prove, were it a proper time, that Hooke was the first to invent or hint of those things about which great heroes of renown had contested the priority. Waller also left us the most affectionate portrait of Hooke, which includes the observation: 'He was in the beginning of his being known to the Learned, very communicative of his Philosophical Discoveries and Inventions, till some Accidents made him to a Crime close and reserv'd. He laid the cause upon some Persons, challenging his Discoveries for their own, taking occasion from his Hints to perfect what he had not; which made him say he would suggest nothing until he had time to perfect it himself, which has been the Reason that many things are lost, which he affirm'd he knew.'

81 For Hunt's arrival in Hooke's household see Hooke, *Diary*, p. 19: 'January 4th. [1673] – [mercury] 160. fair all day like Aprill weather. Thermometer 4 1/2. Wind S. night cleer. very windy. At home till 3. DH. walkd to Mr. Martins. bought 7 treatises of Husbandry. Plat, Austen, &c. 2s. 6d. Mizaldi Ephemerides 6d. at Shoo lane. Mr. Shortgraves bosses

cutts. Harry [Hunt] first out of the Country. Drank 2 Tea. Guiddy and slept not well.'

82 Gunther, *Early Science in Oxford* 10, passim.

83 Waller, 'Life of Dr. Robert Hooke', pp. 59–66.

84 Copley to Kirke, London, 29 April, 1703. Nichols, *Illustrations of the Literary History of the Eighteenth Century* 4, 75.

85 Title on back of sheet says: 'Testamentum Roberti Hook M D defuncti.' PRO Prob 20/1315. I am extremely grateful to Rachel Jardine, who first spotted the unsigned will at the PRO. For the Kirke letter suggesting Wren, Hoskins, Knox and Reeve Williams as the unnamed friends see Hunter and Schaffer, *Robert Hooke*, p. 287.

86 Bennett, 'Wren's last building?', p. 113.

87 For Wren and the Royal Society see Jardine, *On a Grander Scale*.

88 See Batten, 'Architecture of Dr. Robert Hooke', pp. 93–6. The relevant entries from Hooke's diary, as compiled by Batten, are: '[2 September 1674] With Mr. Montacue to Southampton Fields. September 12th, At home all day about Mr. Montacue plat. September 13th Completed Designe. October 12th. At Mr. Montacues with Mr. Fitch and agreed upon setting out ground etc, At the Ground and drank with Mullett and Fitch. December 13th, Drew upright of Wings for Montacue. December 15th, With Mr. Montacue, Mr. Sidley, Fitch, Davys here. Saw module approved. Orderd all haste to be made. [March 5 1675] Finisht estimate for Mr. Montacue. March 17th. Mr. Fitch here, Before he went to Mr. Montacue. Davys men brought in Module. Directed carpenter about the Ceeling of the stairs and partition and shoring plate of dining room May May 22nd in Bloomsberry with Mr. Montacue Mr. Russell, Leak, etc, Measurd out Ground to a square June 29th. Set out Mr. Montacues front. July 6th Set out foundations. July 24th Fell out with Mr. Fits about the stock bricks in the front of the house. September 1st. Saw the chimneys set out. November 13th. Mr. Montacue agreed with Davys. Italian painter Plaisterer and hanging maker. [28 April 1676] to Mr. Montacues. The west half of his Roof up. Resolved on the height of the wings, the rooms to be only 14 foot in the cleer. May 2nd. With Mr. Fitch at Bloomsberry. Directed the placing the chimneys in the garrets. May 10th. Mr. Povey to board the upper part of the Roof. May 24th, At Mr. Montacues. Saw his new bought picture some good. Much discourse with him about high roof. To Bloomsberry. Discoursd Hayward he demanded £30 for higher roof, stair, stairhead, chimneys etc. June 29th. Scarborough here about mending chimney it was crackd and setled June 30th. Scarborough here, Newland asked £4 for new fitting chimneys. Orderd Scarborough to have them proceeded with. July 1st. With Mr. Montacue about covering chimneys . . . To Bloomsberry. At the top of the new flat. Directed covering and trussing chimneys. He ordered Copper guilt balls and iron work for pavilion chimneys. I directed moulding at the bottom of the chimneys. July 3rd. Directed the top of chimneys at Thomsons. July 4th. With Waters about chimney pieces. July 8th. To Thomsons and Bloomsberry. Irons for chimney done. July 24th At Mr. Montacues. Discoursd about Portico and cupelos. August 17th. Spoke with Mr. Montacue . . . about altering the chimneys on the pavilions. September 12th, At Mr. Montacues. He allowed to leave out turret of wings. September 21st To Mr. Montacues. With him to Bloomsberry. Pleasd chimneys. Cupelos over gateways 1, etc.. Discoursd with Thomson about gateway and Stepps. [13 June 1677] Set out garden. August 28th. At Bloomsberry orderd Norris £40 on chimney pieces. November 24th. Waited on Mr. Montacue and Sidley

then read over Fitches demand of overwork. November 28th. With Scarborough to Mr. Montacue with him to his house and into his Garden. Deliverd Fitches papers to Mr. Scowen. December 5th. Discoursed with Mr. Montacue, He seemd well satisfyd in all things . . . Desird me to send him the agreements, Designes and Estimates. December 6th. Mr. Montacues account ended, wherein he is made Debtor to Mr. Fitch £800. [5 January 1678] Directed Thomson about stairs with corbells etc. February 4th. With Norris bespake chimney pieces and agreed for £60. March 8th . . . at Bloomsberry directed passages, stairs, struck stove, wainscoting, staircase. [21 January 1679] With Hayward to Montacue house. Ballisters on top 2 of house and raile on court stairs, February 28th. at Mr. Montacues with Hammond about widening stairs. [2 February 1680] to Mr. Montacue. Looke with Scowan sash windows blown down. July 7th. At Mr. Montacues, spake to him for money he promised me. Speedily viewed the cracks. None but that in the turret at the east of the Cloyster.'

89  Dr Marjorie Caygill of the British Museum confirms that when excavations were carried out for the construction of the new Great Court at the British Museum, no signs of fire damage were discovered, suggesting that such damage as there was was interior to the fabric (personal communication 2002).

90  Turnbull et al., *Correspondence of Isaac Newton* 2, 313.

91  Latham and Matthews, *Diary of Samuel Pepys* 6, 36–7; Turnbull et al., *Correspondence of Isaac Newton* 2, 439.

92  Manuscript note, Hooke diary, Guildhall Library.

93  At the end of the paper labelled N by Wright, Waller has written: 'Q[uaere]. if this be publisht in the Opera Posthuma or Transcribed in the Papers of Clockwork. Vide vide. Dec: 22. 1713. RW'. 'Vide vide' ['look! look!' or 'pay close attention'] suggests that Waller believes such publication might cause a sensation, or, alternatively, that he and Derham ought possibly to protect the sensitive information therein contained. Derham has added, 'This paper enumerates some of ye ways attempted without success and concludes with the {last} Paragr. the third: Dr Hooks Proposals to the K[ing] for his watches wth 2 Balances finding Longit. WD.' Derham adds his customary abbreviation for matter he has decided not to print: 'NP' (see also Royal Society, Classified Papers XX). At the end of manuscript T, Derham has written on the verso, 'first Proposal abt the Longitude NP'. (Wright, 'Robert Hooke's longitude timekeeper', pp. 112, 118.)

94  Inwood, *The Man Who Knew Too Much*, p. 37.

95  This account is closely based on Harris, *Transformations of Love*, pp. 257–60.

96  Hooke, *Diary*, p. 243.

97  John Evelyn to Margaret Godolphin, 18 July 1676, cit. Harris, *Transformations of Love*, p. 259. Evelyn may have feared that the foppish dilettante, Sir Formal Trifle, whom Shadwell brought on stage as Gimcrack's crony, was based on himself, which might explain the intensity of his indignation. I am extremely grateful to Professor Douglas Chambers for giving me access to his transcript of a related letter (Letter 385 in his forthcoming edition).

98  Harris describes him as 'a curious, unprepossessing, even rather sinister figure, skeletally thin and crooked, with pale sharp features and long lank hair hanging about his face. He moved like a spider' (Harris, *Transformations of Love*, p. 257). That is Shadwell's Hooke, rather than the man himself.

# ILLUSTRATIONS ACKNOWLEDGEMENTS

INTEGRATED ILLUSTRATIONS: Chapter heading: fossil engraving reproduced in Hooke's *Posthumous Works*: Museum of the History of Science, Oxford; (page 5) Edmond Halley by Thomas Murray: © The Royal Society; (8) Flamsteed's inscribed copy of Newton's *Principia*, 1686: © The Royal Society; (10) Engraving of Johannes Hevelius from *J. Hevelii Machinae Coelestis* (1673–1679): The British Library; (13) Sir Isaac Newton: © The Royal Society; (18, left) Portrait believed to be of Robert Hooke by Mary Beale: © The Natural History Museum, London; (18, right) Engraving of John Ray by H. Meyer: Mary Evans Picture Library; (27) Engraving of Freshwater Bay: Author's personal collection; (28) Watercolour of Newport by Lambert Doomer, *c.* 1660: Picture Archive, ÖNB Vienna; (30) Pen and ink detail of a study of ships by Willem Schellinks: Picture Archive, ÖNB Vienna; (32) Engraving of Alum Bay: Author's personal collection; (34) Hooke's drawing of a Hampshire 'saltern', 1665: © The Royal Society; (36) Watercolour of ships off the Needles peninsula by Lambert Doomer, *c.* 1660s: Picture Archive, ÖNB Vienna; (40/41) Engravings of fossils reproduced in Hooke's *Posthumous Works*: Museum of the History of Science, Oxford; (45/46) Engravings based on Hooke's own drawings of the various mechanisms in his equatorial quadrant from *Animadversions on the First Part of the Machina Coelestis of Johannes Hevelius*, 1674: Museum of the History of Science, Oxford; (55) Miniature of Charles I by David Des Granges, *c.* 1645, after John Hoskins: National Portrait Gallery, London; (58) Engraving of Dr Richard Busby by James Mason, after John Riley: The Bridgeman Art Library/Fotomas Index; (64) Engraving of a lathe from *L'Art de Tourner* by P. C. Plumier, 1749: The British Library; (68) Engraving of Dr John Wilkins by R. White: Author's personal collection; (70) Engraving of Thomas Willis from a publication by Thomas Birch, 1743: The British Library; (74) Frontispiece from *De anima brutorum* by Thomas Willis, 1672; The Wellcome Trust; (83) Engraved plate showing Chinese

391

mandarins from the Dutch edition of *Itinerario* by J. H. van Linschoten, 1596: The British Library; (84) Engraved plate showing an Indian prostitute from the Dutch edition of *Itinerario* by J. H. van Linschoten, 1596: The British Library; (95) Engraving based on Hooke's drawings illustrating surface tension and capillary action from his first official publication, 1661: Author's personal collection; (98) Sketches by John Evelyn of possible coats of arms for the Royal Society, published 1660, Evelyn Papers 78344: The British Library; (102) Engraved plate for Boyle's *Experiments touching Cold*, 1664; Author's personal collection; (103) Engraved portrait of Boyle by William Faithorne: Ashmolean Museum; (116) Sketches of the 1664 comet by Hooke: © The Royal Society; (122) Fossil shells engraved from original drawings by Hooke in Waller's edition of Hooke's *Posthumous Works*: Museum of the History of Science, Oxford; (124) Illustration of a fracture surface of Kettering Stone from *Micrographia*, 1665: Museum of the History of Science, Oxford; (132/133) engraving of *The Great Fire of London*, 1666, by J. Snow: Guildhall Library, Corporation of London. Photo by Geremy Butler; (136/137/138) Double page and detail of engraving of plan of London by Wenceslaus Hollar, 1666: Guildhall Library, Corporation of London; (153) Drawing by Hooke of the west front of the City church of St Edmund the King: The Warden and Fellows of All Souls College, Oxford; (155) Record of payments made to the City Chamberlain, 1667: Corporation of London Records Office; (157) Certificate of two areas of ground: Corporation of London Records Office; (160) Report of a view by Hooke and Oliver: Corporation of London Records Office; (166/167) Full page and detail of engraving showing Hooke's zenith telescope from *An Attempt to Prove the Motion of the Earth*, 1674: Museum of the History of Science, Oxford; (170) Engraving of the Royal College of Physicians: Guildhall Library, Corporation of London; (172) Section drawing of the Monument to the Great Fire: by John Hare © Lisa Jardine; (174/175) engraving of Bethlehem or Bedlam Hospital: Guildhall Library, Corporation of London; (184/185) Frontispiece and licence to Hooke's *Micrographia*, 1665: Museum of the History of Science, Oxford; (186/187) Engraving of a flea from a drawing by Hooke (or possibly Wren) from *Micrographia*, 1665: Museum of the History of Science, Oxford; (188) Illustration of a stinging nettle, based on a drawing by Hooke, from *Micrographia*, 1665; Museum of the History of Science, Oxford; (189) Christiaan Huygens: Library of Congress; (197) Henry

Oldenburg by Jan Van Cleef: © The Royal Society; (199) Illustration of Christiaan Huygens's balance-spring watch from *Philosophical Transactions*, 1675: © The Royal Society; (204) Page from Hooke's diary, August/September 1675: Guildhall Library, Corporation of London; (205/top) Detail of page from Hooke's diary, August 1678; Guildhall Library, Corporation of London; (205/bottom) Title-page of Hooke's Lectures 'Of Spring', 1678: Museum of the History of Science, Oxford; (218/219) Pages from Hooke's diary, July and August 1678: Guildhall Library, Corporation of London; (222) Seventeenth-century collection of medicine samples (Vigani cabinet): Courtesy Queens' College, Cambridge. Photo by Brian Callingham; (229) Hooke's illustration of 'gravel' in urine from *Micrographia*, 1665: Museum of the History of Science, Oxford; (237) Statue of Sir John Cutler by Arnold Quelling: Guildhall Library, Corporation of London; (241) Nineteenth-century drawing of the Royal College of Physicians by Buckler, 1828: The British Library; (248) Detail of George Vertue's engraving of Gresham College showing Hooke's rooms: Guildhall Library, Corporation of London; (250) Illustration of a fish by Henry Hunt: © The Royal Society; (258) Pen and ink detail of a study of ships by Willem Schellinks: Picture Archive, ÖNB Vienna; (260) Edmond Halley by Sir Godfrey Kneller: © National Maritime Museum; (262/263) Engraving of the island of St Helena from *Itinerario* by J. H. van Linschoten, 1596: The British Library; (265) Engraving of Johannes Hevelius and his wife depicted with quadrant from *J. Hevelii Machinae Coelestis*: The British Library; (267) John Wallis by Gerard Soest: © The Royal Society; (270) John Flamsteed by an unknown artist: © The Royal Society; (273) Engraving of Captain Robert Knox: Bodleian Library, Oxford; (276/277) Frontispiece and title-page of the later Dutch edition of Knox's *An Historical Relation of Ceylon*, published in 1692: The British Library; (278) Engraving of a man under a talipot leaf from the later English edition of Knox's *An Historical Relation of Ceylon*, published in 1681: The British Library; (284) Engraving of a London coffee house: Mary Evans Picture Library; (291) Engraving of William and Mary by Jakob Van der Schley, after Hubert François Gravelot (or Bourguignon): National Portrait Gallery, London; (293) William Bentinck by an artist in the studio of Hyacinthe Rigaud, *c.* 1699: National Portrait Gallery, London; (313) Gresham College accounts book for the 1690s (folios 7v and 8r): Corporation of London Records Office; (318) Engraving of Crane Court by C. J. Smith: © The Royal Society.

The Royal Society; Detail of a page from Hooke's diary with a diagram of springs in his balance-spring watch: Guildhall Library, Corporation of London; Detail of a page from Hooke's diary, April 1674: Guildhall Library, Corporation of London; Hooke's unsigned Will: © Public Record Office.

# BIBLIOGRAPHY

PRE-1800

Bagshaw, E., the younger, *A True and Perfect Narrative of the Differences between Mr Busby and Mr Bagshawe, the first and second masters of Westminster-School. Written long since, and now published, in answer to the calumnies of Mr Pierce* (London, 1659)

Baron, S., *A Description of the Kingdom of Tonqueen*, in T. Wotton et al., *A Collection of Voyages and Travels, some Now first Printed from Original Manuscripts, others Now First Published in English, In Six Volumes. With a General Preface, giving an Account of the Progress of Navigation, from its first Beginning. Illustrated with a great Number of useful Maps and Cuts, Curiously Engraven. Printed by Assignment from Mess<sup>rs</sup> Churchill, for John Walthoe* (1732), vol. 6

Birch, T., *A History of the Royal Society of London for Improving Natural Knowledge, from its first Rise*, 4 vols (London, 1756)

Derham, W. (ed.), *Philosophical Experiments and Observations of the late Eminent Dr. Robert Hooke* (London, 1726)

Evelyn, J., *A Character of England, As it was lately presented in a Letter, to a Noble Man of France* (London, 1659)

Hooke, R., *Micrographia, or some Physiological Descriptions of Minute Bodies made by Magnifying Glasses. With Observations and Inquiries thereupon* (London, 1665)

Hooke, R., *An Attempt to prove the Motion of the Earth from Observations made by Robert Hooke Fellow of the Royal Society* (London: John Martyn, 1674)

Hooke, R., *A Description of Helioscopes, and some other Instruments* (London: John Martyn, Printer to the Royal Society, 1676)

Hooke, R., *Lampas: or Descriptions of some Mechanical Improvements of Lamps & Waterpoises* (London, 1677)

Hooke, R., *Animadversions on the First Part of the Machina Coelestis of . . . Johannes Hevelius* (London, 1674), included in Hooke, *Lectiones Cutlerianae* (London, 1679)

Moore, J., *A New System of Mathematics* (London, 1681)

Moore, J., *A Mathematical Compendium, or, Useful Practices in Arithmetic, Geometry, etc.* (London, 1681)

Newton, I., *Philosophiae naturalis principia mathematica* (London, 1687)

Oughtred, W., *Clavis mathematicae* (Oxford, 1652)

Ray, J., *The wisdom of God manifested in the works of the creation: In two parts. viz. the heavenly bodies, elements, meteors, fossils, vegetables, animals, (beasts, birds, fishes, and insects) more particularly in the body of the earth, its figure, motion, and consistency, and in the admirable structure of the bodies of man, and other animals, as also in their generation, &c* (London, 1691)

Sprat, T., *Observations on Monsieur de Sorbiere's Voyage into England. Written to Dr Wren* (London, 1665)

Sprat, T., *The History of the Royal Society of London for the Improving of Natural Knowledge* (London, 1667)

Waller, R. (ed.), *The Posthumous Works of Robert Hooke* (London, 1705)

Ward, J., *Lives of the Gresham Professors* (London, 1740)

Wilkins, J., *The discovery of a world in the moone, or, a discourse tending to prove, that 'tis possible there may be another habitable world on that planet,* with *A discourse concerning the possibility of a passage thither* (London, 1638)

Wilkins, J., *A discourse concerning a new planet, tending to prove that 'tis probable our Earth is one of the planets* (London, 1640)

Wilkins, J., *Mercury, or the secret and swift messenger, showing how a man may with privacy and speed communicate his thoughts to a friend at any distance* (London, 1641)

Wilkins, J., *Mathematical magick, or the wonders that may be performed by mechanical geometry* (London, 1648)

Wilkins, J., *An Essay towards a Real Character, and a Philosophical Language. With An alphabetical dictionary, wherein all English words … . are either referred to their places in the Philosophical Tables, or explained by such words as are in those Tables* (London, 1668)

Wilkins, J., *Of the Principles and Duties of Natural Religion* (London, 1675)

Worsley, Sir R. (ed.), *The History of the Isle of Wight* (London: A. Hamilton, 1781)

Wren Jr, Matthew, *Monarchy Asserted, or the State of Monarchicall & Popular Government in Vindication of the Considerations upon Mr. Harrington's Oceana* (Oxford, 1659)

Aarsleff, H., 'John Wilkins', *Dictionary of Scientific Biography* 14 (1976)

Ackroyd, P., *London: The Biography* (London: Chatto, 2000)

Adair, J., *By the Sword Divided: Eyewitness Accounts of the English Civil War* (Bridgend: Sutton Publishing, 1998)

Alpers, S., *The Art of Describing: Dutch Art in the Seventeenth Century* (Chicago: University of Chicago Press, 1983)

Andrewes, W. J. H. (ed.), *The Quest for Longitude* (Cambridge, Mass.: Harvard University Press, 1996)

Andriesse, C. D., *Titan kan niet slapen: een biografie van Christiaan Huygens* (Amsterdam: Contact, 1993), French trans. D. Losman, *Christian Huygens* (Paris: Albin Michel, 1998)

Ashworth, W. J., '"Labour harder than *thrashing*": John Flamsteed, property and intellectual labour in nineteenth-century England', in F. Willmoth, *Flamsteed's Stars: New Perspectives on the Life and Work of the First Astronomer Royal (1646–1719)* (Woodbridge: Boydell Press, 1997), pp. 199–216

Aylmer, G., 'Patronage at the court of Charles II', in E. Cruickshanks (ed.), *The Stuart Courts* (Stroud: Sutton Publishing, 2000), pp. 191–202

Bachrach, A. G. H. and R. G. Collmer (eds), *Lodewijk Huygens: The English Journal 1651–1652* (Leiden: Brill, 1982)

Bamford, F., *A Royalist's Notebook. The Commonplace Book of Sir John Oglander Kt. Of Nunwell. Born 1585 died 1655, Transcribed and edited by Francis Bamford* (London: Constable & Co., 1936)

Barclay, A., 'Charles II's failed Restoration: administrative reform below stairs, 1660–4', in E. Cruickshanks (ed.), *The Stuart Courts* (Stroud: Sutton Publishing, 2000), pp. 158–70

Barnett, P. R., *Theodore Haak, FRS (1605–1690)* ('sGravenshage: Mouton & Co., 1962)

Batten, M. I., 'The Architecture of Dr Robert Hooke FRS', *Walpole Society* 25 (1936–7), 83–113

Bédoyère, G. de la, *Particular Friends: The Correspondence of Samuel Pepys and John Evelyn* (Woodbridge: Boydell & Brewer, 1997)

Beer, E. S. de, *The Diary of John Evelyn*, 6 vols (Oxford: Clarendon Press, 1955; reprinted 2000)

Bennett, J. A., 'Wren's last building?', *Notes and Records of the Royal Society* 27 (1972–3), 107–18

Bennett, J. A., 'Hooke and Wren and the system of the world: some points

towards a historical account', *British Journal for the History of Science* 8 (1975), 32–61

Bennett, J. A., 'Robert Hooke as mechanic and natural philosopher', *Notes and Records of the Royal Society* 35 (1980), 33–48

Bennett, J. A., *The Mathematical Science of Christopher Wren* (Cambridge: Cambridge University Press, 1982)

Bennett, J. A., M. Cooper, M. Hunter and L. Jardine (eds), *London's Leonardo: The Life and Works of Robert Hooke* (Oxford: Oxford University Press, 2003)

Bennett, J. A. and S. Mandelbrote (eds), *The Garden, the Ark, the Tower, the Temple: Biblical Metaphors of Knowledge in Early Modern Europe* (Oxford: Museum of the History of Science, 1998)

Biswas, A. K., 'The automatic rain-gauge of Sir Christopher Wren, FRS', *Notes and Records of the Royal Society* 22 (1967), 94–104

Bos, H. J. M., M. J. S. Rudwick, H. A. M. Snelders and R. P. W. Visser (eds), *Studies on Christiaan Huygens* (Lisse: Swets & Zeitlinger, 1980)

Bowen, E. J. and H. Hartley, 'The Right Reverend John Wilkins, FRS (1614–1672)', *Notes and Records of the Royal Society* (1960), 47–56

Bradley, S. and N. Pevsner, *London: The City Churches* (London: Penguin, revised edition, 1998)

Brodsley, L., C. Frank and J. Steeds, 'Prince Rupert's drops', *Notes and Records of the Royal Society* 41 (1986)

Buchanan-Brown, J. (ed.), *John Aubrey: Brief Lives* (London: Penguin Books, 2000)

Burrows, M. (ed.), *The Register of the Visitors of the University of Oxford from AD 1647 to AD 1658* (London, 1881)

Campbell, J. W. P., 'Sir Christopher Wren, the Royal Society and the Development of Structural Carpentry 1660–1710' (University of Cambridge: PhD dissertation, 2000)

Canny, N. P., *The Upstart Earl: A Study of the Social and Mental World of Richard Boyle first Earl of Cork 1566–1643* (Cambridge: Cambridge University Press, 1982)

Carlton, C., *Charles I: The Personal Monarch* (second edition; London: Routledge, 1995)

Colvin, H. M., *The History of the King's Works*, 7 vols (London: Her Majesty's Stationery Office, 1963–82)

Colvin, H., *A Biographical Dictionary of British Architects 1600–1840* (third edition; New Haven and London: Yale University Press, 1995)

Cook, A., *Edmond Halley: Charting the Heavens and the Seas* (Oxford: Clarendon Press, 1998)

Cooper, J. (ed.), *Great Britons: The Great Debate* (London: National Portrait Gallery, 2002)

Cooper, M. A. R., 'Robert Hooke's work as surveyor for the City of London in the aftermath of the Great Fire. Part one: Robert Hooke's first surveys for the City of London', *Notes and Records of the Royal Society* 51 (1997), 161–74

Cooper, M. A. R., 'Robert Hooke's work as surveyor. Part two: certification of areas of ground taken away from streets and other new works', *Notes and Records of the Royal Society* 52 (1998), 25–38

Cooper, M. A. R., 'Robert Hooke's work as surveyor. Part three: settlement of disputes and complaints arising from rebuilding', *Notes and Records of the Royal Society* 52 (1998), 205–20

Cooper, M. A. R., *'A More Beautiful City': Robert Hooke and the Rebuilding of London* (Stroud: Sutton Publishing, 2003)

Coote, S., *Royal Survivor: A Life of Charles II* (London: Hodder & Stoughton, 1999)

Cranston, M., *John Locke: A Biography* (London: Longmans, Green & Co., 1957)

Crowther, J. G., *Founders of British Science: John Wilkins, Robert Boyle, John Ray, Christopher Wren, Robert Hooke, Isaac Newton* (London: Cresset Press, 1960)

Cruickshanks, E. (ed.), *The Stuart Courts* (Stroud: Sutton Publishing, 2000)

Dear, P., 'Totius in verba: rhetoric and authority in the early Royal Society', *Isis* 76 (1985), 145–61

Dickinson, H. W., *Sir Samuel Morland, Diplomat and Inventor 1625–1695* (Cambridge: Cambridge University Press, 1970)

Drake, E. T., *Restless Genius: Robert Hooke and his Earthly Thoughts* (Oxford: Oxford University Press, 1996)

Dunn, R. S. and L. Yeandle, *The Journal of John Winthrop 1630–1649* (Cambridge, Mass.: Harvard University Press, 1996)

Elmes, J., *Memoirs of the Life and Works of Sir Christopher Wren* (London: Priestley & Weale, 1823)

'Espinasse, M. M., *Robert Hooke* (London: William Heinemann, 1956)

Fara, P., *Newton: The Making of a Genius* (London: Macmillan, 2002)

Fauvel, J., R. Flood and R. Wilson, *Oxford Figures: 800 Years of the Mathematical Sciences* (Oxford: Oxford University Press, 2000)

Feingold, M., 'Astronomy and strife: John Flamsteed and the Royal Society', in F. Willmoth (ed.), *Flamsteed's Stars: New Perspectives on the*

Life and Work of the First Astronomer Royal (1646–1719) (Woodbridge: Boydell Press, 1997), pp. 31–48

Feingold, M., 'Of records and grandeur: the archive of the Royal Society', in M. Hunter (ed.), *Archives of the Scientific Revolution: The Formation and Exchange of Ideas in Seventeenth-Century Europe* (Woodbridge: Boydell Press, 1998), pp. 171–84

Feisenberger, H. A., 'The libraries of Newton, Hooke and Boyle', *Notes and Records of the Royal Society* 21 (1966), 42–55

Ferguson, D. W., *Captain Robert Knox . . . Contributions towards a Biography* (Colombo and Croydon: privately printed, 1896–7)

Field, J., *The King's Nurseries* (London: James & James, 1987)

Field, J. V. and F. A. J. L. James, *Renaissance and Revolution: Humanists, Scholars, Craftsmen and Natural Philosophers in Early Modern Europe* (Cambridge: Cambridge University Press, 1993)

Fleming, J., H. Honour and N. Pevsner (eds), *The Penguin Dictionary of Architecture and Landscape Architecture* (fifth edition; London: Penguin Press, 1999)

Forbes, E. G., L. Murdin and F. Willmoth (eds), *The Correspondence of John Flamsteed, The First Astronomer Royal*, 3 vols (Bristol and Philadelphia: Institute of Physics Publishing, 1995–2001)

Frank Jr, R. G., 'John Aubrey FRS, John Lydall, and science at Commonwealth Oxford', *Notes and Records of the Royal Society* 27 (1972–3), 193–217

Frank Jr, R. G., 'The physician as virtuoso in seventeenth-century England', in B. Shapiro and R. G. Frank Jr (eds), *English Scientific Virtuosi in the 16th and 17th Centuries* (Los Angeles: William Andrews Clark Memorial Library, 1979)

Frank Jr, R. G., *Harvey and the Oxford Physiologists: A Study of Scientific Ideas* (Berkeley: University of California Press, 1980)

Frank Jr, R. G., 'Thomas Willis and his circle: brain and mind in seventeenth-century medicine', in G. S. Rousseau (ed.), *The Languages of Psyche: Mind and Body in Enlightenment Thought* (Berkeley: University of California Press, 1990), pp. 107–46

Frank Jr, R. G., 'Viewing the body: reframing man and disease in Commonwealth and Restoration England', in W. G. Marshall (ed.), *The Restoration Mind* (London: Associated University Presses, 1997), pp. 65–110

Geraghty, A., 'New Light on the Wren City Churches: The Evidence of the All Souls and Bute Drawings' (University of Cambridge: PhD dissertation, 1999)

Geraghty, A., 'Introducing Thomas Laine, draughtsman to Sir Christopher Wren', *Architectural History* 42 (1999), 240–5

Geraghty, A., 'Wren's preliminary design for the Sheldonian Theatre', *Architectural History* 45 (2002), 275–88

Gleick, J., *Isaac Newton* (London: Fourth Estate, 2003)

Gouk, P., 'The role of acoustics and music theory in the scientific work of Robert Hooke', *Annals of Science* 37 (1980), 573–605

Gouk, P., 'Acoustics in the early Royal Society 1669–1680', *Notes and Records of the Royal Society* 36 (1982), 155–75

Gouk, P., *Music Science and Natural Magic in Seventeenth-Century England* (New Haven and London: Yale University Press, 1999)

Greengrass, M., M. Leslie and T. Raylor (eds), *Samuel Hartlib and Universal Reformation: Studies in Intellectual Communication* (Cambridge: Cambridge University Press, 1994)

Gunther, R. T., *Early Science in Oxford*, 15 vols (Oxford: printed for the author, Oxford University Press, 1920–67): vols 6 and 7 (*Life and Work of Robert Hooke*, 1 and 2) (Oxford, 1930); vol. 8 (*The Cutler Lectures of Robert Hooke*) (Oxford, 1931); vol. 10 (*Life and Work of Robert Hooke* [contains some post-1688 diary entries], 4) (Oxford, 1935); vol. 13 (*Micrographia: Life and Work of Robert Hooke*, 5) (Oxford, 1938)

Gunther, R. T. (ed.), *The Architecture of Sir Roger Pratt, Charles II's Commissioner for the Rebuilding of London after the Great Fire: Now Printed for the first time from his Note-Books* (Oxford: Oxford University Press, 1928)

Hall, A. R., 'Robert Hooke and horology', *Notes and Records of the Royal Society* 8 (1951), 167–77

Hall, A. R., 'Two unpublished lectures of Robert Hooke', *Isis* 42 (1951), 219–30

Hall, A. R. and M. B. Hall, 'Why blame Oldenburg?', *Isis* 53 (1962) 482–91

Hall, A. R. and M. B. Hall (eds and trans.), *The Correspondence of Henry Oldenburg*, 13 vols: vols 1–9 (Madison: University of Wisconsin Press, 1965–73); vols 10–11 (London: Mansell, 1975–6); vols 12–13 (London: Taylor & Francis, 1986)

Hall, A. R. and R. S. Westfall, 'Did Hooke concede to Newton?', *Isis* 58 (1967), 403–5

Hall, M. B., 'Oldenburg, the Philosophical Transactions and technology', in J. G. Burke (ed.), *The Uses of Science in the Age of Newton* (Berkeley: University of California Press, 1985), pp. 21–47

Hambly, E. C., 'Robert Hooke, the City's Leonardo', *City University* 2 (1987), 5–10

Hardacre, P. H., *The Royalists during the Puritan Revolution* (The Hague: Marinus Nijhoff, 1956)

Harris, E., *British Architectural Books and Writers 1556–1785* (Cambridge: Cambridge University Press, 1990)

Harris, F., 'Ireland as a laboratory: the archive of Sir William Petty', in M. Hunter (ed.), *Archives of the Scientific Revolution: The Formation and Exchange of Ideas in Seventeenth-Century Europe* (Woodbridge: Boydell Press, 1996)

Harris, F., 'Living in the neighbourhood of science: Mary Evelyn, Margaret Cavendish and the Greshamites', in L. Hunter and S. Hutton (eds), *Women, Science and Medicine 1500–1700* (Stroud: Sutton Publishing, 1997), pp. 198–217

Harris, F., 'The letterbooks of Mary Evelyn', *English Manuscript Studies* (1998), 202–15

Harris, F., *Transformations of Love: The Friendship of John Evelyn and Margaret Godolphin* (Oxford: Oxford University Press, 2003)

Hart, V., *Nicholas Hawksmoor: Rebuilding Ancient Wonders* (London: Yale University Press, 2002)

Hart, V. with P. Hicks (eds), *Paper Palaces: The Rise of the Renaissance Architectural Treatise* (London: Yale University Press, 1998)

Hazelhurst, F. H., *Gardens of Illusion: The Genius of André Le Nostre* (Nashville: University of Tennessee Press, 1980)

Heilbron, J. L., *The Sun in the Church: Cathedrals as Solar Observatories* (Cambridge, Mass.: Harvard University Press, 1999)

Heyman, J., 'Hooke's cubico-parabolical conoid', *Notes and Records of the Royal Society* 52 (1998), 39–50

Heyman, J., *The Science of Structural Engineering* (London: Imperial College Press, 1999)

Heyman, J. 'Hooke and Bedlam' (in press)

Hinks, A. R., 'Christopher Wren the Astronomer', in *Sir Christopher Wren AD 1632–1723. Bicentenary Memorial Volume published under the auspices of the Royal Institute of British Architects* (London: Hodder & Stoughton, 1923), pp. 239–54

Hoak, D. and M. Feingold (eds), *Anglo-Dutch Perspectives on the Revolution of 1688–89* (Stanford: Stanford University Press, 1996)

Holmes, G., *The Making of a Great Power: Late Stuart and Early Georgian Britain 1660–1722* (London: Longman, 1993)

Howse, D., *Greenwich Time and Longitude* (second edition; London: Philip Wilson, 1997)

Hull, D., 'Robert Hooke: a fractographic study of Kettering-stone', *Notes and Records of the Royal Society* 51 (1997), 45–55

Hunt, J. D. and E. de Jong (eds), *The Anglo-Dutch Garden in the Age of William and Mary* (London: Taylor & Francis, 1988) [special double issue of the *Journal of Garden History*]

Hunt, J. D. and P. Willis (eds), *The Genius of the Place: English Landscape Garden 1620–1820* (New York: Harper & Row, 1975)

Hunter, L., 'Sisters of the Royal Society: the circle of Katherine Jones, Lady Ranelagh', in L. Hunter and S. Hutton (eds), *Women, Science and Medicine 1500–1700* (Stroud: Sutton Publishing, 1997), pp. 178–97

Hunter, L. and S. Hutton (eds), *Women, Science and Medicine 1500–1700* (Stroud: Sutton Publishing, 1997)

Hunter, M., *John Aubrey and the Realm of Learning* (London: Duckworth, 1975)

Hunter, M., *Science and Society in Restoration England* (Cambridge: Cambridge University Press, 1981)

Hunter, M., *The Royal Society and its Fellows 1660–1700: The Morphology of an Early Scientific Institution* (Oxford: British Society for the History of Science, 1982; second edition, 1994)

Hunter, M., 'Early problems in professionalizing scientific research: Nehemiah Grew (1641–1712) and the Royal Society. With an unpublished letter to Henry Oldenburg', *Notes and Records of the Royal Society* 36 (1982), 189–209

Hunter, M., 'A "College" for the Royal Society: the abortive plan of 1667–1668', *Notes and Records of the Royal Society* 38 (1984), 159–86

Hunter, M., *Establishing the New Science: The Experience of the Early Royal Society* (Woodbridge: Boydell Press, 1989)

Hunter, M. (ed.), *Robert Boyle by Himself and his Friends* (London: Pickering & Chatto, 1994)

Hunter, M., *Science and the Shape of Orthodoxy: Intellectual Change in Late Seventeenth-Century Britain* (Woodbridge: Boydell Press, 1995)

Hunter, M., *Archives of the Scientific Revolution: The Formation and Exchange of Ideas in Seventeenth-Century Europe* (Woodbridge: Boydell Press, 1998)

Hunter, M., *Robert Boyle, 1627–91: Scrupulosity and Science* (Woodbridge: Boydell Press, 2000)

Hunter, M., 'The work-diaries of Robert Boyle: a newly discovered source and its internet publication', *Notes and Records of the Royal Society* 55 (2001), 373–90

Hunter, M., A. Clericuzo and L. M. Principe (eds), *The Correspondence of Robert Boyle*, 6 vols (London: Pickering & Chatto, 2001)

Hunter, M. and E. B. Davis (eds), *The Complete Works of Robert Boyle*, 14 vols (London: Pickering & Chatto, 1999–2001)

Hunter, M. and S. Schaffer (eds), *Robert Hooke: New Studies* (Woodbridge: Boydell Press, 1989)

Hutton, R., *Charles the Second King of England, Scotland, and Ireland* (Oxford: Clarendon Press, 1989)

Huygens, C., *Oeuvres complètes de Christiaan Huygens*, 22 vols (The Hague: Martinus Nijhoff, 1888–1950)

Iliffe, R., '"In the warehouse": privacy, property and priority in the early Royal Society', *History of Science* 30 (1992), 29–68

Iliffe, R., '"Material doubts": Robert Hooke, artisanal culture and the exchange of information in 1670s London', *British Journal for the History of Science* 28 (1995), 285–318

Iliffe, R., 'Mathematical characters: Flamsteed and Christ's Hospital Royal Mathematical School', in F. Willmoth (ed.), *Flamsteed's Stars: New Perspectives on the Life and Work of the First Astronomer Royal (1646–1719)* (Woodbridge: Boydell Press, 1997), pp. 115–44

Iliffe, R., 'Foreign bodies: travel, empire and the early Royal Society of London. Part I. Englishmen on tour', *Canadian Journal of History* (1998)

Iliffe, R., 'Foreign bodies: travel, empire and the early Royal Society of London. Part II. The land of experimental knowledge', *Canadian Journal of History* (1999)

Impey O. and A. MacGregor (eds), *The Origin of Museums: The Cabinet of Curiosities in Sixteenth- and Seventeenth-Century Europe* (Oxford: Clarendon Press, 1985)

Inwood, S., *A History of London* (London: Macmillan, 2000)

Inwood, S., *The Man Who Knew Too Much: The Strange and Inventive Life of Robert Hooke 1635–1703* (London: Macmillan, 2002)

Jacob, J. R. and M. C. Jacob, 'The Anglican origins of modern science: the metaphysical foundations of the Whig constitution', *Isis* 71 (1980), 251–67

Jacob, M. C., *Living the Enlightenment: Freemasonry and Politics in Eighteenth-Century Europe* (Oxford: Oxford University Press, 1991)

Jardine, L., *Erasmus, Man of Letters: The Construction of Charisma in Print* (Princeton: Princeton University Press, 1993)

Jardine, L., *Ingenious Pursuits: Building the Scientific Revolution* (London: Little, Brown, 1996)

Jardine, L., 'Monuments and microscopes: scientific thinking on a grand scale in the early Royal Society', *Notes and Records of the Royal Society* 55 (2001), 289–308

Jardine, L., *On a Grander Scale: The Outstanding Career of Sir Christopher Wren* (London: HarperCollins, 2002)

Jardine, L., 'Paper monuments and learned societies: the Hooke Royal Society Repository', in R. Anderson, M. Caygill and A. MacGregor (eds), *Enlightening the British: Knowledge, Discovery and the Museum in the Eighteenth Century* (London: British Museum Publications, in press)

Jeffery, P., *The City Churches of Sir Christopher Wren* (London: Hambledon Press, 1996)

Johns, A., *The Nature of the Book: Print and Knowledge in the Making* (Chicago: University of Chicago Press, 1998)

Johns, A., 'Miscellaneous methods: authors, societies and journals in early modern England', *British Journal of the History of Science* 33 (2000), 159–86

Jones, E. L., 'Robert Hooke and the Virtuoso', *Modern Language Notes* 66 (1951), 180–1

Jones, J. D., *The Royal Prisoner: Charles I at Carisbrooke* (Northumberland Press, 1965)

Josten, C. H. (ed.), *Elias Ashmole. His Autobiographical and Historical Notes, his Correspondence, and other Contemporary Sources relating to his Life and Work*, 5 vols (Oxford: Clarendon Press, 1966)

Kargon, R. H., 'The testimony of nature: Boyle, Hooke and the experimental philosophy', *Albion* 3 (1971), 72–81

Keay, J., *The Honourable Company: A History of the English East India Company* (London: HarperCollins, 1991)

Keblusek, M. and J. Zijlmans, *Princely Display: The Court of Frederik Hendrik of Orange and Amalia van Solms* (Zwolle: Historical Museum, The Hague, 1997)

Keynes, G., *A Bibliography of Dr. Robert Hooke* (Oxford: Clarendon Press, 1960)

Kitson, F., *Prince Rupert: Admiral and General-at-Sea* (London: Constable, 1998)

Koyré, A., 'A note on Robert Hooke', *Isis* 41 (1950), 195–6

Koyré, A., 'An unpublished letter of Robert Hooke to Isaac Newton', *Isis* 43 (1952), 312–37

Kuyper, W., *Dutch Classicist Architecture: A Survey of Dutch Architecture, Gardens, and Anglo-Dutch Architectural Relations from 1625 to 1700* (Delft: Delft University Press, 1980)

Lang, J., *Rebuilding St. Paul's* (Oxford: Oxford University Press, 1956)

Lansdowne, Marquis of (ed.), *The Petty Papers: Some Unpublished Writings*, 2 vols (London: Constable & Co., 1927)

Latham, R. and W. Matthews (eds), *The Diary of Samuel Pepys*, 11 vols (London: HarperCollins, 1972; reissued 1995)

Lawrence, C. and S. Shapin (eds), *Science Incarnate: Historical Embodiments of Natural Knowledge* (Chicago and London: University of Chicago Press, 1998)

Lehmberg, S. E., *Cathedrals under Siege: Cathedrals in English Society 1600–1700* (Exeter: University of Exeter Press, 1996)

Leopold, J. H., 'The longitude timekeepers of Christiaan Huygens', in W. J. H. Andrewes (ed.), *The Quest for Longitude* (Cambridge, Mass.: Harvard University Press, 1996), pp. 102–14

McCray Beier, L., 'Experience and experiment: Robert Hooke, illness and medicine', in M. Hunter and S. Schaffer (eds), *Robert Hooke: New Studies* (Woodbridge: Boydell Press, 1989), pp. 235–52

MacDougall, E. B. and F. H. Hazelhurst (eds), *The French Formal Garden* (Washington, DC: Dumbarton Oaks Trustees for Harvard University, 1974)

Macfarlane, A. and G. Martin, *The Glass Bathyscaphe: How Glass Changed the World* (London: Profile Books, 2002)

MacGregor, A. (ed.), *The Late King's Goods: Collections, Possessions and Patronage of Charles I in the Light of the Commonwealth Sale Inventories* (London and Oxford: Oxford University Press, 1989)

MacGregor, A. (ed.), *Sir Hans Sloane: Collector, Scientist, Antiquary, Founding Father of the British Museum* (London: British Museum Press, 1994)

McKellar, E., *The Birth of Modern London: The Development and Design of the City 1660–1720* (Manchester: Manchester University Press, 1999)

MacPike, E. F. (ed.), *Correspondence and Papers of Edmond Halley* (London: Taylor & Francis, 1937)

Maddison, R. E. W., 'Studies in the life of Robert Boyle FRS. Part VI', *Notes and Records of the Royal Society* 18 (1963), 104–24

Malcolm, J. P., *Londinium Redivivium*, 4 vols (London, 1802–7)

Malcolm, N. (ed.), *The Correspondence of Thomas Hobbes*, 2 vols (Oxford: Clarendon Press, 1994)

Marshall, W. G. (ed.), *The Restoration Mind* (London: Associated University Presses, 1997)

Masson I. and A. J. Youngson, 'Sir William Petty FRS (1623–1687)', *Notes and Records of the Royal Society* (1960), 79–90

Melton, F. T., *Sir Robert Clayton and the Origins of English Deposit Banking 1658–1685* (Cambridge: Cambridge University Press, 1986)

Middleton, W. E. K., 'A footnote to the history of the barometer: an unpublished note by Robert Hooke, FRS', *Notes and Records of the Royal Society* 20 (1965), 145–51

Middleton, W. E. R. (ed.), *Lorenzo Magalotti at the Court of Charles II: His 'Relazione d'Inghilterra' of 1668* (Waterloo, Ontario: Wilfrid Laurier University Press, 1980)

Millar, O. (ed.), 'The inventories and valuations of the King's goods, 1649–1651', *Walpole Society* 43 (1970–2)

Morrill, J., *Revolt in the Provinces: The People of England and the Tragedies of War 1630–1648* (second edition; London and New York: Longman, 1999)

Morrill, J., *Stuart Britain: A Very Short Introduction* (Oxford: Oxford University Press, 2000)

Mowl, T. and B. Earnshaw, *Architecture without Kings: The Rise of Puritan Classicism under Cromwell* (Manchester: Manchester University Press, 1995)

Mulligan, L., 'Self-scrutiny and the study of nature: Robert Hooke's diary as natural history', *Journal of British Studies* 35 (1996), 311–42

Munby, A. N. L. (ed.), *Sale Catalogues of Libraries of Eminent Persons*, vol. 11 (London: Mansell, 1975) [Hooke]

Murdoch, J., *Seventeenth-century English Miniatures in the Collection of the Victoria and Albert Museum* (London: The Stationery Office in association with the Victoria and Albert Museum, n.d.)

Nakajima, H., 'Robert Hooke's family and his youth: some new evidence from the will of the Rev. John Hooke', *Notes and Records of the Royal Society* 48 (1994), 11–16

Nichols, J. B., *Illustrations of the Literary History of the Eighteenth Century* (London, J. B. Nichols & Sons, 1817 and 1822), vols 1 and 4

Nichols, R., *Robert Hooke and the Royal Society* (Sussex: The Book Guild, 1999)

Nicolson, M. H., *Pepys' Diary and the New Science* (Charlotteville: University Press of Virginia, 1965)

O'Flanagan, P. and C. G. Buttimer (eds), *Cork: History and Society: Interdisciplinary Essays on the History of an Irish County* (Dublin: Geography Publications, 1993)

Ollard, R., *Man of War: Sir Robert Holmes and the Restoration Navy* (London: Phoenix Press, 2001; first published Hodder & Stoughton, 1969)

O'Malley, T. and J. Wolschke-Bulmahn, *John Evelyn's 'Elysium*

*Britannicum' and European Gardening* (Dumbarton Oaks Publications, 1998)

Parry, J. H., *The Age of Reconnaissance: Discovery, Exploration and Settlement 1450–1650* (London: Weidenfeld & Nicolson, 1963; Phoenix Press edition, 2000)

Petrie, C. (ed.), *King Charles, Prince Rupert, and the Civil War from Original Letters* (London: Routledge & Kegan Paul, 1974)

Plowden, A., *The Stuart Princesses* (Stroud: Sutton Publishing, 1996)

Plowden, A., *Henrietta Maria: Charles I's Indomitable Queen* (Stroud: Sutton Publishing, 2001)

Porter, R. S., *The Making of Geology: Earth Science in Britain 1660–1815* (Cambridge: Cambridge University Press, 1977)

Porter, R. and G. S. Rousseau, *Gout: The Patrician Malady* (New Haven and London: Yale University Press, 1998)

Porter, S., *The Great Fire of London* (Stroud: Sutton Publishing, 1996)

Pumfrey, S., 'Ideas above his station: a social study of Hooke's curatorship of experiments', *History of Science* 29 (1991), 1–44

Quarrell, W. H. and M. Mare (eds and trans.), *Travels of Zacharias Conrad von Uffenbach: London in 1710* (London: Faber & Faber, 1934)

Reddaway, T. F., *The Rebuilding of London after the Great Fire* (London: Jonathan Cape, 1940)

Robb, N. A., *William of Orange: A Personal Portrait* (London: William Heinemann, 1962)

Robertson, A., *The Life of Sir Robert Moray, Soldier, Statesman and Man of Science (1608–1673)* (London: Longmans, Green & Co., 1922)

Robinson, H. W., 'An unpublished letter of Dr. Seth Ward relating to the early meetings of the Oxford Philosophical Society', *Notes and Records of the Royal Society* 7 (1949), 69–70

Robinson, H. W. and W. Adams (eds), *The Diary of Robert Hooke MA MD FRS 1672–1680* (London: Taylor & Francis, 1968)

Rostenberg, L., *The Library of Robert Hooke: The Scientific Book Trade of Restoration England* (Santa Monica, Calif.: Mordoc Press, 1989)

Rousseau, G. S. (ed.), *The Languages of Psyche: Mind and Body in Enlightenment Thought* (Berkeley: University of California Press, 1990)

Routh, E. M. G., *Tangier: England's Lost Atlantic Outpost* (London, 1912)

Rowen, H. H., *The Princes of Orange: The Stadholders in the Dutch Republic* (Cambridge: Cambridge University Press, 1988)

Rudwick, M. J. S., *The Meaning of Fossils: Episodes in the History of Palaeontology* (London: Macdonald and Co., 1972)

Russell Barker, G. F., *Memoir of Richard Busby* (London: Lawrence & Bullen, 1895)

Russell Barker, G. F. and Alan H. Stenning (eds), *The Record of Old Westminsters*, 2 vols (London: Chiswick Press, 1928)

Ryan, J. (ed.), *Robert Knox, An Historical Relation of Ceylon together With somewhat concerning Severall Remarkeable passages of my life that hath hapned since my Deliverance out of my Captivity* (Glasgow: James MacLehose & Sons, 1911)

Sargeaunt, J., *Annals of Westminster School* (London: Methuen & Co., 1898)

Schaffer, S., 'Regeneration: the body of natural philosophers in Restoration England', in C. Lawrence and S. Shapin (eds), *Science Incarnate: Historical Embodiments of Natural Knowledge* (Chicago and London: University of Chicago Press, 1998), pp. 83–120

Schama, S., *A History of Britain: The British Wars 1603–1776* (London: BBC Worldwide, 2001)

Schellinks, W., *The Journals of William Schellinks' Travels in England 1661–3*, Camden 5th Series, vol. 1 (Royal Historical Society, 1993)

Schooling, Sir William, 'Sir Christopher Wren Merchant Adventurer', in *Sir Christopher Wren AD 1632–1723. Bicentenary Memorial Volume published under the auspices of the Royal Institute of British Architects* (London: Hodder & Stoughton, 1923), pp. 255–64

Shapin, S., *A Social History of Truth: Civility and Science in Seventeenth-Century England* (Chicago: University of Chicago Press, 1994)

Shapin, S. and S. Schaffer, *Leviathan and the Air-Pump: Hobbes, Boyle, and the Experimental Life* (Princeton: Princeton University Press, 1985)

Shapiro, B. J., *John Wilkins 1614–1672: An Intellectual Biography* (Berkeley and Los Angeles: University of California Press, 1969)

Sharpe, K., *The Personal Rule of Charles I* (New Haven: Yale University Press, 1992)

Shepard, A. and P. Withrington (eds), *Communities in Early Modern England* (Manchester: Manchester University Press, 2000)

Slaughter, M. M., *Universal Languages and Scientific Taxonomy in the Seventeenth Century* (Cambridge: Cambridge University Press, 1982)

Sobel, D., *Longitude: The True Story of a Lone Genius Who Solved the Greatest Scientific Problem of his Time* (London: Fourth Estate, 1995)

Soo, L. M., *Wren's 'Tracts' on Architecture and Other Writings* (Cambridge: Cambridge University Press, 1998)

Stevenson, C., *Medicine and Magnificence: British Hospital and Asylum Architecture 1660–1815* (London: Yale University Press, 2000)

Stewart, L., 'Other centres of calculation, or, where the Royal Society didn't count: commerce, coffee-houses and natural philosophy in early modern London', *British Journal of the History of Science* 32 (1999) 133–53

Stoesser, A., 'Robert Hooke and Holland: Dutch Influence on Hooke's Architecture' (Utrecht University: doctoral dissertation, 1997)

Stoesser-Johnston, A., 'Robert Hooke and Holland: Dutch influence on his architecture', *Bulletin Kunincklijk Nederlands Oudheidkundig Bond* 99 (2000), 121–37

Strauss, E., *Sir William Petty: Portrait of a Genius* (London: Bodley Head, 1954)

Strong, R., *The Artist and the Garden* (New Haven and London: Yale University Press, 2000)

Stroup, A., *A Company of Scientists: Botany, Patronage, and Community at the Seventeenth-Century Parisian Royal Academy of Sciences* (Berkeley: University of California Press, 1990)

Taylor, E. G. R., '"The English Atlas" of Moses Pitt, 1680–83', *Geographical Journal*, 95 (1940)

Taylor, E. G. R., *The Mathematical Practitioners of Tudor and Stuart England* (Cambridge: Cambridge University Press, 1954)

Thrower, N. J. W. (ed.), *Standing on the Shoulders of Giants: A Longer View of Newton and Halley* (Berkeley, University of California Press, 1990)

Torrens, H., 'Etheldred Bennett of Wiltshire, England, the first lady geologist – her fossil collection in the Academy of Natural Sciences of Philadelphia, and the rediscovery of "lost" specimens of Jurassic Trigoniidae (Mollusca: Bivalvia) with their soft anatomy preserved', *Proceedings of the Academy of Natural Sciences of Philadelphia* (2000), 59–123

Turnbull, G. H., 'Samuel Hartlib's influence on the early history of the Royal Society', *Notes and Records of the Royal Society* 10 (1953), 101–30

Turnbull, H. W., J. F. Scott, A. R. Hall and L. Tilling (eds), *The Correspondence of Isaac Newton*, 7 vols (Cambridge: Cambridge University Press, 1959–77)

Turner, A. J., 'In the wake of the Act, but mainly before', in W. J. H. Andrewes (ed.), *The Quest for Longitude* (Cambridge, Mass.: Harvard University Press, 1996), pp. 116–27

van Strien, T. and K. van der Leer, *Hofwijk: Het Gedicht en de Buitenplaats van Caonstantijn Huygens* (Zutphen: Walburg Pers, 2002)

Wall, C., *The Literary and Cultural Spaces of Restoration London* (Cambridge: Cambridge University Press, 1998)

Webster, C. (ed.), *The Intellectual Revolution of the Seventeenth Century* (London: Routledge & Kegan Paul, 1974)

Webster, C., 'The College of Physicians: "Solomon's House" in Commonwealth England', *Bulletin of the History of Medicine* 41, 393–412

Webster, C., 'New light on the Invisible College', *Transactions of the Royal Historical Society*, 5th Series, 24 (1974), 19–42

Webster, C., *The Great Instauration: Science, Medicine and Reform 1626–1660* (London: Duckworth, 1975)

Weiser, B., 'Access and petitioning during the reign of Charles II', in E. Cruickshanks (ed.), *The Stuart Courts* (Stroud: Sutton Publishing, 2000), pp. 203–13

Westfall, R., *Never at Rest: A Biography of Isaac Newton* (Cambridge: Cambridge University Press, 1980)

Westfall, R., 'Robert Hooke, mechanical technology, and scientific investigation', in J. G. Burke (ed.), *The Uses of Science in the Age of Newton* (Berkeley: University of California Press, 1983), pp. 85–110

Williamson, T., *Polite Landscapes: Gardens and Society in Eighteenth-Century England* (Baltimore: Johns Hopkins University Press, 1995)

Willmoth, F., *Sir Jonas Moore: Practical Mathematics and Restoration Science* (Woodbridge: Boydell Press, 1993)

Willmoth, F. (ed.), *Flamsteed's Stars: New Perspectives on the Life and Work of the First Astronomer Royal (1646–1719)* (Woodbridge: Boydell Press, 1997)

Winn, J. A., *John Dryden and his World* (New Haven: Yale University Press, 1987)

Wood, A., *The Life and Times of Anthony Wood, antiquary of Oxford, 1632–1695*, 5 vols (Oxford: Oxford Historical Society, 1891–5)

Woodbridge, K., *Princely Gardens: The Origins and Development of the French Formal Style* (New York: Rizzoli, 1986)

Worp, J. A., 'Fragment eener Autobiographe van Constantijn Huygens', *Bijdragen en Mededeelingen van het historisch Genootschap* (Utrecht) 18 (1897) 1–122

*Wren Society* 20 vols (Oxford: printed for the Wren Society at the University Press, 1924–43)

Wright, M. 'Robert Hooke's longitude timekeeper', in M. Hunter and S. Schaffer (eds), *Robert Hooke: New Studies* (Woodbridge: Boydell Press, 1989), pp. 63–118

Yates, F., *The Rosicrucian Enlightenment* (London: Routledge & Kegan Paul, 1972)

Yoder, J. G., *Unrolling Time: Christiaan Huygens and the Mathematization of Nature* (Cambridge: Cambridge University Press, 1984)

# INDEX

Académie des Sciences 129
Act of Parliament for rebuilding 148
addiction 304
air-pump (Boyle/Hooke) 104, 105, 106, 189–91
All Souls, Oxford 67
ammonium chloride *see* sal ammoniac
Ansell, Noel 303, 304
Arundel House 163, 165
Aston, Francis 9, 266, 268
astronomical instruments 42
Aubrey, John: 174; letter to Wood 11; RH's appearance 16; RH's childhood 25, 54, 60; RH at Westminster School 65, 69; university studies 65–6; views on Wilkins, Wren and RH as thinkers 76; recommends Snell to RH 248; Grace Hooke 253; attends Cutlerian lecture 282; account of *Virtuoso* 322
Auzout, Adrien 107, 125, 129, 200

Bacon, Sir Francis 217
Bagshawe, Edward 59, 60
balance-spring watches 128–9, 198–203, 206, 208, 214
Balle, William 93, 165
'bangue' (cannabis) 280–1
Baron, Samuel 283–5
Barrow, Isaac 235
Barwick, Peter 302
Bathurst, Ralph 69, 77
Beale, John 215
Beale, Mary 17, 18, 91, 309
Beam Hall 78, 79
Bedlam Hospital 170, 174
Bentinck, William, Earl of Portland 292
Berkeley, Lord George 108
Betty (RH's maid) 254
Billingsley, Henry 61
Blackburne, Richard 249

Bloodworth, Sir Thomas 134, 139, 176, 253, 254, 255
Boucher, Charles 261
Boulter, Edmund 242, 244
Boyle, Robert: portrait 17–18, 91; RH tells of sea observation 29; RH assists 43, 65, 75, 81, 82, 87, 99, 100–2, 103, 112, 126, 238; and Greatorex 69; Oxford scientific group 70–1, 82; and Wilkins 70–2; does not attend worship at Beam Hall 79; engravings in early publications 80; moves to London 89; acting President of Royal Society 93; and Christiaan Huygens 94, 189–90; *Experiments touching Cold* 100–2; air-pump 105, 189–91; moves to Oxford 108; Durdans, Epsom 113–14; *Hydrostatical Paradoxes* 113–14; and Oldenburg 127–8; Oldenburg's death 210; drug-taking 221; helps RH see Holmes 257
brick-making 146
British Museum 318–19
Bronowski, Jacob 15
Brooke, Christopher 69
Brouncker, Sir William: 92; President of Royal Society 102, 210; projects for RH 112; and Christiaan Huygens 209; testing pendulum clocks 259
Bruce, Alexander (Earl of Kincardine) 259
building regulations 145–6
Busby, Richard: Westminster School 53, 55, 57–60, 61; identifies RH's talent 61, 62; Christ Church 64; beliefs 77; and RH 300; Willen estate 301; Lutton church 302, 303

Cambridge University 294
cannabis *see* 'bangue'
capillary action of water 93–5
Carisbrooke Castle 25, 48, 300
carriage design 108–11

Cavendish, Margaret (Duchess of Newcastle) 185
caves 36–7
Ceylon 273
Charles I 25, 47–50, 52, 89, 300, 301
Charles II: coronation 58; returns to England 86, 89, 235; and Moray 92; Great Fire 133; Wren's rebuilding London plans 143; Rebuilding Commission appointments 144; and RH 148; Hooke-Tompion watch 201–2; John Hooke's estate 256; and Knox 279
Charles Louis (Elector Palatine) 66, 67
Child, Sir Josiah 278
Christ Church, Oxford 63, 78
Christ's Hospital School 61
City churches rebuilding 149–52
City Churches Rebuilding Act 149
City Lands Committee 158
civil wars 47
Clarendon, Earl of 148
clocks see precision clock design
colour, theory of 295
Colwall, Daniel 243
comets, motion of 106–8, 115–16
Commission for Rebuilding the City Churches 149–50
compensation, for street widening 156–7
Convention Parliament 294
Copley, Sir Godfrey 298, 306, 311, 322
Cork, Earl of, 1st 88
Corporation of London 139, 141, 144, 146, 168
Crane Court 314–15, 317–18
Cromwell, Oliver 49, 67, 72, 300
Cromwell, Richard 82
Cutler, Sir John: 234–6; Cutlerian lectures 32, 168; arrears owed to RH 159, 212, 240, 241–5; Royal College of Physicians 168; endowment to Royal Society 168, 235–40; Royal Society elects honorary Fellow 238; death 244
Cutler, Thomas 235
Cutlerian lectures 32, 33, 168, 169, 191–3, 235–40, 240, 259, 282, 285–6

Dacres, Arthur 236
Dee, John 61
Defisher, Samuel 168
Denham, John 148, 149
Derham, William 62, 320
Dillon, Elizabeth (or Mary) 308, 309
Doomer, Lambert 34, 35, 39

Dove, Dr 303
Drebbel, Cornelijs 179
drug-taking 230
Dryden, John 63
Dulwich waters 223
Durdans, Epsom 108–20

East India Company 260, 261, 272, 274, 278, 279–80, 283
equatorial quadrant 44–7
'Espinasse, Margaret 15
Euclid 61
Evelyn, John: Westminster School 60; attends Royal Society meetings 94–5; Royal Society's name 95–6; Royal Society's coat of arms 97; air-pump 106; visits Durdan 114–15; views on RH 171; Sylva 184–5; and Constantijn Huygens 191; discusses Oldenburg's replacement 211; river excursions 259, 260; attends Cutlerian lecture 282; and Margaret Godolphin 321, 322

Farriner, Thomas 131
Fatio de Duillier, Nicolas 292, 294
Fell, John 75, 77, 78, 80
Fell, Samuel 24, 66, 77, 78
Fitch, John and Thomas 173
Flamsteed, John: Hooke quadrant 43; childhood 91; measurements from RH 165; Royal Society meetings 199; Royal Observatory 261; and Molyneux 269, 270, 270–1
fossils 37–42, 120
French, Peter 67
French, Robina 67
Freshwater 32, 55
Freshwater Bay 120
Freshwater living 24, 66

Gale, Thomas 9, 213, 269
Glanvill, Joseph 77
glass-making 32–3
Goddard, Jonathan 67, 69, 77, 139, 222, 223, 224, 226
Godolphin, Margaret (née Blagge) 321, 322
Godolphin, Sidney 321
Goodman, Cardell 24, 26, 54, 55, 65, 77
Goodman, Cardell, junior 55
Goodwin, Thomas 79
Graunt, John 235
gravitational theory 5–7, 11–12, 319
Great Fire of London 131–5

Greatorex, Ralph 69
Greene, Nan 81
Gresham College: 22, 53, 100; RH lives at 22, 53, 139, 247–8, 314; fossil collection 38; Great Fire 135, 138; Royal Society 135, 165, 312, 314; requisitioned by Corporation of London 138–9; Royal Exchange uses 139; Royal Society's Repository 272, 275
Grew, Nehemiah 237, 311
Grocers' Company's Hall 235
Gyles, Cecily (RH's mother) 23, 24
Gyles, Hannah 252
Gyles, Robert (RH's cousin) 251, 252, 307
Gyles, Thomas (RH's cousin) 307, 308, 309
Gyles, Thomas (RH's uncle) 251
Gyles, Tom (son to Robert Gyles) 251–2, 307

Haberdashers' Company 246
Halley, Edmond: and Newton 3–5, 271; Royal Society's Clerk 9, 269, 270; travels 259, 260–1, 264–6, 271–2; Hevelius dispute 268; accession of William and Mary 289, 290; away at RH's death 307
Hammond, Robert 25, 48, 49, 300
Hammond family 301
Hampden, John 292
Harrison, Dr 257
Hartlib, Samuel 72, 88
Hautefeuille, Jean de 207, 298–9
Henrietta Maria, Queen 108
Herbert, Philip, Earl of Pembroke 25
Hevelius, Johannes 9, 43, 125, 264–8
Hill, Abraham 235
history of trades, Royal Society project 32, 33, 235, 244, 272
Hockley, Nicholas 52, 55
Holder, William 77, 289
Hollis, Anne 307, 308
Holmes, Mary 257
Holmes, Sir Robert 256, 257
Hooke, Anne (RH's sister) 24
Hooke, Grace (RH's niece) 176, 250, 251, 253–6, 256, 257
Hooke, John (RH's brother) 24, 25, 47, 52, 120, 251, 253, 254, 256
Hooke, John (RH's father) 23–4, 26, 50, 52, 53, 54
Hooke, Katherine (RH's sister) 24, 25
HOOKE, ROBERT: and Wren see Hooke's friendship and collaboration with Christopher Wren; desires acknowledgement in Newton's *Principia Mathematica* 5, 7, 10; gravitational theory claim 5–7, 11–12, 319; priority claims 5–7, 11–12, 191, 199–200, 208, 298–9, 319, 320; relations with Royal Society 8, 209, 214, 295, 297–8; Aubrey's letter to Wood 11; desires recognition for his scientific contributions 12; reputation 13; portrait 15, 17–19, 309; appearance 16, 63, 202, 217; career's peak 18; birth 22; lives at Gresham College 22, 53, 139, 247–8, 314; religious beliefs 24, 78, 89–90; childhood 25, 28–30, 50, 91; instrument making 28–9, 42–7, 63, 87, 117, 261, 319; observes sea 29; industrial processes 31–2; mineral waters 31; Royal Society's Curator of Experiments 31, 53, 97–9, 161–7, 236–7; Cutlerian lectures 32, 33, 168, 169, 191–3, 235–40, 240, 259, 282, 285–6; fossils 38, 39, 42, 120; *A Discourse of a New Instrument . . . in Astronomy* 42–3; precision clock design 42, 111–12, 128–9, 199–202, 320–1; publications 42–3, 120, 140, 169, 240, 261; assists Boyle 43, 65, 75, 81, 82, 87, 99, 100–2, 103, 112, 126, 238; and Hevelius 43, 264, 265; *Micrographia* 43, 75, 169, 181, 183, 188, 228, 295; microscopy 43; *Animadversions* 44, 264; equatorial quadrant 44–7; universal joint 47; arrives in London 53; depression 53, 215, 224; wealth 53, 287, 307, 316, 317; Westminster School 57, 58–61; governor of Christ's Hospital School 61; mathematical ability 61, 319; and Busby 62, 300, 302; interest in music 65; assists Willis 66, 72, 75, 81; copy of *De anima brutorum* (Willis) 73–4; loyalty to friends 73, 82, 153–4; Wilkin's last illness 74; honours Wilkins 75–6; artistic skills 80, 87–8, 183; personality and qualities 80–1, 123, 126–7, 141, 161, 178, 194, 202, 214, 216, 217, 234, 266, 299, 304–5, 319, 320; love of science 81–2; interest in travel and exploration 82–5, 272; diary 89, 91, 127, 159–61, 175, 217, 220, 230; health 89–90, 127, 161, 215–17, 221, 296, 298, 304; architectural work 91; and Boyle family 91; capillary action of water 93–5; demands on 98, 107–8, 112, 125–7, 161, 164–5, 212, 216; correspondence 99; daily life 99, 126–7, 139, 175, 217, 221, 247–8;

Hooke, Robert – *cont.*

and Oldenburg 99, 102, 127–8, 146–7, 200, 207, 211; Royal Society elects as Fellow 99; Professor of Geometry Gresham College 100, 235–6, 239, 314; air-pump 104, 105, 106, 189–91; cometary motion 106–8, 115–16; Durdans, Epsom 108–20, 206; carriage design 109–11; determination of longitude 117, 140; quadrant 117; well-based experiments 117–20, 123; *Posthumous Works* 120, 266, 315; rock formations 121; returns to Gresham College 123; balance-spring watch 128–9, 199–200, 201–2, 206, 208, 214; City Surveyor 141–2, 152–3, 154–9, 168, 174; London rebuilding plans 143; Corporation of London 144; Rebuilding Commission 144, 145; building regulations 145–6; intermediary between Royal Society and Rebuilding Commission 146; street widening 148; and Charles II 148, 201–2, 256, 279; rebuilding churches 149; financial position and earnings 150–1, 168, 212, 236–7, 240, 241–5, 297; certificates for ground lost 156; settles rebuilding disputes 157; City Lands Committee 158; drug-taking 161, 215–17, 221–3, 226, 230–4, 304; private building commissions 168–71, 174, 245, 301; Monument (to the Great Fire) 171; and Grace Hooke 176, 250, 251, 253–5, 257–8; and Constantijn Huygens 178–82, 196; and Christiaan Huygens 182, 299; as correspondent 182; Royal Society's Secretary 182, 213; patents 201–2, 214; *Helioscopes* 208; scheme to re-establish Royal Society 210; Royal Society's acting Secretary 211–12; Cutler arrears 212, 240, 241–5; insomnia 221; illness 223–6, 231, 309; clouded urine 228; self-experimenting 230–4, 304; mental alertness, drug assisted 231, 233, 234; *Lectiones Cutlerianae* 240; domestic life 247–8, 252, 299–300; lodgers 248–52; helps young relatives 251–2; maids 252–3, 254, 305; and Young 252–3, 254, 255, 256; liking for sea 258–61; testing pendulum clocks 259–60; and Knox 272–5, 283; Royal Society's Repository 272, 311–12; preface to Knox's book 274–5; importance of foreign

informants 285–6; interest in universal language 286; accession of William and Mary 289–90; career in decline 295; experiments in optics 295; lectures defending his contributions 296–7; attitude to money 298, 300; weather-gauges 298; death 305–6; posthumous reputation 305, 307, 310, 320; funeral 306–7; claimants to RH's estate 307; final illness 309; draft will 316–17; library 317; contemporary detractors 321; Scotland Yard 321, 322; attends *Virtuoso* 322

Hooke joint *see* universal joint

Hooke's friendship and collaboration with Christopher Wren: formation and nature of 14–15, 78, 80–1, 153; cometary motion 106–8, 115–17; carriage design 111; determination of longitude 117, 140; Rebuilding Commission 147, 148, 150; Wren's architectural office 150–2, 168, 173–4, 297; Monument (to the Great Fire) 171; Wilkin's illness 227; Cutler arrears 243; RH gains audience with Charles II 256; accession of William and Mary 289; decline in 307

Hopkins, William 23, 25, 50

Horsington, Sarah 216

Hoskins, Sir John: and RH 8–9, 98, 151, 256; Royal Society President 212; Cutler endowment 235; Cutler arrears 243; Royal Society position 269; and Baron 283, 285; accession of William and Mary 289; account of *Virtuoso* 322

Hoskins, John (painter) 54

Houblon, Sir James 286

Hunt, Henry (Harry): lodges with RH 249–51; draws Grace Hooke 254; RH's death and after 305, 307, 317; Royal Society's Repository 311; assists RH's experiments 319

Huygens, Christiaan: precision clock design 44, 111, 129, 180–1, 191, 192, 198–202; mathematical education 61; in England 94, 188–9, 292–4, 311, 319; air-pump 105, 189–91; admitted to Royal Society 106; cometary motion 107; patents 173, 198–9, 200–1, 214; *Horologium oscillatorium* (On Pendulum Clocks) 180, 191, 192; and Royal Society 180–1; opinion of RH 182, 188, 196, 207; and Boyle 189–90; lives in Paris 192; and Moray 192, 203; and Oldenburg

194, 198–9, 200–1, 202, 203, 206, 207–8;
balance-spring watch 198–9, 200, 203,
214; appearance 202; depression 214–15;
retires to Hofwijk 290–1, 295; and
Newton 293
Huygens, Sir Constantijn: introduces
Leeuwenhoek to RH 178–81; microscopy
183; air-pump 191; political position 194,
195; and Oldenburg 195, 196, 197;
withdraws from priority controversy
208; Christiaan's depression 214–15
Huygens, Constantijn, junior 194, 290, 295
Huygens family 99

Iles, Dr 66

Jaggard, Abraham 168
James I 48
James II (earlier Duke of York) 89, 133,
134, 194, 288, 289, 294
Jeffreys, Lord 294
Jerman, Edward 141, 142, 144, 145, 149
Jerome, Earl of Portland 25
Jones, Richard 71, 91, 93

Kedges, Mrs 252
Kirke, Thomas 298
Kneller, Godfrey 16–17
Knox, Robert: and RH 272–5, 283; An
Historical Relation of Ceylon 273–5, 278;
travels 278–83; scientific experiments
282; niece 287; RH's death and after
305, 307
Knox (Robert's brother) 272

Langley, Henry 67
lathes 63
laudanum 223
Lawrence, Sir John 143
Lawson, Margaret 24
Leeuwenhoek, Antoni van 178–9, 180, 195,
319
Lely, Sir Peter 53, 54
Levitt, Sir Richard 244, 246
Linschoten, Jan van, Itinerario 83–4
Locke, John 62, 65, 77, 291
Lodowick, Francis 286
London: Great Fire 131–5; Corporation of
139, 141, 144, 146, 168; rebuilding 140–59;
churches 149–50
longitude, determination of 117, 140
Loubère, Simon de la 286
Louis XIV 129

Lower, Richard 77
Lutton church 300, 301, 302–4

Magalotti, Lorenzo 206
Mallet, John 72
Mary II (Stuart) 288
mathematics 60–1, 320
Maurice, Prince John 189
May, Hugh 144, 148
microscopy 43, 179, 181, 183, 195
Millington, Thomas 69
Mills, Peter 141, 142, 144, 145, 148, 156, 157,
158
Molyneux, William 266, 268, 269, 270, 271
Montagu, Ralph 170, 250, 318
Montagu House 250, 318
Monument (to the Great Fire) 171
Moore, Sir Jonas 201, 202
Moray, Sir Robert: 92, 93; suggests RH as
Curator of Experiments 99; project
proposal 106; cometary motion 107;
moves to Oxford 108; comments on RH
125–6; precision clock design 129; air-
pump 189; and Constantijn Huygens
191; and Christiaan Huygens 192, 203,
206

Needles, Isle of Wight 35–6
Neile, Sir Paul 92
Newland, Benjamin 34
Newton, Isaac: Principia Mathematica 3–5,
271, 291, 295; gravitational theory 5–7,
319; and RH 5–7, 10, 295; access to
Philosophical Transactions 9; reputation
13; RH's portrait 15; portraits 16–17;
childhood 30, 91; Royal Society
meetings 199; proposed mastership of a
Cambridge College 292; and Christiaan
Hugyens 293; Cambridge University's
representative to national Convention
294; and Fatio de Duillier 294; Royal
Society President 314; mathematical
view of science 319

Offenbach, Zacharias Conrad von 310
Oglander, George 23
Oglander, Sir John 23, 48, 50, 51
Oldenburg, Henry: Oxford scientific group
71; joint Secretary of Royal Society 93;
and RH 99, 102, 127–8, 147, 200, 207,
211; air-pump 104, 106, 189; hopes Boyle
will release RH from duties 105; on
plague 110; and Boyle 127–8, 190;

Oldenburg, Henry – cont.
precision clock design 129; rebuilding London plans 143; apologises for RH's comments 178; and Christiaan Huygens 194, 198–9, 200–1, 202, 203, 206, 207–8; and Constantijn Huygens 195, 196, 197; disseminates Royal Society activities internationally 200; opinion of RH 201; death 210; and Hevelius 268; and Newton 295
Oliver, John 141–2, 151, 156, 157
optics 295
Oughtred, William 60, 61
Owen, John 77, 79
Oxford: 65–71; scientific group 69–71, 73, 76–7; Charles II's court 108

Palmer, John 67
Pell, John 61
Pembroke, Oxford 67
Pepys, Samuel 88, 109, 181, 184, 258–9, 282
Pett, Peter 77, 79
Petty, Sir William: Oxford scientific group 69, 77; and Willis 81, 82; Royal Society experiments 108, 111, 112; and Boyle 215; Cutler endowment 235, 239; Cutler arrears 243, 244
Philosophical Collections 212
Philosophical Transactions 9, 198, 200, 209, 266, 268, 269
Phoebe (Knox's niece) 287
Pitfield, Alexander 286
plague 108, 110
planetary motion, laws of 5–7
Plot, Robert 213
pocket watches 198
Pope, Walter 77, 81, 140
Pratt, Roger 144, 148
precision clock design: RH's interest in 42, 320–1; equatorial quadrant 44; marine timekeepers 111–12; balance-spring watches 128–9, 198–203, 206, 208, 214; Christiaan Huygens 180–1; RH and Christiaan Huygens 191–209, 214
precision instruments 42–7, 63

quadrants 43, 44–7, 117

Ranelagh, Lord Arthur Jones 88
Ranelagh, Lady Katherine (née Boyle) 87, 89, 91, 210–11
Rawlinson, Richard 69
Ray, John 17

Rebuilding Commission 144–8, 150
religious beliefs 78–80
Robinson, Tancred 9, 266, 268
rock formations 121
Rooke, Lawrence 69
Royal College of Physicians 168–9, 240, 242
Royal Exchange 139, 149, 247
Royal Observatory, Greenwich 261
Royal Society: history of trades project 33, 235, 244, 272; fossil collection 38; origins of 82, 91–2; founding 91–3; name 95–6; appoints RH as Curator of Experiments 97–9, 102; coat of arms 97; carriage design 108–11; experimental expectations of RH 125–7, 142, 161–7; internal rivalry 127–9; Gresham College 135, 165, 167, 312, 314; Arundel House 163, 165; and Leeuwenhoek 195; balance-spring watch 198–200, 206; official records 206; priority claims 206; Cutler endowment 235–40; Cutler arrears 242, 243; Hevelius letters review 268–70; investigations into peoples, cultures and trades 275; collecting specimens 278–9; and Knox 282; Crane Court 314–15, 317–18; publications 183–5, see also Philosophical Collections; Philosophical Transactions; royal charter 92, 96–7, 99; records 99; work at Durdans, Epsom 108–20, 206; response to Great Fire 140, 143, 144; RH's salary 168, 209; statement regarding RH and Oldenburg 209; scheme to re-establish 210; replacement for Oldenburg 211; success of early years 211; Repository 272, 275, 310–12, 314–15, 317; reputation 295; relations with RH 297, 299
Rupert, Prince, Count Palatine 106

sal ammoniac 216, 231
salt manufacture 33
Scarborough (measuring clerk) 173
Scarburgh, Charles 81
Schellinks, William 34, 39
Scotland Yard 321
Scovell, Alice 50
Shadwell, Thomas 321, 322
Sharrock, Richard 87
Sheldon, Gilbert 66, 75
Sheldonian Theatre 75
Shortgrave, Richard 163
Sloane, Hans 17, 19, 298

Snell, Mr 248–9
Somers, Lord John 312
Somerset, Duke of 292
Sorbière, Samuel 106
South, Robert 59, 63
Sprat, Thomas 77, 80, 177
spring-regulators 203
St Anne's and St Agnes 152
St Benets Finck 152
St Edmund the King 152
St Lawrence Jewry 151, 152
St Magnus 152
St Martin within Ludgate 152
St Mary le Bow 152
St Michael Bassishaw 152
St Paul's Cathedral 235; Great Fire 134
St Stephen's Walbrook 151, 152
Stephens, Elizabeth 307, 308, 309
strangers, suspicion of 177, 178
Stubbe, Henry 77
surveyors 141–2, 154, 156

talipot leaves 275, 278
telescopes 42
Tillotson, John 68, 73, 74, 77
Tompion, Thomas 43, 201, 322
toxic substances 304
Turner, Sir William 18

universal joint 47
University Church (St Marys, Oxford) 79
urine, clouded 228
Urrey, Elizabeth 55
Urrey, John 50
Urrey, Robert 24, 50, 54, 55
Urrey family 32

Virtuoso, The (Shadwell) 321–2

Wadham College 66, see also Oxford
    scientific group
Waller, Richard: 90, 120; RH's appearance
    16, 63, 217; RH's literary executor 22,
    140; RH's wealth 174; Cutler arrears 245;
    Grace Hooke 253, 258; Posthumous
    Works (Hooke) 266; accession of
    William and Mary 289; RH's personality
    299; RH's funeral 306–7; after RH's
    death 307, 315, 317, 320; Royal Society's
    Repository 311, 314, 315
Wallis, John 69, 77, 107, 266–8
Warburton, George 24
Ward, Seth 69, 77

Warwick, Mary, Countess of 103, 190
watches see precision clock design
Watson, William 19
wave-theory of light 295
weather-gauges 298
well-based experiments 117–20, 123
Westminster School 57–61, 63
Whistler, Dr 223
Whistler, Mrs 253
Wight, Isle of 26–8, 30–9, 47–52, 54,
    120–3
Wilkins, John: 66–71; telescopes 42; and
    RH 66, 75; Wadham College 66, 67;
    Oxford scientific group 69, 73, 76–7;
    and Boyle 70–2; death 74, 224, 226–7,
    230; influence of 75–7; beliefs 77; and
    beginnings of Royal Society 82, 91–2;
    portrait 91; joint Secretary of Royal
    Society 93; Durdans, Epsom 108;
    projects 112; treatment 226; Cutler
    endowment 238, 239; donation to Royal
    Society 311
Willen church 61, 301
Willen estate 300, 301
William III (of Orange) 89, 194, 195, 288,
    290, 292
Williams, Reeve 309
Williamson, Sir Joseph 77, 212
Willis, Thomas: RH assists 66, 72, 75, 81;
    experiments at Wadham 69–70; De
    anima brutorum 73; Oxford scientific
    group 77; and Fell 78; Cerebri anatome
    80; religious beliefs 80; and Wilkins 82
Winthrop, John 27
Wood, Anthony 11, 65
Wood, Roger 77
Woodroffe, Edward 149, 150, 151
Wren, Christopher: and RH see Hooke's
    friendship and collaboration with
    Christopher Wren; mathematical
    education 61; Oxford scientific group
    69, 77, 82; religious beliefs 78, 80;
    drawings used in Cerebri anatome
    (Willis) 80; personality and qualities
    80–1; assists Scarburgh 81; drawings 88;
    after Restoration 89; avoids private
    building commissions 91; childhood 91;
    lectures at Gresham College 91;
    cometary motion 106–8, 115–16;
    determination of longitude 117, 140;
    building houses in St James's 123;
    precision clock design 129; plans for
    rebuilding London 143; Rebuilding

Wren, Christopher – *cont.*
Commission 144, 145, 148; Surveyor of the Royal Works 149, 150, 152; architectural office 150, 151–2, 174; scheme to re-establish Royal Society 210; discusses Oldenburg's replacement 211; Royal Society President 212; Royal Exchange 247; costs Lutton church works 304; proposal for Royal Society building 312, 314, 315; after RH's death 317; Scotland Yard 321
Wren, Christopher, junior 314, 315
Wren, Matthew 77
Wren, Susan 80

Yarburgh, Lady 322
Yarmouth 27, 52
Young, Nell 252–3, 254, 255, 256

P.S.

Ideas,
interviews
& features ...

## About the author

2 Profile of Lisa Jardine

4 Snapshot

6 Top Ten Favourite Books

7 Life Drawing

## About the book

8 Hooke's Lost Legacy: What Really
Happened?

## Read on

16 If You Loved This, You'll Like ...

# Profile

*Lisa Jardine talks to Rachel Holmes*

LISA JARDINE IS sitting on the sofa with David Attenborough, watching her father's 1973 TV series, *The Ascent of Man*, about to be screened again by BBC Worldwide. 'I can probably only tell you this,' she whispers to Attenborough about Bronowski, TV's first and most loved popular science guru, 'but for thirty years I've assiduously avoided watching these programmes, in case I tried to emulate him. Now, I'm experiencing pure Oedipal envy: he's *so* good!'

'All ambitious offspring emulate their parents,' Attenborough replies, 'but usually by the time they are measuring themselves against their parent, that parent is on the wane. You're approaching the age at which Bronowski made *The Ascent of Man*, and you are competing with him as an equal.'

It is a sharply insightful compliment. Competing as an equal in domains once ring-fenced for men is at the heart of what makes Lisa Jardine tick – or, as she might prefer it, 'kick ass'. I wonder what she would have been if she had lived in her period of expertise?

'I couldn't have lived in the Renaissance. That's why I do history. If I had been born at any time before the Second World War, I couldn't have had the intellectual life I've had, and I would probably have died in childbirth.'

The pragmatic note is characteristic of a daughter of Eastern European immigrants. Her father was forced from his native Poland, and then Germany, arriving in London in 1920 where he was seduced by

talented and determined sculptress Rita, daughter of Russian immigrants. I am weak with the romance of the story, but the reality was of success earned by determination, ingenuity and hard graft. Lisa bears the firm stamp of these hard work ethics and the ingrained understanding that dissent is the mark of freedom.

'My parents believed unwaveringly in education as the route out of deprivation. So I was really lucky with that. I am the eldest of four daughters; so my father had to make do with me as his boy child. I was brought up to believe I could be anything. Which is what immigrants do.'

She started writing academic books at Cambridge, where she lectured in English literature. 'At Cambridge I was a boy. I reached high academic position by being indistinguishable from a man.' The publication of *Still Harping on Daughters*, her 1983 book about women in Shakespeare, was her wake-up call. The book's explicit feminism meant she could no longer be mistaken for one of the boys, and, predictably, she came under attack. Outspokenness on topics which took her on a collision course with the male establishment revealed the existence of previously concealed glass ceilings. She left Cambridge for a post at London University, 'Because I couldn't stand the complete invisibility of women in the academy a minute longer.' As she says it, there is still great impatience in her voice.

Architect husband John Hare and Lisa ▶

> ❛ I was brought up to believe I could be anything. ❜

## Profile *(continued)*

◀ brought their family of two sons and a
daughter with them. London, she says,
allowed her to tumble down from the ivory
tower and 'connect the academic world with
the real world'. She became Professor of
Renaissance Studies at Queen Mary, and
thereafter held almost every senior position,
including Dean and Head of Department.
'If you want to be a woman leader, you
can't duck the dreary bits of institutional
leadership. I had a responsibility to show
how bloody well women run things,
although the fiction persists that they lack
the balls to do so.' She is notoriously
intolerant of prima donnas who mimic the
wafting mode of big boy intellectual genius
and won't dirty their sleeves with the real
work required to change institutions.

Along with institutional engagement,
family life remains an important part of
who she is. She can sing, cook and sew (with
neat, even stitches). 'I would be gutted to
be someone who couldn't casually operate
in the domestic sphere.'

Lisa published six scholarly academic
books on Renaissance studies of various
sorts before writing *Worldly Goods*, her first
book for a larger audience. Why did she do
it? 'It was a response to a dare from an ex-
student. He said to me, "People mob your
lectures. Why do you just write books for
ten people you already know?"' It was an
irresistible challenge to leave the shelter of
academic authority and open up her ideas
to a bigger, more demanding audience.

*Worldly Goods* and *Ingenious Pursuits*
rewrote the Renaissance, 'because the old

version was wrong'. The first laid bare the pleasures and pitfalls of Renaissance consumer culture; the second the military and competitive networks that made the scientific revolution. 'Art and science are not as esoteric as we always thought.'

Debunking the esoteric is a principle she applies to many other areas of life. When Lisa went to her publishers HarperCollins and said she wanted to write a book on Robert Hooke, she got the 'Who's he?' response familiar to many writers with new biographical subjects. She explained that he was Christopher Wren's architectural partner and best friend. So instead she was encouraged to write her book on Wren, *On a Grander Scale*. As soon as she'd finished Wren, she went back to HarperCollins and asked, 'Now can I write the Hooke book?' 'Yes,' said editor Michael Fishwick, 'but it has to be ready for Hooke's 300th anniversary, so you have to do it in a year.' And she did.

For Lisa, the fact that Wren and Hooke were best friends is more than an incidental biographical detail. With this pair of books what preoccupied her was 'the disastrous drag of the idea of the lonely solitary genius on our understanding of the world. Everywhere I looked, I saw fabulous teams of people collaborating to move the world forward.' She is contemptuous of intellectual property rights, arguing that every major breakthrough has come out of some kind of partnership and sharing. It is a scientifically minded position that reveals her original training as a ▶

Fellow of the Royal Society for the Encouragement of Arts, Manufactures and Science; Honorary Fellow, King's College, Cambridge

## TOP TEN
### FAVOURITE BOOKS

1. **The Life of Pi**
   *Yann Martel*

2. **Rembrandt's Eyes**
   *Simon Schama*

3. **The Return of Martin Guerre**
   *Natalie Zemon Davis*

4. **The Great Cat Massacre**
   *Robert Darnton*

5. **Foucault's Pendulum**
   *Umberto Eco*

6. **Flesh in the Age of Reason**
   *Roy Porter*

7. **Daughters of the House**
   *Michèle Roberts*

8. **Fugitive Pieces**
   *Anne Michaels*

9. **Beloved**
   *Toni Morrison*

10. **Leviathan and the Air-Pump**
    *Steven Shapin and Simon Schaffer*

## Profile *(continued)*

◄ mathematician. 'There's a tradition of thinking about big men in splendid isolation. I think that's silly. They are just one link in a chain. It's lazy thinking to want to attribute historical change to individuals.' She insists that her books are collaborative, drawing on the work of scholars whom she is careful to acknowledge. She regards herself as a person who can communicate the excitement of that scholarship to a general audience. 'I suppose the only thing that hurts my feelings is that people understand that inclusive, collaborative aspect so well about my books that the real research discoveries of my own are not always recognised. I suppose I just tend not to foreground them.'

We finish the interview in Lisa's office. Her current project, *Going Dutch: How Holland Shaped Our Identity*, is a big-themed, big-ideas book about forces of change which don't observe national borders, and life and thought constantly crossing boundaries. The shift away from historical biography is characteristic of a mind restlessly seeking to connect history, science, and art on a broad, far-reaching and inclusive canvas. 'I think I can be more than one thing. I never want to believe that the thought I've had, nobody else could have had. That would mean being out of touch.' As she is vibrantly dressed in this season's keynote green, her office walls pinned with protest against the war on Iraq, and the screen of her signature Apple Mac completely obscured by new publications on a dizzying array of subjects, there seems no risk of that. ∎

# Life Drawing

*What is your idea of perfect happiness?*
Thinking by a pool in the sun.

*What is your greatest fear?*
Not being good enough.

*Which living person do you most admire?*
Historian Natalie Zemon Davis.

*What single thing would improve the quality of your life?*
More hours in a day.

*What is the most important thing life has taught you?*
That it's never worth losing your temper.

*What would be your desert island luxury?*
An iPod.

*Which writer has had the greatest influence on your work?*
Thomas Babington Macaulay.

*Do you have a favourite book?*
The last book I couldn't put down: most recently, *My Name is Red* by Orhan Pamuk.

*Where do you go for inspiration?*
Any archive anywhere.

*Which book do you wish you had written?*
*Renaissance Self-Fashioning* by Stephen Greenblatt (it made Renaissance studies sexy).

*What are you writing at the moment?*
A short book about the first assassination of a head of state with a handgun – in 1584. ■

# Hooke's lost legacy: What really happened?

*by Lisa Jardine*

TO THE VERY end of his life Hooke
remained active at the Royal Society and
prominent in London coffee-house society.
How did it happen that within five years of
his death he was all but forgotten? When I
had finished *The Curious Life of Robert
Hooke* it still worried me that I had not
managed entirely to explain his mysterious
disappearance.

Was there any evidence I had discarded
which could shed light on the mystery of
Hooke's lost reputation? With hindsight I
think that there was.

We mostly have to rely on contemporary
anecdote to reconstruct events surrounding
Hooke's death in March 1703. There are his
much younger friend Richard Waller's
remarks that Hooke had been ill and
reclusive for some time. There are gossipy
letters exchanged between Royal Society
members to the effect that in the last
months his miserliness verged on insanity
and that he even begrudged his servants
money for food.

Then there are fragments of fact.
Although Hooke died technically intestate,
I discovered in the course of my research
that there was in fact an unsigned will,
though it lacks the attached schedule
specifying the size and purpose of the
legacies, and the names of the 'four friends'
he intended to nominate to administer his
estate. Once again, contemporary gossip
has something to say about this: 'Dr Hook

hath left this World & was laid in the earth last Saturday. He designed to have made Sir Christopher Wren, Sir John Hoskins & one Reeve Williams & Capt. Knox Executors or Trustees but some accident or other Hindred his Executing of his Will, for it seems there was one made.'

Some more substantial materials in the National Archive, which came to light while I was researching *The Curious Life of Robert Hooke*, turned out to contain telling new detail about Hooke's death. These are lengthy records – petitions, complaints, witness statements, court rulings – of a case in the Court of Chancery, contesting the settlement of Hooke's estate. It was lodged three years after Hooke's death and rumbled on for years, finally fizzling out unresolved around 1711. The problem was that the material contained in these records was like a low-resolution image on a computer screen – the shadowy outline was there, but it contained many gaps and contradictions. There was not quite enough to turn into a narrative. In the end I reluctantly restricted my treatment of these fascinating documents to a couple of paragraphs (pp. 309–10). I now think that story adds considerably to our understanding of the posthumous fortunes of Robert Hooke.

A few months before his death (some witnesses say seven, some four) Hooke's health failed, and he told an old coffee-house companion, the mathematician ▶

❝ Within five years of his death Hooke was all but forgotten. ❞

## Hooke's Lost Legacy *(continued)*

◀ and navigator Reeve Williams, that he needed live-in help. He probably indicated that he was not prepared to pay much. Williams recommended Elizabeth Stephens, who he said he thought was a relative, daughter of Hooke's father's brother, Thomas Hooke of Wroxall in Warwickshire. Elizabeth was too elderly (though it may be she was the 'old woman' whom he had 'starved to death', according to the gossip), but her daughter Mary Dillon took on the job of nursing him. According to Lewis Stephens (Elizabeth's husband), Mary Dillon had 'a great love and kindness for to attend and look after him in his sickness', while Elizabeth 'often herself went to visit', and Hooke called them both 'cozen'. According to counter-claimants in the suit, Hooke denied that the Stephenses or Dillons were any relation at all.

The night Hooke died – between 11 and 12 midnight on 2 March, though not certified dead till the next morning – the 'Girle that wayted on him', who ran to fetch his friend Captain Knox, may have been Mary Dillon. It was certainly Mary Dillon who took charge over the following weeks, returning items in Hooke's possession which belonged to the Royal Society (which continued to meet in his rooms at Gresham College), donating scientific items to the Society as gifts, and passing personal papers to friends of Hooke's like Richard Waller (thereby fulfilling the expectations of members: 'I have heard he had may valuable things in his Papers, 'tis pity they should be lost, presume they will fall to

❝ There are gossipy letters exchanged between Royal Society members to the effect that in the last months Hooke's miserliness verged on insanity. ❞

the Royal Society, who may possibly in time produce such things as will be of publick use.'). Even before the administration of Hooke's estate had been settled, she was confidently acting as administrator of his affairs. Hooke was buried on 6 March. By the end of April the Dillons had wrapped up the estate, emptied his rooms, disposed of his property on the Isle of Wight and auctioned his library for the substantial sum of £250.

Some witnesses in the later court case claimed that Mary and her husband had begun disposing of substantial items among Hooke's possessions while he lay sick, and that the sums of money in the house immediately before his death 'did amount to thirteen or fourteen thousand pounds or some such great sum', rather than the £8,500 (some versions say £9,500) recorded in the probate inventory (for which Joseph Dillon was responsible). Royal Society gossip also set the sums much higher than the inventory, on the authority of Lewis Stephens: 'he left behind him (as I am creditably Informed by Mr Lewis [Stephens] his Uncle [actually cousin] who was one of his neighbours) in old hammered money £7000 & upwards & in other money £5000 in all £12000 all Lockt up in Chests in the House'; others set the sum as high as £20,000. It was also claimed that Joseph Dillon had settled the deeds to one of Hooke's Isle of Wight properties on other 'relatives' of Hooke's who had appeared on the scene shortly after his death, also laying claim to the estate, thereby dissuading ▶

❛Some witnesses claimed that Mary and her husband had begun disposing of substantial items among Hooke's possessions while he lay sick. ❜

## Hooke's Lost Legacy *(continued)*

◄ them from pursuing that claim through the courts.

Although, thanks to Reeve Williams's intervention, the Stephenses and Dillons were on hand to take control of Hooke's affairs, their entitlement to inherit never seems to have been fully substantiated. A John Hooke of Wroxall does appear to have been Hooke's grandfather. It is plausible, therefore, that Thomas Hooke of Wroxall was another of his sons. It is less clear that Thomas Hooke had a daughter named Elizabeth (there was a daughter named Mary, and a son, John, who had died in 1672). By contrast, another claimant, Anne Hollis, who came forward within months of Robert Hooke's death, could prove that she was the daughter of Thomas Giles (or Gyles), Hooke's mother's elder brother. According to testimony, Anne agreed to accept a lump sum of around £3,500 from the estate, leaving the Stephenses and Dillons in possession of the rest.

All of this is on the record because in 1706 Anne Hollis's younger brother, Thomas Giles, who had settled and prospered in Virginia (and whom she had failed to mention when she made her own claim), learned of Hooke's death from one of his nieces, and sent letters to the Court of Chancery making his own bid for part of the estate. He had, indeed, an identical claim to that of Elizabeth Stephens and Anne Hollis; all three were (or claimed to be) the children of uncles of Robert Hooke. Once this was established (in 1708) the Court appears to have been minded to rule that

❝ After close scrutiny of the often contradictory legal documents, it is Reeve Williams's involvement in the whole affair which seems anomalous. ❞

Giles should get the third of Hooke's estate he was entitled to. By now, however, faced with the need to come up with money and goods long since disposed of, others involved in the case had begun their own claims and counter-claims against one another. Elizabeth Stephens had died, leaving her share of Hooke's estate to the Dillons, who claimed that her will overrode any new claim. They also began proceedings against Anne Hollis for restitution of some of the money given to her, alleging that she had incited Thomas to come forward in order to obtain a larger portion for herself. By 1711 Thomas Giles may have been too old to care any longer (he died in 1715), and there was no one left who felt strongly enough to pursue the matter.

So can we lay the blame for the obliteration of everything that remained of Hooke's affairs (and hence, effectively, his enduring reputation) at the feet of anyone in particular? After close scrutiny of the often contradictory legal documents, it is Reeve Williams's involvement in the whole affair which seems anomalous. Williams was technically a member of the Royal Society (nominated by Hooke in 1699), but had never taken an active part in its proceedings. He belonged to the growing band of exponents of practical science and mathematics who lectured and gave experimental demonstrations for less élite audiences, in the coffee-houses – a 'City' milieu in which Hooke also moved. Williams was no friend of Newton, President of the Royal Society, who had ▶

‘ According to one rumour, an iron chest containing as much as £10,000 in coin, found in Hooke's library, had been removed by the Dillons to Williams's house. ’

## Hooke's Lost Legacy *(continued)*

◄ blocked his appointment to a post at Christ's Hospital Mathematical School some years earlier, preferring a less practically minded candidate (who proved a disaster).

Those close to Hooke believed he had intended to leave his wealth to the Society, to fund a 'handsome Fabrick for the Societies use, with a Library, Repositary, Laboratory, and other Conveniences for making Experiments, and to found and endow a perpetual Physico-Mechanick Lecture'. By finding a living heir for Hooke's vast fortune, all hope was lost of the Royal Society taking charge of his legacy for such a purpose. Contemporary gossip implicated Williams further in some sort of 'conspiracy'. According to one of the rumours recorded in the court depositions, an iron chest containing as much as £10,000 in coin, found in Hooke's library, had been removed by the Dillons to Williams's house in Cornhill and the undeclared contents divided between them. Though there is no evidence to support this, it captures the widespread belief that some kind of skulduggery had taken place – that Hooke had been 'lost' to posterity through the meddling of those who did not have his best interests at heart.

The murky, contradictory evidence surrounding the competing claims made posthumously on Hooke's fortune and the dispersal of his wealth, scientific instruments, rarities and personal possessions help explain his posthumous disappearance from the public record. The

❦ Admirers and predators alike siphoned off instruments, rarities and cash from Hooke's Gresham College lodgings. ❦

actors centre-stage were for the most part people who had scarcely known him. Old friends like Waller, Hunt and Wren could do no more than stand by and watch, as admirers and predators alike siphoned off instruments, rarities and cash from Hooke's Gresham College lodgings, dismantling his legacy in front of their eyes. For their part, they had to use the same means as the Dillons – carrying away what they could of his intellectual remains as the opportunity arose. As I suggested in *The Curious Life of Robert Hooke*, the Royal Society's Repository at Crane Court may have been built with money Waller and Hunt succeeded in getting their hands on, with or without the approval of Mary Dillon.

In 1708 Joseph Dillon gave Hooke's precious manuscript diary to Waller. Mary Dillon had already passed him a considerable quantity of loose papers, which he had published in a volume of *Posthumous Works* in 1705. Waller wrote on a blank page at the end of the diary: 'Mr Dillon the husband of Dr Hookes Neice who was Administratrix to Dr Hook who dyed without a Will gave mee this manuscript about December in the year 1708. he having found it amongst Dr Hooks Remains. to whome and to his Wife I am obliged for all the papers I had put into my hands of that great genius Dr Hook.' The recovery of the cryptic, fragmentary diary could not, however, compensate for the disappearance of Hooke's more substantial legacy. ▶

❛Hooke's memory was drowned out in a hubbub of greed.❜

# Read on

## If You Loved This, You'll Like...

*The Lunar Men: A Story of Science, Art, Invention and Passion*
Jenny Uglow

.........................................

*London's Leonardo: The Life and Work of Robert Hooke*
Jim Bennett, Michael Cooper, Michael Hunter, Lisa Jardine

.........................................

*The Man Who Knew Too Much: The Inventive Life of Robert Hooke 1635–1703*
Stephen Inwood

.........................................

*A More Beautiful City: Robert Hooke and the Rebuilding of London After the Great Fire*
Michael Cooper

.........................................

*A Bibliography of Robert Hooke*
Geoffrey Keynes

## Hooke's Lost Legacy (continued)

◄ What emerges from the confusion of claim and counter-claim is that because of the size of Hooke's fortune – historians suggest multiplying by 100 to get a modern sense of sums of money in the period, hence Hooke's estate was worth somewhere between £850,000 and £2,000,000 – all attention, in the period immediately following his death, was focused on the man's wealth rather than his impressive public reputation. As those who had hardly known him, and never known him as the popular, gregarious, talented, remarkable person he had been in his prime, squabbled among themselves and plotted to get their hands on his money and goods, his memory was drowned out in a hubbub of greed. How ironical that Hooke had refused to spend any of his hard-earned wealth on himself in his last days, for fear he would 'outlive his Estate'. His final misfortune was his fortune. ∎